ART INFORMATION AND THE INTERNET

How to Find It, How to Use It

by Lois Swan Jones

Oryx Press
1999

Art Information and the Internet

is dedicated to Caroline H. Backlund,

who has assisted me in the

development and production of this book,

and to my friends and colleagues in

the Art Libraries Society of North America and

the Visual Resources Association.

Thank you for all your encouragement and support.

The rare Arabian Oryx is believed to have inspired the myth of the unicorn. This desert antelope became virtually extinct in the early 1960s. At that time, several groups of international conservationists arranged to have nine animals sent to the Phoenix Zoo to be the nucleus of a captive breeding herd. Today, the Oryx population is over 1,000, and over 500 have been returned to the Middle East.

© 1999 by Lois Swan Jones
Published by The Oryx Press
4041 North Central at Indian School Road
Phoenix, Arizona 85012-3397

Published simultaneously in Canada

Printed and bound in the United States of America

∞ The paper used in this publication meets the minimum requirements of
American National Standard for Information Science—Permanence
of Paper for Printed Library Materials, ANSI Z39.48, 1984.

Library of Congress Cataloging-in-Publication Data
Jones, Lois Swan.
 Art information and the internet : how to find it, how to use it /
by Lois Swan Jones.
 p. cm.
 Includes bibliographical references and index.
 ISBN 1-57356-162-2 (alk. paper)
 1. Art—Computer network resources. I. Title.
N59.J66 1998
025.067—dc21 98-34061
 CIP

CONTENTS

Part Three. How to Use and Supplement Web Information 105

FOREWORD

The name of Lois Swan Jones immediately comes to mind for those of us who study and work in the field of art documentation and research methodology. Her publications have greatly advanced knowledge of the extensive range of art literature and have provided a systematic approach to research methodology. In her distinguished career, Jones has worked as an educator and lecturer in art history and museum studies, a producer of video documentaries, and a professor of art history.

Three art bibliographies and research guides brought her recognition as an art research authority. These works became widely used in art history and art bibliographic instruction courses. The first book, *Art Research Methods and Resources: A Guide to Finding Art Information*, published in 1978, was followed by an enlarged second edition in 1984, and a third edition, retitled *Art Information: Research Methods and Resources,* in 1990. In all three, the bibliographic material was extensive and well annotated. International in scope, the books included sources past and present in all available formats—text, visual materials, microforms, CD-ROMs, videos, and the new electronically produced resources that gradually have been introduced.

An outstanding and popular feature of Jones's books is her practical, problem-solving approach. She takes her readers step by step through a well-organized, fact-finding process, presenting the many basic and specialized scholarly art research tools in the different media. With effective working methods in mind—and directed to the widest possible audience—Jones's bibliographic guides reached an enthusiastic readership worldwide.

Three years ago, as Jones began work on her latest edition, it became abundantly clear that the traditional approach was no longer adequate. The electronic medium is rapidly transforming the way information is documented, accessed, and transmitted. As institutions and individuals respond in various ways to the evolving information revolution, the need has become obvious for a new type of reference source. At a time when changes in formats and procedures are rapidly taking place—and when publishers and producers of equipment and software are themselves uncertain what directions the electronic changes are taking them—the task is clearly daunting. Anyone seeking information in this new environment is often confused by the seemingly unorganized mass of data becoming available. It was evident that background knowledge of the electronic sources, supported by an expanded and changed research methodology, was needed. Aware of the situation, Jones decided to meet the challenge, and the result is this groundbreaking book.

Given the exponential growth of resources on the World Wide Web, no guide can pretend to be definitive. Furthermore, many traditional text resources will continue to be used, either alone or updated by new formats. Lois Swan Jones effectively points the way toward what art information is out there and how best to find it. For her perspective, dogged research, and helpful guidance in this publication, the art research community will be grateful.

Caroline H. Backlund
Librarian (Retired), National Gallery of Art
Washington, D.C.

ACKNOWLEDGMENTS

This book was made possible by the editorial assistance of Caroline H. Backlund, formerly collection development librarian of the National Gallery of Art, Washington, D.C. Caroline encouraged the development of this book and then assisted me in the organization of the material; she read the entire manuscript—certain chapters not once, but several times—and edited, cajoled, and encouraged me every step of the way. I will never be able to thank her adequately.

Other experts were also gracious with their time and expertise, checking specific sections of the manuscript and offering valuable suggestions. I would especially like to thank Research Librarian Annette Weir at the Mayer Library, Dallas Museum of Art, for her sound advice and assistance in completing the manuscript. I would also like to thank other wonderful colleagues and friends who read sections of the manuscript, suggesting additions, deletions, and changes. Thanks go to Mary F. Williamson, fine arts bibliographer emeritus, Scott Library, York University; Margaret Culbertson, art and architecture librarian, Jenkins Architecture and Art Library, University of Houston; Pat M. Lynagh, head of reader services, National Museum of American Art/National Portrait Gallery Library; and Janet L. Stanley, chief librarian, National Museum of African Art.

In addition, I wish to express my appreciation for the assistance of Louis V. Adrean, assistant librarian for public services, Ingalls Library, the Cleveland Museum of Art; Kenneth Chamberlain, formerly head librarian, Emily Carr College of Art; Susan V. Craig, art and architecture librarian, University of Kansas; Milan Hughston, head librarian, and Sam Duncan, assistant librarian/cataloguer, the Amon Carter Museum; Janis K. Ekdahl, chief librarian for administration, and Daniel A. Starr, chief librarian for technical services and planning, the Museum of Modern Art Library; Clayton C. Kirking, director of the Gimbel Library, Parsons School of Design; and Nancy S. Allen, director of information resources, the Museum of Fine Arts, Boston.

In the early stages, research was conducted in London, where the following gave their assistance:

Director Ruth Kamen, British Architectural Library of the Royal Institute of British Architects; Brendan Cassidy and Ruth Rubinstein, Warburg computer directors, Warburg Institute Library; Catherine Gordon, director of the Witt Computer Index at the Courtauld Institute of Art; and Ian Jacobs, manager, *Macmillan Encyclopedia of Art*.

During the past three years, research was conducted in a number of U.S. institutions. In addition to those mentioned above, I would like to thank the following for their assistance while working in their libraries:

At the Ingalls Library, Cleveland Museum of Art, Head Librarian Ann B. Abid and Visual Resource Librarian Sara Jane Pearman.

In New York City, Reader Services Coordinator Linda E. Seckelson and Associate Museum Librarian Robert C. Kaufmann, the Thomas J. Watson Library of the Metropolitan Museum of Art; Faith Pleasanton, librarian at Christie's; Curator Paula A. Baxter of the Art and Architecture Collection, New York Public Library; as well as the staff at the Museum of Modern Art.

In Washington, D.C., Coordinator Christine M. Hennessey, Inventory of American Paintings; Chief of Reference Services Judith Throm, Archives of American Art; as well as the staffs of the National Gallery of Art and the National Museum of American Art.

In Texas, Fine Art Librarian Kathryn A. Jackson, Hamon Arts Library, Southern Methodist University, and the staff at the Amon Carter Museum.

At the University of North Texas, Visual Resource Curator Ann Graham, School of Visual Arts, and NTIEVA Project Coordinator Nancy Walkup, as well as the Willis Library staff.

The writing of the book owes a great deal to a number of people, some of whom answered my questions via e-mail. Thank you Katharine Martinez, member services officer for art, Research Libraries Group; Chief Slide Librarian Gregory P. J. Most, National Gallery of Art; Director Max C. Marmor, Art and Architecture Library, Yale University; Wolfgang M. Freitag, senior lecturer and librarian emeritus, Harvard University; Christopher L. C. E. Witcombe, professor of art history, Sweet Briar College; and Laura Schwartz, art

reference librarian, Fine Arts Library, University of Texas, Austin. I also wish to express my appreciation to the many commercial firms who so promptly answered my questions and to the people at Oryx Press, especially editor Elizabeth Welsh, who have continually assisted me.

I would like to thank my many Dallas friends for their support and thoughtfulness, especially my long-time friends Kathryn Lacy Keane and Jean Ann Thompson Titus. Thanks also go to Martine Frezard Tarver, and to my neighbor Louise Kent Kane.

And in conclusion, I would like to thank my family for their patience and understanding, especially my sister—Phyllis Swan Dorsey—and my sons and their wives—Preston and Lisa Jones and Jeff and Kathleen Jones.

INTRODUCTION

Why This Book?

One of the world's fastest-growing phenomena is the Internet—in both its number of sites and its cultural effects. The Internet is a vast system providing access to information through numerous types of resources, such as the Web, Telnet, Gopher, e-mail, and discussion groups. This cyberspace system is used by all types of people in various professions and is accessed through personal computers as well as those provided at libraries and universities.

The development of the World Wide Web—a division capable of displaying graphic material—has increased the popularity of the Internet among those involved in art and art research. The Web, the main emphasis of this book, has quickly become a sprawling, confusing place—full of text and visual material, but with no central indexing system. Finding what is wanted or needed becomes more complex and time consuming as the number of sites expands. There is need for a book that characterizes and organizes the extensive art information in cyberspace.

Individuals and organizations concerned with the arts develop and maintain Web sites for many purposes: to inform and share their expertise or databases with others, to communicate material to specific audiences, to answer frequently asked questions, or, more often, to advertise, sell, or promote something—exhibitions, objects for sale, or special points of view. Some Internet sites are scholarly in nature, created by specialists; others are the work of amateurs or entrepreneurs, often technicians who know more about computers than a special field, such as art. To be successful at finding pertinent data, it is important to know what can and cannot be located on this information highway and, most important, how to appraise and use the material found there.

Too often, individuals have been led to believe that all their information requirements will be met online—yet what they seek may never be available on the Internet. And because some information on the Web can be superficial, temporary, incomplete, or even wrong, users need to be able to judge its value. Moreover, they need to learn how Internet material compares to information provided in other formats—print sources, CD-ROMs, documentary videos, and microfiche sets—and how it can be complemented with these additional resources. This book shows how to locate visual and text data on the Internet and how to evaluate and supplement that data with material from other information formats to produce quality research results.

Organization of the Text

Part One

Art Information and the Internet is presented in three parts, each with a separate introduction. Part One, "Basic Information Formats," discusses various information resources, including electronic data and print publications. Its first chapter is concerned with Internet data, discussing the components of Web addresses, various search engines, and some methods for evaluating Internet sites for research purposes. The second chapter briefly examines other information formats and provides methods for locating reviews of these resources and the Web sites of their publishers.

Part Two

One way to answer a question is to ask the person or institution that possesses the information. This is the premise of the six chapters in Part Two, "Types of Web Sites and How to Find Them." The material found at various types of Internet locations are organized by the associations and individuals contributing the data. The strengths and limitations of these Web sites are discussed, examples are provided, and addresses—URLs (Uniform Resource Locators)—are furnished. Because the Internet is constantly changing, you never know for sure what is available and how long it

will remain online. An important aspect of this book is the inclusion of search strategies for finding pertinent Web sites. For readers who wish only to surf the Net, the wealth of material found in Part Two will expedite the trip.

Part Three

In spite of the Web's continual modification, research methodology utilizing the information highway remains as basic and essential as ever. The eight chapters of Part Three, "How to Use and Supplement Web Information," focus on this subject. The methodological discussions are organized into seven basic steps covering material needed for all types of research, including the in-depth approach required for writing academic papers or preparing lectures. This book furnishes researchers with the titles of significant reference sources in all information formats and suggests methods for locating and using these resources to enhance and verify Web data.

Part Three contains the core material of this book. In each of its chapters, different types of reference questions are posed, and various methodologies for answering them are discussed. The questions seek answers using all information formats. A general overview of research methods detailed in Chapter IX is followed by chapters on specific areas: studying art historical styles and cultures, locating material on artists working in various media, and analyzing the form and subjects of works of art. The last chapter covers such topics as art education, writing about art, copyright problems, conservation, and issues concerning buying and selling art. Both basic and scholarly resources are noted, because this book is addressed to people at various levels of understanding and expertise.

Appendixes

Two supplements complete the book. Appendix One lists books that index individual artists who participated in significant group exhibitions and suggests methods for locating reprints of the catalogues. Appendix Two provides the Internet addresses for some art-related professional associations, accompanied by the titles of their publications.

Special Features

In this book, most URLs for Web sites are placed at the end of the paragraph in which they are discussed. Cross references are placed in brackets; the numbers and letters correspond to those in the headings and in the table of contents. For example, [II-B-2] indicates that additional information concerning a subject is located in Chapter II, Section B, Subsection 2. In addition, endnotes are used to assist those unfamiliar with art and library terms. The cross references and endnotes, as well as the comprehensive index, will assist you in maneuvering through the book. Illustrations show graphically how particular resources look and what they provide.

Some of the Web sites discussed here will have disappeared or changed their nature or emphasis by the time this book is published. The open and flexible nature of the Internet makes this inevitable. To keep *Art Information and the Internet* current, a special Web site has been created. Periodically, updates to the book will be posted at <http://www.oryxpress.com/artupdate>. Readers are encouraged to send e-mail to <artupdate@oryxpress.com> to report changes in Web site addresses and to provide data on additional art information resources that pertain to this book's contents. Updates on the Web site will use the book's page numbers, so be sure to have it handy.

Scope and Purpose

Throughout the book, material from various information formats is noted, with an emphasis on English-language publications and Web sites. The Web sites listed were chosen as examples of particular points or ideas—or because their hyperlinks serve as guides to other material. Published resources, as well as Web sites, had to be limited due to space considerations and the need to avoid duplication. Material on Western European and North American art predominates; references on art of other cultures are included to indicate the types of material available in these areas. The resources cited from the Internet, as well

from the publication world, are by no means complete or comprehensive, but should serve as catalysts to assist you in starting your research.

Although the Web sites listed were checked for their usefulness, none are endorsed by the author or the publisher for the accuracy of their data. Instead, this guide provides methods by which material on the Internet can be evaluated, a process for which each researcher is responsible.

Art Information and the Internet is a reference book, written for many types of people in all art disciplines and at a variety of different levels: students of all ages, as well as professors, educators, art dealers and collectors, curators, museum personnel, and other art professionals. The book also provides a compact, handy guide for librarians, particularly those responsible for art reference and visual resource work. This book was written to assist people in maneuvering through cyberspace: how to find Internet data on art and how to use it.

PART ONE

BASIC INFORMATION FORMATS

Over the centuries, as people who admired and collected art wanted to know more about it, there developed a body of literature providing information on its various aspects. Dating as early as classical times, these writings were composed first in longhand and later printed in books, pamphlets, and articles. If any illustrations of the objects were added, they were prints or drawings.

During the 19th century, photography was invented, and in the 20th century, additional publication formats were created: microforms, videotapes, CD-ROMs, and computer electronic tape. Libraries have historically been the purchasers and distributors of vast amounts of data, but recently, during the past decades, a new information storehouse has evolved—the Internet.

The Internet—basically a network of computers—was developed by the United States Department of Defense in the late 1960s to create links to various military research contractors (for a list of articles on the history of the Internet, see the Library of Congress Web site <http://lcweb.gov/global/internet/history.html>). A major asset of this invention is the ability for people with unlike computers—IBM compatibles, Macintosh, or some other brand—to communicate. Use of the Internet has multiplied, and all types of people—government officials, business people, educators, computer hackers, and amateurs—and all disciplines now use this extraordinary, revolutionary system, which is still governed by few rules or regulations.

Part One is particularly important for those who are just beginning to use the Internet, since it considers different information formats. Chapter I explains the components constituting Web addresses, some methods for locating and evaluating Web sites, and some aspects of e-mail and discussion groups. Chapter II discusses the other information formats: their assets and liabilities, some suggestions for discovering important publications, and the Web sites of firms publishing them.

Remember, *Art Information and the Internet* has its own Web site. If you discover changes in the Web site addresses included in this publication or locate any other remarkable Web sites pertinent to this book's contents, e-mail that information to <artupdate@oryxpress.com>. Periodically, updates will be added to <http://www.oryxpress.com/artupdate>.

I. Electronic Data and the Internet

The original purpose of the Internet was to allow scientists in various parts of the world to exchange information regardless of their type of computer. Later, some Internet areas became increasingly sophisticated, allowing a more advanced technology to be transmitted online. Although some earlier protocols, such as Telnet and Gopher, can read only text and cannot transmit illustrations and graphics, they are still employed at certain online sites, such as libraries, which may use them for their online cataloguing systems. The most popular and fastest-growing part of the Internet, however, is the World Wide Web and its multimedia environment.

The World Wide Web is the emphasis of this book. Its numerous assets include

- the ability to reproduce graphics, sound, and movement
- the capability to leap from one idea or subject to another via hyperlinks
- the currency of its data
- the direct access it provides to organizations and businesses
- the ability to combine ideas and subjects in new and challenging ways
- the universal scope of its subjects
- the uniqueness of its material, which often can be obtained in no other way
- the absence of geographical barriers
- the stimulation it furnishes by providing the unexpected

The Web is truly an outstanding vehicle for self-discovery and self-education!

At the same time, you must be aware of the Web's shortcomings. Beginning researchers often believe that everything they require in the collection of data will be on the Internet. However, due to issues such as copyright and a crowded cyberspace, the Internet will never include everything a reseacher needs. The Internet has a number of liabilities:

- locating exactly what is wanted can be difficult due to the Web's constant, ever-expanding nature
- finding pertinent information may be impossible, because it is often ephemeral and may not be on the Web when you want it
- searching for significant facts is often slow and tedious, costing both time and money and often producing no results
- discovering authentic and accurate data may be an arduous task, because the Web lacks the standards of other information formats

This last liability is becoming a genuine problem, since anyone can add almost anything to the Internet. Sometimes information and visual material are placed there by technicians, who may know little about the topic presented. Some academic sites are experimental in nature, reserved for student use. Obviously, these Web sites must be examined closely and the material carefully appraised. When you use online data, both text and visual, you must be cautious about what you are using. The information may be wrong, it may be plagiarized, or the material may be protected by copyright [XVI-C].

This chapter discusses the Internet, focusing on (a) understanding its Web sites, (b) discovering pertinent material, (c) confirming its costs, (d) evaluating its sites, (e) communicating with other Internet users in discussion groups, and (f) locating information on the technological aspects of the Internet.

I-A. Understanding Web Sites

The World Wide Web uses *hypertext,* a technology that allows documents to be created with built-in references, called *hyperlinks* that allow you to connect immediately to other online sites anywhere in the world with similar or other relevant material. To utilize the Web effectively, you should understand its various aspects, such as (a) the components of URLs, (b) the use of mirror sites, and (c) the challenge of locating new addresses for domain pages. This section is concerned with these topics.

I-A-1. URLs: Their Components and Uses

Because each Web site has a special Internet address, in order for one computer to locate another, users must either know the correct site address, called a *URL (Uniform Resource Locator)*, or utilize a search engine to find it. Hypertext addresses or URLs are composed in a specific way. First, *http://*—the abbreviation for *HyperText Transport Protocol*—indicates the use of hypertext and that the section of the Internet to be accessed is the World Wide Web. Second, *http://* is sometimes (but not always) followed by *www,* for *World Wide Web.* The *www* usually ends in a period, but a hyphen can be used. Third comes the name or abbreviation for the organization, university, or commercial firm hosting the site, accompanied by a period, called a *dot.* In the United States, the fourth section consists of one of the following:[1]

- .com for *commercial enterprise*
- .edu for *educational institution*
- .gov for *nonmilitary government*
- .mil for *military*
- .net for *network*
- .org for *organization*

In other areas of the world, different abbreviations are sometimes used. For example, in Great Britain, *.ac* stands for *academic.* The fifth item is a single slash.

The second, third, and fourth elements, which make up the *domain address*, normally connect to an organization's *home page,* a simplified table of contents for the material at the site. If an organization has its own domain address, it will usually not change, since domain addresses are registered to ensure that one and

only one entity has that URL. This is an international number, unique to each organization, distinguishing it from every other Web site.

Example

The domain address (which includes everything after the *http://* and before the first single slash) for the University of North Texas is *www.unt.edu.* <http:// www.unt.edu/> will always take you to the University of North Texas home page.

Although people use the Internet worldwide and speak many languages, English predominates. Some countries use a slightly different system than the United States. Instead of ending the domain address with a three-letter abbreviation for the type of institution hosting the Web site, an abbreviation for the country may be cited (in Canada, the province is frequently added).

Example

<http://www.vanartgallery.bc.ca/> is the domain site of the Vancouver Art Gallery in British Columbia (.bc), Canada (.ca).

A few abbreviations are cited below; notice that the letters used are taken from the country's official name for itself.

- .au for *Australia*
- .ch for *Confederation Helvetia,* or *Switzerland*
- .de for *Deutschland,* or *Germany*
- .es for *España,* or *Spain*
- .fi for *Finland*
- .gr for *Greece*
- .it for *Italy*
- .jp for *Japan*
- .mx for *Mexico*
- .se for *Sverige,* or *Sweden*
- .uk for the *United Kingdom (England, Scotland, and Wales)*

A URL is really a series of numbers, but to make them easier to remember, they have usually been converted into letter abbreviations for the host institution and formed into the domain name as explained above. But some institutions, such as the Acropolis Museum, Athens, use numbers <http:// www.culture.gr/2/21/211/21101m/e211am01.html>. The series of numbers is known as the *Internet Protocol (IP) address.*

A Web site often contains a prodigious amount of material that needs to be organized in some logical manner so that it can be located when required. Many institutions place *divisions, departments,* or *programs* within their corporate structure after their domain name. The abbreviation for a division often ends with a slash. For instance, <http://www.utexas.edu/cofa/> indicates the College of Fine Arts division at the University of Texas, Austin. Some common abbreviations for schools or departments include the following:

cofa for *college of fine arts*
cs for *computer science*
dic for *digital image center*
fa for *fine arts department*
gsfa for *graduate school of fine arts*
sils for *school of information and library science*
sova for *school of visual arts*

At times, a major division or program within an institution will be provided with a special URL so that it can be accessed more quickly. Frequently called *servers,* these major divisions are abbreviated and placed before the domain name of the Web site, sometimes replacing the *www.* For instance, you will locate a number of library servers in this book [VI-C-2], such as <http://www.library.unt.edu/> for the library server at the University of North Texas and <http://library.usc.edu/> for the library server at the University of Southern California. Institutions can have numerous servers, and these are relatively stable; once created, they will probably retain the same URL.

Both servers and divisions have vast quantities of information, which is usually organized by *directories.* These directories consist of *documents* or *files* that end in *.htm, .html, .shtml,* or some variation thereof. The suffixes indicate that the files are *HTML (HyperText Markup Language)* documents that provide signals and technical information for displaying and linking information. As cyberspace becomes more crowded and institutions and companies develop increasingly extensive material at their Web sites, the URLs for directories and files have become longer and longer. Remember, there is no standard convention for naming URLs.

Example
The URL <*http://lanic.utexas.edu/ilas/active.html#ToC6*> indicates that the division ILAS (*ilas*) is attached to the LANIC (*lanic*) server at the Uni-

versity of Texas domain Web site. LANIC refers to the Latin American Network Information Center; ILAS is a multidisciplinary organization of more than 30 University of Texas academic departments. The html file—*active.html#ToC6*—provides information on the 1998 ILAS conference.

Within some URLs, you will find a *tilde* (~) after the domain name's first slash, indicating that the address has been shortened. The tilde is usually followed by an abbreviation or the name of a directory. The directory can be for various entities, such as a program, a museum, an academic department, or someone's personal Web page attached to the domain site.

Example
In the URL below, the tilde means that a person named J. Lynch developed or maintains this directory on 18th-century resources. All of the material is attached to the English department's server at the University of Pennsylvania <http://www.english.upenn.edu/~jlynch/18th/>.

One problem with discussing the Internet is that its vocabulary is still evolving. Not all resources define or use terms the same way. At some Internet locations and in some books, there may be other names for a server or division. But regardless of the terminology, within this framework are a myriad of directories with documents or files. Shifting a file from one place to another or renaming it creates misplaced material. To assist patrons in locating desired files, the hosts of extensive domain sites usually provide a method for searching for specific material within their Web locations.

Example
In 1997, the University of Texas stated that it had 300 servers attached to its Web site. Various methods for locating material within it is provided at <http://www.utexas.edu/search/>.

Images must be digitized before they can be used in a computer or on the Internet. In this format, the images require an enormous amount of computer space. Sometimes there is a notation of the number of kilobytes (Ks) of space needed before a file can be downloaded. One K is equal to 1,000 bytes of memory.[2]

There are also special designations for files containing digitized visual material.

.gif or *.GIF* for *Graphics Interchange Format* or *Graphics Image File*

.jpeg or *.jpg* or *.JPEG* for *Joint Photographic Experts Group*

The former has the capability of showing up to 256 colors on the screen; the latter stores digitized reproductions, both black-and-white and color. To fill most computer screens with text data takes about 1K (1,000 bytes); visual material takes many times this amount of space. Your computer may not be able to download a file that contains visual material if it requires too much "space."

Examples

1. *The California Heritage Digital Image Access Project* of the University of California, Berkeley, provides three photograph sizes: thumbnail (20K GIF), medium resolution (55K JPEG), and high resolution (200K JPEG). Its Web site has an important message for users concerning the hazards of some computer software programs and the various resolutions. Be sure to visit this Internet location <http://sunsite.berkeley.edu/CalHeritage/>.

2. The *Web Design Page* discusses the differences between the two principal graphic file formats, GIF and JPEG <http://ds.dial.pipex.com/pixelp/wpdesign/wpdgraph.htm>.

For files transmitting sound, one of the following designations may be used:

.wav or *.au*　for *audio files*
.mpg or *.mov* for *multimedia files*

Your computer must have the appropriate software to run these files.

Throughout this book, URLs are placed within angled brackets; however, the brackets are not part of the address. In some browsers, you do not need to type the *http://*, although this is still part of the formal address. Remember also that URLs are case sensitive: You must utilize capitals or lowercase letters when so indicated. There are no spaces, and every punctuation mark must be exact. Persistence and patience may be needed not only to obtain the proper Web address, but also to enter a long, complicated URL correctly.

Example

<http://www-oi.uchicago.edu/OI/MUS/OI_Museum.html> is the Web site address for the museum (MUS) of the Oriental Institute (oi and OI) at the University of Chicago.

If an organization, such as a museum, does not have its own domain Web site, some other institution may put information concerning it on the Web. Moreover, a few locations have more than one URL, a primary or principal one and others that are termed alias, subsidiary, or secondary addresses. All of these addresses will access the same Internet location.

Examples

1. General information about the British Museum, London, was available on the Web prior to summer 1997 through the University College of London <http://www.cs.ucl.ac.uk/local/museums/BritishMuseum.html>. The University College (ucl) hosted the domain Web site. When the British Museum procured its own domain Web site, its official URL became <http://www.british-museum.ac.uk/>, an address that probably will not change.

2. *Online Today* in Dallas has two URLs: <http://onlinetoday.com/> is the primary address; <http://www.ont.com/> is its alias.

Web sites are maintained by people called *webmasters*; you can often contact the webmaster directly from the site. Although a webmaster is not necessarily the person who produced the material for the Web or first initiated its Internet location, he or she may be able to help when material you once accessed on the site is no longer made available.

I-A-2. Mirror Sites

A mirror site is a Web location that duplicates material on another, separate Web site. By carrying the identical information, the new Web site usually provides quicker access for people within the geographical region where the mirror is located, since there may be less traffic-related interference. Duplication of sites frequently creates confusion when search engines, see [I-B-2], list the locations as if they contained different material.

Example

The *WebMuseum* [IV-C] has more than 30 mirror sites worldwide. For instance, the University of North Carolina hosts the *WebMuseum* <http://sunsite.unc.edu/wm/> for people on North America's east coast. In the URL, *wm* is the abbreviation for *WebMuseum*. The University of Chile repeats this identical material for easy access from South America <http://sunsite.dcc.uchile.cl/wm/>.

In the search for data on the French Impressionist Alfred Sisley (1839–99), numerous sites were located by two search engines. When the first Internet locations were scrutinized, 7 of the first 20 URLs were mirror sites for the same *WebMuseum* material. The second search engine found 20 records, of which 5 were mirror sites for duplicate information.

I-A-3. Displaced Web Sites

Professional association home pages are sometimes located through a member's academic affiliation. Consequently, if a member's duties alter within the organization, the URL may change. Once the association obtains its own domain address, however, it probably will not change.

> ### Example
>
> Until 1997, the College Art Association (CAA) had its Web site through MIT, the Massachusetts Institute of Technology <http://www.sap.mit.edu/caa/>; it then obtained its own domain address <http://www.collegeart.org/>.

If a file or a document attached to a Web site changes its address, you can sometimes discover the new one by cutting back the URL to its stem or domain address—everything after the *http://* and before the first or second single slash—from which you might be able to locate the correct directory and then the desired file or page. Although files and directories are frequently deleted, added, or altered, the domain addresses of most organizations do not change.

Sometimes you can not connect to a Web site for which you have the correct URL. Try cutting back to the first slash from the right. This may give you a list of the files in the directory. Choose the proper file and access it. Another method for locating files that have changed their URLs is to access the home page of the host institution, since it may provide a search method for locating the URLs of servers, directories, files, documents, or pages attached to its domain site.

> ### Examples
>
> 1. One search engine provided this URL for archival material on the architect Louis Kahn: <http://www.upenn.edu/gsfa/archives/kahn.html>. However, the University of Pennsylvania had changed the location of this online file. By checking the home page for the university's Graduate School of Fine Arts <http://www.upenn.edu/gsfa/>, the new, correct site address was located: <http://www.upenn.edu/gsfa/archives/majorcollections/kahn/kahn.html>.
>
> 2. In trying to locate an online copy of *Roget's Thesaurus* at the address <http://humanities.uchicago.edu/forms_unrest/ROGET.html>, access was denied. When this address was cut back to <http://humanities.uchicago.edu/forms_unrest/>, an index to the files under *forms_unrest* was located. Among the 27 files was *ROGET.html*, which was then accessed.

I-B. Methods for Discovering Web Material

The Internet is basically a place to deposit and transmit information—material that can be quickly deleted, moved, added, or altered. Its transitory nature means that searches conducted on a specific date may not be possible to replicate at a later time. Sometimes Internet information seems to be standing on shifting sand—now you see it, now you don't. Unlike libraries and media centers, the Web has yet to develop an orderly system for organizing and indexing this information.

To search for a specific magazine article, you would consult an index to periodical literature; for bibliographical data, an online library catalogue or a standard bibliography. Currently, there is no such established and systematic indexing source for Web data; there are, however, some specialized indexes to guide you, which are discussed later in this book, see [III-A-5] and [IV-A-4]. This chapter discusses two methods that may be used to overcome this handicap: (a) accessing specific Web sites directly and (b) using search engines.

I-B-1. Specific Web Sites

The World Wide Web contains enormous quantities[3] of material, frequently placed on the Internet in a haphazard, untimely manner. To find anything, you must search for it—unless you have the correct address for the needed location. Lists of Internet sites accompanied by some indication of their contents can be

found everywhere and anywhere, including in this book. Newspapers, magazines, and television programs furnish URLs, as do colleagues and friends. Moreover, once you access a Web page, it often offers hyperlinks to other URLs containing related material.

Finding an organized, annotated URL list is sometimes a challenge, so when you locate a Web site you expect to reuse, be sure to make a note of the address. You can add it to this book or to the bookmark section of your browser.[4] Remember, however, that if you do not categorize and keep weeding your browser's bookmark section, you will soon have assembled a jumbled array of URLs.

The Internet has grown so massive and unwieldy that users need several means for finding Web addresses. First, you can surf the Net, browsing by using hyperlinks to jump from one Web site to another, thus locating data in a serendipitous manner. This is an inefficient, time-consuming, and sometimes frustrating method. It can also be fun!

Second, you can employ search engines—tools or databases that help you discover specific Web sites. Since search engines do not consistently find the most significant Web sites, you should not rely on them as the sole method for locating material. The efficiency of your research will be affected.

A third method, usually quicker, is to access a distinct Internet site—all you need is the correct URL. Knowing the address for a specific location can reduce your search time tremendously. That is the rationale for Part Two of this volume, which discusses the kinds of information available at certain types of Web sites and suggests efficient methods for locating other similar locations.

Examples

1. What exhibition is going to be at the Art Gallery of Ontario in Toronto this spring? What is the name of the architect who planned the Kimbell Art Museum in Fort Worth, Texas? Go to Chapter III, find the URLs for these museums, access them, and your questions should be answered.

2. Three Internet search engines were used to locate information on Australian sculptor Bertram Mackennal (1863–1931). The number of records found were almost meaningless—a total of 1,991 Internet locations. Even so, none of these search engines discovered the best, most comprehensive Web site for online data on Mackennal—the *Victorian Web Overview* <http://www.stg.brown.edu/projects/hypertext/landow/victorian/victov.html>. This il-

lustrates the kinds of frustrations encountered if search engines are used exclusively to find Internet data.

I-B-2. Search Engines

The term *search engine* has become an umbrella phrase for different systems that help people find specific Web sites. The search engines collect their material in various ways, so be sure to check their home pages for definitions and instructions on their use. Some engines report URLs and/or provide excerpts from the sites. Most have sections on search strategies, often titled *Frequently Asked Questions (FAQ), Search Tips,* or *Help.* Be sure to read this material. For definitions and general answers to FAQs on search engines, see the information supplied by the Boutell Company <http://www.boutell.com/faq/www_faq.html>.

To improve the quality and relevance of the material these search engines find, you need to know something about their characteristics and organizational systems. Unfortunately, there is no easy way to assess the size of the catalogues and directories that are formed. Nor is size a good measure of the usefulness of the service.

Their Organizational Systems

Some browsers preselect a few search engines for their patrons and make them easy to access. These prechosen tools are not necessarily the best search engines for every project, for innovative new indexing tools may be excluded. If you have this type of browser, remember to choose the search engines you want to use, not just those chosen by a commercial firm.

Unfortunately, there is no way of knowing which search engines will continue to do a top-quality job over the years. They may change their formats or coverage, or they may be merged with each other or with some other technological aspect of the Web. They need to be evaluated according to set standards, such as those discussed below.

The number and usefulness of these tools change constantly, so access their locations frequently. Some services are forming partnerships to improve their ability to compete in the ever-expanding World Wide Web; others are merging and altering their designs. Be sure to access each search engine's Web site for the most current information. There are several methods

used by search engines to locate and organize Web material; only a few examples are included below.

Directories

One method is to arrange Internet material by subject classifications to form directories. The information in these directories may be submitted by the owner of the Web site, then sorted into subject categories and subcategories by the search engine staff. Yahoo, which organizes Web sites by a hierarchy of subject categories, provides a quick method for locating pertinent Web sites that fit into Yahoo's framework <http://www.yahoo.com/>.

Spiders

Another method is the use of *spiders* or *crawlers* that reach out into the Internet, gather material, and organize it into catalogues, which can be searched using keywords. These search engines spread a large web over the material and often locate more Web sites than directory-type search engines, but not necessarily the most pertinent ones. Examples are (a) AltaVista, which is in partnership with Yahoo <http://www.altavista.digital.com/>; (b) Excite, which has purchased Magellan and WebCrawler and also has a directory called Excite Reviews <http://www.excite.com/>; and (c) Lycos, which often reports a greater number of sites than the other search engines, since all hits, or relevant records, are listed <http://www.lycos.com/>.

Reviews

Some search engines review or rate Web sites. Magellan, produced by the McKinley Group and now a subsidiary of Excite, maintains a subject database for which many Web sites are reviewed <http://www.mckinley.com/>.

Engines Searching Limited Areas

Because there is so much material on the Internet, a few search engines curtail their searches to one subject. A *limited area search engine (LASE)* usually locates a greater percent of relevant material than the other types of engines. An outstanding example is Argos, a LASE for ancient and medieval material, designed by Managing Editor Anthony F. Beavers and Technical Director Hiten Sompel of the University of Evansville. Argos, a quality-controlled index, is rebuilt each week, thus deleting out-of-date material <http://argos.evansville.edu/>.

Multi-Engine Searching

A multi-engine approach provides for the probing of other search engines and then reporting their results. These services, which have no internal database of their own, are becoming especially important in an ever-expanding cyberspace. For instance, Dogpile <http://www.dogpile.com/> examines the results of your search strategy with numerous search engines, including those cited above: AltaVista, Excite, Lycos, Yahoo, and Magellan. Dogpile not only reports the total number of results from each search engine but reproduces them for you. By checking the section called *query string*, you can determine the best search compositions for the various search engines.

Another search engine with a multi-engine approach is MetaCrawler, which queries nine search engines, including Lycos, Infoseek, WebCrawler, Excite, AltaVista, and Yahoo! <http://www.metacrawler.com/>.

Relevance of the Sites

Search engines locate only a small portion of the material on the Internet, but the huge number of sites they sometimes report can be daunting. The use of mirror sites may be one reason the numbers are high. Another is the taking of information from one site and adding it to another. As you become familiar with the Internet, you will realize that much of the material is either redundant or is insignificant, and at times may have nothing to do with your research.

Example

Looking for material on French artist Jean Lurçat (1892–1966) illustrates how confusing the number of entries found by search engines can be. Three search engines produced a total of more than 33,500 sites for the query *Jean Lurcat*. Yet only one entry was relevant; it was for Saint-Céré, a town in the French Midi-Pyrénées region where Lurçat had his weaving studio <http://www.ags.fr/metiers/midi/saint-cere.html>. Most of the Web sites listed referred to places named for the artist, such as Place Jean Lurçat in Aubusson, or for people called Jean, a common name in France.

Narrowing the Subject

Sometimes a word or words—such as *art education* or *John Smith*—are so prevalent in a nation's vocabulary that the search engines find too much irrelevant material. Narrowing the subject often produces better

results. Because each search engine has specific conventions peculiar to its system, be sure to check the policy of each engine as to its methods and procedures. Remember to beware of popular terms and proper names!

By placing proper names between quotations marks—such as *"John Marin"*—some search engines will locate only entries containing both of these words in that order. A plus sign (+) before a word usually indicates that the word must be present in the record. Some search engines allow the use of Boolean operators, such as *AND, OR,* and *NOT* [VI-E-1]. Another means of narrowing the subject is by checking the number of sites reported for each word in the search; this helps you decide the pertinence of the total number.

In addition, if a word has accent marks or umlauts, try searching the Web using both the word without its diacritical marks and the word with the spellings used by some indexers, such as with umlauts replaced by two vowels: the *ä* by *ae,* the *ö* by *oe,* and the *ü* by *ue.* For example, in the URL for *Würzburg On Line,* Würzburg is spelled *wuerzburg.*

Example

In pursuit of material on Impressionist Alfred Sisley, one search engine located a total of 14,078 records. When the two terms were broken down, it was found that there were 14,078 entries for *Alfred,* but only 155 for *Sisley.* Obviously, without the artist's last name in the entry, you will discover nothing relevant. Better searches would be *"Alfred Sisley",* *Alfred +Sisley, Alfred NEAR Sisley,* or *Alfred ADJ Sisley.* Your choice would depend upon the methods the various search engines recognize. A major asset of the multi-engine search tools, discussed above, is that they change your inquiry format to coincide with that used by each of the search engines investigated.

Difficult-to-Locate Data

Obvious as this may seem, finding information on the Internet depends upon someone placing the needed data on the Web.

Example

In seeking material on a 1996 exhibition of art from Russian palaces held in Jackson, Mississippi, the search engines brought forth nothing concerning the exhibition when it first opened. Information was not found until the *Mississippi Business Journal* provided material for the Internet that mentioned the show. By that time, "Palaces of St. Petersburg: Russian Imperial Style" was ready to close <http://www.teclink.net/mbj/>.

Entry Denied

Sometimes you will try to access a specific URL but will be denied entry or will be told there is no longer any such location. Check the URL for spelling and spacing errors, but do not assume your typing is at fault. Remember, patience may be required. Repeated efforts may be essential to bring results! An entry may be denied because

- the site is temporarily overloaded; too many people are simultaneously trying to access it (try again later)
- the material is available only to people with the proper identification and password
- the material has been removed and the search engine has not culled its database for obsolete or outdated material
- the site is in the process of being updated and reloaded and will be available later
- the material contains information that your browser does not recognize
- the data may still be at this Web site, but under a slightly different URL
- the Web site does not exist

Awards Presented by Search Engines

Some search engines are now giving awards or ratings for Internet locations. These honors may be interesting but will not necessarily assist you in evaluating the Web sites. The accolades are based on a set of criteria, but no aspect of the evaluation refers to standards of scholarship, authenticity, or original research. Nor are the sites checked to insure that no copyrighted or illegal material has been included. For awards of erudition, you need to look to other institutions, not the search engines. For an example of a Web site with all types of awards, see *Paris Pages* <http://www.paris.org/WMC/media.html>.

Examples

1. Magellan reviews Internet sites, granting them from 1 point to 10 points for (a) comprehensiveness of material or clarity of presentation, (b) navigational ease within the site, and (c) appeal and innovation. Based on these points, sites are awarded from one star to four stars, which are then included in the search results.

2. The search engine Lycos lists its Top 5% Sites based upon their presentation, experience, and excellence. Although cited as its principal criterion, excellence is an undefined quality and does not refer to the authenticity of the contents. At one time, Lycos stated that some sites are commended "because they're so deliciously silly" <http://point.lycos.com/categories/criteria.html>.

Judging Search Engines

In deciding upon the search engines you wish to use, consider the following:

- relevance of the found material to the search topic
- regularity with which the search engine updates its material
- inclusion of URLs
- addition of annotations or brief comments to assist you in determining whether the site will be useful for your research
- size of the database or index covered by the engine
- frequency with which the engine culls and removes URLs no longer in service
- speed for locating and reporting sites
- ease of use
- options available to narrow or refine the search

I-C. The Cost of the Internet

The United States has the greatest library system in the world; it is the envy of other countries, few of which have public libraries on the same scale. Free access to information through libraries has been an American tradition,[5] but there is a question as to whether it really is free. The costs are there, even though patrons are not always aware of them. Another storehouse of knowledge is now available to the world: the Internet. But this, too, requires time and money for someone to put something on the Internet you want and can trust.

To provide material for the Internet can be expensive. Notice the number of foundation grants required to develop and maintain some Web sites. Webmasters at some sites implore people to assist them with their monetary pressures; other locations are adding charges for downloading or viewing material. Much like television with its cable and premium channels, the Internet is developing a two-tier system: (a) direct pay or (b) indirect pay through university fees and local taxes. If someone did not reimburse authors and publishing companies for the costly work of researching, compiling, and writing the data they publish, these types of references would cease to exist.

I-D. Evaluating Web Sites for Research Purposes

Still in the process of developing, the Internet can sometimes be like the Wild West: few rules and regulations in a field where data-slingers can add what they wish. Since practically anyone can put almost anything on the Internet, as a researcher, you must appraise the data you find on the Web before you use it. Online material does not necessarily have a known author or authors whose credentials can be checked, and it may not have been vetted by experts or reviewed by an editor or editorial board. Begin by asking yourself why you are accessing a Web site. Are you there for fun and entertainment? Or are you there to further your research pursuits?

I-D-1. Issues to Consider

If you are accessing a Web site to obtain data for research purposes, you must evaluate the information furnished there. Material you quote may need to be acknowledged in a footnote or reference list, so you must consider whether the information is plagiarized from some other source. Will the data from the Web

site withstand this scrutiny? Below are some suggestions for evaluating Web sites for research purposes, a process for which each reader is responsible. The Web sites cited in this book have been examined for their usefulness. None were checked for legality, accuracy, or correctness of the data; none are endorsed by the author or the publisher of this book.

Credentials of the Data Provider

Authors with credentials in a specific field are more likely to be both accurate and scholarly. Some academic institutions that need to allow students to practice placing material on the Internet have created special URLs for student use [IV-A-6]. Remember that the webmaster may not be responsible for the material at a Web site.

Beware of people placing material on the Web whose only credentials are that they like art! They may be taking other people's labor—research, writing, publishing, and/or photography—and adding it to the Internet without the permission of the copyright owner and without credit to those who did the work. Unless permission has been received, this may be plagiarism.

Host Institution

Web sites with information developed by the personnel of an institution—museum, academic institution, or foundation—usually have more authentic, accurate, and current data concerning that establishment. You must recognize, however, that some academic institutions may host student material.

Visual Material

If there is no accompanying material identifying an artist, the location of a work of art, and/or a photo credit, be careful. If the visual material has been plagiarized, the rest of the data may also be questionable.

Usefulness of the Text

Is the material offered on the site significant or just fluff? Is the subject matter covered adequately? The information must be both accurate and objective, and the writing style should contribute to its understandability. The addition of clarifying data, such as footnotes and references that may be verified, often attests to the quality of the resources.

Currency of the Data

When was the last update of the Web site? Always check to determine when the information was last amended or enhanced. At most Internet locations, this is reported at the end of the home page. Remember, some material has been in cyberspace without anyone claiming or modifying it for years. Some information quickly becomes obsolete and must be corrected frequently. At out-of-date locations, the hyperlinks also may be useless; many of them will have disappeared.

Navigating the Web Site

Sometimes directions at a Web site are not clearly stated, and you may not be sure how to locate the material you are seeking. If you cannot understand how to advance and move through the Internet location, you will miss relevant material.

Theme of the Web Site

Is this a Web site for advertising or to illustrate the latest technological razzmatazz? Does the design and layout of the location give you confidence in the material? You must be vigilant to filter out biases and advertising that seek to look legitimate.

Stability of the Web Site

Take note of the material and whether or not it constantly changes directories, files, or domain addresses. Will the material be located there the next time it is needed? What is the volatility of the location?[6]

I-D-2. Evaluating Web Sites

The following list is just a sample of what is available. These Web sites will probably continue to update this data, even if the specific files are changed.

"Evaluating Information Found on the Internet," by Elizabeth E. Kirk, Milton S. Eisenhower Library, Johns Hopkins University
<http://milton.mse.jhu.edu:8001/research/education/net.html>

"How Do I Know What's Good on the Web?" University of California, Santa Barbara
<http://www.library.ucsb.edu/libinst/lib101/webfaq08.html>

"Learn the Internet," Paradesa Media
<http://www.learnthenet.com/>

"Search Engine Watch," by Danny Sullivan. This site provides material on how to use search engines and has a search engine tutorial.
 <http://www.searchenginewatch.com/>
"Thinking Critically about World Wide Web Resources," by Esther Grassian, UCLA College Library
 <http://www.library.ucla.edu/libraries/college/instruct/critical.htm>

"Web As a Research Tool: Evaluation Techniques," by Jan Alexander and Marsha Tate, Wolfgram Memorial Library, Widener University, Chester, Pennsylvania
 <http://www.science.widener.edu/~withers/evalout.htm>
"Web Searching," Internet Public Library [VI-F-1]. This site compares search engines.
 <http://ipl.org/ref/websearching.html>

I-E. E-Mail and Discussion Groups

An asset of the Internet is the user's ability to communicate with other Internet users around the world, especially through e-mail and discussion groups. *E-mail*, a contraction of *electronic mail*, has become as popular as long-distance telephoning and is now used more than any other Internet service. In 1997, it was estimated that there were some 11 million e-mail users.[7]

There are advantages and disadvantages to e-mail communication. The greatest assets are its speed and relative economy. There is, however, some cost involved: You need a computer, access to the Internet, and a computer site where your mail can be sent. The disadvantages include not always knowing if the mail was delivered and whether or not the person received a garbled message. E-mail addresses even receive junk mail, known as *spam!* A few advertisers launch, at one time, a huge number of e-mail messages, a process called *spamming.* This ties up the Internet, as well as the receivers of these advertisements.

Communicating by e-mail is not private. Messages can be monitored; employers may object to their employees gossiping or having personal discourses while at work and have a right to check their e-mail. An e-mail address is similar to a URL for a Web site: (a) your name or the name of the firm's webmaster is followed by (b) an @ to signify mailbox, then (c) the abbreviations for the computer receiving the mail. For assistance in locating e-mail addresses, see the suggestions below.

Example
 <Lois_Swan_Jones@unt.edu> indicates that the author has a mailbox at the University of North Texas, an educational institution.

Through Internet discussion groups, members send and receive e-mail on specific subjects by means of a mailing list. Some electronic discussion forums are open only to members of the group sponsoring the list. Others are monitored—someone reviews and edits or formats submitted material before it is sent to subscribers. Usually, any member can post a message to the entire e-mail list. In some groups, the material expires after a short time, due to the immense volume of material posted daily. Estimates of the daily volume on some Internet discussion groups are as high as the equivalent of 400 pages.

These ever-changing interactive groups are categorized in different ways, making them hard to define. Because you are usually conversing with people with like concerns, you may discover that joining a group is beneficial. Before you join an electronic discussion group, you may wish to read the information at the Internet location of the University of California, Berkeley, concerning the *Web4Lib Electronic Discussion Group,* which is composed of some 3,400 subscribers. You may not be interested in this specific discussion group, but the material will contribute to your understanding of what is expected of members. This Web site provides information on the purpose of the discussion group, the audience, posting policy, and guidelines for appropriate behavior, as well as how to subscribe and unsubscribe (cancel a subscription) <http://sunsite.berkeley.edu/Web4Lib/>.

To follow proper Net etiquette, see the list of dos and don'ts published at the *Deja News* Web site <http://www.dejanews.com/info/primer3.shtml>. Another source is *The Net: User Guidelines and Netiquette,* by Arlene H. Rinaldi, Florida Atlantic University, Boca Raton <http://www.fau.edu/rinaldi/net/index.html>.

I-E-1. E-Mail Addresses

If the person works for an academic institution, try the institution's Web page. Other sources for individual e-mail addresses include

- the *Internet Address Finder (IAF)* <http://www.iaf.net/frames/body/aboutiaf.htm>
- museum personnel can often be located through the museum's Web site [III-C]
- Web sites providing information on locating telephone numbers sometimes include e-mail addresses [VI-F-4]
- *World E-Mail Directory* searches for e-mail addresses of individuals, businesses, and organizations <http://www.worldemail.com/>

I-E-2. Discussion Groups

Art Teacher provides a list of discussion groups for those interested in art and education
<http://www.artteacher.com/forum/forum.htm>

Deja News lists more than 20,000 active discussion groups
<http://www.dejanews.com/info/idg.shtml>

H-Net is *Humanities and Social Sciences Online,* Michigan State University
<http://www.h-net.msu.edu/>

Liszt Web Site provides access to more than 85,000 listserves, organized by subject
<http://www.liszt.com/>

Tile.Net indexes discussion groups by subject, host country, and sponsoring organization
<http://www.tile.net/tile/listserv/index.html>

Additionally, professional organizations often sponsor discussion groups (see Appendix Two).

I-F. Bibliography on Internet Technology

The trend is for the Internet to use more and more advanced technology. You update your computer system to the latest body of technology and it seems that almost immediately there is yet another more complicated technological procedure. Web sites, especially those maintained by technicians, often incorporate these new systems. One of the biggest challenges of the Internet is to keep abreast of the changing technology. Some technologically advanced sites include virtual reality projects and fast-paced uses of sound and movement. This ongoing adventure necessitates careful consideration of future developments, choosing what is needed, and discarding what is frivolous.

I-F-1. Computer Technology

Have you heard of the initiative called Internet2?[8] Do you want to know more about the bills the U.S. Congress is proposing to regulate the Web? A number of Web sites provide access to glossaries of Internet terms and to recent information on technical innovations; a few are cited below.

Beginner's Guide to HTML, University of Illinois, Urbana-Champaign
<http://www.ncsa.uiuc.edu/General/Internet/WWW/HTMLPrimer.html>

C/Net Information on Computer Hardware
<http://www.computers.com/>

Especially for Librarians: Issues, Internet Public Library [VI-F-1] includes public Internet access
<http://ipl.org/>

Learn About the Internet, Library of Congress, provides links to a variety of sources
<http://lcweb.loc.gov/global/explore.html>

Netdictionary, produced by Albion Cybercasting, defines Internet terms
<http://www.netdictionary.com/html/index.html>

New York Times, Cybertimes Section
<http://www.nytimes.com/>

New York Times Glossary
<http://www.nytimes.com/library/cyber/reference/glossary.html>

Wired News has search capabilities to locate the full-text articles in past issues
<http://www.wired.com/news/>

I-F-2. PBS Internet Programs

There are numerous videos and books for the beginner to learn about the Internet, some accompanied by CD-ROMs. The television Public Broadcasting System (PBS) often provides its viewers with informative series; three are listed below. Since there are 156 PBS stations with Web sites, access their central location

to determine the URL for your station <http://www.pbs.org/stations/bystate.html>. Each of the following series is composed of numerous half-hour presentations:

On the Internet, with Leo LaPorte
 <http://ontheinternet.com/>

Computer Chronicles and *Internet Café,* with Stewart Cheifet
 <http://www.pctv.com/>

I-F-3. Computer Technology Companies

Another method for learning more about the Internet is to contact the commercial firms that have developed computer hardware and software; a few are cited below. Their Web sites feature the most current information. For a list of computer and communication companies, see Webstart Communications <http://www.cmpcmm.com/cc/companies.html>.

Adobe Systems
 <http://www.adobe.com/>

Apple Computer
 <http://www.apple.com/>

Applied Microsystems
 <http://www.amc.com/>

Hayes Microcomputer Products
 <http://www.hayes.com/>

IBM
 <http://ibm.com/>

Netscape
 <http://www.netscape.com/>

RealAudio
 <http://www.realaudio.com/>

Sun Microsystems
 <http://www.sun.com/>

U.S. Robotics
 <http://www.usrobotics.com/>

Notes

1. By May 1997, one million domain names were registered with Network Solutions, now a wholly owned subsidiary of Science Application International Corporation <http://www.netsol.com/>. A new system is being spearheaded by two special U.N. organizations that are suggesting there be a global network of registrars in order to end U.S. domination of the domain-naming process. Additional organizational abbreviations would be made available, such as *.nom* (individuals hosting a site), *.firm* (company), *.store* (product sales), *.arts* (cultural), *.rec* (recreation), *.info* (information), and *.web* (to emphasize the World Wide Web).

2. One *byte* of memory is equal to one character, or about one letter in a word. Thus, the word *art,* with its three letters, requires three bytes.

3. Various estimates have been made of how many individual Web sites exist. Since *.gov, .mil,* and *.edu* have specific meanings, these domain sites are no longer growing as fast as some of the other suffixes. Network Solutions stated in April 1998 that from 1995 through 1997, 1,500,000 new domain names with *.com* addresses were registered for companies throughout the world <http://www.netsol.com/>.

4. A *browser* is the software that allows you to view and manipulate the material on the Internet, such as Netscape Navigator or Microsoft Internet Explorer.

5. The first United States public library paid for by taxes was the Boston Public Library, which opened its doors in 1754. The library did not loan books, but was a depository for reference material where people could conduct research. By 1875, the United States had 275 public libraries. The concept of a storehouse of knowledge became popular, and Andrew Carnegie's donation of $50 million for library construction between 1881 and 1920 encouraged communities to provide these institutions for their citizens. More than 1,400 libraries were constructed in the United States with funds from Carnegie's foundation. For a brief history, see *Encyclopedia of Library History,* edited by Wayne A. Wieg and Donald G. Davis Jr. (New York: Garland Publishing, 1994).

6. See "Lost in Cyberspace," by David Brake <http://www.newscientist.com/keysites/networld/lost.html>.

7. Quoted at Web site <http://www2.computerworld.com/home/>.

8. See note 7, above, and <http://www.internet2.edu/>.

II. Other Information Formats and Their Publishers' Web Sites

Electronic data found on the Internet, the newest site to store information, is becoming an important aspect of art research. For most research projects, however, this online material needs to be supplemented with other information formats. Good researchers know the tools of their trade: the pros and cons of different formats, which formats are better for what purposes, and how to locate significant material using these information tools. This chapter briefly discusses (a) printed books, (b) archives and vertical files, (c) microforms, (d) CD-ROMs, and (e) documentary videos. An overview of each format is provided, accompanied by review sources and publishers' Web sites.

II-A. Locating Pertinent Books: Online and Printed Sources

Printed books, the references we have been using and loving for years, remain the most prevalent form for disseminating art information. Written on all aspects of art, books run the gamut of subject matter, quality, configuration, and appearance. Some are picture books, others offer a survey of a subject, while still others discuss an artist or topic in depth. The traditional book is portable, simple to use, and widely distributed. This oldest and most popular information format will not be displaced easily. This section discusses (a) a library's OPAC as a bibliography, (b) the standard general art bibliographies, (c) book review sources, and (d) publishers and book dealers.

II-A-1. A Library's OPAC As a Bibliography

To discover pertinent material on a specific topic, you need to locate books published on the subject. One method is to consult bibliographies compiled by experts in that field. In its broadest sense, a library's *online public access catalog*, called an *OPAC*, is a bibliography[1] of the collection of the institution; a history of its collecting. The library's OPAC is a database of the holdings of this single institution, replacing the traditional card catalogue. Many libraries have made their OPACs available on the Internet, a subject detailed in Chapter VI.

In New York City, there are numerous excellent art libraries with extensive collections of art reference material; many have their OPACs available on the Internet. The three libraries mentioned below also have printed catalogues of their bibliographic holdings, some of which are available on CD-ROM.

The Watson Library of the Metropolitan Museum of Art [VI-C-3] is one of the world's largest art museum libraries. Its OPAC contains all material catalogued since 1980, or about 70 percent of the library's entire holdings <http://www.metmuseum.org/htmlfile/gallery/first/library.html>. For earlier material, consult *Library Catalog of the Metropolitan Museum of Art* (48 vols. 2nd ed. Boston: G. K. Hall, 1980. *First Supplement*, 1982; *Second Supplement,* 4 vols., 1985; *Third Supplement*, 1983–86, 1987).

The New York Public Library [VI-C-1] is one of the world's great research institutions. Its OPAC contains material catalogued since 1971, plus many older titles that the NYPL has recatalogued <http://catnyp.nypl.org/>. For the printed volumes, see below (for additional data, [VI-C-1]).

The Museum of Modern Art Library has one of the world's finest holdings of 20th-century art history materials. Its OPAC—called Dadabase—is the online

The New York Public Library Web Page <http://www.nypl.org/libraries.html>

version of its printed volumes [II-A-2], <http://moma.org/>.

II-A-2. Standard General Art Bibliographies

There are several general art bibliographies that have extensive information on dictionaries and encyclopedias, art history references, special bibliographies, and journals and magazines. The more useful bibliographies have annotations[2] that assist researchers in choosing references. Although they lack currency, these bibliographies are excellent sources (a) of early publications that are often important to a study, (b) for identifying the scholars in specific disciplines, and (c) for learning something about the history of the literature on the subject. These books provide access to a core of established scholarly material.

Annual Bibliographic Publications

A few collections of the more famous libraries are published annually as bibliographic guides. The printed books are used by (a) researchers searching for material and (b) librarians involved in collection development. The following resources, originally published as multivolume sets, are now issued as annual updates. In addition, both institutions provide Internet access (see [II-A-1]), but coverage in the online versions is not always the same as in the annual printed volumes.

Annual Bibliography of Modern Art, Museum of Modern Art (Annual. Boston: G.K. Hall, 1977+)
 Includes books, periodicals, and exhibition catalogues. Updates *Catalog of the Library of the Museum of Modern Art* (14 vols. Boston: G.K. Hall, 1976).

Bibliographic Guide to Art and Architecture, New York Public Library (Annual. Boston: G.K. Hall, 1975+)
 Includes all formats: books, exhibition catalogues, videos, and CD-ROMs. Updates *Dictionary Catalog of the Art and Architecture Division* (30 vols. Boston: G.K. Hall, 1975).

Art Bibliographies

The art bibliographies cited below list material not necessarily owned by any single institution. Although all are out of print, they can be found at most libraries and they remain invaluable references.

Art Information: Research Methods and Resources, by Lois Swan Jones (3rd ed. Dubuque, IA: Kendall/Hunt, 1990)
 Discusses methodology for locating art data; contains 1,900 citations, many annotated. Includes microfiche, CD-ROMs, and documentary videos, as well as extensive lists of art bibliographies.

Fine Arts: A Bibliographic Guide to Basic Reference Works, Histories, and Handbooks, by Donald L. Ehresmann (3rd ed. Littleton, CO: Libraries Unlimited, 1990)
 Annotates approximately 2,000 works; includes extensive list of topography handbooks

Guide to the Literature of Art History (Chicago: American Library Association) continues Mary W. Chamberlin's *Guide to Art Reference Books*, published in 1959 by the ALA
 Volume I, by Etta Arntzen and Robert Rainwater, 1980, annotates more than 4,000 entries for publications issued between 1957 and 1977; it is noted for foreign-language titles. An excellent source for earlier art bibliographies, it is commonly abbreviated as Arntzen/Rainwater.

 Volume II, by Max Marmor and Alexander D. Ross, to be published in 1999, will cover publications from 1977 through 1997.

II-A-3. Book Review Sources

An objective book review that provides a critical analysis of the material will assist you in determining how significant a publication may be to your research. Some reviews afford additional insight into the discipline, reporting other important resources. However, since a book review reflects someone's opinion, it, too, must be judged. Is the reviewer nit-picking, or do the comments and criticisms have merit? The publication in which the review appears must also be judged as to the quality of the serial. For instance, a critique printed in *Art Bulletin* is more likely to be written by an expert in the same art field as the author than a review in a more general publication. Book reviews assist you in

- assessing the quality and quantity of the research completed by the author
- understanding books that are confusing or difficult to comprehend
- deciding whether or not specific books warrant being used as textbooks or as references to be studied or quoted extensively
- staying informed of current publications

Art books are sometimes reviewed in professional journals; occasionally, the organization's Web site furnishes some information on the critiques (Appendix Two). Book reviews are usually included in indexes to art literature, including *Book Review Digest* and *Book Review Index* [VII-B]. Published reviews often take months or even years to be indexed. For more popular books, a critique may appear in a newspaper that has a review section, such as the *New York Times* <http://www.nytimes.com/>. Some critiques can be searched through *Bookwire,* which reproduces the full text <http://www.bookwire.com/>.

Publishers frequently include abbreviated reviews of the books they publish; see below. Another Internet source is the Amazon.com bookstore, which has search capabilities for the approximately 2,500,000 books it lists for sale. Once a book is located, the entry provides you with a synopsis of any review in the *New York Times* Book Review Section. In addition, you are furnished the titles of other books by the same author <http://www.amazon.com/>.

II-A-4. Publishers and Book Dealers

Traditional methods of buying books is changing with the growing popularity of the Internet. Many publishers, some of which are cited below, have an online presence. At their Web sites, publishers place details of recently issued books. These may include the basic bibliographical entry—author, title, date of publication—plus a summary, excerpts of reviews it has received, the table of contents, number of pages, ISBN,[3] and information on any supplements available. Sometimes information on the author is included.

Many art book dealers are placing information on the Web concerning the availability of publications, which can be purchased online or by telephone. At these Web sites, you can sometimes search for publications by author, title, subject, keyword, or ISBN, thus providing you with yet another avenue to locate publications.

Acquiring exhibition catalogues is often a challenge, because they often are produced in small numbers and sometimes are sold only through museum bookstores. The problems are compounded if a foreign-language catalogue from a small museum in an out-of-the-way

place is sought. The Worldwide Books Company, founded in 1965, has wide distribution and an extensive database of more than 35,000 exhibition catalogue titles concerned with artists, art subjects, and cultures. The database, which includes both current and retrospective titles, is a fundamental research tool for locating important international and domestic catalogues <http://www.worldwide.com/>.

For foreign material—current, rare, or out of print—you may need to consult book dealers specializing in these types of publications. Remember, the Web is international in scope; book dealers outside North America frequently concentrate on works—books, dictionaries, and/or serials—issued in their countries. Some firms will conduct archival or library research in their area of expertise, for which there is a fee.

This section cites some URLs for (a) publishers of books on art and art-related subjects, (b) university presses, (c) indexes to publishers' Web sites, (d) book and exhibition catalogue dealers, (e) indexes to book dealers' Web sites, and (f) Web resources for out-of-print and used books. The lists that follow are not exhaustive, but are intended only to suggest the types of material available. To discover the names of publishers and dealers, see *Literary Market Place* (Annual. New York: R. R. Bowker), which has a subject index to book publishers, lists photograph and picture resources, and includes U.S. agents of foreign publishers.

Web Sites of Publishers of Books Related to Art

ABC-CLIO
 <http://www.abc-clio.com/>
Academic Press
 <http://www.apnet.com/>
Antique Collectors' Club
 <http://antiquecc.com/>
Facts On File
 <http://www.chronbooks.com/>
Gale Research
 <http://www.thomson.com/gale.html>
Getty Trust Publications
 <http://www.gii.getty.edu/publications/index.html>
G. K. Hall
 <http://w3.mlr.com/mlr/gkhall/>
Gordon and Beach
 <http://www.gbhap.com/>
Greenwood Publishing Group, Inc.
 <http://www.greenwood.com/>
Harcourt Brace
 <http://www.harbrace.com/>

Harry N. Abrams
 <http://www.abramsbooks.com/index.htm>
Holt, Rinehart & Winston
 <http://www.hrw.com/>
H. W. Wilson
 <http://www.hwwilson.com/>
John Benjamins
 <http://www.benjamins.com/>
McGraw-Hill
 <http://www.mcgraw-hill.com/>
Macmillan Computer Publishing
 <http://www.mcp.com/>
Macmillan Library Reference
 <http://w3.mir.com/mir/>
Macmillan Reference, Ltd.
 <http://www.macmillan-reference.co.uk/>
Oryx Press
 <http://www.oryxpress.com/>
Penguin USA
 <http://www.penguin.com/usa/>
Prentice Hall
 <http://www.prenhall.com/>
Random House
 <http://www.randomhouse.com/>
R. R. Bowker
 <http://www.reedref.com/bowker/index.html>
K. G. Saur
 <http://www.saur.de/>
Simon & Schuster
 <http://www.SimonSays.com/>
Thames & Hudson
 <http://www.thameshudson.co.uk/thudson.htm>
University Microfilms
 <http://www.umi.com/>
Van Nostrand Reinhold
 <http://www.thomson.com/vnr.html>
W. W. Norton
 <http://www.wwnorton.com/>

Web Sites of University Presses

Cambridge University Press
 <http://www.cup.org/>
Columbia University Press
 <http://www.cc.columbia.edu/cu/cup/>
Harvard University Press
 <http://www.hup.harvard.edu/>
Johns Hopkins University Press
 <http://www.jhu.edu/~jhupress/>
MIT (Massachusetts Institute of Technology) Press
 <http://www-mitpress.mit.edu/>
Oxford University Press
 <http://www.oup-usa.org/>
Princeton University Press
 <http://pup.princeton.edu/>
Stanford University Press
 <http://www.sup.org/>

University of Arizona Press
<http://www.uapress.arizona.edu/home.htm>

University of California Press
<http://www-ucpress.berkeley.edu/>

University of Chicago Press
<http://www.press.uchicago.edu/>

University of Indiana Press
<http://www.indiana.edu/~uipress/>

University of Michigan Press
<http://www.press.umich.edu/>

University of Texas Press
<http://www.utexas.edu/depts/utpress/>

University of Toronto Press
<http://www.utpress.utoronto.ca/cww/>

Yale University Press
<http://www.yale.edu/yup/>

Indexes to Publishers' Web Sites

American Association of University Presses
<http://aaup.pupress.princeton.edu/>

ARLIS/NA Art Publishers, Distributors, and Vendors
<http://www.lib.duke.edu/lilly/arlis/web/
artpublishers.html>

Oxford University Publishers List
<http://www.comlab.ox.ac.uk/archive/
publishers.html#publishers>

Vanderbilt University Directory of Publishers and Vendors
<http://www.library.vanderbilt.edu/law/acqs/pubr/
links.html>

Yahoo's List of Publishers
<http://www.yahoo.com/Business_and_Economy/
Companies/Publishing/>

Web Sites of Art Book Dealers

Andrew Cahan Bookseller
<http://www.cahanbooks.com/>

Antiquarian Association
<http://www.antiquarian.com/>

Ars Libri, Ltd.
<http://www.arslibri.com/>

Auldbooks Bibliophile Bookshelf
<http://www.auldbooks.com/biblio/index.html>

Baker and Taylor
<http://www.baker-taylor.com/>

Blackwell Publishing Group
<http://www.blackwell.com/>

Casalini Libri, Florence, Italy, furnishes data on titles published in Italy and Italian-speaking countries. It will conduct personal research at Tuscan archives and libraries.
<http://casalini.com/>

G+B Arts International
<http://www.gbhap.com/>

Harrassowitz, Wiesbaden, Germany
<http://193.96.147.133/>

Howard Karno Books, concerning Latin America
<http://www.karnobooks.com/>

Librairie Léonce Laget, Paris, are rare book specialists, especially for French publications and foreign architecture.
<http://www.franceantiq.fr/slam/laget/laget_uk.htm>

Michael Shamansky Bookseller
<http://www.artbooks.com/>

Rare and Secondhand Books, Therwil, Switzerland
<http://www.rsb.ch/main.htm>

Ursus Books and Prints Ltd.
<http://www.ursusbooks.com/>

Worldwide Books specializes in exhibition catalogues
<http://www.worldwide.com/>

Indexes to Book Dealers' Web Sites

Antiquarian Booksellers' Association of America (ABAA) has a search feature for locating booksellers by specialty or geographic location.
<http://www.abaa-booknet.com/booknet.html>

ARLIS/NA Art Publishers, Distributors, and Vendors
<http://www.lib.duke.edu/lilly/arlis/web/
artpublishers.html>

Book Dealers, University of Houston, lists associations and organizations, book dealers, and preservation resources
<http://info.lib.uh.edu/specres.html>

Yahoo's List
<http://www.yahoo.com/Business_and_Economy/
Companies/Books/Booksellers/>

Resources for Out-of-Print and Half-Priced Books

Advanced Book Exchange
<http://www.abebooks.com/>

Bibliofind
<http://www.bibliofind.com/>

Half-Price Books
<http://www.halfpricebooks.com/>

Interloc: The Electronic Marketplace
<http://www.interloc.com/>

II-B. Archives, Vertical Files, and Picture Collections

When you go through a box of material you have kept from earlier days, you are likely to find all kinds of ephemeral material: invitations, letters, newspaper clippings, and even photographs. The questions arise: What should be done with the material? Will it ever be used? Will it last much longer? These same questions are asked by librarians and archivists whose institutions have archival material, vertical files, and/or picture collections.

An archive contains original material; vertical files and picture collections contain all types of material, some original, some not. At one time, archival material was defined as unpublished documents, but this is now misleading. Some archives—as well as vertical files and picture collections—have been published on microforms and made available to the public. The question of conserving the archival material for posterity has thus been answered for a few important collections.

Some libraries are storehouses for various kinds of archival material: documents and records, personal diaries and letters, sketchbooks, and architectural drawings and plans. Libraries often have archival data on the architects who designed their buildings, the libraries' patrons and directors, and artists who worked in the region. After the primary material is catalogued, a method must be devised for informing patrons of its existence. The Internet has become a highway for this information.

Many libraries, especially in museums and public institutions, preserve vertical file material organized by individual artists, local architectural monuments, and area museums and galleries. These open-ended files—to which material can be added continually—may contain letters, newspaper clippings, gallery and exhibition reviews, brief articles, obituaries, photographs of artists, exhibition brochures, and illustrations of works of art. In the past, this material was not usually indexed; increasingly, however, the broad subjects that the vertical files comprise is being placed on the Internet.

A picture collection consists of various types of illustrative material, such as photographs, postcards, and book jackets, as well as reproductions from magazine articles, exhibition and sales catalogues, and advertisements. These collections are compiled on (a) individual artists; (b) significant buildings, sites, and monuments; or (c) subjects, such as animals, flowers, or buildings, that researchers and studio art students might use for documentation and inspiration. Some collections are for all types of art, including paintings, sculpture, and architecture. Others cover only art from a particular country, such as the collections of the Yale Center for British Art <http://www.yale.edu/ycba/> and the National Museum of American Art, Smithsonian Institution <http://www.nmaa.si.edu/>, or a specific type of art, such as the National Portrait Gallery, Smithsonian Institution, Washington, D.C. <http://www.npg.si.edu/>. A few large picture collections have been reproduced on microfiche.

In Europe and North America, there are two types of picture collections: (a) those that clip and save and (b) those that have extensive collections of acquired photographic collections and large picture collections reproduced on microforms. There are three excellent collections of the first type: (a) the Frick Art Reference Library, New York City <http://www.frick.org/>; (b) the Netherlands Institute for Art History,[4] Den Haag, Netherlands <http://www.konbib.nl/rkd/engalg/gsch-en.htm>; and (c) the Witt Library of the Courtauld Institute of Art in London, which is the only one available on microfiche [V-G-2]. Two institutions with outstanding collections of acquired material are the National Gallery of Art, Washington, D.C. <http://www.nga.gov/>, and the J. Paul Getty Center in Los Angeles, California <http://www.gii.getty.edu/>. For information on these picture collections, access their Web sites.

Information on archives, vertical files, and picture collections used to be difficult to locate, but with the use of the Internet, more and more data concerning these collections are being made public. Some of the more important collections are highlighted in the appropriate sections of this book. For others, consult the following:

Library of Congress, Library and Information Science Resources, which provides links to special collections
<http://lcweb.loc.gov/global/library/>
Yahoo's Special Reference Libraries Collections
<http://www.yahoo.com/Reference/Libraries/Special_Collections/>

Yahoo: Arts: Humanities: History: Archives
<http://www.yahoo.com/Arts/Humanities/History/Archives/>

II-C. Microforms

Microforms are used to condense massive amounts of information into a small space. These celluloid formats contain large quantities of compressed bibliographic or visual material placed on either microfilm or microfiche.[5] Because they require special equipment to view and to photocopy, these reference tools are usually expensive and located in libraries, often in media centers. Microforms have not always been popular with researchers, because they can be difficult to use.

The greatest asset of microfiche is the enormous number of frames of text and images they reproduce. Moreover, some photographs taken in the late 19th or early 20th century and now preserved on film are of art that no longer exists or that has changed significantly. Although photocopies made from microfiche are not always satisfactory, good copies of individual illustrations can frequently be purchased through the institution whose collection has been reproduced.

Microfiche collections have not overcome certain liabilities, such as the visual quality of the photographs, which varies from excellent to poor. Mostly in black-and-white, microforms are inflexible, making it difficult to compare material. The typed text may be difficult to read or the illustrations too dark to distinguish details. Sometimes pertinent research information has been excluded, such as measurements or sales data, and a work's scale may be difficult to determine. Moreover, artist attributions may represent outdated scholarship.

Most photograph collections reproduced on microfiche are accessed by geographic location or by individual artist, in a linear method by which researchers check the city or artist and then look at every image until the desired object is located. The constant changing of cards or rolls can be frustrating and time-consuming.

Since microforms are not always included in a library's OPAC, locating them is sometimes a challenge. Significant titles are included in the appropriate areas of this guide. For a longer list of the resources important to the field of art, see *Guide to Microforms in Print: Author-Title* (Annual. 2 vols. Westport, CT: Meckler Publishing) or *Guide to Microforms in Print: Subjects* (Annual. 2 vols. Westport, CT: Meckler Publishing).

Microform Publishers
Microform sets are often described at the publisher's Web site.

Chadwyck–Healey
<http://www.chadwyck.com/>
Emmett Publishing
<http://www.emmettpub.co.uk/>
Norman Ross Publishing, which distributes many European publications
<http://www.nross.com/>
K. G. Saur
<http://www.saur.de/>

II-D. CD-ROMs

Similar to microforms in that they condense data, CD-ROMs are growing in popularity, in part because they are remarkably adaptive to visual arts resources. These disks are capable of containing immense quantities of information for both illustrations and text, but to be accessed, they require a computer with a special drive. With the prevalence of personal computers equipped with this hardware and the lower cost of multimedia CD-ROMs, more information and visual material is being packaged in this format.

CD-ROMs have several assets, including ease of access and excellent color fidelity. Most important, they are a permanent format, ready for use at any time. Care must be taken, however, when deciding which CD-ROMs to purchase. Be sure they are compatible with your system—Macintosh or IBM—and with your Windows application. CD-ROM technology can be complicated; the disks do not always work in every system. Read the outside cover carefully to be sure technical help is available. If there is no telephone number or Web site you can access, you may wish to defer your purchase until you have investigated the product further.

CD-ROMs that store only text have become almost fundamental in publishing multi-volume reference works, indexes of art literature, out-of-print exhibition and auction catalogues, and sales price indexes. These references may be published in several formats, but as CD-ROMs they can be issued on a regular basis, combining past and current material, making searching for specific items quicker and easier.

Multimedia CD-ROMs—which may incorporate art, text, sound, and film—cover many subjects, including art historical styles and periods, artists, and museums. Often reasonably priced, they contain more detailed material than is now available on the Web. Some CD-ROMs use the word *virtual*—meaning "looking like something, but not the actual thing"—in their advertising. The meaning of this term varies, but *virtual reality,* in relation to a museum recreated on screen, usually shows how the gallery space looks with art displayed on its walls.

The use of multimedia CD-ROMs as learning tools for adults and children is expanding. The staffs of some museum education departments are producing multimedia disks to encourage students and patrons to learn more about the museum's collections. Some incorporate games and puzzles; others require looking closely at works to analyze them. A number of museums are producing CD-ROMs specifically for young patrons.

Multimedia CD-ROMs are also produced to highlight a museum, its history, and its collections, as well as to supplement part of a catalogue of the museum's permanent collection. London's National Gallery has developed several CD-ROMs: *The Art Gallery* (CD-ROM. Redmond, WA: Microsoft, 1993) furnishes extensive data on the museum's paintings and includes illustrated tours through exhibition halls, a glossary of terms, and discussions of various subjects depicted in the art. The oral pronunciation of the names of more than 750 artists whose works are displayed at the museum is also provided. *CIC on CD-ROM* (CD-ROM. London: National Gallery Publications, 1995) is a systematic catalogue of the museum's permanent collection, reproducing all of the institution's paintings, in both thumbnail size and in a format that can be magnified to observe details.

Because of this superior method for indexing voluminous material, CD-ROMs are being used in combination with catalogues raisonnés.[6] These disks are excellent formats for visual material, as well as the voluminous notes and bibliographic records that can impede the flow of text. *Edward Hopper: A Catalogue Raisonné,* by Gail Levin (New York: W. W. Norton, 1996), is a boxed set of four volumes: three for text plus a CD-ROM containing images of the artist's works, exhibition histories, and bibliographies.

Reviews of CD-ROMs are scattered, sometimes appearing in the popular press and sometimes in scholarly publications. Three Web sites that consistently provide information on art-related CD-ROM reviews are (a) the *VRA Bulletin*, the official magazine of the Visual Resources Association <http://www. vra.oberlin.edu/>; (b) *Art Teacher* <http://www. artteacher.com/cdrom/cdrom.htm>; and (c) Mark Harden's *Texas.net Museum of Art* Web site <http:// www.artchive.com/cdrom.htm>.

Although some academic libraries include their CD-ROM titles in the library's OPAC, this may not reflect the complete holdings of the institution. Frequently, the institution's art department also collects CD-ROMs and documentary videos, which usually are not reported in the main library's OPAC. You may wish to check under an academic art department to see if there is a listing of the departmental holdings. For a listing of the Rotch Visual Collections at MIT, for instance, see <http://www.libraries.mit.edu/rvc/cd-rom.html>. For a book reference, see *Gale Directory of Databases* (Semiannual. 2 vols. Detroit: Gale Research, 1993+). Some commercial firms selling videos are beginning to sell CD-ROMs. Some significant CD-ROM titles are included in the appropriate sections of this book.

II-E. Documentary Videos and Other Audiovisual Formats

For many projects, such as term papers, illustrated lectures, and academic publications, visual material will be required. You should decide what format you need: (a) slides for multimedia presentations, (b) good color illustrations to indicate the work's intensity and shades, (c) details of specific sections of the work, (d) black-and-white, thumbnail-size reproductions for identification purposes, or (e) visuals for which publication rights must be obtained, a subject also discussed in [XVI-B-4].

Visual material can be reproduced in a number of formats: videodiscs, slides, photographic prints, and videotapes. Technical hardware innovations usually outpace software development. For instance, the videodisc is a large disc compressing a great deal of material, such as popular Hollywood movies, large picture collections, and reproductions of a museum's permanent collection. Not all libraries will have purchased the hardware needed to operate videodiscs, even though there are a number of art-related discs on the market.

Slides are important to professors, curators, and educators who use them for illustrating lectures. They are frequently digitized and put on the Web. The latest technology now being developed is the digital versatile disc, or DVD, which has yet to be used in most libraries and therefore is not discussed here.

For some projects, good photocopies—black-and-white or color—will be needed. One place to purchase reproductions, either for study or publication, is the institution that owns the art. Museums frequently sell reproductions, especially black-and-white glossy prints and color slides, of the art in their collections. For instance, the Minneapolis Institute of Arts sells curriculum materials for teachers and students <http://www.artsmia.org/tta/tta_materials_for_sale.html>. You will need to contact each museum on an individual basis.

Documentary videos strive for factual information to provide an accurate rendition of the subjects covered. Because they are richly illustrated, these non-Hollywood films also give extra dimensions, furnishing a sense of scale and size, as well as aerial views of architecture. In addition, documentaries frequently incorporate history and music within their varied

scope, which may include vintage photographs and film clips. These videos cover various art historical periods, as well as individual artists, collectors, and museums.

Two publications that consistently review art documentary videos are (a) the *VRA Bulletin,* the official magazine of the Visual Resources Association <http://www.vra.oberlin.edu/>, and (b) *Video Librarian.* Its Web site, *Video Librarian Online,* provides an index to the 200 critical video reviews in each bimonthly issue of the printed publication. It explains its one- to four-star rating system and furnishes a search mechanism to locate titles of videos reviewed since 1986 <http://www.videolibrarian.com/>.

There are several major methods for locating pertinent audiovisual material: (a) the program called *Art on Film,* which covers videos; (b) academic collections that place this information on the Internet; and (c) Web sites of commercial firms. To locate publishers' addresses, check the following major print sources for art documentaries: (a) *Video Source Book 1997/98: A Guide to Programs Currently Available on Video* (Issued every other year. 19th ed. 2 vols. Detroit: Gale), a subject index to 156,000 videos; (b) *Books in Print* (Annual. Boston: R. R. Bowker), which has a subject index for videos; and (c) *Bowker's Complete Video Directory* (Annual. 3 vols. Boston: R. R. Bowker) <http://www.bowker.com/>.

Art on Film

Art on Film is a program formed in 1984 by the Metropolitan Museum of Art and the J. Paul Getty Trust. Directed by Nadine Covert, this membership program maintains a database containing more than 23,000 videos and films on the visual arts. Entries are indexed by subject and include basic data—titles, producers, and production dates—plus content synopses, published reviews, and awards. Available publications include (a) *Art on Screen* (Boston: G. K. Hall, 1992), an annotated directory of 700 selected documentaries with reviews and festival awards; (b) *Art on Screen on CD-ROM* (New York: G. K. Hall, 1995); and (c) *Architecture on Screen* (Boston: G. K. Hall, 1994), which covers 900 documentaries <http://www.artfilm.org/>.

Academic Web Sites

Although some libraries include titles for documentary videos in their OPACs, the art department may have a separate collection of documentary videos. In such an instance, this list will not be in the library's OPAC, though it may be on the Internet.

Example

The Rotch Visual Collections, Massachusetts Institute of Technology (MIT), cites videotapes on art, architecture, and photography. The list of MIT online holdings, directed by Katherine Poole, can be searched by titles or subject categories <http://libraries. mit.edu/rvc/film_video/rvcvid_new.html>.

Firms Selling Visual Material

When publishing an illustrated article or book, you need (a) good visual material, perhaps black-and-white photographs and/or color transparencies; and (b) the right to reproduce them. Remember, there are often two kinds of copyright for photographs of art works: one for the art, one for the photograph. So even if the art is old and no longer carries a copyright, the person who photographed it may have a copyright for the picture he or she took. The firms cited below may be able to assist you with these legal matters.

There are commercial companies that concentrate on selling good-quality slides. At its Web site, the Visual Resources Association lists some important publications for those seeking guidance on this subject <http://www.oberlin.edu/~art/vra/pub.html>. There are numerous companies that sell documentary videos, including many Public Broadcasting System companies. At their Web sites, a few commercial firms are providing brief annotations on the videos' contents. This section lists some Web sites (a) that provide information on purchasing slides; (b) for commercial firms selling slides and documentary videos; (c) for firms selling slides, photographs, and transparencies that can be used for publication; and (d) that assist you in locating video and film distributors and producers. Only companies with Web sites are listed; check the resources cited below for additional firms.

Information on Purchasing Slides

Management for Visual Resources Collections, Second Edition, by Nancy S. Schuller (Littleton, CO: Libraries Unlimited, 1990)

Rutgers University Directory of Image Vendors
 <http://www-rci.rutgers.edu/~beetham/vendor.htm>

Slide Buyer's Guide, by Norine D. Cashman and Mark M. Braunstein (6th ed. Littleton, CO: Libraries Unlimited, 1990). The 7th edition is now in the planning stage, with a revised tentative title of *Image Buyers' Guide,* reflecting the broadening of the subject.
 <http://www-rci.rutgers.edu/~beetham/ vendslid. htm>

Slide Collection Management in Libraries and Information Units, by Glyn Sutcliffe (Brookfield, VT: Gower, 1995)

Web Sites for Firms Selling Slides/Videos

American Library Color Slide Company
 <http://www.artslides.com/>

Archivision: A Visual Arts Image Bank
 <http://www.archivision.com/>

Creative Concepts of California
 <http://simpworld.com/creative/>

Davis Art Slides, formerly called Rosenthal Art Slides
 <http://www.davis.art.com/>

Hartill Art Associates
 <http://www3.sympatico.ca/hartills.art/>

Media for the Arts
 <http://www.art-history.com/>

Saskia, Ltd.
 <http://www.saskia.com/>

Universal Color Slide
 <http://www.universalcolorslide.com/main.html>

University of Michigan Slide Distribution Project
 <http://www.umich.edu/~hartspc/umsdp/ UMSDinfo.html>

Web Sites for Firms Selling Reproductions of Art for Commercial Use

Academic Press Image Directory
 <http://www.imagedir.com/>

Alinari, Italy
 <http://www.alinari.it/>

Art Resource represents, in North America, a number of European and American museums and photographic archives, providing the purchaser with the rights and permissions to publish the material. These include Alinari Archive, Bildarchiv Foto Marburg of Germany, Scala Find Arts of Italy, the Tate Gallery and the Victoria and Albert Museum of London, and some Smithsonian Institution museums, as well as the Pierpont Morgan Library and the Jewish Museum of New York City.
 <http://www.artres.com/>

Bildarchiv Foto Marburg
 <http://fotomr.uni-marburg.de/>

Corbis
 <http://www.corbis.com/>

Deutsches archäologisches Institut in Rome (RomeDAI)
 <http://www.uic.edu/depts/lib/archartlib/RomeDAI/>

Fine Art Prints, Posters, and Photographs sells visual material, especially works by contemporary artists
 <http://www.postershop.com/>

Poster Gallery, fine art and photography prints
 <http://www.postergallery.com/>

Locating Video and Film Distributors and Producers

Documentary videos are often produced by smaller companies that sell their products through distributors. Use the following to locate the names, addresses, telephone numbers, and URLs of these distributors.

Film and Video Distributors and Producers, Gary Handman, Media Resources Center, University of California, Berkeley
<http://www.lib.berkeley.edu/MRC/Distributors.html>

Films and Videos: Information and Sources at MIT and Beyond
<http://libraries.mit.edu/rvc/film_video/rvcvid_new.html>
Video Librarian Distributors Search Engine
<http://www.videolibrarian.com/producers.html>

Notes

1. A *bibliography* is a list of various materials—including books, exhibition catalogues, and articles—on a specific subject.
2. An *annotation* is a few sentences or phrases that describe the contents and/or state the merits of the work.
3. An *ISBN* (*International Standard Book Number*) is a number unique to each book publication, distinguishing it from any other.
4. Its Dutch name is Rijksbureau voor Kunsthistorische Documentatie.
5. *Microfilm* is a continuous role of film; *microfiche* is a 4 inch×6 inch film card, usually holding either 30 or 98 frames.
6. A *catalogue raisonné* lists every work of art either in an artist's complete output or in a specific medium. For each object, detailed data is supplied on exhibition history, provenance, scholarly literature that discusses the work, unusual or pertinent facts, and a critical or analytical account of the art. See also Chapter XI.

PART TWO

TYPES OF WEB SITES AND HOW TO FIND THEM

The Internet is a bank of computers that can reproduce only what someone has added to it. The accuracy of Web material must, therefore, be judged by the persons inputting the data. Some people place material on the Web because they want to share their enthusiasm and expertise in a particular subject. Others are using the Internet as a means of publishing their thoughts and ideas in a type of vanity press.

When the World Wide Web first became popular, computer technicians and others avidly placed reams of material on this electronic highway. Many still are. Since everything placed on the Internet takes someone's time and money, Web sites disappear or become inactive as interest wanes or money is depleted. The material at many Web sites is not current; be sure to check the last update of any data you access.

This book includes the URLs for more than 1,200 Web sites. Many URLs are for specific directories or files within a domain site, because it is often time consuming to locate them from the home page of the hosting institution. Some of these specific addresses may be moved, renamed, or deleted (see [I-A-3] for suggestions on locating the latest addresses within a domain site). The URLs in this book have been checked for usefulness or to illustrate a point, but they are not guaranteed as to accuracy, scholarship, or

authenticity. For these qualities, you must be the judge. However, to assist you, methods for evaluating and appraising Web sites are included in Chapter I.

Before downloading or printing online material, you should read the specific copyright statement appended to the Web site and investigate this legal subject [XVI-C]. As you visit different Internet locations, you will soon determine which are worth a second trip. But because online data can be changed radically overnight, you should revisit these sites periodically to determine whether the material has been updated or augmented, or the topic broadened.

As you visit Web sites, please note any changes in URLs that you discover, as well as any additional Internet resources that pertain to this book's content, and send this information to <artupdate@oryxpress. com>. Periodically, some of these updates and additions will be posted at the Web site for *Art Information and the Internet*: <http://www.oryxpress.com/ artupdate>.

When you access the Internet, you often are seeking the quick retrieval of specific information. You need to decide exactly what type of information you are seeking, since "information" is a broad term that runs the gamut from unrelated facts to detailed knowledge of a subject. Do not confuse *facts* and *knowledge*. A fact is something known to exist, such as the opening time

of a museum or the author of a book. Knowledge, however, is more complicated. It incorporates material derived from experience and/or insight, based on investigation into primary and secondary sources [IX-B-6], which has then been processed and enriched by a human mind. One aspect of research is to convert facts into knowledge. Examples of knowledge documents are the essays that accompany the Berkeley Art Museum online catalogue for "The New Child" [III-A-4] and those that discuss the technical aspects of Rembrandt's paintings at the Amsterdam Pavilion Web site [V-A].

The contents of Web sites can be roughly categorized as (a) factual information, (b) knowledge documents, (c) visual material, (d) indexes to these types of documents or to locations of material you need, or (e) various combinations of these four. This section explores the types of material you might find at various Web sites. Since only a fraction of the quality Internet material could be discussed in this book, the URLs of Web sites that index various types of data

are furnished. Many Internet locations have large quantities of excellent material; space allows only a brief summary here.

The next six chapters consider different kinds of Web sites, arranged by the institutions and people devising and manipulating them.

- Chapter III explains the important role of art museums
- Chapter IV discusses academic institutions and corporate sponsors, as well as entrepreneurs and Web technicians
- Chapter V considers various art-related organizations and foundations
- Chapter VI explores how libraries are using the Internet
- Chapter VII surveys the online aspects of art literature and its indexes
- Chapter VIII provides an overview of the art market's presence on the Internet

III. WEB SITES OF MUSEUMS

With the development of the World Wide Web and its ability to display graphic material, museums became the ideal institutions to use this newest information format. The Internet is providing an excellent means for museums to expand their audiences. Not only are well-known institutions represented, but smaller museums with more regional reputations are providing significant material. Museums of all sizes and descriptions have Internet home pages. These institutions are embracing the Web, in order to

- disseminate basic museum information
- encourage people who surf the Web to visit the museum, to view special exhibitions and the permanent collection, and to attend lectures and workshops
- share the museum staff's expertise and databases through online exhibitions, library facilities, and educational programs
- promote their resources to a worldwide community

The Web's popularity has an added benefit: Lesser-known museums and their programs are being brought to the attention of a universal online audience. This chapter is divided into (a) an examination of the types of data to be found at art museum Web sites, (b) a brief discussion of the importance of using non-art museums, and (c) some ways of locating specific URLs, accompanied by a list of museum Web sites and multimedia CD-ROMs created for these institutions.

III-A. Art Museums

The best source for current information about a specific museum is the museum's Web site, which may include (a) general visitor information, (b) data on current and future exhibitions, (c) illustrations of the permanent collections, (d) educational programs, and (e) hyperlinks to other Web sites. A museum's home page may also provide data on the library and the museum archives, as well as access to its library's OPAC. Museum libraries are discussed and compared with other such resources in Chapter VI; for material on American (U.S.) and Canadian archives, see Chapter XIV.

III-A-1. General Visitor Information

Before visiting a museum, you may need to know certain basic facts, such as hours and days open, entrance fees, special facilities for individuals with disabilities, and parking accommodations. Knowledge concerning ongoing and special programs—gallery talks, concerts, lectures, films, art classes, and workshops—may also be required. The best and quickest way to find answers to these types of inquiries is to contact the museum. This can be done by telephone or through the museum's Web site, since electronic data can be added and altered faster than print sources. Another useful aspect of a museum's home page is access to the museum's shop and publications department. Here, museums are providing sales data concerning the availability of their publications. In addition, the Web sites may furnish a variety of other facts, such as membership categories, news items, historical background, and data on the building's architect.

Examples

1. The Metropolitan Museum of Art has initiated a category for Internet users called the Met Net Members, who receive special privileges <http://www.metmuseum.org/htmlfile/member/Netintro.html>.

2. At its Web site, the Wallace Collection provides a news page to relate various events. When, in 1996, the National Gallery of Art in Washington, D.C., sent Sir Thomas Lawrence's painting of the Third Marquess of Hertford to this London museum for exhibition, the news page presented an illustration and a brief essay on the history of the portrait, which once hung in Sir Richard Wallace's study <http://www.demon.co.uk/heritage/wallace/>.

Guggenheim Museum Web Page <http://www.guggenheim.org/>

3. The National Gallery of Canada, Ottawa, provides extensive information on Moshe Safdie, the architect who designed its 1988 building <http://national.gallery.ca/english/history/1988.html>. A hyperlink takes you to the Blackader-Lauterman Library of Architecture and Art at McGill University in Montreal, which provides a biographical sketch and information on the Safdie Archive at the Canadian Architecture Collection (CAC) <http://blackader.library.mcgill.ca/cac/safdie/index.html>.

III-A-2. Current and Future Exhibitions

An important activity for museums is the arranging and mounting of special exhibitions. These exhibitions run the gamut from displaying only a few art objects to showing a vast collection of works that provide visitors with an encyclopedic view of the subject. One essential function of a museum's Web site is to report the schedule for current and prospective exhibitions. Even if tentative, the proposed dates are usually posted, since it is important to alert viewers as far in advance as possible.

This section (a) defines two types of catalogues; (b) compares the quantity and quality of exhibition material available both in a printed format and on the Web; (c) discusses online and printed data concerning large, popular exhibitions; (d) considers the use of online material for small exhibitions; and (e) raises the issue of what to do with online data once an exhibit closes.

Summary Catalogues and Scholarly Catalogues: Definitions

To accompany an exhibition, there is often a printed catalogue, which disseminates the most current research on the subject and frequently illustrates works of art not previously reproduced. Such catalogues can include either summary or scholarly entries.

A *summary exhibition catalogue* or *checklist* contains only a minimal entry—artist's name, plus title, medium, dimensions, probable date created, and present location—for each work of art, which may or may not be illustrated.

A *scholarly exhibition catalogue* is a more comprehensive document, providing the data recorded in a summary catalogue, plus such additions as exhibition records; provenance, or list of all known owners and sales in which the work figured after leaving the artist's studio; literature referring to the piece; information on any related works; and, if possible, something concerning the subject. Moreover, many of the works of art are illustrated in color. Scholarly catalogues—which usually include pertinent essays concerning the artist, the style, and/or the historical period—are frequently the best and most recent investigation and interpretation of an artist's work or of a specific subject. Depending upon the topic, an exhibition catalogue can remain the most significant research on a subject for years, or even decades.

Example

Georges de La Tour and His World, by Philip Conisbee (Washington, D.C.: National Gallery of Art, 1996), was compiled for the first United States exhibition of La Tour's work at the National Gallery in Washington, D.C., and the Kimbell Art Museum in Fort Worth, Texas. This was the largest display of the French artist's paintings since his first and only retrospective exhibition in 1972 at the Orangerie des Tuileries, Paris. The 1996 scholarly catalogue, which added to the scholarship of this little-known artist, has become an important research publication.

Exhibition Material: Printed and on the Web

Prior to 1995, the printed catalogue was the only major documentation for a temporary exhibition. Two other formats are now being used: (a) multimedia CD-ROMs, discussed below under the Cézanne exhibition, and (b) online information placed at the museum's Web site. The information in the printed catalogue is seldom the same as the Web material; the two usually complement each other. Remember that the online data may be transitory. Although the Web information will not be sufficient for in-depth research, it will add another dimension to your study. But will the online material be printed and saved? Will the museum archive this data and keep it on the Web, and if so, for how long?

Examples

1. To promote its 1996 exhibition, "Metropolitan Lives," the National Museum of American Art (NMAA) provided online access to extensive visual and text data. Its Web site has brief material for each of the six artists in the exhibition, while the more permanent, printed exhibition catalogue, *Metropolitan Lives: The Ashcan Artists and Their New York,* by Rebecca Zurier, Robert W. Snyder, and Virginia M. Mecklenburg (Washington, D.C.: National Museum of American Art, 1995), has a greater number of illustrations of the six artists' works, plus four lengthy essays <http://nmaa-ryder.si.edu/metlives/ashcan.html>.

2. For "Glass Today: American Studio Glass from Cleveland Collections," the Cleveland Museum of Art librarians compiled a reference guide available both at the museum's Web site and as a printed booklet. The 26-page guide included (a) 16 pages of bibliographical references for literature written on the 51 artists whose work appeared in this 1997 exhibition, (b) a listing of recent publications on glass and glass-making, (c) the names of the 9 artists whose archival material was located at the museum, (d) the titles of 11 videotapes on glass, and (e) the URLs for Web sites for 8 artists with their own Internet locations, museums with good collections of contemporary glass, and other glass-related Internet sources <http://www.clemusart.com/>; see Exhibitions, Past, Reference guide.

Large, Popular Exhibitions: How Much Material?

How much online data concerning specific art exhibitions is placed on the Internet depends upon the institution hosting the exhibit and the interest of other subsidiary organizations. In addition, the star quality of the artist being highlighted determines, to a great extent, the quality and quantity of the Web material. For international, blockbuster shows, the material on the Web can almost be a case of overload!

During the 1995–96 Cézanne exhibitions held in Paris, London, and Philadelphia, a tremendous amount of online data from Europe and the United States accompanied this first major exhibition in 60 years of the French artist's work. The exhibition provided an outstanding example of the quantity and quality of the data generated by these events, both on and off the Web. And the most significant fact is that all of the fabulous online material discussed here is gone; it is no longer available on the Internet.

"Cézanne": European Internet Material

Information, both in French and English, was placed on the Internet in 1995 by various people before the Cézanne show left France. The extensive online text included a biography, brief paragraphs on Cézanne's acquaintances, and a short bibliography. The most essential Web material for some scholars was a list of the works of art—oil paintings, watercolors, and drawings—that would be displayed at the three museum sites. None of the exhibiting institutions displayed exactly the same oil paintings: Paris had 116; London and Philadelphia, 106 each, with some differences in the selections. This was significant for those wishing to know the exact titles of the paintings sent to each museum <http://www.cezanne.com.eng/accueil.html>.

"Cézanne": U.S. Internet Material

The Philadelphia Museum of Art, the last stop for the Cézanne exhibition, presented outstanding material at its Web site to try to answer every question anyone might pose. There were large quantities of data, from dates, times, and admission fees to information on package deals with trains, planes, and hotels. Special events and related publications were highlighted. Membership information was provided, since large, major exhibitions help expand a museum's membership rolls.

Nor was scholarship neglected. At the museum's Web site, there was a brief overview by curator Joseph Rishel, plus an online illustrated catalogue organized by the 13 galleries in which the artist's works were displayed. One painting, accompanied by a summary catalogue entry and a description of the piece, represented each gallery. And remember, this was all on the Internet!

"Cézanne": Removal of Promotional Material

The fascinating online information that enticed visitors to the Cézanne exhibition is no longer on the Internet. Researchers must remember that Web material is often ephemeral. In the legal contracts, the photographs of loaned works could be used only for promotional purposes. Once the exhibition closed, reproductions of the paintings had to be removed from the Web. The Cézanne exhibition material was placed under the URL <http://www.libertynet.org/~pma/>. Later, the museum obtained a new URL:

<http://www.philamuseum.org/>. The museum's webmaster relates that the Cézanne exhibition material still exists and that it may yet appear in a modified form at the museum's new Web site.

Permanent Record: The Printed Catalogue, *Cézanne*

One permanent source on the exhibition is the printed catalogue, *Cézanne*, by Françoise Cachin and others (New York: Abrams, 1996). The 600-page work includes material not on the Web: quotations from Cézanne, an essay on the criticism that the artist's work engendered, a detailed chronology of his life, and data on major collectors of his paintings. Moreover, each of the 227 works is illustrated in color and provided a scholarly entry. The printed catalogue, *Cézanne*, is a formidable accomplishment!

Multimedia CD-ROM on Cézanne

To add to the wealth of material, a multimedia CD-ROM, called *Paul Cézanne: Portrait of My World* (Bellevue, WA: Corbis, 1996) in English and *Moi, Paul Cézanne* in French, was created to enhance the exhibition. It contains illustrations of 200 of Cézanne's works, plus an additional 250 photographs, several short videos, a soundtrack, virtual environments of five locales the artist frequented, and some of the artist's quotations. In addition, there is an interactive CD-ROM for children: *A is for Art, C is for Cézanne* (Philadelphia Museum, 1996).

Even More Material on Cézanne

With all of this material available on Cézanne, you would think there was little need for any more. But more appeared, from both sides of the Atlantic. Someone at Cambridge University in England recorded news releases concerning London's Tate Gallery's Cézanne exhibition <http://www.bio.cam.ac.uk/~cyk10/cezanne.html>. There was the familiar coverage by the *WebMuseum* [IV-C]. A creative approach was provided by the *Philadelphia Inquirer* <http://www.phillynews.com/>, which sent photographer Eric Mencher to Aix-en-Provence, France, to photograph the subjects Cézanne painted.

Small Exhibitions: Online Material

Small exhibitions sometimes become a major online resource for artists and subjects. Thus, the Web is becoming a particularly important avenue to broaden the exposure of a wide range of artists to an international Internet public.

Example

The Los Angeles County Museum of Art (LACMA) sponsored a series of shows entitled "Artist Interviews on the Internet." In 1995, the contemporary multimedia French artist Annette Messager was highlighted. LACMA furnished illustrations of her work, an introduction to the exhibition, a brief biography, an interview with the artist, and a discussion and illustration of seven themes the artist uses. With this Web site, a contemporary artist became better known to a vast cyberspace audience <http://www.lacma.org/Exhibits/AM/default.htm>.

Archiving Online Exhibition Material

As discussed earlier, promotional material disappears from some museums' Web sites after an exhibition closes. Other museums may preserve the information and leave it on the Web. The data may not be as detailed, and the illustrations may be curtailed to the museum's own collection, but this important material is sometimes saved for archival use. There is not, as yet, consensus as to where this material should be filed. The stored material on past exhibitions is frequently placed under the Education section. The questions have now become, how permanent is this material? and under what category should the archival data be placed?

Example

At their Web site, the Los Angeles County Museum of Art has a section called Archived Exhibition Materials <http://www.lacma.org/>, a location for the extensive data written for past exhibitions. "The American Discovery of Ancient Egypt" includes 25 illustrations and data that complement the two printed catalogues available for this 1995–96 show. For Egyptology students, both catalogues are a must. For the generalist, the Web format provides an excellent beginning to further study <http://www.lacma.org/Exhibits/default.htm>.

III-A-3. Permanent Museum Collections

A major concern for all museums is the documentation of their permanent collections. Museums often publish two types of books that provide information on their collections. One is the *guidebook,* which highlights a few major works of art from each of the institution's departments, with color reproductions but brief text. Another is the *scholarly catalogue,* which contains the same material as a scholarly exhibition catalogue for every work of art owned by the museum. Unfortunately, only a few museums have published the latter for their permanent collections; among them, the British Museum, the National Gallery, the Tate Gallery, the Victoria and Albert, and the Wallace Collection, all in London. Others include the Kunsthistorisches Museum, Vienna; the Bayerische Staatsgemäldesammlungen, Munich; the National Gallery of Canada, Ottawa; the Metropolitan Museum of Art and the Frick Collection, New York City; and the Samuel H. Kress Foundation. The National Gallery of Art, Washington, D.C., has inaugurated a series of systematic scholarly catalogues for its collection.

Museum administrators are trying to determine the type and amount of information that should be placed on the Internet concerning their institutions' permanent collections. This segment discusses three of these issues: (a) the quantity of material, (b) methods for locating specific works of art within the collection, and (c) a comparison of the number and quality of Web illustrations with those of other information formats.

Quantity of Material on the Web

The question of how extensive a museum's material should be at its Web site is being handled in different ways. Two methods are prevalent: (a) presenting special departments and highlighting specific works of art; and (b) placing some, or most, of the collection on the Internet.

Accenting Special Departments

At their Web sites, most museums are placing information under their various curatorial departments, sometimes called collections—such as those for painting, sculpture, prints, and drawings—and providing a few examples of the works of art within each department. A few institutions are featuring one or two of these works in a more detailed manner; others are highlighting the owners and collectors of the work. This documentation corresponds to the popular printed guidebooks many museums publish.

Example

At its Web site, the Indianapolis Museum of Art furnishes a brief description of each department accompanied by one or two illustrations. For in-

stance, the African Art Collection is described as having more than 1,400 objects, with strength in the art of the Yoruba people and the Benin Kingdom. One work of art is illustrated: a Nigerian warrior chief depicted on a 16th- or 17th-century commemorative plaque <http://web.ima-art.org/ima/home.html>.

Putting Collections on the Web

Some museums are providing extensive Internet data, placing virtually their entire collections on the Web. The visual material is not always accompanied by scholarly text.

Examples

1. The Web site of the Museo di Capodimonte, Naples, Italy, furnishes extensive records on the palace in which it is housed, the Farnese collectors, and the art collection. Each room is listed, accompanied by the names of the artists and the titles of the works displayed there. Hyperlinks are added to illustrations of specific works, accompanied by summary catalogue entries and additional facts on the art. For researchers, this is a bonanza, since the printed collection catalogue is written in Italian and not accessible in most libraries <http://capodimonte.selfin. net/capodim/home.htm>.

2. The Fine Arts Museums of San Francisco, consisting of the DeYoung Museum and the Legion of Honor, have created *Art Imagebase* as a means of preserving and accessing the works on paper in the collection of the Achenbach Foundation for Graphic Arts. The *Art Imagebase*—with 70,000 records spanning six centuries—includes prints, drawings, illustrated books, and other media on paper. This ambitious undertaking will eventually include illustrations for all works in these museums <http://www.thinker.org/imagebase/index.html>.

3. The National Gallery of Art, Washington, D.C., is placing its entire collection on the Internet, each work of art accompanied by a scholarly entry. For details on the contents of these records, see Chapter XII, which uses the museum's collection of Alfred Sisley's paintings as an example <http://www.nga.gov/>.

Fine Arts Museums of San Francisco Web Page <http://www.famsf.org/>

Locating Specific Works of Art

If you are searching for a specific work of art, or works by a particular artist, just accessing the museum's Web page may not assist you in finding the needed material. This is especially true for museums with extensive, encyclopedic collections. A few institutions are trying to address the researcher's needs.

Example

The National Gallery of Art, Washington, D.C., has a method for searching its collection by (a) artist's name, (b) title of artwork, and (c) an expanded search using such information as school of art, style, medium, year created, medium used, or popular subject <http://www.nga.gov/collection/srchart.htm>.

The results can be fantastic! In a search for the title of a painting containing the word *rabbit*, Sturtevant Hamblin's *Little Girl with Pet Rabbit*, c. 1845, was found immediately. Moreover, there was an illustration accompanied by a detailed catalogue entry. Data on the artist included four bibliographic references. The remarkable part is that the painting is not one of the many masterpieces in the collection. The National Gallery furnishes material on all the art they own, not just a few well-known works.

Online Material versus Other Formats

Researchers must weigh the advantages and disadvantages of obtaining visual material from museum Web sites compared to obtaining similar material in other information formats, especially the many multimedia CD-ROMs now being produced. This section makes such a comparison. Remember, Web material, both in size and number of reproductions, can fluctuate overnight. The Internet and its ever-changing ways are both frustrating and fascinating!

Le Musée du Louvre's collection, one of the largest in the world, consists of approximately 6,000 paintings, as well as about 2,500 sculptures, 10,000 objets d'art, and 144,000 antiquities. The entire Paris collection will probably never be placed on the Web. Yet, illustrations of selected works owned by the museum are available online. In addition, several published books and an excellent multimedia CD-ROM are available, as cited below.

Louvre Web Site

Le Musée du Louvre's Web site has extensive information on the development of the palace and its art collections.

The history of the medieval château, as well as the present concept of "The Grand Louvre," is discussed and illustrated. The Collections section reproduces (a) floor plans locating the curatorial departments within the palace and (b) color illustrations with summary catalogue entries for objects in these departments. Four areas, such as the French School and the Italian School, can be accessed from the Department of Paintings. Under each school, there are three or four small details of works of art that must be enlarged to be seen. Out of a total of 6,000 paintings, only 26 illustrations were provided in December 1997.

<http://mistral.culture.fr/louvre/louvrea.htm>

Books on Le Louvre

Treasures of the Louvre, by Michel Laclotte (New York: Abbeville Press, 1993), has color reproductions with summary catalogue entries for a total of 152 paintings

The Louvre, by Germain Bazin, once the museum's conservateur-en-chef (*The World of Art Library Series,* revised ed., London: Thames & Hudson, 1966), provides an extensive history of the palace and its painting collection. This informative book contains color illustrations of about 95 major paintings accompanied by summary catalogue entries and historical notes. In addition, black-and-white thumbnail-size reproductions of 238 more paintings indicate the vastness of the collection. This is a total of 333 illustrations.

Louvre CD-ROM

Le Louvre: The Palace and Its Paintings (CD-ROM. Paris: Montparnasse Multimedia/Réunion des Musées Nationaux, 1995) explores seven periods of building history and features 100 paintings accompanied by two and a half hours of spoken commentary. For each painting, reproduced in full with zoom capabilities to show details, there is a summary catalogue entry and a brief discussion on the subject and composition of the work. In addition, there are museum floor plans indicating where the paintings are displayed, 155 artists' biographies providing the pronunciation of the artists' names, and historical footnotes about the works of art. The material placed at the Louvre's Web site must be evaluated against the quality color illustrations, permanency, and accessibility of this multimedia CD-ROM.

III-A-4. Museum Educational Programs

One of the key mandates for most museums is the education of its patrons; consequently, the majority of institutions have an education department responsible for providing special programs, lectures, and workshops for adults and children. The Internet has become an excellent source for information on these educational activities. The J. Paul Getty Museum, which is part of the Getty Information Institute, has a number of educational programs under its ArtsEdNet program [V-G]. Other museums have also developed programs accessible from the Web itself; five are highlighted below.

For Classroom Teachers

In many U.S. schools, there are no art instructors; consequently, the classroom teachers are often the only source for art activities. These teachers need assistance in integrating visual material into the academic curriculum. Increasingly, they are finding material through museums—information that can be used whether the students actually visit the museum or not.

Example

The staff of the National Museum of American Art (NMAA) of the Smithsonian Institution develops educational materials, such as teacher guides and student activity packets, for programs both at the museum and throughout the United States. The NMAA's Web site details these programs and provides instructions for ordering the packets. The online information furnishes such items as a brief history of the art being studied, illustrations accompanied by data on each work, and questions and activities students might consider. Usually included are facts on the artists, cultural definitions, lists of readings, and audiovisual material <http://www.nmaa.si.edu/>.

Online Self-Guided Tours

Museum educators have long been developers of self-study tours for children who visit their institutions. Now they are extending this concept to the Internet, usually coordinating the material with a special exhibition or with a specific work in the permanent collection.

Examples

1. The educators of the Berkeley Art Museum/Pacific Film Archive, University of California at Berkeley, developed a children's program to complement the 1995–96 touring exhibition "The New Child: British Art and the Origins of Modern Childhood, 1730–1830." Both an online and a printed catalogue are available <http://www.bampfa. berkeley.edu/exhibits/newchild/>.

At its Web site, there were brief essays, 45 illustrations, and an 18th-century cultural and political timeline. In addition, for young people and their families, the museum provided an online self-guided tour concentrating on four paintings. Each family portrait was reproduced, accompanied by questions encouraging viewers to look more closely at details. This essay was on the museum's exhibition section as of December 1997 <http://www.bampfa. berkeley.edu/exhibits/newchild/famguide1.html>.

2. The Minneapolis Institute of Arts (MIA) offers a number of programs for students, often with additional material for the teacher. One section, "Take a Closer Look at a Specific Work of Art," highlights a work from the MIA collection. In 1997, Grace Hartigan's *Billboard*, 1957, was the subject. The online information included a discussion of the painting, its style and technique, and the artist, as well as information on abstract expressionism, terms specific to this period, and books on Hartigan (American, born 1922). Other programs include "World Mythology," "Amazing Animals in Art," and "Art in America" <http://www.artsMIA.org/>.

Highlighting Works of Art

Analyzing works of art through composition and subject is part of art appreciation courses taught in most academic institutions of higher learning. Applying this same type of scrutiny to highlight works in their collection, museums are expanding the audience to include schools, retirement homes, and hospitals, bringing the museum collections into the community.

Examples

1. The Metropolitan Museum of Art has developed an outstanding educational program called Looking at Art. Works of art are explored through themes, such as portraits and symbols, and compositions, such as perspective, light, color, form, motion, and proportion. At its Web site, a color illustration of Emanuel Gottlieb Leutze's *Washington Crossing the Delaware*, 1851, is used to lead viewers to examine various aspects of the painting. Details are depicted; comparisons to other works of art are made. Looking at Art is both informative and fun! <http://www.metmuseum.org/htmlfile/education/look.html>

2. Under Highlights, the National Gallery of Art is experimenting with various aspects of specific works of art. In 1997, *Watson and the Shark*, by John Singleton Copley, was featured. The profusely detailed information centered around the story depicted, the artist, some facts concerning the painting, and historical sources that influenced the artist. This is a great place to begin your self-education in cyberspace! <http://www.nga.gov/highlights/webfeatr.htm>

III-A-5. Hyperlinks to Other Web Sites

Some museums provide hyperlinks to other Web sites concerned with the art their institution collects. This indexing provides researchers additional pertinent ma-

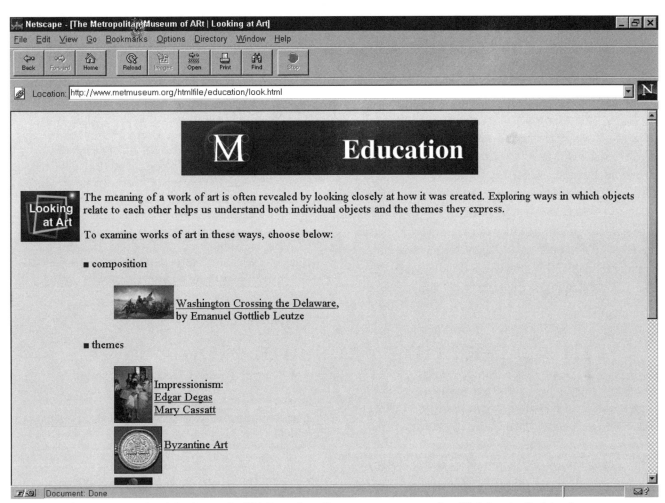

The Metropolitan Museum of Art's Looking at Art Web Page <http://www.metmuseum.org/htmlfile/education/look.html>

terial, expanding the world of art information. These sites will change as corrections and additions appear, so be sure to check them frequently.

Examples

1. The Lita Annenberg Hazen and Joseph H. Hazen Center for Electronic Information Resources, Metropolitan Museum of Art, New York City, indexes selected Internet resources. They are arranged by general subjects and by art-related subjects categorized according to the museum's curatorial departments, such as Islamic art, European paint-

ings, and 20th century art <http://www.metmuseum.org/htmlfile/watson/hazen.htm>.

2. The Meadows Museum of Southern Methodist University in Dallas is dedicated to displaying Spanish art. Its Web site includes hyperlinks to other locations concerned with Spanish art <http://www.smu.edu/meadows/museum/directory.html>.

3. The J. Paul Getty Museum provides an annotated list of art and art history sites <http://www.gii.getty.edu/iforum/>.

III-B. Museums and Historic Sites

In addition to art museums, you may need to access institutions concerned with other disciplines, especially cultural history. Some historical homes are sponsored by the country's national trust association, others by local administrations. Some works of art

were created for particular places or types of locations, for instance, a small living room, a large entrance to a business office, or a church altar. Try to examine sites where the works of art you are studying would have been displayed during the period they rep-

resent. For example, portraits painted in Virginia during the American Colonial period might have been displayed in houses similar to George Washington's Mount Vernon. Visiting this estate and viewing its interiors will help you understand where and how art was seen <http://mountvernon.org/>. This is an important aspect of understanding historical works.

In studying the art of the past, you need to know the social and cultural history of the period [X-A-6]. This leads you to clues as to how art was valued and displayed, whether the object was an integral part of everyday life or a prized, once-in-a-lifetime possession. Frequently, reconstructed villages and houses will assist you in visualizing this aspect of your study. As these sites expand and improve, they will be even more useful to art researchers, especially those interested in antiques or early design and dress.

Example

One of the most extensive cultural Internet programs is provided by the administrators of the Château de Versailles. The extensively illustrated online exhibition discusses the various apartments of the palace, the monarchs who lived there, and the everyday life at the French court. A chronicle of a day with the Sun King, Louis XIV; the details of the culinary dishes served to royalty; and the festivals and ceremonies that entertained the court are highlighted. This Web site is an excellent example of the melding of historical location and people, notable interiors and furnishings, and the social history of the period <http://www.chateauversailles.fr/en/>.

III-C. Locating Museum Home Pages

Museums usually host their own domain Web sites, with the data provided by the museum's staff. Information developed and maintained by a museum's personnel is usually more authentic, accurate, and current than that provided by outside sources. However, if a museum does not develop its own Web site, some other group may fill this information gap. This section is organized by (a) indexes to museum URLs, (b) URLs and multimedia formats for specific art museums, and (c) URLs of historic houses, towns, and museums.

III-C-1. Indexes to Museum URLs

The following URLs provide hyperlinks to the museums they index. Because these are ever-changing lists and addresses, check them frequently for additions and corrections. Often search engines provide a list of museums; some report the URLs, while others include only hyperlinks to the museums' sites. Yahoo's list is one of the best.

Art Museum Network highlights the exhibition schedules of the members of the Association of Art Museum Directors (AAMD)
 <http://www.EXCALENDAR.net/>
Virtual Library Museums Pages is supported by ICOM (International Council of Museums)
 <http://www.icom.org/vlmp/>

World Wide Arts Resources Museums Index
 <http://wwar.com/museums.html>
Yahoo: Arts: Museums and Galleries provides hyperlinks to an extensive list of museums
 <http://www.yahoo.com/Arts/Museums_and_Galleries/>

III-C-2. Art Museum Web Sites and CD-ROMs

The following art museums are organized by continent, then country. For the United States and Canada, there are further subdivisions by state or province. Also included are museum multimedia CD-ROMs concerned either with an institution's permanent collection or with a children's program based on the collection. After some countries' listings, there are sources for (a) additional museum URLs and/or (b) current exhibition information.

Information concerning museum sculpture gardens is cited under the name of the garden in [XIII-F]. There are about 150 university museums in the United States, not all of which have Web locations; only a few are listed.

The following list of museums with English-language Internet sites is not exhaustive. Remember, URLs for museums that do not have their own domain Web sites will probably change.

North America

Canada

For a more complete list, see:

Associations of Universities and Colleges of Canada
<http://www.aucc.ca/english/>
CHIN listing
<http://www.chin.gc.ca/Museums/>

British Columbia

Art Gallery of Greater Victoria, Victoria
<http://vvv.com/aggv/>
Vancouver Art Gallery, Vancouver
<http://www.vanartgallery.bc.ca/>
Royal British Columbia Museum, Victoria
<http://rbcm1/rbcm.gov.bc.ca/>

Manitoba

Winnipeg Art Gallery, Winnipeg
<http://www.infobahn.mb.ca/wag/>

New Brunswick

Beaverbrook Art Gallery, Fredericton, New Brunswick
<http://www.beaverbrookartgallery.org/>

Ontario

Art Gallery of Ontario, Toronto
<http://www.ago.net/>
McMichael Canadian Art Collection, Kleinburg
<http://www.mcmichael.on.ca/>
National Gallery of Canada/Musée des Beaux-arts de Canada, Ottawa
<http://national.gallery.ca/>
Royal Ontario Museum, Toronto
<http://www.rom.on.ca/>

Quebec

Canadian Centre for Architecture/Centre Canadien d'Architecture, Montreal
<http://cca.qc.ca/contents.html>
Canadian Museum of Civilization, Hull
<http://www.civilization.ca/>
Montreal Museum of Fine Arts, Montreal
<http://www.mmfa.qc.ca/e-sommaire.html>
Musée d'art contemporain de Montréal, Montreal
<http://www.media.MACM.qc.ca/homea2.html>

Mexico

Mexico City

For additional sites, see:
<http://mexico.web.com.mx/fmuseos.html>
Museo de Arte Contemporaneo Carrillo Gil
<http://www.conet.com.mx/macg/>
Museo de Arte Modern
<http://www.arts-history.mx/museos/mam/home2.html>
Museo Franz Mayer
<http://museos.web.com.mx/mfm/mfm0000e.html>

United States

Alabama

Birmingham Museum of Art, Birmingham
<http://www.hansonlib.org/index/>

Arizona

Heard Museum, Phoenix
<http://www.heard.org/>
Phoenix Art Museum
<http://www.azcentral.com/community/phxart/home.html>
University of Arizona, Center for Creative Photography, Tucson
<http://dizzy.library.arizona.edu/branches/ccp/ccphone.html>

California

Asian Art Museum of San Francisco
<http://asianart.org/>
DeYoung Museum, San Francisco
<http://www.famsf.org/>
Fine Arts Museums of San Francisco
<http://www.famsf.org/>
Huntington Library, Art Collection, and Botanical Gardens
<http://www.huntington.org/>
J. Paul Getty Museum, Los Angeles
<http://www.getty.edu/museum/>
Legion of Honor, San Francisco
<http://www.famsf.org/>
Los Angeles County Museum of Art
<http://www.lacma.org/>
Museum of Contemporary Art, Los Angeles
<http://www.moca.org/mocamain.htm>
Museum of Contemporary Art, San Diego
<http://www.mcasandiego.org/>
Norton Simon Museum, Pasadena
<http://www.citycent.com/CCC/Pasadena/nsmuseum.htm>
Oakland Museum of Art
<http://www.museumca.org/>
San Diego Museum of Art
<http://www.sddt.com/sdma.html>
San Francisco Museum of Modern Art
<http://www.sfmoma.org/>
Stanford University Museum of Art
<http://www-leland.stanford.edu/dept/SUMA/>
Timken Museum of Art, San Diego
<http://gort.ucsd.edu/sj/timken/index.html>
University of California, Berkeley Art Museum and Pacific Film Archive
<http://www.bampfa.Berkeley.edu/>

Colorado

Denver Art Museum
<http://www.denverartmuseum.org/>

Connecticut

Wadsworth Atheneum, Hartford
<http://www.hartnet.org/~wadsworth/index.htm>

Yale Center for British Art, New Haven
<http://www.yale.edu/ycba/>
Yale University Art Gallery, New Haven
<http://pantheon.cis.yale.edu/~yups/yuag/lobby.html>

District of Columbia

Arthur M. Sackler Gallery, Smithsonian Institution (now administratively connected to the Freer Gallery)
<http://www.si.edu/organiza/museums/freer/start.htm>
Corcoran Gallery of Art
<http://www.corcoran.org/>
Dumbarton Oaks Research Library and Collection
<http://www.doaks.org/>
Freer Gallery of Art, Smithsonian Institution
<http://www.si.edu/organiza/museums/freer/start.htm>
Hirshhorn Museum and Sculpture Garden, Smithsonian Institution, Washington, D.C.
<http://www.si.edu/organiza/museums/hirsh/start.htm>
National Gallery of Art
<http://www.nga.gov/>
American Art from the National Gallery of Art (Videodisc. Washington, D.C.: National Gallery of Art, 1993). Illustrates some 2,600 works of art.
National Museum of African Art, Smithsonian Institution
<http://www.si.edu/organiza/museums/africart/nmafa.htm>
National Museum of American Art, Smithsonian Institution
<http://www.nmaa.si.edu/>
National Museum of American Art: A CD-ROM (CD-ROM. New York: Macmillan Digital, 1996) See
<http://www.macdigital.com/>
National Museum of the American Indian, Smithsonian Institution
<http://www.si.edu/organiza/museums/amerind/start.htm>
National Museum of Women in the Arts
<http://www.nmwa.org/>
National Portrait Gallery, Smithsonian Institution
<http://www.npg.si.edu/>
National Portrait Gallery: Permanent Collection of Notable Americans (CD-ROM, Boston: G.K. Hall, 1991). Has 3,093 images and an index that can be searched 13 ways, including by artists' and sitters' names.
Portraits of Americans (Microfiche. Teaneck, NJ: Chadwyck-Healey, n.d.)
Renwick Gallery, National Museum of American Art
<http://nmaa-ryder.si.edu/renwick/renwickhomepage.html>
Textile Museum
<http://www.textilemuseum.org/>

Florida

John and Mable Ringling Museum of Art, Sarasota
<http://206.215.110.37/> and <http://www.ringling.org/>
Morikami Museum and Japanese Gardens, Delray Beach
<http://www.icsi.com/ics/morikami/>

Salvador Dali Museum, St. Petersburg
<http://www.webcoast.com/Dali/dalimuseum.htm>
Florida Association of Museums
<http://www.flamuseums.org/>

Georgia

Emory University, Michael C. Carlos Museum, Atlanta
<http://www.emory.edu/CARLOS/>
High Museum of Art, Atlanta
<http://www.high.org/>

Illinois

Art Institute of Chicago
<http://www.artic.edu/>
Telling Images: Stories in Art, by Alan Newman and Jean Sousa (CD-ROM. Chicago: Art Institute of Chicago, 1997)
With Open Eyes: Images from the Art Institute of Chicago (CD-ROM. New York: Voyager, 1995). For children.
Museum of Contemporary Art, Chicago
<http://www.mcachicago.org/>
University of Chicago, Oriental Institute
<http://www.oi.uchicago.edu/OI/MUS/OI_Museum.html>
University of Illinois at Urbana-Champaign, Krannert Art Museum
<http://www.art.uiuc.edu/kam/>

Indiana

Indiana University Art Museum, Bloomington
<http://www.indiana.edu/~uartmus/home.html>
Indianapolis Museum of Art
<http://web.ima-art.org/ima/home.html>

Iowa

University of Iowa, Museum of Art, Iowa City
<http://www.uiowa.edu/~artmus/>

Kansas

University of Kansas, Spencer Museum of Art
<http://www.ukans.edu/~sma/>

Louisiana

Louisiana State Museum
<http://www.crt.state.la.us/crt/museum/Ismnet3.htm>
New Orleans Museum of Art
<http://www.noma.org/>

Maryland

Baltimore Museum of Art
<http://www.artbma.org/>

Massachusetts

Amherst College, Mead Art Museum, Amherst
<http://www.amherst.edu/~mead/>
Harvard University Art Museums, Cambridge: Fogg Art Museum, Arthur M. Sackler Museum, Busch-Reisinger Museum, Straus Center for Conservation
<http://www.artmuseums.harvard.edu/>
Masterpieces of World Art: Highlights from the Collections (CD-ROM. Berkeley, CA: Digital Collections, 1997)

Isabella Stewart Gardner Museum, Boston
 <http://www.boston.com/gardner/>
Museum of Fine Arts, Boston
 <http://www.mfa.org/>
Smith College Museum of Art, Northampton
 <http://www.smith.edu/artmuseum/>
Sterling and Francine Clark Art Institute, Williamstown
 <http://www.clark.williams.edu/reghome.htm>
Worcester Art Museum, Worcester
 <http://www.worcesterart.org/>

Michigan
 Cranbrook Art Museum, Bloomfield Hills
 <http://www.cranbrook.edu/museum/>
 Detroit Institute of Arts
 <http://www.dia.org/>

Minnesota
 Minneapolis Institute of Arts
 <http://www.artsMIA.org/>
 A Prairie School Gem: The Virtual Tour of the Purcell-Cutts House (CD-ROM. Minneapolis: MIA, 1996)
 Walker Art Museum
 <http://www.walkerart.org/>

Missouri
 Nelson-Atkins Museum of Art, Kansas City
 <http://www.nelson-atkins.org/>
 St. Louis Art Museum
 <http://www.slam.org/mainmenu.html>

Nebraska
 Joslyn Art Museum, Omaha
 <http://www.joslyn.org/>
 University of Nebraska–Lincoln, Sheldon Memorial Art Gallery and Sculpture Garden
 <http://sheldon.unl.edu/>

New Jersey
 Princeton University, Princeton Art Museum
 <http://webware.princeton.edu/artmus/>

New Mexico
 Georgia O'Keeffe Museum, Santa Fe
 <http://www.okeeffe-museum.org/>
 Museum of International Folk Art, Santa Fe
 <http://www.state.nm.us/moifa/>

New York
 Albright-Knox, Buffalo
 <http://www.albrightknox.org/>
 Brooklyn Museum
 <http://www.brooklynart.org/>
 Ancient Egyptian Art, The Brooklyn Museum (CD-ROM. Berkeley, CA: Digital Collections, 1989)
 Cooper-Hewitt National Design Museum, Smithsonian Institution, New York City
 <http://www.si.edu/organiza/museums/design/start.htm>
 Corning Museum of Glass, Corning
 <http://www.pennynet.org/glmuseum/corningm.htm>

Frick Collection, New York City
 <http://www.frick.org/>
 The Frick Collection: Great Paintings, Renaissance to Impressionism. (CD-ROM. Alameda, CA: Digital Collections, 1993)
Guggenheim Museum, New York City
 <http://www.guggenheim.org/>
Guggenheim Museum Soho
 <http://www.guggenheim.org/soho.html>
Jewish Museum, New York City
 <http://www.thejewishmuseum.org/>
Metropolitan Museum of Art, New York City
 <http://www.metmuseum.org/>
Museum of Modern Art, New York City
 <http://www.moma.org/menu.html>
 Data also added by the School of Visual Arts
 <http://www.sva.edu/moma/>
Whitney Museum of American Art, New York City
 <http://www.echonyc.com/~whitney/>
For New York City exhibitions, see
 <http://www.metrobeat.com/New_York/Arts_and_Entertainment/Museums/>

Ohio
 Akron Art Museum
 <http://www.winc.com/~aam/>
 Cincinnati Art Museum
 <http://www.cincinnatiartmuseum.org/>
 Cleveland Museum of Art
 <http://www.clemusart.com/>
 Oberlin College, Allen Memorial Art Museum
 <http://www.oberlin.edu/~allenart/>
 Toledo Museum of Art
 <http://www.toledomuseum.org/>

Oklahoma
 Gilcrease Museum, Tulsa
 <http://www.lawnchaps.com/index.htm>
 Philbrook Museum of Art, Tulsa
 <http://www.philbrook.org/index.htm>

Oregon
 Portland Art Museum
 <http://www.pam.org/pam/>

Pennsylvania
 Andy Warhol Museum, Pittsburgh
 <http://www.warhol.org/warhol/>
 Barnes Foundation, Merion
 <http://libertynet.org/phila-visitor/art/barnes.html>
 A Passion for Art: Renoir, Cézanne, Matisse and Dr. Barnes (CD-ROM. Redmond, WA: Microsoft, 1995)
 Brandywine River Museum, Chadds Ford
 <http://www.brandywinemuseum.org/>
 Carnegie Museum of Art, Pittsburgh
 <http://www.clpgh.org/cma/>
 Museum of American Art of the Pennsylvania Academy of the Fine Arts, Philadelphia
 <http://www.pond.com/~pafa/>

Philadelphia Museum of Art
 <http://www.philamuseum.org/>
 A is for Art; C is for Cézanne (CD-ROM. produced by
 the museum, 1996. For children).

Rhode Island

Rhode Island School of Design Museum, Providence
 <http://www.risd.edu/museum.html>

South Carolina

Columbia Museum of Art
 <http://www.scsn.net/users/cma/>

Texas

Amon Carter Museum, Fort Worth
 <http://www.cartermuseum.org/>
Contemporary Arts Museum, Houston
 <http://www.camh.org/>
Dallas Museum of Art
 <http://www.dm-art.org/>
Kimbell Art Museum
 <http://www.kimbellart.org/>
McNay Art Museum, Austin
 <http://www.mcnayart.org/>
The Menil Collection, Houston
 <http://www.menil.org/~menil/>
Museum of Fine Arts, Houston
 <http://www.mfah.org/>
Museum of Modern Art, Fort Worth
 <http://www.mamfw.org/>
San Antonio Museum of Art
 <http://www.samuseum.org/>
Southern Methodist University, Meadows Museum
 <http://www.smu.edu/meadows/museum/
 directory.html>
University of Texas, Austin, Huntington Art Gallery (in
1998, renamed the Jack S. Blanton Museum)
 <http://www.utexas.edu/ftp/cofa/hag/>

Virginia

Chrysler Museum of Art and Historic Houses, Norfolk
 <http://www.whro.org/cl/cmhh/>
Virginia Museum of Fine Arts, Richmond
 <http://www.state.va.us/vmfa/>

Washington

Frye Art Museum, Seattle
 <http://www.fryeart.org/>
Seattle Art Museum
 <http://www.seattleartmuseum.org/>

South America

Uruguay

MUVA, Virtual Museum of Contemporary Uruguayan
Art, is a Web-only museum; this is the English-language
site
 <http://www.diarioelpais.com/muva2/>

Venezuela

Caracas: Sofia Imber Contemporary Art Museums
 <http://www.maccsi.org/>

Europe

Because European museums are now beginning to de-
velop their own domain Web sites, this list will
expand in the future. Only museums with English-
version Web sites are included here.

Belgium

Museum of Fine Arts, Tournai
 <http://www.plug-in.be/plugin/museum/
 ht2.html>

Denmark

Louisiana Museum of Modern Art, North Zealand
 <http://www.louisiana.dk/english1.html>

Great Britain

For current exhibitions, see Gallery Guide Online
 <http://www.gallery-guide.com/gg/exhibits.htm>

Cambridge

Fitzwilliam Museum, University of Cambridge
 <http://www.cam.ac.uk/CambArea/Fitz.html>

London

British Museum
 <http://www.british-museum.ac.uk/>
Courtauld Gallery
 <http://www.courtauld.ac.uk/Pages/gallery.html>
Hayward Gallery
 <http://www.hayward-gallery.org.uk/>
Museum of London
 <http://www.museum-london.org.uk/>
National Gallery
 <http://www.nationalgallery.org.uk/>
 The Art Gallery, (CD-ROM. Redmond, WA:
 Microsoft, 1993)
 Great Artists (*Exploring Painting in Association with the
 National Gallery, London*) (CD-ROM. London:
 Marshall Cavendish, 1994). (Distributed by Indeo:
 Intel Video Technology; for children).
National Maritime Museum, Greenwich
 <http://www.nmm.ac.uk/>
National Portrait Gallery
 <http://www.npg.org.uk/>
Queens Gallery
 <http://www.royal.gov.uk/collect/>
Royal Academy of Arts
 <http://www.royalacademy.org.uk/>
Sir John Soane's Museum
 <http://www.demon.co.uk/heritage/soanes/>
Tate Gallery
 <http://www.tate.org.uk/>
Victoria and Albert Museum
 <http://www.vam.ac.uk/>
Wallace Collection
 <http://www.demon.co.uk/heritage/wallace/>

Oxford

Ashmolean Museum of Art and Archaeology, University
of Oxford
 <http://www.ashmol.ox.ac.uk/>

Finland

Finnish National Gallery
 <http://www.fng.fi/fng/html2.en/>

France

Paris

For current Parisian art exhibitions, see *Paris Pages, Calendar* then highlight Expositions under the desired month.
 <http://www.paris.org/Calendar/>

Centre Georges Pompidou, Musée National d'Art Moderne
 <http://www.cnac-gp.fr/>

Galerie Nationale du Jeu de Paume
 <http://www.paris.org.:80/Musees/JeudePaume/>

Musée du Louvre
 <http://mistral.culture.fr/louvre/louvrea.htm>

Le Louvre: The Palace & Its Paintings (CD-ROM. New York: Montparnasse Multimedia, 1995)

The Orsay Museum (Videodisc. Paris: ODA, 1990). Includes 2,100 works of art.

Musée National Picasso
 <http://www.paris.org:80/Musees/Picasso/>

Musée d'Orsay
 <http://musee-orsay.fr/>

Germany

Deutsche Guggenheim Berlin
 <http://www.guggenheim.org/dgb.html>

Hamburger Kunsthalle, Hamburg
 <http://www.hamburg.de/Behoerden/Museen/kh/Galerien/welcome.en.html>

Greece

Acropolis Museum, Athens
 <http://www.culture.gr/2/21/211/21101m/e211am01.html>

Archaeological Museum of Thessaloniki
 <http://alexander.macedonia.culture.gr/2/21/211/21116/e211pm01.html>

National Archaeological Museum, Athens
 <http://www.culture.gr/2/21/214/21405m/e21405m1.html>

Italy

Florence

See *Firenze by Net* for museums
 <http://www.italink.com/>

For sculpture in Florence
 <http://www.thais.it/scultura/default_uk.htm>

Galleria degli Uffizi
 <http://www.uffizi.firenze.it/welcomeE.html> and <http://www.arca.net/uffizi/>; has index to artists

National Museo di Bargello
 <http://www.arca.net/db/musei/bargello.htm>

Pitti Palace
 <http://www.arca.net/db/musei/pitti.htm>

Naples

Museo Gallerie Nazionali di Capodimonte
 <http://capodimonte.selfin.net/capodim/home.htm>

Perugia

Galleria Nazionale dell'Umbria
 <http://www.selfin.it/perugia/welcome.html>

Rome

Villa Giulia National Museum
 <http://www.roma2000.it/zvilagiu.html>

Siena

La Pinacoteca Nazionale di Siena
 <http://www.comune.siena.it/pinaco/pinaco.htm>

Venice

Peggy Guggenheim Collection
 <http://www.guggenheim.org/venice.html>

Palazzo Grassi
 <http://www.palazzograssi.it/>

Netherlands

Amsterdam

Rijksmuseum
 <http://www.inform.nl/rijksmus/index.htm>

Rijksmuseum Vincent van Gogh
 <http://www.channels.nl/gogh.html>

Stedelijk Museum of Modern Art
 <http://art.cwi.nl/stedelijk/eng/index.html>

Russia

Pushkin Museum of Fine Arts, Moscow
 <http://www.global-one.ru/english/culture/pushkin/>

Hermitage, St. Petersburg
 <http://www.hermitage.ru/eng.htm>

The Hermitage: The Art Treasures Tour (CD-ROM. Intersoft, Inc., 1996. Distributed by Cascade Marketing, Wenatchee, WA 98801).

Spain

Bilbao

Guggenheim Museum Bilbao
 <http://www.guggenheim.org/bilbao.html>

Madrid

Museo del Prado
 <http://www.mcu.es/prado/index_eng.html>

Thyssen-Bornemisza Museum
 <http://www.offcampus.es/thyssen/homepage-eng.html>

Africa

Durban Art Gallery, South Africa
 <http://durbanet.aztec.co.za/exhib/dag/dagmain.htm>

National Museum of Namibia, Windhoek
 <http://www.natmus.cul.na/>

Egypt

Cairo: Coptic Museum
<http://www.idsc.gov.eg/culture/cop-mus.htm>
Egyptian Museum
<http://www.idsc.gov.eg/culture/egy-mus.htm>

Middle East

Israel

Israel Museum, Jerusalem
<http://www.imj.org.il/current.html>

Kuwait

Tareq Rajab Museum
<http://www.kuwait.net/~trm/overview.html>

Asia

Japan

Kyoto National Museum
<http://www.kyohaku.go.jp/>
Tokugawa Art Museum, Tokyo
<http://www.cjn.or.jp/tokugawa/index.html>

Singapore

Singapore Art Museum (SAM)
<http://www.museum.org.sg/sam/>

Australia

Canberra

National Gallery of Australia
<http://www.nga.gov.au/>
National Museum of Australia
<http://www.nma.gov.au/>

Monash

University Gallery
<http://www.monash.edu.au/mongall/monash.html>

Victoria

National Gallery of Victoria
<http://www.ngv.vic.gov.au/main.html>

III-C-3. Historic Houses and Museums: URLs

United States

Delaware

Winterthur Museum, Garden, and Library
<http://www.udel.edu/winterthur/>

District of Columbia

White House
<http://www1.whitehouse.gov/WH/Welcome.htm>

Louisiana

Louisiana State Museum
<http://www.crt.state.la.us/crt/museum/exhibit.htm>
The Office of Culture, Recreation and Tourism has information on attractions, including historic buildings and costumes. Some are online exhibitions.

Massachusetts

Old Sturbridge Village
<http://www.osv.org/>

Minnesota

Minneapolis Institute of Arts manages the 1913 Purcell-Cutts House
<http://www.artsMIA.org/>
A Prairie School Gem: The Virtual Tour of the Purcell-Cutts House (CD-ROM. Minneapolis: MIA, 1996)

Virginia

Chrysler Museum of Art and Historic Houses
<http://www.whro.org/cl/cmhh/>
Colonial Williamsburg
<http://www.history.org/>
James River Plantations
<http://www.williamsburg.com/plant/plant.html>
Jamestown
<http://www.williamsburg.com/james/james.html>
Monticello (Thomas Jefferson's home)
<http://www.monticello.org/>
Mount Vernon (George Washington's home)
<http://mountvernon.org/>
Yorktown
<http://www.williamsburg.com/tour/york/york.html>

Europe

England

The *British Monarchy* Web site includes information on the royal homes at Buckingham Palace, Windsor Castle, the royal art collection, and the monarchy past and present
<http://www.royal.gov.uk/>

Bury St. Edmunds

Manor House Museum
<http://www.stedmunds.co.uk/manor_house.html>
Moyse's Hall Museum
<http://www.stedmunds.co.uk/moyses_hall.html>

London

Apsley House, the Wellington Museum
<http://www.vam.ac.uk/apsley/>
Geffrye Museum
<http://www.lattimore.co.uk/geffrye/>

France

Fontainebleau

Château de Fontainebleau
<http://www.w3i.com/eng/cities/
fontainebleau.htm>

Rueil-Malmaison

Château de Malmaison, home of Josephine and Napoleon Bonaparte
<http://www.w3i.com/eng/rueil.htm>
Versailles: Château de Versailles
<http://chateauversailles.fr/en/>

Netherlands

Amsterdam, Rembrandt's House
<http://www.channels.nl/remhuis.html>

Turkey

Istanbul, Topkapi Palace Museum
<http://www.ee.bilkent.edu.tr/~history/
topkapi.html>

IV. WEB SITES OF ACADEMIC INSTITUTIONS, CORPORATE SPONSORS, AND INDIVIDUALS

There are numerous reasons people place material on the World Wide Web. Sites may be developed (a) to provide entertainment, (b) to showcase a hobby or passion, (c) to further some specific interest, (d) to promote material for sale, (e) to answer questions about a topic, and/or (f) to disseminate information and scholarly material. In the Web's early days, the art material being added was closely related to the first three issues. Frequently, the Web acted as a type of vanity press, allowing those who wished to produce

material to highlight their achievements. Businesses interested in advertising their wares often sponsored a Web site designed to draw numerous viewers. As the Web has become a popular avenue for museums, professional associations, and academic institutions, the last two points have become the focus of many sites. This section discusses Web sites that cover a diverse spectrum of subjects, organized by (a) academic institutions, (b) corporate sponsors, and (c) entrepreneurs and Web technicians.

IV-A. Academic Institutions

Web sites hosted by academic institutions include many facets. Some information is placed online by professors, some by graduate students, and some by computer technicians who may be very knowledgeable about the Internet but may not have done research on art subjects. Some academic institutions allow other organizations or groups to post material on their Web sites. These include professional organizations, local museums, students, and groups with nonacademic concerns.

At some institutions, the unofficial material has proliferated, being placed on the Internet by unaffiliated organizations and individuals. Many schools have begun developing rules and regulations for those using their Web sites and emphasizing that Internet authors must comply with all laws that govern the use of intellectual property, libel, and copyright.

Example

At its Web site, Purdue University has penned a statement explaining that since the information at the site comes from a variety of sources, the university does not assume responsibility for their material <http://www.purdue.edu/>.

IV-A-1. General Information

University Web sites furnish quick, easy access to material formerly disbursed only by telephone, mail, and campus visits. At these locations, you can uncover data on degrees offered, matriculation procedures, and student housing and activities. Lists of faculty members are often accompanied by their credentials, professional publications and projects, and e-mail addresses. Other topics often included are the research activities of the various academic departments and information on alumni activities.

Example

The University of Michigan's School of Information offers an annotated list of programs involving students and faculty <http://www.si/umich.edu/hp/ei/research.html>. There are more than 37 projects, many of which are collaborative and are discussed elsewhere in this book.

IV-A-2. Academic Courses: Online Syllabi

Some academic Web sites can be particularly rewarding because the professors who devise the material are usually well-educated specialists in the discipline. At

the Web sites of their academic institutions, some professors are posting their course syllabi with recommended textbooks and reading lists. You do not need to be a member of the professor's class to investigate these courses. The professors are creating a wealth of information that is yours to read just by connecting to the Internet. These locations define the perimeters of study: assignments, grading, and examinations. They often contain visual material and hyperlinks to other pertinent Web sites, leading the interested reader to a more detailed study of the topic. These sites may also provide brief overviews of material and even reprint complete articles. Two types of online syllabi prevail, interdisciplinary and individual studies.

Interdisciplinary Courses

Some universities are promoting interdisciplinary humanities courses, which may furnish information on literature, music, theater, religion, and history, as well as artistic monuments. These are sometimes required

courses, maintained by a board of experts in the field. Frequently, money has been raised through grants or sponsorships to help defray the costs of program development. The material may be continuously altered and improved, but probably will stay on the Internet.

Example

A particularly creative and extensive program has been developed by the University of Evansville in Indiana. *World Cultures* is a three-part series required for all freshman and sophomore students. This program is the foundation of the school's award-winning General Education Program, and its importance can be judged by the fact that at one time, the university's home page included a direct link to *World Cultures* <http://www.evansville.edu/>.

Exploring Ancient World Cultures (EAWC) is organized into eight ancient and medieval cultures: the Near East, India, Egypt, China, Greece, Rome, Islam, and Europe <http://eawc.evansville.edu/about.htm>. Each section includes a tremendous amount of online material, such as an anthology of primary texts, a list of print and film resources, and

Netscape - [The EAWC Site Index]

File Edit View Go Bookmarks Options Directory Window Help

Back Forward Home Reload Images Open Print Find Stop

Location: http://eawc.evansville.edu/www/index.htm

Exploring Ancient World Cultures
Index of Internet Resources

The EAWC Site Index

Navigate the EAWC Internet Index	Search the Ancient and Medieval Internet
Sites ▼ Global ▼ Go	_____ Argos

The EAWC Site Index is reserved for links to special exhibitions, virtual centers of study, interactive resources, specific internet indices, and other sites that do not fall easily into one of the other categories. Resources that are generally relevant to the ancient world appear below. To access those that are culture-specific, select a location in the second menu box under "Navigate the EAWC Internet Index" above and click "Go".

Ancient Medicine from Homer to Vesalius

Argos Limited Area Search of the Ancient and Medieval Internet
> **Argos** is a search engine explicitly designed for the ancient and medieval worlds. Using an innovative system of multiple indexing and peer-review, Argos limits the range of search results so that users may view only a selected portion of the internet, in this case the ancient and medieval portions. Argos was designed by Anthony F. Beavers and Hiten Sonpal at the University of Evansville.

The Asclepion
> Devoted entirely to ancient medicine and maintained by Mark Hayes and Ethan Watrall, **The Asclepion** features an introduction to the field of study and individual pages on Egypt, Mesopotamia and Greece. The section on Greece is further divided into subsections: Medicine in Homer, The Foundations of Hippocratic Medicine, The Hippocratic Oath, Overview of Hippocratic Epidemics, The Hippocratic Treatise *On Fractures* and The Illness of Maidens.

Document: Done

Exploring Ancient World Cultures (EAWC) Web Page <http://eawc.evansville.edu/>

an index of Web sites that complement this study. Especially important is the lengthy chronology that covers historical events from 3450 B.C.E. to 1509 C.E..[1] Remember, all this material is on the Web!

EAWC, which has an editorial board of eight directors, is headed by Dr. Anthony F. Beavers. The syllabus material for the three courses is on the Internet; access these courses through <http://cedar.evansville.edu/showcase/culture/>.
WC 101: "The Ancient World" (the introductory course)
WC 102: "The Emergence of the West, Renaissance to Sixteenth Century"
WC 203: "The Modern World"

Individual Courses

Web sites for individual courses not only vary greatly but are constantly changing and may be available only for a short time, during the period the course is taught. Students whose professors have placed material online for their courses obviously start there. Other professors' courses may also assist students in understanding the material. Since numerous course sites are being developed for classes with large numbers of students, some administrators request that the faculty hand out their syllabi. The popularity of these Web sites has created a traffic jam on the information highway!

Art history survey courses sometimes have Web sites that parallel the general art history textbooks [IX-B-1]. Reading lists, glossaries, and data on the history of the period are provided at these sites, which may also include thumbnail-size reproductions of related art works. These small identifying illustrations can be enlarged only by students with the proper identification numbers and passwords. At some Internet locations, there are also hyperlinks to other pertinent URLs.

Example
University of Wisconsin Art History Survey
Course 201: "Ancient and Medieval," Dr. Nick Cahill
<http://www.wisc.edu/arth/ah201/index.html>
Course 202: "Italian Renaissance to Contemporary Art," Dr. James M. Dennis
<http://www.wisc.edu/arth/ah202/jmd/index.html>

The syllabi of upper-level or graduate courses are sometimes placed on the Internet. You can semi-audit these online courses; you will miss the lectures and class activities, but you can follow the process the professor takes with the subject. These courses can be especially rewarding, since they usually recommend advanced-level readings. Often the suggested scholarly articles contain references leading the reader to a greater richness of material.

Example
The syllabus of "Art and Archaeology of Medieval Byzantine," developed by Dr. Sharon E. J. Gerstel of the University of Maryland, consists of (a) a glossary of terms and subjects, (b) hyperlinks to other Web sites, and (c) a section on Byzantine monuments, with illustrations of church exteriors and interiors <http://www.inform.umd.edu/EdRes/Colleges/ARHU/Depts/ArtHistory/arthfac/gerstel/arth406.htm>. The visual material is not available except to Maryland students.

IV-A-3. Single-Subject Web Sites

Some Web sites are concerned with only one subject, providing hyperlinks to other URLs concerned with the same topic. These are often developed by professors or graduate students, focused on their subject of expertise and special interests. Interdisciplinary in content, single-subject sites are a service to other scholars, as well as to students.

Many art-related single-subject Web locations have a humanities orientation and provide information and links to locations covering a number of disciplines: geography, history, religion, literature, music, theater, and the arts. There is often so much concerning a specific subject that you may feel you are on overload! But remember, the more you approach a subject from various angles, seeing different views and perspectives, the more you will learn and understand its diverse ramifications.

Example
Victorian Web Overview, developed by Professor George P. Landow at Brown University, includes information on visual arts, literature, social context, religion, philosophy, politics, technology, and even gender matters. Hyperlinks expand this coverage to other Web sites concerned with all aspects of Victorian life <http://www.stg.brown.edu/projects/hypertext/landow/victorian/victov.html>.

The topics of single-subject Web sites, some covering expansive periods of time, vary greatly, ranging from individual countries during a specific period of

their history to historical periods and outstanding geographical locations. There seems to be a trend toward developing sites on individual artists; many of these are cited in Chapter X under the appropriate historical periods. These single-subject Web sites are truly remarkable achievements!

Historical Periods: The *Perseus Project*

One of the most scholarly academic programs on the Web is the *Perseus Project,* which combines Internet and CD-ROM technology. Under the directorship of Gregory Crane, editor-in-chief and associate professor of classics at Tufts University, this extensive, continuing project is concerned with primary and secondary data on ancient Greek literature, art, and culture. The information is disseminated in two sections: through a Web site <http://www.perseus.tufts.edu/> and through several CD-ROMs.

Perseus 2.0 CD-ROM (CD-ROM for Macintosh computers. New Haven, CT: Yale University Press, 1996). For a comparison of the material on the Perseus 2.0 CD-ROMs with the Web site, see <http://www.perseus.tufts.edu/order.html>. For instance, there are more than 24,000 images on the CD-ROMs, but only 16,000 at the Web site.

The Web site consists of items such as those cited below. This is only part of the material that constitutes the *Perseus Project,* which also has a section on teaching methods. For examples of the types of material located through this project, see [X-A]. The *Perseus Project* includes

- text from Thomas Martin's *Overview of Archaic and Classical Greek History* (an expanded print form is available through Yale University Press)
- the *Perseus Encyclopedia,* which contains references to Greek subjects, linking the entries to appropriate ancient Greek authors

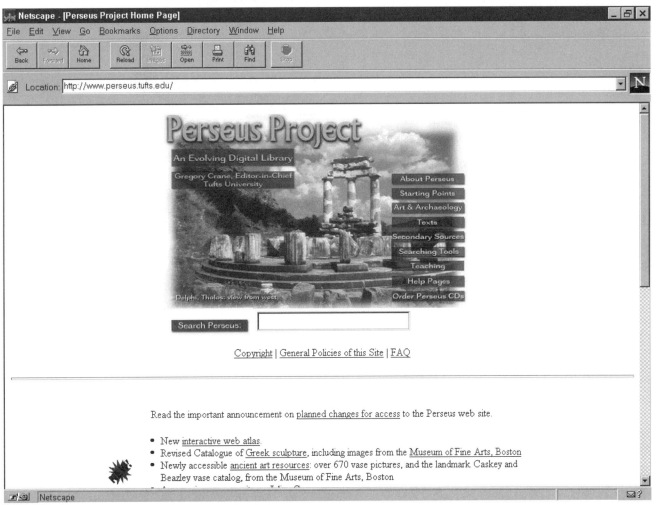

Perseus Project Web Page <http://www.perseus.tufts.edu/>

- English translations of ancient Greek texts (presently the works of 33 authors are provided, with more being added)
- catalogues of Greek vases, coins, architecture, and sites, with illustrations reproduced on the Internet
- special online exhibits (such as "Hercules: Greece's Greatest Hero," which provides biographical material, maps, and discussions of his labors)
- links to related Web sites
- most important of all, the Perseus Lookup Tool, which allows a global query of all the data in the *Perseus Project* databases

Individual Artists: William Blake

The *William Blake Archive* is a hypermedia Web site for this visionary artist. Begun in 1995, the archive provides access to various material on the English artist (1757–1827), who was a poet, engraver, and painter. When finished, it will contain about 3,000 images: about two-thirds will be the art Blake created for illuminated books; the rest will be paintings, drawings, and engravings. All of the visual material will be indexed by subjects, dates, and themes. This Web site also includes a bibliography and hyperlinks to related sites <http://jefferson.village.virginia.edu/blake/>.

This project was developed and edited by three professors from three universities: Morris Eaves, the University of Rochester; Robert Essick, the University of California at Riverside; and Joseph Viscomi, the University of North Carolina, Chapel Hill. The Institute of Advanced Technology in the Humanities at the University of Virginia hosts this project, which is sponsored by a number of organizations, including the Library of Congress and the Getty Grant Program.

IV-A-4. Indexes to Subject Matter on the Web

The material on the Web has been, and is still being, added in a disjointed, haphazard manner. There is no universal method for naming the sites, nor is there a catalogue or bibliography organizing the data. The Web sites that index Internet data by specific subjects are therefore especially important for locating pertinent material. They are also valuable because the

search engines do not always find all relevant locations. Several major indexes covering art and history subjects are discussed below; you may need to access several of them to obtain the best list.

Art History Resources on the Web, under the direction of Dr. Christopher L. C. E. Witcombe, is hosted by Sweet Briar College in Virginia. At this Web site, Internet material is indexed according to specific art periods and styles, artists, architects, and historical monuments, following the art history approach used by many academic institutions. The brief notes that are included help you find just what is needed, eliminating duplications. Another asset is the detailed indexing of material at large Web sites, such as those of the French Ministry of Culture [V-C]. Dr. Witcombe's indexing is presently available through the program called *Gateway to Art History*, which follows the chapters in Gardner's *Art through the Ages* <http://www.harbrace.com/art/gardner/>.

Part One includes prehistoric, ancient, and medieval art <http://witcombe.bcpw.sbc.edu/ARTHLinks.html>

Part Two covers Renaissance, Baroque, and eighteenth-century art <http://witcombe.bcpw.sbc.edu/ARTHLinks2.html>

Part Three covers nineteenth- and twentieth-century art <http://witcombe.bcpw.sbc.edu/ARTHLinks5.html>

Part Four furnishes hyperlinks to non-European art <http://witcombe.bcpw.sbc.edu/ARTHLinks3.html>

Part Five, Research Resources in Art History, includes various aspects of art: prints, image resources, lists of artists, visual resources, and online journals and periodicals <http://witcombe.bcpw.sbc.edu/ARTHLinks4.html>

Part Six covers museums and galleries <http://witcombe.bcpw.sbc.edu/ARTHLinks6.html>

The *Malaspina Interdisciplinary Matrix* is hosted by the Malaspina University College, British Columbia, Canada. It is an extensive interdisciplinary index of Western art, architecture, and sculpture developed by Russell McNeil. Under historical periods—antiquity, medieval, Renaissance, Baroque, classical, romantic, and modern—are lists for about 275 artists. Hyperlinks are provided for each artist to (a) a brief biographical sketch; (b) titles of the bibliographic resources located through the National Library of Canada, the U.S. Library of Congress, and the English COPAC; and (c) Web sites that reproduce the artist's work. Frequently, in-print books on the artist available at Web bookstores are included <http://www.mala.bc.ca/~mcneil/matrix.htm>.

The *Index of Resources for Historians* was developed by the Departments of History of the University of Kansas and the Universität Regensburg, Germany. This prolific file, maintained by Lynn Nelson and Eric Marzo, furnishes hyperlinks to more than 2,400 other sites containing historical material. Organized by large historical categories, it indexes numerous subjects—such as African studies, ancient Rome, India, and American Indian history—and subdivisions of United States history. Some categories include hyperlinks to material on art <http://www.ukans.edu/history/>.

ArtSource, hosted by the University of Kentucky and developed by Mary Molinaro, furnishes annotated hyperlinks to various art-related sites. The material is organized by general resources and bibliographies, architecture resources, art and architecture programs, artists' projects, art and architecture libraries, vendor information, image collections, electronic exhibitions, museum information, and online art journals <http://www.uky.edu/Artsource/>.

Voice of the Shuttle: Web Page for Humanities Research is hosted by the University of California at Santa Barbara. Under the direction of Dr. Alan Liu, the site indexes eclectic material dealing with archaeology, architecture, art history, classical studies, history, teaching resources, libraries, and museums <http://humanitas.ucsb.edu/>.

IV-A-5. Web Sites for Visual Material

The study of art requires visual material, and more and more institutions are placing illustrations on the Internet for their students. Due to contractual agreements and copyright problems, most of these locations are restricted to the university's students and faculty. To gain access, you must have the proper identification and password.

A few academic Web sites provide online reproductions for identification purposes, either in a thumbnail size or with a large C covering it. Presently, these Web sites are free, but this may change. A few require registration; others charge for viewing larger, clearer images. It is difficult to predict the future of these academic locations.

AICT: Art Images for College Teaching, Minneapolis College of Art and Design, photographed by Allan Kohl
<http://www.mcad.edu/AICT/index.html>
ArtServe, University of Australia
<http://rubens.anu.edu.au/index2.html>
Digital Image Center, University of Virginia [XIII-A-5]
<http://www.lib.virginia.edu/dic/collections/collections.html>
Fine Arts History Home Page, University of Colorado at Colorado Springs
<http://harpy.uccs.edu/index.html>
SILs: Art Image Browser, University of Michigan
<http://www.sils.umich.edu/Art_History/>
SPIRO, University of California, Berkeley [XIII-A-5]
<http://www.ced.berkeley.edu/>

Example

SILs: Art Image Browser at the University of Michigan (UM), is a Web site that reproduces photographs of art, architecture, and museum objects. The database can be searched by (a) artists' names or nationalities; (b) works of art using titles, media, or dates, and (c) subjects. The visual material is derived from (a) UM's Museum of Art, which owns about 12,000 works of art; (b) the Kelsey Museum of Archeology, with about 98,500 ancient art objects; (c) the Los Angeles Chicano Murals Photographic Collection, with works dating 1970 to 1994; and (d) the slide and photograph collection owned by UM's art history department, which illustrates art from the ancient world, Asia, Africa, Europe, and North America. *SILs* is maintained by Dr. C. Olivia Frost and Dr. Karen Drabenstott <http://www.sils.umich.edu/Art_History/>.

IV-A-6. Experimental Web Sites

Many institutions allow students to post material on their academic Web site. This can sometimes cause problems for Web users, because there is frequently little or no information on the credentials of these Internet authors. The sites are experimental in nature and later are usually removed from the hosting institution. Some schools have set aside special URLs for student use. Be careful how you utilize this material; the data may be the work of students who may not be knowledgeable about their topic. On the other hand, there can be jewels of information located at these sites.

Examples

1. The University of North Texas, Denton, hosts a section for personal Web sites, where students can experiment with an Internet page. The university

clearly states that the opinions of the authors of this material do not represent the university. The URL is <http://people.unt.edu/~userid/>, where *userid* is the identification of the user or author.

2. Monash University, Australia, states that student files are deleted at the end of each year. The student's URL includes the word *personal*, such as <http://www-personal.monash.edu.au/~student's name/>. The university explains this at its Web site <http://www.arts.monash.edu.au/visarts/diva/aborig1.html>.

IV-A-7. Locating Academic URLs

The domain page of an academic institution is the table of contents to various types of campus informa-

tion and services: the library, courses taught, and e-mail addresses for professors and personnel. To locate academic URLs, consult one of the following:

Association of Universities and Colleges of Canada <http://www.aucc.ca/english/canada/>

Collegiate Home Pages <http://www.collegiate.net/>

College and University Home Pages: Alphabetical Listing, MIT, maintained by Christina DeMello <http://www.mit.edu:8001/people/cdemello/univ.html>

College and University Home Pages: Geographical Listing, MIT, maintained by Christina DeMello <http://www.mit.edu:8001/people/cdemello/geog.html>

Yahoo lists academic institutions under Regional, such as Regional: Countries and Regional: U.S. States <http://www.yahoo.com/Regional/>

IV-B. Corporate Sponsors

As U.S. public funding for the arts has decreased, the need for corporate sponsorship has increased. This is especially evident in the business world's donation of money and assistance to museums to help them produce exhibitions and cultural events. Companies are also giving monetary support for placing information on the Internet; the domain host usually acknowledges the assistance at the Web site, which often has a hyperlink directly to the company's home page.

Examples

1. AT&T Canada sponsored the OH! Canada Project at the Art Gallery of Ontario: <http://www.ago.net/>, then choose "Archive."

2. The Metropolitan Museum of Art has a special acknowledgments page to thank its corporate sponsors. Information on future and current exhibitions is provided, accompanied by special links to the sponsors' domain pages <http://www.metmuseum.org/>.

Business firms have long been sponsors of cultural groups and events. Web sites are an extension of this relationship between art and the corporate world. The information placed on the Internet often endeavors to encourage tourism and understanding concerning specific geographical regions, countries, states, and cities. Some Web sites are being developed by groups of businesses, each with a hyperlink to its home page.

Having a Web site sponsored by a number of business firms may be a future trend for the Internet.

Example

AsianNet is maintained by more than 60 commercial corporations [XV-B-3] <http://www.asiannet.com/index.html>.

IV-B-1. The Travel Connection

Web sites maintained by travel bureaus often have outstanding reproductions of historical monuments and museum collections. Because they are promoting a region, these travel agencies usually obtain the best visual material available. This ever-expanding area includes various combinations of tourist bureaus with corporate sponsorship. Remember to access this type of Internet location.

Example

Paris Pages, whose corporate sponsor is IBM France/Europe, is officially recognized by the Paris Tourist Office and the French Government Tourist Office. At this Web site, there is information on museums that do not have their own domain Web sites. General information, a short history of the museum, and sometimes several illustrations of its collection are provided <http://www.paris.org/>.

For the *Musée National Picasso* <http://www.paris.org/Musees/Picasso/picasso.html>, there is a brief description of the Hôtel Salé, reporting that the collection consists of 203 paintings, 191 sculptures, and 85 ceramics.

Paris Pages also has a calendar covering several months that reports forthcoming Parisian exhibitions <http://www.paris.org/Calendar/>. Once a specific exhibition is located, a hyperlink connects you to the appropriate home page with general information and a hyperlink to the Paris Metro, where a map of the underground subway gives travel directions to the exhibition.

Paris Pages also has a hyperlink to the *Museums and Monuments Card* <http://www.paris.org/monuments/mmc.html>, the special *Carte Musées et Monuments,* which, when purchased, entitles the buyer to admission to 63 museums and monuments in Paris, as well as some in the surrounding area, including Versailles and Vincennes.

In addition, *Paris Pages* has a monthly online magazine called *Paris Kiosque* <http://www.paris.org:80/Kiosque/>, containing signed articles, an image of the month, and brief essays. One recent issue published an illustrated essay on the Luxembourg Palace and its gardens. The Image of the Month section highlights such places as the I. M. Pei Pyramid at the Musée du Louvre.

IV-B-2. Consortiums

Different associations are banding together to provide extensive quality material on the Internet concerning their particular interests. Often this is to encourage tourism to a particular area. Municipalities bring together various aspects of their cities to provide broad, detailed tourist information. It is usually a winning combination for researchers.

Example

Firenze by Net provides data on transportation, hotels, restaurants, libraries, and churches in Florence. There is an enormous amount of material on the museums and art galleries. Under a section called the Florence Art Guide, written by Gloria Chiarini, there is a city map, a calendar of events, and an index to illustrated essays on 17 churches and art museums and 34 artists, such as Fra Angelico, Ghirlandaio, Masaccio, and Michelangelo. There are also essays on the Renaissance and a genealogical table for the d'Medici Family. This is a particularly important Web site that is worth revisiting often <http://www.italink.com/>.

IV-C. Entrepreneurs and Web Technicians

Computer specialists often place material on the Web, sometimes hoping to obtain corporate sponsorship or sell their technical skills. The far-ranging subjects that they place online include all periods and styles of art. They may provide brief presentations on a subject, recycled material from other sites, sources for visual material, and indexes to art historical online information. There are numerous Web sites developed and maintained by individuals who seem to love art and wish to share it with others. The question is whether or not these computer experts are subject specialists, entrepreneurs, or Web technicians. Frequently, technicians are immersed in the culture of the World Wide Web, emphasizing freedom of information and access to it, regardless of the material's copyright status.

All of this costs time and money: to own a computer, a modem, and a telephone line, to pay for access to the Internet, to obtain text and visual material, and to design and maintain a Web site. Many webmasters are asking Web surfers for monetary assistance to allow them to keep their URLs active. The following two sites—the *WebMuseum* and the *Alexander Palace*—are visited by many surfers on the Web. You must decide the category in which they belong.

WebMuseum

One of the most popular Internet sites is the *WebMuseum,* started in March 1994 by Nicolas Pioch.[2] By spring 1996, he had a number of contributors, whom he acknowledged, and about 30 worldwide mirror sites [I-A-2]. Pioch stated that he received no support or funding for the *WebMuseum,*[3] which at that time was visited weekly by approximately 200,000 visitors. When this site was accessed in fall 1998, the section called "What's New" had not been updated since June 1996 <http://sunsite.unc.edu/wm/>.

The *Webmuseum* home page directs you to several categories: Special Exhibitions, with one for Paul Cézanne, another for *Les très riches heures du Duc de*

Berry, and General Exhibitions of Paintings, subdivided into a theme index for artistic styles, an artist index, and a glossary. Within each section, there are numerous illustrated essays, mostly with quality reproductions; however, there are no references to sources for the reproductions, footnotes, or bibliographies. The articles usually have numerous hyperlinks to artists, terms, and ideas.

Originally Pioch's Web site was entitled *LeLouvre*, but in June 1994, after the French Ministry of Culture objected, it was changed to *WebLouvre*. In February 1995, due to copyright restrictions, it was renamed the *WebMuseum*. In 1996, Pioch appended a section on legal issues, stating that the information on the *WebMuseum* site is not in the public domain—meaning that the material is still under copyright to someone. He declared that the information was for educational use only, that he did not assume any legal liability for its accuracy, and that certain stipulations must be met in using the information; for example, no fees may be charged and permission must be obtained from the rightful copyright owners, whom he does not name. Pioch states that he only manages the technical aspects of this online location. The addition of this section to the *WebMuseum* site points to some of the problems of using online material.

Alexander Palace

The World Wide Web is the perfect place for a crusade. And that is what Bob Atchison has begun: a crusade to save the Alexander Palace in Tsarskoye Selo, also called the Pushkin, just outside St. Petersburg, Russia. Ever since the second grade, Atchison has endeavored to learn everything possible concerning the Romanov rulers and their lives at Tsarskoye Selo. His first Russian trip in 1977 was followed by his consistent collection of data and photographs of this house, which was originally commissioned by Catherine the Great.

Atchison has made numerous trips to Russia, visiting the royal residence and working to involve local officials in its restoration. To publicize and explain this favorite home of Tsar Nicholas II, last ruler of Russia, Atchison developed the *Alexander Palace* Web site, which is well illustrated and documented in detail. The extensive material on the palace includes floor plans, illustrated biographies of the Romanov family, and photographs of some rooms and details of a few art objects <http://205.187.161.152/palace/index.html>.

Atchison formed the nonprofit Alexander Palace Association to assist him in raising the $3 million needed to renovate the building. And partly because of his endeavors, the mansion was chosen by the World Monuments Fund as one of the 100 endangered cultural landmarks worldwide. Atchison is continually seeking money to renovate the palace, as well as sponsors to assist him in continuing his Web endeavor. He is making a major contribution[4] by sharing his expertise and passion with others!

Notes

1. B.C.E. means *Before Common Era*; C.E., *Common Era*. These correspond to the familiar B.C. and A.D.
2. On July 6, 1995, Pioch, a computer science teacher at the École Polytechnique in Paris, won the second prize in the Initiatives 1995 contest, sponsored by the BMW Foundation.
3. The *WebMuseum* has been using the SunSITE location at the University of North Carolina. SunSITE (Sun Software, Information and Technology Exchange) is sponsored by Sun Microsystems, which in 1992 created this mechanism to distribute software. It is now home to a vast collection of electronic data; its disclaimer states the conditions for materials installed on its Internet server <http://sunsite.unc.edu/DISCLAIMER.html>.
4. Just how large a contribution was acknowledged in the *Wall Street Journal* article, "The Last Czar's Home Opens to the People" (September 9, 1997), when author Lee Rosenbaum mentioned that the palace interiors depicted in some archival photographs and watercolors could be viewed on the Web site of Bob Atchison, president of the U.S.–based Alexander Palace Association.

V. Cultural, Civic, and Professional Organizations; National Trusts; and Foundations

Some administrators of private foundations, ministers of culture, and civic and professional organizations are initiating programs concerned with the arts and placing them on the Internet. These highlight a country's heritage and encourage tourism. Others have such a variety of programs and interests that you must either (a) visit their sites periodically to observe the newest additions or (b) access one of the Web sites that indexes material on the Internet, such as *Art History Resources on the Web* [IV-A-4].

This chapter discusses some excellent examples of projects sponsored by such groups as (a) Amsterdam Heritage, (b) the Canadian Heritage Information Network (CHIN), (c) the French Ministry of Culture, (d) professional associations, (e) national trust associations, (f) the Berger Foundation of Switzerland, and (g) the J. Paul Getty Trust in the United States. URLs for other cultural and civic organizations and foundations are provided at the end of this chapter.

V-A. Amsterdam Heritage at Amsterdam Park

The Internet 1996 World Exposition was "building a public park for the global village." This Dutch Web site, called *Amsterdam Park*, has various pavilions on different subjects; two important ones are *Amsterdam Heritage* and *Rembrandt* <http://amsterdam.park.org:8888/Netherlands/pavilions/culture/>. Some pavilions are in English; additional translations are in progress. The Amsterdam Pavilion[1] features the historic buildings of this ancient city. Extensive data and some illustrations are available for art historical styles and categories. There are essays on Dutch architects working from the 17th century to the early 19th century that provide biographical data, as well as inventories and illustrations of buildings they designed in Amsterdam <http://amsterdam.park.org/Amsterdam/Guest/bmz/adam/adam_e.html>.

The Rembrandt Pavilion is built around the Rembrandt Research Project (RRP), a program whose team received financial support from the Netherlands Organization for the Advancement of Scientific Re-

search to examine the estimated 600 paintings worldwide that are said to have been created by Rembrandt. At its Web site, the project is explained and a multimedia section is available for four of the Dutch artist's paintings <http://amsterdam.park.org:8888/Netherlands/pavilions/culture/rembrandt/>. There are also two illustrated essays by Ernst van de Wetering: "Rembrandt's Manner: Technique in the Service of Illusion" and "The Invisible Rembrandt." The latter discusses the results of the various technical and scientific examinations to which the paintings were subjected. Both essays were originally published in an exhibition catalogue, *Rembrandt: The Master and His Workshop* (New Haven, CT: Yale University Press, 1991), which also contains four other essays and entries for 83 paintings. This 1991–92 exhibition was hosted by the Gemäldegalerie, Altes Museum, Berlin; the Rijksmuseum, Amsterdam; and the National Gallery, London.

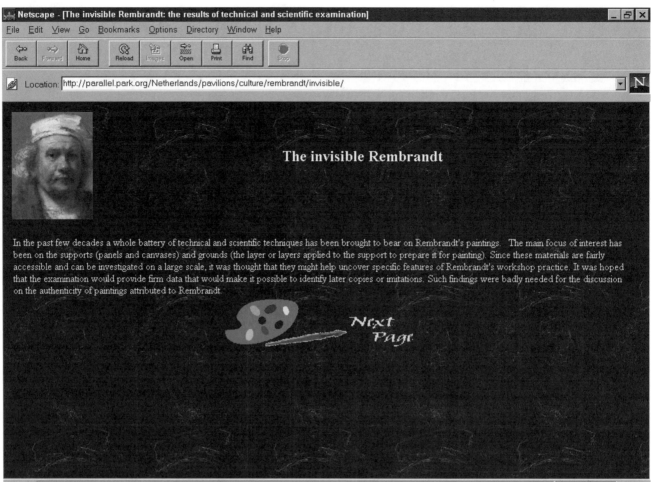

The Invisible Rembrandt Web Page <http://parallel.park.org/Netherlands/pavilions/culture/rembrandt/invisible/>

V-B. Canadian Heritage Information Network (CHIN)

The Canadian Heritage Information Network, known as CHIN, is a special agency of the Department of Canadian Heritage. The French name of the organization is Réseau canadien d'information sur le patrimoine (RCIP). Some CHIN projects are open to all Web surfers, including information on (a) Canadian museums, with hyperlinks to their Web sites; (b) the *Artists in Canada Vertical Files* [XIV-B-8]; and (c) special projects with other cultural institutions. Other projects are available only to members. <http://www.chin.gc.ca/>.

Example

Christmas Traditions in France and Canada provides extensive data on the religious aspects of the Christian holy day and the secular history of Santa Claus. This project was created in cooperation with the French Ministère de la culture, through which the program can also be accessed <http://www.chin.gc.ca/christmas/>.

V-C. French Ministry of Culture

The mission of the French Ministry of Culture (Ministère de la culture) is to create programs concerned with the major works of French art and

artifacts using multimedia technology and networking. This organization has cooperated with other cultural institutions in producing Internet programs

such as *Christmas Traditions in France and Canada* (see [V-B]) <http://www.culture.fr/culture/noel/angl/noel.htm>.

This Web site includes various types of material, all of which are profusely illustrated. There are two main types: (a) current information on exhibitions in French museums, and (b) scholarly, in-depth illustrated art programs. Some of these Web sites have English translations of the material. Examples, some of which are listed below, can all be accessed through the index <http://www.culture.fr/cgi-bin/cookie-test-en/>.

Examples

1. *Age of Enlightenment in the Paintings of France's National Museums* clarifies this historical period and discusses specific groups of paintings exemplifying such terms as "lightheartedness," "philosophers," and "virtues of ancient and republican Rome." Each painting illustrating these terms can be accessed to obtain a summary catalogue entry, provenance, present location, and additional data. It is both a fun and informative site! <http://www.culture.fr/lumiere/documents/files/imaginary_exhibition.html>.

2. *L'art préhistorique des Pyrénées* discusses and illustrates prehistoric paintings located in the Pyrenees <http://www.culture.fr/culture/app/eng/artprepy.htm>.

3. *Le concours des prix de Rome* documents (a) the history of the fine-arts school, Ecole nationale supérieure des Beaux-arts (ENSBA); (b) the prizes awarded, called the prix de Rome; and (c) the winners' works of art, which constitute the ENSBA's collection. Each annual contest dictates the subject to be depicted, categorized as Biblical, mythological, historical, or allegorical. Indexes to the winners' works by artists' names and by dates are available <http://www.culture.fr/ENSBA/ensba.html>.

4. *Jean-Baptiste Camille Corot*, the 1996 Corot exhibition at the Grand Palais, Paris, centered on the effects of conservation and scientific analysis. The Web site offers a brief chronology of Corot's life and two examples of his work that are owned by the Musée du Louvre: *Woman with a Pearl*, 1869, and *Chartres Cathedral*, 1872. For each painting, there is a brief history, data on the subjects, and the results of investigations using various scientific methods, such as radiography, as well as examination in infrared, ultraviolet, and raking light <http://www.culture.fr/culture/corot/expos/corot.htm>.

Corot was additionally highlighted by (a) information on *Corot: 1796–1875*, a CD-ROM illustrating and discussing 94 of the artist's works in the Musée du Louvre, with an emphasis on scientific analysis, and (b) a hyperlink to the Musée Condé, which presents a comprehensive, well-illustrated discussion on a Corot painting in its collection, *Concert Champêtre*, although the Web site has since disappeared.

V-D. Professional Associations

Through their professional organizations, members keep abreast of the problems and issues of their disciplines. The Internet has become a major means of communication. These organizations offer a wealth of information at their Web sites:

- the history of the organization
- the names, titles, and addresses of their executive board, staff, and committee members
- the offices of the various regional and state chapters
- the procedure for becoming a member
- the names of winners of awards and honors
- the process and/or style for submitting papers to the organization
- the specific interests of the membership
- hyperlinks to other pertinent organizations or sites

Visit the home pages of professional associations often to learn more about their activities. For a list of art-related organizations, accompanied by their online addresses and the titles of their journals, see Appendix Two.

Examples

1. At its Web site, the Art Libraries Society of North America (ARLIS/NA) furnishes information on its upcoming conventions, abstracts from past conferences, announcements of workshops, and a jobs network where positions are posted. A section called Guide to the World Wide Web provides URLs for numerous items, including discussion groups, electronic journals, copyright and legal issues, museums and galleries, and Internet locations concerned with art, architecture, and interior design <http://www.lib.duke.edu/lilly/arlis/>.

2. The Association of Art Museum Directors (AAMD) provides information on the exhibition schedule of their member institutions <http://www.EXCALENDAR.net/>, and information on their project, Art Museum Image Consortium (AMICO) <http://www.AMICO.net/>. The latter proposed program seeks to formulate a library of digital documentation of art in the members' collections that can be licensed for educational use to other institutions.

V-E. National Trust Associations

Throughout the world, nonprofit societies are being created to safeguard the heritage of their regions or local sites from industrialization, destruction, and neglect. The first such society, the Massachusetts Trustees of Public Preservations, was established in 1891; England's National Trust followed in 1895. There has been a rapid growth of these national trust foundations, which are mainly concerned with (a) raising money to publicize and assist in restoring historic places and (b) publishing pamphlets and books on restoration and architectural monuments.

At their Web sites, these nonprofit societies provide a variety of material concerning their activities: membership data, lists of endangered sites, and information on places they have helped restore. Frequently there will be descriptions and illustrations of the buildings. To stimulate the interest of its patrons, England's National Trust Web site <http://www.ukindex.co.uk/nationaltrust/themes.html> has developed a database of their properties from which you may request a list of places to visit based on various themes, such as furniture, ceramics and glass, paintings, and even ghosts!

The preservation of architectural monuments is a responsibility at all levels of government—national, state, county, and local. The first U.S. tax-exempt foundation, the Mount Vernon Ladies Association, was formed in 1858 to purchase George Washington's Virginia home.

By 1940, the growing interest in the documentation of U.S. history as well as the preservation of the U.S. heritage had expanded to the extent that the American Association for State and Local History (AASLH) was established. The AASLH develops activities and programs and assists communities in the preservation of their historical resources <http://www.aaslh.org/>.

National trust foundations have flourished throughout the world. Some of the homes they sponsor have been restored and refurbished to allow the public to visualize and experience life during the time the home was built or at the height of its renown. The URLs of some historical houses and museums are cited in [III-C], such as Old Sturbridge Village in Massachusetts <http://www.osv.org/>, and the Château de Fontainebleau in France <http://www.w3i.com/eng/cities/fontainebleau.htm>.

Example
America's National Trust for Historic Preservation (NTHP), chartered in 1949 as an educational institution, has two unusual features: a list of videos concerned with historic preservation and a section on current U.S. legal decisions affecting restoration <http://www.nthp.org/>.

V-F. Berger Foundation and the World Art Treasures

The World Art Treasures was developed by the Jacques-Edouard Berger Foundation in Switzerland. The foundation, named after a much-traveled curator at the Museum of Fine Arts in Lausanne, encourages the discovery and appreciation of art. Toward this end, it has produced a wide range of diversified programs, all well illustrated and some based on Berger's lectures. To access these online programs, use the index: <http://sgwww.epfl.ch/BERGER/index.html>.

"A Shared Vision of Sandro Botticelli" traces the Italian Renaissance artist's life through his paintings.

"Discovery of Painting: Titian (1490–1576)" is an art appreciation lecture illustrated with three Titian paintings.

"Enchanted Gardens of the Renaissance" furnishes a general overview of the subject and highlights three Italian ex-

amples: the Sacred Grove of Bomarzo, the Villa Lante Gardens in Bagnaia, and the Villa d'Este Gardens in Tivoli.

"Georges de la Tour" is a biographical discussion of the artist and his works, which are illustrated by hyperlinks to the museums that own them.

"Johannes Vermeer" contains information on the artist and his paintings, as well as a section on world affairs during Vermeer's life. The events are subdivided as to those happening in Rome, Madrid, Paris, and Delft.

"Pilgrimage to Abydos (Egypt)," a pictorial trip through the ancient Temple at Abydos, discusses the shrine and provides a glossary of terms, a map, the history of the pharaohs, and information on the excavation of the temple.

"Roman Portraits from Egypt," which illustrates art owned by 26 international museums, considers the relationship of the portraits to their history and the artists who made them.

V-G. The J. Paul Getty Trust

The J. Paul Getty Trust is a private foundation with several branches, which supports numerous, far-reaching activities. The trust's Web site <http://www.getty.edu/> provides access to the J. Paul Getty Museum <http://www.getty.edu/museum/> and five organizational sections: (a) the Getty Research Institute, (b) the Getty Information Institute, (c) the Getty Education Institute for the Arts, (d) the Leadership Institute for Museum Management, and (e) the Getty Conservation Institute <http://www.getty.edu/gci/>. In addition, the trust has an extensive grant program <http://www.getty.edu/grant/>. The museum and the five institutes are physically united at the Getty Center in Los Angeles, which opened in December 1997. The first three institutes are discussed below.

V-G-1. Getty Research Institute

The Getty Research Institute for the History of Art and the Humanities is concerned with the understanding of art within its historical and cultural contexts <http://www.getty.edu/gri/>. Under its auspices, exhibitions and publications are produced. The latter include such 1997 Getty books as *Censorship and Silencing: Practices of Cultural Regulation*, edited by Robert Post, and *Irresistible Decay: Ruins Reclaimed*, by Michael S. Roth, Claire Lyons, and Charles Merewether. To support this research, the Getty provides a wide variety of excellent reference material available at the Getty Center. Its OPAC, called IRIS, is available through its Web site <http://opac.pub.getty.edu/>.

The Getty Research Institute contains an excellent collection of photographs; the Photo Study Collection contains about 2,000,000 items. The Gary Edwards Collection consists of more than 1,000 photographs and other forms of reproducing images created in the 19th and early 20th centuries. About 200 photographs from this collection are displayed through an online exhibition that illustrates ancient Greek architecture and sculpture during this time period. The Web site can be searched by geographic location, type of art, and photographer <http://www.getty.edu/gri/greece/>.

V-G-2. Getty Information Institute

The objective of the Getty Information Institute (GII)[2] is to bridge the gap between information technology and scholarly research on art and culture. The institute has supported numerous projects to assist researchers, such as the *Bibliography of the History of Art* [VII-B]. In addition, the Getty Trust supports various workshops, conferences, and an ever-extending list of projects, such as the protection of cultural objects <http://www.gii.getty.edu/gii/pco/>.

Information on future, current, and past conferences can be obtained through the Getty Internet Forum. This is an important source for material pertaining to art, culture, and the Internet. For instance, many papers presented at the 1997 meeting, "Museums and the Web: An International Conference," were reprinted on the Web. Studying the contents, footnotes, and hyperlinks of this stimulating material presented by worldwide experts is a superior method for keeping current in today's rapidly changing environment <http://www.gii.getty.edu/iforum/>.

Three ongoing GII interests are (a) databases that index various art, architecture, and sales information,

(b) the development of structured vocabularies of terms, artists' names, and geographical sites, and (c) descriptive guidelines for electronic documentation, which can be used to assist institutions in the exchange of art information. Some publications have resulted from these interests; they can be purchased, accessed through the Internet, or obtained in print or CD-ROM format at your area library. Free demonstration diskettes are available for some databases; consult the Web sites listed below.

The Getty Information Institute is concerned with the retrieval of information in the numerous existing databases, as well as future ones yet to be produced. Information databases use a variety of cataloguing terms that do not necessarily coordinate with other information databases and which have not been consistently used over the span of their existence. Structured vocabulary systems can be used (a) as authority files to assist those indexing or cataloguing material or creating databases and (b) to assist users in retrieving needed online information as quickly and economically as possible. This method for locating material catalogued under disparate terms will provide access to existing bodies of knowledge through the use of technology.

The Getty Information Institute furnishes online searching for some of its databases as an experiment in retrieving different types of information using a common set of terms. Presently available are (a) *Avery Index to Architectural Periodicals,* containing material indexed between 1977 and 1992 [VII-B], (b) *RILA: International Repertory of the Literature of Art,* a closed database with information indexed from 1975 to 1989 [VII-B], (c) the *Provenance Sale Catalogues Database,* and (d) the *Provenance Sale Contents Database.* When you search these databases, you can frequently enhance your results by adding the structured vocabulary systems of (a) the *Art & Architecture Thesaurus,* (b) the *Union List of Artist Names,* or (c) the Thesaurus of Geographic Names. Whether or not the online access will continue is not known at this time. The Getty Information Institute states that this is "on an experimental basis for a limited time." Access these databases through <http://www.gii.getty.edu/index/aka.html>.

Of the Getty Information Institute's many projects, eight are discussed below: (a) Art & Architecture Thesaurus, (b) Union List of Artist Names, (c) Thesaurus of

Geographical Names, (d) the *Provenance Index Project,* (e) Witt Library Project, (f) Census of Art and Architecture Known to the Renaissance, (g) Museum Education Site Licensing Project, and (h) Categories for the Description of Works of Art. Current information on Getty publications is located at <http://www.getty.edu/publications/>.

Art & Architecture Thesaurus (AAT)

The Art & Architecture Thesaurus (AAT) is a thesaurus of about 120,000 terms for describing and cataloguing objects, images, architecture, decorative art, and material culture dating from antiquity to the present. When added to other computer databases, the *AAT* automatically looks for synonyms, different spellings, or similar terms. Because it brings together variant spellings—such as American *color* and *jewelry* with the British *colour* and *jewellery*—as well as related terms, the *AAT* broadens your search. Presently, it is used by more than 200 organizations, such as the Library of Congress's Prints and Photographs Department, the Canadian Centre for Architecture, the Marburger Index, and a number of university slide departments <http://www.gii.getty.edu/vocabulary/aat.html>.

Electronic version: Electronic data is available through the Getty Institute, CHIN, and RLG [VI-B-2]. *Art & Architecture Thesaurus: Authority Reference Tool, Version 2.0* (New York: Oxford University Press, nd).

Print version: *Art & Architecture Thesaurus,* Toni Petersen, director (2nd ed. 5 vols. New York: Oxford University Press, 1994). Includes almost 90,000 terms and nearly 25,000 descriptors.

Reference book: *Guide to Indexing and Cataloging with the Art & Architecture Thesaurus,* edited by Toni Petersen and Patricia J. Barnett (New York: Oxford University Press, 1994).

Union List of Artist Names (ULAN)

A major problem when researching people who lived in past centuries, during a time when spelling was not as standardized as it is today, is the variant forms of artists' names. This is being addressed by the *Union List of Artist Names (ULAN),* a database providing various forms for the proper names of some 100,000 Western civilization artists and architects. *ULAN* includes artists who lived from antiquity to the present and is especially good for European and American names.

Each *ULAN* entry provides the artist's nationality and birth and death dates, plus the various names by

which the artist has been known. There is also a bibliography, which gives the names of biographical dictionaries that refer to the artist. There is an abbreviated list for 362 dictionaries that contain information on 74 percent of the artists at the Getty Web site <http://www.gii.getty.edu/vocabulary/ulan_biblio.html>. This list can be used to pinpoint references you should consult in your research.

ULAN can be essential when the subject is an early artist, especially if resources providing older material are to be studied, and is useful in locating little-known artists or names for which you are unsure of the spelling. It can be used with Boolean operators. Moreover, *ULAN* can be added to other online databases, such as *RILA* and *The Provenance Index,* to enhance and extend the results. You can search *ULAN* through the Getty Web site. Be sure to utilize this excellent tool where applicable <http://www.gii.getty.edu/vocabulary/ulan.html>.

Electronic version: Online through the Getty Institute and *Union List of Artist Names: Authority Reference Tool, Version 1.0* (Diskettes. Boston: G. K. Hall, 1994)

Printed version: *Union List of Artist Names* (4 vols. Boston: G. K. Hall, 1994)

Examples

1. Under *Annibale Carracci, ULAN* lists more than 50 variations for this 16th-century painter's name. These include such alternate spellings as Anibale, Annibal, and Hannibal, as well as Carache, Caraggi, Corache, Carache, Caracciolo, and Carraccioli. The differences reflect variations used in different Italian states and in other countries. Remember, there was little insistence upon one universal, proper spelling until the late 19th century.

2. *ULAN* was used to locate the 20th-century Swiss architect Le Corbusier's real name, Charles Edouard Jeanneret; nine variations of his name were provided.

3. If you do not know how to spell a name, use Boolean operators in your *ULAN* search. If you are unsure of whether it should be Bruegel, Breughal, or Brueghel, use *breug* AND brueg**. This locates 28 variations on the Flemish artist's name. The underlined *Bruegel, Pieter, the elder* indicates that this is the preferred spelling.

Thesaurus of Geographical Names (TGN)

The Getty Thesaurus of Geographical Names (TGN) is a database presently containing information on about 900,000 sites, arranged from the broader to the narrower term, from continent, nation, state, and province to city or inhabited place. This tool can be used to learn the names of places during different historical periods. Notes are often added that provide additional information concerning the geographical site. TGN is available only on the Internet; access through the Getty Web site <http://www.gii.getty.edu/vocabulary/tgn.html>.

Example

In a search for Halicarnassus, one entry was located. The record provided the various spellings for the mausoleum and the ancient city of Bodrum, as well as a brief history of the site.

The *Provenance Index Project*

The *Provenance Index Project* collects and disseminates information that documents individual works of art sold during the 19th century. An important aspect of establishing a work's provenance[3] is to check and interpret all of the sales in which it might have figured. This means coordinating and searching all known auction catalogues—a tremendous undertaking! Fortunately, a portion of the work has been accomplished by the *Provenance Index Project,* which has developed several databases, primarily consisting of (a) the Sale Catalogues Databases, and (b) the Inventories Databases, which contain information on unpublished 17th- and 18th-century inventories of collectors in Italy, the Netherlands, and Spain <http://www.gii.getty.edu/index/databases.html>.

Provenance Sale Catalogues Databases

When the *Provenance Index Project* began in the 1980s, information was gathered on paintings sold in Great Britain during the 19th century. Since then, the project has broadened in scope to include records from the 17th and 18th centuries for France, the Netherlands, Belgium, Germany, and Scandinavia. The Provenance Sale Catalogue Databases consist of two databases: (a) the Provenance Sale Catalogue Database, which provides information on the individual sales catalogues, and (b) the Provenance Sale Contents Database, which indexes the contents of those sales catalogues. In the former, the catalogues—which are often annotated catalogues or the original auctioneer's copy—are described in detail and their locations provided. In the latter, the sales catalogues are analyzed according to their contents. The owners, buyers, and sale prices are added, when known. This

material is available in a printed version and a searchable database, presently available through the Getty. This is an excellent reference for scholars searching for data on artists, collectors, provenance, and changes in the art market <http://www.gii.getty.edu/index/databases.html/>.

Printed version: *The Index of Paintings Sold in the British Isles during the Nineteenth Century,* edited by Burton B. Fredericksen, is a projected 20-volume set that publishes material from the Provenance Sale Contents Database. Each volume covers five years and is organized into a chronological index of sales, an index to paintings listed under artists' names, and an owners' index. As of 1997, four volumes covering more than 2,800 sales between 1801 and 1820 have been issued. The introduction to the first volume discusses the 19th-century European art market. The fifth volume, which will be published in 1998, includes British sales for 1821 to 1825; French sales, 1801–25; a Dutch sales index, 1801–10; Belgian sales, 1801–1820; and German, Scandinavian, and Swiss sales, pre-1800. For current information, access the Getty publication department <http://www.getty.edu/publications/>.

CD-ROM edition: *The Getty Provenance Index: Cumulative Edition on CD-ROM* consists of (a) material from the five printed volumes of *Index of Paintings,* plus (b) information on unpublished 17th- and 18th-century documents of collectors in Italy, the Netherlands, and Spain, accompanied by the inventory contents.

Internet site: The Provenance Sale Contents Database can be accessed through the Getty Web site. This online database can be searched by artist, painting title, seller, buyer, and the price for which the item sold. The database includes meaningful information not in the printed version, such as an indication of the subject of the painting, any subsequent provenance, or its present location.

> ### Example
> When a search was made for the collector John Julius Angerstein, the Provenance Sale Contents Database reported that Angerstein purchased Rembrandt's *The Woman Taken in Adultery.* It was bought on June 13, 1807, Lot Number 0044, at Christie's in London for £5,250 from Pierre Joseph Lafontaine. A paragraph describing the work of art is accompanied by information on the artist, a report that the previous owner had been Jan Six, and the fact that the painting's present location is the National Gallery, London.

The Witt Library Project

The Witt Library of the Courtauld Institute of Art, London, has the largest picture collection in the world. As of 1997, it included approximately 1.5 million reproductions of drawings and paintings, mostly by 75,000 European and American artists[4] who lived from about A.D. 1200 to the present. This picture collection, founded in the 1890s, contains all types of illustrations procured from books, articles, and exhibition, museum, and auction catalogues. Due to copyright issues, this index will probably never be distributed on the Internet. The Witt Library Project is twofold: (a) to reproduce the picture collection on microfiche and (b) to provide a subject index to the photographs <http://www.gii.getty.edu/index/databases.html>.

The Witt Library on Microfiche

The Witt Library in the Courtauld Institute of Art (Microfiche. Haslemere, Surrey: Emmett Publishing) is issued in two editions. The first, *The Witt Library,* published in 1990, covers about 50,000 artists and more than 1,400,000 images, reproducing the contents of the Witt Library Collection as of 1981. The 1992 edition updates this material with 560,000 more images that were added to the Witt Library picture files from 1981 to 1991. A printed list of the artists' names accompanies both microfiche publications, which are available at only a few research libraries.

The *Witt Library Computer Index*

The Witt Library Computer Index provides subject access to the paintings in the picture collection. Categories include subjects, symbols, sitter identification, historic events, topography, and locations illustrated. Iconclass is used [IX-B-7]. In addition to subject, the computer files can be searched by artist and date of painting. Presently, the subect index is available only at the Courtauld Institute in London. Most inquiries are answered; contact the director, Dr. Catherine Gordon, via e-mail: <cath.gordon@courtauld.ac.uk>. Two sections are being indexed:

American School Computer Index Project furnishes subject access to the 57,000 works of art by 3,800 American artists working since the 17th century

18th-Century British Artists Computer Index Project, as of 1997, covers about 55,000 works by 380 British artists born between 1718 and 1770

Census of Art and Architecture Known to the Renaissance

The Census of Art and Architecture Known to the Renaissance is an important documentation of classical art that might have influenced the work of Renaissance artists. The census indexes classical art and architecture that might have been known to artists living between 1400 and the mid-16th century. The information is collected from drawings, guidebooks, Renaissance sketchbooks, treatises, and other

archival material. Detailed information and an illustration are provided for each work of art. *The Renaissance Artists & Antique Sculpture: A Handbook of Visual Sources,* by Phillis Bober and Ruth Rubenstein (Oxford: Oxford University Press, 1986), is based on this material. A CD-ROM of the census will soon be available from the German firm of Biering and Brinkmann <http://www.gii.getty.edu/index/databases.html>.

Museum Educational Site Licensing Project (MESL)

The Museum Educational Site Licensing Project (MESL) is a special pilot program of the Getty Imaging Initiative Project that explores using computer technology to create a wider use for art historical images. MESL is a collaboration of the Getty Information Institute with 14 institutions to explore digitizing images and related data from museum art collections and to develop a model of a site licensing for museum-academic partnerships. For current information, see <http://www.gii.getty.edu/mesl/>.

Booklet: *Introduction to Imaging: Issues in Constructing an Image Database*, by Howard Besser and Jennifer Trant (Santa Monica, CA: The Getty Art History Information Program, 1995). This booklet, which explains various aspects of digital imaging, is also available on the Internet <http://www.gii.getty.edu/intro_imaging/>.

Categories for the Description of Works of Art (CDWA)

The Art Information Task Force (AITF), sponsored by the Getty Information Institute and the College Art Association, was formed in 1990 to create descriptive guidelines for the automation of art documentation. One of the AITF's goals is to define the types of data to be included in descriptions of works of art. This has resulted in an electronic document entitled Categories for the Description of Works of Art (CDWA) which facilitates the exchange of art information. CDWA, which can be accessed through the Getty Web site, provides guidelines for the material to be included in descriptions of art objects and images. This corresponds to the information included in museum catalogue entries, discussed in Chapter XII <http://www.gii.getty.edu/cdwa/INTRO.HTM>.

V-G-3. Getty Education Institute for the Arts

The objective of the Getty Education Institute for the Arts is to make art an essential part of every child's education. This broad mission has resulted in the formation of *ArtsEdNet*, an online service program that provides content and hyperlinks to other appropriate sites on the Internet. This online service program for art educators working with students from kindergarten through the twelfth grade is concerned with (a) advocacy of arts education, (b) the professional growth of art educators, (c) curriculum development, and (d) the dissemination of ideas, especially discipline-based art education (DBAE) <http://www.artsednet.getty.edu/>.

Discipline-based art education is an integrated approach interested in the creation of works of art as well as art criticism, art history, and aesthetics. The Getty Web site has comprehensive materials on DBAE and the Regional Professional Development Consortia, established in 1982 at six institutions to develop DBAE pilot programs throughout the United States. You can learn more about these long-term programs through the example presented in [XVI-A-1], as well as the Getty Web site <http://www.artsednet.getty.edu/> and the participating groups:

ArtNet Nebraska
 <http://artnet.nde.state.ne.us/>
California Consortium for Visual Arts Education
 <http://artsednet.getty.edu/ArtsEdNet/Overview/Rigs/calif.html>
Florida Institute for Art Education
 <http://www.fsu.edu/~svad/FIAE/fiae.html>
North Texas Institute for Educators on the Visual Arts, University of North Texas, Denton
 <http://www.art.unt.edu/ntieva/>
Ohio Partnership for the Visual Arts: Regional Institute for Educators
 <http://www.arts.ohio-state.edu/OPVA/>
Southeast Center for Education in the Arts
 <http://www.utc.edu/SCEA/>

The Regional Professional Development Consortia has created lesson plans and curriculum ideas for three separate age groups: elementary, middle school, and high school. At this Web site, you will discover a number of well-designed, extensive programs for each of these categories <http://www.artsednet.getty.edu/ArtsEdNet/Resources/index.html>.

Examples

1. Lesson plans: *Experiencing Original Works of Art in a Museum* is a program for those enrolled in middle schools, although it can be adapted for other students. These lesson plans—which furnish only ideas and suggestions—provide objectives, special vocabulary lists, information on materials needed for classroom activities, questions to ask students, and artists' biographical data. In one lesson, Albert Bierstadt's *Yosemite Valley,* c. 1875 (Yale University Art Gallery), is compared with other works by the same artist: *Among the Sierra Nevada Mountains, California,* 1868 (National Museum of American Art, Washington, D.C.), and *Cho-looke, The Yosemite Fall,* 1864 (Timken Museum of Art, San Diego, CA). And with the marvel of Web hyperlinks, you are electronically sent to the museums that own the paintings <http://artsednet.getty.edu/ArtsEdNet/Resources/lps.html>.

2. Curriculum ideas: This section contains essays by DBAE experts and suggestions on using multicultural art prints in teaching. The latter includes art from various cultures—African American, Mexican American, Pacific Asian, and Native American—and by women artists. For each work of art, there is an illustration, a cultural context discussion, information on the print medium, suggestions for questions and activities, a timeline of the subject, a glossary, a pronunciation guide, and a reading list. Because of the superb quality of these materials, anyone interested in these subjects should access this site <http://artsednet.getty.edu/ArtsEdNet/Resources/ci.html>.

V-H. Cultural and Civic Groups and Foundations: URLs

The following is a list of cultural groups that have Web sites, some of which have been previously discussed. At some of these sites, you will find only brief information on the association, but at others, especially those discussed in this chapter, you will discover a diversity of material. As time passes, there will probably be more data and illustrations added to these sites. For a listing of some international trust organizations, see New Zealand Historic Places Trust <http://canterbury.cyberplace.org.nz/public/histrust/ histworld.html>.

American Association for State and Local History (AASLH)
<http://www.aaslh.org/>

Amsterdam Heritage at Amsterdam Park
<http://amsterdam.park.org:8888/Netherlands/pavilions/culture/>

Berger Foundation's Web site, World Art Treasures
<http://sgwww.epfl.ch/BERGER/index.html>

Canadian Heritage Information Network (CHIN)
<http://www.chin.gc.ca/>

French Ministère de la culture
<http://www.culture.fr/cgi-bin/cookie-test-en/>

J. Paul Getty Trust
<http://www.getty.edu/>

Hellenic Ministry of Culture Web site has information for its numerous Internet projects, especially the preservation of Athens' archaeological sites and material on Greek museums.
<http://www.culture.gr.welcome.html>

From the Cultural Map of Hellas <http://www.culture.gr/2/21/maps/hellas.html>, you can choose the area of the country to explore online. Each section has two lists, one of museums and one of sites and monuments. Hyperlinks then take you to illustrated discussions of these subjects.

Heritage Conservation and Historic Preservation for Australia's Heritage
<http://yarra.vicnet.net.au/~conserv/hp-hc.htm>

Historic Places Trusts lists worldwide organizations interested in saving the heritage of their countries
<http://canterbury.cyberplace.org.nz/public/histrust/histworld.html>

Ministère des Affaires étrangères publishes a quarterly Internet magazine, *Label France,* for which some selections are translated into English. This is a great source for French haute couture fashion, artists, and museums.
<http://www.france.diplomatie.fr/label_france/label.gb.html>

National Endowment for the Arts furnishes information concerning its programs and how to submit grants. There is a special section for the art community.
<http://arts.endow.gov/>

National Endowment for the Humanities documents its programs and tells how to submit grants
<http://www.neh.fed.us/>

National Trust for Historic Preservation
<http://www.nthp.org/>

National Trust for Ireland
<http://www.commerce.ie/ca/antaisce/>

National Trust for Places of Historic Interest or Natural Beauty in England, Wales, and Northern Ireland, originally established in 1895 as the National Trust of England, pro-

tects manor houses, historic buildings, villages, and more than 200 houses of historic importance
 <http://www.ukindex.co.uk/nationaltrust/>

New York Foundation for the Arts sponsors *ArtsWire*, a monthly online publication featuring social, economic, philosophical, and political issues affecting the arts
 <http://artswire.org/>

New Zealand Historic Places Trust includes mostly text descriptions of the historical sites open to the public and also has a listing of worldwide national trusts
 <http://canterbury.cyberplace.org.nz/public/histrust/histworld.html>

UNESCO World Heritage Web Site discusses the criteria by which the worldwide sites are chosen and then lists them. Each site has a brief descriptive entry with an illustration. As of 1997, there were 506 properties on the World Heritage List: 380 cultural sites, 107 natural sites, and 19 mixed properties. On this list, 18 U.S. properties are reported, including Jefferson's home, Monticello, and Philadelphia's Independence Hall. Canada has 10 properties with Quebec City's entire historic area being cited.
 <http://www.unesco.org/whc/index.htm>

Notes

1. Amsterdam Pavilion is copyrighted by the City of Amsterdam and the Municipal Department for Preservation and Restoration of Historic Buildings and Sites.

2. Before July 1996, the GII was called the Getty Art History Information Program, or AHIP.

3. A *provenance* is a listing of all known owners and sales involving a work of art after it left the artist's studio.

4. To assist the Witt Library in standardizing artists' names, the Courtauld compiled and published two dictionaries: *A Checklist of Painters c. 1200–1994 Represented in the Witt Library, Courtauld Institute of Art, London* (2nd ed. Chicago: Fitzroy Dearborn; London: Mansell, 1995) and *The Checklist of British Artists c. 1200–1990 Represented in the Witt Library* (London: Courtauld Institute, 1995). The latter includes approximately 14,000 artists' names from England, Ireland, Scotland, and Wales. Most of these names are included in *ULAN* [V-G-2].

VI. WEB PRESENCE OF LIBRARIES: OVERVIEWS, SEARCH STRATEGIES, AND SERVICES

One significant asset of the Internet for art researchers is the ability to investigate various libraries' collections to discover material that has been written or compiled on a specific subject. Many libraries have Internet sites that provide search capabilities of their *online public access catalogues* or *OPACs*. Some are available through Telnet, others via the Web. This computerization of a library's bibliographic holdings was made possible in 1968 when the U.S. Library of Congress developed LC MARC tapes, a library system capable of being used through computers. This made it easier for libraries to develop their own online catalogues.

Due to money and time constraints, the bibliographic records for material catalogued prior to 1968 were not immediately recatalogued for inclusion in the online systems, which most libraries began using. This resulted in some institutions having two records

of their holdings: the new online computer catalogues and their old card catalogues, which they gradually closed. However, as earlier publications are added to the OPACs, the problem of two separate systems is diminishing, and OPACs are becoming the catalogue of record.

Throughout this chapter, the American watercolorist John Marin (1870–1953) is used as an example of an artist being researched. Remember, artists are considered the authors or creators of books that contain mainly reproductions of their art with little accompanying text. This chapter discusses (a) national libraries; (b) bibliographic utilities; (c) public, university, and museum libraries; (d) library special collections; (e) search strategies; (f) library online reference sources and exhibitions; and (g) some methods for choosing which library OPAC to search.

VI-A. National Libraries

Many national libraries[1] now have a presence on the Internet. Four are discussed here: (a) the Library of Congress in Washington, D.C., (b) the British Library in London, (c) the National Library of Canada/ Bibliothèque nationale du Canada in Ottawa, and (d) the Bibliothèque nationale de France in Paris. The last two library Web sites include both English- and French-language versions. Visit the Web sites of these depository libraries[2] to determine the full extent of their online involvement.

VI-A-1. The Library of Congress

The Library of Congress (abbreviated *LC* or *loc*), founded in 1800, has the world's largest collection of bibliographic resources. LC's main emphasis has been

the cataloguing and organizing of its holdings under certain subject headings, see [VI-E-3]. These catalogued items, plus additional listings from some 700 participating libraries, are published in the *National Union Catalogs* (*NUC*). For earlier works, there is *The National Union Catalog: Pre-1956 Imprints* (754 vols. Chicago: American Library Association, 1968–81), organized mostly by authors' names or corporate entries, allowing researchers to find material only if one of these is known. Various annual and quinquennial print cumulations followed, but after December 1982, the *NUC* ceased being issued in bound editions and is now available only on microforms and computer tapes.

Since 1968, LC has catalogued its bibliographic material using computerized tapes through a system called MARC—an acronym for *machine-readable cata-*

loguing—which provides similar information to that of the previous Library of Congress catalogue cards.[3] MARC tapes are purchased by libraries to produce OPACs of their individual holdings. The *NUC* is now composed of these MARC tapes, making research simpler and more efficient, since you can now use titles, subjects, and keywords, as well as authors or corporate entries, to locate information.

You can search LC MARC records through various means: (a) individual libraries using MARC tapes, (b) databases of OCLC and RLG, (c) DIALOG, and (d) LC itself. All of these are discussed later in this book. You must be careful, however, to discover the parameters of the database you are using, such as the size, the material included, and the publication dates covered.

The LC home page acts as a condensed table of contents for the vast material it has placed on the Web. There are five major sections, each with numerous subsections, that can be accessed: (a) Research Tools, (b) Library Services, (c) American Memory (which acts as an index to specific programs developed by various LC divisions), (d) Exhibitions (see [VI-F]), and (e) Thomas: Legislative Information, which records the full-text of current U.S. Congressional bills and is beyond the scope of this book. From each of these five sections, there are numerous links to the extensive and varied LC material. This section discusses Research Tools, Library Services, and the LC Prints and Photographs Division. The Library of Congress has a broad presence on the Internet; consult its Web site to learn more about its important contribution <http://lcweb.loc.gov/>.

Research Tools

The section of the Library of Congress's Web site titled Research Tools links to many LC programs, some of which are discussed later in the appropriate sections of this book. The most significant link is the access it provides to the Library of Congress databases, which are of primary importance to art researchers. There is more than one LC database, due to the library's vast holdings and the history of recording material using MARC format. The number of items included and the dates covered by these databases are subject to change, so be sure to read the fine print to determine the extent of the material in each file. At LC's Web site, its catalogues can be searched by four different methods: Word Search, Browse Search,

Command Search, and Experimental Search System (ESS). Only the last is discussed here <http://lcweb.loc.gov/catalog/>.

ESS is accessible 24 hours a day and allows you to locate material in a large portion of the LC bibliographic database covering the broadest number of years. This is a test system that can be searched using either (a) a Basic Search—by title, subject, author, or notes—or (b) an Advanced Search, in which you select the method for limiting your search by language, publisher, and/or date. If none of the basic search areas are selected, the complete database is searched. Although earlier publications may be located through this database, their inclusion is erratic. For new editions and the latest publications issued in the United States, the ESS system is probably the best OPAC you can utilize.

Example

For *John Marin,* the Advanced Search located 54 titles of books and catalogues published on the artist between 1906 and 1995.

Library Services

Under the heading Library Services you can access the many special programs and services LC offers, including (a) a research and reference section that furnishes general information about visiting the Washington library, its publications and guides, and various studies conducted by LC and placed on the Internet, (b) for those without Web access, a Gopher-based information system called LC MARVEL <Gopher://marvel.loc.gov:70/>, and (c) subject guides to Internet resources that index and provide hyperlinks to other pertinent research material <http://lcweb.loc.gov/global/subject.html>. The LC Web site provides essential material for librarians, including data on Z39.50 Gateway, a national standard defining a protocol for computer-to-computer information retrieval <http://lcweb.loc.gov/z3950/gateway.html>.

LC Prints and Photographs Division

The Prints and Photographs Division of the Library of Congress was organized in the late 1890s. LC's extensive holdings, consisting of original graphic items, are world renowned and probably constitute the largest worldwide collection of such material. Although most of these prints and photographs relate to American history, biography, and culture, the collection is inter-

national in scope, dating from the 15th century to the present. The holdings are not all listed on the Internet. Three areas of the Prints and Photographs Division are discussed below.

Prints and Photographs Reading Room furnishes links to such items as general information and frequently asked questions, guides and finding aids, exhibits and exhibit loans, and a thesaurus for graphic materials <http://lcweb.loc.gov/rr/print/>.

Prints and Photographs: An Illustrated Guide furnishes information on how to obtain copies of the material in the collection, as well as the publication rights to the art. Reproduced on the Web are portfolios centered around specific subjects, such as "American Landscape and Cityscape" and "Architecture, Design, and Engineering." Each portfolio includes brief data on the theme and reproduces seven to eight photographs that enrich the subject <http://www.loc.gov/coll/print/guide/>.

> ### Example
>
> When looking for landscape photographs by William Henry Jackson (1843–1942), the portfolio on American Landscape and Cityscape was accessed. Jackson's *Panorama of Marshall Pass and Mt. Ovray* was illustrated and information on the artist provided.

American Memory: Historical Collections for the National Digital Library furnishes information on the National Digital Library and links to various formats—prints, photographs, movies, maps, caricatures, and cartoons—in the collection <http://lcweb2.loc.gov/amhome.html>. There are sections for searching, browsing, and learning about these formats. In addition, there is a listing of special collections within the Prints and Photographs Division, such as *Civil War Photographs* by Matthew Brady and *Architecture and Interior Designs for 20th Century America: Photographs* by Samuel Gottscho and William Schleisner, 1935–55 <http://lcweb2.loc.gov/amhome.html>.

> ### Examples
>
> 1. When looking for works by the American photographer William Henry Jackson, a search produced information on the LC collection *Touring Turn-of-the-Century America: Photographs from the Detroit Publishing Company, 1880–1920.* In addition, there were links to material on Jackson: a brief biography, a selected bibliography, and the locations of Jackson's diaries.

> 2. Using this same Web site in a search for a specific Jackson photograph of India's Ganges River, a reproduction of the photograph was retrieved, accompanied by data on the type and size of the work, the date it was taken, the company that commissioned it, and the donor of the work to the Library of Congress <http://lcweb2.loc.gov/amhome.html>.

VI-A-2. The British Library

The British Library (BL) was founded in 1973 by combining several institutions with The British Museum Library, which had a collection dating from the 18th century. The British Library's Web site, called *Portico* <http://portico.bl.uk/>, provides information on the institution, its collections, and its numerous publications. The section on catalogues and databases <http://portico.bl.uk/nbs/catalist.html> discusses the printed catalogues, material available on CD-ROM, and the main online databases. The British Library's OPAC may be searched (a) through the Blaise Line or Blaise Web, a fee-based service for which a password is required, (b) at the British Library itself, and (c) through OPAC97, a free service that provides brief notations of material in the major reference and document supply collection of the British Library <http://opac97.bl.uk/>.

The British Library includes The Map Library, with a collection of 13,400,000 atlases, maps, globes, and cartography references. Its Web site furnishes information on this special department and reproduces some ancient maps <http://portico.bl.uk/services/map-overview.html>.

VI-A-3. National Library of Canada/Bibliothèque nationale du Canada

The National Library of Canada/Bibliothèque nationale du Canada (NLC/BNC), founded in 1967, focuses on Canadiana. *Canadian Subject Headings* was issued by NLC/BNC in 1978 and 1985 to supplement the *Library of Congress Subject Headings;* [VI-E-3], below. In 1962, the U.S. *Library of Congress Subject Headings* was translated into French, due to Canada's bilingual society.

The NLC/BNC section called Canadian Information by Subject Service furnishes hyperlinks to Canadian subjects such as arts councils, art museums, and individual Web programs concerned with architecture, sculpture, decorative arts, painting, and photography. Visit the Internet site to discover other services this institution is developing <http://www.nlc-bnc.ca/>.

A fee is charged to use the NLC/BNC OPAC, called *AMICUS.* You can, however, use *resAnet,* a subset of this database with brief records, which is free through the Web <http://www.amicus.nlc-bnc.ca/wapp/resanet/introe.htm>, and *Telnet* <Telnet//amicus.nlc-bnc.ca/>. The *resAnet* database is available only during certain time periods, so be sure to check availability.

Example

In a search for Canadian painter Thoreau MacDonald (1901–89), both the U.S. Library of Congress and the National Library of Canada/Bibliothèque nationale du Canada were used. LC reported 3 citations; Canada's National Library, 41.

VI-A-4. Bibliothèque nationale de France

The French bibliographic collection, one of the oldest in Western Europe, was started by King François I, who in 1537 decreed that all French printers and booksellers must deposit copies of their printed books at the royal Château de Blois. Known as the Dépôt Légal, or legal or copyright deposit, this depository library, later transferred to Paris, became the basis for the Bibliothèque nationale de France. At its Web site, information on the history of the institution, its online exhibitions, and its bibliographic database, the BN-OPALE, is provided. Its OPAC or bibliographic database can be searched only by users with proper identification and passwords <http://www.bnf.fr/bnfgb.htm>.

"Creating French Culture: Treasures from the Bibliothèque nationale de France," an online exhibition highlighting this ancient library, was created by the U.S. Library of Congress <http://lcweb.loc.gov/exhibits/bnf/bnf0001.html>.

VI-B. Bibliographic Utilities

Two widely used U.S. bibliographic utilities, OCLC and RLG, are companies that have developed databases based on the LC MARC tapes from 1968, supplemented by contributions from other participating institutions, some of which have put their entire records into the systems. Thus, the bibliographic utility databases contain many entries published prior to 1968. These records include titles of books, journals, newspapers, videotapes, films, and slides. These utilities have also created special databases and resources for their patrons.

The bibliographic utilities databases are used by librarians in cataloguing material in their institutions and in processing interlibrary loans, since this is a union list[4] of material owned by the cooperating institutions. If librarians wish to supplement or change a bibliographic record that is already in the database, they may do so. This duplication of material makes these databases so massive that the extensive list of titles retrieved in a search may not be as useful as the large number would indicate, since culling them for relevant entries can be time consuming. Therefore, it

is important to determine exactly how you wish to limit your search. This section discusses OCLC and RLG.

VI-B-1. OCLC

OCLC, the Online Computer Library Center,[5] has developed a database that is used by a vast number of libraries; in 1997, there were approximately 21,000 member institutions in 63 countries <http://www.oclc.org/>. A useful project developed by OCLC is FirstSearch, a research tool available at more than 6,000 libraries. FirstSearch consists of a number of databases, one of which is WorldCat, the OCLC bibliographic database. When you search WorldCat, you locate titles of books and other materials owned by the various participating libraries in the OCLC system. These institutions, which pay for the services, provide FirstSearch access to their patrons, who must have the correct authorization number and password. Access is also available to individual researchers and small libraries through the purchase of a specific num-

ber of searches <http://www.oclc.org/oclc/menu/fs.htm>. Methods for utilizing this excellent system are detailed in [VII-D-2].

The records found by WorldCat often contain duplicate entries, foreign-language material, and numerous entries not owned by your area libraries. When you use any of the FirstSearch databases, practice evaluating the titles in order to locate only the essential material; with time, you will be able to discern the meaningful from the less important. Limiting your search to certain formats and particular publication dates also helps.

Example

Employing FirstSearch to locate art from Western Africa, the phrase *Yoruba art* was used; 266 records were found. This broad subject produced too many results to be useful. But with careful planning, the search was narrowed to *Yoruba AND art AND animal* and limited to English-language books published since 1990. FirstSearch then became an excellent tool for locating specific works of art and located the significant entry sought: *Elephant: The Animal and Its Ivory in African Culture* (Los Angeles: Fowler Museum of Cultural History, University of California Press, 1992).

VI-B-2. RLG

RLG, the Research Libraries Group, was established in 1974 by the universities of Harvard, Yale, and Columbia with the New York Public Library. RLG presently has 150 members from nonprofit institutions. It owns a database—RLIN, Research Libraries Information Network—that is reserved for the institution's patrons and can be searched only with a special identification number. EUREKA is a user-friendly interface for using the database.

RLIN contains the LC MARC files from 1968, plus records from RLG's members, most of which have added all their bibliographic holdings. The RLG institutions are some of the oldest and most prestigious art libraries in the United States. The material they have added to RLIN provides information on rare and unusual books and manuscripts. Moreover, many member libraries are posting data on their archival collections on RLIN.

Although some libraries belong to both OCLC and RLG, the latter is not readily available to most people. Therefore, RLG has instituted search-only accounts that access several special databases, most of which are discussed later in this book:

Online Avery Index to Architectural Periodicals [VII-B-2]

SCIPIO [VIII-B]

BHA database, which combines RILA and RAA so that one search covers these three indexes to art literature from 1973 to the present [VII-B-2]

English Short Title Catalog (*ESTC*). Rare books receive annotated cataloguing through *ESTC,* which consists of bibliographic records for English-language publications issued in Great Britain and its dependencies from the beginning of print to 1800.

Access the RLG home page to learn more about this network <http://www.rlg.org/>

VI-C. Libraries and Their OPACs

The ability to investigate a library's bibliographic records to discover material that may have been written on a specific topic is one of the greatest assets provided by the Internet. Three major types of libraries—public, academic, and museum—have been making their OPACs available to a greater public via this international information highway. All serve different audiences and their needs. In addition, consortiums—through which a number of libraries band together to share their assets—are becoming increasingly popular. The examples used in this chapter were chosen to reflect differing institution sizes; all have easy-to-access OPACs available to anyone on the Internet.

For assistance in locating other libraries, special collections, and library vendors, consult (a) the Library of Congress section, Library and Information Science Resources <http://lcweb.loc.gov/global/library/>; (b) the IFLA section of the *Art Libraries International Directory of Art Libraries* <http://iberia.vassar.edu/ifla-idal/>, and (c) Yahoo's list of reference libraries <http://www.yahoo.com/Reference/Libraries/>.

VI-C-1. Public Libraries

Fine arts divisions of public libraries include resources for the visual arts, as well as for such diverse fields as music, theater, sports, and recreation. Their patrons

represent a wide range of capabilities and interests, from novices to scholars. Consequently, these libraries will have diverse types of resources, reference works, how-to books, and general material. The library's OPAC normally contains holdings of the entire library, including any separate divisions.

The American Library Association <http://www.ala.org/library/fact26.html> relates that in 1996, about 44.6 percent of all U.S. public libraries had some Internet connections. Moreover, of the public libraries not then connected, 70 percent planned to establish a connection within the year.[6] To locate the URL of a public library, telephone your regional institution or check Yahoo's two lists:

Reference Libraries
 <http://www.yahoo.com/Reference/Libraries/>
Public Libraries
 <http://www.yahoo.com/Reference/Libraries/Public_Libraries/>

Examples

1. The Cleveland Public Library and 22 other systems in northern Ohio formed CLEVNET, a consortium that has combined holdings of 10,200,000 items <http://www.cpl.org/>. In using this catalog, called MARION, you can restrict the language of the material, as well as the format <http://js-catalog.cpl.org:8001/newcat_22.html>.

2. The New York Public Library (NYPL) contains more than 40,000,000 items, of which about 13,000,000 are book-type resources. *CATNYP (CATalog of the New York Public)* is the catalogue of record, containing entries for material catalogued since 1971, plus many older titles that the NYPL has recatalogued. Due to its size and outstanding collections, the NYPL Web site is often busy; you may receive the notice "no more logins available" <http://catnyp.nypl.org/>. See also NYPL's Artists File [IX-B-6]. Access the Web site for detailed information <http://www.nypl.org/>.

VI-C-2. Academic Libraries

University and college libraries acquire resource material to reflect the subjects taught by their faculties. Not all university libraries, however, have OPACs accessible to the public: Some can be used only by RLG members ([VI-B-2], above); others are closed to those outside the academic community. The two state academic institutions used as examples below both have large art schools; one has a main general library, the other a separate fine arts library.

The American Library Association <http://www.ala.org/library/fact26.html> reports that in 1996, virtually all staff members of academic libraries had access to the Internet. Students and faculty have Internet access from terminals at 93 percent of the institutions granting doctorate degrees, 82 percent of those granting master's degrees, and 76 percent of those that offer bachelor's degrees.[7] The Internet has increasingly become an important component of higher education. To locate a specific library, access the institution's home page or check Yahoo's list of university libraries <http://www.yahoo.com/Reference/Libraries/University_Libraries/>.

Examples

1. The OPAC of the University of North Texas (UNT) contains about 1,300,000 catalogued items for its three libraries: the main Willis Library, the Media Library, and the Science and Technology Library <http://www.library.unt.edu/>. This OPAC also provides access to other state university libraries.

2. The University of Southern California (USC) Library System consists of more than 17 libraries with a combined total of about 2,800,000 items. Its easy-to-operate OPAC, called HOMER <http://library.usc.edu/>, includes the records of the Helen Topping Architecture and Fine Arts Library collection of more than 58,000 volumes <http://www.usc.edu/Library/AFA/index.html>.

VI-C-3. Museum Libraries

Museum libraries have a different orientation: they primarily serve the research needs of their curatorial and education staffs. Although they may have smaller collections than public and academic libraries, their reference collections are dominated by material reflecting the art in the institutions' collections. Some museums, especially larger ones, participate in exchange programs, by which exhibition and collection catalogues, as well as bulletins and journals, are distributed to other participating institutions. Consequently, museum libraries are usually good sources for these items, as well as for extensive material on artists and cultures displayed at their institutions. Another useful feature is the collection of sales catalogues these institutions accumulate for curatorial and business needs.

Some museum libraries are open to the public, usually with certain restrictions. To inform the public

concerning their library facilities, museums are placing information on the Web, such as days and hours open, entrance requirements, and special rules or restrictions. Increasingly, museum libraries are providing Internet access to their OPACs, although not all of them are available to everyone. To locate a specific library, access the museum's home page or check Yahoo's list <http://www.yahoo.com/Arts/Libraries/>.

Examples

1. The Art Institute of Chicago <http://www.artic.edu/aic/libraries/catalog.html> has two libraries: the Ryerson, its general art reference library, and the Burnham Library of Architecture. You can access the combined libraries' easy-to-use OPAC with its 225,000 catalogued titles directly from its Web page <http://widow.artic.edu/aic/library/library.html>.

2. The Watson Library of the Metropolitan Museum of Art reflects the interests of the museum with 2,000,000 works of art spanning more than 5,000 years. The library's OPAC contains 360,000 catalogued items. It includes all of the material catalogued since 1980 and about 70 percent of the library's entire holdings <http://www. metmuseum.org/htmlfile/gallery/first/library.html>.

VI-C-4. COPAC: An English Consortium

The COPAC Project, a consortium of university research libraries in the United Kingdom and Ireland, presently has database records from the main libraries of its nine current contributing members. These include Cambridge University, Dublin's Trinity College, Edinburgh University, Glasgow University, Imperial College, Leeds University, London's University College, Oxford University, and the University of London. Fourteen more university libraries will be joining over the next few years.

Although the oldest material dates from about A.D. 1100, most of the titles were published after 1960. This, however, will change as the libraries convert

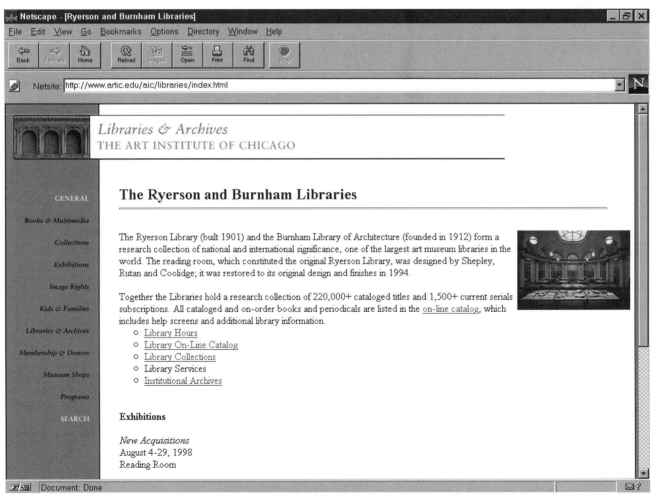

The Art Institute of Chicago's Ryerson and Burnham Libraries Web Page <http://www.artic.edu/aic/libraries/index.html>

their card catalogues to electronic data. You may search COPAC by author, title, subject, or periodical title. It is especially useful for locating titles of works

published in the United Kingdom or on English or Irish subjects <http://cs6400.mcc.ac.uk/copac/>.

VI-D. Library Special Collections

Many special collections located in libraries are underused because few people know of their existence, since they are not always reported in the OPACs. The Internet is becoming an ideal site to inform the public concerning these resources. Some special collections can be defined as archives, vertical files, or picture collections. Others are an accumulation of rare text or images placed in a limited-access area and restricted in use. These often include collections of artists' books, illuminated manuscripts, early printed books, and books with notable dust jackets or original graphics. For information on archives, vertical files, and picture collections, see [II-B]; for auction catalogues, [VIII-A] and [VIII-B].

To locate special collections, access the library's Web page or use one of the following indexes:

Library of Congress: Library and Information Science Resources
 <http://lcweb.loc.gov/global/library/>

Yahoo Special Collections
 <http://www.yahoo.com/Reference/Libraries/Special_Collections/>

 Example
 The National Art Library is housed in London's Victoria and Albert Museum, which was established in 1852 as the Museum of Ornamental Art. At its Web site, the library has placed data concerning its various archives (such as the Archive of Art and Design, which compiles material on individual designers and associations) and its special collections (such as Queen Mary's collection of children's books). The library's future projects encompass (a) the ADAM Project to provide access to art and design information on the Internet and (b) the V & A Publications Project, to identify, locate, and create a bibliography of all known publications produced by, for, or in association with the Victoria and Albert Museum <http://www.nal.vam.ac.uk/>.

VI-E. Search Strategies

Most libraries organized their online public access systems prior to the existence of any national guidelines. Thus, their OPACs may have their own names, methods of accessing, and means of searching. Since some institutions do not have their entire holdings on their OPACs, you need to check the synopsis for each library. Most OPACs can be searched by keyword, author, title, subject, or some combination of these; many allow the use of Boolean operators. It is well to note that there is no consistency in how these online catalogues sign on or off. Be sure to write down the methods for exiting; this information is usually stated as you enter the program but may not be repeated later. Some systems are slow; patience may be needed.

When searching a library's OPAC, you should understand the meaning of your selections, such as (a) Boolean operators and truncation, (b) keyword

searches, (c) the Library of Congress subject headings, (d) study guides that may assist you in your research, and (e) the availability of interlibrary loans. This section provides a brief discussion of these concerns. For those who would like to acquire better library skills, there are Web sites that provide tutorials, such as the University of California, Santa Barbara's *Library 101: Learn to Use the Library* <http://www.library.ucsb.edu/libinst/lib101/>.

VI-E-1. Boolean and Positional Operators and Truncation

Boolean operators—*AND, OR,* and *NOT*—link several ideas together in a research statement in order to obtain quicker, more efficient results. These operators

express a relationship between words and/or phrases. For instance, *AND* indicates that both terms must be in the record, thus narrowing the topic. When *OR* separates two terms, the record must contain one of the words (either word); this broadens the topic.

The operator *NOT* indicates that the word or words cannot be used in the record. This narrows the search. Be careful using *NOT,* since eliminating material before you are sure you don't need it can keep you from obtaining important references. Sometimes this operator is stated as *AND NOT* or *BUT NOT.*

Boolean operators are effective in many types of bibliographic searches, including keyword searches, explained below. Moreover, these flexible operators can retrieve material from two different fields[8] within a database, such as *authors* and *titles.* In some OPACs, the operators must be in upper case; also, some substitute *&* for *AND.*

In addition to Boolean operators, some systems use positional operators that determine the placement of two or more terms. *ADJ* indicates the two must be adjacent, and in some systems, *ADJ* plus a number indicates how many intervening words are to be allowed between the stated words. *NEAR* placed between two words means they must be in close proximity to each other. *WITH* signifies that the terms must be in the same field and the same record, but not necessarily adjacent. Positional operators help pinpoint your topic and keep you from receiving records that are completely irrelevant to your search.

Another useful strategy is truncation. In truncation, you substitute a specific sign for certain letters in a word in order to retrieve various combinations of terms. Truncation is using a sign—*$* or *¿* or *** or some other symbol—to enable you to retrieve word variations. Using the truncated *photograph¿* will locate *photograph, photographs, photographic, photography, photographer,* and *photographers.*

For more on Boolean operators, see:

University of Alabama
 <http://www.lib.ua.edu/boolean.htm>
University of California at San Diego
 <http://scilib.ucsd.edu/electclass/Compendex/
 Boolean.html>
WebCrawler
 <http://webcrawler.com/WebCrawler/Help/
 ImproveResults.html>
 <http://webcrawler.com/WebCrawler/Help/
 Advanced.html>

Example

In *John AND Marin AND trees,* the *AND* links the three terms together, indicating that all three are to be included in the record. If the search is for *Marin AND Trees NOT birds,* the *NOT* means that any entry with the word *birds* is to be excluded. A search for *Marin AND trees OR wood* specifies that either *trees* or *wood* must be in the record.

VI-E-2. Keyword Searches

Keyword searches enhance results, because the computer examines more fields than just titles or authors and corporate entries. Not all keyword searches, however, cover the same fields; some check titles, content notes, and/or subject sections, while others have different parameters. The popularity of keyword searching is due to its effectiveness in discovering information on a subject when little is specifically known concerning it. Boolean operators frequently can be added to keyword searches to enhance your results. Since the search capabilities and operating procedures of OPACs and databases vary, be sure to read each institution's FAQ (Frequently Asked Questions) section before you engage in important searches.

Examples

1. In a keyword search for *John Marin,* one irrelevant entry was for the sound recording of the 1994 Disney movie *The Lion King.* Since the search did not stipulate that the painter's two names had to be adjacent, one record included two different names—Elton *John* and Cheech *Marin.* By using *John ADJ Marin,* the computer knows to search only records with these two terms together.

2. Someone recommends a book concerning Rembrandt and his painting *Polish Rider;* you do not know the author, title, or date of publication. A keyword search for *Rembrandt AND Polish Rider* using the Metropolitan Museum of Art's WATSONLINE immediately found the desired title: *Responses to Rembrandt,* by Anthony Bailey (New York: Timken Publishers, 1994). This book was located because keyword searches in WATSONLINE include words from titles, subjects, and corporate bodies. The subjects category refers to the Library of Congress entries, explained below; Bailey's book was listed under the LC subjet heading *Rembrandt Harmenszoon van Rijn,— 1606–1669—polish rider* <http://www.metmuseum. org/>.

VI-E-3. Standard Vocabulary: *LC Subject Headings*

The fastest, most efficient method for searching a database is to use the same terms the indexers do when they classify the material. The Library of Congress establishes and publishes its subject headings under which material is located. Because the LC subject headings are widely used, you should familiarize yourself with this system [IX-B-4].

The LC terms are published in the *Library of Congress Subject Headings* (Annual. 4 vols. 20th ed. Washington, D.C.: Library of Congress, 1997), which now contains a total of about 234,000 headings and references. Abbreviations include *UF,* meaning the term is to be *used for* another; *BT,* indicating a *broader term*; *NT,* a *narrower term*; *RT,* a *related topic*; and *SA,* meaning *see also*. Libraries often have a copy of this important, multivolume, red-bound work near their computer terminals.

Some library OPACs have a section called Subject Search that uses the *LC Subject Headings (LCSH)*. Frequently the electronic records include additional *LCSH* terms that can be used to form more precise searches. By checking them, you may learn different methods for directing your research. For more information, see the pathfinder devised by the University of Alabama librarians: <http://www.lib.ua.edu/lcsh.htm>. For a list of the entire LC classification system;[9] see the York University Libraries Web site <http://www.library.yorku.ca/lc/lc.html>.

Examples

1. In searching for an English art critic whose name has been forgotten, the Metropolitan Museum of Art's OPAC was used. A subject search for *art criticism* located 96 LC subject headings, with a total of 390 records. Instead of culling all 390 entries, the 96 subject headings were checked. Under *Art criticism— England,* there were 6 records. One entry was for *Clive Bell's Formalism in Historic Perspective,* a Ph.D. thesis from the University of Georgia by Martha Johnson Harris (Microfiche. Ann Arbor, MI: University Microfilms, 1985). Thus the puzzle was solved.

2. The following is similar to the keyword search above. Someone suggests a book concerning Rembrandt's correspondence that you should read; you do not know the author, title, or date of publication. A keyword search for *Rembrandt* using the Metropolitan Museum of Art's WATSONLINE located 612 titles; obviously, too many to cull. There

was, however, a cross-reference to *Rembrandt Harmenszoon van Rijn,—1606–1669* that listed 53 individual LC subject headings with a total of 502 records. From these 53 LC subject headings, *Rembrandt Harmenszoon van Rijn,—1606–1669—Correspondence* was located. When this heading was used, only one entry was produced: *Seven Letters by Rembrandt,* H. Gerson (The Hague, Netherlands: LJC Boucher, 1961) <http://www.metmuseum.org>.

VI-E-4. Study Guides and Pathfinders

Librarians frequently produce study guides to assist their patrons in learning the reference tools needed to discover specific information. The entries, which are often annotated, vary as to content and format but often include author/title entries for special dictionaries and encyclopedias, reference works specific to the topic, indexes to art literature covering the subject, and sometimes, research methodology. These guides, also known as pathfinders, are usually for broad subjects and generally report material owned by that particular library. Thus the pathfinders are bibliographies for material at one specific library.

No longer tied to one library's bibliographic collection, pathfinders are now being placed on the Internet to assist scholars and students and to supplement museum exhibitions. These Internet guides are developed on specific subjects produced by such institutions as the Library of Congress; the Internet Public Library; and academic, museum, and public libraries.

Example

For a glass exhibition held at the Cleveland Museum of Art, the librarians produced a reference guide and placed it on the Internet [III-A-2]. The 26-page guide furnished hyperlinks to relevant Web sites <http://www.clemusart.com/>.

VI-E-5. Interlibrary Loans

Since no one library can have all the resources needed for in-depth research, librarians have developed a remarkable system of sharing their resources with patrons of other institutions through interlibrary loans. Not all libraries share with all institutions, but due to the various systems of networking and consortiums, libraries usually have one or more sources for needed loans.

Once you verify that a reference exists—often through searching another institution's OPAC—check your own library again to be sure that it does not own the work. When your request is presented to the interlibrary loan department, the administrator will locate the item owned by the closest participating institution. This can usually be done by searching the databases of OCLC or RLG, as discussed above, which act as union lists for their members' holdings.

An interlibrary loan may require a one- to three-week period to arrange; the material will be sent to your institution for a period varying from one to two weeks. There may be restrictions on what materials can be loaned, as well as stipulations concerning the use of the loaned works; sometimes there is a small charge. This interlibrary loan service can also obtain photocopies of journal articles; there usually is a service charge and/or fee per page. You may not obtain every item you wish through an interlibrary loan, but you will find that this is a tremendous service for researchers.

Interlibrary loans are expensive; libraries have to pay for the phone, fax, or e-mail communications; the sending charges; and the labor to locate the needed material. Because of this cost, some libraries restrict who may use the interlibrary loan service and the number of requests that may be made. It is important to discern from studying catalogue entries which books are essential to your study. You undoubtedly will not have the time to make—and the interlibrary loan service will probably not be able to handle—more than one or two requests.

VI-F. The Virtual Library: Reference Sources and Exhibitions

You may no longer need to visit your library in order to see an exhibition or to obtain certain reference books that are too expensive or consist of too many volumes for you to own. The virtual library is now on the Internet. Libraries usually have a reading/reference area where dictionaries, encyclopedias, and other reference materials are shelved. The Internet is developing its own type of reference area by placing on the Web either out-of-copyright books, which may be accessed free, or recent publications, the use of which incurs a fee. This section discusses (a) a virtual library called the *Internet Public Library*, (b) full-text literature on the Web, (c) library reference works on the Web, (d) methods for locating addresses and telephone numbers, (e) resources that assist in locating granting institutions, and (f) online library exhibitions.

VI-F-1. *Internet Public Library*

The *Internet Public Library (IPL)*[10] has no bibliographic collection and no OPAC. It is, however, on the Web. The librarians of this virtual library are developing various types of indexes to Internet locations. *IPL* maintains a collection of more than 12,000 Internet resources on all types of subjects, which they describe and organize into special groups <http://www.ipl.

org/>. Pertinent IPL resources are cited throughout this book.

Exhibit Hall provides information on the online exhibitions planned by *IPL;* individual titles are in the appropriate chapters of this book
 <http://www.ipl.org/exhibit/>
Frequently Asked Reference Questions explains methods for answering some reference queries
 <http://www.ipl.org/ref/>

VI-F-2. Full-Text Literature on the Web

Placing the full text of books and other references on the Web is in the tradition of the Internet: the free transmission of information. The *etext,* as the electronic text is called, is usually out-of-copyright or public domain material that either has a wide appeal or is desired by scholars. The selections are particularly rich in poetry, classical literature, and political treatises. Several major universities have etext projects, only a few of which are cited here.

Project Bartleby at Columbia University has placed several important publications on the Internet. Especially useful for research is the 9th edition of *Bartlett's Familiar Quotations,* published in 1901 <http://www.columbia.edu/acis/bartleby/>. In November

1996, Project Bartleby concluded and became an archive at Columbia University. Steven H. van Leeuwen, editor and publisher of the project, began a new national digital library in April 1997 called the New Bartleby <http://www.bartleby.com/>.

Project Gutenberg of the University of Illinois aspires to place 10,000 out-of-copyright books on the Internet by the end of 2001. The editors choose the texts to be included based on the principle that the literature should be available in the simplest form possible and useful to 99 percent of their audience. There are three categories: (a) light literature, such as *Aesop's Fables* and *Alice in Wonderland;* (b) heavier reading, such as the Bible and Shakespeare; and (c) reference works, such as *Roget's Thesaurus* and dictionaries. *Project Gutenberg* also provides hyperlinks to other electronic-text projects <http://www.promo.net/pg/>.

The *Internet Classics Archive* at MIT features writings by Homer, Virgil, Ovid, Thucydides, and Plato <http://classics.mit.edu/>. The *Electronic Text Center* of the University of Virginia Library <http://etext.lib.virginia.edu/uvaonline.html> and *CETH: Center for Electronic Texts in the Humanities* at Rutgers University <http://www.ceth.rutgers.edu/> provide links to many full-text projects. The American and French Research on the Treasury of the French Language, directed by Robert Morrissey of the University of Chicago, is publishing full-text material in French <http://tuna.uchicago.edu/forms_unrest/ENC.query.html>.

Other electronic text resources are the single-subject Web sites [IV-A-3] that sometimes provide hyperlinks to pertinent full-text material. For a list of electronic text collections, see (a) the Library of Congress resource page <http://lcweb.loc.gov/global/etext/etext.html>, (b) *Art.Net.Links Online Literature References* <http://www.art.net/inks/litref.html>, and (c) Online Texts Collection, *Internet Public Library*, which provides information and Web sites for over 5,500 online texts <http://www.ipl.org/reading/books/>.

Example

The Web site *Labyrinth* has hyperlinks to translations of medieval texts in Latin, Old English, and Middle English, as well as works in French, Italian, German, and Spanish. This site is an index to translations of works by such authors as Geoffrey Chaucer and William Langland (who wrote *Piers Plowman*) and the texts of medieval dramas <http://www.georgetown.edu/labyrinth/library/library.html>.

VI-F-3. Library Reference Works on the Web

Every library needs reference tools to answer patrons' questions. Some resources available through the Internet are (a) current material with restrictions, such as acceptable identification and/or a fee, and (b) free out-of-copyright sources. The commercial firms selling current reference tools license them to libraries, which must limit use to people who visit their institutions and/or those within their library community. Researchers may sometimes obtain an individual search account directly from the firm. If someone did not reimburse these companies for the labor-intensive work of compiling and organizing the data they publish, these types of references would cease to exist.

Example

To use the *Encyclopædia Britannica Online* <http://www.eb.com/>, you need an identification number and password, which can be obtained from libraries providing this service. Individual accounts and a free trial of the service are available <http://www.eb.com/>. For examples of how it is used, see [IX-B-2] and [X-A-2].

The Getty Institute has, on an experimental basis, placed some of its text on the Internet free of charge. The demand for some resource material is so great, however, that you can now locate Web sites that provide free access to earlier, out-of-copyright editions of important reference works.

Resource Tools Presently without Charge

Art & Architecture Thesaurus [V-G-2]
 <http://www.gii.getty.edu/>
ArtLex: A Dictionary of Visual Art Technology
 <http://www.artlex.com/>
Bartlett's Familiar Quotations, by John Bartlett, 9th edition, published in 1901
 <http://www.columbia.edu/acis/bartleby/bartlett/>
Catholic Encyclopedia—an earlier edition is being put on the Web, article by article
 <http://www.knight.org/advent/cathen/cathen.htm>
Excite City Maps
 <http://city.net.maps/address/>

French-English Dictionary
<http://humanities.uchicago.edu/forms_unrest/FR-ENG.html>

Holy Bible, King James Version, which includes the Apocrypha
<http://etext.virginia.edu/kjv.browse.html>

OneLook Dictionaries
<http://www.onelook.com/>

On-line Dictionaries provides hyperlinks to Web sites with various language dictionaries
<http://www.bucknell.edu/~rbeard/diction.html>

Provenance Index Sale Catalogues Databases [V-G-2]
<http://www.gii.getty.edu/>

RILA: International Repertory of the Literature of Art [VII-B-2]
<http://www.gii.getty.edu/aka/>

Roget's Thesaurus, 1911 edition
<http://humanities.uchicago.edu/forms_unrest/ROGET.html>

The Elements of Style, by William Strunk Jr., published in 1918
<http://www.columbia.edu/acis/bartleby/strunk/>

ULAN: Union List of Artist Names [V-G-2]
<http://www.gii.getty.edu/>

Webster's Revised Unabridged Dictionary, edited by Noah Porter (Springfield, MA: G&C Merriam Co., 1913)
<http://humanities.uchicago.edu/forms_unrest/webster.form.html>

Finding Web Reference Material

The following sources, which assist you in finding other reference works on the Web, will probably be kept current.

Internet Public Library, Ready Reference Collection, provides hyperlinks to relevant data on numerous disciplines—fine arts, archaeology, arts and crafts, and history—and general reference aids, such as dictionaries and encyclopedias
<http://ipl.org/ref/RR/>

Librarians' Index to the Internet: Digital Library SunSITE
<http://sunsite.berkeley.edu/InternetIndex/>

Library of Congress
Electronic Texts and Publishing Resources
<http://lcweb.loc.gov/global/etext/etext.html>
Library and Information Science Resources provides links to special collections.
<http://lcweb.loc.gov/global/library/>
Online Books
<http://lcweb2.loc.gov/catalog/online.html>

Reference Internet Resources, Rutgers University
<http://www.libraries.rutgers.edu/rulib/ref.html>

Yahoo's Lists
Arts: Humanities: History: Archives
<http://www.yahoo.com/Arts/Humanities/History/Archives/>
References
<http://www.yahoo.com/Reference/>
Special Collections
<http://www.yahoo.com/Reference/Libraries/Special_Collections/>

VI-F-4. Locating Addresses and Telephone Numbers

Addresses, telephone numbers, and zip codes can sometimes be found through a directory on the World Wide Web. Some directories provide the service free; others require that users register and may charge a fee. Be sure to read the FAQ (Frequently Asked Questions), if this is provided. Some directories require that users comply with their use agreement, so be sure to read this, too. The indexes do not cover all areas of the world, so read the annotations carefully. As with everything else on the Web, these directories can add, delete, and change their coverage at any time. Most of the following, which can be searched for telephone and/or e-mail numbers, are included here to assist you in finding difficult-to-locate libraries and institutions.

International Directory of Arts: Internationales Kunst-Adressbuch (Annual. 2 vols. Frankfurt/Main: Verlag Muller) provides current, hard-to-find important information on museums, art galleries, academic institutions, associations, and publishers

Big Book
<http://www.bigbook.com/>

Colleges and Universities
<http://www.mit.edu:8001/people/cdemello/univ-full.html>

ESP (E-mail Search Program), which searches for United Kingdom numbers.
<http://www.esp.co.uk/>

GTE SuperPages
<http://superpages.gte.net/>

Netscape Guide by Yahoo
<http://guide.netscape.com/guide/>

United States Postal Service (USPS), which provides information concerning the postal service, inspection services, and USPS news releases and has a USPS information locator
<http://www.usps.gov/>

WhoWhere?
<http://www.whowhere.com/>

VI-F-5. Locating Granting Institutions

Mid Atlantic Arts Foundation
<http://www.charm.net/~midarts/geninfo2.htm>

Money for Artists: A Guide to Grants and Awards for Individual Artists, by Laura R. Green (New York: ACA Books, 1987)

Money to Work II: Funding for Visual Artists, edited by Helen M. Brunner and Donald H. Russell with Grant E. Samuelsen (Washington, D.C.: Art Resources International, 1992)

National Endowment for the Arts
<http://arts.endow.gov/>

National Endowment for the Humanities
 <http://www.neh.fed.us/>

New York Foundation for the Arts, which sponsors the monthly magazine *ArtsWire*
 <http://artswire.org/>

Oryx Press GRANTS series
 <http://www.oryxpress.com/grants.htm>

 Directory of Grants in the Humanities (annual; Phoenix, AZ: Oryx Press)

 Directory of Research Grants (annual; Phoenix, AZ: Oryx Press)

 GrantSelect: The GRANTS Database Online (forthcoming)

 Dialog OnDISC (GRANTS Database on CD-ROM)
 <http://www.oryxpress.com/grntcd.htm>

Proposal Planning and Writing, 2nd ed., by Lynn Miner, Jeremy Miner, and Jerry Griffith (Phoenix, AZ: Oryx Press, 1998)

Research Funding Information, University of Southern California
 <http://www-lib.usc.edu/Info/Ref/Guides/>

Successful Fundraising for Arts and Cultural Organizations, 2nd ed., by Karen Brooks Hopkins and Carolyn Stolper Friedman (Phoenix, AZ: Oryx Press, 1997)

Yahoo
 <http://www.yahoo.com/Arts/Organizations/Councils/>

VI-F-6. Online Library Exhibitions

Some libraries produce online exhibitions highlighting their collections, especially books and photographs. The titles of these exhibitions are placed in the appropriate sections of this book. To search for the latest Internet exhibits, check the Web sites of the institutions that frequently produce this type of material, such as those listed below.

Bibliothèque nationale de France
 <http://www.bnf.fr/bnfgb.htm>

The British Library
 <http://portico.bl.uk/exhibitions/>

Internet Public Library
 <http://www.ipl.org/exhibit/>

The Library of Congress
 <http://lcweb.loc.gov/exhibits/>

The National Library of Canada/Bibliothèque nationale du Canada
 <http://www.nlc-bnc.ca/events/exhibits.htm>

The New York Public Library
 <http://www.nypl.org/admin/pro/exhibit/exprog.html>

Examples

1. The British Library has both permanent and temporary exhibitions. All are illustrated. The permanent exhibitions include reproductions of such items as King John's 1215 Magna Carta and single pages from the A.D. 698 Anglo-Saxon *Lindisfarne Gospel* and Tyndale's New Testament <http://portico.bl.uk/exhibitions/>.

2. For its 1996 exhibition "Enchanted Chessmen: A World of Fantasy," the Cleveland Public Library provided information on the Internet. Its Web site contained a copy of the introduction, the 21 illustrated entries, and directions for ordering the 66-page exhibition catalogue. This online presentation encourages people to visit the actual library and disseminates accurate data concerning the game of chess on the World Wide Web <http://www.cpl.org/Chess1.htm>.

VI-G. Which Library's OPAC to Search

Being able to access the OPACs of worldwide libraries to determine the existence of material on a specific subject is a boon to researchers. Once a specific reference is known to exist, you may be able to obtain it through an interlibrary loan. It thus becomes important to know which library's OPAC to search.

The difficulty in comparing libraries is in assessing the quantity and quality of their holdings, for they do not all include the same material in their OPACs or enumerate items the same way. Furthermore, there is no standard method for assessing a collection's size.

With these problems firmly in mind, consider the following issues when deciding which OPACs to access.

Accessibility

The best procedure is to start with your regional institutions—public, university, and museum. If the material is owned locally, there is a greater likelihood of procuring it. If the bibliographic list culled from your regional OPACs is not adequate, use the OPACs of other libraries. If you search a national library or bibliographic utility, you will probably obtain an ex-

tensive list, along with information on the very latest publications. Remember, searching a particular library's OPAC locates only material owned by that institution. You may need to try more than one institution to find relevant material.

Subject Emphasis

Choose a library that has a bibliographic collection reflecting your subject. If studying an American topic or artist, you might select the library of the National Museum of American Art, which is accessed through SIRIS, the Smithsonian Institution Research Information System <http://www.siris.si.edu/>. Although this library has references on European art, as well, other libraries will probably produce more extensive lists.

Relevance of the Entries

The size of the bibliographic database is always an important criterion. There is not always an advantage to discovering a tremendous number of entries, since checking each entry for relevance can be time-consuming. When searching a national depository library or a bibliographic utility, you may obtain a longer list, and sometimes earlier publications, but it may or may not include more items pertinent to your study.

Frequently, it is easier to use a library's OPAC that represents a smaller and more specialized collection. Bibliographers of research libraries are experts in the field; the material available at their institutions has been selected by specialists through the use of specific criteria.

Ease and Speed of the System

Some library OPACs are difficult to use, but this may change overnight if the institution changes its type of service. You will need to judge the ease of the system, library by library. Remember, you do not have access

to all OPACs; this is determined by your affiliations, such as academic institution and RLG or OCLC membership.

Ability to Use Boolean Operators

Boolean operators clarify your searches. For a discussion of these operators, see [VI-E], above; for examples, see [IX-B-4].

Library of Congress Subject Headings

LC Subject Headings are the terms used in most subject cataloguing; for a discussion, see [VI-E-3], above; for examples, see [IX-B-4] and [XI-A-4].

Inclusion of Earlier Publications

Although a library may have quantities of early publications, this is not always reflected in its OPAC, which may contain only catalogued holdings as of a certain date. If you need earlier material, be sure that the OPAC you are searching includes these publications. Otherwise, you may need to consult one of the printed art bibliographies discussed in [II-A].

Size of the OPAC

Statistics for OPACs frequently state that there are specified numbers of catalogued titles or classified items, but these reports often neglect to define the information formats included in the count. Some OPACs of libraries encompass non-book formats, such as sound recordings, videos, microfiches, and/or slides. Others are limited to books and exhibition catalogues.

Be aware of the differences in OPACs; check to see what the library's Web site says concerning the inclusion and exclusion of material. Size is not the major factor in choosing which OPAC to search, for the total number of items in a collection does not necessarily indicate the quality of the holdings.

Notes

1. For a list of national libraries and their URLs, access the Library of Congress Web site <http://lcweb.loc.gov/global/library/>. For a brief history of these institutions, see *Encyclopedia of Library History*, edited by Wayne A. Wiegand and Donald G. Davis Jr. (New York: Garland Publishing, 1994).

2. A nation's *depository library* is the institution to which anyone copyrighting material in that country must send a copy of the copyrighted work.

3. MARC records include author or corporate entry, title, translator, publication data, classification number (Dewey decimal, LC, or another system), LC subject headings, ISBNs and ISSNs (international numbers

unique to each publication: ISBN covers books; ISSN, serials), and information on number of pages, inclusion of bibliographies and illustrations, and name of series to which the book might belong.

4. A *union list* is a compilation of specific materials available at a particular group of libraries.

5. The Online Computer Library Center (OCLC), founded by the Ohio College Association in 1967, officially changed its name from the Ohio College Library Center in 1981.

6. Statistics taken from John Carlo Bertol, et al., *The 1996 National Survey of Public Libraries and the Internet* (Washington, DC: National Commission of Libraries and Information Science, 1996).

7. Statistics from *Electronic Services in Academic Libraries* (Chicago: American Library Association, 1996).

8. Databases are usually organized into different *fields* of information; when searching a database, you can direct the computer to check specific fields for data. For instance, in bibliographic databases, you might search one or several of the following fields: (a) author or corporate entry, (b) title, (c) subject, (d) content notes or abstracts, and (e) ISBN.

9. There are two popular classifications systems used in the United States. LC developed a system whereby letters represent specific subject areas: N indicates fine arts; NA, architecture; NB, sculpture; NC, drawing, design, and commercial art; ND, painting; NE, prints; NK, decorative and applied arts; and NX, arts in general. Other pertinent letters are TR, photography; GE, fashion and costume; and CC, archaeology. The older Dewey decimal system uses numbers to represent these areas; the 700s are for the arts.

10. *IPL* began as a 1995 graduate seminar at the School of Information, University of Michigan, having as one of its missions the evaluation and creation of Web information resources.

VII. WEB SITES OF SERIALS AND INDEXES TO ART AND LITERATURE

Periodical literature refers to magazines or other publications normally issued on a regular basis. The librarian's term *serial* extends this definition to publications that intend to continue indefinitely and thus have a designation indicating the volume and/or date of the issue. Libraries frequently provide statistics on the number of serials in their collection, either in current subscriptions or bound periodical volumes. The availability of the former is important if you are searching for a recent article and the latter if you are doing retrospective research. Sometimes these statistics are provided at the library's Web site.

Serials encompass a large category, including popular magazines, scholarly journals, museum bulletins, proceedings of learned societies, and newspapers. Material published in serials is often narrowly focused and the only source for this information. Since this data can be significant long after it is published, indexes to this literature are essential. This chapter is concerned with (a) serials, (b) indexes to art and literature, (c) methods for locating serial articles and choosing periodical indexes, (d) the advantages of using such databases as FirstSearch and InfoTrac, and (e) the URLs for some serials.

VII-A. Serials: The Web Presence

Diverse types of serials are making their presence known on the Internet, online news magazines being especially prevalent. A few serials are available only on the Web; others are printed publications using the Internet to obtain feedback from their readers and to provide them with extra services. Currently, the professional journals have only limited representation on the Internet. Online magazines produce a wide range of material, from the pedantic to utter spoof! Some embody all the arts: music, theater, film, and dance, as well as the fine and applied arts. Scholarly articles and job opportunities are interspersed with news of festivals and exhibitions. The online serials may be trendy, include a political slant, provide practical data, or report the activities and interests of specific groups. These Web sites can be elusive, changing their character overnight; they are difficult to categorize and describe.

Some publishers of online art magazines produce highly visual pages with lots of design elements but little text, hoping to burst the "Gutenburg look" of the printed page. Others are interested in news, particularly legal reports concerned with the arts. Many of these online magazines have valuable hyperlinks to other Web sites with related material. Only by accessing these Web sites frequently will you be able to keep abreast of their changes in coverage and style.

Example
OneEurope Magazine (OEM) is an independent publication of AEGEE (Association des Etats Généraux des Etudiants de l'Europe), which was founded in 1985 in Paris. Published three times a year, *OneEurope Magazine,* which is not linked to any political party or religion, provides a forum for student concerns throughout Europe. For individual issues, see <http://www.informatik.rwth-aachen.de/AEGEE/oneEurope/>.

Many larger cosmopolitan newspapers now have a domain Web site, yet these sites do not reflect the extent of the coverage in the printed versions. The online emphasis is business, politics, sports, and current news and the articles published in their Sunday editions. Only as art fits these categories is there online coverage. Local printed newspapers can be crucial sources for finding information on regional art exhibitions and the professional affairs of local artists who may not have an international reputation or an individual Web site. These daily or weekly publications report such items as announcements of awards, critical commentaries and interviews, book reviews, and obituaries.

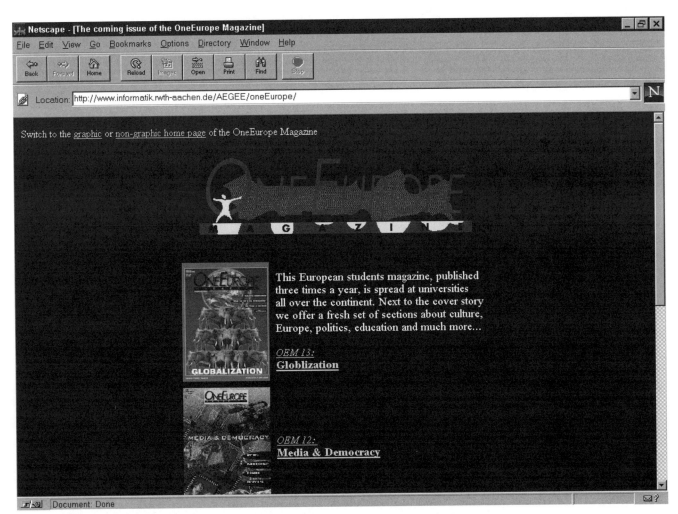

One Europe Magazine Web Page <http://www.informatik.rwth-aachen.de/AEGEE/oneEurope/>

Example

San Diego Daily Transcript, a newspaper founded in 1886, has a Web site that covers international and local events and supplies tourist information, including data on local museums, art galleries, and arts organizations, as well as extensive material on this California region and nearby Tijuana, Mexico <http://www.sddt.com/>.

Frequently, you need the correct title of a magazine or journal to locate it on the Web. A list of art-associated professional associations and their journals is provided in Appendix Two. Some museum libraries that subscribe to numerous art serials list them at their Web sites. Serial titles indexed by *BHA* (see [VII-B-2]) can be located at the Getty Web site <http://www.gii.getty.edu/bhalist.index.html>. Firms indexing periodical literature (see [VII-B-1]) may report on the Internet the serial titles covered by each database. For instance, WILSONLINE lists the more than 300 titles covered by *Art Index* and *Art Abstracts* <http://www.hwwilson.com/>.

Some academic library systems allow you to search their periodicals database. A number are consortiums pooling the information of individual libraries and serving as a union list of the participating institutions. For instance, the *MELVYL Periodicals Database* is based on the California Academic Libraries List of Serials. This consists of 18 institutions including the nine University of California campuses, the University of Southern California, Stanford University, and the Getty Center for the History of Art and the Humanities <http://www.dla.ucop.edu/dlaweb/CALLS.html>.

Example

The *MELVYL Periodicals Database* was searched for serials concerned with *Australia AND art.* Twenty-one items were located; this broad-based list ranged from the current publication *Art and Australia*, which has been published since 1963, to *Records of the Western Australian Museum and Art Gallery*, which was issued only from 1910 to 1939.

Printed serials have often had a checkered history of title changes and varying publication dates. See the standard general art bibliographies listed in [II-A-2] to learn more about these alterations. Arntzen/Rainwater provides an in-depth history of international serials on pages 481–520. Jones's *Art Information* cites serials throughout her book under the appropriate subject classifications. The serials are accompanied by initial publication dates and title variations.

For additional material on serials, use the following:

Concordia University Art Index to Nineteenth-Century Canadian Periodicals, edited by Hardy George (Montreal: Concordia University, 1981). This work covers 26 journals published from 1830 to 1900.

Frick Art Reference Library, Original Index to Periodicals (12 vols. Boston: G. K. Hall, 1983). Compiled between 1923 and 1969, this author-subject index to 27 serials emphasizes Western European and American painting, drawing, and sculpture and some decorative arts from the 11th century to 1860. A list of the serials is provided at:

<http://www.frick.org/html/access.htm>

Index to Art Periodicals Compiled in Ryerson Library, The Art Institute of Chicago (11 vols. Boston: G.K. Hall, 1962). First Supplement, 1974. Begun in 1907, this index includes subject entries with particular emphasis on 19th- and 20th-century painting, decorative art, Oriental art, and Chicago architecture. It indexes about 350 serials.

<http://www.artic.edu/aic/libraries/serials/indexes.html>

VII-B. Indexes to Art and Literature

To locate articles published in serials, you need to use an index to periodical literature. Since the 1980s, the commercial firms that index serial articles have been creating electronic files to produce CD-ROMs and/or databases. This has made searching for art literature easier but sometimes more expensive. Libraries frequently either purchase the hardbound copies of the indexes or subscribe to the CD-ROM or database service. The trend is toward institutions providing only one format for patrons, since indexing serials is labor intensive and costly.

Today there are so many international databases for serials that no person or library would subscribe to them all. Consequently, you will need to decide which databases are best for your research needs. To locate current and retrospective information published in specific serials, you need to find the indexing or abstracting services[1] that cover them. Keep in mind that not all serials are indexed, and those that are indexed have not necessarily been covered throughout their entire publication history. There are several printed volumes that will assist you in locating information on serials, including: (a) *Standard Periodical Directory* (Biannual. New York: Oxbridge Communications, 1964+) and (b) *Ulrich's International Periodical Directory* (3 vols. Annual. New York: R. R. Bowker, 1932+), also available on *CD-ROM: Ulrich's Plus* (Quarterly, 1988+).

Some firms provide printed guides, workshops, and videos to assist you in learning the refinements of da-tabase searching. There are also special classroom programs by which databases are made available for academic instruction at special rates. Take advantage of any aids available to you. This section is concerned with (a) the firms providing online indexing services and (b) the periodical indexes available online.

VII-B-1. Firms Providing Online Indexing Services

Indexing and abstracting databases are often available in more than one format: printed books, CD-ROMs, microforms, and/or computerized tapes that constitute databases. Some firms are now offering full-text databases through which the entire article or all information is available online or can be sent to you for a small charge. Presently, full-text capabilities are used mostly for newspapers and business topics. These choices do not always simplify the researcher's decisions.

To use some formats—such as hardbound volumes, CD-ROMs, or microforms—you may need to visit a library. To search the databases, you can (a) go to the library, where a librarian will conduct or oversee your database search, for which there is usually a fee; (b) locate a library offering a database service ([VII-D], below); or (c) set up a personal account with the company and search the database from your own computer. The last can be expensive, frequently as much as several hundred dollars for the set-up fee,

with specific searches incurring an additional cost per minute.

Over the years, some firms have either (a) created their own databases or (b) taken the indexing/abstracting material produced by other firms to devise files with a uniform search mechanism. WILSONLINE is an example of the former; DIALOG started out as the latter, but now also creates its own databases. Both have Internet home pages from which prodigious amounts of information can be gleaned. For catalogues, call their toll-free numbers. Only these two firms are used as examples here.

Each online database has its own individual information sheet concerning methods of searching. DIALOG's guides, called *Bluesheets*, provide (a) a description of the file, (b) subjects and types of documents and the dates they cover, (c) the size of the database in total number of entries or records, (d) the frequency of updating, (e) search options, and (f) fees for using the files. WILSONLINE's *Information Guides* provide all this data plus a list of serials covered by each database. Individual guides are available through the company's Web site.

WILSONLINE, owned by the H. W. Wilson Company, one of the premier U.S. indexing companies, has about 18 print indexes, some of which now include abstracts. Most are available in several formats: print, CD-ROM, and online <http://www.hwwilson.com/>. Some are available through FirstSearch, which is discussed below in [VII-D-2]. For a catalog, call 1-800-367-6770.

DIALOG, owned by Knight-Ridder Information, Inc., furnishes access to more than 450 individual online databases and can provide complete text of articles from the more than 2,500 serials they cover <http://www.krinfo.com/>. Although the major emphasis is in other fields, art and art-related subjects are represented. For more information, call 1-800-334-2564.

VII-B-2. Types of Indexes

The use of electronic tape by indexes to art literature has changed two important issues: their currency and their ease of searching. The ability to update material frequently has made the indexes more significant in locating recent data. The greatest asset of these indexes, however, is their flexibility. For example, when

searching a printed format, you must search unilaterally, one subject or topic at a time; with a database, you have multiple access points and can link several ideas and concepts together to obtain more efficient and quicker results. This is especially important for the larger databases, such as *Dissertation Abstracts Online*, which contains more than 1,200,000 records dating from 1861 to the present. To search each volume of the printed publication is daunting!

Although most indexes first appeared in a print format, many are now issued both on CD-ROM and through magnetic tape used in database services, such as FirstSearch, or through WILSONLINE or DIALOG, discussed above. These later formats are updated more frequently than the printed volumes, the frequency varying with the publication. The following information briefly identifies these indexes, which mostly cover material published after the 1970s. For publications that index articles prior to that date, check (a) the standard general art bibliographies [II-A]; (b) the three reference works cited earlier from Concordia University, the Frick Art Reference Library, and the Ryerson Library; and (c) ask a reference librarian for assistance. This section is divided into databases indexing (a) general art subjects, (b) architectural material, (c) biographical data, (d) citations, (e) design material, (f) dissertations, (g) humanities subjects, (h) educational concerns, (i) book reviews, (j) Library of Congress MARC records, and (k) newspapers.

General Art Indexes

The three major art indexes, *Art Index*, *Bibliography of the History of Art (BHA)*, and *ARTbibliographies Modern*, have changed the dates and serials covered and increased the number of formats in which they are available. This inconsistency makes it confusing to discover just what is being searched in which format.

Art Index (New York: H. W. Wilson) has the broadest coverage, including all styles and periods of art. It indexes approximately 300 international serials, mostly written in English. It has not always covered the same serials continuously, and it includes titles of illustrated works of art. There are three formats: (a) *Art Index,* a quarterly with an annual cumulation printed in hardcover, beginning with 1929 material; (b) *Art Index Database*, WILSONLINE, with coverage from September 1984; and (c) *Art Abstracts,* an expanded version of

Art Index Database that has added some abstracts since spring 1994. It is also available through FirstSearch.

ARTbibliographies Modern (Santa Barbara, CA: American Bibliographical Center–Clio Press) is particularly concerned with contemporary artists and events, concentrating on all aspects of art, design, and photography. The index has varied its scope over the years. From 1974 through 1988, it covered art created since 1800, while in 1989, it became more narrowly focused on art since 1900. It indexes approximately 330 serials and is available on CD-ROM and through DIALOG, File 56. For more information, access <http://www.abc-clio.com/>.

BHA: Bibliographie d'Histoire de l'Art/Bibliography of the History of Art, a joint effort of the Getty Information Institute and the Institut de l'Information Scientifique et Technique, began in 1990 with the merger of *Répertoire d'art et d'archéologie* and *RILA: International Repertory of the Literature of Art.* It covers European art from the 4th century (late antiquity) to the present, and American art from the time of the European discoveries until the present. Included are all types of media, as well as bibliographies, dissertations, *Festschriften,* corpora, conference reports, and exhibition catalogues. Some abstracts are added. This represents the most international coverage of all the indexes to art literature. *BHA* is available in hard copy, CD-ROM, and through DIALOG, File 190. A combined database of *BHA, RAA,* and *RILA,* all discussed below, is available through RLG [VI-B-2], with records from 1973 to the present. A list of serial titles is available on the Internet <http://www.gii.getty.edu/bhalist.index.html>.

In addition to the three main art indexes discussed above, there are two closed databases with material from before 1989.

Répertoire d'art et d'archéologie (RAA), under the direction of the Comité Français d'Historie de l'Art, Paris, Centre de Documentation Sciences Humaines, is a closed database that covered art from about A.D. 200 to the present, excluding Islamic, Far Eastern, and primitive art, as well as post-1940 works of art and artists born after 1920. The *Répertoire d'art,* which indexed about 420 serials, began its coverage in 1910 and continued until 1990, when it merged with *RILA* to form *BHA.*

RILA: International Repertory of the Literature of Art, a Bibliographic Service of the J. Paul Getty Trust (Williamstown, MA: Sterling and Francine Clark Art Institute), is a closed database that, from 1975 to 1989, covered art from the 4th century to the present, excluding prehistoric, ancient, Far Eastern, Indian, Islamic, African, Oceanic, and ancient and Native American art. It included all types of media and indexed some 400 serials. It is available through DIALOG, File 191, and the Getty Information Institute Web site <http://www.gii.getty.edu/index/aka.html>.

Architecture Indexes

Although the art indexes cited above cover architecture, there are two exceptional resource centers—the Avery Architectural and Fine Arts Library at Columbia University in New York City, and the British Architectural Library of the Royal Institute of British Architects, known as RIBA, in London—that continuously provide detailed indexing to architectural serials.

Architectural Periodicals Index (London: Royal Institute of British Architects) covers material on applied arts, architecture, engineering, and construction from more than 500 international serials from 45 countries. Since 1984, other material collected by this library, including books, exhibition catalogues, technical reports, and videos, has been added. RIBA also produces a CD-ROM version—*Architectural Publications Index on disc,* known as *APId.* It includes the material from the *Architectural Periodicals Index* since 1978, with the addition of the books and audiovisual material catalogued by the British Architectural Library since 1984. It is available through DIALOG, File 179. See <http://www.riba.org/>.

Avery Index to Architectural Periodicals (New York: Getty Institute) has broad international coverage, including architectural history, design, and practice; interior design; landscape concerns; city planning; and historic preservation. This architecture index, begun by the Avery Architectural and Fine Arts Library in 1934, now surveys more that 700 U.S. and foreign serials. A section of the database containing 133,000 records indexed between 1977 and 1992 was published as *Avery Index on Disc* (CD-ROM. Boston: G. K. Hall, 1994). Presently, this part of the database may be searched on the Internet; see <http://www.gii.getty.edu/index/aka.html>. *Avery* is also available through RLG [VI-B-2].

Biography Indexes

These indexes assist in locating information on contemporary artists.

Biography Index (New York: H. W. Wilson, 1946+) has biographical data on international personalities gleaned from about 2,700 serials and 1,800 books. It is available through FirstSearch and WILSONLINE, both with material since February 1984.

Current Biography (11 times a year with annual cumulation. New York: H. W. Wilson, 1940+) has international coverage of people living in the 20th century, including artists, architects, and designers. *Current Biography 1940–Present* on CD-ROM covers 15,000 individuals.

Citation Index

Arts & Humanities Citation Index (Philadelphia: Institute for Scientific Information, 1979+) covers material from a prodigious number of books and serials, organizing them under names of artists and authors. This is an index to references on an artist's work, citing specific titles. It is also available through DIALOG, File 439; a CD-ROM; and FirstSearch. Check its Web site <http://isinet.com/>.

Design Index

Design and Applied Arts Index (CD-ROM. Annual. Woodlands, East Sussex, England: Design Documentation, 1997+) annotates material from more than 300 design and craft journals, published 1973–97. Its coverage includes design history and theory, interior and furniture design, graphic and industrial design, advertising and packaging, architecture, fashion, jewellery,[2] textile design, ceramics, and glass. Technical support is available through its Web page: <http://ourworld. compuserve.com/homepages/design_documentation/>.

Dissertation Abstracts

The valuable work of doctoral students should not be overlooked. This research, much of which is never published, often provides insights and detailed information on small segments of specific subjects; moreover, the bibliographies and footnotes can be invaluable. *BHA, RILA,* and *ARTbibliographies Modern* also index dissertations.

Dissertation Abstracts International (Monthly. Ann Arbor, MI: University Microfilms, 1938+) provides abstracts of dissertations and theses, written from 1861 to the present, from 285 U.S. universities; it began including British dissertations in 1988. This service covers all subjects, including fine arts. Numbers are cited for ordering dissertations through University Microfilms <http://www.umi.com/>. *Dissertation Abstracts Online Database* includes material from *Dissertation Abstracts International, American Doctoral Dissertations, Comprehensive Dissertation Index*, and *Masters Abstracts*, and thus is more inclusive than the hardbound copies. It is available through DIALOG, File 35, and FirstSearch.

Humanities Indexes

The increasing interdisciplinary aspects of art research makes humanities indexes, which cover art subjects and information on various influences on art, more important.

Humanities Index (New York: H. W. Wilson) covers archaeology, art, photography, film, history, and philosophy from between 300 and 400 English-language serials. It is available through WILSONLINE for material published since May 1984.

Magazine Database, created by DIALOG, indexes general interest subjects, such as arts and crafts, architecture, and U.S. interior design. It covers about 400 popular magazines, including those indexed by *Reader's Guide to Periodical Literature*. It is available through DIALOG, File 47.

Reader's Guide to Periodical Literature (New York: H. W. Wilson) covers broad, popular subjects from between 240 and 300 international serials. Started in 1900, this reference indexes articles, biographical sketches, obituaries, and reviews of books, CD-ROMs, and videotapes. There is now a *Reader's Guide Abstracts Full Text Mega Edition,* which has indexed material published since January 1983, abstracts for the 240 serials covered by the print version since January 1984, and full texts of 121 of these serials from January 1994. It is available through WILSONLINE with files from 1983.

Education Indexes

ERIC (Educational Resources Information Center) was created by the U.S. government to disseminate educational research materials. Its database can be searched in a number of ways; for more information, see [XVI-A] and <http://www.gwu.edu/~eriche/>.

ERIC Database contains the educational material indexed since 1966. Copies of the abstracted material are available in paperback or microfiche from ERIC Document Reproduction Service; some can be purchased through University Microfilms International <http://www.umi.com/>. For indexing terms, use the *Thesaurus of ERIC Descriptors,* edited by James E. Houston (13th ed. Phoenix, AZ: Oryx Press, 1995). In this standard vocabulary, *SN* indicates scope notes; *BT,* broader term; and *RT,* related topic [VI-E-3]. ERIC is available on CD-ROM, and for the years 1989 to the present, through the Syracuse University Web site, *AskERIC* <http://ericir.syr.edu/About/>.

Education Index (New York: H. W. Wilson), begun in 1930, is international in scope, covering articles, editorials, interviews, and law cases as well as reviews of books, educational films, and software from over 400 serials. It is available through WILSONLINE with files from December 1983.

```
ART ACTIVITIES                        Jul. 1966
         CIJE: 1507      RIE: 801        GC: 420
    SN   Productive or appreciative participation in
         aesthetic experiences, including the use of
         such experiences generally in the school
         curriculum
    BT   Activities
    RT   Art
         Art Appreciation
         Art Education
         Art Materials
         Art Products
         Art Therapy
         Arts Centers
         Childrens Art
         Creative Activities
         Creative Art
         Cultural Activities
         Enrichment Activities
         Extracurricular Activities
         Fine Arts
         Handicrafts
         Recreational Activities
         Visual Arts
```

"Art Activities" Entry from the *Thesaurus of ERIC Descriptors*

Book Review Sources

Most abstracts and indexes listed in this chapter include book reviews. To reach the widest possible coverage, check more than one index, since each covers different serials.

Book Review Digest (New York: H. W. Wilson), begun in 1905, lists book reviews on English-language fiction and nonfiction. It is available through WILSONLINE with files from July 1984.

Book Review Index (Detroit: Gale Research), begun in 1965, includes book reviews from about 500 journals and newspapers. It is available through DIALOG, File 137, with material since 1969. For more information, access <http://www.thomson.com/gale.html>.

LC MARC Records

The Library of Congress (LC) has the largest bibliographic collection in the world. Since 1968, the cataloguing records have been placed on computer MARC tape [VI-A-1] and can be accessed through LC and other sources, such as OCLC and RLG [VI-B] and DIALOG. The DIALOG records, which can be searched by author, title, and subject, differ from the LC publications in that individual library holdings are not included.

LC MARC–Books Database contains the LC records of English-language monographic works processed since 1968; other foreign-language publications date later. The MARC records are updated monthly. The database is available through DIALOG, File 426.

REMARC Database provides access to catalogued collections of LC from 1897 to between 1968 and 1980, depending on the language of the work. These records correspond to the extensive multivolume LC publications—*National Union Catalogs,* issued in hardcover and microfiche editions—many of which could be searched only by authors' names or corporate entry [VI-A]. It is available through DIALOG, Files 421–425.

Newspaper Indexes

Many large newspapers, such as the *New York Times,* are reproduced on microfilm; their articles are thus available in some libraries several months after being issued. Their usefulness is handicapped by the lack of a good index. Since the 1970s, selective newspaper indexing has been available through various databases, many of which provide full-text service. This is an expanding market; newspaper indexes are added continuously. A good resource is often one of the database services; see [VII-D].

Example

The search engine Excite has a special News Channel, a Web site that locates articles from U.S. and world newspapers, including the *New York Times* and the *Los Angeles Times*, plus *CNN Interactive* and *U.S. News Online*. The coverage is strong on business and the major story of the day. Although art articles are located only if they are a top headline, the fashion world is well represented <http://nt.excite.com/>.

DIALOG is one of the few firms that provide indexing for numerous newspapers. Their coverage is often in flux, so it is best to access the *Bluesheets* to determine exactly which newspapers are included during what specific time periods <http://www.krinfo.com/>. These databases are available only in electronic tape format; there will probably be no printed volumes or CD-ROMs. Some databases are full text, which means the material is easily obtainable, for a price.

VII-C. Locating Pertinent Articles: Choosing Which Indexes

In building a bibliography, you need to locate pertinent articles on your topic, since they often are the most current information and are subject-specific. There are four basic decisions that must be made: (a) what type of data to seek, (b) which serials are most likely to publish this kind of information, (c) which indexes of periodicals and/or art literature should be searched, either individually or through a database service, discussed below, and (d) how easy will it be to obtain the article.

Searching for serial articles usually begins after you have surveyed the subject by reading encyclopedia articles and general survey books, as discussed in [IX-B-1] and [IX-B-2]. In this way, you will have a fairly good idea of what type of material you wish to discover from the serials. For instance, it may be the latest news item, a dissenting opinion, or a peripheral theme that is needed to enhance and strengthen the paper you are writing. Once you have an idea of what you are seeking, you will be able to decide which serials are most likely to publish this material. Once you know the type of serials, you need to discover which of the various indexes of periodical literature cover them.

Compiling a comprehensive bibliography requires searching every index and abstracting service that covers the serials that might have pertinent material on your subject. This can be accomplished by checking either (a) the indexes annotated above, or (b) a database service, such as those discussed below, to discover those that best correlate with your needs. The various formats can be confusing, so be sure to ana-

lyze each database you consult. This will save you both time and money.

In choosing which indexes of art literature to use, the following questions should be asked and answered:

- What are the subjects or scope of the search? Checking the subjects included in the database is an important element of the search. If you are seeking information on the 17th-century painter Annibale Carracci, you will not use *ARTbibliographies Modern* database, since it begins its coverage with the 19th century. Review the scope of the databases carefully.

- What kinds of documents are wanted? The type of document you want determines the index you should choose. Documents include such varied items as (a) data on exhibition and sales catalogues; (b) information on reports and essays included in symposia, corpora,[3] and *Festschriften;*[4] (c) reviews of books, films, and exhibitions; (d) titles of works of art illustrated in the serials; (e) obituary notices; and (f) dissertations, which often cover narrow topics and may never be published in any other form.

- What types of serials will have the desired material? Identifying the types of serials that include the information you are seeking is also essential. To search for articles in popular magazines, such as *Vogue* or *Better Homes and Gardens*, you must discover which databases cover these serials. The *Reader's Guide to Periodical Literature, WILSONLINE*, indexes them, as does DIALOG's

Magazine Database. However, *Art Index* and *BHA: Bibliography of the History of Art* do not.

In the information guides, WILSONLINE provides you with a list of the specific serials included in each database. For DIALOG databases that also have printed counterparts, you may need to consult the print version for a list of the serials covered by the electronic equivalent. Remember, there is also the question of whether or not the index has covered a serial continuously.

- What dates does the index cover? The dates of the material indexed by a particular format are essential to know, since the computer files and the hardbound publications do not necessarily cover the same time periods. Most databases provide only material published over the past decade. If you need earlier published material, supplement your database search with the hardbound volumes in the library. In addition, some databases are closed, meaning that no additional data will ever be added.

- How frequently is the material updated? For those who need the most current facts, databases that are updated monthly or daily, such as *Biography Index* and some newspapers, should be considered. Electronic databases are always updated more quickly than hardbound or CD-ROM formats.

- What terms should be used for this search? When searching online databases, the quickest way to obtain pertinent citations is to use the same terms the indexer employed; see the discussion on structured vocabulary [V-G-2]. For a few databases, there are special thesauri to guide you to the best word or subject heading.

- Which indexing format—print, CD-ROM, or online tape—is best for the subject? In choosing a bibliographic database, you need to understand just what is included in that format. Some indexes have merged, creating confusion as to what is included and in which database. Another disconcerting aspect is that not all online bibliography databases, such as *Dissertation Abstracts*, correspond to their printed versions. Moreover, some include supplementary material not in the printed editions. So read carefully to determine just what you are searching.

- How easy will it be to locate the articles? Today there are several easy methods for locating articles. Consult (a) a full-text index, (b) a database service [VII-D], (c) the interlibrary loan service [VI-E-5], or (d) a document delivery service such as UnCover. UnCover is a database of current article information, which provides data on more than 17,000 multi-disciplinary journals. Only material since fall 1988 is included; copies of the publications are sent via an electronic system, such as fax. Access the UnCover Web site for additional material <http://uncweb.carl. org/uncover/unchome.html>.

VII-D. Database Services

A quick method for compiling an initial reading list is to use one of the computer search systems found at your local library. These services are collections of various databases, usually managed by different companies, that can be searched at one time using the same search strategy and one pay system. These services can also obtain many of the articles for you. The firms that coordinate the databases contract with libraries, which pay for the services. The participating institutions thus provide access to their patrons, who must have the correct authorization numbers and passwords. Access is also available through the purchase of a specific number of searches. Two generally used database services are InfoTrac and FirstSearch.

VII-D-1. InfoTrac

InfoTrac provides various combinations of services to reflect the interests of different libraries. It indexes more than 1,100 general-interest serials, at least 700 of which are full text. Such serials as *Art Bulletin, Art in America, Art Journal,* and *ARTnews* are included, as are chemistry and business journals. Also covered are more than 15 reference books. This database is for the

most current information; most coverage extends about four years back. The indexing of newspapers, such as the *New York Times* and the *Wall Street Journal,* is usually for only the most recent two months <http://www.iacnet.com/library/searchbank/search.html>.

VII-D-2. FirstSearch

FirstSearch, developed by OCLC, is an important research tool available at more than 6,000 libraries <http://www.oclc.org/oclc/menu/fs.htm>. It includes a basic group of OCLC databases, many of which are updated daily. Important databases for art researchers are:

WorldCat, the OCLC Online Union Catalog, which contains bibliographic records from libraries worldwide. It covers thousands of subjects and is updated daily [VI-B-1].

ArticleFirst, which indexes nearly 13,000 general-interest serials, some covered since January 1990, others since July 1992. A list of the serials is available at <http://www.oclc.org/oclc/man/serialslist/toc.htm>.

FastDoc, which indexes full-text articles from more than 1,000 serials that can be delivered to you either online or by U.S. mail.

NetFirst, which provides URLs for bibliographic citations found on the Internet. It emphasizes library resources and evaluation of material for quality and authoritativeness.

FirstSearch is a custom-built system in which each library chooses the individual databases it wishes to offer its patrons. There are 70 individual databases in 14 topic areas from which the library may choose, although for financial reasons, most libraries subscribe to only a few. The choices include *Art Abstracts* (the newest version of *Art Index*), *Biography Index,* and *Dissertation Abstracts.* For descriptions of the individual databases, see <http://www.oclc.org/oclc/fs/database.htm>.

An important inclusion is *News Abstracts,* which is updated weekly. This database reports material published in 25 national and regional newspapers, including the *New York Times, USA Today,* the *Boston Globe,* the *San Francisco Chronicle,* and the *Wall Street Journal.*

Example

In a search for material on the robbery of Old Master paintings from the Isabella Stewart Gardner Museum, *News Abstracts* located 110 records. When the search was limited to 1990, the year of the theft, 63 were reported; for 1997, when there was news that the paintings might be found, there were 8 records. Limiting the scope of the search saved tremendously on search time.

VII-E. URLs of Selected Serials

This section provides the URLs for (a) online serials, (b) indexes to online serials, (c) newspapers, and (d) indexes to the Web sites of newspapers.

Online Serials

ARCA.net (Italian Information Exchanger)
<http://www.arca.net/index.htm>

ArtsWire
<http://artswire.org/>
For the site where past issues are archived:
<http://www.artswire.org/Artswire/www/current/archive.html>

Chronicle of Higher Education
<http://Chronicle.merit.edu/>

C/NET: The Computer Network
<http://www.cnet.com/>

Ctheory
<http://www.ctheory.com/>

Eighteenth-Century Life, an online subscription journal
<http://muse.jhu.edu/journals/eighteenth-century_life/>

eye.net
<http://www.eye.net/>

Grilled Pterodactyl
<http:///www.ozemail.com.au/~drgrigg/ptero.html>

Left Curve
<http://www.wco.com/~leftcurv/>

National Geographic
<http://www.nationalgeographic.com/>

OneEurope Magazine
<http://www.informatik.rwth-aachen.de/AEGEE/oneEurope/>

Paris Kiosque
<http://www.paris.org:80/Kiosque/>

Project Muse
<http://muse.jhu.edu/muse.html>

Postmodern Culture: An Electronic Journal of Interdisciplinary Criticism
<http://jefferson.village.virginia.edu/pmc/contents.all.html>

Slate, a general news magazine available only online
<http://www.slate.com/>

So It Goes
<http://www1.pitt.edu/~soitgoes/>

Time Warner Company, with access to *Fortune, Life, Money, People,* and *Time*
<http://pathfinder.com/>

Indexes to Online Serials

Art History Resources on the Web
<http://witcombe.bcpw.sbc.edu/ARTHLinks4.html>

ArtSource
<http://www.uky.edu/Artsource/frjournals.html>

Electronic Journals on the Web
<http://www.usc.edu/Research/ejournals.html>

Internet Public Library, Online Serials, which furnishes hyperlinks to full-text serials on the Internet
<http://www.ipl.org/reading/serials/>

Internet Resources for Heritage Conservation, Historic Preservation, and Archaeology
<http://www.cr.nps.gov/ncptt/irg/irg-ej.html>

Journals, a list from Oxford University
<http://users.ox.ac.uk/~scat0385/journals.html>

Source References: On-line Journals and Magazines from the *San Diego Daily Transcript*
<http://www.sddt.com/files/library/journals.html>

University of London Library
<http://www.ull.ac.uk/ull/ull09.html>

Voice of the Shuttle
<http://humanitas.ucsb.edu/>

Yahoo's List of Magazines
<http://yahoo.com/News_and_Media/Magazines/>

Web Sites of Selected Newspapers

Boston Globe
<http://www.boston.com/globe/>

Chicago Sun Times
<http://suntimes.com/>

Chicago Tribune
<http://www.chicago.tribune.com/>

Dallas Morning News
<http://www.dallasnews.com/>

Los Angeles Times
<http://www.latimes.com/>

New York Times, published since 1851
<http://www.nytimes.com/>

Philadelphia Daily News
<http://www2.phillynews.com/>

Philadelphia Inquirer
<http://www2.phillynews.com/>

San Diego Daily Transcript
<http://www.sddt.com/>

San Francisco Chronicle
<http://cyber.sfgate.com/examiner>

San Francisco Examiner
<http://cyber.sfgate.com/examiner>

The Times, London, published since 1790
<http://www.niss.ac.uk/news/times.html>

USA Today
<http://www.usatoday.com/>

Wall Street Journal
<http://www.wsj.com/>

Washington Post Online
<http://www.washingtonpost.com/>

Indexes to Newspapers

Newspapers provides hyperlinks to other newspapers worldwide, which can then be searched individually.

Internet Public Library
<http://ipl.org/reading/news/>

Yahoo's List of U.S. Newspapers
<http://www.yahoo.com/News_and_Media/Newspapers/>

Notes

1. An *index* organizes the bibliographic citation—author, title, serial name, date, and pages—under specific subject categories; information concerning the inclusion of bibliographies, illustrations, or indexes may be added. An *abstracting service* covers this same material but adds a brief summary, which assists you in deciding on the relevance of the material.

2. *Jewellery* is the British spelling for *jewelry*. Remember that when you are using a British publication, such as *Design and Applied Arts Index*, the spelling will conform to the British rules, such as *colour* for *color.*

3. *Corpora* are multivolume multilingual works providing extensive data on a specific subject and published over an extended period of time. Each *corpus*, or individual volume, also known as a *fascicle*, may have complete

documentation on the subject accompanied by extensive bibliographies and archival material.

4. *Festschriften* are multilingual works composed of scholarly essays, written by various people, honoring a well-known person. Locating individual articles may be difficult, because the title of the book usually refers to the honored person instead of the subject of the articles. For assistance in locating earlier pertinent material, see Betty Woelk Lincoln's *Festschriften in Art History 1960–1975: Bibliography and Index* (New York: Garland Press, 1988). This book indexes *Festschriften* under the name of the honoree, providing for each the table of contents with authors and essay titles. It also has separate indexes to subjects, authors, and honorees.

VIII. BUYING AND SELLING ART

The World Wide Web is becoming an active site through which data concerning the buying and selling of art can be located quickly. The Internet allows fast dissemination of material concerning future auctions and the prices realized from past sales. This commercial aspect of art has its own vocabulary and resources. You will need to learn as much about the art auction market and its trends as possible.

There are often articles and current news on the auction market in such newspapers as the *Wall Street Journal* and the *New York Times,* which can be searched through InfoTrac and FirstSearch [VII-D], as well as directly through their Web sites: <http://www.wsj.com/> and <http://www.nytimes.com/>. Serial articles are another source, such as those in *Connoisseur* or the

publications many auction houses issue. Art market summations are provided on the Internet by some indexes to auction information, such as *Art Sales Index* <http://www.art-sales-index.com/> and *Gordon's Art Reference* <http://www.gordonart.com/>.

This chapter is organized by (a) information on auction houses and their sales; (b) methods for locating catalogues of past auctions; (c) suggestions for using auction sale data; (d) art and antique galleries, some of which both advertise and sell on the Internet; (e) appraisal information; and (f) multiuse Web sites concerned with auction information, galleries, museums, and artists. For additional information relating to buying and selling art, see [XVI-E].

VIII-A. Auction Sales

This section discusses the methods by which auction information is presented and disseminated. It is organized by (a) auction houses, (b) finding information on post-1990 auction sales, (c) price guides for decorative arts, and (d) suggestions for locating data on pre-1990 auction sales.

VIII-A-1. Auction Houses

During the 18th century, a number of auction houses opened their doors in London. Four are still in existence: Sotheby's, founded by Samuel Baker in 1744; Christie's, by James Christie in 1766; Bonhams, in 1793; and Phillips, by Harry Phillips in 1796.[1] Christie's, Bonhams, and Phillips still maintain their main offices in London; Sotheby's headquarters is in New York City. Over the centuries, two of the largest auction houses, Sotheby's and Christie's, have expanded to include numerous salesrooms and regional representatives throughout major cities of the world. For instance, Christie's maintains salesrooms in such places as New York City, Los Angeles, Melbourne, Sydney, Hong Kong, and Singapore. For a full listing of

locations, see the Web sites of the auction houses listed below.

There are numerous smaller auction houses worldwide. In the United States, the Latimer and Cleary Gallery commenced business in Washington, D.C., in 1853; it later changed its name to Sloan's Auction Gallery and in 1997 added an office in Miami. The tradition of auction houses has been to inform the public of forthcoming sales by publishing catalogues that (a) provide the dates and times of the auctions, (b) describe the items to be sold, (c) list price estimates for which the objects might sell, and (d) sometimes include photographs of the works of art.

Since catalogues are expensive to produce, only art works expected to bring high prices receive detailed documentation in the catalogue, such as the work's provenance, exhibition records, and other background information. Catalogues can be for one specific work of art, for an individual collection, or, most commonly, for a number of items grouped together for an auction.

Auction houses, large and small, are now effectively using the Internet to disseminate information worldwide. An auction house's Web page often provides data concerning

- worldwide offices: locations, opening hours, and personnel
- future auctions: calendars of coming events, types of art, and dates and methods for obtaining catalogue subscriptions
- types of art that the auction house covers, such as French furniture, pre-Renaissance paintings, prints, photography, textiles, and Americana
- terms used at auctions, such as the meanings of *bought in* and *hammer price* (discussed below)
- terms and conditions of the auctions, which usually include commission rates and methods used in evaluating objects
- answers to frequently asked questions (FAQ)
- prices for selected items sold at auctions held recently
- availability of appraisal services
- educational programs sponsored by the auction house
- the history of the auction company

Each auction house provides slightly different Web information. For instance, Sotheby's reprints articles previously published in *Sotheby's Preview Magazine* and lists newsgroups interested in collecting specific types of art, which Net surfers may contact <http://www.sothebys.com/>. Of interest to new collectors is information on assessing the value of artworks and caring for and protecting various items, such as paintings, decorated furniture, ceramics, and Oriental carpets.

Through their Web sites, Bonhams <http://www.bonhams.com/aboutus/valuefrm.html> and Phillips <http://www.phillips-auctions.com/usa/ph_valtn/index.html> provide an initial valuation for works of art. To receive this, you supply the artist's name, the subject of the work, plus its measurements and medium. You then send an image of the work by post or e-mail. Remember to read carefully the stipulations for this service, for it may incur a fee.

Sotheby's Web Page <http://www.sothebys.com>

Some auction houses publish annual reviews, such as *Christie's Review of the Season* and *Art at Auction: The Year of Sotheby's*. Another service suggests books on collecting and on the history of art. Both Sotheby's and Christie's recommend a number of book titles, all of which can be purchased on the Internet.

A major service of the auction houses is to sell catalogues to their forthcoming auctions and provide some information concerning these auctions on the Internet. There is, however, a difference between the Web data and that available through the catalogue, as the example below illustrates. For some people, the online information will suffice; others will need to consult the auction catalogue.

Example

In May 1996, Christie's offered for sale nine works of art, all by different artists, from the collection of Joseph H. Hazen. At its Web site, there were approximately one-and-a-half pages of information on this sale. For a pastel by the 19th-century French painter Edgar Degas, the online information included the work's title, its date of creation, a photograph, and an estimated sale price. There were also several essays on the artist and the collector. In addition, six other artists were mentioned. When the Web site for Christie's was accessed a few months later, the material was no longer on the Internet.

On the other hand, the Christie's Hazen sales catalogue is a 61-page, hardbound book containing (a) a brief history of the collector; (b) separate essays on Edgar Degas, Chaim Soutine, Juan Gris, and Joan Miro; and (c) color reproductions of nine works of art accompanied by scholarly catalogue entries and estimated sale prices. After the sale, purchasers of the catalogue received a price list recording the exact amounts for which the paintings actually sold. The sales catalogue is an important and permanent art historical record of this transaction.

Examples of Auction Houses with Web Sites

Bonhams, London
 <http://www.bonhams.com/>
Christie's, London
 <http://www.christies.com/>
Hôtel Drouot, Paris
 <http://www.drouot.com/>
Lunds Auctioneers & Appraisers, Victoria, British Columbia
 <http://www.lunds.com/~lunds/>
Phillips, London
 <http://www.phillips-auctions.com/>
Sloan's, Washington, D.C.
 <http://www.sloansauction.com/>

Sotheby's, New York City
 <http://www.sothebys.com/>

Indexes to Auction House Web Sites

Art Sales Index
 <http://www.art-sales-index.com/auct.html>
Yahoo's List of Auction Houses
 <http://www.yahoo.com/Business_and_Economy/Companies/Auctions/>

VIII-A-2. Information on post-1990 Auction Sales

Buyers and sellers, appraisers, and art researchers need to know the recent value of individual works of art, often for research, investing, insurance, and/or tax purposes. There are two kinds of resources providing this type of information: auction sales indexes and price guides. The former report the sale prices for specific items; the latter furnish probable ranges in broad categories for which objects might sell.

An auction sales index lists works of art sold by certain auction houses and organizes them under an artist's name. The types of entries for these works of art differ according to the index. Most include data on (a) the auction—name of auction house, date of sale, title of catalogue, lot number, and price realized; and (b) the work of art—title, medium, dimensions in inches and centimeters, year of creation, and whether signed and dated. Many indexes indicate whether the sales catalogue provides the work's provenance, exhibition record, and literary references, and whether the art is illustrated in the sales catalogue.

A citation of any catalogue raisonné (see the introduction to Chapter XI) written on the artist's work, accompanied by the auctioned work's number in that catalogue, is important—this scholarly record provides additional data on the object and means that its author considered the work to be authentic. Some indexes provide the name of the present seller of the work; none include the buyer's name.

Some firms publishing auction indexes issue them in several formats: printed hardbound volumes, CD-ROMs, and/or searchable databases. The printed versions usually cover one year and must be searched one artist at a time, one volume at a time. The databases and CD-ROMs, which can cost anywhere from $500 to $2,000 per year, allow much more flexibility, since you can combine several items—such as the

artist's name with the title of the work of art or the auction house where it was sold—to obtain a quicker answer. The computer formats cover more than one auction period and are easier to search for material on specific works of art, artists, collectors, and auction houses.

You can use auction sales databases either on the Internet, which incurs a fee, or by visiting a library that subscribes to the indexes you need. Remember, you may need to use more than one of these indexes to obtain as wide a range of sales information as possible and because the data may differ. This section lists sales indexes covering recent sales of (a) paintings, drawings, and sculpture; (b) prints; (c) photographs; and (d) decorative arts and collectibles. A few references overlap, covering more than one of these categories. Unless otherwise indicated, all of the following are for international sales. Only English-language indexes are cited.

Indexes to Auctions: Paintings, Drawings, and Sculpture

ADEC/Art Price Annual, founded by Eric Michel (Paris: Société Anonyme au capital, 1987+). Covers sales from some 750 auction houses in 40 countries. Includes paintings, drawings, works on paper, photography, and sculpture and provides catalogue raisonné numbers. In January 1998, it purchased *Art Price Index International* (see below).

 <http://www.artprice.com/>

 ADEC: Art Price Annual: CD-ROM 1987–97

Art Price Index International, edited by Peter Hastings Falk (Annual. 2 vols. Madison, CT: Soundview Press, 1994–98//). Included oils, watercolors, pastels, drawings, miniatures, sculpture, posters, and prints. Covered more than 350 auction houses. In 1998 this index was sold to *ADEC/Art Price Annual* (see above).

Art Sales Index, edited by Duncan Hislop (2 vols. Weybridge, Surrey, England: Art Sales Index, 1972+). This index supersedes *Connoisseur Art Sales Annual,* 1969–71. Presently covers sales from more than 400 auction houses. Includes only works sold above a certain minimum price, a monetary value that has changed over the years. The index originally covered paintings only, but in 1975–76 added drawings and in 1983–84, sculpture, bronzes, and other 3-D works of art. Its *Market Bulletin* reports on the art auction season; *A Report on the 1996/97 Art Auction Season and the Autumn 1997 Period,* by Ruth Corb and Jeremy Eckstein, was available on the Internet in 1997.

 <http://www.art-sales-index.com/>

 ArtQuest: The Art Sales Index Database, with files dating from October 1970, can be searched for a fee; when you set up an account, you will be provided a U.S. telephone number to call.

 Art Sales Index 1990–1995: CD-ROM

Artfact Pro Fine Arts CD-ROM, edited by Stephen Abt (North Kingstown, RI: Artfact Inc., 1988+). Available now on CD-ROM. Its Web site lists the estimated 90 auction houses whose sales it indexes, covering all sales from $10 up. The index includes paintings, prints, photographs, and sculpture in all price ranges and reproduces the full text from the catalogues. It supplements its databases with *ULAN, AAT,* and *Dictionary of Signatures & Monograms* [XI-C-4]. As a service to subscribers, the company is frequently able to provide a copy of the photograph reproduced in the auction catalogue. See also Decorative Arts and Collectibles, below.

 <http://www.artfact.com/>

 Artfact Pro Fine Arts Archives: CD-ROM (1988–92). Lists retrospective sales.

 Artfact Pro Fine Arts: CD-ROM (1993+). In 1998, this will include links to the Artfact Internet database.

ArtNet's Auctions Online is a pay-for-view Internet service that furnishes results for sales at approximately 600 auction houses from 1989 to the present. Covers paintings, photographs, prints, and sculpture. This online service often provides images of the sold art. See [VIII-F] for a description of this company. There is a search demonstration at its Web site.

 <http://www.artnet.com/>

 ArtNet Auction Preview Service contacts customers when works of art by artists they collect are offered for sale.

Canadian Art Sales Index (Annual. Vancouver, BC: Westbridge Publications, 1977/80+). Includes oil paintings, watercolors, drawings, prints and etchings, sculpture, Native art, and art books by Canadian artists. Covers 18 to 22 auction houses in Canada and the United Kingdom and reports Canadian societies and associations to which artists belong. It is available only in hardbound format.

Leonard's Annual Price Index of Art Auctions, edited by Susan Theran (Newton, MA: Auction Index, 1980+). Indexes paintings, drawings, mixed media, and sculpture sold at about 350 American auction houses. All works of art are included, no matter how low the price. It thus locates artists whose names would not appear in indexes that report only art sold for a higher cut-off price. A valuable feature is the ability to locate collectors by placing their name in the Information field. An asterisk indicates that a 10 percent buyer's premium has been added to the price. The index provides a glossary of terms and abbreviations.

 Leonard's Combined Price Index of Art Auctions: CD-ROM contains data from the hardbound publications—*Leonard's Index of Art Auctions* (vols. 1–17, September 1980–August 1997), *Leonard's Annual Price Index of Prints, Posters & Photographs* (vols. 1–3, August 1991–June 1994//), and *Leonard's Annual Price Index of Posters & Photographs* (vol. 4, August 1994–June 1995//).

Mayer International Auction Records: Engravings, Drawings, Watercolors, Paintings, Sculpture, edited by Enrique Mayer (Annual. Paris: Editions Enrique Mayer. First English edition, 1967+). Covers engravings, drawings, watercolors, paintings, and sculpture sold at 800 auction houses, including numerous Belgian and German houses.

 Mayer International Auction Records: CD-ROM (1987–1997).

World Collectors Annuary (Annual. Voorburg, The Netherlands: BV. Repro-Holland. Volume 1, (1946–49+). Covers paintings, watercolors, pastels, and drawings sold at 38 auc-

tion houses in 14 countries, mostly European. Entries often record exhibitions, literary references, and provenance; illustrations are sometimes included. It is available only in hardbound and often lacks currency due to uneven publishing .

Index to Auctions: Prints

See also (above): *Art Price Index International (1994–98 only)*, *Artfact Pro Fine Arts, Canadian Art Sales Index,* and *Leonard's (1991–94 only)*. All the publications for prints cited below are issued by *Gordon's Art Reference* <http://www.gordonart.com/>.

Gordon's Print Price Annual, edited by Jodie Benson (New York: Martin Gordon, 1978+). An important source for print sales, covering about 300 European and U.S. auction houses. Scholarly entries include edition numbers, condition of prints, signature data, and bibliographic sources. The listing of auction houses reports commissions charged.

Gordon's Print Price Annual: CD-ROM (1985+).

Lawrence's Dealer Print Prices covers the fine print market and sales through print/art dealers' catalogues. An annual, *Lawrence's* is available in hardbound and CD-ROM.

Print Price Index includes a glossary of terms, essays on the print market, a bibliography, and a directory of print dealers, appraisers, and auction houses.

Indexes to Auctions: Photographs

See also (above): *ADEC/Art Price Annual, Artfact Pro Fine Arts*, and *Leonard's* (1991–95 only).

Gordon's International Photography Price Annual (New York: Martin Gordon, 1995+). Provides similar data for 25 auction houses, as does *Gordon's Print Price Annual.*
<http://www.gordonart.com/>

Photographic Art Market, edited by Stephen Perloff (Langhorne, PA: Photograph Collector 1980–81+).

Indexes to Auctions: Decorative Arts and Collectibles

Artfact Database on CD-ROM (North Kingstown, RI: Artfact, 1988)
<http://www.artfact.com>

Decorative Arts 1988–1992 is the archival disk for retrospective sales. *Decorative Arts 1993+* is the only index that covers the actual prices for decorative arts and collectible items rather than a range of evaluations. It includes *Maloney's Collectibles Dictionary.*
<http://www.maloneyonline.com/>

VIII-A-3. Price Guides: Decorative Arts and Collectibles

Price guides furnish a probable range for which various items—such as furniture, objets d'art, collectibles, pottery, and sometimes paintings, drawings, and

prints—might sell. Some guides cited below are published at irregular intervals. See also *Artfact Database on CD-ROM* (above).

Complete Antiques Price List: A Guide to the Market for Professionals, Dealers, and Collectors, compiled by Ralph M. Kovel and Terry H. Kovel (New York: Crown Publishers,1969+). Items are listed in a general way.

Miller's International Antiques Price Guide (Usually an annual. New York: Viking, 1979; London: Reed International Books, Ltd.). An illustrated guide to the decorative arts that provides price ranges for which objects might sell. The publications are distributed by the Antique Collectors' Club; see its Web site.
<http://www.antiquecc.com/>

There are related publications covering narrower subjects, which receive frequent updates:

Miller's Art Nouveau and Art Deco Buyer's Guide, 1995

Miller's Collectibles Price Guide, 1989+

Miller's Picture Price Guide, 1992+, a topical index to works of art depicting landscapes, peasants and country life, people, and cartoons and book illustrations. It includes a list of dealers of paintings, prints, and photographs accompanied by their addresses and telephone numbers, a directory of specialists, and a glossary.

Miller's Pine & Country Furniture Buyer's Guide, 1995

VIII-A-4. Locating Data on pre-1990 Auction Sales

Information on 19th- and early 20th-century auction sales remains significant, especially to those researchers who wish to

- establish the value of an artist's work at a given time
- determine the provenance of a work of art, since the names of sellers and buyers may be reported
- discover information on little-known artists or ones whose work sold pre-1990, but for whom insufficient documentation exists
- locate rarely published illustrations of an artist's works or on a particular subject
- compile a catalogue entry for a specific work of art (a subject discussed in Chapter XII), because data—such as dimensions, physical description, and probable date of completion—are provided
- evaluate the auction market
- trace artistic taste and trends, since sales prices are an indicator of the market's reaction to works of art and artists

Sales information is scattered and can be difficult to collect because of its international nature, its exten-

sive coverage, and the wide range of its literature. Since this information is usually gleaned from the sales catalogues and the indexes that cover them, you will need to search these reference tools, some of which date from the early 1900s. Without the technological advances of databases and CD-ROMs, these indexes require that you search systematically through each volume. This can be a tedious, time-consuming task.

For a list of indexes to auction sales pre-1990, see the sales indexes discussed in the standard general art bibliographies [II-A]: Arntzen and Rainwater's *Guide to the Literature of Art History,* pages 33–36; and Jones's *Art Information,* 3rd ed., pages 51–54 and 183–90.

Comparing prices over a period of years or centuries is extremely complicated, because there are so many variables. The annual indexes to auction sales provide the monetary conversion rates for each year, but there are few conversion tables that cover an extended period of time. In front of the first volume of Bénézit's *Dictionnaire* [XI-C-2] is a table providing the French franc equivalents to U.S. and British currency from 1901 to 1973. For additional data, see *Statistical Abstract of the United States* (Washington, D.C.: U.S. Government Printing Office, 1978+), which includes information on the annual Consumer Price Index (CPI). In his *100 Years of Collecting in America: The Story of Sotheby Parke Bernet* (New York: Harry N. Abrams, 1984), Thomas Norton uses the CPI to compare sales prices for works of art sold between 1880 and 1982.

To ascertain the provenance of a work of art [XII-A-2], you need the names of buyers and sellers of the work, if possible. Today this has become more difficult, because many collectors wish to remain anonymous. Earlier auction catalogues and the auctioneer's copy frequently contain data on sellers, buyers, and prices, thus providing excellent sources for this type of information. The most important reference tool for locating scholarly sales information on 19th-century auctions held in Great Britain is the *Provenance Index Project* of the Getty Information Institute [V-G-2], presently available on the Internet <http://www.gii.getty.edu/aka/>. Detailed material

covering auctions held from 1800 to 1820 is available. In addition, below are a few reference books that provide retrospective sales records and sometimes an analysis of the market:

American Art Annual (Published irregularly. New York: R. R. Bowker, 1898–1948//). Reported sales information on American auctions, 1898–1945, including prices and buyers' names.

Art Sales: A History of Sales of Pictures and Other Works, by George Redford (2 vols. London: Redford, 1888) is an excellent provenance resource. Volume 1 has a historical account of sales of great collections as well as many lesser ones. Volume 2 cites sale prices under individual artist's names and sales information on works obtained by (a) the National Gallery of London from 1824 through 1887, (b) the National Gallery of Ireland, and (c) the Houghton Gallery, owned by Sir Robert Walpole. Sales information includes names of sellers and purchasers, as well as sales prices.

Art Sales from Early in the Eighteenth Century to Early in the Twentieth Century (Mostly Old Master and Early English Pictures), by Algernon Graves (3 vols. London, 1918–21; reprint ed., New York: Burt Franklin, 1970). Includes information on early paintings sold at English auction houses. Reports standard sales data plus purchasers' names and sales prices in English pounds. This book is slowly being replaced by the *Provenance Index Project* discussed in [V-G-2].

Dictionnaire critique et documentaire des peintres, sculpteurs, dessinateurs, et graveurs, by Emmanuel Bénézit (10 vols. Paris: Librairie Grund, 1976). A biographical dictionary that, under individual artists' names, reports sales prices, dates, and names of sellers for a few of their works.

Dictionnaire des ventes d'art faites en France et à l'étranger pendant les XVIIIme et XIXme siècles: tableaux, dessins, estampes, aquarelles, miniatures, pastels, gouaches, sépias, fusains, émaux, eventails peints, et vitraux, by Hippolyte Mireur (7 vols. Paris: Maison d'éditions d'œuvres artistiques, chez de Vincenti, 1911–12). An especially good source for 18th- and 19th-century sales in France, covering paintings, drawings, prints, watercolors, pastels, and enamels. Under artists' names are brief sales data, plus names of sellers and sales price in French francs.

Economics of Taste, 1961–1970, by Gerald Reitlinger (total 3 vols., first 2 vols. New York: Holt, Rinehart & Winston, 1962–63). Provides prices for individual paintings, sculpture, and decorative arts in its analyses of the art market.

Vol. 1: *The Rise and Fall of the Picture Market 1760–1960*

Vol. 2: *The Rise and Fall of the Objets d'Art Market since 1750*

Vol. 3: *The Art Market in the 1960's* (London: Barrie and Jenkins, 1970)

French Art Market: A Sociological View, by Raymonde Moulin, translated by Arthur Goldhammer (New Brunswick, NJ: Rutgers University Press, 1987). Concentrates on contemporary painting in France of the 1950s and 1960s.

VIII-B. Catalogues of Past Auctions

There are thousands of sales catalogues covering auctions worldwide published each year. Since they are expensive to acquire and house, most libraries buy them selectively, based on their budgets and special interests. Libraries usually purchase sales catalogues in certain categories. Individual auction catalogues are not generally entered into the library's OPAC. Consult the librarian if you need assistance.

The challenge is to find the required catalogue. First, you need to discover the specific sale date and auction house; sometimes it helps to know the name of the collector who sold the item. With this information, you can then use some of the resources cited below to locate the precise information regarding particular auction catalogues. This process may still take additional steps, since some catalogues use the numbers cited in Lugt and Lancour—discussed below—for identification purposes.

This section suggests some methods for locating sales catalogues, by investigating (a) union lists of libraries owning individual sales catalogues, (b) sources for reprinted catalogues, and (c) visual material from sales catalogues on microfiche.

VIII-B-1. Union Lists of Sales Catalogues

The following are the four major sources for locating sales catalogues:

American Art Auction Catalogues 1785–1942: A Union List, by Harold Lancour (New York: New York Public Library, 1944). Covers all media but reports only American sales. Its strength is the index to more than 60,000 collectors. It was updated to 1960, reproduced on microfilm, and made available through the Archives of American Art [XIV-A-8]. This union list for 150 participating libraries states which institutions own the catalogues.

Répertoire des catalogues de ventes publiques intéressant l'art ou la curiosité, tableaux, dessins, estampes, miniatures, sculptures, bronzes, émaux, vitraux, tapisseries, céramiques, objets d'art, meubles, antiquités, monnaies, autographes, médailles, camées, intailles, armes, instruments, curiosités naturelles, etc., by Frits Lugt (3 vols. The Hague: Martinus Nijhoff)

Vol. 1: *Première période vers 1600–1825*, 1938

Vol. 2: *Deuxième période 1826–1860*, 1953

Vol. 3: *Troisième période 1861–1900*, 1964

Vol. 4: *Quatrième période 1901–1925* (published under the direction of the Fondation Custodia in association with the J. Paul Getty Trust, Paris: Fondation Custodia, 1987)

Lugt's *Répertoire* provides an international chronology of European and American auctions for all media. The four volumes list 148,200 sales dating from 1600 to 1925. Lugt reports dates and locations of sales, names of many collectors or owners, the contents of the sales, the auction houses, and the international libraries that have copies of the catalogues. Access is through the dates of the sales or the collectors' names, when provided.

The *Provenance Index Project,* sponsored by the Getty Information Institute [V-G], provides auction information for paintings sold in the British Isles during the 19th century. After the unrest caused by the 1789 French Revolution, England became the major world art market; the sales included in this scholarly project will eventually cover all known 19th-century European auctions.

<http://www.gii.getty.edu/aka/>

SCIPIO (Sales Catalog Index Project Input Online) Database is a computer index of sales catalogues from worldwide auctions dating from 1599 to the present.

Covering all media, *SCIPIO* was initiated in 1980 by the Art Institute of Chicago, the Cleveland Museum of Art, and the Metropolitan Museum of Art. By 1989, the project had been joined by five additional participants: the National Gallery of Art, the Getty Center for the History of Art and the Humanities, the Nelson-Atkins Museum of Art, the Sterling and Francine Clark Art Institute, and the University of California at Santa Barbara. Recently, there have been some increases in *SCIPIO*'s membership and scope. Four new libraries have joined: the National Gallery of Canada; The Fogg Art Museum of Harvard University; the Museum of Fine Arts, Boston; and the National Library, Victoria and Albert Museum, London. Rare book sales catalogues are also being added.

Data has been added from *The Knoedler Library Sales Catalogues*, which are microfiche reprints of auctioneers' catalogues. This valuable feature makes *SCIPIO* an index for this material. Available through RLG, *SCIPIO* locates catalogues on (a) specific topics and (b) art collectors. Only the information on the title page or cover of each catalogue—such as the catalogue's title, sale year and date, auction house, and collectors' names if available—is reported. Since there is no analysis of the contents of individual catalogues, *SCIPIO* does not normally record the sales of works by individual artists unless the artist's name is on the sales catalogue's title page. *SCIPIO* includes the identification numbers cited in Lugt and in Lancour (see above).

VIII-B-2. Reprinted Catalogues

Some sales catalogues have been reprinted onto microforms, thus preserving and disseminating the information more widely. Access to most of these reprinted catalogues is by auction house and date of sale.

American Art Auction Catalogues on Microfilm is an Archives of American Art project that has reproduced more than 30,000 items published in America between 1785 and 1960. Most of the catalogues, reproduced on more than 550 microfilm reels, are for auctions held in New York City and Philadelphia. There is no index to this collection; you must know the date of the sale, the auction house, and the catalogue number cited in Lancour's *American Art Auction Catalogues*. The microform copies of the catalogues are available at the Archives of American Art or through their interlibrary loan system [XIV-A-8].

Art Sales Catalogues, 1600–1825 (Microfiche. Leiden, Netherlands: Inter Documentation Company, 1989+), plans to reprint every page of the sales catalogues cited in Lugt's *Répertoire, 1600–1825*.

The Knoedler Library Sales Catalogues (Microfiche. New York: Knoedler Gallery, 1970s) reproduces this New York art gallery's collection of about 13,000 international sales catalogues. Many of the catalogues were annotated by the Knoedler staff, thus providing significant data, such as who purchased the work and at what price. The catalogues are organized by country, auction house, then date. The collection is strongest in late 19th- and early 20th-century publications, particularly those of France and the United States. It includes Christie's of London and Parke Bernet of New York, but not Sotheby's branch in London. There is no printed index, but the catalogue titles are included in the *SCIPIO* database.

Sotheby & Co.: Catalogues of Sales (Microfilm. Ann Arbor, MI: University Microfilms, 1973). Reproduces more than 15,000 sales catalogues issued at Sotheby's London auction house, from the first brochure in 1734 through 1970. Arranged chronologically, the sales are for all types of art—prints, drawings, paintings, art objects, and antiquities—as well as such items as autographed letters, manuscripts, books, and coins. There is no index. Because it was filmed from the auctioneers' annotated copies, the sales prices and purchasers' names are often included.

VIII-B-3. Visual Material from Sales Catalogues on Microfiche

Christie's Pictorial Archive (Microfiche. London: Mindata, 1980+): photographs from Christie's files or from pages of sales catalogues. Access is through individual artists.

Painting and Graphic Art: works sold in London 1890–1979

Decorative and Applied Art: furniture, silver, ceramics, and Oriental and other decorative objects sold in London, 1890–1979

Impressionist and Modern Art: works sold in London, 1885–1973

New York 1977–1985: paintings and decorative arts sold in New York City

Christie's Pictorial Sales Review: works sold in London, 1980–85

Christie's Pictorial Sales Review: both London and New York sales, published annually (1985/86+)

VIII-C. Using Auction Sales Data

The resources that index auction sales do not all include the same art media or identical auction houses. Some overlap, covering more than one category of art. Moreover, the various formats may not always correspond with the print versions. You must be aware of the differences and know exactly what you are searching. You may need to consult more than one index.

The availability of sales indexes and auction catalogues becomes an important factor as to whether or not this type of research is even possible. Auction reference tools are expensive; not every institution will own them. Using abbreviated titles for the indexes discussed above, some key issues to consider in choosing an auction sales index are discussed below.

Accuracy of the Data

This can be difficult to determine unless you take the time to compare the indexes and read reviews of their accuracy.

Auction Houses

Which auction houses are indexed is particularly important, since there can be a significant difference in the coverage. Most indexes include Sotheby's and Christie's, but not every one of their many international branches. Some indexes provide information on smaller auction houses, which is useful for researchers searching for local or lesser-known artists.

Example

Leonard's, which covers only American auction houses but indexes about 350 of them, is the only sales index that includes a number of U.S. regional houses, such as Selkirk's in St. Louis.

Dates

An auction season is similar to an academic year, with the foremost sales being held from the fall of one year through the spring and early summer of the next. You need to know if you are searching a full 1992 year or

only the winter and spring of 1992 plus the fall of 1991. Always check the title page for the exact coverage. It is important to pinpoint the dates of the material: (a) what is covered by the index format you are using and (b) how each index lists a date of sale.

> #### Example
>
> *Artfact* states the year/month/day, 96/05/01 (May 1, 1996). *Mayer* gives the day/month/year and would report this date as 01/05/96. Be aware of the idiosyncrasies of each index.

Method for Stating Artists' Names

The use of authority control in stating artists' names and dates may determine whether or not you locate the information needed.

> #### Example
>
> The importance of knowing the name that the indexer uses for an artist is imperative in order to locate pertinent data. See the example in [XI-C-5], where Michiel Carree's name can be spelled Michael Carre as well as Carré, Quarré, and Quarre. And not all the indexes to auction sales use the same spelling!

Policy for Stating the Artist's Name

The method for stating the artist's name to indicate the opinion of the auction house specialists as to the involvement of the artist in the work of art is important, since not all auction houses use the same system. The method is usually stated in each auction house catalogue and sometimes appears on the Internet.

> #### Example
>
> At its Web site, Bonhams describes its different methods for stating the artist's name. *Jacopo Bassano* means that, in the auction house's opinion, it is a work by him, as opposed to *attributed to Jacopo Bassano,* which indicates that the work may be by the Italian artist but the authorship does not have the same certainty as just using his name. Bonhams also defines *studio of, circle of, follower of, manner of,* and *after* <http://www.bonhams.com/aboutus/termscon.html>.

Method for Stating the Price

In checking the sales price listed in an index, be aware of the following: (a) the reported price—the hammer price or the actual price the buyer paid, (b) the price range being reported and whether this varied during the index's publication history, and (c) what currency is being reported.

Once an auction is concluded, auction houses usually send a price list to those who purchase the catalogues. This same information is available at the auction house's Web site for a short period after the sale. It is important to understand the different ways for reporting auction prices:

- *Estimated price* is furnished by the auction houses prior to the event.
- *Hammer price* is the highest and last bid for the work of art sold when the auctioneer's hammer came down.
- *Price list* or the *actual realized price* is the hammer price added to the *buyer's premium,* or the percent that is paid to the auction house. In addition to any tax obligations, this is the actual price the buyer pays.
- *Reserve price* is an amount predetermined by the owner and the auctioneer—and known only to them—that controls whether a work is *bought in* (returned to the seller to keep it from selling below the reserve price). If the reserve price is not reached, the work will not be sold but will be bought in. The bought-in price is usually not recorded by the auction house.

Some sales indexes report the hammer price; others, the price list, which includes the auction house buyer's premium or the commission added to every purchase, usually on a sliding scale of 15 to 10 percent. Some indexes do not indicate whether a work of art was bought in, yet this can be important for some types of research, such as provenance.

> #### Example
>
> In a search of the sale price for Alfred Sisley's *Le chemin dans la campagne,* 1876, which sold on November 9, 1994, at Christie's in New York, some auction houses stated the sale price as $390,000; others reported it as $431,500. The latter reflects the addition of the buyer's premium.

Narrowing the Search

To narrow the search of what might be an incredible amount of material, be as exact as possible. Boolean operators may need to be used.

> #### Example
>
> In a search using *Artfact Database on CD-ROM* for *tiffany dragonfly lamp,* 33,472 records were discovered. When Boolean operators were used—*tiffany AND dragonfly AND lamp*—the entries were reduced to 57, a more reasonable number to evaluate.

The Ability to Search Various Aspects of the Auction

Auction catalogues are a major source for locating data on collectors. Much of this information is elusive, especially during this time period when collectors wish to preserve their anonymity. Thus the ability to search for this data can be very important.

Example

Leonard's CD-ROM has the capability to search for collectors; the user simply inputs the name in the information field.

VIII-D. Art and Antique Galleries

The Internet is becoming a popular place for sellers of art to display their wares. There are thousands of listings for small art and antique galleries. Most include illustrations of selected sale items; some furnish additional data, such as glossaries of terms and calendars of upcoming fairs, crafts shows, and auctions. Some conduct auctions over the Internet.

At its Web site, the *Maine Antique Digest* includes a variety of material: a calendar of regional and international antique shows and auctions, information concerning advertisers, reviews of books on decorative arts and antiques, and reprints of articles first published in the magazine. There are also articles concerning buying and selling on the Internet. An important aspect of this extensive Internet location is the illustrated list of stolen art and antiques, which has hyperlinks to other Web pages concerned with stolen art <http://www.maineantiquedigest.com/Welcome.html>.

Whenever you purchase something, the old adage "buyer beware" applies. Before committing yourself to buying through the Internet, you may wish to read some articles concerning those who have used the information highway to buy art. "Buying and Selling on the Internet," by John Reid, who writes a regular column for the *Maine Antique Digest,* is a good start; it is available on the Web <http://www.maineantiquedigest.com/articles/comp0497.htm>. Before purchasing items, you may also wish to read some of the material being written on the security of the Internet. One place to begin is with the MIT Web site; see "The World Wide Web Security FAQ" <http://www.genome.wi.mit.edu/WWW/faqs/wwwsf7.html#Q64>.

Some Web sites, such as the *Art Shopping Mall*, are maintained by art brokerage firms that advertise artists' works <http://www.artbrokerage.com/mall/mall.htm>.

AABART Fine Art Auctions
<http://www.aabart.com/index.html>

Antiques & Collectibles Guide, which also has a section to report stolen antiques/collectibles
<http://www.tias.com/amdir/>

Antiques and the Arts Weekly
<http://www.thebee.com/aweb/aa.htm>

Art Dealers Association of America (ADAA)
<http://www.artdealers.org/>

Artisans Folk Art
<http://www.folkartisans.com/>

ArtNet, discussed below
<http://www.artnet.com/>

Art Now Gallery Guide Online
<http://www.gallery-guide.com/content/current/index.htm>

ArtScene: The Guide to Art Galleries and Museum in Southern California
<http://artscenecal.com/index.html>

ArtsLink
<http://www.artslink.com/>

Auctions-on-Line
<http://www.auctions-on-line.com/>

Cornell University Fine Arts Library
<http://finearts.library.cornell.edu/>

Every Era Antiques
<http://www.every-era.com/>

Maine Antique Digest Magazine
<http://www.maineantiquedigest.com/Welcome.html>

Maloney's Online Antiques & Collectibles Resource Directory
<http://www.maloneyonline.com/>

National Antique & Art Dealers Association
<http://www/dir-dd.com/naadaa.html>

Netis Auctions on the Web
<http://www.auctionseek.com/>

WWAR, discussed below in [VIII-F]
<http://wwar.com/>

One of the best sources for locating these galleries is through Yahoo's list of auctions for arts and crafts
<http://www.yahoo.com/Business_and_Economy/Companies/Arts_and_Crafts/Services/Auctions/>
and of auctions in general
<http://www.yahoo.com/Business_and_Economy/Companies/Auctions/>

VIII-E. Appraisal Information

The best way to make wise art purchases is either to know a great deal about what is being bought or to obtain the advice of an art expert. Since the art of connoisseurship demands years of study, an expert opinion is usually worth the price charged. Such opinions can be sought from reputable art dealers, auction houses, or accredited appraisers. Be aware that there are different evaluation methods, such as those used for (a) insurance purposes and (b) for buying or selling, for charitable contributions, as well as for estate purposes. The former is concerned with replacement value; the latter with the fair market value, or the amount someone might be willing to pay for the object. In the United States, only appraisers of real estate are certified.

The American Society of Appraisers (ASA) is an organization concerned with all groups of appraisers, including those who evaluate fine arts. For members assessing personal property, the ASA provides steps for accreditation. It requires adherence to the rules set forth in the Uniform Standards of Professional Appraisal Practice (USPAP), determined by the Appraisal Foundation. Some ASA publications address this issue. ASA also publishes (a) *Appraisal and Valuation Resource Manuals* (Washington, D.C.: American Society of Appraisers, 1955+) and (b) *Professional Appraisal Services*

Directory (Annual. Washington, D.C.: American Society of Appraisers). At its Web site, ASA provides information on the association and its publications, recounts some pertinent legal decisions, and assists people in locating an appraisal expert <http://www.appraisers.org/>.

Most auction houses, such as those cited above, provide appraisal services. Often these are geared toward those selling their art through one of the commercial firms. Other appraisal services are primarily directed toward real estate or to museums and large collections. Some associations may be accessed through the Web site of the *Maine Antique Digest* <http://www.maineantiquedigest.com/appraise/appraise.html>

American Society of Appraisers (ASA)
 <http://www.appraisers.org/>

Appraisers Association of America (AAA)
 <http://www.maineantiquedigest.com/appraise/search_aaa.htm>

Art Dealers Association of America (ADAA)
 <http://www.artdealers.org/>

Fine Arts Dealers Association
 <http://www.fada.com/>

International Society of Appraisers (ISA)
 <http://www.isa-appraisers.org/>

VIII-F. Indexes to Auctions, Galleries, Museums, and Artists

Some commercial firms provide searchable databases to assist Web surfers in locating artists, museums, and galleries. People often pay these companies to be listed as part of their databases. This means the contents are a form of advertising and do not always provide the best or most complete information. Sometimes there is a charge to the customer; at other sites, advertisers pay. There are a number of companies entering this commercial market, such as *Art Library Online*, a business based in London and Brussels that began operations in May 1997. At its Web site, the firm provides information on *Mayer International Auction*

Records, which it distributes <http://www.artlibrary.com/>. The two commercial firms discussed below index information on the art market.

ArtNet (founded in 1989 as Centrax Corporation) has two types of services: free access and pay-for-view. The free access through its Web site maintains data on art fairs, museums, and arts organizations <http://www.artnet.com/>. There is also an online *ArtNet Magazine* and an online store. The pay-for-view services include the following:

Auctions Online, discussed above under [VIII-A-2]

Galleries Online, which disseminates information on the exhibition and sales activities of 250 international member

galleries. The galleries are organized by type of art sold such as sculpture or Japanese antiques.

Artists Online furnishes biographies, bibliographies, and illustrated portfolios for artists who have joined *ArtNet*

World Wide Art Resources, WWAR, provides free searchable databases for such items as art galleries, art museums, art exhibitions, art for sale, commercial arts, art schools, arts agencies, children's resources, art history, film resources, antiques, and crafts, as well as information on individual artists, both contemporary and deceased. The museum's index is particularly thorough; you can find separate listings for various countries, time periods of art history, and types of museums. This database can also be searched by alphabetical listing <http://wwar.com/>.

Example

In a search for the Bargello Museum in Florence (Firenze), Italy, the *Museums Index* was accessed, followed by *Italian Museums,* then *Firenze Museums.* This produced a city map locating the 26 cited museums, one of which was the Museo Nazionale del Bargello. A view of the museum's exterior, accompanied by 41 views of sculpture from its collection, was reproduced at this Web site <http://www.thais.it/scultura/default_uk.htm>.

Note

1. Some auction houses have changed their names over the years, especially when they have merged with other firms. For instance, Sotheby's has altered its name a number of times since it was founded in 1744. Sotheby's was headed by the bookseller Samuel Baker, who was the sole proprietor until 1767 when G. Leigh became his associate, an arrangement that lasted until 1778. On that date, Baker's nephew John Sotheby became a member of the firm, which was then called Leigh & Sotheby and later changed to Sotheby's. In 1964, when the English company purchased the New York firm of Parke Bernet, the name was changed to Sotheby Parke Bernet. In 1984, all of the branches of the firm were called Sotheby's. For a brief history of the auction house, see Thomas E. Norton's *100 Years of Collecting in America: The Story of Sotheby Parke Bernet* (New York: Harry N. Abrams, 1984).

PART THREE

HOW TO USE AND SUPPLEMENT WEB INFORMATION

Methods for supplementing Internet material with other information formats is the foundation of this book. In the following eight chapters, various questions are posed and methods for answering them presented. Some inquiries can be answered by consulting an encyclopedia or dictionary or by using the Web sites mentioned in Part Two. Other queries require a more extensive search for pertinent data located both on the Internet and at the library. In addition, there are suggestions for obtaining visual material through the World Wide Web, multimedia CD-ROMs, documentary videos, and microfiche collections.

The organization of this material is similar to that used by the art history survey books: the main focus is on Western European styles and periods, with separate sections for different cultures around the world. Chapter IX details seven fundamental steps of research methodology. Everyone should read this explanation, since later chapters build upon it and supplement the data. Chapter X records references for research on art historical styles and periods; Chapter XI, on artist's biography; Chapter XII, on works of art. Chapter XIII, similar in format to Chapter XI, focuses on architects and artists working in other

media. Chapter XIV covers additional references on American and Canadian art and history. Non-European cultures, discussed in Chapter XV, are included to indicate the types of material available in these areas. Chapter XVI discusses art education, writing about art, copyright, conservation and preservation, and issues concerned with buying and selling art.

Throughout Part Three, lists of valuable resources are cited that help you augment the Web material. Individual monographs are not reported, except as examples. Although most of the printed books mentioned are written in English and were published or reissued after 1980, a few basic sources, some available only in foreign languages, are included. The resources cited from the Internet, as well as those in traditional printed format, are by no means complete or comprehensive, but they will assist you in locating other resources needed for your research project.

As a method for keeping its content current, *Art Information and the Internet* has its own Web site! Periodically, updates will be posted at <http://www. oryxpress.com/artupdate>. As you roam the Internet, please report changes you discover in URLs and provide data on any additional resources that pertain to this book's contents. Send your information to <artupdate@oryxpress.com>.

IX. Basic Research Methodology: Finding and Supplementing Web Data

Part of the fascination of surfing the Net is discovering something that arouses your curiosity and then pursuing its many facets through hyperlinks. Web sites with numerous connections to related material are expanding rapidly; they are some of the most stimulating on the Web. These Internet sites are visited for many reasons, including entertainment and research.

The discipline of art covers a vast array of subjects: art historical styles and cultures, artists' biographies, and individual works of art, as well as the study of different media, iconography, art education, and buying and selling art. To discover information on these subjects—both on the Internet and in more traditional formats—in an economical and efficient manner, you should devise a plan, which for most studies will include the procedures discussed in this chapter. Various examples will be used to clarify the material.

The Research Plan

First, choose the research level needed. Then decide how your subject should be narrowed or broadened to produce a better study. This will indicate which methodological steps you should consult and to what depth they need to be pursued.

Second, make a systematic investigation of the topic to collect pertinent facts, ideas, and opinions. Where possible, use the World Wide Web to facilitate your search. However, a word of caution is in order: You must learn to evaluate Internet material. Remember, anyone can put almost anything on the Internet! This information is rarely filtered through an editorial process; consequently, online data must be appraised, since some of it is misleading, wrong, or plagiarized. Unless you are certain of its source, you should substantiate and authenticate online material.

Because of the necessity to supplement Internet data, the following chapters combine the Web sites discussed in Part Two with other information formats, especially printed books and exhibition catalogues. For some, the cited titles will be too elementary; for others, too erudite. The procedures discussed, however, should assist most researchers in locating material.

While collecting information, organize it in some coherent fashion, since this will assist you later. Follow the seven basic steps of research methodology, detailed below, to learn how to find data through the Internet, libraries, and media centers.

Third, after collecting information, you must analyze it and measure its worth in regard to your investigation. Examining and appraising the findings will help you determine what other data and visual resources may be required. You may discover that you need to repeat some of the research process. Always keep in mind the end product of your research.

By following the steps outlined in this chapter, you will be able to accumulate a massive quantity of facts, as well as a great deal of scholarly interpretation. All "facts" may not agree, nor will they always be complete or correct. Just citing bare data is not enough, for it must be analyzed and organized in order to interpret the subject. This evaluative process is necessary in order to (a) understand the subject, (b) develop or revise some proposition or aspect of the topic, and (c) discover or develop new or original data, hypotheses, or conclusions.

Fourth, complete your project, whether a written or oral report, academic paper, or lecture. Always bear this step in mind, for your time must be budgeted toward completing the whole project, not just the collection phase. Remember to leave time for determining the ideas and conclusions generated by the project. Producing an end result to the study may require you to write and rewrite, then edit and rewrite again. For assistance in this last phase, see [XVI-B].

Finally, reflect upon your findings. Refining the results will afford you insight into future investigations. You should also consider where additional research might lead and what other facets of this study you

would like to explore. For instance, you might wish to learn more about a specific art historical period (see Chapter X) or the artist who created the work (see Chapters XI and XIII). And, of course, the old adage is true: The more you know about a subject, the more you want to know. This chapter discusses the first two procedures cited above: (a) determining the level of research and (b) following the seven basic steps of research.

IX-A. What Level of Research?

Because this book addresses a broad audience, the research methodology needs to address a wide range of concerns. Various questions users might seek to answer have been devised and classified into three levels, from the simplest to the most complex: (a) minimum identification, (b) brief reports, and (c) in-depth academic projects. This section discusses these three levels.

IX-A-1. Minimum Identification

This category applies to those computer users who want to surf the Net for brief or minimal answers to simple or broad questions. These questions can usually be answered by

- consulting some of the material in this book
- using one of the general encyclopedias described below
- checking some of the many Web sites discussed in the six chapters of Part Two
- reviewing Web locations listed under various subjects in Chapters IX through XVI
- employing one of the search engines detailed in Chapter I

Art information on the Web is usually just a slice of data and is seldom discussed in relation to its time or place in the discipline of art. Consult one of the art history textbooks and/or encyclopedias discussed below before connecting to the Internet, since they will provide an overview of the subject and will help you to limit and improve your Web searches.

Examples

1. To discover information on a civilization museum located in Canada, check the list in [III-C], find the URL, and connect to the Internet.

2. If you want to know the differences between a Greek *kore* and a *kouros,* you can locate the terms in one of the art history survey books or art encyclopedias cited in [IX-B-1] and [IX-B-2], below. Searching the Internet without some preparation on your part may consume both time and money and may end in frustration.

IX-A-2. Brief Reports

If you need to write or present a brief report or gain information on a specific topic, follow the basic steps discussed below in order to strengthen your grasp of the subject. Reading material from the general art history textbooks will provide you with an overview of the specific period in art, although they offer little on individual artists. An encyclopedia will furnish a synopsis of the subject matter. These resources will provide you with a quick survey of the subject—information that will enhance your search strategy, both on and off the Internet.

The depth in which you follow the basic research steps depends upon the significance of your report. For instance, for many projects, only a preliminary reading list will be needed, while others require a comprehensive bibliography. Usually brief reports do not require a researcher to (a) use interlibrary loans [VI-E-5], which can require up to three or four weeks to obtain material, or (b) conduct extensive searches for material located under the heading "Special Resources" (see [IX-B-6], below).

Example

You need to write a five-page report on John Marin's marine paintings. Follow the basic research steps. First, check the general art history textbooks listed below. These books, however, do not include this American watercolorist, who lived from 1870 to 1953. Second, consult the art encyclopedias, which may have material on such artists. Third, conduct a search of your library's OPAC, either at the library or through your Internet connection. You will prob-

ably discover at least a couple of books on the subject, but if they are insufficient, you will need to pursue the additional steps discussed below.

The Web will not necessarily locate material on an artist, nor will it always be relevant. Searching the Internet for *John Marin marine paintings* found nothing. Narrowing the search to *John Marin* located 347 documents through one search engine alone! Most Web sites were for art galleries that sold Marin's watercolors. They included neither biographical material nor illustrations of his work. Obviously, a more in-depth academic approach was needed.

IX-A-3. In-Depth Academic Projects

The in-depth level of research is required for those writing scholarly papers, theses, and articles or presenting academic lectures and reports. Two important considerations for answering these more complex questions are

- the time period set aside for the project, since enough time must be available for interlibrary loans and finding special resources

- the subject should take into account the published body of literature on the topic (if the subject is too narrow, there may not be enough material; if too broad, there may be too much)

Often, beginning researchers do not realize the challenges created by choosing too broad or popular a subject. For many artists and topics, there is so much written that it is impractical, if not impossible, for all of the material to be read and digested. Even narrowing a subject to one type of painting an artist created, such as portraits, or to a specific time frame, such as the early years, can still produce a prodigious amount of information. Consequently, you must try to discover the most accurate and comprehensive works to pursue. Evaluating books and other resources is an integral part of research.

Example

In a subject search of the OPAC of the Watson Library of the Metropolitan Museum of Art <http://www.metmuseum.org/> for material on the Dutch artist Rembrandt van Rijn (1606–69), records for 502 books, exhibition catalogues, and other material were located; for French Impressionist Claude Monet (1840–1926), there were 124; and for Spanish artist Pablo Picasso (1881–1973), there were an incredible 547. And this reflects just one library's holdings!

IX-B. Seven Basic Steps of Research

Finding information and illustrative materials on a topic can be time consuming, since they may be located in many places, including the Internet, libraries, archives, museums, and media centers. The data can be in assorted formats—original works of art, electronic data, books, primary data and documents, microforms, CD-ROMs, and videotapes, as well as other audiovisual material. The seven steps discussed below are concerned with

- obtaining an overview of the subject
- consulting dictionaries and encyclopedias
- connecting to the Internet
- compiling a comprehensive bibliography
- learning correct pronunciation
- using special resources
- locating visual material

IX-B-1. Step 1: Art History Survey Books

Begin your library research by reading the relevant sections of a general art history survey book, available at most libraries or through academic or comprehensive bookstores. This is important to obtain an overview of the subject and to assist you in understanding specific elements of your study. As you collect data, list any artists associated with the topic, for it is often easier to locate resources through the creators of works of art than through the styles or periods in which they worked.

Although not adequate for in-depth research, art survey books will clarify art historical periods and styles and will place artists within a framework of time and culture. These sources can be classified as (a) general art history survey textbooks and (b) more

advanced survey books. Even when studying the more advanced textbooks, you should consult the general art history books for background information on the time and culture of your subject.

General Art History Survey Textbooks

The four general art history books cited below (a) contain glossaries, maps, timelines, and brief scholarly bibliographies and (b) provide summaries of the art of Western civilization from the prehistoric to the contemporary period. These well-illustrated references all cover Islamic art. Three also include non-European art: Asian, Precolumbian, African, and Pacific cultures. Check the Web sites of the publishers, Harcourt Brace <http://www.harbrace.com/art/gardner/> and Prentice Hall <http://www.prenhall.com/>, for any new editions.

Art History, by Marilyn Stokstad (Englewood Cliffs, NJ: Prentice Hall, 1995). Includes non-European art.

Gardner's Art Through the Ages, edited by Richard G. Tansey and Fred Kleiner (10th ed. New York: Harcourt Brace, 1996). Includes non-European art.

History of Art, H. W. Janson and Anthony F. Janson (Revised 5th ed. Englewood Cliffs, NJ: Prentice Hall, 1997).

The Visual Arts: A History, by Hugh Honour and John Fleming (4th ed. Englewood Cliffs, NJ: Prentice Hall, 1995). Includes non-European art.

> ### Example
> The project is to locate data on Annibale Carracci and his masterpiece: the ceiling—dated 1597 to 1601—in the Palazzo Farnese in Rome. It is important to distinguish him from other members of his family, many of whom were also artists. All the above textbooks discuss the interrelationships of the Carracci family and reproduce the same color illustration of Annibale's Farnese ceiling.

Advanced Survey Books

The general art history textbooks cited above provide a survey of art history. They are not treatises covering all media or specific artists. Consequently, they are inadequate for certain art disciplines—such as crafts, decorative arts, and fashion—as well as for some art historical periods. Titles of books covering the history of these disciplines are listed in the appropriate chapters of this book. Only a few additional titles are recommended, since these volumes can quickly be superseded by more up-to-date works. The titles are limited to a few well-known textbooks, such as those by John Boardman on Greek art and some individual

volumes of the Pelican History of Art Series, especially those published after 1985.

The Pelican History of Art Series was originally published in the 1950s by the British Penguin Press; more than 40 volumes surveying international art from the prehistoric period to contemporary times have been produced. Although varying in quality, most volumes contain informative text and extensive bibliographies. Many individual volumes are being revised by Yale University Press, which took control of the series in the 1990s. Check the publisher's Web site to discover the latest editions <http://www.yale.edu/yup/>.

If your subject is outside the mainstream of the general art survey books and is not substantially covered by the titles cited in this book, you will need to locate other references. One method is to check the bibliographies appended to the general art survey books listed above. Although these books may not provide the depth of material needed for a particular style or period of art, their bibliographies cite references that will.

These bibliographies, which all too often are underused, are kept current with each new edition. Although not all are signed, many were compiled by art experts, such as Susan V. Craig, head of the Art and Architecture Library, University of Kansas, who prepared the bibliography for Stokstad's *Art History,* and Max C. Marmor, director of the Art and Architecture Library, Yale University, who compiled Janson's list. Other methods for locating specialized, more narrowly focused reference books are provided below.

IX-B-2. Step 2: Dictionaries and Encyclopedias

For minimal answers to uncomplicated questions, you may discover adequate material from one of the general encyclopedias cited below. Some general encyclopedias available online or on CD-ROM are technically advanced, including numerous images, interactive features, audio clips, short videos and animations, and even Internet links. These reference tools offer good color reproductions, but the text is not usually adequate or detailed enough for research purposes. You will probably need to consult an acknowledged scholarly art encyclopedia.

This section is organized by (a) general encyclopedias on CD-ROM or online and (b) printed art

encyclopedias. The references are compared as to the material they include on Annibale Carracci (Italian, 1560–1609). Because there are so many dictionaries, both on wide and narrow art subjects, only a few will be reported in this book. Additional resources can be located by (a) checking the standard general art bibliographies [II-A] and the bibliographies in the art history textbooks, cited above; (b) using a pathfinder or library guide available at your library or on the Internet [VI-E-4], or (c) asking the reference librarian for assistance.

General Encyclopedias: CD-ROM and Online

The longest continuous encyclopedia publication is *The Encyclopaedia Britannica*. When first sold in 1777, this scholarly reference consisted of three printed volumes. It has since had many editions and revisions. The 29-volume 11th edition, issued in 1910–11 and sponsored by Cambridge University, is considered one of its finest versions. Today, the 32-volume set published by the University of Chicago is available in three forms: hardbound, CD-ROM technology, and the Internet <http://www.eb.com/>.

Encyclopaedia Britannica Online (also called *Britannica Online)* includes full-text articles, usually signed, covering diverse general subjects and providing hyperlinks to related Web sites. Because online information can be easily changed, this material is constantly being updated and supplemented. An interesting feature is that if you do not know the spelling of your topic, you can search for part of the word and receive (a) a list of terms that sound similar to your topic and (b) an alphabetical list of words near this spelling in the encyclopedia. For examples of how it can be used, see below, as well as [X-A-2] and [XI-A-2].

Several multi-volume encyclopedias are available for the home market either through CD-ROMs or the Internet. The material constituting these online encyclopedias is based on their printed counterparts and must be judged according to the hardbound publications. The online versions—which may include other reference books, such as dictionaries—provide color illustrations, videos, sound clips, and access to additional current material on the World Wide Web. For the Internet service, you usually need an identification number and password from an individual account or a library that provides this service. Free

trials are usually available; revised editions are published fairly regularly.

Encarta Encyclopedia (2 CD-ROMs. Redmond, WA: Microsoft). Reproduces the 24-volume *Collier's Encyclopedia* and *Columbia Encyclopedia.*
<http://www.encarta.com/>

Encyclopaedia Britannica CD (2 CD-ROMs. Chicago: University of Chicago). Includes all material in the 32-volume print set; see above.
<http://www.eb.com/>

Grolier Multimedia Encyclopedia (2 CD-ROMs. Danbury, CT: Grolier). Duplicates the 30-volume *Academic American Encyclopedia* and the *New Book of Knowledge.*
<http://gme.grolier.com/>

World Book Multimedia Encyclopedia (1 CD-ROM. Chicago World Book, Inc.). Provides access to all the articles in the 22-volume hardbound edition.
<http://www.worldbook.com/>

Example

The Encyclopædia Britannica Online includes 4 paragraphs on the life of Annibale Carracci and a detail of his ceiling in the Palazzo Farnese, Rome. The titles of 8 works are cited, accompanied by the dates they were created and their present locations. The briefly annotated bibliography consists of 9 items, and there are 14 hyperlinks to Web sites reproducing illustrations of Annibale Carracci's works.

Art Encyclopedias: Print Volumes

Printed reference tools usually include some color reproductions, but their real asset is their scholarly text. Although most libraries will own an art encyclopedia, not all will have purchased the most current publication, *The Dictionary of Art.*

The Dictionary of Art

The most authoritative art encyclopedia is *The Dictionary of Art* (34 vols. Edited by Jane Turner. New York: Grove, 1996), which has extensive worldwide coverage of the many facets of the discipline. The 41,000 signed articles provide bibliographical data and are usually illustrated. About 20,000 international artists working in all media are discussed. Remember to use Volume 34: *Index,* with its extensive cross references to additional material. At its Web site, *The Dictionary of Art* furnishes excerpts from a few sample articles <http://www.groveartmusic.com/90/TDA/index.html>.

Example

The Dictionary of Art devotes almost 12 pages to the life, work, techniques, and critics' opinions of Annibale Carracci, together with illustrations of 6 works of his art. Discussed in detail are more than 35 of his works, each accompanied by the date of

IX. Basic Research Methodology: Finding and Supplementing Web Data

creation, its present location, and often the influence other works had on it. This signed article includes a 50-item bibliography organized by early sources and documents, monographs, drawings, prints, the Farnese Gallery, and other specialized areas. Moreover, by furnishing the titles of two books that themselves contain exhaustive bibliographies on the artist, the Annibale Carracci article greatly extends its suggested reading list. Five monographs[1] on Carracci are cited, three written in English. Two titles are accompanied by information on an important review of the book, providing the name of the reviewer and publication data.

Volume 34: *Index* lists 14 major entries with page references for additional material on Annibale, such as information on his assistants, attributions, collaborations, copies of his works, drawings, and engravings. Under *patrons and collectors*, there is a list of 49 individuals, including Cardinal Farnese and Joachim Murat, the King of Naples. The 10 subsections for paintings index such items as allegorical works, altarpieces, frescoes, mythological works, landscapes, and pietàs.

Earlier Publications: Art Encyclopedias

There are three older, well-established resources, cited below, that are still relevant to many research projects. Notice, however, that these multivolume reference works were issued between 1958 and 1971. You will, therefore, need to use other sources for material on (a) contemporary art and ideas; (b) artists, styles, and cultures whose histories have recently undergone revision by scholars; and (c) subjects, such as photography, that are now better documented.

The Encyclopedia of World Art (15 volumes. New York: McGraw-Hill, 1958; updated by Vol. 16, 1983; Vol. 17, 1987)

McGraw-Hill Dictionary of Art (5 volumes; New York: McGraw-Hill, 1969)

Praeger Encyclopedia of Art (5 volumes; New York: Praeger, 1971)

IX-B-3. Step 3: The Internet

Once your question is more focused, you are ready to connect to the Internet. Check all of the following: (a) the OPACs of your local libraries to form a preliminary reading list, (b) single-subject Web sites, (c) online indexes to Web material, and (d) search engines.

Preliminary Reading List

For all but the simplest queries, a reading list should be compiled. Although this preliminary reading list may be sufficient for some projects, it will be inad-

equate for in-depth research, which requires that you extend this brief list to form a comprehensive bibliography; see Step 4, below.

To compile an introductory reading list, you need to locate several books and articles on your specific topic and/or covering the style or period in which the subject is discussed. Start with the reference titles recorded in the (a) bibliographic section of the art history textbooks and/or (b) encyclopedia articles.

Then, conduct a search of the OPACs of your local libraries to determine whether these titles are available and to locate additional books on your topic. This search, which can be made at the institution itself or online, should be of your regional university, public, and/or museum libraries. If your local institutions have the material, you can obtain it more easily.

Finally, supplement this list of books with articles derived from using an art indexing service, such as *Art Index* or *Bibliography of the History of Art (BHA)*, both detailed in [VII-B]. If your library provides FirstSearch or InfoTrac, you might wish to use them [VII-D].

Example

A subject search for *Marin, John* through the OPAC of the University of North Texas located 15 records for books and exhibition catalogues. One publication—*John Marin and the Sea*, a 1982 exhibition catalogue—was especially significant to the study of the watercolorist and marine painting <http://library.unt.edu/search/>.

Single-Subject Web Sites

These are discussed in [IV-A-3]. Two types of Web sites especially important for research are those that (a) furnish syllabi for academic courses and (b) concentrate on one particular subject. These sites usually

- are developed and maintained by experts in the field, whose names and credentials are known
- supply a tremendous amount of information on all aspects of the subject, including reading lists
- strive to be comprehensive, furnishing data on the history, religion, and daily life of the period
- include illustrations
- furnish hyperlinks to other significant material

Example

Dr. Paul Halsall of Fordham University is creating a number of special sourcebooks for broad subjects, including ancient, medieval, and modern history. Each individual Web site is organized by historical

OPAC of the University of North Texas <http://library.unt.edu/search/>

Indexes to Web Material

These are discussed in [IV-A-4]. An enormous difficulty with the Internet is that not only is information constantly being added, sometimes in places you do not expect to find it, but there is no overall index. A tremendous service is provided by the indexes that organize and list pertinent Web sites by subject. They often use clear, appropriate categories, such as Baroque art. The use of these indexes, examples of which are cited in [III-A-5] and [IV-A-4], will save you time, money, and frustration!

Example

Art History Resources on the Web, which includes individual artists, has links to Web sites with material on three artists used here as examples: Annibale Caracci, John Singleton Copley, and Giovanni

Battista Tiepolo <http://witcombe.bcpw.sbc.edu/ARTHLinks2.html>.

Search Engines

These are discussed in [I-B]. To locate additional material on the Internet, use one of the search engines. In the research methodology detailed in the following chapters, three engines capable of keyword searches were selected:

AltaVista
 <http://www.altavista.digital.com/>
Excite
 <http://www.excite.com/>
Lycos
 <http://www.lycos.com/>

These were chosen because during the long hours of research to develop this book, they proved to be the most fruitful. Only the first 20 entries cited for each given topic were analyzed, since after that number the relevance of the material dwindled to almost

none. In addition, examine the URLs reported by the search engines [I-A].

Example

When searching the Internet for *Annibale Carracci,* AltaVista found 100 sites; Excite, 6; Lycos, 69.

Of the 175 total Web sites located at the time the Carracci search was conducted, most were related to the *Museo di Capodimonte* in Naples, Italy <http://capodimonte.selfin.net/capodim/home.htm>. Of the first 20 sites cited by AltaVista, 19 referred to this museum. Some were duplicate entries for specific paintings; some were written in Italian.

Of the total Web sites found there was one entry for the WebMuseum [IV-C], which contained a brief section on the Baroque period; the rest were irrelevant. It was especially important to grasp the interrelationships of the Carracci family, since references to Web sites for Annibale's family members were frequently confused with his.

IX-B-4. Step 4: Comprehensive Bibliography

All in-depth research begins with a review of the literature written on the subject. You must compile a bibliography that is as comprehensive as possible. Just making an extensive list of books and articles is not the purpose; you must then locate, read, and analyze the material. Because you could compile what might be an unwieldy list, you may wish to restrict the bibliography in some way, such as by excluding certain languages or establishing date limitations. Be careful when eliminating older publications, because the age of a reference does not necessarily diminish its importance.

If you have followed the recommended research steps discussed above, you already have a preliminary reading list. It can be developed into a comprehensive bibliography by following the suggestions cited below. All of the examples use WATSONLINE, the Watson Library's OPAC of the Metropolitan Museum of Art. At the time of the searches, this OPAC included all titles catalogued since 1980, plus 70 percent of all pre-1980 material <http://www.metmuseum.org/>.

Search Other Libraries' OPACs

You have already searched the OPAC of the institution with which you are affiliated. Now expand to other online catalogues to augment your reading list. It is important to choose an institution known for collecting material on your research subject. Since some library OPACs do not contain records for all the items owned by the institution, especially material purchased before computerized records became the norm, be careful to note what the library's OPAC includes. You can sometimes discover titles of earlier publications by (a) searching OPACs of libraries that have placed most of their material online and (b) consulting a standard general art bibliography [II-A].

The *Library of Congress Subject Headings LCSH* [VI-E-3] is particularly valuable when you are searching for people or terms that have an abundant number of bibliographic entries in an OPAC. In these searches, the LC subject headings can curtail your search time.

Example

The OPAC of the Watson Library listed 5 categories for American artist John Marin, with a total of 39 entries <http://www.metmuseum.org/>. This library, noted for its collection of American resources, had records for 25 exhibition catalogues, 1 item of correspondence, and 2 catalogues raisonnés—one for Marin's paintings, one for his etchings. All 15 items in the earlier University of North Texas search (discussed above) were located. The divisions made locating any catalogue raisonné on Marin's etchings easier. See below:

Marin John—1870–1953
Marin John—1870–1953—Catalogues Raisonnés
Marin John—1870–1953—Correspondence
Marin John—1870–1953—Etchings Catalogues
 Raisonnés
Marin John—1870–1953—Exhibitions

Check Printed Bibliographies

An efficient way to enhance your own reading list is to find an annotated bibliography published on the specific subject. These resources reflect the cumulative work of scholars upon which your research can be built. Moreover, the historical overviews and the schematization devised by these authors may assist you in the organization of your own work. Although these bibliographies are not always current, they can be supplemented by later publications. Unfortunately, there are few specific bibliographies published, and trying to locate one can be time-consuming and futile. Using Boolean operators in a keyword or title search, however, you just might find one of these jewels.

Example

In a title search for *bibliography AND Chartres,* Jan van der Meulen's *Chartres: Sources and Literary Interpretation: A Critical Bibliography* (Boston: G.K. Hall, 1989) was located.

Discover Relevant Exhibition Catalogues

Since scholarly exhibition catalogues are frequently the latest, most factual treatises on art subjects, it is essential to discover them. Some will already have been located through your library's OPAC, but you may extend this list with searches using Boolean operators. For instance, *(name of subject) AND exhibition* will frequently bring additional catalogue information. Another source is the *Worldwide Books Online* Web site <http://www.worldwide.com/>. To locate reprints of exhibition catalogues, see Appendix One.

Example

Using *Copley, John Singleton 1738–1815—Exhibitions,* the LC subject heading, the Watson Library's OPAC located four separate exhibition catalogues, published 1965, 1980, 1995, and 1995. The last two were for dual shows: *John Singleton Copley in England* and *John Singleton Copley in America.* These were the latest and best references on this famous artist.

The University of North Texas's OPAC reported only the two 1995 catalogues. *Worldwide Books Online* cited five Copley exhibition catalogues, the two 1995 catalogues plus three that the two libraries did not own: *American Portraits by John Singleton Copley,* 1975; *Copley, Stuart, West in America and England,* 1977, and a reprint of a 1948 work. Sometimes it is worth checking several places to obtain a better set of references <http://www.worldwide.com/>.

Locate Pertinent Recent Material

Your bibliography should include current material, which is most often located in recent serial articles and sometimes in dissertations. The currency of the material is important, because it frequently takes one to two years for research data to be issued in a magazine or journal and approximately three to five years to appear as a printed book. Thus the most up-to-date information is usually found in serials. Moreover, this material may never be printed in any other form, and the articles—which often discuss some narrow aspect of a subject—may become the only publication source.

A major decision is which indexes of art literature to use. There are only two that cover most art historical periods, styles, and cultures: *Art Abstracts* and *BHA: Bibliographie d'Histoire de l'Art/Bibliography of the History of Art.* These indexes have a number of formats:

printed volumes, CD-ROMs, and electronic tape through the Internet. This has made it easier to locate some material, but also has made it more confusing as to just what time periods and serials are being searched. Because of the complex nature of indexes to art literature, [VII-B] and [VII-C] discuss them in detail.

IX-B-5. Step 5: Pronunciation

As part of your research, you should learn the correct pronunciation of artists' names and art terms prevalent in your project. There are several avenues open to you.

Art Terms and Artists' Names

Use CD-ROM encyclopedias or dictionaries, such as the *American Heritage Talking Dictionary* (3rd ed. New York: Houghton Mifflin, 1992–94) or *Microsoft Bookshelf* (CD-ROM. Redmond, WA: Microsoft, 1995). These two sources give oral and written pronunciations. Hearing the names spoken is usually much easier than deciphering the different written accents and pronunciation keys.

Artists' Names Only

Access the Web site sponsored by A&E Television Network called *Biography.* This location reproduces the brief entries in *The Cambridge Biographical Encyclopedia,* edited by David Crystal (London: Cambridge University Press, 1994). Each short paragraph provides the full name, including maiden names stated as *née* or *born,* birth and death dates, and a few other pertinent facts. The phonetically written pronunciation of the person's last name is included. <http://www.biography.com/>. Also try one of the multimedia museum CD-ROMs [II-D], since these often furnish the oral pronunciation of artists' names. If these do not have the required name, see the following:

Klee As in Clay: A Pronunciation Guide, by Wilfred J. McConkey (Lanham, MD: Madison Books, 1992)

Pronunciation Dictionary of Artists' Names (Revised ed. of G.E. Kaltenbach's *Dictionary of Pronunciation of Artists' Names,* 1935. Chicago: Art Institute of Chicago, 1993)

Pronunciation Dictionary of Proper Names: Pronunciations for More than 23,000 Proper Names, Selected for Currency, Frequency, or Difficulty of Pronunciation, edited by John K. Bollard (Detroit: Omnigraphics, 1993)

Example

Microsoft Bookshelf furnishes the correct oral pronunciation for *Carracci.* The CD-ROM of London's National Gallery of Art, *The Art Gallery,* gives the correct oral pronunciation for his full name, *Annibale Carracci.*

IX-B-6. Step 6: Special Resources

Most in-depth research requires locating additional, sometimes peripheral, information to assist you in understanding the various ramifications and subtleties of the subject. Two important resources often overlooked by students are primary and secondary data. The phrases *primary data* and *primary sources* mean first-hand information: the letters and diaries of an individual, eyewitness accounts, personal interviews, and the original drawings and works of art. The phrases *secondary data* and *secondary sources* mean subordinate or indirectly derived information provided by authors who have examined the primary data and have reached certain conclusions concerning them. These resources are important, because research, by necessity, is built upon other scholars' work. The significance of these first-hand and second-hand accounts is demonstrated by the fact that English translations of some primary and secondary data are reproduced in Janson's revised fifth edition of *History of Art* [IX-B-1]. This type of material can be a gold mine for researchers!

Determining sources is a major challenge with Internet material. Who did the research? Is it a scholar who investigated primary and secondary data and came to appropriate conclusions? Remember that not everything found on the Web, or even in published books, is correct. Knowing the credentials of the author and the prestige of the publisher are important elements in your decision of whether to use the material. To verify a scholar's work, it is essential to gather and study as many facts as possible and then to ascertain which are correct or reliable.

As much primary data as possible should be studied. Fortunately, researchers do not always have to travel to out-of-the-way places to obtain this material. Some of it is now available through facsimiles, often published on microforms and sometimes made available through interlibrary loans. Primary and secondary data are usually located in (a) archives, (b) vertical

files, and (c) books that reproduce documents and sources. Typically, these resources, discussed in [II-B] and below, include ephemeral material that is rarely, if ever, indexed by another method.

Archival Material

The most important storehouse of primary and secondary material on people working in various fields of art in America is the *Archives of American Art* [XIV-A-8]. It contains information on artists, people working with crafts, museum personnel, and art societies, as well as art dealers, critics, and collectors. Some of this archival material has been indexed and reproduced on microfilm, which can be viewed by researchers through interlibrary loans or by visiting one of the archives' regional branches. To discover if anything on your subject is available in the archives, access this important collection through the Smithsonian Institution Web site <http://www.si.edu/organiza/start.htm>.

Example

In a search for material on John Singleton Copley, 20 entries were found in the *Archives of American Art.* Most of the references are from galleries that exhibited and sold the painter's work; several resources are letters and exhibition announcements from 18th-century art collectors. Also represented are private files, such as those by New York art dealer Albert Duveen, who collected material on about 150 artists, including Copley.

Vertical Files

A vertical file is an open-ended system for preserving ephemeral material on specific subjects, such as artists, architectural monuments, and museums and galleries. Most vertical files are concerned with local people and issues. These files contain all types of items: gallery and exhibition reviews, obituaries, photographs of the artist, letters, small exhibition catalogues, short articles, illustrations of works of art, postcards, and other assorted memorabilia. Frequently there are clippings from local newspapers as well as one or two major newspapers, such as the *New York Times.* For monuments and buildings, there may be articles on the project's plans, old photographs, and architectural blueprints.

Because vertical file material is generally not indexed, there is usually no indication in the library's OPAC that these files or the subjects they contain

even exist. Fortunately, a small number of exceptional vertical files have been published on microfiche. They are, however, expensive and owned by few libraries. An important resource is *The New York Public Library: The Artists File* (Microfiche. Alexandria, VA: Chadwyck-Healey, 1989), covering 90,000 architects, artists, designers, collectors, historians, museum directors, dealers, and others associated with art. The material covers international artists from all periods of art history. In this publication, one fiche consists of 30 frames, each reproducing several pages of text or one or more illustrations.

Example

The New York Public Library: The Artists File has five fiche on John Singleton Copley. This total of 150 pages of early material—mostly newspaper clippings and short articles—is not easily retrievable anywhere else.

Documents and Sources

To discover documentation contemporary with the period being studied, you need to retrieve (a) any writings by or interviews with the artist and (b) the opinions of critics of the artist's work. These can be located through

- the material deposited in an archive or vertical file, such as those discussed above
- scholarly exhibition catalogues or monographs written on a single person, since these often reprint, and usually translate, this type of data
- video- or audiotapes that record interviews with 20th-century artists and critics [X-B-4]
- books containing collections of artists' writings or critical reviews

Throughout Part Three, books are listed that pertain to the last point. Some references provide quotations from artists; a few index this type of material. Other volumes translate critics' opinions concerning an artist's work. In addition, the brief essays accompanying the entries greatly illuminate the material. These books are especially advantageous to researchers who lack the time or resources needed for searching archives and vertical files. The editors of these books have culled the material and selected what they consider important.

Example

American Art 1700–1960, from the *Sources & Documents in the History of Art Series,* contains copies of the 1766–67 correspondence between John Singleton Copley, Captain R.G. Bruce, and Benjamin West.

IX-B-7. Step 7: Visual Resources

Any study of art is incomplete without inspecting the work itself, as well as other similar or related objects, for it takes many views and various angles before art can be related to its environment and other works of art. Naturally, the best method is seeing the original work of art, since it provides primary data that can be gathered in no other way. When you examine a work in situ,[2] you can judge the effect of the art's surroundings, its scale, color, and condition, and the artist's handling of the medium. However, most art is no longer in situ, and if it is, the environment may have changed it. To visit the locations of all the works of art needed for a study is virtually impossible or, at least, impractical. Consequently, good reproductions will be required for detailed and comparative studies.

If you followed the basic research steps discussed above, you already have viewed a number of reproductions of an artist's works, some in color, others in black-and-white. They will have come from many places, including the Internet and printed books. Before searching for extra visual material, you should evaluate the material you have already gathered. Then consider the following two procedures:

First, make a list of the specific reproductions required, by artist, citing, when known, each work's (a) title, (b) date created, and (c) present location. Remember, art is international, as is the language used in research literature. This often makes titles of works of art confusing. For instance, if a painting is called *Landscape* in English, it will be entitled *Paysage* in French, *Landschaft* in German, *Paisage* in Spanish, and *Paesaggio* in Italian. Moreover, if the picture is just titled *Paysage,* knowing the date it was created becomes especially important, since the artist could have painted numerous works with this same generic title. Discovering the work's present location further helps pinpoint the exact work of art.

Second, determine as closely as possible what types of illustrations you need: (a) black-and-white, thumbnail-size reproductions for identification purposes; (b) good color illustrations to indicate the work's intensity and shades; (c) details of specific sections of the

work; and/or (d) slides for multimedia presentations. These may be available on the Internet or at the library, or you may need to contact a museum or commercial firm to purchase the required material.

The major indexes of art literature [VII-B-2] are significant sources for finding reproductions of works of art since they often report their present owners. For instance, under "Reproductions," *Art Index* provides titles of works illustrated in the serials it covers. *BHA* frequently includes titles of reproductions, often noting their present locations. An efficient method for discovering specific works of art is an online database search, because artist and title can be linked using Boolean operators.

In order to discover additional visual material, use some of the following: (a) museums with good collections of the artist's works, (b) resources listing owners of works of art, (c) Web sites for geographical locations, (d) noncommercial Web sites for visual material, (e) commercial Web sites for visual resources, (f) CD-ROMs, (g) documentary videos, (h) the indexing tool Iconclass, and (i) microform collections.

Locating reproductions of paintings created by Italian painter Giovanni Battista Tiepolo (1696–1770) is used in this section as an example, where applicable. The emphasis is to discover visual material for Tiepolo's ceiling painted for the Residenz Palace in Würzburg, Germany. This masterpiece, which is still in situ, is illustrated in color in several art history textbooks [IX-B-1]. The problem is not to find one reproduction but to locate various angles and details of this outstanding work of art.

In formulating a bibliography, you might have located *Tiepolo: Masterpieces of the Würzburg Years,* by Peter O. Krückmann (trans. by John Ormrod. New York: Prestel, 1996). This book reproduces 40 color photographs and more than 50 black-and-white illustrations of drawings and studies of Tiepolo's Residenz ceiling. This book was the best source for color reproductions of Tiepolo's Residenz ceiling.

Museums

Once you have followed the six basic research steps detailed above, you should have the titles of works of art, plus the names of museums owning them. If it has a Web site, a museum can be contacted through the Internet to discover additional data and, perhaps, a reproduction of the work. Use the resources that

index works of art by title, discussed below. Another method is to locate museums with good collections of a particular type of art and access their Web sites for additional data. Two hardbound books that index museum collections by broad subjects are (a) the *American Art Directory* (Biennial. New York: R.R. Bowker) and (b) *The Official Museum Directory* (Biennial. Washington, DC: American Association of Museums). These books do not index specific works or individual artists.

Sometimes there is an exhibition of the type of art you are studying either displayed in a nearby museum or coming soon to an institution close to you. Use the search capabilities of the exhibition calendar provided by the Association of Art Museum Directors (AAMD) <http://www.EXCALENDAR.net/>.

Example

> In a search for works by Sisley, the AAMD database located the Courtauld Collection, which was on tour in North America; one of the works on display was by Alfred Sisley.

Resources Listing Owners of Works of Art

If a work of art is owned by a museum, you can access the institution's Web site to determine if it still owns the work and the availability of additional data and visual resources. The problem arises when you need to locate the owner. Three resources that may assist you are (a) inventories, (b) archives and vertical files, and (c) books that index art by title. For information on the titles of works of art, see [XII-A-2].

Inventories

The Smithsonian Institution and the U.S. government have inventoried art works and placed data concerning them on the Internet. Often this material provides such information as titles of works, dates created, media, dimensions, subjects, plus provenance and present owners. Going through extensive inventory lists is time consuming, but the material gleaned can be significant. See [XIV-A-9] for information on *Art Inventories*, the Catalog of American Portraits, the U.S. White House and Department of State, and the U.S. General Services Administration.

Example

> In a search for works by John Singleton Copley, the Web site for *Art Inventories* cited 1,101 records for his paintings, many of which are owned by U.S. muse-

ums. Illustrations for many of these works are available at the Art Inventories Office in Washington, D.C.

Archives and Vertical Files

Remember to check the *Archives of American Art* [XIV-A-8] and the vertical file material discussed earlier in this chapter. In addition, there are extensive Canadian provincial archives [XIV-B-7] that have artist information. Also check the *Artists in Canada Vertical File* [XIV-B-8].

Resources That Index Works by Titles

Consult the following appropriate references, which are organized under artists' names and pinpoint exact titles owned by specific institutions. The works listed index paintings from all periods of art history. Remember that some computer databases, such as the *Marburger Index* (see below), index works of art. For references that index photographs, prints, and sculpture, see Chapter XIII.

Example

Wright's *World's Master Paintings,* cited below, lists almost 440 titles of paintings, sketches, modelli,[3] and frescoes by Tiepolo, owned by 190 museums. Also cited are 16 institutions with major collections of his work, such as the Art Institute of Chicago, the Metropolitan Museum of Art in New York City, and the Courtauld Institute of London. Since the Residenz ceiling is still in situ, it is not in a museum.

Indexes of Works by Titles

Census of Pre-Nineteenth-Century Italian Paintings in North American Public Collections, compiled by Burton B. Fredericksen and Federico Zeri (Cambridge, MA: Harvard University Press, 1972). Indexes works of art and includes an index to subjects: religious works, secular subjects, portraits and donors, and unidentified subjects and fragments.

Computerized Index of British Art 1550–1945: Photo Archive is a computer index to paintings, drawings, watercolors, sculpture, and prints by British and foreign artists working in Britain. Locations are known for most works. It is available only at the Yale Center for British Art; most telephone or written requests are answered.
<http://www.yale.edu/ycba/>

Dutch Art in America, compiled by Peter C. Sutton (Grand Rapids, MI: Wm. B. Eerdmans, 1986). Organized under 74 U.S. museums; includes thumbnail-size reproductions.

Old Master Paintings in Britain: An Index of Continental Old Master Paintings Executed before c.1800 in Public Collections in the United Kingdom, by Christopher Wright (London: Sotheby Parke Bernet, 1976). Indexes 1,750 artists in 233 British museums. It includes titles of catalogues of these museums.

Paintings in Dutch Museums: An Index of Oil Paintings in Public Collections in the Netherlands by Artists Born before 1870, by Christopher Wright (London: Sotheby Parke Bernet, 1980).

Indexes 3,500 artists in 350 Dutch institutions and includes titles of permanent-collection catalogues of these museums.

Paintings in German Museums: Gemälde in Deutschen Museen, compiled by Hans F. Schweers (2nd ed., greatly revised and expanded. 3 parts in 10 vols. Munich: K.G. Saur, 1994). Reports titles of works of art in the language the museums assign them. Covers art in 420 German museums including those formerly in the GDR (East Germany).

Part I: *Artists and Their Works* (Vols. 1–4)

Part II: *Iconographic Index* (Vols. 5–7)
Vol. 5: *Religious Themes, Mythologies, Historical Themes*
Vol. 6: *Depictions of Human Beings; Landscapes*
Vol. 7: *Everyday Life: Past and Present, Interior Scenes, Animal and Flower Paintings, Still Lifes, Fantastic Imagery, Allegories, Abstract Art, Action Painting*

Part III: *Museums and Their Paintings* (Vols. 8–10)

Witt Library Computer Index [V-G-2]

World's Master Paintings: From the Early Renaissance to the Present Day, by Christopher Wright (2 vols. New York: Routledge, 1992). A comprehensive listing of works in public museums by 1,300 painters and a guide to their worldwide locations. It also cites major collections and any catalogues raisonnés.

Resources That Index Works in Books

Another avenue for locating the owners of certain paintings is to consult books that index art reproduced in books and exhibition catalogues. Some entries include locations, when known. Below are books issued since 1977 that report paintings from all periods of art history; for references for architecture and prints, see Chapter XIII. For earlier publications, see the standard general art bibliographies [II-A-2].

Index to Two-Dimensional Art Works, by Yala H. Korwin (2 vols. Metuchen, NJ.: Scarecrow, 1981). Covers 250 books published 1960–77.

World Painting Index, by Patricia Pate Havlice (2 vols. Metuchen, NJ: Scarecrow, 1977). Indexes works of art in 1,167 books and catalogues, issued from 1940 to 1975.

First Supplement 1973–1980, 2 vols., 1982, covers 617 publications

Second Supplement 1980–1989, 2 vols., 1995, covers 697 publications

Web Sites for Geographical Location

If your topic is a well-known building or outdoor sculpture, search the Internet for its most precise geographical location. Sometimes governments place views of their most famous tourist attractions on the Internet to encourage people to visit them. For example, Amsterdam has posted extensive material on Dutch historical styles represented in that city [V-A]. A multi-engine search tool can be especially good for this type of search [I-B-2].

Example

Using a multi-engine search tool, an entry was found for *Würzburg On Line*. This Web site for the Residenz reproduced five illustrations of the palace <http://www.wuerzburg.de/wue/index/eng.html>. Notice that in the URL, *Würzburg* is spelled with a *ue; de* stands for *Deutschland*. From this Web site, you must choose *Tourism, famous sites, Residenz*.

Noncommercial Web Sites for Visual Material

The following Web sites from academic communities and the Library of Congress Web site consist mainly of reproductions, mostly for architecture, prints, and photographs. This category of Internet material, which is free for the viewer, is constantly changing; this is just a sample of what might be found. Some of the Web sites that were once free are now charging or requiring registration; see below.

Digital Image Center, University of Virginia [XIII-A-5]
<http://www.lib.virginia.edu/dic/collections/collections.html>

LC Prints and Photographs Division [VI-A-1]
<http://lcweb.loc.gov/>

SILs: Art Image Browser, University of Michigan [IV-A-5]
<http://www.sils.umich.edu/Art_History/>

SPIRO, University of California, Berkeley [XIII-A-5]
<http://www.ced.berkeley.edu/>

Example

In checking the Web site of *SILs: Art Image Browser* for illustrations of works by Giovanni Battista Tiepolo, four illustrations were reproduced: two etchings and two paintings. The former were owned by the University of Michigan Museum of Art; the latter, by the New Orleans Museum of Art. Nothing was located on the Residenz.

Commercial Sites for Visual Resources

Access the Web sites of commercial firms, listed in [II-E] and [VIII-F], to learn if they have any reproductions for sale that fit your requirements or any indexing services that will help you locate needed works of art. Some reproduce thumbnail-size pictures on the Internet for identification purposes. Most firms require you to register to view their Web sites.

Example

World Wide Arts Resources listed three sources for prints and a drawing by Tiepolo <http://wwar.com/artists1.html>. The prints were from an Australian site that you had to pay to view. The other was no longer available. Nothing was located on the Residenz.

CD-ROMs

Multimedia CD-ROMs contain a wealth of visual material on art; the subjects run the gamut from prehistoric art to the contemporary period. These CD-ROMs generally have outstanding color and furnish a scope not always available in other media. Moreover, CD-ROMs are a relatively permanent format that can be used with a computer anytime you wish. Samples of multimedia CD-ROMs appropriate to specific time periods are cited in [X-B], as well as in other chapters of this book. Remember to use museum-oriented CD-ROMs [III-C] that illustrate art in the museum's collection accompanied by additional data on the objects. Samples of some CD-ROMS are provided in the appropriate sections; for locating others, see [II-D].

Examples

1. For the 300th anniversary of the birth of the Venetian artist, the Metropolitan Museum of Art held an exhibition of Tiepolo's work. There were both a catalogue—*Giambattista Tiepolo: 1696–1770* (New York: Metropolitan Museum, 1996)—and a CD-ROM—*Giambattista Tiepolo: 1696 Venice–1770 Madrid* (CD-ROM. Rome: SACIS International, 1996). The multimedia CD-ROM, which contains a prodigious amount of Tiepolo's output, organizes its color illustrations as to place and time, paintings, the exhibitions, and the great fresco cycles, including the Residenz.

2. *Great Paintings: Renaissance to Impressionism: The Frick Collection* (CD-ROM. Digital Collections, 1994) reproduces full-color views of 138 paintings, many of which can be enlarged. If you know that Tiepolo's *Perseus and Andromeda* is owned by this New York museum, you can locate a reproduction of a study for his Milanese palace fresco on this CD-ROM.

Documentary Videos

Documentary videos, which usually have good color reproductions, furnish an overview of a subject that assists you in placing the art within its historical context. Currently, there are two videos that survey the wide range of Western European art. Samples of some pertinent documentaries are provided in the appropriate sections of this book; to locate others, see [II-E].

Art of the Western World, with Michael Wood (9 videocassettes of 50 minutes each Santa Barbara, CA: The Annenberg/CPB Project, 1989)

Civilization Video Series, written and narrated by Kenneth Clark (13 programs of 50 minutes each. Reissued London: BBC Lionheart Television, 1993).

Example

Program 9: *The Pursuit of Happiness,* of the *Civilization Video Series,* illustrates and discusses Tiepolo's Residenz ceiling for a full seven minutes. This is a wonderful overview of the palace hall that features Tiepolo's art.

An Indexing Tool: Iconclass

Some iconographic resources use the iconographic classification system called Iconclass, which uses numbers instead of language to pinpoint specific subjects. This language-neutral system is used in a number of indexes to prints [XIII-D-5] and some of the microfiche sets discussed below. Check Iconclass's Web site for more information <http://iconclass. let.ruu.nl/> or the publication *Introduction to Iconography* [XII-B].

Microfiche

Microfiche, with its ability to store massive amounts of material, is used to preserve and reproduce large collections of photographs, vertical file ephemera, and illustrations of art. Most of the material is reproduced in black-and-white; the sets are usually not indexed. However, they are arranged in some logical order, frequently organized by location, followed by types of buildings, religious architecture, and museums and their collections. Most of the illustrative material was photographed over a number of years, some of it decades ago. Even so, microforms assist researchers in locating certain historical art; they can be especially important if the art was destroyed or stolen after the photographs were taken. Remember, these microfiche sets are expensive; not all libraries will have them.

Conway Library, The Courtauld Institute of Art, The University of London: Photographic Research Library for Art History, has an estimated 800,000 images [XIII-A-5].

Marburger Index: Photographic Documentation of Art in Germany (Microfiche. Munich: K. G. Saur, 1977+). A collection of photographs, taken since 1850, covering material from the Middle Ages to the present. It includes art owned by German institutions that may or may not be by German artists. Three different sets, issued between 1978 and 1990, consist of a total of more than 920,000 images illustrating architecture, painting, sculpture, and arts and crafts. There are indexes for artists, portraits, topography, and subjects organized by Iconclass (see above).

Marburger Index: Guide to Art in Germany: Database on CD-ROM (CD-ROM. 2nd ed. Munich: K. G. Saur, 1996). Indexes material on the microfiche sets and includes an additional 21,000 images. This is the first of a series that will eventually cover the entire 300,000 works of art in the above microfiche sets.

Other microfiche sets published by K. G. Saur include

Austrian Index, 1996, with approximately 20,000 photographs

Index of Ancient Art and Architecture, 1988–90, with 270,000 photographs on monuments of Greek and Roman cultural heritage

Index Photographique de l'Art en France, 1979–81, with 95,000 photographs

Italien Index, 1991–92, with 60,000 photographs

Spanien und Portugal Index, 1995, with 30,000 photographs

Swiss Index, 1995, with 15,000 photographs

Example

To locate visual material on Tiepolo's Würzburg ceiling, the *Marburger Index: Photographic Documentation of Art in Germany* was consulted. This microfiche set, consisting of 98 frames per fiche, encompasses art located in Germany, arranged by city, followed by municipal architecture, sacred and secular architecture, and the museums and their collections. The visual material for Tiepolo's ceiling was formidable: a total of 980 separate black-and-white photographs including floor plans, outside views, and 100 illustrations of the frescoes, shown from various perspectives and in numerous details. This was the most extensive illustrative material located on the Residenz. None of it was in color.

Notes

1. A *monograph* is a treatise on an individual artist or subject, providing historical and biographical material and some information on the artist's works.

2. *In situ* means *in the place* and implies that the work of art is still at the site for which it was planned.

3. A *modello* is a drawing or painting—usually more finished than a sketch—frequently of a proposed work to be presented to a patron in hopes of receiving a commission; *modelli* is the plural form.

X. Art Historical Styles and Periods: Ancient World to Modern Era

One of the earliest and longest-lasting art history textbooks is Helen Gardner's *Art Through the Ages.* First published in 1926, the book follows the chronology of Western art from the prehistoric period to the 20th century. Profusely illustrated with black-and-white photographs and drawings, plus four-color reproductions, the 506-page first edition includes a glossary of terms, bibliographies, and separate chapters on India, China, and Japan. The contemporary art section is concerned with art created from 1900 to 1925. The third edition, which was issued in 1946 shortly before Gardner's death, has endured with revisions over the years by various art historians.

Since the 1930s, there have been extensive changes in art history textbooks [IX-B-1]. They have all followed a similar direction: (a) more and better visual material, (b) emphasis on contemporary art and the 19th-century works that influenced it, and (c) frequently expanded coverage of non-European art. These textbooks are expensive to produce; the cost of the legal rights to the visual material alone can be enormous. Consequently, you will probably never see a Web site displaying the contents of an art history book that is still in copyright. If you are in school,

save your art history textbook. If you do not own one, you might consider purchasing either a new or used one, for these books are good sources for concise material for beginning students and Web surfers.

These printed textbooks, however, cannot satisfy the demand for good visual material. Whereas a book may reproduce a single, frontal view of a building, students and researchers need to examine various sides and details plus aerial views and floor plans. This is one of the assets of the newer visual formats such as CD-ROMs, documentary videos, and microfiche sets, as well as the Web sites that include illustrations. Thus, there is developing a symbiotic relationship: Web material supplemented with scholarly printed text, and printed material enhanced with visuals from various sources including the Web.

This chapter is concerned with Western European artistic styles and periods from the ancient world to the modern era. It is subdivided into (a) a discussion of additions to the seven methodological steps explained in Chapter IX that need to be considered for art historical research and (b) an outline of additional resources for four major time periods.

X-A. Additions to the Seven Basic Research Steps

The previous chapter detailed seven basic steps in art history research, including suggestions for locating visual material. Since the information outlined below supplements that data, you should (a) review the material in Chapter IX; (b) read the seven steps discussed below, which pertain directly to art historical subjects; (c) choose your subject's specific time period to discover additional references, located in [X-B], below; and (d) check for additional material in Chapter XIII

that specializes in architecture, photographs, prints, and sculpture.

X-A-1. Step 1: Art History Survey Books

Art history textbooks are discussed in [IX-B-1]. A first research step is to narrow the subject to one that can be completed within the allotted time frame. An over-

view of an art history subject often can be quickly obtained by reading general art history textbooks. Determine the historical dates of the art you are researching as closely as possible, inasmuch as some references categorize art styles by dates, such as 4th-century Greek art or 18th-century painting. When applicable, note any specific artists associated with the historical style or period, since resources on individuals are frequently easier to locate. Remember the importance of viewing actual art objects and, if this is impractical, of obtaining numerous visual images of the art being studied. You are then ready to follow the next steps.

Example

The project is to write an illustrated report on one of the Seven Wonders of the World. Of the four art history survey books cited, only Stokstad includes *Seven Wonders of the World* in the index. Two books—Stokstad and Janson—discuss the Mausoleum at Halicarnassus. Each includes several paragraphs on the monument, a map locating Halicarnassus in Turkey, and two illustrations: of the statue of Mausolus in London's British Museum and a reconstructed drawing of the tomb. Since both include just this detail of the monument, other material will be needed to visualize the entire mausoleum.

One book dates the mausoleum to c. 353 B.C., the other provides a range, 359–351 B.C. Remember, the dates ascribed to ancient monuments often conflict, due to the various methods by which historical time is calculated. The spellings also differ: One book uses the Greek, *Halikarnassos*; the other, *Halicarnassus*, the preferred spelling reported in the *LC Subject Headings* [VI-E-3]. The subject was narrowed to "The Mausoleum at Halicarnassus: The Original Monument and Its Present State."

X-A-2. Step 2: Dictionaries and Encyclopedias

Dictionaries and encyclopedias are discussed in [IX-B-2]. Consult the latest art encyclopedia available to you, since this will reduce your research time considerably.

General Encyclopedia Example

An advantage to *The Encyclopædia Britannica Online* is that it enables you to locate an entry even if you do not know how to spell the word—a potential problem with *Halicarnassus,* which has two proper spellings. By entering a section of the word—in this case, *Halicarn*—you will receive (a) a list of terms

that sound similar to your topic and (b) an alphabetical list of words near this spelling in the encyclopedia. Although there are only two short paragraphs on the mausoleum, there is a hyperlink to the Web site for the Seven Wonders of the World, discussed below <http://www.eb.com/>.

Art Encyclopedia Example

The Dictionary of Art contains a four-and-a-half-page essay on the Halikarnassos mausoleum. Written by the noted expert G. B. Waywell, the article discusses the monument, ancient literary sources, and the results from various site excavations. Mention is made that some of the frieze was probably carved by the Greek sculptor Skopas and that the mausoleum is located in the Turkish region of Caria. The article includes a map, a reconstructed elevation, and two illustrations: (a) statues thought to be Mausolus and his wife Artemisia and (b) a section of the mausoleum frieze. Both are in London's British Museum. In addition, there is a bibliography listing 22 items published from 1581 to 1992.

X-A-3. Step 3: The Internet

Using the Internet for research is discussed in [IX-B-3]. Once the topic is narrowed, you are ready to access the Web. Remember, the search engines do not always discover the same material or important Web sites; be sure to consult (a) the OPACs of your local libraries to form a preliminary reading list, (b) single-subject Web sites, (c) online indexes to Web material, and (d) search engines.

Preliminary Reading List

If you have followed the steps outlined above, you probably have a number of bibliographic citations. This does not mean, however, that your library owns the books or the serials containing the articles. You still need to search your local institution's OPAC (a) to determine the availability of the material for which you have references and (b) to discover additional resources.

Example

The Dictionary of Art furnishes the titles of 13 English-language books and mentions that the fourth-century B.C. Greek sculptor Skopas probably created some of the mausoleum frieze. A keyword search of a local library's OPAC for *Halicarnassus*—the LC cataloguer's spelling—brought forth six items, none of which were for the ancient mausoleum. A keyword search for *seven wonders world*

produced no entry, nor did *Skopas*. A subject search for *Greek sculpture*, however, found several publications, each with about a page of text on *Skopas*.

Single-Subject Web Sites

Two types of Internet sites with extensive information on early civilizations are (a) those on academic courses and (b) those concerned with a single historical style or period.

Academic Courses

See the list of interdisciplinary courses and the individual art history courses suggested in [IV-A-2]. Check the indexes to Web material, cited below, and use the search engines to locate academic courses on specific subjects.

Examples

1. The Web site of *Exploring Ancient World Cultures* [IV-A-2] has special sections on the Near East <http://eawc.evansville.edu/about.htm>.

2. *The University of Wisconsin Art History Survey Course: Ancient and Medieval Art* includes information on the mausoleum, a map, several photographs, and two reconstructions of the monument. Mausolus's death is given as 353 B.C.; his wife Artemisia, 351 B.C. Included are small identifying illustrations of (a) the frieze depicting the Battle of the Greeks and the Amazons, (b) details of the statues of Mausolus and Artemisia, and (c) views of a lion and a horse. This was the most extensive visual material located on the Web <http://www.wisc.edu/arth/ah201/index.html>.

Web Sites on Single Subjects

The following are some of the Web sites listed below in [X-B-1].

Examples

1. *The Perseus Project,* Tufts University, is an outstanding scholarly Web site concerned with primary data on ancient Greek literature, art, and culture [IV-A-3] <http://www.perseus.tufts.edu/>.

2. *Abzu: Guide to Resources for the Study of the Ancient Near East Available on the Internet* is a project and publication of the Oriental Institute at the University of Chicago. This Web site has hyperlinks to numerous worldwide projects, museums, and exhibitions concerning the ancient Near East <http://www-oi.uchicago.edu/OI/DEPT/RA/ABZU/ABZU.HTML>.

3. *Diotima: Materials for the Study of Women and Gender in the Ancient World* has essays, bibliographies, an index to visual material, and hyperlinks to significant Web sites <http://www.uky.edu/ArtsSciences/Classics/gender.html>.

4. *Focus: MultiMedia* concentrates on countries surrounding the Mediterranean. Under Turkey, Caria, there is historical information on Halicarnassus, once Caria's capital <http://www.focusmm.au/welcome.htm/>.

5. *Seven Wonders of the World,* Boston University, briefly describes the mausoleum and its present condition. Its bibliography was the most comprehensive found on the Web <http://pharos.bu.edu/Egypt/Wonders/>.

Indexes to Web Material

There are few Internet locations that index the material on individual Web sites; be sure to check these resources, see [III-A-5] and [IV-A-4]. Perhaps not surprisingly, none of these indexes located anything on the rare and not widely known site of Halicarnassus. Their focus is on better-known subjects.

Search Engines

Search engines are discussed in [IX-B-3]. Remember that they do not always locate the most relevant Web sites. For assistance on using the search engines, see [I-B].

Example

Trying both spellings and searching for *Halicarnassus* and *Halikarnassos*, AltaVista found 200 sites; Excite, 303; and Lycos, 129.

It is interesting to note which search engines located the five Web sites cited above. Both Excite and Lycos found *Diotima*. Only AltaVista located *Focus* and *Seven Wonders of the World.* None of the search engines located *The Perseus Project*, which is one of the most scholarly Web sites on the list. *Perseus* [IV-A-3] furnishes enormous amounts of pertinent information on Halicarnassus <http://www.perseus.tufts.edu/>. Nor did any of the search engines locate *Abzu: Guide to Resources for the Study of the Ancient Near East Available on the Internet,* another important Web site.

AltaVista cited the *Speakeasy Cafe,* which was not found by the other search engines <http://www.speakeasy.org/~music/hal.html>. This Web site reproduces pictures of the Mausoleum of Halicarnassus frieze and furnishes an English translation of material written on Amazons by the ancient historian Herodotus. The other Web sites located by the three search engines added little to the Halicarnassus

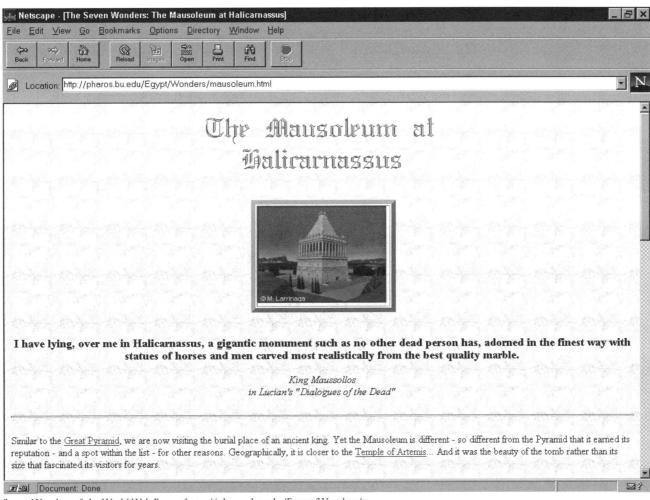

Seven Wonders of the World Web Page <http://pharos.bu.edu/Egypt/Wonders/>

study. To search and check all the Internet sites that the search engines reported required more than an hour of computer time. To obtain comparable data, it was quicker to check *The Dictionary of Art.*

X-A-4. Step 4: Comprehensive Bibliography

Comprehensive bibliographies are discussed in [IX-B-4]. For a brief report, you may need only a preliminary reading list, but for academic papers and presentations, you need to develop a more comprehensive bibliography. To produce it, augment your reading list by following the steps discussed in Chapter IX:

- search other libraries' OPACs, especially those with outstanding collections of works on your subject
- check published bibliographies
- discover the latest scholarly exhibition catalogues

- locate significant articles in the periodical literature

Example

A keyword search for *Halicarnassus* using the OPAC of the New York Public Library brought forth seven items, two of which were significant to the study: *Architect and Sculptor in Classical Greece,* by Bernard Ashmole (Wrightsman Lecture. New York: New York University Press, 1972), and *The Free-Standing Sculptures of the Mausoleum at Halicarnassus in the British Museum: A Catalogue,* by G.B. Waywell (London: British Museum Publications, c. 1978). Remember, Waywell wrote the Halikarnassos entry for *The Dictionary of Art* <http://catnyp.nypl.org/>.

A keyword search for *seven wonders world,* using this same New York library, produced entries for *The Seven Wonders of the Ancient World,* edited by Peter Clayton and Martin Price (New York: Dorset Press, 1988) and *The Seven Wonders of the World: A History of Modern Imagination,* by John and Elizabeth Romer (New York: Henry Holt, 1995). In the former, Waywell wrote the Halikarnassos entry.

No separately published bibliographies or exhibition catalogues on the topic were discovered. None of the searches of the indexes of art literature located any pertinent material on this topic. The four books discovered through the New York Public Library's OPAC were the best sources for this study.

X-A-5. Step 5: Pronunciation

Pronunciation is discussed in [IX-B-5]. You should learn the correct pronunciations for all artists, monuments, styles, and historical characters.

Example

The dictionary section of *Microsoft Bookshelf* provides the oral pronunciation of Halicarnassus, plus information on the tomb and its location.

X-A-6. Step 6: Special Resources

Special resources are discussed in [IX-B-6]. While special resources are needed primarily by those conducting in-depth research, those with simpler projects will still find it profitable to use some of the references cited here. First, remember that archival material, vertical files, and documents and sources—all discussed in [IX-B-6]—may provide significant information. When trying to comprehend an artistic style and/or period, the following six items may also assist you in your endeavors.

Understanding the Historic Changes Made in the Calendar over the Centuries

There have been a number of different calendars since history has been recorded. Prior to 153 B.C., the Roman calendar began the new year on March 1 and had its months named after the Roman gods or the Roman terms for 1 through 10. Thus, September really was the seventh month and December, the tenth. The beginning of the new year changed to January first when the Roman consuls, who paid to have the years named after them, began to take office on that date.

The Roman calendar was changed in 46 or 45 B.C., when its sponsor, Julius Caesar, declared that a year consisted of 365¼ days. Leap year was created to even out the days, and 90 days were added to synchronize the then Roman calendar. Julius Caesar also inserted

the month of July, named for himself. When, in 7 B.C., Caesar Augustus rearranged this Julian calendar, renaming a month for himself, the calendar was on the road to creating confusion.

Our present Gregorian calendar is based on the Roman Julian one and named for Pope Gregory XIII (1502–85; papal reign 1572–85). It was recognized by Catholic countries on October 4, 1582, which became October 15, as this alteration necessitated losing 11 days. The Gregorian calendar was finally accepted by Britain and her colonies on September 3, 1752, a date that immediately became September 14. Russia did not change to the Gregorian calendar until 1918. You will thus find that dates, especially in the early centuries prior to 1752, often disagree.

A reprint of the article "Calendars," by L. E. Doggett, is available on the Internet <http://astro.nmsu.edu/~lhuber/leaphist.html>. For assistance in converting specific dates, see *Calendar Conversions Overview* <http://genealogy.org/~scottlee/caloverview.html> and *The English Calendar,* by Ian MacInnes <http://www.albion.edu/fac/engl/calendar/>. For a concise history of changes made since the beginning of time in various parts of the world, read G. J. Whitrow's *Time in History: The Evolution of Our General Awareness of Time and Temporal Perspective* (New York: Oxford University Press, 1988).

Formulating a Chronology of the Period in Which the Art Was Created

To comprehend the interaction of different countries and cultures during the period you are researching, you should formulate a chronological list of major events. Always expand the timeline on either side of the date the art you are studying was created. Search for dates that pinpoint what was happening throughout the then-known world. Some of the general art history textbooks, especially Janson's *History of Art,* have good chronologies that will help you create your own.

If a general chronology of the period can be located, it may indicate the important events occurring in other disciplines and in different parts of the world. Finding a chronology upon which to build may assist you in developing one pertinent to your study. You will quickly discover, however, that not all timelines

are created equal: Some are superior, but most are sketchy. Constructing a meaningful chronology can be a slow and painstaking project.

There are a number of detailed timelines available on the Internet; most are concerned with literature and/or history. This type of material is becoming more prevalent as Web sites proliferate. For some timeline examples, see the following Web sites:

Exploring Ancient World Cultures
 <http://eawc.evansville.edu/about.htm>

Media History Project Web Site
 <http://www.mediahistory.com/time/century.html>

Timelines, North Texas Institute for Educators on the Visual Arts, an index to art and cultural timelines
 <http://www.art.unt.edu/ntieva/artcurr/time.htm>

Timelines of Art History
 <http://www.dc.infi.net/~gunther/>

Chronology Print Sources

Anchor Atlas of World History, by Hermann Kinder and Werner Hilgemann, translated by Ernest A. Menze (New York: Anchor Books, 1974)

 Vol. I: *From the Stone Age to the Eve of the French Revolution*

 Vol. II: *From the French Revolution to the American Bicentennial*

Asimov's Chronology of Science and Discovery, by Isaac Asimov (New York: Harper & Row, 1989)

History's Timeline: A 40,000 Year Chronology of Civilization, by Jean Cooke, et al. (New York: Crescent Books, 1981)

Kingdoms of Europe: An Illustrated Encyclopedia of Ruling Monarchs from Ancient Times to the Present, by Gene Gurney (New York: Crown, 1982)

Past Worlds: The Times Atlas of Archaeology (Maplewood, NJ: Hammond, 1988)

People's Chronology: A Year-by-Year Record of Human Events from Prehistory to the Present, by James Trager (Revised ed. New York: Henry Holt, 1992). Also available through the Chronology section of *Microsoft Bookshelf* (multimedia CD-ROM. Redmond, WA: Microsoft, 1995).

Timetables of History, by Bernard Grun (3rd ed. New York: Simon & Schuster, 1991)

Women's Chronology: A Year-by-Year Record, from Prehistory to the Present, by James Trager (New York: Henry Holt, 1994)

Example

 Since the Mausoleum of Halicarnassus was constructed in the fourth century B.C., any pertinent information concerning this period and area of the world might assist you in discerning why this art was produced at that particular time in history. The dates gleaned from the previous readings included:

 359 B.C.: Sometime between this date and 351 B.C., mausoleum was created

 353 B.C.: Death of Mausolus

 351 B.C.: Death of Artemisia, wife of Mausolus
 The People's Chronology added:

 432 B.C.: Parthenon in Athens finished

 404 B.C.: End of Peloponnesian War between Persia and Greece

 384 B.C.: Birth of Aristotle (384–322 B.C.)

 356 B.C.: Temple of Artemis in Ephesus built

 350 B.C.: First reference to wheat suitable for breadmaking

Finding Historical Maps to Illustrate the Country's Size and Neighbors

Locate a historical map of the period to determine the relationships of countries or geographical locations at specific points in time. The printed resources cited below may assist you in learning about the history of mapmaking.

The Image of the World: 20 Centuries of World Maps, by Peter Whitfield (London: The British Library, 1994; reprint, Rohnert Park, CA: Pomegranate Artbooks, 1997). Discusses the history of mapmaking and reproduces more than 50 maps.

Maps and History: Constructing Images of the Past, by Jeremy Black (New Haven, CT: Yale University Press, 1997). Explores the development of historical maps and their impact on history.

Maps and Map-Makers, by R.V. Tooley (7th ed. New York: Dorset Press, 1987). Contains about 100 illustrations and lengthy bibliographies for the history of maps.

The importance of historical maps and the lack of good ones is illustrated by the *Classical Atlas Project,* initiated by the American Philological Association. The project is under the directorship of Professor Richard Talbert, University of North Carolina, Chapel Hill. One aspect of the project is the future publication, scheduled for 1999, by Princeton University Press of an atlas of the Greek and Roman world, covering from about 1000 B.C. to A.D. 640. The planned 175 maps will be supplemented by cultural data provided by an international team of more than 70 scholars <http://www.unc.edu/depts/cl_atlas/>.

Historical Maps

Anchor Atlas of World History, mentioned above

Atlas of British History: From Prehistoric Times until 1978, by G.S.P. Freeman-Grenville (London: Rex Collings, 1979)

Harper Atlas of World History (New York: Harper & Row, 1987)

The Image of the World, British Library, illustrates maps dating from about A.D. 150 to 1849. This material was reproduced in *Earth & the Heavens: The Art of the Mapmaker,* and is available as a book, CD-ROM, or on the Internet (London: Macromedia, 1995).
 <http://portico.bl.uk/exhibitions/maps/>

National Geographic Atlas of World History (Washington, D.C.: National Geographic, 1997)

Perry-Castañeda Library Map Collection, University of Texas, Historical Map Web Sites
<http://www.lib.utexas.edu/Libs/PCL/Map_collection/map_sites/hist_sites.html>

Rand McNally Atlas of World History (Chicago: Rand McNally, 1987), a revision of *Hamlyn Historical Atlas* (London: Hamlyn, 1981)

Times Atlas of World History, edited by Geoffrey Barraclough (Maplewood, NJ: Hammond, 1993)

Example

The *Perseus Project* [IV-A-3] furnishes a map showing the relationship of Halicarnassus to Athens, Greece. The *Anchor Atlas of World History* reproduces two significant maps: Greece and Macedonia under Philip II and Alexander the Great's campaign, 336–323 B.C.

Checking Topographical Guides and Travel Books for Locations of Art Monuments

When studying architectural history, you need to understand the topography during the time of the studied monument or building. Topographical guides and travel books that cover specific buildings and monuments in various regions often provide significant information concerning changes in international boundary lines and national affiliations. These changes may have influenced concepts and/or building techniques.

Travel books, such as the Baedeker and Michelin Guide series, often describe the appearance and condition of buildings at particular historical periods. Because some of these books were issued during the 19th century, they describe European monuments that have since been destroyed or damaged by two world wars. Only four titles are cited below, accompanied by the date of their earliest publication. For additional titles, see the standard general art history bibliographies [II-A].

Baedeker Guides, by Karl Baedeker (Leipzig: Baedeker, 1843+). Provides individual books on cities, regions, and countries, especially of Europe. Special issues, such as *Guide to the Public Collections of Classical Antiquities in Rome*, translated by Wolfgang Helbig, 1895, are especially valuable for classical studies.

Eyewitness Travel Guides (London: Dorling Kindersley Publishing, 1990s). Cover mostly cities—London, Paris, Rome, Florence, Venice, Prague, and Amsterdam—and a few countries, including France and Ireland. Include numerous color illustrations.

John Murray Handbooks (London: John Murray, 1842+). Include individual books on European countries and India, as well as a number of English shires.

Michelin Guides (Paris: Michelin, 1919+). Publishes green guides to various regions in France as well as to international countries, which include detailed local maps for discovering difficult-to-find works. In 1919, Michelin published a book on areas of France during and after World War I.

Consulting Some Resources on the Social History of the Period

Art was not created in a vacuum. Each work of art reflects many influences: artistic, educational, literary, religious, musical, theatrical, historical, political, economical, social, geographical, and scientific. In addition, pressure on the artist could be exerted by the patron who commissioned or purchased the work. These factors have an impact on the form as well as the subject of art. Books emphasizing the social history aspects of a period will help you understand the civilization in which the art was produced.

Social history was not the concern of historians until about the 18th century, a period when history painting increased in popularity, especially in England[1] and France. This precipitated the need to create authentic backgrounds relative to the time period being depicted. History books on furnishings, military accouterments and attire, fashionable dress, and native costumes were compiled. The small volumes of such series as *Everyday Things* and *Everyday Life* and the history of costume books often provide insights into the social living conditions of specific time periods. The *Godey's Lady's Book*, which is being placed online, discusses 19th-century fashion and furnishings and describes children's games and other customs of the period <http://www.history.rochester. edu/godeys/>. A few titles of these types of books are included in [X-B], below.

Museums are placing more information concerning the social history of specific historical periods on their Web sites. This can be in relationship to their collection or an exhibition. For example, the Maltwood Art Museum, University of Victoria, Canada, is mounting a continuing online exhibition concerned with the arts in relationship to the natural world, religion, the economy, leisure, everyday life, death, and scholarship. For each subject, there is a brief overview and illustrations that reflect the theme <http://www. maltwood.uvic.ca/>.

To locate information on social history, consult the general encyclopedias, pertinent genealogy tables, and resources for historical material. These will increase your knowledge of (a) the society for which the art was created; (b) the legal, religious, and cultural events affecting the people of the region; and (c) any special changes impacting the style of the art. Although insufficient for in-depth studies, encyclopedia articles often provide an overview of the subject. Another good source is *Western Civilizations: Their History and Their Culture*, by Robert E. Lerner, et al. (13th ed. 2 vols. New York: W. W. Norton, 1998)

If you need to understand the ruling monarchs of a country, consult genealogy tables, such as the Web site of the *Directory of Royal Genealogical Data,* prepared by Brian C. Tompsett of the University of Hull <http://www.dcs.hull.ac.uk/public/genealogy/royal/>. You may also need pertinent documents and sources from which historical concepts were derived; some of these types of resources are included in the appropriate sections of this book.

A word of warning: historians and art historians do not always agree on terms or dates. Use the suggested historical reading lists found through academic course syllabi and/or single-subject Web sites. Remember to check the *Index of Resources for Historians* [IV-A-4], which furnishes hyperlinks to historical and regional subjects <http://www.ukans. edu/history/>.

Example

The best source for a brief discussion of the history of the country and time period of the Mausoleum at Halicarnassus was *The Encyclopædia Britannica Online.* In addition to the two paragraphs under Halicarnassus, there are related categories—accompanied by hyperlinks to the material—such as the ancient Near East, religious and commemorative architecture, and the Achaemenid Persian Empire. There are also separate entries for the ruler Mausolus; his country, Caria; the Greek sculptor Scopas; the Amazons of Greek mythology; and the Roman writer Pliny the Elder, who described the Halicarnassus Mausoleum.

Discovering Literature That Either Might Have Influenced the Art or Is Pertinent to Its Understanding

Discover literature important to the period that might have (a) discussed the work of art or the artist or (b) influenced the subject or symbolism depicted in the art. The literature prevalent at the time the art was created may be located (a) in the cultural history books, such as those noted above; (b) in documents and sources [IX-B-6]; or (c) through one of the Web sites, such as those offering academic courses. Once the title of the literature is known, a copy of an English translation of the work can sometimes be found on the Internet. Check the sites that reproduce full-text literature on the Web [VI-F].

Example

The Perseus Project's special interest is primary data [IV-A-3]. At this Web site, there are entries for Mausolus, his wife Artemisia, and the sculptor Scopas. Although there is no text describing these individuals, three ancient authors—Herodotus, Pausanias, and Apollodorus—who mention them are cited. Hyperlinks take you to English translations of their writings.

The Dictionary of Art states that Roman authors Pliny the Elder (A.D. 23–79) in his *Natural History* and Vitruvius (first century B.C.) in his *On Architecture* describe the mausoleum. Since the title of the frieze is the *Battle of the Greeks and the Amazons*, material on the historical interpretations of Amazons is important. There were quotes from Herodotus and Plutarch on Amazons located through the *Speakeasy Cafe* Web sites <http://www.speakeasy.org/~music/amazon7.html>. For a brief biographical entry on Herodotus, see <http://www.focusmm.com.au/~focus/heradot.htm>. For excerpts from his *History*, written about 440 B.C., see the George Rawlinson translation <http://www.focusmm.com.au/~focus/civcty/ant_book/ history1.htm>.

At the time of this search, there was no full-text English translation of Pliny's *Natural History*. This may soon change; either one of the institutions placing full-text material will choose this Roman author's work or the *Roman Perseus Project* will have been launched. Administrators of *The Perseus Project* have already received a grant to establish a Web site similar to the Greek one <http://www.perseus.tufts.edu/neh.ann.html>.

Project Bartleby [VI-F-2] at Columbia University has placed the entire ninth edition of *Bartlett's Familiar Quotations*, published in 1901, on the Internet. Although not adequate for in-depth research purposes, there are quotations from Pliny's *Natural History* <http://www.columbia.edu/acis/bartleby/>. For a printed source, see Pliny the Elder's *Historia Naturalis,* translated by K. Jex-Blake (10 volumes. Chicago: Argonaut, 1968).

X-A-7. Step 7: Visual Resources

Follow the steps discussed in [IX-B-7]. Locate the pertinent art museums, CD-ROMs, and documentary videos cited in the appropriate part of [X-B], below.

Examples

1. London's British Museum owns most of the surviving Halicarnassus sculpture pieces, but this art is not presently documented at the museum's Web site <http://www.british-museum.ac.uk/highligh.htm>.

2. The only CD-ROM to include Halicarnassus, *Perseus 2.0 CD-ROM,* displays four views of the mausoleum art in the British Museum: two views of Mausolus and one each of Artemisia and the horse, but none of the frieze itself. There is, however, a drawing that illustrates how the mausoleum might have appeared. The Web site provides a scholarly entry for each work of art. [IV-A-3].

3. The second videotape of John Romer's *Seven Wonders of the World* discusses the mausoleum and illustrates the archaeological site today.

X-B. Sources for Art History Periods

The sources cited below are just suggestions of the kinds of material that are available; they are not definitive lists. Additional material on architecture, sculpture, graphic arts, and photography is provided in Chapter XIII; archaeology material is excluded. Choose the period that most closely resembles that of your study to discover additional resources for your research:

- Early civilizations: Egypt, Mesopotamia, Greece, and Rome
- The Middle Ages and the Byzantine world
- The Renaissance and Baroque periods, and the 18th century
- The 19th and 20th centuries

The following sources, which are only a sample of what is available, are organized into seven categories:

- art history survey books, most of which were published or reissued post-1980; for earlier works, see general art bibliographies [II-A]
- Web sites encompassing all subjects concerned with the period, including those for individual artists
- Web sites for museums and libraries noted for material on the period
- documents and sources
- history references, which may be divided into (a) general works and encyclopedias and (b) social history books
- historical maps and timelines
- CD-ROMs and videos

X-B-1. Early Civilizations: Egypt, Mesopotamia, Greece, and Rome

Early Civilizations Art Survey Books

Art in the Hellenistic Age, by Jerome Jordan Pollitt (New York: Cambridge University Press, 1986)

Greek Art, by John Boardman (Rev. ed. New York: Thames & Hudson, 1985)

Greek Sculpture: Archaic Period, by John Boardman (New York: Thames & Hudson, 1985)

Greek Sculpture: An Exploration, by Andrew Stewart (New Haven: Yale University Press, 1990)

Greek Sculpture: Classical Period, by John Boardman (New York: Thames & Hudson, 1985)

Greek Sculpture: The Late Classical Period and Sculpture in Colonies and Overseas, by John Boardman (New York: Thames & Hudson, 1995)

Handbook of Greek Art, by Gisela Richter (9th ed. Jersey City, NJ: DaCapo Press, 1987)

Pelican History of Art Series, Nikolaus Pevsner and Judy Nairn, original joint editors (Baltimore, MD: Penguin, 1953–92; New Haven: Yale University Press 1990s+)

 Ancient Iraq, 2nd edition, by Georges Roux, 1985

 Greek Architecture, 5th edition, by A. W. Lawrence, 1996

 Roman Art, 2nd edition, by Donald Strong, 1988

Penguin Guide to Ancient Egypt, by William J. Murnane (Harmondsworth, Middlesex, England: Penguin, 1983)

Understanding Greek Sculpture, by Nigel Spivey (London: Thames & Hudson, 1996)

Early Civilizations Web Sites

This section is divided into Web sites covering (a) general early civilizations, (b) Egyptian art, (c) Greek art, and (d) Etruscan and Roman art.

General Early Civilizations Web Sites

Abzu: Guide to Resources for the Study of the Ancient Near East Available on the Internet, Oriental Institute, the University of Chicago
<http://www-oi.uchicago.edu/OI/DEPT/RA/ABZU/ABZU.HTML>

Ancient World Web, Julia Hayden
<http://www.julen.net/aw/>

Argos: Limited Area Search of the Ancient and Medieval Internet [I-B-2]
<http://argos.evansville.edu/>

ArtServe, Australian National University
<http://rubens.anu.edu.au/>

Diotima: Materials for the Study of Women and Gender
<http://www.uky.edu/ArtsSciences/Classics/gender.html>

Focus: MultiMedia is concerned with countries surrounding the Mediterranean. This is a travel site with extensive cultural material on Spain, France, Italy, Greece, Malta, Morocco, Turkey, Lebanon, Israel, Jordan, Egypt, and Tunisia. It provides illustrated essays and maps on the ancient history and art of countries; and on historical characters, such as Alexander the Great, Herodotus, and the Crusaders.
<http://www.focusmm.au/welcome/htm>

Internet Resources for Classical Studies, University of Indiana
<http://www.indiana.edu/~kglowack/internet.html>

Pilgrimage to ABYDOS (Egypt), Berger Foundation
<http://sgwww.epfl.ch/BERGER/>

Seven Wonders of the World under the direction of Dr. Alaa K. Ashmawy, Boston University, provides the location and history for each archaeological monument, accompanied by renditions of its supposed original appearance. This site, which also includes a bibliography, covers the Great Pyramid of Giza, Hanging Gardens of Babylon, Statue of Zeus at Olympia, Temple of Artemis at Ephesos, Colossus of Rhodes, and Pharos (lighthouse) at Alexandria.
<http://pharos.bu.edu/Egypt/Wonders/>

Yahoo's List of Classical Resources
<http://www.yahoo.com/Arts/Humanities/Classics/>

Egyptian Art Web Sites

American Discovery of Ancient Egypt
<http://www.lacma.org/Exhibits/a.d.AE/default.htm>

Art of the Fake: Egyptian Forgeries from the Kelsey Museum of Archeology
<http://www.ipl.org/exhibit/kelsey/>

Egypt Page, University of Pennsylvania
<http://www.sas.upenn.edu/African_Studies/Country_Specific/Egypt.html>

Egypt WWW Index, Boston University
<http://pharos.bu.edu/Egypt/>

Egyptology Resources, Cambridge University
<http://www.newton.cam.ac.uk/egypt>

Greek Art Web Sites

Ancient Greek World at the University of Pennsylvania
<http://www.museum.upenn.edu/Greek_World/Intro.html>

Dilos Holiday contributes illustrated data for historical monuments throughout Greece and presents extensive material on Crete's Minoan culture.
<http://www.dilos.com/>

Greek Jewelry: Five Thousand Years of Tradition
<http://www.addgr.com/jewelelka/index.html>

Greek Vase Tour, Krannert Art Museum, University of Illinois at Urbana-Champaign
<http://www.art.uiuc.edu/kam/GreekKam/grkintro.html>

Masterworks of Greek and Roman Art includes material on daily life, death rituals, and vocabulary
<http://www.bampfa.berkeley.edu/exhibits/greek/>

The Perseus Project (see [IV-A-3])
<http://www.perseus.tufts.edu/>

Web Site for Greek and Roman Culture, Holycross University, Professor Thomas R. Martin
<http://perseus.holycross.edu/>

Women's Life in Greece and Rome, compiled by Mary R. Lefkowitz and Maureen B. Fant
<http://www.uky.edu/ArtsSciences/Classics/wlgr/wlgr-index.html>

Etruscan and Roman Art Web Sites

Classical and Mediterranean Archaeology Home Page, University of Michigan, has extensive hyperlinks to every aspect of this subject, including field projects
<http://rome.classics.lsa.umich.edu/welcome.html>

Etruscan Art and Archaeology Course, Bowdoin College
<http://www.bowdoin.edu/dept/library/classes/clas/305/index.html#internet>

"Palace" of Diocletian at Split, Michael Greenhalgh, University of North Carolina
<http://www.sunsite.unc.edu/expo/palace.exhibit/intro.html>

Roman Portraits from Egypt, Berger Foundation
<http://sgwww.epfl.ch/BERGER/>

Romarch: Roman Art and Archaeology, University of Michigan, has hyperlinks to scholarly data and is organized by countries having Roman ruins
<http://www.personal-umich.edu/~pfoss/ROMARCH.html>

Museums with Early Civilization Collections

This section is divided into (a) Egyptian and Mesopotamian collections, and (b) classical collections of Greek, Etruscan, and Roman art.

Egyptian and Mesopotamian Collections

British Museum, London
<http://www.british-museum.ac.uk/highligh.htm>

Brooklyn Museum
<http://www.brooklynart.org/>

Egyptian Museum, Cairo
<http://www.idsc.gov.eg/culture/egy_mus.htm>

Institute of Egyptian Art and Archaeology, University of Memphis
<http://www.memst.edu/egypt/main.html>

Metropolitan Museum of Art, New York City
<http://www.metmuseum.org/>

Musée du Louvre, Paris
<http://mistral.culture.fr/louvre/louvrea.htm>

Museum of Archaeology and Anthropology, University of Pennsylvania
<http://www.upenn.edu/museum/>

Museum of Fine Arts, Boston
<http://www.mfa.org/>

Oriental Institute, University of Chicago
<http://www.oi.uchicago.edu/OI/MUS/
OI_Museum.html>

University of Wales, Swansea, Great Britain
<http://www.swan.ac.uk/classics/mushp.html>

Classical Collections of Greek, Etruscan, and Roman Art

Acropolis Museum, Athens
<http://www.culture.gr/2/21/211/21101m/
e211am01.html>

Ancient Olympic Games Virtual Museum, Dartmouth University
<http://devlab.dartmouth.edu/olympic/>

Archaeological Museum of Thessaloniki, Greece
<http://alexander.macedonia.culture.gr/2/21/211/
21116/e211pm01.html>

Ashmolean Museum of Art and Archaeology, University of Oxford, Cast Museum
<http://www.ashmol.ox.ac.uk/>

British Museum, London
<http://www.british-museum.ac.uk/highligh.htm>

Brooklyn Museum
<http://www.brooklynart.org/>

Harvard University Art Museums
<http://www.artmuseums.harvard.edu/>

J. Paul Getty Museum, Los Angeles
<http://www.getty.edu/museum/>

Metropolitan Museum of Art, New York
<http://www.metmuseum.org/>

Musée du Louvre, Paris
<http://mistral.culture.fr/louvre/louvrea.htm>

Museum of Archaeology and Anthropology, University of Pennsylvania
<http://www.upenn.edu/museum/>

Museum of Classical Archaeology, University of Cambridge, Cast Collection of classical art founded in 1897
<http://www.classics.cam.ac.uk/ark.html>

National Archaeological Museum, Athens
<http://www.culture.gr/2/21/214/21405m/
e21405m1.html>

Villa Giulia National Museum, Rome
<http://www.roma2000.it/zvilagiu.html>

Early Civilizations Documents and Sources

The Perseus Project [IV-A-3]

Perspectives on Western Art: Source Documents and Readings from the Ancient Near East through the Middle Ages, by Linnea H. Wren and David J. Wren (New York: Harper & Row, 1987)

Select Passages from Ancient Writers Illustrative of the History of Greek Sculpture, edited and translated by Henry Stuart Jones (New York: Macmillan, 1895; reprint ed., with introduction, bibliography, and index by Al. N. Oikonomides, Chicago: Argonaut, 1966)

Sources and Documents in the History of Art Series (Englewood Cliffs, NJ: Prentice-Hall, 1965/66; reprint ed., New York: Cambridge University Press)

> *Art of Greece: 1400–31 B.C.,* by Jerome Jordan Pollitt, revised ed., 1990

> *Art of Rome: c. 753 B.C.–A.D. 337,* by Jerome Jordan Pollitt, 1983

Early Civilizations History

General Works and Encyclopedias

Art and Culture of Early Greece, by Jeffrey Hurwit (Ithaca, NY: Cornell University Press, 1985)

History of Private Life, Philippe Ariès and Georges Duby, general editors, translated by Arthur Goldhammer (5 vols. Cambridge, MA: Belknap Press)

> Vol. I: *From Pagan Rome to Byzantium,* edited by Paul Veyne, 1987

History of Their Own: Women in Europe from Prehistory to the Present, by Bonnie S. Anderson and Judith P. Zinsser (2 vols. New York: Harper & Row, 1988–89)

History of Women in the West, Georges Duby and Michelle Perrot, general editors, translated by Arthur Goldhammer (Cambridge, MA: Belknap Press)

> Vol. I: *From Ancient Goddesses to Christian Saints,* by Pauline Schmitt Pantel, 1992

Oxford History of the Classical World, edited by John Boardman, et al. (New York: Oxford University Press, 1986)

> Vol. 1: *Greece and the Hellenistic World*
> Vol. 2: *The Roman World*

Penguin Dictionary of Archaeology, by Warwick Bray and David Trump (2nd ed. Harmondsworth, England: Penguin, 1982)

Pictorial Dictionary of Ancient Rome, by Ernest Nash (2 vols. New York: Frederick A. Praeger, 1962; reprint ed., New York: Hacker, 1980)

Princeton Encyclopedia of Classical Sites, edited by Richard Stillwell (Princeton, NJ: Princeton University Press, 1976)

Scrolls from the Dead Sea, Library of Congress
<http://lcweb.loc.gov/exhibits/scrolls/toc.html>

Mythology Resources

Egyptian Mythology, by Veronica Ions (London: Paul Hamlyn, 1968; reprint ed., New York: Peter Bedrick Books, 1983)

Greek Mythology, by John Pinsent (London: Paul Hamlyn, 1969; revised ed., New York: Peter Bedrick Books, 1983)

Near Eastern Mythology: Mesopotamia, Syria, Palestine, by John Gray (London: Paul Hamlyn, 1969)

Olympian Gods, Hellas On-Line, has a section on the ancient gods by J.M. Hunt
> <http://www.hol.gr/greece/mythology/olympian.html>

Persian Mythology, by John R. Hinnells (London: Paul Hamlyn, 1973; reprint ed., New York: Peter Bedrick Books, 1985)

Roman Mythology, by Stewart Perowne (London: Paul Hamlyn, 1969; reprint ed., New York: Peter Bedrick Books, 1984)

Social History Resources

Ancient Lives: Daily Life in Egypt of the Pharaohs, by John Romer (New York: Holt, Rinehart & Winston, 1984)

Everyday Life of the Etruscans, by Ellen Macnamara (Cambridge, MA: Harvard University Press, 1991)

Masterworks of Greek and Roman Art includes daily life in the ancient Mediterranean and death rituals in Greece and Rome
> <http://www.bampfa.berkeley.edu/exhibits/greek/>

People of the Nile: Everyday Life in Ancient Egypt, by John Romer (New York: Crown, 1982)

Early Civilizations Maps and Timelines

Atlas of the Greek and Roman World, to be published in 1999; see [A-VI-3].
> <http://www.unc.edu/depts/cl_atlas/>

Atlas of the Jewish World, by Nicholas de Lange (New York: Facts On File 1984)

Cultural Atlas of the Viking World, by Colleen Batey, et al. (New York: Facts On File, 1994)

Penguin Historical Atlas of Ancient Egypt, by Bill Manley (New York: Penguin Books, 1996)

Penguin Historical Atlas of Ancient Greece, by Robert Morkot (New York: Penguin Books, 1996)

Penguin Historical Atlas of Ancient Rome, by Chris Scarre (New York: Penguin Books, 1995)

Early Civilizations Videos and CD-ROMs

This section is organized under (a) surveys of early Western European civilizations, (b) Egyptian art, and (c) Greek/Roman art. All items are videos unless documented as CD-ROMs.

Early Western European Civilizations

Art Historian Project (CD-ROM. 2 vols. Boulder, CO; Reindeer Co., 1997). Serves as a supplement to academic art

history classes. Each style is discussed, examples are provided, and study questions are asked.
> Vol. I: *Ancient Near East to Gothic*
> Vol. II: *Early Renaissance to Modern with African, Asian, and Oceanic Art*

Electronic Library of Art. Renaissance Masters. 2 volumes. (TDC Interactive, 1994)
> Vol. I: *From Late Gothic through Early Italian Renaissance*

Seven Wonders of the World, by John Romer (4 videotapes. London: BBC, 1996)

Egyptian Art

Ancient Egyptian Art, The Brooklyn Museum (CD-ROM. Berkeley, CA: Digital Collections, 1989)

Ancient Lives, series of eight documentary videos narrated by John Romer (Humanities, 1980s)

Heritage of the Pharaohs (International Adventure Video, 1983)

Pyramids (Unicorn, 1988)

Pyramids and the Cities of the Pharaohs (Questar Video, 1995)

Stonehenge (Horizon, 1989)

Tut: The Boy King (Warner Home Video, 1988)

Greek and Roman Art

Art of the Western World, with Michael Wood (nine 50-minute videocassettes. Annenberg/CPB Project, 1989).
> Program 1: *The Classical Ideal*

Athens and Ancient Greece (Questar Video, 1995)

Crete and Mycenae, Museum without Walls Series (Indianapolis: Kartes, 1986)

Greek Temple, Museum without Walls Series (Indianapolis: Kartes, 1986)

In Search of the Trojan War, narrated by Michael Wood (six 50-minute tapes. BBC, 1985)

Pandora's Box: The Roles of Women in Ancient Greece, by Ellen D. Reeder (Baltimore: Walters Art Gallery, 1995)

Perseus 2.0: Interactive Sources and Studies on Ancient Greece on CD-ROM [IV-A-3]

Rome and Pompeii (Questar Video, 1995)

X-B-2. The Middle Ages and the Byzantine World

Medieval and Byzantine Art Survey Books

Art of Medieval Spain A.D. 500–1200 (New York: Metropolitan Museum of Art, 1993)

Early Christian Art and Architecture, by Robert Milburn (Berkeley: University of California Press, 1988)

Glory of Byzantium: Art and Culture of the Middle Byzantine Era, A.D. 843–1261, edited by Helen C. Evans and William D. Wixom (New York: Metropolitan Museum of Art, 1997)

Medieval Art, by Marilyn Stokstad (New York: Harper & Row, 1986)

Medieval Art: Painting, Sculpture, Architecture, 4th–14th Century, by James Snyder (Englewood Cliffs, NJ: Prentice Hall, 1989)

Pelican History of Art Series (Baltimore, MD: Penguin; New Haven, CT: Yale University Press)

Art and Architecture in Italy: 1250–1400, by John White, 2nd ed., 1987

Early Christian and Byzantine Architecture, by Richard Krautheimer, 2nd ed., 1986

Gothic Sculpture, 1140–1300, by Paul Williamson, 1995

Pictorial Arts of the West 800–1200, by C. R. Dodwell, 1993

Sculpture in Britain: The Middle Ages, by Margaret Whinney and John Physink, 2nd ed., 1988

Religious Art in France, by Emile Mâle (Princeton, NJ: Princeton University Press)

The Twelfth Century: A Study of the Origins of Medieval Iconography, 1978

The Thirteenth Century: A Study of Medieval Iconography and Its Sources, 1984

The Late Middle Ages: A Study of Medieval Iconography and Its Sources, 1986

Romanesque Sculpture: The Revival of Monumental Stone Sculpture in the Eleventh and Twelfth Centuries, by M.F. Hearn (Ithaca, NY: Cornell University Press, 1981)

Medieval and Byzantine Studies Web Sites

Age of King Charles V (1338–80), Bibliothèque nationale de France, includes color reproductions of seven illuminated manuscripts from the period
 <http://www.bnf.fr/enluminures/aaccueil.shtm>

Amiens Cathedral Project, Columbia University
 <http://www.learn.columbia.edu/Amiens.html>

Argos: Limited Area Search of the Ancient and Medieval Internet [I-B-2]
 <http://argos.evansville.edu/>

Art and Archaeology of Medieval Byzantine, University of Maryland, Sharon E. J. Gerstel
 <http://www.inform.umd.edu/EdRes/Colleges/ARHU/ Depts/ArtHistory/arthfac/gerstel/arth406.htm>

Book of Kells, Trinity College, Dublin
 <http://www.tcd.ie/kells.html>

Bibliography on Women in Byzantium lists primary and secondary sources available in translation, compiled by Thalia Gouma-Peterson, Wooster College
 <http://www.wooster.edu/Art/wb.html>

Byzantium: Byzantium Studies on the Internet, sponsored by Paul Halsall
 <http://www.bway.net/~halsall/byzantium.html>

Chronological Guide to Byzantine Emperors: From Augustus to Constantine XI, Dragases, sponsored by Paul Halsall
 <http://www.bway.net/~halsall/texts/byzemps.html>

Constantinople Home Page, School of Architecture, University of Illinois, Urbana-Champaign, coordinated by Robert Ousterout, has links to (a) classical and Mediterranean archaeology, (b) medieval, and (c) Byzantium.
 <http://www.arch.uiuc.edu/research/rgouster.index. html>

Fayum Portraits from Roman Egypt, sponsored by the Berger Foundation
 <http://sgwww.epfl.ch/BERGER/index.html>

Focus: MultiMedia provides illustrated essays and maps on history—ancient, medieval, modern; art of countries surrounding the Mediterranean; and historical characters, including Alexander the Great, Herodotus, and the Crusaders
 <http://www.focusmm.au/welcome.html>

Internet Medieval Sourcebook, sponsored by Paul Halsall, provides links to Western and Byzantine material
 <http://www.fordham.edu/halsall/sbook.html>

Jorvik Viking Centre, York, England
 <http://www.jorvik-viking-centre.co.uk/>

Knights Templar Preceptory explains various castle rooms, with a background of medieval chants
 <http://www.trantex.fi/staff/heikkih/knights/ portcull.htm>

Labyrinth: A World Wide Web Server for Medieval Studies, sponsored by Georgetown University, co-directors Deborah Everhart and Martin Irvine, provides data on medieval cultures—Anglo-Saxon, French, German, Iberian, and Italian—and on international subjects—archaeology, arts and architecture, history, religion, and science. Special topics include studies on King Arthur, heraldry and chivalry, and the Vikings.
 <http://www.georgetown.edu/labyrinth/>

On-Line Text Materials for Medieval Studies (ORB), sponsored by Carolyn Schriber, Rhodes College
 <http://orb.rhodes.edu/>

Temple Mount, Jerusalem, provides maps and a history of the site, including Solomon's Temple and the Dome of the Rock
 <http://templemount.org/>

Museums and Libraries: Medieval and Byzantine Collections

Bodleian Library, University of Oxford, collection of illuminated manuscripts
 <http://www.bodley.ox.ac.uk/welcome.html>

British Museum, London
 <http://www.british-museum.ac.uk/>

Dumbarton Oaks, Washington, D.C.
 <http://www.doaks.org/>

Metropolitan Museum of Art, New York
 <http://www.metmuseum.org/>

Musée du Louvre, Paris
 <http://mistral.culture.fr/louvre/louvrea.htm>

Indexes to Medieval Sculpture in American Museums

Gothic Sculpture in America, edited by Dorothy Gillerman (New York: Garland, 1989); Vol. I: *New England Museums* was the only volume issued

Romanesque Sculpture in American Collections, by Walter Cahn and Linda Seidel (New York: Burt Franklin, 1979)

Medieval and Byzantine Documents and Sources

Documentary History of Art. Volume I: *The Middle Ages and Renaissance,* edited by Elizabeth Gilmore Holt (Garden City, NY: Doubleday, 1957; reprint ed., Princeton, NJ: Princeton University Press, 1981).

Online Medieval and Classical Library, Berkeley Digital Library, University of California, reproduces pertinent literature
 <http://sunsite.berkeley.edu/OMACL/>

Perspectives on Western Art: Source Documents and Readings from the Ancient Near East through the Middle Ages, by Linnea H. Wren and David J. Wren (New York: Harper & Row, 1987)

Sources and Documents in the History of Art Series (Englewood Cliffs, NJ: Prentice Hall; reprints, Toronto: University of Toronto)

 Early Medieval Art: 300–1150, by Caecila Davis-Weyer, 1971; reprint ed., 1986

 Art of the Byzantine Empire, 312–1453, by Cyril A. Mango, 1972

 Gothic Art: 1140–c. 1450, by Teresa Frisch, 1971; reprint ed., 1987

Medieval and Byzantine History

General Works and Encyclopedias

Dictionary of Medieval Civilization, by Joseph Dahmus (New York: Macmillan, 1984)

Dictionary of the Middle Ages, Joseph R. Strayer, editor-in-chief (12 vols. New York: Charles Scribner's, 1982–85)

History of Private Life, Philippe Ariès and Georges Duby, general editors, translated by Arthur Goldhammer (5 vols. Cambridge, MA: Belknap Press)

 Vol. I: *From Pagan Rome to Byzantium,* edited by Paul Veyne, 1987

History of Their Own: Women in Europe from Prehistory to the Present, by Bonnie S. Anderson and Judith P. Zinsser (2 vols. New York: Harper & Row, 1988–89)

History of Women in the West, Georges Duby and Michelle Perrot, general editors, translated by Arthur Goldhammer (Cambridge, MA: Belknap Press)

 Vol. I: *From Ancient Goddesses to Christian Saints,* by Pauline Schmitt Pantel, 1992

 Vol. II: *Silences of the Middle Ages,* edited by Christiane Klapisch-Zuuber, 1992

Illustrated Encyclopedia of Medieval Civilization, by Aryeh Grabois (New York: Mayflower, 1980)

Making of Byzantium, 600–1025, by Mark Whittow (Berkeley: University of California Press, 1996)

New Cambridge Medieval History, edited by Rosamond McKitterick (2 vols. Cambridge: Cambridge University Press, 1995); covers from Constantine to the 15th century

Oxford Dictionary of Byzantium (3 vols. New York: Oxford University Press, 1991)

Oxford Illustrated History of Medieval Europe, edited by George Holmes (New York: Oxford University Press, 1988)

Social History Books

Everyday Life in Medieval England, by Christopher Dyer (London: Hambledon Press, 1994)

Everyday Life Series (London: B.T. Batsford; reprint, New York: Dorset)

 Everyday Life in Byzantium, by Tamara Talbot Rice, 1967; reprint ed., 1987

 Everyday Life in Medieval Times, by Marjorie Rowling, 1968; reprint ed., 1987

 Everyday Life in Ottoman Turkey, by Raphaela Lewis, 1971; reprint ed., 1988

 Everyday Life in Renaissance Times, by E. R. Chamberlin, 1965; reprint ed., New York: Perigee, 1980

Medieval and Byzantine Maps and Timelines

Atlas of the Christian Church, edited by Henry Chadwick and G.R. Evans (New York: Facts On File, 1987)

Atlas of the Jewish World, by Nicholas de Lange (New York: Facts On File, 1984)

Medieval Chronology 1066–1314, by Eric J. Griffin in Finland, provides hyperlinks to articles in the *Catholic Encyclopedia* and the *Knights Templar Preceptory;* see above
 <http://www.atl.mindspring.com/~vgriffin/chrono.htm>

New Penguin Atlas of Medieval History, by Colin McEvedy (New York: Penguin Books, 1992)

Medieval and Byzantine Videos and CD-ROMs

Anglo Saxons: An Exploration of Their Art, Literature, and Way of Life (CD-ROM. London, British Museum, 1994. Distributed by Cambrix, Woodland Hills, CA)

Art of the Western World, with Michael Wood [IX-B-7]

 Program 2: *A White Garment of Churches*

Byzantine: Lost Empire, by John Romer (Bethesda, MD: Discovery, 1997)

Castles (Unicorn, 1985)

Civilization, written and narrated by Kenneth Clark [IX-B-7]

 Program 1: *The Skin of Our Teeth*

 Program 2: *The Great Thaw*

 Program 3: *Romance and Reality*

Development of Christian Symbolism Series, the first three volumes of which use medieval sculpture to trace meanings of symbols: *Madonna and Child, Crucifixion and Resurrection,* and *Heaven or Hell: The Last Judgment* [XII-B-1]

Frozen World (London: BBC, 1970)

X-B-3. The Renaissance and Baroque Periods and the 18th Century

Renaissance, Baroque, and 18th-Century Art Survey Books

This section is divided into early biographies and more recent publications.

Early Biographies

Dutch and Flemish Painters, by Carel van Mander, translated by Constant van de Wall (New York: Arno Press, 1969). Includes the earliest biographies of Northern European painters; first published as *Het Schilder-boeck,* 1604.

Lives of the Most Eminent Painters, Sculptors, and Architects, by Giorgio Vasari, translated by Gaston du C. de Vere. (10 vols. London: Macmillan, 1912–15; reprint ed., 3 vols., New York: Harry N. Abrams, 1979, as *English Lives of the Most Eminent Painters, Sculptors, and Architects*). One of the first art historians, Vasari discussed 175 artists in his first publication of two volumes, in 1550. The second edition of 1568, of 250 artists covering a 300-year span, is the one usually translated. There are numerous editions and abridgements. For information on Vasari, see

 <http://www.italink.com/eng/egui/pers/vasa.htm>

A translation can be found at the Australian National University's Web site

 <http://rubens.anu.edu.au/imageserve/texts/vasari/>

Recent Publications

Art in an Age of Revolution, 1750–1800, by Albert Boime (Chicago: University of Chicago Press, 1987)

Art in Europe 1700–1830: A History of the Visual Arts in an Era of Unprecedented Urban Economic Growth, by Matthew Craske (New York: Oxford University Press, 1997)

Birth and Rebirth of Pictorial Space, by John White (3rd ed. Cambridge, MA: Harvard University Press, 1987)

Circa Sixteen Hundred: A Revolution of Style in Italian Painting, by S. J. Freedberg (Cambridge, MA: Harvard University Press, 1986)

History of Italian Renaissance Art: Painting, Sculpture, Architecture, by Frederick Hartt (3rd ed. Englewood Cliffs, NJ: Prentice Hall, 1987)

Mirror of the Artist: Northern Renaissance Art in Its Historical Context, by Craig Harbison (New York: Harry N. Abrams, 1995)

Northern Renaissance Art: Painting, Sculpture, the Graphic Arts from 1350 to 1575, by James Snyder (New York: Harry N. Abrams, 1985)

Painting for Money: The Visual Arts and the Public Sphere in Eighteenth-Century England, by David H. Solkin (New Haven, CT: Yale University Press, 1992)

Painters and Public Life in Eighteenth-Century Paris, by Thomas E. Crow (New Haven, CT: Yale University Press, 1985)

Pelican History of Art Series (Baltimore, MD: Penguin; New Haven: Yale University Press)

Architecture in Britain: 1530–1830, by John N. Summerson, 9th ed., 1993

Architecture in France in the Eighteenth Century, by Wend von Kalnein, 1995

Architecture in Italy: 1500–1600, by Wolfgang Lotz, 1995

Art and Architecture in Italy: 1250–1400, by John White, 3rd ed., 1993

Dutch Painting 1600–1800, by Seymour Slive, 1995

Painting and Sculpture in France 1700–1789, by Michael Levy, 1993

Renaissance Artists & Antique Sculpture: A Handbook of Visual Sources, by Phyllis Bober and Ruth Rubenstein (Oxford: Oxford University Press, 1986). Based on the "Census of Antique Art & Architecture Known to the Renaissance" [V-G-2]. This book includes similar data for 200 ancient sculptures.

Renaissance, Baroque, and 18th-Century Web Sites

Age of Enlightenment in the Paintings of France's National Museums, French Ministère de la culture
 <http://mistral.culture.fr/lumiere/documents/files/imaginary_exhibition.html>

Complete Writings & Pictures of Dante Gabriel Rossetti: A Hypermedia Research Archive
 <http://www.jefferson.village.virginia.edu/rossetti/rossetti.html>

Eighteenth-Century Resources, Jack Lynch, provides hyperlinks to relevant sites, such as those concerned with art, architecture, and costume
 <http://www.english.upenn.edu/~jlynch/18th/>

Eighteenth-Century Studies, Geoffrey Sauer, Carnegie Mellon University
 <http://english-www.hss.cmu.edu/18th/>

Enchanted Gardens of the Renaissance, Berger Foundation
 <http://sgwww.epfl.ch/BERGER/>

Florence, its artists and monuments, see *Firenze by Net,* which includes essays on 34 artists and 17 monuments
 <http://www.italink.com/eng/egui/index.htm>

1492: An Ongoing Voyage, Library of Congress Exhibitions
 <http://lcweb.loc.gov/exhibits/1492/intro.html>

Johannes Vermeer, Berger Foundation
 <http://sgwww.epfl.ch/BERGER/>

Leonardo Internet, virtual museum for da Vinci's work
 <http://www.leonet.it/comuni/vinci/>

Library of Congress, *Rome Reborn: The Vatican Library and Renaissance Culture*
 <http://lcweb.loc.gov/exhibits/vatican/toc.html>

Mask of Venice: Masking, Theater, and Identity in the Art of Tiepolo and His Time
 <http://www.bampfa.berkeley.edu/exhibits/tiepolo/>

Renaissance, Firenze by Net
 <http://www.italink.com/eng/egui/epo/rina.htm>

Sandro Botticelli, Berger Foundation
 <http://sgwww.epfl.ch/BERGER/>

William Blake Archive
 <http://jefferson.village.virginia.edu/blake/>

William Hogarth and the 18th-Century Print Culture, Northwestern University
<http://www.library.nwu.edu/spec/hogarth/main.html>

Museums: Renaissance, Baroque, and 18th-Century Collections

Firenze by Net provides hyperlinks to Florentine art museums
<http://www.italink.com/>

Galleria degli Uffizi, Florence
<http://www.televisual.it/uffizi>
<http://www.arca.net/db/musei/uffizi/>

Leonardo da Vinci Museum provides extensive material on the artist
<http://leonet.it>

Metropolitan Museum of Art, New York
<http://www.metmuseum.org/>

Musée du Louvre, Paris
<http://mistral.culture.fr/louvre/louvrea.htm>

Museo di Capodimonte, Naples
<http://selfin.it/musei/capodim/welcome.html>

National Gallery, London
<http://www.nationalgallery.org.uk/>

National Gallery of Art, Washington, D.C.
<http://www.nga.gov/>

Pinacoteca Nazionale di Siena
<http://www.comune.siena.it/pinaco/pinaco.htm>

Pitti Palace, Florence
<http://www.arca.net/db/musei/pitti.htm>

Renaissance, Baroque, and 18th-Century Documents and Sources

Dictionary of Art Quotations, by Ian Crofton (New York: Scribner, 1989)

Documentary History of Art, edited by Elizabeth Gilmore Holt (Garden City, NY: Doubleday, 1957–58; reprint ed., Princeton, NJ: Princeton University Press, 1981)

Vol. 1: *The Middle Ages and Renaissance*

Vol. 2: *Michelangelo and the Mannerists: The Baroque and the Eighteenth Century*

French Painters and Paintings from the Fourteenth Century to Post-Impressionism, edited by Gerd Muehsam (New York: Frederick Ungar, 1970). Includes critics' remarks on 100 artists and a brief survey of art criticism.

Letters of the Great Artists, edited by Richard Friedenthal (translated by Daphine Woodward et al. New York: Random House, 1963)

Vol. 1: *From Ghiberti to Gainsborough*

Vol. 2: *From Blake to Pollock*

Sources and Documents in the History of Art Series (Englewood Cliffs, NJ: Prentice Hall)

Italian Art 1400–1500, by Creighton Gilbert, 1980; reprint ed., Evanston, IL: Northwestern University Press, 1992

Italian Art: 1500–1600, by Robert Klein and Henri Zerner, 1966

Italian and Spanish Art, 1600–1750, by Robert Enggass and Jonathan Brown (Evanston, IL: Northwestern University Press, 1992, a reprint of the authors' *Italy and Spain: 1600–1750,* 1970)

Italy and Spain: 1600–1750, by Robert Enggass and Jonathan Brown, 1970

Neo-classicism and Romanticism: 1750–1850, by Lorenz Eitner, 1970; reprint ed., New York: Harper & Row, 1989

Northern Renaissance Art: 1400–1600, by Wolfgang Stechow, 1966; reprint ed., Evanston, IL: Northwestern University Press, 1989

Renaissance, Baroque, and 18th-Century History

General Works and Encyclopedias

Blackwell Companion to the Enlightenment, edited by John W. Yolton, et al. (London: Blackwell, 1991). A dictionary format concerned mostly with 1720–80.

Civilization and Capitalism 15th–18th Century, by Fernand Braudel, translated by Sian Reynolds (New York: Harper & Row)

Vol. 1: *The Structures of Everyday Life: The Limits of the Possible,* 1981

Vol. 2: *The Wheels of Commerce,* 1982

Vol. 3: *The Perspective of the World,* 1984

Civilization of the Renaissance in Italy, by Jacob Burckhardt (Translation of *Die Kultur der Renaissance in Italien,* 1945. London: Phaidon, 1995). Now also available on the Internet.
<http://www.idbsu.edu:80/courses/hy309/docs/burckhardt/burckhardt.html>

Concise Encyclopaedia of the Italian Renaissance, by J. R. Hale (New York: Oxford University Press, 1981)

Cultural History of the French Revolution, by Emmet Kennedy (New Haven, CT: Yale University Press, 1989)

Embarrassment of Riches: An Interpretation of Dutch Culture in the Golden Age, by Simon Schama (Berkeley: University of California Press, 1988)

Encyclopedia of the Renaissance, by Thomas Goddard Bergin (New York: Facts On File, 1987)

Florentine Painting and Its Social Background: The Bourgeois Republic before Cosimo de'Medici's Advent to Power, XIV and Early XV Centuries, by Frederick Antal (London: K. Paul, 1948; illustrated reprint, Cambridge, MA: Belknap Press of Harvard University Press, 1986)

History of Private Life Series translated by Arthur Goldhammer (Cambridge, MA: Belknap Press of Harvard University Press)

Vol. II: *Revelations of the Medieval World,* edited by Georges Duby, 1988, covering the 11th through 15th centuries.

Vol. III: *Passions of the Renaissance,* edited by Roger Chartier, 1989

History of Their Own: Women in Europe from Prehistory to the Present, by Bonnie S. Anderson and Judith P. Zinsser (2 vols. New York: Harper & Row, 1988–89)

History of Women in the West, Georges Duby and Michelle Perrot, general editors, translated by Arthur Goldhammer (5 vols. Cambridge, MA: Belknap Press)

Vol. III: *Renaissance and Enlightenment Paradoxes*, edited by Natalie Zemon Davis and Arlette Farge, 1993

Italian Renaissance: Culture and Society in Italy, by Peter Burke (Princeton, NJ: Princeton University Press, 1986)

New Cambridge Modern History (14 vols. Cambridge: Cambridge University Press, 1957–79); covers from 1493 to 1945

The New Child: British Art and the Origins of Modern Childhood, 1730–1830, by James Christen Steward (Berkeley: University Art Museum and Pacific Film Archive, University of California, 1995)

Paintings of the British Social Scene from Hogarth to Sickert, E. D. H. Johnson (New York: Rizzoli, 1986)

Prospect before Her: A History of Women in Western Europe, 1500–1800, by Olwen Hufton (New York: Alfred A. Knopf, 1996)

Romantic Chronology: Web Chronologies & Timelines covers 1799–1851
 <http://humanitas.ucsb.edu/projects/pack/rom-chrono/others.htm#arts>

Siena, Florence and Padua: Art, Society and Religion 1280–1400, edited by Diana Norman (2 vols. New Haven, CT: Yale University Press, 1995)

Social History Resources

Everyday Life in the Eighteenth Century, by Neil Grant (Lexington, MA: Silver, Burdett & Ginn, 1983)

Everyday Life in the Seventeenth Century, by Laurence Taylor (Lexington, MA: Silver, Burdett & Ginn, 1983)

Everyday Life in the Sixteenth Century, by Haydn Middleton (Lexington, MA: Silver, Burdett, & Ginn, 1982)

Images of Childhood: An Illustrated Social History, by Anita Schorsch (New York: Mayflower Books, 1979; reprint ed., Pittstown, NJ: Main Street Press, 1985)

Masks and Meanings in Tiepolo's Venice, by James Christen Steward
 <http://bampfa.berkeley.edu/exhibits/tiepolo/maskessay.html>

Yesterday's Children: The Antiques and History of Childcare, by Sally Kevill-Davies (Woodbridge, England: Antique Collectors' Club, 1991)

Renaissance, Baroque, and 18th-Century Maps and Timelines

Anchor Atlas of World History, by Hermann Kinder and Werner Hilgemann, translated by Ernest A. Menze (New York: Anchor Books, 1974)
 Vol. I: *From the Stone Age to the Eve of the French Revolution*
 Vol. II: *From the French Revolution to the American Bicentennial*

Penguin Atlas of Modern History (to 1815), by Colin McEvedy (New York: Penguin Books, 1972)

Renaissance, Baroque, and 18th-Century Videos and CD-ROMs

Art of the Western World, with Michael Wood [IX-B-7]
 Program 3: *The Early Renaissance*

 Program 4: *The High Renaissance*
 Program 5: *Realms of Light—the Baroque*
 Program 6: *An Age of Reason, An Age of Passion*

Civilization, written and narrated by Kenneth Clark [IX-B-7]
 Program 3: *Romance and Reality*
 Program 4: *Man—The Measure of All Things*
 Program 5: *The Hero As Artist*
 Program 6: *Protest and Communication*
 Program 7: *Grandeur and Obedience*
 Program 8: *The Light of Experience*
 Program 9: *The Pursuit of Happiness*
 Program 10: *The Smile of Reason*
 Program 11: *The Worship of Nature*

Eighteenth-Century Women (New York: Metropolitan Museum of Art, 1982)

Giambattista Tiepolo: 1696 Venice–1770 Madrid (CD-ROM. Rome: SACIS International, 1996)

Giotto and the Pre-Renaissance, Museum without Walls Series (Kartes, 1986)

Raphael, three films: *The Apprentice Years, The Prince of Painters, Legend and Legacy* (London: ARTS/BBC, 1983)

Return to Glory: Michelangelo Revealed (Nippon TV, Crown, 1986)

Series of CD-ROMs on various artists (Sevres Cedex, France: Réunion des Musées Nationaux, 1995) includes *The Age of Van Eyck, The Age of Bruegel, The Age of Vermeer, The Age of Rubens,* and *The Age of Rembrandt.* Each CD-ROM includes about 120 paintings in 40 museums, created by approximately 10 artists. The index provides access to artists, museums, and themes.

Virgin Mary in Art, Renaissance to Reformation, Vol. IV: *Development of Christian Symbolism Series,* which uses paintings to trace the meanings of symbols [XII-B-1].

X-B-4. The 19th and 20th Centuries

19th- and 20th-Century Art Survey Books

Books that survey the contemporary art scene or discuss new trends are sometimes difficult to locate. References concerned with the criticism of art are listed in [XII-C]; for exhibition catalogues, search *Worldwide Books* <http://www.worldwide.com/>.

ARTbibliographies Modern is particularly concerned with contemporary artists and events; use this index to art literature to locate books, catalogues, and articles [VII-B-2].

ArtSource has a section for new media art
 <http://www.uky.edu/Artsource/>

A Century of Artists' Books, by Riva Castleman (New York: Museum of Modern Art, 1994)

Art since 1940: Strategies of Being, by Jonathan Fineberg (New York: Lawrence King, 1995)

Art since Mid-Century: 1945 to the Present, by Daniel Wheeler (New York: Vendome Press, 1991)

Art since 1960, by Michael Archer (New York: Thames & Hudson, 1997)

Art Today, by E. Lucie-Smith (New York: Phaidon Press, 1995); covers art since 1960

Bibliography of Gay and Lesbian Art, edited by James Saslow (New York: College Art Association, 1994). A second edition edited by Sherman Clarke and Ray Anne Lockard will be published by G. K. Hall in 1998.

Gay and Lesbian Studies in Art History, edited by Whitney Davis (New York: Haworth Press, 1994)

History of Modern Art, by H. H. Arnason (3rd ed. revised by Daniel Wheeler. Englewood Cliffs, NJ: Prentice Hall, 1997)

History of Surrealism, by Maurice Nadeau, translated by Richard Howard (Cambridge, MA: Belknap Press, 1989)

Idiosyncratic Identities: Artists at the End of the Avant-Garde, by Donald Kuspit (New York: Cambridge University Press, 1996)

Movements in Art since 1945: Issues and Concepts, by Edward Lucie-Smith (New York: Thames & Hudson, 1995)

19th Century Art, Robert Rosenblum and H. W. Janson (New York: Harry N. Abrams, 1984)

Nineteenth Century Art: A Critical History, by Stephen F. Eisenman, et al. (New York: Thames & Hudson, 1994)

On the Edge of America: California Modernists Art, 1900–1950, edited by Paul Karlstrom (Berkeley: University of California Press, 1996)

Outline of 19th Century European Painting: From David through Cézanne, by Lorenz Eitner (New York: Harper & Row, 1988; reprint ed., New York: Icon Editions, 1992)

Oxford Companion to Twentieth-Century Art, edited by Harold Osborne (New York: Oxford University Press, 1981; reprint ed., 1988)

Pelican History of Art Series (Baltimore, MD: Penguin) *Painting and Sculpture in Europe: 1880–1940*, by George Heard Hamilton, 6th ed., 1993

Sexual Perspective: Homosexuality and Art in the Last 100 Years in the West, by Emmanuel Cooper (New York: Routledge, 1994)

Shock of the New, Robert Hughes (New York: Alfred A. Knopf, 1981); for the video, see "19th- and 20th-Century Videos and CD-ROMs," below

Theories of Contemporary Art, by Richard Hertz (Englewood Cliffs, NJ: Prentice Hall, 1985)

Theories of Modern Art, by Herschel B. Chipp (Berkeley: University of California Press, 1968, reprint ed., 1984)

Visual Arts in the Twentieth Century, by Edward Lucie-Smith (New York: Harry N. Abrams, 1997)

19th- and 20th-Century Studies Web Sites

Alexander Palace, former home of the Romanov Tsar Nicholas II in Tsarskoye Selo, Russia [IV-C]
 <http://205.187.161.152/palace/index.html>

Art in Chicago 1945–1995, Museum of Contemporary Art, Chicago
 <http://www.mcachicago.org/aic/index.html>

Century of Sculpture: The Nasher Collection, Guggenheim Museum
 <http://www.guggenheim.org/nasher.html>

Corot, French exhibitions
 <http://www.culture.fr/culture/corot/expos/corot.htm>

Daguerreian Society
 <http://java.austinc.edu/dag/>

Elihu Vedder's Drawings for the Rubáiyát, National Museum of American Art
 <http://nmaa-ryder.si.edu/vedder/rubaiyat.html>

Felix Gonzalez-Torres, Guggenheim Museum
 <http://www.guggenheim.org/felix.html>

Georg Baselitz: Portraits of Elke, Modern Art Museum of Fort Worth
 <http://www.mamfw.org/exhibit.htm>

Goya, University of Zaragoza in Spain, and Institución Fernando el Católico
 <http://goya.unizar.es/>

Hans Hofmann and the New York School, Berkeley Art Museum
 <http://www.bampfa.berkeley.edu/exhibits/abex/>

In the Light of Goya/Bajo las luces de Goya, Berkeley Art Museum
 <http://www.bampfa.berkeley.edu/exhibits/goya>

Jackson Pollock 1912–56, National Gallery, Washington, DC
 <http://www.nga.gov/feature/pollock/>

Leslie-Lohman Gay Art Foundation
 <http://www.3wnet.com/corp/Leslie_Lohman/>

Louise Bourgeois Drawings, Berkeley Art Museum
 <http://www.bampfa.berkeley.edu/exhibits/bourgeois/>

Picasso: The Early Years, 1892–1906, 1997 online exhibition, Boston Museum of Art
 <http://boston.com/mfa/picasso/>

Picasso and Portraiture: Representation and Transformation, 1996 exhibition, Museum of Modern Art, New York City
 <http://www.moma.org/exhibitions/past/1996.html>

Pre-Raphaelite Critic: Contemporary Criticism of the Pre-Raphaelites from 1849–1900, Thomas J. Tobin, Duquesne University
 <http://www.engl.duq.edu/>

Queer Arts Resources
 <http://www.queer-arts.org/indx_win.htm>

Prix de Rome [V-C]
 <http://www.culture.fr/ENSBA/ensba.html>

Richard Diebenkorn Whitney Museum Exhibition
 <http://www.echonyc.com/~whitney/WMAA/dieben/index.html>

Robert Gore Rifkind Center for German Expressionist Studies, Los Angeles County Museum of Art
 <http://www.lacma.org/Exhibits/bible/CTR.HTM>

Robert Rauschenberg: A Retrospective, Guggenheim Museum
 <http://www.guggenheim.org/rauschenberg.html>

Sargent at Harvard
 <http://baobab.harvard.edu/sargent/archive.html>

Science and the Artist's Book
 <http://silweb.sil.si.edu/exhibits/artistsbook/title.htm>

Self-Taught Artists of the 20th Century: An American Anthology Exhibition, Philadelphia Museum of Art
 <http://www.philamuseum.org/sta/intro.html>

La Tauromaquia: The Art of Bullfighting includes a history of the activity and some illustrations by artists, such as Goya and Picasso, who have depicted the event
 <http://coloquio.com/toros.html>

Victorian Web Overview
 <http://www.stg.brown.edu/projects/hypertext/landow/victorian/victov.html>

Video Spaces: Eight Installations, Museum of Modern Art, New York City
 <http://www.sva.edu/moma/videospaces/homepage.html>

Museums: 19th- and 20th-Century Collections

Contemporary artists are often prominently featured by museums and galleries; be sure to visit these sites. For instance, MoMA retains information on its past exhibitions, providing the press release for some, an illustrated essay for a few.

For an additional list of museums, see Yahoo's List:
 <http://yahoo.com/Arts/Museums_and_Centers/Modern_and_Contemporary/>

Albright-Knox, Buffalo
 <http://www.albrightknox.org/>

Andy Warhol Museum, Pittsburgh
 <http://www.warhol.org/warhol/>

Art Institute of Chicago
 <http://www.artic.edu/>

Contemporary Arts Museum, Houston
 <http://www.camh.org/>

Guggenheim Bilbao, Spain
 <http://www. guggenheim.org/bilboa.html>

Guggenheim Museum, New York City
 <http://www.guggenheim.org/srgm.html>

Hirshhorn Museum and Sculpture Garden, Smithsonian Institution, Washington, D.C.
 <http://www.si.edu/organiza/museums/hirsh/start.htm>

McNay Art Museum, San Antonio, Texas
 <http://www.mcnayart.org/>

Metropolitan Museum of Art, New York City
 <http://www.metmuseum.org/>

Modern Art Museum of Fort Worth
 <http://www.mamfw.org/menu.htm>

Musée d'Orsay, Paris
 <http://www.musee-orsay.fr/>

Musée National d'Art Moderne, Centre Georges Pompidou, Beaubourg, Paris
 <http://www.cnac-gp.fr/>

Musée National Picasso, Paris
 <http://www.paris.org:80/Musees/Picasso/>

Museum of Contemporary Art, Chicago
 <http://www.mcachicago.org/contents.html>

Museum of Contemporary Art, Los Angeles
 <http://www.MOCA-LA.org/>

Museum of Fine Arts, Boston
 <http://www.mfa.org/>

Museum of Modern Art, New York
 <http://www.moma.org/menu.html>

Museum Jean Tinguely, Basel, Switzerland
 <http://www2.tinguely.ch/tinguely/>

National Gallery of Art, Washington, D.C.
 <http://www.nga.gov/>

Tate Gallery, London
 <http://www.tate.org.uk/>

Walker Art Center, Minneapolis
 <http://www.walkerart.org/>

Whitney Museum of American Art, New York City
 <http://www.echonyc.com/~whitney/>

19th- and 20th-Century Documents and Sources

See Appendix One for Elizabeth Gilmore Holt's two books on the emerging role of exhibitions and critics: *Art of All Nations, 1850–73* and *Triumph of Art for the Public.* Check the standard general art bibliographies [II-A-2] for individual titles for the following series:

Art Criticism Series (Ann Arbor, MI: U.M.I. Research Press, 1980+)

Documents of 20th-Century Art Series, Robert Motherwell, general ed. (New York: Viking; Boston: G.K. Hall, 1971+)

Studies in the Fine Arts: Art Criticism Series (Ann Arbor, MI: U.M.I. Research, 1982)

Dictionary of Art Quotations, by Ian Crofton (New York: Scribner, 1989)

Documentary History of Art, edited by Elizabeth Gilmore Holt (Garden City, NY: Doubleday, 1966; reprint ed., Princeton, NJ: Princeton University Press, 1981) Vol.3: *From the Classicists to the Impressionists: A Documentary History of Art and Architecture in the 19th Century*

French Painters and Paintings from the Fourteenth Century to Post-Impressionism, edited by Gerd Muehsam (New York: Frederick Ungar, 1970); includes critics' remarks on 100 artists and a brief survey of art criticism

Sources and Documents in the History of Art Series (Englewood Cliffs, NJ: Prentice-Hall)

 Neo-classicism and Romanticism: 1750–1850, by Lorenz Eitner, 1970 (reprint ed., New York: Harper & Row, 1989).
 Realism and Tradition in Art: 1848–1900, by Linda Nochlin, 1966
 Impressionism and Post-Impressionism: 1874–1904, Linda Nochlin, 1966

Theories and Documents of Contemporary Art: A Sourcebook of Artists' Writings, edited by Kristine Stiles and Peter Selz (Berkeley: University of California Press, 1996)

Twentieth-Century Artists on Art: An Index to Writings, Statements, and Interviews by Artists, Architects, and Designers, by

Jack S. Robertson (2nd ed. Boston: G.K. Hall, 1996); covers 14,400 artists and includes bibliographic references

Voices of Women Artists, by Wendy Slatkin (Englewood Cliffs, NJ: Prentice Hall, 1993)

19th- and 20th-Century History

Everyday Life in the Nineteenth Century, by Russell Chamberlin (Lexington, MA: Silver, Burdett & Ginn, 1983)

Experience of Women: Pattern and Change in Nineteenth Century Europe, by Priscilla Robertson (Philadelphia: Temple University Press, 1982); covers English, French, German, and Italian women, and includes some information on the 18th century

History of Private Life, Philippe Ariès and Georges Duby, general editors, translated by Arthur Goldhammer (5 vols. Cambridge, MA: Belknap Press)

Vol. IV: *From the Fires of Revolution to the Great War*, edited by Michelle Perrot, 1990

Vol. V: *Riddles of Identity in Modern Times*, edited by Antoine Prost and Gérard Vincent, 1991

History of Their Own: Women in Europe from Prehistory to the Present, by Bonnie S. Anderson and Judith P. Zinsser (2 vols. New York: Harper & Row, 1988–89)

History of Women in the West, Georges Duby and Michelle Perrot, general editors, translated by Arthur Goldhammer (5 vols. Cambridge, MA: Belknap Press)

Vol. IV: *Emerging Feminism from Revolution to World War*, edited by Geneviève Fraisse and Michelle Perrot, 1993

Vol. V: *Toward a Cultural Identity in the Twentieth Century*, edited by Françoise Thébaud, 1994

When Did You Last See Your Father? The Victorian Painter and British History, by Roy Strong (London: Thames & Hudson, 1978)

19th- and 20th-Century Maps and Timelines

Anchor Atlas of World History, by Hermann Kinder and Werner Hilgemann, translated by Ernest A. Menze (New York: Anchor Books, 1974)

Vol. II: *From the French Revolution to the American Bicentennial*

Penguin Atlas of Modern History (to 1815), by Colin McEvedy (New York: Penguin Books, 1972)

Penguin Atlas of Recent History: Europe Since 1815, by Colin McEvedy (New York: Penguin Books, 1982)

19th- and 20th-Century Videos and CD-ROMs

The Video Data Bank of the School of the Art Institute of Chicago has a collection of more than 1,500 titles of tapes by and about contemporary American artists <http://www.artic.edu/saic/vdb/vdb.html>. Following is a sampling of other visual material available on this period of art history. Remember to consult [II-E] for locating relevant videos.

Art of the Western World, with Michael Wood [IX-B-7]

Program 7: *Fresh View: Impressionism and Post-Impressionism*

Program 8: *Into the Twentieth Century*

Program 9: *In Our Own Time*

Civilization, written and narrated by Kenneth Clark [IX-B-7]

Program 11: *The Worship of Nature*

Program 12: *The Fallacies of Hope*

Program 13: *Heroic Materialism*

Cubist Epoch (Museum without Walls, Indianapolis: Kartes, 1986)

Day in the Country: Impressionism and the French Landscape (Whittier, CA: Holiday, 1984)

David: The Passing Show (RM/ARTS/BBC 1986)

Delacroix: The Restless Eye (RM/ARTS/BBC, 1986)

Goya (Museum without Walls, Indianapolis: Kartes, 1986)

Germany-Dada (Museum without Walls, Indianapolis: Kartes, 1986)

Hudson River and Its Painters (New York: Metropolitan Museum of Art, 1987)

Paul Cézanne: Portrait of My World (CD-ROM. Bellevue, WA: Corbis, 1996) [III-A-2]

Paul Gauguin: The Savage Dream (Washington, DC: National Gallery of Art, 1988)

Picasso: War, Peace, Love (Museum Without Walls, Indianapolis: Kartes, 1986)

Shock of the New, written and narrated by Robert Hughes, shown on PBS (eight 52-minute cassettes. London: BBC Production, 1988); for the book, see 19th- and 20th-Century Art Survey Books, above

Van Gogh "Starry Night", by Albert Boime (CD-ROM. New York: Voyager, 1995)

Microfiche Vertical Files

Museum of Modern Art Artists Scrapbooks (Microfiche. Alexandria, VA: Chadwyck-Healey, 1986). Covers 44 artists, including Degas, Giacometti, Matisse, Picasso, and van Gogh.

Museum of Modern Art Artists Vertical Files (Microfiche. Alexandria, VA: Chadwyck-Healey, 1990). Covers about 30,000 contemporary international artists. For an index to the individuals in the *Vertical Files*, access the museum's OPAC <http://moma.org/>

Note

1. Two books that influenced English painters were *The History of England* (10 vols. issued 1726–31) by Paul de Rapin-Thoyras and *History of England* (1754) by David Hume.

XI. Documenting the Lives of Artists and Art Collectors

One of the earliest biographies of artists, *Lives of the Most Eminent Painters, Sculptors, and Architects,* was written by Giorgio Vasari in 1550. The book, which has had numerous editions, discusses 175 Italians over a 300-year span, from Cimabue to Michelangelo. It is a measure of the importance of both this book and the Internet as a new transmitter of information that a translation of Vasari's work can be found at the Australian National University's Web site <http://rubens.anu.edu.au.imageserve/texts/vasari/>. Moreover, *Firenze by Net* <http://www.italink.com/eng/egui/pers/vasa.htm> provides a two-page essay on Vasari himself!

Although everything you need for biographical research will probably not be found on the World Wide Web, using the Internet will decrease your search time. Moreover, if you have a good methodological plan, you will know how to supplement the Web data. This means reading printed sources and viewing the artist's works reproduced in various formats: books, CD-ROMs, documentary videos, and microfiche. This chapter is a guide to locating the basic biographical data on artists and art collectors. Although the information is for artists working in all media, the emphasis is on painters. Chapter XIII has suggestions for locating material on artists working in other media.

One of the most important procedures in biographical research is compiling a chronology on the life and work of the artist. This will assist you in understanding the artist's place in history and the interrelationship of individual works of art with the artist's whole body of work, or œuvre.[1] In formulating a chronology, salient dates to include involve birth, death, education, family ties, travel, artistic influences, relationships, prizes, honors, and writings. The titles of major works of art should be recorded, accompanied by the dates they were created and their present locations, when known. The chronology should also contain any important exhibitions in which the artist's works were displayed during her or his lifetime and thereafter. Any significant prices for which the artist's work sold should be reported, since this may reflect the artist's reputation with the buying public. Retrospective exhibitions should also be recorded, because they help in determining an artist's prominence, both before and after death.

If you are writing about a well-known artist or one who recently had a major retrospective exhibition, you will discover that the amount of material written on this artist will exceed your ability or time to obtain, study, and analyze it. You must, therefore, search for the most significant references: pertinent monographs, œuvre catalogues, catalogues raisonnés, and scholarly exhibition catalogues. Moreover, the bibliographies in these sources will lead you to other meaningful material. Because of the importance of these references, every effort should be made to obtain them.

An *œuvre catalogue* lists every work of art either in the artist's complete output or in a specific medium. For each object, a brief summary—title of the work, medium, dimensions, and probable date created—is recorded. An illustration is often reproduced.

A *catalogue raisonné* employs the same information as an œuvre catalogue, but has more extensive data for individual works: (a) exhibition history of the piece; (b) provenance, or record of all known owners and sales in which it has figured; (c) scholarly literature that discusses the object; (d) any unusual or pertinent facts; and (e) a critical or analytical account of the art. In addition, every work by the artist is usually illustrated. Because of their comprehensive and authoritative nature, catalogues raisonnés are usually the most significant references written on artists and their artistic endeavors.

Scholarly exhibition catalogues are often the most recent examination of an artist's work or a specific art subject [III-A-2]. These catalogues are usually compiled by a team of scholars, chosen by the museums that are hosting the exhibitions and underwritten by commercial firms. It is important to locate the most

current exhibition catalogues on your research topic. This chapter is organized into four sections, with suggestions for discovering information on (a) most artists, (b) contemporary artists, (c) difficult-to-locate artists, and (d) art collectors.

XI-A. Biographical Methodology: French Impressionist Alfred Sisley (1839–99)

Before you begin your biographical research, develop your strategy of action by following the research plan outlined in Chapter IX. You may need to reread the seven basic methodological steps to strengthen your research skills. Then follow the supplementary material in this chapter. Contemporary artists are discussed in [XI-B], below; difficult-to-locate artists are discussed in [XI-C].

Example

The project is to select a French artist and write a report on the artist's life and work. You select Alfred Sisley—but just who *was* Sisley? This is the type of general question often asked about an artist: vague, limitless, and all-encompassing. To write fully on Alfred Sisley, his life and work, would require a book, and some have been written on this artist. For most projects, you will need to narrow the subject. For example, the project could be altered to "Alfred Sisley's major paintings, 1874–78." This limits the topic but will require a more in-depth, academic approach.

XI-A-1. Step 1: Art History Survey Books

Research on most artists begins with the biographical dictionaries and art encyclopedias, since the general art history textbooks [IX-B-1] cover only the major artists. You should, however, read these survey books to obtain an overview of the art being created at the time your artist was working. This will also help you in compiling a chronology.

Since the general survey textbooks do not adequately cover secondary artists, you will need to consult other references with a narrower focus. A few resources are cited in this book under the appropriate historical periods, cultures, or media. Under [X-B-4], sources for "19th- and 20th-Century Art Survey Books," there is an entry for *19th Century Art* by Robert Rosenblum and H. W. Janson. This book provides an overview of the entire 19th century but has only two mentions, and no discussion, of Sisley. Obviously, a book on Impressionism will be needed. The first book cited in the Rosenblum bibliography is John Rewald's *History of Impressionism*. By checking the bibliographies appended to the encyclopedia articles and the general survey textbooks, you will usually discover the names of experts in the various fields.

Example

Because Alfred Sisley is just outside the mainstream of the Impressionist movement, he is not included in the general art history textbooks. Their bibliographies, however, all cite the *History of Impressionism* by John Rewald (4th ed., rev. New York: Museum of Modern Art, 1976). *The Dictionary of Art* also mentions this book. These many references to Rewald's book, originally written in 1946, confirm that he is an expert on the subject. Remember, a book with numerous editions has withstood the test of time and the opinions of other scholars.

XI-A-2. Step 2: Dictionaries and Encyclopedias

By first consulting an encyclopedia, you will obtain basic information on an artist's life, as well as some clues as to how to direct your study. Although the material in general encyclopedias [IX-B-2] is usually not sufficient for art research, the information is often relevant and a starting point for further research. An art encyclopedia, on the other hand, will include more in-depth biographical data, some bibliographical references, and frequently an illustration of the artist's work. Also consult the special biographical dictionaries cited later in this chapter.

General Encyclopedia Example

The Encyclopædia Britannica Online entry for Sisley consists of two brief paragraphs that include the titles of 20 of his paintings, accompanied by the

museums that own them. Each painting links to a Web site that illustrates the work. The encyclopedia article has no illustrations or bibliography.

Art Encyclopedia Example

The Dictionary of Art signed article on Sisley relates that he was a French Impressionist painter who exhibited in the Paris Salons[2] of 1866, 1868, and 1870. Sisley later entered the French Impressionist Exhibitions of 1874, 1876, 1877, and 1882. The 3.5-page article includes 2 illustrations and a list of 21 titles of oil paintings, accompanied by the dates of their creation and their present locations. All titles are translated into English.

The Sisley bibliography contains a total of 40 items divided by catalogues, specialist studies, the artist's correspondence, and works of a general nature. The last category mentions the *History of Impressionism* by J. Rewald. This helps verify what you will find cited in other resources: Rewald is an expert on the Impressionists. A principal research activity should be to obtain and read this book.

One of the most important references in *The Dictionary of Art* bibliography is *Alfred Sisley: Catalogue raisonné de l'œuvre peint,* by François Daulte (Lausanne: Durand-Ruel, 1959). Also mentioned is the auction catalogue of the artist's estate. Volume 34: *Index of The Dictionary of Art* contains invaluable sources of additional material for Alfred Sisley under *dealers, exhibitions, groups and movements, methods, paintings, patrons and collectors, prints,* and *teachers.* The patrons and collectors section alone has 22 cross-references to individual collectors of Sisley's work.

Sisley, Alfred (*b* Paris, 30 Oct 1839; *d* Moret-sur-Loing, nr Paris, 29 Jan 1899). British painter, active in France. Although overshadowed in his lifetime by Monet and Renoir, Sisley remains a quintessential representative of the Impressionist movement. He was almost exclusively a painter of landscape.

1. Life. 2. Work.

1. LIFE. Alfred Sisley was born into a family of Anglo-French descent, the second of four children following the marriage of William and Felicia Sisley who were cousins. His father was director of a business concerned with the

"Sisley, Alfred" Entry from *The Dictionary of Art* (excerpt)

XI-A-3. Step 3: The Internet

Using the Internet for research is discussed in [IX-B-3]. Upon connecting to the Internet, use (a) the OPACs of your local libraries to form a preliminary reading list, (b) the online indexes to Web material, and (c) the search engines. There are only a few single-subject Web site for individual artists [IV-A-3],

which usually can be located through the indexes to Web material.

Preliminary Reading List

Begin searching the OPAC of the institution with which you are affiliated. If what you want is there, you have quickly solved the problem of how to obtain the needed reference.

Example

A subject search of the University of North Texas's OPAC produced the LC subject heading *Sisley, Alfred, 1839–1899,* plus subsets for *Sisley, Alfred, 1839–1899—Criticism and interpretation* and *Sisley, Alfred, 1839–1899—Exhibitions* <http://library.unt.edu/search/>. This yielded a total of 8 records, of which 6 were pamphlets, ranging from 16 to 90 pages in length. One was for a monograph on Sisley by Richard Shone, published by Abrams in 1992. The other was for an exhibition catalogue edited by Mary Anne Stevens and distributed by Yale University Press in 1992. This provided enough material for many research projects.

Indexes to Web Material

For locating Internet material on specific artists, see (a) *Art History Resources on the Web* <http://witcombe.bcpw.sbc.edu/ARTHLinks.html> and (b) *World Wide Art Resources* with its Artist Index <http://wwar.com/artists1.html>.

Example

Art History Resources on the Web contained nothing specifically on Sisley, but included numerous resources for the Impressionists. *WWAR* provided hyperlinks to six illustrations of Sisley's paintings: one from the *WebMuseum,* five at Washington's National Gallery of Art.

Search Engines

When this search was conducted, only a few of the hundreds of sites located by the search engines were appropriate. Dominating the entries was the *WebMuseum,* which had three different essays: on Sisley, on Impressionism, and on Renoir, the last of which included an illustration of Renoir's painting of Sisley and his wife. One search engine listed seven *WebMuseum* records, with duplications reflecting the various mirror sites. A few Internet sites illustrated a single painting without indicating the date of creation or the present location. These illustrations were colorful, but the information was inadequate.

paintings are furnished. Some bulletins noted the owners of some of the works; this assists scholars in tracing the provenance of these paintings. The statement "Appartient á M. Durand-Ruel" indicates that the painting belongs to Mr. Durand-Ruel.

Sales Information

Although records of past auctions may not be needed by most researchers, they are important to (a) curators establishing the provenance of works of art; (b) art historians compiling monographs, œuvre catalogues, catalogues raisonnés, and exhibition catalogues; and (c) researchers seeking additional or unusual material, especially for difficult-to-locate artists. For a discussion on sales information, see Chapter VIII; for an example of how to use this data to assist you in locating material on hard-to-find artists, also consult [XI-C-5], below.

One difference between a summary and a scholarly exhibition catalogue is the latter's inclusion of a work's provenance. This list of all known owners and sales in which a work figured since it left the artist's studio helps to establish its authenticity. When art historians compile œuvre catalogues or catalogues raisonnés, they must locate all of the auctions involving the artists' works. Each work must be viewed, if possible, and the artist's chronology established. This information is not easy to collect, since it requires searching everywhere for data, leaving no stone unturned. A major source is the *Provenance Index Project* [V-G-2], which in 1997 provided material on British auctions between 1801 and 1820. The dating is too early to document Sisley's sales records.

Another major resource for sales data is information gleaned from indexes to auction catalogues and the catalogues themselves. In a search for information on Sisley's *Le chemin dans la campagne,* 1876, the various indexes to auction sales were examined. All of the indexes listed the painting as having been sold on November 9, 1994, at Christie's in New York. Most indexes reported the painting's title, medium, dimensions, date of creation, and whether it was signed by the artist. Some entries referred to *Alfred Sisley: Catalogue raisonné de l'œuvre peint*, by François Daulte (Lausanne: Durand-Ruel, 1959). The painting's number in Daulte's catalogue was reported, which helps authenticate the work.

Any outstanding prices for which an artist's works sold are significant, since this may reflect the artist's reputation with the buying public. The material also provides an overview of the popularity of the artist's work. The researcher may need to locate some of the indexes to auctions [VIII-A], past and present. A comparison of prices can then be made for similar sold paintings. Other considerations include (a) the quality and size of the work; (b) any unusual history concerning it that would make it more valuable, such as having been exhibited at one of the Impressionist Exhibitions; and (c) the vagaries of the auction market.

Example

When an artist dies, the artist's estate may sell the contents of the studio; this becomes a resource for data on the items in the artist's collection upon his or her death. *The Dictionary of Art* mentions the auction catalogue of Sisley's estate. By checking the references discussed in [VIII-B], the following material was located:

Under Sisley's name, Lugt's *Répertoire des catalogues de ventes* provided the date of the estate sale—1899 Mai 1—which led to the entry for the catalogue: #57175. The abbreviations in the entry indicate that the sale, held at Galerie Georges Petit, Paris, consisted of 79 paintings, studies, and pastels. Lugt also reports that the 38-page catalogue included a frontispiece and four plates. Three U.S. libraries are listed as having copies of the catalogue.

With these facts, *SCIPIO* was searched and four additional libraries owning the catalogue were located. Moreover, the *SCIPIO* entry indicated that the catalogue was part of the *Knoedler Library Sales Catalogues* reproduced on microfiche. Thus, a copy of the Sisley estate sale catalogue would be owned by institutions that purchased this microfiche set. Once the catalogue was located, it could be studied to add another dimension to the research.

XI-A-7. Step 7: Visual Resources

Once you have a list of the essential works of art you need to view, follow the basic methodological steps outlined in [IX-B-7] and supplement them with the references reported in [X-B]. During the collection process, you will have discovered the titles of works of art and their present locations. If you know the

museum where a piece is located, you can access it via its Web site to learn whether any supplementary data or an illustration is available. For institutions without Web sites, obtain any published catalogues of their permanent collections to determine if there is additional information on the artist.

Examples

1. *SILs: Art Image Browser* [IV-A-5] <http://www.sils.umich.edu/Art_History/> reproduced an illustration of Sisley's painting *Spring in Veneux-Nadon*, owned by the New Orleans Museum of Art.

2. *World's Master Paintings* lists the titles for more than 250 Sisley paintings owned by 133 museums. Also cited are major collections at seven museums, such as the Musée d'Orsay, Paris; Museum of Fine Arts, Boston; and Metropolitan Museum of Art, New York City. *Paintings in Dutch Museums* lists four Sisley paintings in four Dutch museums.

Alfred Sisley
Paris 1839 — Moret-sur-loing 1899

Sisley was the least adventurous of the Impressionists. His range was even narrower than that of Pissarro (qv) and he rarely included figures in his pictures. His concern was always with atmospheric naturalism, and most of his pictures succeed on this level, especially with effects of snow or strong sunlight. He had a short stay in England (his parents were English) and produced a series of views of the Thames, especially at Hampton Court. His style changed little as he grew older; unlike the other Impressionists, he was unaffected by later trends.

BIBLIOGRAPHY François Daulte, *Alfred Sisley, catalogue raisonné de l'oeuvre peint*, Lausanne, 1959.

MAJOR COLLECTIONS Boston, Massachusetts, Museum of Fine Arts Glasgow, Burrell Collection Leningrad, Hermitage New York, Metropolitan Museum Paris, Musée d'Orsay Rouen, Musée des Beaux-Arts Tokyo, Bridgestone Museum of Art

Aberdeen *Art Gallery*
The banks of the Loing (1897)
The little square (1874)
A yard at Sablons (1885)
Agen *Musée des Beaux-Arts*
September morning (1888)
Aix-les-Bains *Musée Dr Faure*
The Seine at Argenteuil (1872)
Algiers *Musée National des Beaux-Arts*
The bridge at Moret-sur-Loing (1890)
The canal of the Loing, winter (1891)
Baltimore *Museum of Art*

Bucharest *Zambaccian Collection*
Bridge at Suresnes across the Seine
Budapest *Museum of Fine Arts (Szépművészeti Museum)*
The banks of the Loing, autumn
Buenos Aires *Museo Nacional de Bellas Artes*
The Seine at Paris (1878)
Snow effect (1876)
Buffalo *Albright-Knox Art Gallery*
Road at Marlotte (1866)
Cambridge *Fitzwilliam Museum*
The flood, Pont-Marly (1876)
Street at Moret-sur-Loing
Cambridge, Massachusetts *Fogg*

"Alfred Sisley" Entry from *The World's Master Paintings,* Volume 1 (excerpt)

XI-B. Contemporary Artists

Although *The Dictionary of Art,* published in 1996, furnishes information on many older, more famous artists, it does not include lesser-known, contemporary artists. The biographical dictionaries that cover only artists working in a specific medium, such as *Contemporary Photographers* [XIII-E-2], are often the best sources for locating information on current artists. These dictionaries are usually issued every couple of years and thus document the most recent and meaningful information on artists, such as (a) their nationalities, education, families, careers, and awards; (b) the names and addresses of their agents; (c) the dates and locations of individual and group exhibitions in which their works were shown; (d) the museums and galleries owning their work; (e) publications by and about the artists; and (f) brief signed essays on their work. See Chapter XIII for individual titles.

One of the best sources for information on contemporary artists is the gallery selling the artist's work. For locating this association between artist and gal-

lery, check the biographical dictionaries discussed below or the August issue of *Art in America,* which annually publishes a "Guide to Galleries, Museums and Artists." Another strategy is to search the art literature, especially using *ARTbibliographies Modern* [VII-B], since it concentrates on 20th-century art.

Another method is to search the OPAC of a library that specializes in contemporary art to locate exhibition catalogues; these will usually lead you to the galleries that represent the artist or museums that own the artist's work. Information on contemporary artists who have exhibited their work in museums that compile catalogues can often be located through these publications. Use the *Worldwide Books Online* database, which is international in scope and includes both foreign and regional catalogues <http://www.worldwide.com/>. Up to three artists whose names are part of the catalogues' titles are indexed.

Popular forms for preserving information on contemporary artists are oral history programs, vertical files, and archives. A major source is the Archives of

American Art [XIV-A-8]. The School of the Art Institute of Chicago has one of the largest oral history collections; its *Video Data Bank* contains more than 1,500 titles of tapes by and about contemporary American artists <http://www.artic.edu/saic/vdb/vdb.html>.

Material on some contemporary artists was added to the two vertical files that have been reproduced on microfiche: (a) *Museum of Modern Art Artists Vertical Files* [X-B-4] and (b) *The New York Public Library: The Artists File* [IX-B-6]. For an artist without a cosmopolitan reputation, contact the library in the city where he or she lived or worked, since it may maintain a vertical file in which the artist is one of the subjects.

A number of artists have individual Web pages that furnish brief biographical data and often a sample of their work. These Internet locations are sponsored by (a) the galleries who sell their works; (b) universities that illustrate the works of their faculty and students; (c) someone interested in the artists, such as a professional organization; and/or (d) the artists themselves. To locate the URLs for these Web pages, access the galleries representing the artists or the alumni association of any academic institutions they attended. These sources may have material on the artist, or at least the artist's current address, which would enable you to write him or her, if necessary. You might also contact any professional organization to which the artist belongs (see Appendix Two).

For well-known artists or those with a rising reputation, other excellent sources are museums, especially those with (a) active exhibition programs and/or (b) an outstanding collection of the artist's works. Contemporary museums—listed in [X-B-4]—frequently have exhibitions that include both online and printed catalogues and post important information at their Web sites. In addition, the art school that the artist attended may have material on its former students.

Example

In 1995, the Los Angeles County Museum of Art highlighted French artist Annette Messager <http://www.lacma.org/>. The Museum of Modern Art, New York City, was another host for this exhibition of Messager's work <http://www.moma.org/webprojects.html>. Both museums have archived material concerning this contemporary multimedia artist; the information includes biographical data and illustrations of her work.

Biographical Indexes for Contemporary Artists

Remember, artists work in various media and can be considered a combination of photographers, printmakers, and sculptors. You may need to check all six sections in Chapter XIII, since these references are not repeated here. Additional biographical dictionaries are listed for American, Canadian, and Native American artists in Chapter XIV and for artists from non-European cultures in Chapter XV. Follow the leads suggested in the basic biographical methodology section above, then check the following:

Biography Index (New York: H.W. Wilson, 1946+)

Canadian Who's Who (Toronto: University of Toronto Press. Vol. 1, 1910+)

Contemporary Artists, edited by Joann Cerrito (4th ed. Updated about every 5 to 8 yrs. New York: St. James Press, 1996)

Contemporary Latin American Artists: Exhibitions at the Organization of American States, edited by Annick Sanjurjo (Lanham, MD: Scarecrow Press)

 Volume I: *1941–1964,* 1997
 Volume II: *1965–1985,* 1993

Current Biography Yearbook (11 times per year with annual cumulation. New York: H. W. Wilson. Vol. 1, 1940+). *Current Biography 1940–Present,* on CD-ROM, covers 15,000 individuals.

Who's Who in American Art: A Biographical Directory (now published every other year by New York: R. R. Bowker. Vol. 1, 1936–37+)

Women Artists Archive, maintained by Sandra Walton, Special Collections Librarian, Salazar Library, Sonoma State University, contains information on 1,000 women artists from the Middle Ages through the present day and includes illustrations of their works
 <http://libweb.sonoma.edu/special/waa/>

Individual Artists' Web Pages

The list below includes Web sites that index artists' home pages; one of the best is Yahoo's list of sites.

Art America Gallery
 <http://www.hrac.com/art/>

ArtNet Italia Artists Agenda
 <http://www.thru.com/art/uk/calendar.html>

ArtNet's Artists Online
 <http://www.artnet.com/>

Maison Europeenne de la Photographie
 <http://www.pictime.fr/mep/>

Pont des Arts–Nanyang Artists in Paris
 <http://www.ncb.gov.sg/nhb/pontdesArt/contents.html/>

World Wide Art Resources
 <http://wwar.com/>

Yahoo's Lists of Artists, subdivided into architects, illustrators, painters, photographers, printmakers, and sculptors
 <http://www.yahoo.com/Art/Art_History/Artists/>

XI-C. Difficult-to-Locate Artists

You may be asked to prepare a research paper or report on an artist on whom you have no information and on whom there is little or no data in the usual biographical references. Material on some artists is almost impossible to find, either in the popular biographical dictionaries or on the Internet.

The two examples provided below may help you in devising a plan for discovering data on difficult-to-locate artists. The first step is to discover the artist's nationality and dates. Because you will need to use earlier publications and material that is not always reliable, you should obtain the artist's correct name and possible alternatives. Remember to begin with *ULAN* [V-G-2]; it often saves the day!

Then consult (a) the older art encyclopedias [IX-B-2], which sometimes include artists who were popular earlier in this century; (b) the additional biographical dictionaries cited in Chapters XIII through XV; and (c) the resources cited below.

Good sources for in-depth research are the resources to auction sales (Chapter VIII) and *The Witt Library on Microfiche* [V-G-2]. For additional titles of these types of special reference tools, see the standard art bibliographies [II-A-2]. The fact that many of these works were published long ago does not diminish their usefulness.

XI-C-1. Special Biographical Dictionaries

For a longer list of biographical dictionaries, see the one used by *ULAN* [V-G-2]
 <http://www.gii.getty.edu/vocabulary/ulan_biblio.html>

Chronological History of the Old English Landscape Painters from the XVIth Century to the XIXth Century: Describing More than 800 Painters, by Maurice Harold Grant (8 vols. Rev. and enlarged. Leigh-on-Sea, England: F. Lewis, 1957–61)

Dictionary of British Artists, 1880–1940, by J. Johnson and A. Greutzner (Suffolk, England: Antique Collectors' Club, 1976). Lists about 41,000 artists.

Dictionary of British Watercolour Artists up to 1920, by H. L. Mallalieu (2 vols. Poughkeepsie, NY: Apollo, 1986)

Dictionary of Flower, Fruit, and Still Life Painters, by Sydney Paviere (3 vols. in 4 books. Leigh-on-Sea, England: F. Lewis, 1962)

Dictionary of Marine Artists, by Dorothy Brewington (Poughkeepsie, NY: Apollo, 1982). Covers 3,074 American, European, and Asian artists.

Dictionary of Miniaturists, Illuminators, Calligraphers, and Copyists: From the Establishment of Christianity to the Eighteenth Century, by John William Bradley (3 vols. London: Quaritch, 1887–89; reprint, New York: Burt Franklin, 1973)

Dictionary of Sea Painters, by E. H. H. Archibald (Woodbridge, England: Antique Collectors' Club, 1980). Includes about 800 artists. It often reports current ownership and location and includes depictions of European historic maritime flags and essays on ships.

Dictionary of Venetian Painters, by Pietro Zampetti (5 vols. Leigh-on-Sea, England: F. Lewis, 1969–79)

Dictionary of Victorian Painters, by Christopher Wood (2nd ed. Woodbridge, England: Antique Collectors' Club, 1978)

Dictionary of Women Artists, edited by Delia Gaze (Chicago: Fitzroy Dearborn Publishers, 1997)

Dictionary of Women Artists: An International Dictionary of Women Artists Born before 1900, by Chris Petteys, et al. (Boston: G.K. Hall, 1985)

International Dictionary of Art and Artists, edited by James Vinson (2 vols. Chicago: St. James Press, 1990). Signed articles in Volume I provide biographical data, lists of major collections of artists' works, and bibliographical information on major artists from the 13th to the 20th centuries. Volume II illustrates and discusses 500 individual works of art.

Making Their Mark: Women Artists Move into the Mainstream, 1970–85, by Randy Rosen II, et al. (New York: Abbeville, 1989)

National Museum of Women in the Arts: Artists' Profiles; provides bibliographies and lists of the women's works of art accompanied by their present location, covering all periods of history
 <http://www.nmwa.org/library/bibs/bibsd.htm>

Spanish Artists from the Fourth to the Twentieth Century: A Critical Dictionary, Frick Art Reference Library (4 vols. Boston: G. K. Hall, 1994–97). Covers about 10,000 artists born in Spain or who chiefly worked there, including artists working in all media.

Women, Art, and Power and Other Essays, by Linda Nochlin and Ann Sutherland Harris (New York: Harper & Row, 1988)

Women Artists Archive, by Sandra Walton, Special Collections Librarian, Salazar Library, Sonoma State University, contains information on 1,000 women from the Middle Ages through the present day. It includes illustrations of the artist's work and links to entries at the National Museum of Women in the Arts, listed above.
 <http://libweb.sonoma.edu/special/waa/>

Women Artists in History: From Antiquity to the 20th Century, by Wendy Slatkin (Englewood Cliffs, NJ: Prentice Hall, 1985)

XI-C-2. Foreign Language Biographical Dictionaries

For a CD-ROM that includes articles from three of the following dictionaries, see *World Biographical Dictionary of Artists,* below.

Allgemeines Lexikon der bildenden Künstler von der Antike bis zur Gegenwart, by Ulrich Thieme and Felix Becker (37 vols. Leipzig: EA. Seemann, 1907–50; reprint ed., Leipzig: F. Allmann, 1964) Abbreviated "Thieme-Becker."

Allgemeines Künstlerlexikon (Proposed 60 vols. Leipzig: Seemann; Munich: K.G. Saur, 1983+) A dictionary very slowly updating and replacing Thieme-Becker (above). As of 1997, Band 16: *Campagne-Cartellier* has been issued.
<http://www.upapubs.com/saur.htm>

Allgemeines Lexikon der bildenden Künstler des XX. Jahrhunderts, by Hans Vollmer (6 vols. Leipzig: EA. Seemann, 1953–62). Continues Thieme-Becker's work (see above).

Dictionnaire critique et documentaire des peintres, sculpteurs, dessinateurs, et graveurs, Emmanuel Bénézit (10 vols. Paris: Librairie Grund, 1976). Reproduces many artists' signatures.

Kindlers Malerei Lexikon (6 vols. Zurich: Kindler Verlag, 1964–71; reprint ed., Hanover: Max Buchner, 1976). Reproduces some artists' signatures.

World Biographical Dictionary of Artists (Internationale Künstlerdatenbank) (CD-ROM. 2nd. ed. Bethesda, MD: University Publications of America). Includes articles from Thieme-Becker, Vollmer, and the first eight volumes of *Allgemeines Küustlerlexikon.* Information on more than 260,000 worldwide artists can be searched in English or German.

XI-C-3. Indexes to Biographical Dictionaries

If little is discovered in the above resources, consult an index to biographical information in dictionaries, which may pinpoint the exact dictionary that includes your particular artist.

Artist Biographies Master Index, Barbara McNeil, editor (Detroit: Gale Publishing, 1986). Covers 275,000 names.

Biography Index [VII-B-2]

Current Biography [VII-B-2]

Index to Artistic Biography, by Patricia Pate Havlice (2 vols. Metuchen, NJ: Scarecrow, 1973; 2 vols. First Supplement, 1981)

Mallett's Index of Artists, by Daniel T. Mallett (New York: R.R. Bowker, 1935; Supplement to *Mallett's Index of Artists,* 1940)

Marquis Who's Who Publications: Index to All Books (Chicago: Marquis Who's Who, 1974)

XI-C-4. Designations and Signatures of Artists and Collectors

Facsimiles of artists' signatures can be located in some exhibition and museum collection catalogues [XII-A-2, item 6]. Also consult Bénézit's *Dictionnaire* and *Kindlers Malerei Lexikon,* listed above.

American Artists, Signatures and Monograms, 1800 to 1989, by John Castagno (Lanham, MD: Scarecrow Press, 1990)

Classified Directory of Artists' Signatures, Symbols, and Monograms: American Artists with New UK Additions, by H. H. Caplan (New and enlarged ed. London: Grahame, 1987). Covers over 5,000 items divided into artists' names, monograms, illegible or misleading signatures, and symbols.

Concise Dictionary of Artists' Signatures: Including Monograms and Symbols, by Radway Jackson (New York: Alpine Fine Arts, 1981). An index to artists' signatures and visual index to monograms and pictorial devices, including about 8,000 items.

Dictionary of Signatures & Monograms of American Artists: From the Colonial Period to the Mid-20th Century, edited by Peter Falk (Madison, CT: Soundview Press, 1996)

Latin American Artists: Signatures and Monograms—Colonial Era to 1996, by John Castagno (Lanham, MD: Scarecrow Press, 1997)

Les marques de collections de dessins et d'estampes: marques estampillées et écrites de collections particulières et publiques. Marques de marchands, de monteurs et d'imprimeurs. Cachets de vente d'artistes décédes. Marques de graveurs apposées après le tirage des lanches. Timbres d'édition. Etc. Avec des notices historiques sur les collectionneurs, les collections, les ventes, les marchands et éditeurs, etc., by Frits Lugt (Amsterdam: Vereenigde Drukkerijen, 1921; Supplément: Den Haag: Martinus Nijhoff, 1956; reprints, San Francisco: Alan Wofsy Fine Arts, first edition, 1975; Supplement, 1988). Reproduces identification marks placed on drawings and prints. Marks are grouped into (a) names, inscriptions, and monograms; (b) figures; (c) marks difficult to decipher and Japanese marks; (d) numbers; and (e) specimens of writings. Includes extensive sales information and an index to names of collectors, artists, dealers, and publishers.

Monogramm Lexikon: Internationales Verzeichnis der Monogramme bildender Künstler seit 1850, by Franz Goldstein (Berlin: Verlag Walter de Gruyter, 1964). Entries cite artists' names, nationalities, dates, and media used. Includes an index to names and a section on artists who used figures, signs, or symbols. Covers artists active since 1850, thereby supplementing Nagler (see below).

Die Monogrammisten und diejenigen bekannten und unbekannten Künstler aller Schulen. . . , by Georg Kaspar Nagler (5 vols. Munich: G. Franz, 1858–79). *General-index zu dr. G. K. Nagler Die Monogrammisten* (Munich: G. Hirth Verlag, 1920; reprint of all 6 vols. Nieuwkoop, Holland: De Graaf, 1966). Reproduces over 30,000 facsimiles of monograms, alphabetized by chief initials in monograms or by symbols used by artists active before the mid-19th century. Includes painters, sculptors, architects, engravers, lithographers, gold- and silversmiths, and ceramists, bringing together

work by such artists as Adam von Bartsch and A. P. F. Robert-Dumesnil. Volume 4 was finished by Andreas Andresen; Volume 5, by Andresen and Carl Clauss. The last volume has a general index and bibliography.

Old Masters Signatures and Monograms, 1400–Born 1800, by John Castagno (Lanham, MD: Scarecrow Press, 1996)

XI-C-5. Examples: Drury and Carree

Susanna Drury

The research problem is to find information on *Susanna Warter.* Who was she? *ULAN* indicates Warter is the married name of the artist Susanna Drury, whose first name could also be spelled Susannah or Susane. This Getty database also reports that she was either a British or Irish painter and that she was active from about 1733 to 1770. In addition, *ULAN* provided the names of five reference works that list Drury; these include Thieme-Becker's *Allgemeines Lexikon* and Mallalieu's *Dictionary of British Watercolour Artists,* both cited above. *ULAN* also cited Walter Strickland's *Dictionary of Irish Artists* (2 vols. Dublin: Maunsel, 1913).

Armed with this information, the regular biographical references were checked; Thieme-Becker has a brief notation on Drury. Since she is not adequately covered by any of the biographical dictionaries, the search was extended to include the indexes to biographical dictionaries cited above, with the following results: *Artist Biographies Master Index* provided *Dictionary of Women Artists,* by Chris Petteys (Boston: G.K. Hall, 1985). Havlice's *Index to Artistic Biography* cites another reference, Maurice H. Grant's *Chronological History of Old English Landscape Painters* (8 vols. Leigh-on-Sea, England: F. Lewis, 1957–61).

In searching the OPAC of the Watson Library, Metropolitan Museum of Art, for a dictionary on Irish watercolorists, two were located <http://www.metmuseum.org/htmlfile/gallery/first/library.html>. One was Patricia Butler's *Three Hundred Years of Irish Watercolours and Drawings* (London: Weidenfeld & Nicolson, 1990), which provides a half-page entry for Drury plus a color illustration of her *Giant's Causeway, Co. Antrim,* now in the Ulster Museum, Ireland. Drury is called a topographical artist who was encouraged by the newly created Dublin Society, which today is the National College of Art and Design of Ireland.

The second source was *Irish Watercolours and Drawings: Works on Paper c. 1600–1914,* by Anne Crookshank (New York: Harry N. Abrams, 1995). It states that Drury painted two works on the Giant's Causeway—one in the Ulster Museum, the other in a private Irish collection—and reports that Lady Llanover's letter of October 1758 mentions Drury.

Once her correct name and dates were known, other references located material on Drury. For instance, *RILA* <http://www.gii.getty.edu/>, which was searched through the Internet home page of the Getty Institute, cited an article in a 1980 issue of *Art History.* The additional leads—Ulster Museum, Dublin Society, the Giant's Causeway, and Lady Llanover's letter—could then be followed.

Michiel Carree

The research project is to learn more about *Michiel Carree. ULAN,* which was consulted for name variations, reports that Michiel Carree is the preferred spelling, but that his first name can be spelled Michael and his last Carre, Carré, Quarré, or Quarre. Thus any of these names might be used in a biographical dictionary or a reference tool. *ULAN*'s bibliography notes that Carree is cited in Thieme-Becker.

Thieme-Becker's *Allgemeines Lexikon* includes a quarter-page signed article on the Dutch artist, plus a bibliography of titles for six German references, which probably will be arduous to obtain and, unless you understand German, difficult to read. Carree's dates are given as 1657–1727; his father, Franciscus Carree, also has an entry.

Allgemeines Künstler Lexikon, which is slowly updating Thieme-Becker's *Allgemeines Lexikon* cited above, has a one-page signed article on the Carree (Carre) family of Dutch artists; the eighth member listed is Michiel, with dates of 1657–1727. His entry has a brief biographical paragraph, the names of 14 institutions that own his art, and references to 16 publications—mostly Dutch—that refer to him.

Although there was no entry for an artist under any of the above names in *The Dictionary of Art,* Michiel Carrée was located in the 1969 encyclopedia *McGraw-Hill Dictionary of Art* [IX-B-2]. The sketchy paragraph states that he was a Dutch landscape and decorative painter who lived from 1657 to 1727. It mentions that there is confusion between this artist and one by the same name who lived from 1652 to 1694. A biblio-

graphical reference is provided to W. Bernt's *Die niederländischen Maler des 17. Jahrhunderts* (Munich, 1948). The first name of the author and the specific publisher in Germany were not provided.

The entry for a Michiel Carré or Carree in Bénézit's *Dictionnaire critique et documentaire* reports that he was born in 1657 and died in 1747 or 1727. The half-page article includes a short biographical paragraph, 20 locations of his paintings, 25 sales of his paintings between 1853 and 1966, and an example of his signature.

Havlice's *Index to Artistic Biography* lists two Dutch artists: Michel Carré, 1666–1728, and Michiel Carree, 1666–1727. The former is listed in Michael Bryan's *Dictionary of Painters and Engravers*, revised by George C. Williamson (5 vols. New York: Macmillan, 1926–34). The latter is cited in *Cyclopedia of Painters and Paintings,* edited by John Champlin (4 vols. New York: Scribner, 1885–87), and Walther Bernt's *Netherlandish Painters of the Seventeenth Century* (3 vols. Trans. by P. S. Falla. London: Phaidon, 1970), which is an English translation of the previously cited reference in the *McGraw-Hill Dictionary.*

The researcher now needs to resolve whether or not Michel Carré is the same Dutch artist as Michiel Carree? And what are his dates? *ULAN* states that both names could be used for the artist and that in some publications *é* is sometimes replaced with *ee*. Moreover, some biographical dictionaries report a range of dates an artist is known to have worked, not necessarily his birth and death dates.

Another source for biographical data is the auction literature: *The Provenance Index* [V-G-2] and the indexes to auction sales, especially the CD-ROM formats. In a search of *The Provenance Index* database supplemented by *ULAN*, which searches all the variations of the artist's name, 175 sales of Michiel Carree's art were located. The majority of the entries were for paintings called *Landscape and Cattle*. Under an 1810 sale, there is a note that Carree was the favorite pupil of Berghem. Although the notation needs to be confirmed, this auction record has provided you with a lead that might be significant.

The indexes of auction sales often provide important clues for research. In checking the indexes for auction sales of the 1990s for this Dutch artist, it was interesting to note that his work is still selling. Under Carree, *Artfact* had 15 entries; under a different spelling, Carre, Mayer reported 15 sold works. *Leonard's* listed a total of 17 works that were either wholly by Carree or attributed to him or his school, circle, or manner. All of the works were sold at U.S. auction houses, the only ones covered by *Leonard's*. The lowest price for a painting considered to be authentic, *Sheep in a Landscape,* sold in 1986 for $660. By 1990, Caree's *Herdsmen Watering Their Flock in a Landscape* brought $7,150. As you can see, the sales information was erratic, with the indexes using different names. This is the confusing world of auction sales. In trying to locate data on difficult-to-find artists, you will need all the analytical skills and luck you can get!

XI-D. Art Collectors

During the Renaissance, the wealthy and powerful commissioned and avidly collected works of art. Information on some of these collectors is now being placed on the Internet. *Firenze by Net* provides a genealogical tree for the Italian d'Medici dynasty, with special illustrated essays for some individual members and the art they commissioned <http://www.italink. com/eng/egui/index.htm>. The Web site of the Museo di Capodimonte in Naples furnishes extensive records on the Italian Farnese family and its collection <http://capodimonte.selfin.net/capodim/home. htm>. The Bibliothèque nationale de France has an online exhibition called "The Age of King Charles V

(1338–1380)," which disseminates information on and reproduces sections of seven illuminated manuscripts from the period, some of which were collected by this monarch <http://www.bnf.fr/enluminures/aaccueil. shtm>.

XI-D-1. Research on Art Collectors

During the past decades, interest in art collectors and individual taste has resulted in museum exhibitions and books devoted to them. Edgar Degas, for instance,

is now viewed as an art collector who purchased works by Cézanne, Gauguin, Manet, and van Gogh. A 1997–98 Metropolitan Museum of Art exhibition was accompanied by a catalogue, *The Private Collection of Edgar Degas* (New York: Metropolitan Museum of Art, 1997). This excellent printed volume includes 13 essays organized by data on the artist-collector, Degas in relation to other artists, and the dispersal of the collection. The last section translates and reprints critical reactions to the Degas Estate sale, providing a historical perspective to this auction. At the museum's Web site, brief information on Degas, his life, and his collection is reported <http://www.metmuseum.org/htmlfile/education/degas/html/index.html>.

Researching material on prominent collectors is a twofold proposition, requiring data (a) on the art collector—a chronology of the person's life, including the dates each work in the collection was purchased or sold and any exhibitions of the collection, and (b) for each work in the collection—catalogue entries, illustrations, and biographical information on artists represented in the collection. The first part is the concern of this section; the second part is the subject of [XI-A] and Chapter XII. All of this can be difficult research, which may end in frustration and the accumulation of insufficient or no data. But it can also be rewarding when elusive material is tracked down.

To locate information on an art collector such as John Julius Angerstein, follow the seven basic steps outlined in [XI-A], with special emphasis on the encyclopedias and biographical dictionaries that cover collectors and a search of the Internet. Although general encyclopedias that furnish data on famous people sometimes include art collectors, the best source for this type of information is *The Dictionary of Art*. Moreover, in its index, this dictionary lists individual patrons and collectors of various artists' works.

Examples

1. *The Encyclopædia Britannica Online* mentions that London's National Gallery was founded in 1824 after the British government purchased 38 paintings collected by the merchant John Julius Angerstein. The site for the new museum was Angerstein's London house at 100 Pall Mall.

2. *The Dictionary of Art* provides a half-page entry on Angerstein, plus cross-references (located in the index) to five entries concerning his collection and four more on paintings he had owned. The signed article discusses Angerstein's heritage, wealth, and collection, not all of which today is in London's National Gallery. The article includes titles of six paintings accompanied by their present locations and two untraced works known through prints. The bibliography cites four references published from 1823 to 1974, the earliest being an inventory of Angerstein's collection.

3. The search engines located two Web sites with information on Angerstein: Lloyd's of London <http://www.lloydsoflondon.co.uk/info/atoz.htm> and Woodlands Art Gallery <http://www.gre.ac.uk/directory/woodlandsgallery/cont.html>. The first explained Angerstein's role as chairman of Lloyd's from 1790 to 1796. Woodlands Art Gallery is located in Angerstein's former country home. The three paragraphs on the collector detail his rise in the financial world and his purchases of art masterpieces with the advice of such luminaries as Benjamin West, Joshua Reynolds, and Thomas Lawrence.

In addition to the encyclopedias and the Internet, check the four items cited below.

Museums That Have Received Some of the Collection

Over the years, the expansion of many art museums has been due to the largess of individual art collectors, such as Andrew Mellon and his son Paul, who have donated many significant works to the National Gallery of Art, Washington, D.C. At its Web site, this museum features its donors, including such information as (a) brief biographies, (b) short lists of books and articles that discuss them, and (c) the titles and donation dates of the works the collectors presented to the institution.

Example

For Paul Mellon, the National Gallery of Art provides a brief biography, the titles of five bibliographical references to him, and information on the 1,008 items that he has generously donated <http://www.nga.gov/search/search.htm>.

Some collections are housed in special museum wings, such as the Robert Lehmann Collection at the Metropolitan Museum of Art in New York City, or in institutions built especially for their collections. As you would expect, these institutions usually have information on their benefactors.

Example

> The Isabella Stewart Gardner Museum, Boston, has comprehensive data on Gardner's life, philosophy, and circle of friends, as well as the arrangements she made for her museum <http://www.boston.com/gardner/>.

Other resources that may assist you in tracing information on famous collections are the printed museum catalogues of permanent collections that have indexes to collectors and previous owners. Because scholarly catalogues are time-consuming, labor-intensive, and expensive to produce, few museums have this type of catalogue for their entire collection. One that does is London's National Gallery, which has separate publications for the different schools of art represented in the museum. Each volume includes several indexes: to topography, religious subjects, profane subjects and portraits, and previous owners.

Example

> In the National Gallery catalogue *The Dutch School*, by Neil MacLaren, the index to previous owners cites three paintings from this school that were once owned by Angerstein. Under Rembrandt's *The Woman Taken in Adultery* (1644), there are almost three pages of information on this one painting! Over and beyond the basic data provided, there is a lengthy provenance.

Inventories of the Collection

When searching for art collectors, you should try to locate two important items: (a) archival material on the collector, which might include letters and other primary documents, and (b) a detailed list of the works that were accumulated. If the collection was exhibited, there may be archival material at the museum or public institution that displayed the art. The Archives of American Art [XIV-A-8] includes collectors, as do *The New York Public Library: The Artists File* [IX-B-6] and the *U.S. Inventories* [XIV-A-9].

Collectors of the past, however, rarely exhibited their art outside their own establishments. Upon their death, the objects may have been purchased, sold, given away, lost, or destroyed, making the individual art works laborious to trace. Sometimes an inventory was made when an estate was settled or when it was sold, or the collector might have compiled a catalogue and privately published it. Finding such an inventory is the challenge!

Sometimes you may discover the existence of such an inventory through other scholars' bibliographies or footnotes, such as the books published on art collections cited below. For American collectors, you can check the Web sites of the *U.S. Inventories*. Some privately published catalogues may be located through searching the OPACs of institutions, especially (a) the national libraries, such as the Library of Congress; (b) the better-established libraries, such as those of the Metropolitan Museum, the J. Paul Getty Museum, or the New York Public Library; or (c) major consortiums, such as COPAC, the English consortium of university research libraries in the United Kingdom and Ireland.

Example

> In a search for a published inventory or listing of Angerstein's art collection, both the Library of Congress and the Watson Library, Metropolitan Museum of Art, were found to have copies of *A Catalogue of the Celebrated Collection of Pictures of the Late John Julius Angerstein, Esquire* (London: Moon, Boys and Graves, 1823), which contains historical notes and a print of each painting by engraver John Young. The title of this booklet was discovered in the bibliography of *The Dictionary of Art's* article.

Exhibitions That Displayed the Collection

When a private collection is displayed outside of its usual location, information on the collection becomes more prominent, since the media may cover the event and there is often a catalogue or book to accompany the exhibition. To locate these exhibition catalogues, try a title search using the collector's name through a major library's OPAC and the *Worldwide Books Online* database <http://www.worldwide.com/>.

Examples

> 1. Until London's Royal Academy of Arts displayed works collected by Swiss Baron Hans Heinrich Thyssen-Bornemisza, few people had seen this marvelous collection. *Old Master Paintings from the Thyssen-Bornemisza Collection*, the 1988 exhibition catalogue by David Ekserdjian, was an excellent addition to the knowledge of the 53 paintings exhibited. The *London Sunday Times Magazine*, March 13, 1988, publicized the news far and wide.

> 2. A more recent example is the 26 Impressionist and modern masterpieces owned by Swiss collector Rudolf Staechelin that were exhibited in 1997–98 at the Kimbell Art Museum in Fort Worth, Texas.

NAFEA: The Rudolf Staechelin Collection Basel,[4] by Hans-Joachim Müller (Basel: Wiese Publishing, 1991), was for sale to the public. This publication provides material on each work of art and Rudolf Staechelin (Swiss, 1881–1946).

After the collector's death, his son Peter placed the core of the collection on a long-term loan to the Kunstmuseum Basel, where it remained until 1997. The Rudolf Staechelin Family Foundation Collection, which now owns the paintings, then placed them on a three-year loan to the Kimbell Art Museum. At its Web site, the foundation explains that it removed the collection from Switzerland to protest the UNIDROIT-Convention, a legal procedure concerning export control presently being discussed in Europe. Access this Web site for more information concerning the problems of international art law <http://www.staechelin.ch/RSF/index.html>.

To discover if this collection had been previously exhibited, a title search for *Staechelin* of the *Worldwide Books Online* database was conducted <http://www.worldwide.com/>. A catalogue, *Fondation Rodolphe Staechelin: De Corot à Picasso,* was published in 1964 for an exhibition held at the Musée National d'Art Moderne, Paris.

Information on Buying or Selling of Works

To trace the provenance of a work, you need to locate records of past auction sales [VIII-B] that include the names of the buyers and sellers; this can be a formidable task. One method is to search for auctioneers' copies of auction catalogues, since they frequently added the names of sellers, buyers, and prices. Reprints of these, such as the *Knoedler Library Sales Catalogues,* can be a source for this type of information. For 19th-century sales at British auctions, consult the *Provenance Index* [V-G-2]; for more recent sales, some indexes to auction sales on CD-ROM or through the Internet can be searched using collectors' names. For the names of the sellers, try to trace the catalogues through *SCIPIO* or Lugt's *Répertoire des catalogues de ventes publiques.*

Example

In a search for information on art collector Angerstein, the *Provenance Index* located a Rembrandt painting purchased by John Julius Angerstein in 1807. To discover other works of art purchased by this collector, you would need to study each entry reported by the *Provenance Index* and then check with the catalogues of the permanent collection of the National Gallery to locate the works Angerstein donated to this London museum.

Other items that may assist you in tracing information on famous collections are (a) any signature, seal, or crest on works of art once owned by the collector, see [XI-C-4], above, since these may be the owner's personal seals or stamps; (b) depictions of heraldry, medals, or decorations found on the works; (c) books discussing collectors; and (d) material on the dissolution of collections. The books listed below are concerned with several collectors. For individuals collectors, remember to use a title search of a library's OPAC or *Worldwide Books Online.* Exhibition catalogues of private collections usually have the name of the collector in the titles.

Example

One reference cited in Chapter VIII is George Redford's *Art Sales: A History of Sales of Pictures and Other Works* (2 vols. London: Redford, 1888). The annotation states that the book records sale prices, as well as the names of sellers and purchasers, on works of art obtained by London's National Gallery from 1824 through 1887. Obviously, this is an important work for the study.

XI-D-2. Heraldry, Medals, and Decorations

If coats of arms, shields, or symbols of heraldry were added to a work of art, you should check the list of resources below, which might provide a clue as to a previous owner. Most of these books were compiled in the 19th or early 20th century; there are numerous reprints of this material.

Burke's Genealogical and Heraldic History of the Peerage, Baronetage, and Knightage, edited by Peter Townend (London: Burke's Peerage, 1826; frequent eds. since). Reproduces coats of arms and includes historical accounts of lineage. Titles of different editions vary slightly.

Complete Guide to Heraldry, by Arthur Charles Fox-Davies (Rev. and annotated by John Philip Brooke-Little. London: T.C. & E.C. Jack, 1909; reprint ed., London: Thomas Nelson & Sons, 1969). Illustrates the history of shields, crests, and symbols of heraldry.

Genealogical History of the Dormant, Abeyant, Forfeited, and Extinct Peerages of the British Empire, by John Bernard Burke (London: Harrison and Sons, 1883; reprint ed., William Clowes and Sons, 1969). Illustrates the coats of arms.

Glossary of Terms Used in Heraldry, by Henry Gough and James Parker (Oxford, England: James Parker, 1894; reprint ed., Detroit: Gale Research, 1966)

Heraldic Alphabet, John Philip Brooke-Little (London: Macdonald, 1973). Covers the history, development, grammar, and law of heraldry.

Heraldry of the Royal Families of Europe, by Michael Maclagan (New York: Clarkson N. Potter, 1981)

Orders, Medals and Decorations of Britain and Europe in Colour, by Paul Hieronymussen, translated by Christine Crowley (London: Blandford, 1967)

Popes through the Ages, Joseph Stanislaus Brusher (Princeton, NJ: Van Nostrand, 1959). Covers the popes from St. Peter through John XXIII. Entries include reproductions of personal coats of arms.

XI-D-3. Books on Art, Taste, and Collectors

The texts—as well as the bibliographies and footnotes—in the works cited below may provide clues to locating the collector you are researching. Some references provide data on inventories and private collections. Remember to consult the material in the *Provenance Index Project* [V-G-2].

Art of the Popes from the Vatican Collection, edited by Maurizio Fagiolo dell'Arco (New York: Crown, 1982)

Artful Partners: Bernard Berenson and Joseph Duveen, by Colin Simpson (New York: Macmillan, 1986)

Courts of Europe: Politics, Patronage and Royalty 1400–1800, edited by A.G. Dickens (New York: McGraw-Hill, 1977; reprint, New York: Greenwich House, 1984)

Courts of the Italian Renaissance, by Sergio Bertelli, et al. (Trans. by Mary Fitton and Geoffrey Culverwell. New York: Facts On File, 1986)

Cultures of Collecting, edited by John Elsner and Roger Cardinal (London: Reaktion Books, 1994)

Documents for the History of Collecting, edited by the Getty Provenance Index (Bethesda, MD: K.G. Saur)

 Volume 1: *Collections of Paintings in Naples 1600–1780,* 1992

 Volume 2: *Collezione dei dipinti Colonna inventari, 1611–1795,* Part 1, 1996

 Volume 3: *Collections of Paintings in Madrid 1601–1755,* 1997

Finders, Keepers: Eight Collectors, by Rosamond Wolff Purcell and Stephen Jay Gould (New York: W. W. Norton, 1992)

Illustrated Inventory of Famous Dismembered Works of Art, UNESCO (New York: K.G. Saur, 1974). Illustrate how art pieces are often dismembered and sold in sections.

Impressionism: The First Collectors, by Anne Distel (Trans. by Barbara Perroud-Benson. New York: Harry N. Abrams, 1990)

Kings and Connoisseurs: Collecting Art in Seventeenth-Century Europe, by Jonathan Brown (Princeton, NJ: Princeton University Press, 1995)

Magnificent Obsessions: Twenty Remarkable Collectors in Pursuit of Their Dreams, by Mitch Tuchman (San Francisco: Chronicle Books, 1994)

Past and Present in Art and Taste, by Francis Haskell (New Haven, CT: Yale University Press, 1980)

Patrons and Painters: A Study in the Relations between Italian Art and Society in the Age of the Baroque, by Francis Haskell (Rev. ed. New Haven, CT: Yale University Press, 1980)

Rediscoveries in Art: Some Aspects of Taste, Fashion, and Collecting in England and France, by Francis Haskell (2nd ed. Ithaca, NY: Cornell University Press, 1979). Covers 1780 to 1870.

"Paintings and Other Works of Art in Sixteenth-Century English Inventories," by Susan Foster (*Burlington Magazine* 123, May 1981: 273–82).

Princes and Artists: Patronage and Ideology at Four Habsburg Courts 1517–1633, by Hugh Trevor-Roper (New York: Harper & Row, 1976)

Power and Display in the Seventeenth Century: The Arts and Their Patrons in Modena and Ferrara, by Janet Southorn (Cambridge: Cambridge University Press, 1988)

Proud Possessors: The Lives, Times, and Tastes of Some Adventurous American Art Collectors, by Aline Saarinen (New York: Random House, 1958)

Rediscoveries in Art: Some Aspects of Taste, Fashion, and Collecting in England and France, by Francis Haskell (Ithaca, NY: Cornell University Press, 1976)

Répertoire des tableaux vendus en France au XIXe siècle, Volume 1: 1801–1810, edited by Benjamin Peronnet and Burton Fredericksen (Malibu, CA: Getty Institute, 1998)

Royal Heritage: The Treasures of the British Crown, by J.H. Plumb and H.U.W. Wheldon (New York: Harcourt Brace Jovanovich, 1977)

Seventeenth-Century Barberini Documents and Inventories of Art, by Marilyn Aronberg Lavin (New York: New York University, 1975)

Taste and the Antique: The Lure of Classical Sculpture 1500–1900, by Francis Haskell and Penny Nichols (New Haven, CT: Yale University Press, 1981)

Taste of Angels: A History of Art Collecting from Rameses to Napoleon, by Francis Henry Taylor (Boston: Little, Brown, 1948)

The Vatican Collections: The Papacy and Art (New York: Metropolitan Museum of Art, 1982)

Virtue and Magnificence: Art of the Italian Renaissance Courts, by Alison Cole (New York: Harry N. Abrams, 1995)

Women and Art in Early Modern Europe: Patrons, Collectors, and Connoisseurs, edited by Cynthia Lawrence (University Park: Pennsylvania State University Press, 1997)

XI-D-4. Books on the Plunder of Art

Recently, there has been better documentation on the dissolution of art during the great upheaval that occurred with World War II. Once owned by private collectors, this art has become the subject of exhibitions and scholarly books. But the plunder of art is not only a 20th-century occurrence; it has been a problem throughout history.

Art Plunders: The Fate of Works of Art in War and Unrest, by Wilhelm Treue, translated by Basil Creighton (New York: John Day, 1961). Covers art from antiquity through World War II, with a lengthy section on the French Revolution and Napoleon.

Beautiful Loot: The Soviet Plunder of Europe's Art Treasures, by Konstantin Akinsha Konstantin and Grigorii Kozlov (New York: Random House, 1995)

Loot!: The Heritage of Plunder, by Eric Russell Chamberlin (New York: Facts On File, 1983)

Plunder of the Arts in the Seventeenth Century, by Hugh Trevor-Roper (London: Thames & Hudson, 1970)

Rape of Europa: The Fate of Europe's Treasures in the Third Reich and the Second World War, by Lynn H. Nicholas (New York: Alfred A. Knopf, 1994)

Spoils of War: World War II and Its Aftermath: The Loss, Reappearance, and Recovery of Cultural Property, edited by Elizabeth Simpson (New York: Harry N. Abrams, 1997)

Notes

1. An *œuvre* is an artist's complete artistic output, either in a specific medium or in total creative effort.
2. See the section on competitive exhibitions [XII-A-2], item 10, and Appendix One.
3. Note that the *M.* indicates *Monsieur* or *Mr.*; it does not represent the first name of Gleyre.
4. *NAFEA*, meaning *When Will You Marry?* is the Tahitian title of one of Paul Gauguin's paintings, a prized work in the collection.

XII. STUDYING WORKS OF ART

The study of art frequently centers around specific objects that (a) illustrate certain styles or particular cultures and/or (b) depict subjects or symbols related to some idea or concept. In-depth research is often concerned with the many ways to approach these works of art. The most important component of this type of investigation is the original work of art itself. What can be learned from closely observing the actual work cannot be overestimated!

For most research on a work of art, you must know the current owner. The institution or person who possesses it can often be discovered through the following resources, all of which were discussed in previous chapters:

- biographical dictionaries (Chapter XI)
- catalogues raisonnés or œuvres catalogues [XI-A-6]
- indexes of art literature [VII-B-2]
- indexes to works of art [IX-B-7]
- exhibition, museum, and sales catalogues (Chapters III and VIII)

Once you discover where the work of art is located, you should strive to view it. Taking a trip to observe the art, however, may not be feasible or practical. It is therefore of the utmost importance that you locate the best possible images with regard to clarity of detail and color fidelity. These images may be in a variety of formats: photographs, CD-ROMs, slides, microforms, or published books.

The examples used in this chapter are primarily from the Getty Art Museum, Malibu, California, and the National Gallery of Art, Washington, D.C., because these two institutions have placed at their Web sites extensive material concerning their permanent collections. The institutions will be abbreviated as Getty and NGA. When studying a work of art, it is important to discover information on the following eight points, the first four of which are discussed in this chapter:

- basic characteristics of the work
- subjects and symbols depicted
- criticism of the work
- art in context; its special history
- social, cultural, and religious history of the country at the time the work was created [X-A-6]
- artist's life, works, and influences (Chapter XI)
- style of the work in relationship to art history (Chapter X)
- patrons of the artist or collectors who owned the work [XI-D]

XII-A. Information Derived from the Work of Art

You must either see the actual work of art or have an excellent reproduction in order to (a) study its design analysis and (b) compile a summary record of the work's basic characteristics. These items are discussed below.

XII-A-1. Design Analysis

All too often, people study art history without ever learning the fundamental components of art. Before you can grasp all aspects of a work of art, you should understand the basics: (a) the art elements—line, shape, form, space, texture, and color—and (b) the principles of design, such as balance, proportion, emphasis, rhythm, and movement. In addition, you should understand the various media, their techniques, and their effect on the finished work of art. These essential principles are the subject of numerous books and some Web sites developed by education departments of academic institutions and museums. A few are listed here.

Books Covering Design Analysis

Two of the books cited below, *Art of Seeing* and *Living with Art,* furnish excellent introductions to design analysis. They (a) discuss the differences between two-dimensional and three-dimensional objects and (b) define the special vocabulary used by the various media. Their special strengths are the placing of works of art next to each other for comparison by contrasting different art media, styles, and art from various time periods. All of the following books will further your appreciation of art.

Art and Illusion: A Study in the Psychology of Pictorial Representation, by E.H. Gombrich (5th ed. London: Phaidon Press, 1977)

Art History, by Marilyn Stokstad (Englewood Cliffs, NJ: Prentice Hall, 1995). Includes a glossary of terms and brief explanations of art techniques.

Art of Seeing, by Paul Zelanski and Mary Pat Fisher (3rd ed. Englewood Cliffs, NJ: Prentice Hall, 1994)

Changing Images of Pictorial Space: A History of Spatial Illusion in Painting, by William V. Dunning (Syracuse, NY: Syracuse University Press, 1991)

Learning to Look, A Handbook for the Visual Arts, by Joshua C. Taylor (2nd ed. Chicago: University of Chicago, 1981)

Living with Art, by Rita Gilbert (4th ed. New York: McGraw-Hill, 1995). Includes plastic overlays to assist you in better understanding the visual elements and the principles of design.

Web Site Examples

1. *Art Production,* North Texas Institute for Educators on the Visual Arts, introduces the elements of art <http://www.art.unt.edu/ntieva/artcurr/prod/prod3.htm>.

2. *Looking at Art,* an educational program of the Metropolitan Museum of Art, explores composition—perspective, light, color, form, motion, and proportion—as well as themes, using as an example Emanuel Gottlieb Leutze's *Washington Crossing the Delaware,* 1851. Be sure to access this exciting Web site <http://www.metmuseum.org/htmlfile/education/look.html>!

3. *Analysis of Visual Images,* University of Newcastle, Australia, furnishes examples of analyzing various art works <http://www.newcastle.edu.au/department/fad/fi/woodrow/analysis.htm>.

4. In *On the Internet,* Joseph Dauben discusses Renaissance art and mathematical perspective <http://bang.lanl.gov/video/stv/arshtml/arstoc.html>. Included are video clips, perspective drawings, and a reference to John White's classic book, *Birth and Rebirth of Pictorial Space* (3rd. ed. Cambridge, MA: Harvard University Press, 1987).

XII-A-2. Basic Characteristics

When studying a work of art, you should begin by recording all pertinent data that can be found. First, an illustration of the work must be located. Second, a record for the object should be compiled from both (a) the work itself and (b) peripheral sources. The material can be organized into 13 categories, which are detailed below. Information will not be discovered for all sections; for instance, some works of art have never been included in a publication or displayed in an exhibition. Furthermore, because a record is a compilation of known information, it will change as more information is uncovered and added. To clarify these 13 categories, Sisley's *Boulevard Héloïse, Argenteuil,* owned by the National Gallery of Art in Washington, D.C., is used as an example. To locate the NGA entry, access <http://www.nga.gov/search/search.htm> then request material on Sisley and Argenteuil.

For a discussion on works of art, read "Categories for the Description of Works of Art," the guidelines developed for describing a work of art. It is available at the Getty Web site [V-G-2] <http://www.gii.getty.edu/cdwa/INTRO.HTM>.

Data Gleaned from Work

This part of the record covers eight types of information.

1. Artist's Name and Dates

The artist's names and dates can usually be located through (a) *ULAN* <http://www.gii.getty.edu/aka/>; (b) *Biography,* the Web site discussed in [IX-B-5] <http://www.biography.com/>; or (c) the biographical dictionaries (Chapter XI). If the artist is unknown, provide information on any style or school whose presence or influence is discerned in the work.

2. Title of the Piece

Other than the name by which the artist called it, a work's title may be (a) a generic name, such as *Abstract Painting* or *Archaic Greek Statue;* (b) abbreviated, altered, or modified; or (c) translated from another language. Titles are often abbreviated and can easily be changed. Because owners have the right to name and rename any art they own, some works have a history of name changes.

National Gallery of Art's Web Page for Sisley's *Boulevard Héloïse, Argenteuil* <http://www.nga.gov/search/search.htm>

Example

The Sisley painting now known as *Overcast Day at Saint-Mammès,* c.1880 (Museum of Fine Arts, Boston), has also been titled *Saint-Mammès, temps gris* and *Saint-Mammès, Cloudy Weather.*

A title may be altered, modified, or translated over the years. For instance, John Singleton Copley's famous painting of a man and a shark in Havana Harbor is now entitled *Watson and the Shark,* 1778 (National Gallery of Art, Washington, D.C.). Research in the *Provenance Index* revealed other titles for this painting, although the reasons for these changes were not provided. These other titles included *The Late Sir Brook Watson Bathing in the Harbour of Havannah* and *The Miraculous Escape of the Late Sir Brook Watson.* The word "shark" is not even mentioned!

The foreign-language dictionaries [XI-C-2] frequently report titles for works of art in the language of the publisher. For instance, Bénézit's *Dictionnaire critique et documentaire* records titles in French; *Kindlers Malerei Lexikon,* in German. This means that as you

are searching for the provenance of a work of art, care must be taken to use the various names by which the work has been called.

Example

Sisley's painting *Inondation à Port-Marly,* owned by the Paris Musée d'Orsay, might be translated as *Flooding at Port Marly* by an English institution and *Die Überschwemmung in Port-Marly* by a German museum.

The information needed for the next six categories must come from either the owner of the work or a publication whose author has inspected and measured the work or obtained this data from the owner. These facts include date, medium, size, condition of work, acquisition number, and any information, such as signature or date, located on the work.

3. Approximate Date It Was Created

The date is sometimes written on the work of art. If not, you may need to research it by using the same tools utilized in compiling a chronology of the artist

[XI-A]. If the exact date is not known, an approximation or range of dates should be provided.

4. Materials and Support

The medium of an art object should be defined as accurately as possible. For instance, if a painting, state whether it was created in oil, watercolor, or acrylic and whether it was painted on board, canvas, or paper.

5. Dimensions

In English-language catalogues, dimensions are reported either in both centimeters and inches or only the metric system is used. Most measurements are written with the height of the object preceding the width.

6. Specific Data on the Object

Any data on the work—such as date, written name, monogram, or watermark—can prove to be of the utmost importance. If there is a signature, this might assist you in ascertaining the authenticity of an object, since you might be able to compare it with other known signatures by the artist. For artists who have changed the way they inscribe their names over the years, signatures can sometimes be used to determine the work's probable date.

Some sources that reproduce artists' signatures and monograms include:

- books cited under designation and signatures [XI-C-4]
- catalogues of museums, such as
 Frick Collection, New York City
 Rijksmuseum, Amsterdam
 Statens Museum for Kunst, Copenhagen
 Bayerische Staatsgemäldesammlungen, Munich
 Hamburger Kunsthalle, Hamburg
- catalogues raisonnés and printed exhibition catalogues on a single artist
- Web sites of museums that include this documentation

Example

For Sisley's painting *Boulevard Héloïse, Argenteuil,* the NGA includes its date, 1872, and its measurements in both meters and inches. There is no information concerning a signature, but a detail of the section of the painting containing it is reproduced.

Specific data found on the object obviously vary with the form of art. For instance, an important fac-

tor for drawings and prints is whether or not the paper contains a watermark, a distinct design or pattern impressed or incorporated into sheets of paper. Watermarks designate the paper's maker or manufacturer and can assist in determining locations and approximate dates of works of art. At its Web site, the Institute of Paper Science and Technology provides access to the Robert C. Williams American Museum of Papermaking. The virtual tour of this institution includes information on the making of paper, its history, and watermarks <http://www.ipst.edu/amp/>.

7. The Condition of the Work

The work's physical condition should be included in the catalogue entry, especially if it has been damaged, cleaned, or restored. Although few works of art have been scientifically analyzed, researchers must be cognizant of those that have. For some excellent examples of this type of information available on the Internet, see the *Rembrandt Pavilion* [V-A] and the examples of Corot's paintings [V-C].

8. Current Location and, Where Applicable, Accession Number

The present location or owner should also be included in the catalogue entry, accompanied by the accession or acquisition number the owner assigned the object upon receiving it into the collection.

Example

For Sisley's painting *Boulevard Héloïse, Argenteuil,* the accession number is 1970.17.82. This indicates that the painting was the 82nd item of lot 17 received by the museum's registrar in 1970.

Peripheral Data

The peripheral information that needs to be collected can present a challenge. This includes four categories: provenance, exhibitions, literature, and any related works. Since the methodology for determining the subject and/or symbols depicted in a work can be complicated, it is discussed separately below.

Example

The NGA entry for Sisley's painting *Boulevard Héloïse, Argenteuil,* discussed above, includes its provenance, its bibliography or literature that mentions the painting, a chronology of its exhibition history from 1899 to the present, and a narration taken from an NGA virtual tour called the Beginning of Impres-

sionist Landscape. The NGA furnishes these scholarly entries; not all museums' entries are as comprehensive.

9. Provenance

The work's provenance requires tracing its movements from the time it left the artist's studio to when it reached its present location. In collecting data on changes of ownership and auctions in which the artwork might have figured, you are obtaining information that may assist you in determining attribution. In establishing provenance, which can be elusive and is sometimes impossible to trace, you may need to decide whether various references for works with similar titles but in varying dimensions are referring to the same or different works of art.

In searching for a work's provenance, investigate:

- exhibition catalogues, catalogues raisonnés, and œuvre catalogues [XI-A]
- any existing inventories or collection inventories [XI-D]
- auction catalogues and indexes covering them (Chapter VIII)
- archival material or vertical files that might include sales information and other ownership clues [IX-B-6]

Example

The NGA catalogue entry for Sisley's *Boulevard Héloïse, Argenteuil,* states that the painting was the gift of Alisa Mellon Bruce, one of 183 works she donated to the museum. The changes in ownership from the time it left the artist's studio to Bruce's purchase in 1955, and its bequest to the museum, are summarized.

10. Various Exhibitions in Which the Work Has Been Displayed

A list of exhibitions in which the object has been shown should be compiled, accompanied by their locations and dates. It is not easy to establish the exhibition record for a work of art. Although the owner will be able to provide you with information concerning the work, exhibition records prior to this ownership date may be more difficult to find. First, a notation that the work was displayed in a specific exhibition needs to be discovered; then the exhibition catalogue should be consulted to verify the citation. Remember: not all published reports are accurate. Checking and corroborating data are an integral part of all research.

For exhibitions that displayed the work before it left the artist's studio, consult Appendix One. Remember that early exhibition catalogues have no illustrations, making it particularly difficult to ascertain whether or not a listed work of art is the same as the one you are researching. Some resources available for this research are (a) the OPACs of major libraries [VI-C], (b) indexes to art literature [VII-B], (c) vertical files and scrapbooks [IX-B-6], and (d) indexes to past exhibitions (Appendix One).

11. Literary References That Discuss the Piece

In citing literature that refers to the work of art, you may need to curtail the list depending upon the prominence of the artist and the work of art. For instance, a list of all literary references to Picasso's *Guernica,* 1937 (Centro de Arte Reina Sofia, Madrid), would be so extensive as to be meaningless. You should cite only the references that are historically important or that discuss some new information or innovative aspect of the work.

12. Related Works of Art

Locating material on any similar works of art, engravings or graphics based on the work, and/or studies, sketches, or drawings is usually one of the hardest tasks. Exhibition catalogues and catalogues raisonnés often include preliminary studies. You may also wish to check some of the drawings that constitute the collections of large museums, such as Paris's Musée du Louvre and London's British Museum. For graphic material, see the *Art Imagebase* at the Fine Arts Museums of San Francisco [III-A-3] and the Prints and Photographs Division of the Library of Congress [VI-A-1]. Unless a famous work of art is similar to or based on the work being catalogued, the search for such an item may be futile. Remember, information for some categories of a catalogue entry may never be found.

13. Additional Pertinent Information

A record of a work of art includes any data known about the object. In a scholarly entry, this section is often the longest and the most revealing. It may include any of the following items, which are discussed below:

- subject and symbolism depicted, including data on sitters, items, or locations illustrated
- unusual or important criticism of the art
- the art in context; its special history

XII-B. Subjects Depicted in Works of Art

Although not all art depicts a subject, many artistic creations are intended to impart a message. Symbols, objects, and emblems illustrated in works of art often represent ideas, concepts, or persons to convey meaning. The subject can also be a symbol, although these symbols do not necessarily have the same interpretation throughout all periods of history. For instance, the swastika used by many ancient and non-Western cultures probably conveyed a number of meanings, one of which involved the four cardinal directions. During the 20th century, the swastika became the emblem for a particular political party—the German National Socialist Party, whose members were known as Nazis. Over the years, many symbols have lost their meaning for viewers. You may need to research the subject to discover the symbol's original significance, which is often complicated and may have various levels of intent.

Example

> Figures portraying Adam and Eve depict the Genesis story and humankind's fall from grace. During the Middle Ages, this was a symbol for three major sins: lust, in craving the fruit; avarice, in desiring power and wealth; and pride, in aspiring to be God-like. Depictions of the disobedient couple were also prefigurative symbols for the redemption of humanity through the grace of the second Adam, Christ, and the second Eve, the Virgin Mary.

Two terms used in discussions of symbols are iconography and iconology. *Iconography* is the study of the meaning of a work's subjects and symbols and of any literary references from which they derive. Covering a broader and more in-depth scope, *iconology* provides a deeper meaning for themes in relation to the history, religion, mores, customs, and social concerns of a particular milieu at a specific time. This requires multidisciplinary research on the influences on the work of art. For a discussion of these two terms, consult one of the art encyclopedias [IX-B-2] and the subject matter section in the Categories for the Description of Works of Art [V-G-2] <http://www.gii.getty.edu/cdwa/>.

An analysis of the subject of a work of art can be the most significant part of its record. This type of study usually requires research in various peripheral fields. Remember that identifying subjects and symbols can be open to different interpretations. Not all scholars will agree with every interpretation. You need to be careful not to attribute a meaning to a work which the artist did not intend. The problem arises when a work of art is used to illustrate a specific idea or thought, whether or not it really does.

There are some publications that feature one work of art, providing all types of information concerning it; similar material is being placed on the Web by a few museums. Below are lists of (a) dictionaries and Web sites for general iconographic studies, (b) indexes to subjects depicted in art, and (c) references that discuss many aspects of one work. For additional references on subjects and symbols, see *Sources in Iconography in the Blackader Lauterman Library of Architecture and Art: An Annotated Bibliography,* edited by Irene Zantovská Murray and compiled by Kathryn A. Jackson (Montreal: McGill University, 1997) and Jones's *Art Information* [II-A], pages 273–86.

Example

> At its Web site, the NGA uses *Watson and the Shark* by John Singleton Copley to explain certain aspects of works of art <http://www.nga.gov/highlights/ webfeatr.htm>. Copley's painting is discussed as to its story, the artist, some facts concerning the painting, and historical sources that influenced the artist. This is an excellent place to begin your study of understanding works of art.

General Subject Dictionaries and Web Sites

Dictionary of Subjects and Symbols in Art, by James Hall (2nd ed. rev. New York: Harper & Row, 1979). The best general subject dictionary for Western European themes and symbols in art, commencing with classical Greece.

Dictionary of Symbolism: Cultural Icons and the Meanings Behind Them, by Hans Biedermann, translated by James Hulbert (New York: Meridian, 1992)

Encyclopedia of Comparative Inconography: Themes Depicted in Works of Art, edited by Helene E. Roberts (2 vols. Chicago: Fitzroy Dearborn, 1998). Discusses 119 subjects—such as adultery, femme fatale, grieving, laughter, and marriage—in relation to mythology, the Bible, and other literature. Illustrated entries include examples of art depicting the themes and reading lists. Seven indexes complete the volumes.

Hall's Illustrated Dictionary of Symbols in Eastern and Western Art, by James Hall (London: John Murray, 1994). Covers abstract signs, animals, artifacts, earth and sky, human body and dress, and plants.

Illustrated Book of Signs & Symbols, by Miranda Bruce-Mitford (New York: DK Publishing, 1996)

Illustrated Dictionary of Narrative Painting, by Anabel Thomas (London: John Murray, 1994)

Image as Insight: Visual Understanding in Western Christianity and Secular Culture, by Margaret R. Miles (Boston: Beacon Press, 1985)

Introduction to Iconography, by Roelof van Straten, translated by Patricia de Man (Langhorne, PA: Gordon and Breach, 1994)

"Power of Symbols," *OneEurope Magazine,* a German publication, January 1995
 <http://www.informatik.rwth-aachen.de/AEGEE/oneEurope/oem195.html>

Secret Language of Symbols: A Visual Key to Symbols and Their Meanings, by David Fontana (New York: Chronicle Books, 1994)

Indexes to Subjects Depicted in Art

Locating individual works of art depicting a specific subject is often a challenge, because there are not enough indexes to this type of material. Only a few references index titles of works of art by subject. A few museums have iconographic indexes in their printed catalogues of permanent collections; these include the National Gallery, London; Yale University Art Gallery, New Haven, Connecticut; the National Gallery, Washington, D.C., and the Samuel H. Kress Collection. A few of the resources cited below use Iconclass [IX-B-7].

Computerized Index of British Art 1550–1945 [IX-B-7]

Fine Arts Museums of San Francisco
 <http://www.famsf.org/>

Iconographic Index to Stanislas Lami's Dictionaire [XIII-F-5]

Marburger Index [IX-B-7]

National Gallery of Art [III-A-3] includes a subject index at its Web site
 <http://www.nga.gov/>

Witt Library Computer Index [V-G-2]

Works on One Work of Art

You may wish to study some of the following references that clarify a work's subject and historical meaning. The museums developed the publications for works in their permanent collections.

Amon Carter Museum of Western Art, Focus Exhibitions Series (Fort Worth, TX: Amon Carter Museum)

 Ominous Hush: The Thunderstorm Paintings of Martin Johnson Heade, by Sarah Cash, 1994

 Thomas Cole's Paintings of Eden, by Franklin Kelly, 1994

 Thomas Eakins and the Swimming Picture, edited by Doreen Bolger and Sarah Cash, 1996

J. Paul Getty Museum, Studies on Art Series (Malibu, CA: J. Paul Getty Museum)

Andrea Mantegna: "The Adoration of the Magi," by Dawson W. Carr, 1997

Anthony van Dyck: "Thomas Howard, The Earl of Arundel," by Christopher White, 1995

Camille Silvy: "River Scene, France," by Mark Haworth-Booth, 1992

Edgar Degas: "Waiting," by Richard Thomson, 1995

Jacques-Louis David: "The Farewell of Telemachus and Eucharis," by Dorothy Johnson, 1997

Jan Steen: "The Drawing Lesson," by John Walsh, 1996

Lawrence Alma Tadema: "Spring," by Louise Lippincott, 1990

Pierre-Auguste Renoir: "La Promenade," by John House, 1997

Pontormo: "Portrait of a Halberdier," by Elizabeth Cropper, 1997

Roger Fenton: "Pasha and Bayadère," by Gordon Baldwin, 1996

Manet: The Execution of Maximilian: Painting, Politics, and Censorship, by Juliet Wilson-Bareau (London: National Gallery Publications in association with Yale University Press, 1992)

National Gallery, London, Making and Meaning Series (London: National Gallery Publications)

 Turner: "The Fighting Temeraire," by Judy Egerton, 1995

 Making and Meaning, Wilton Diptych, by Dillian Gordon, 1993

 Rubens's Landscapes: Making and Meaning, by Christopher Brown, 1996

 Young Michelangelo, by Michael Hirst and Jill Dunkerton, 1994

Van Gogh "Starry Night": A History of Matter, by Albert Boime (CD-ROM. New York: Voyager, 1995)

The following section suggests a methodology for locating information on subjects depicted in art and lists Web sites and printed references covering these topics. The examples include (a) Judeo-Christian subjects, (b) classical mythology, (c) portraiture, and (d) other secular subjects.

XII-B-1. Judeo-Christian Subjects

This section includes (a) a suggested methodology, (b) reference tools, (c) relevant literature, (d) documentary videos, and (e) indexes to Judeo-Christian works of art.

A Methodology for Judeo-Christian Subjects

You are assigned to write a report on a Judeo-Christian religious work of art. You choose Bernardo Daddi's *Triptych: Madonna, Saint Thomas Aquinas, and Saint Paul,* c. 1330, from the J. Paul Getty Museum <http://www.getty.edu/museum/objects/Paintings/93_PB_16_A.htm>. By pursuing the nine basic steps

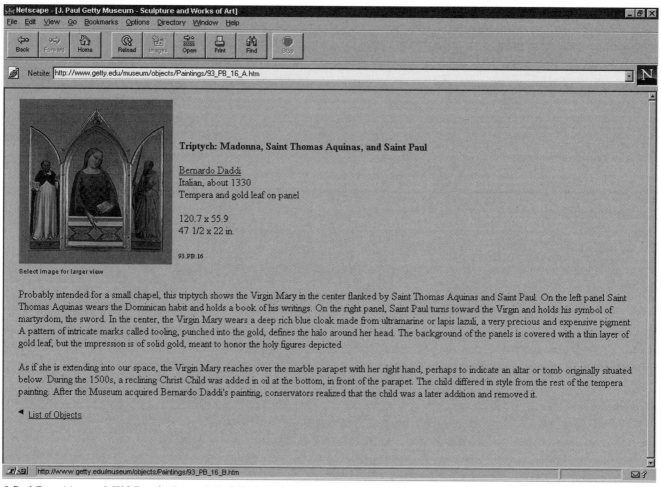

J. Paul Getty Museum's Web Page for Bernardo Daddi's *Triptych* <http://www.getty.edu/museum/objects/Paintings/93_PB_16_A.htm>

discussed below, you may meet the challenge of documenting the subject of the work. All of the OPAC searches were conducted using the OPAC of the Library of Congress <http://lcweb.loc.gov/catalog/>. When you search for artists with double names, you may find that the indexes vary: some cite Bernardo Daddi under B, for Bernardo; others under D, for Daddi.

1. Examine the Work of Art Carefully and Describe What Is Depicted

All iconographic studies depend upon a correct description of what is depicted. You should inspect every detail of the work of art closely to discern exactly what is being illustrated. For the Daddi painting, the Getty includes a reproduction of the work and a description of the figures, their attributes, and their dress. The entry does not indicate the reason the Virgin is carrying a book; it is up to you to search for the image's meaning.

2. Check Specialized Dictionaries to Locate Information on the Subject

Although the three figures in the triptych have already been named, you should still consult the general subject dictionaries listed above to discover more about the objects represented. One of the best iconographic reference books is James Hall's *Dictionary of Subjects and Symbols in Art*. Under the section for the Virgin Mary, Hall explains the meaning of the Virgin holding a book and the development of the *Sacra Conversazione* (Sacred Conversation), in which the Virgin is placed between two saints.

3. Consult All Types of Reference Material, Exhibition Catalogues, and Any Pertinent Web Sites to Learn More about the Subject and Symbols

You will need to read the resources on the Holy Family, as well as those on the saints. *Bible and the Saints* provides a good summary of the saints' lives; for more extensive information, use Butler's *Lives of the Saints*.

Read about "Sacred Conversations" in the art encyclopedias.

4. Read the Literature from Which the Story or the Symbols Might Have Derived

Most symbols derive from literary works—religious and historical documents, sermons, poetry, or traditions pertinent to a particular culture. You need to read the material, in a version close to what the artist would have known, to determine how the artistic concept derived from the written one. *The Golden Legend* includes material on the Virgin and St. Paul that would have been known in the 14th century; the *Catholic Encyclopedia* will also provide relevant material.

5. Learn As Much about the Artist As Possible

The Getty entry includes a brief biographical sketch of Bernardo Daddi (active about 1280–1348, Florence, Italy), mentioning that Giotto di Bonadone may have been his teacher and that he was influenced by Sienese art. For in-depth studies, you may need to follow the research steps outlined in Chapter XI. Both Florentine and Sienese art of the trecento[1] must be explored.

For an overview of the historic period, consult the *History of Italian Renaissance Art: Painting, Sculpture, Architecture* [X-B-3], which includes 42 pages of discussion on early trecento art in Florence and Siena. For Bernardo Daddi, there are two paragraphs and illustrations for two paintings, one from the Musée du Louvre, the other from the Villa I Tatti in Florence. For an in-depth study, material specifically on the artist will be needed. A keyword search for *Bernardo Daddi* located only one book published in the past 20 years: *100 Masterpieces: Bernardo Daddi to Ben Nicholson,* edited by Dennis Farr (London: Courtauld Institute Galleries, University of London, 1987). Obviously, more extensive searches will be required to obtain material specifically on Daddi.

6. Formulate a Record of the Work and Place It within Its Art Historical Period

The J. Paul Getty Museum provides the basic characteristics of the triptych and includes information on its restoration. When the Getty obtained the painting, there was a depiction of the Christ Child in front of the parapet. Once they realized that this was a later addition, the conservators removed the figure. This is important, because earlier photographs or prints of this work will include a child.

7. Compile a Reading List on the Social History of the Period

By checking the social history books listed in [X-B-3], you will locate several that might assist you, such as (a) *Florentine Painting and Its Social Background* and (b) *Siena, Florence and Padua: Art, Society and Religion 1280–1400.* Use the Library of Congress subject heading *Painting, Italian—Italy—Florence* to locate other pertinent works. A search of a library's OPAC brought forth *Painting in Florence and Siena after the Black Death,* by Millard Meiss (Princeton, NJ: Princeton University Press, 1951).

8. Study Individual Works on the Subject Related to the Geographical Region and Time

To read and view works of art depicting Sacred Conversations, check Gertrud Schiller's *Iconography of Christian Art,* which, in Volume 1, has excellent material on the Virgin Mary. The references on the studies of Christian saints, such as *Iconography of the Saints in Italian Painting from Its Beginnings to the Early XVIth Century,* also contain numerous illustrations. Both are cited below.

As discussed in [IX-B-7], consult the indexes to works of art in museums, such as Christopher Wright's *World's Master Paintings* and *Old Master Paintings in Britain,* as well as the *Census of Pre-Nineteenth-Century Italian Paintings in North American Public Collections.* Another source is Helene E. Roberts's *Iconographic Index to New Testament Subjects.* Once you establish an artist's work in a specific museum, access the institution's Web site. Also check the Web sites of museums with good collections of trecento Florentine and Sienese religious art. For instance, the Uffizi Gallery, Florence, owns four Daddi paintings <http://www.arca.net/uffizi/>.

The NGA owns three of Daddi's works, including *Madonna and Child with Saints and Angels* from the 1330s. These works were located through the NGA artist and title search section <http://www.nga.gov/cgi-bin/psearch/>. Because the museum provides details for this painting, you can obtain a close-up of the head of the Madonna to compare with the Getty Madonna. In addition, the NGA has an illustrated tour of Byzantine art and painting in Italy during the 1200s and 1300s, which provides an overview of the

subject and is illustrated by six paintings <http://www.nga.gov/collection/gallery/gg1/gg1-main1.html>.

Another method for examining art contemporary with Daddi's *Triptych* is to view several documentary videos on the 14th century [X-B-3], such as Civilization's Program 3: *Romance and Reality* and *Giotto and the Pre-Renaissance,* Museum without Walls Series. For information on the cultural and religious changes affecting symbolism during this period, see *The Virgin Mary in Art, Renaissance to Reformation,* Volume IV of the *Development of Christian Symbolism Video Series,* cited below.

9. Read Any Scholarly Monographs, Catalogues Raisonnés, Œuvres Catalogues, or Exhibition Catalogues on the Artist, Studying with Care Their Footnotes and Bibliographies

Check the bibliographies of the books you have already consulted and access a major library's OPAC. Remember, a relatively few artists have been the subject of extensive research that has then been published.

Resources for Judeo-Christian Subjects

Catholic Encyclopedia, a 15-volume encyclopedia published between 1907 and 1914, but often imprinted 1913
<http://www.knight.org/advent/cathen/cathen.htm>

Christus Rex provides illustrations for religious art
<http://www.christusrex.org/>

Clash of the Gods: A Reinterpretation of Early Christian Art, by Thomas F. Mathews (Princeton, NJ: Princeton University Press, 1993)

Dictionary of Christian Art, by Diane Apostolos-Cappadona (New York: Continuum Publishing, 1994)

Fruit of Devotion: Mysticism and the Imagery of Love in Flemish Paintings of the Virgin and Child, 1450–1550, by Reindert L. Falkenburg, translated by Sammy Herman (Philadelphia: John Benjamins, 1994)

Iconography of Christian Art, by Gertrud Schiller, translated by Janet Seligman (2 vols. Greenwich, CT: New York Graphic, 1971)
Vol. 1: *Christ's Incarnation, Childhood, Baptism, Temptation, Transfiguration, Works, and Miracles*
Vol. 2: *The Passion of Christ*

New Catholic Encyclopedia (15 vols. New York: McGraw-Hill, 1967)

Orthodox Page, Icons
<http://www.ocf.org/OrthodoxPage/icons/icons.html>

Signs and Symbols in Christian Art, by George Ferguson (New York: Oxford University Press, 1954; reprint ed., 1967). Covers the Holy Family and saints, meanings of animal and floral symbols, and symbolism of religious dress and objects.

Judeo-Christian Literature

There is an extensive amount of Judeo-Christian literature being placed on the Internet; the following is just an indication of the scope of this important material.

Biblical Sources

In Christian iconography, be sure to use the Bible, which would have been available to those who planned the artwork during the time period of the study. The Christian Bible consists of the Old Testament, or the Hebrew Scriptures, and the New Testament, which was written in Greek. The Vulgate is the Latin Bible, which St. Jerome (c. 340–420) translated from the Hebrew and Greek. Some of St. Jerome's material was based on the Septuagint, an early translation of Hebrew writings containing 14 pieces of literature that were not incorporated into the official Hebrew Scriptures. Although these pieces, called the Apocrypha, are sometimes deleted from Protestant Bibles, you may need to consult them for some Christian symbols and stories. The Catholic Bible includes the Apocrypha with the Old Testament. Remember the verse numbers for some of the psalms and proverbs in the Catholic Bible do not coordinate with those in the Protestant Holy Scriptures.

The Roman Catholic Douay/Rheims Bible, translated between 1582 and 1609, is the closest to the Latin Vulgate. For the Holy Bible translated from the Latin Vulgate, see <http://www.cybercomm.net/~dcon/drbible.html>; to search the New Testament (Rheims 1582), use <http://www.hti.umich.edu/relig/rheims/>.

The Protestant King James Version is the 1604 translation ordered by King James I of England and completed about 1611. For the Holy Bible, King James Version, see <http://etext.virginia.edu/kjv.browse.html>.

Non-Biblical Sources

During the Middle Ages, two non-biblical sources, *The Infancy Gospel* and *The Golden Legend,* greatly influenced artists' works. The former is composed of apocryphal stories that were never endorsed by the ecclesiastical authorities. Some of these tales were later described in *The Golden Legend,* by Jacobus de Voragine, the earliest printed book on the lives of the

Holy Family and the Christian saints. *The Golden Legend* was the literature Renaissance artists consulted. In Christian iconography, these books, as well as *Meditations on the Life of Christ,* once thought to have been written by St. Bonaventura, are important to understanding the symbols some artists used, since they were the popular literature of the day.

The Golden Legend or Lives of the Saints, as Englished by William Caxton, by Jacobus de Voragine; see entry below

Meditations on the Life of Christ: An Illustrated Manuscript of the Fourteenth Century, edited by Isa Ragusa and Rosalie B. Green, translated by Isa Ragusa (Princeton, NJ: Princeton University Press, 1961). Once attributed to Pseudo St. Bonaventura, it is now believed to have been written by a 13th-century Franciscan monk living in Italy. Extensively illustrated, its text relates the story of the Virgin Mary and Christ.

Other Bible: Jewish Pseudepigrapha, Christian Apocrypha, Gnostic Scriptures, edited by Willis Barnstone (New York: Harper & Row, 1984)

Judeo-Christian Videos

Development of Christian Symbolism Video Series (Dallas: Swan Jones Productions). Traces the meanings of symbols from the sixth century to 1700. Each volume is accompanied by a booklet providing the location of each illustration in the video. The first three volumes use Romanesque and Gothic church sculpture and small carved ivories. Volume IV is illustrated by paintings <http://www.ont.com/users/swanjones/>.

 Volume I: *Madonna and Child,* 1992

 Volume II: *Crucifixion and Resurrection,* 1994

 Volume III: *Heaven or Hell: The Last Judgment,* 1995

 Volume IV: *The Virgin Mary in Art, Renaissance to Reformation,* 1996

Testament, by John Romer (Seven 50-minute videos. London: BBC, 1989). Corresponds to Romer's book, *Testament: The Bible and History* (New York: Holt, 1989).

Indexes to Judeo-Christian Works of Art

Iconographic Index to New Testament Subjects Represented in Photographs and Slides of Paintings in the Visual Collections, Fine Arts Library, Harvard University, by Helene E. Roberts (New York: Garland Press, 1992+)

 Volume I: *Narrative Paintings of the Italian School,* with Rachel Hall

Iconographic Index to Old Testament Subjects Represented in Photographs and Slides of Paintings in the Visual Collections, Fine Arts Library, Harvard University, by Helene E. Roberts (New York: Garland Press, 1987)

The Index of Christian Art on the Internet contains records for nearly 9,000 medieval works of art dating from the early apostolic times to A.D. 1400. Each art record provides information on data created, style, location, subjects, and bibliographic data. Begun in 1917 by Professor Charles

Rufus Morey, the *Index* is based at Princeton University, where it is available to researchers. Other locations include Dumbarton Oaks in Washington, D.C., and the University of California, Los Angeles. The fee-based online version can be accessed through:
 <http://www.Princeton.edu/ica/>

Paintings in German Museums: Gemälde in Deutschen Museen [IX-B-7], in which the iconographic index in Volume 5 locates religious themes

Studies of Christian Saints

In the early Christian Church, local authorities could proclaim sainthood. It was not until about the 990s, with the first Roman Catholic papal canonization of St. Ulrich, that this tradition started changing. Finally, in the 12th century, Pope Alexander III forbade reverence to any person not authorized by the Papal See. Thus, there is often scanty information and no documentation on early saints. Hagiographic literature often lists saints under their feast day, which is the day the saint died, was canonized, or had relics moved. In Europe, a saint's feast date is written with the day preceding the month: *22 juillet, 22.7,* and *July 22* are the same day.

Bible and the Saints, by Gaston Duchet-Suchaux and Michel Pastoureau (New York: Flammarion, 1994). Includes illustrations and a list of attributes associated with the saints.

The Golden Legend or Lives of the Saints, as Englished by William Caxton, by Jacobus de Voragine translated by William Caxton (7 vols. London: J. M. Dent, 1900. Trans. by Granger Ryan 2 vols. Princeton, Nd; Princeton University Press, 1995). First published in Latin in 1275 by Jacobus de Voragine, Archbishop of Genoa (also spelled Varagine, and in French translations listed as Jacques de Voragine). There are numerous translations and editions.

How to Distinguish the Saints in Art by Their Costumes, Symbols, and Attributes, by Arthur de Bles (New York: Art Culture, 1925; reprinted, Detroit: Gale Research, 1975)

Iconography of the Saints in Italian Painting from Its Beginnings to the Early XVIth Century, by George Kaftal (4 vols. Florence: Sansoni and La lettere, 1952–85). Has numerous black-and-white illustrations.

Internet Medieval Sourcebook: Saints Lives, by Paul Halsall
 <http://www.fordham.edu/halsall/sbook2.html>

Lives of the Saints, by Alban Butler, edited and supplemented by Herbert Thurston and Donald Attwater (4 vols. New York: Kennedy and Sons, 1956). The standard authoritative reference with bibliographic data and footnotes. Butler's original work was published between 1756 and 1759.

Oxford Dictionary of the Popes, by J.M.D. Kelly (Oxford: Oxford University Press, 1986)

Oxford Dictionary of Saints, by David Hugh Farmer (Oxford: Clarendon, 1978). A good introduction to hagiography and the 1969 reform of the Roman calendar, with bibliographical references.

Religious Art in France, by Emile Mâle, see [X-B-2]

Saints and Their Emblems, by Maurice Drake and Wilfred Drake (London: T. W. Laurie, 1916; reprinted, New York: Burt Franklin, 1971)

XII-B-2. Classical Mythology

This section provides (a) a suggested methodology, (b) a list of Web sites and dictionaries on the classical gods, (c) literature on classical myths, and (d) an index to visual material on classical mythology.

Classical Myths: Methodology

You are asked to discover the classical myth depicted in a particular early-17th-century Italian print by an anonymous artist thought to be the Italian printmaker Tempesta and to write an essay concerning it. The same nine basic steps should be followed:

1. Examine the Work of Art Carefully and Describe What Is Depicted

In the scene, two men are wearing wings; the younger is hurtling downward from the sky.

2. Check Specialized Dictionaries to Locate Information on the Subject

The first book to consult is Hall's *Dictionary of Subjects and Symbols in Art,* cited above, because it is one reference book that allows you to discover the subject of a work if you can describe it. Under "Wings," Hall states that "DAEDALUS fashions wings with which he and his son ICARUS fly from Crete." This gives you two entries to explore: *Daedalus* and *Icarus.* In most dictionaries, you have to know these names to begin your search.

3. Consult All Types of Reference Material, Exhibition Catalogues, and Any Pertinent Web Sites to Learn More about the Subject and Symbols

Read the entries for Icarus and his father, Daedalus, in the mythology dictionaries and at the numerous Internet sites that recount Greek mythology. When studying iconography, try to locate a recently published scholarly catalogue on the subject, since this may include pertinent information. A search of a library's OPAC located *The Loves of the Gods: Mythological Painting from Watteau to David,* by Colin B. Bailey. This catalogue includes five essays by international scholars, plus detailed analyses of the exhibited works.

4. Read the Literature from Which the Story or the Symbols Might Have Derived

Most Greek myths originated through an oral tradition; later, when the stories were transcribed, variations occurred, since authors perceived the events differently. Consequently, there is not a single correct version that can be told in only one way. For this reason, researchers may need to study a myth as recorded by several writers.

5. Learn As Much about the Artist As Possible

To learn about the artist requires an in-depth study of prints and printmakers, using the resources cited in Chapter XI and [XIII-D]. You should try to locate printmakers whose work is similar to the print you are studying. *The Iconclass Indexes: Italian Prints,* Volume 3: *Antonio Tempesta and His Time* may provide clues [XIII-D-5].

To locate other prints depicting the subject, access the Web site of the *Art Imagebase* of the Fine Arts Museums of San Francisco <http://www.thinker.org/imagebase/>. A search located 216 entries for Tempesta, whose *Fall of Icarus* of his Metamorphoses Series resembles the anonymous print. Since Antonio Tempesta (Italian, 1555–1630) produced almost 1,500 different prints based upon famous artists' works between 1575 and 1625, you may wish to pursue information on this printmaker.

6. Formulate a Record of the Work and Place It within Its Art Historical Period

You will need to locate as much basic information on the print as possible—a difficult task if you do not know the name of the artist or the location of the work. But considering it might be by Tempesta, check to see if one of the volumes of the *Illustrated Bartsch: Le Peintre-Graveur Illustre* [XIII-D-5] covers this printmaker.

7. Compile a Reading List on the Social History of the Period

Study interdisciplinary texts and pertinent history books for background for understanding the historic period and the country from which the art object comes. Develop a bibliography on the topic, starting with general information and proceeding to more specific material. Checking encyclopedias and searching OPACs of various libraries and the indexes to art literature will provide you with a good reading list. Also consult the references cited below and the history references listed in [X-B].

8. Study Individual Works on the Subject Related to the Geographical Region and Time

One excellent research tool for locating various works of art depicting mythological characters and scenes is *The Oxford Guide to Classical Mythology in the Arts, 1300–1990s.* Under "Icarus and Daedalus," there is a brief account of the legend, citations for 12 classical sources, and a listing of more than 200 creators of works of art, poetry, and music on the subject. The list of works is diverse, including paintings by Pieter Bruegel the Elder, Annibale Carracci's fresco in the Palazzo Farnese, a statue by Italian sculptor Canova, a drawing by Francisco da Goya, and Pablo Picasso's mural for the UNESCO Building in Paris.

9. Read Any Scholarly Monographs, Catalogues Raisonnés, Œuvres Catalogues, or Exhibition Catalogues on These Artists, Studying with Care their Footnotes and Bibliographies

Since the *Fall of Icarus* print dates from the early 17th century, consult books on 16th- and 17th-century artists who depicted this theme. Because there are so many books that consider the iconography of Bruegel's 16th-century works of art, you might read their interpretations of the theme. Although this may not provide you with a direct answer concerning the meaning of the print, the discussions may lead you to other avenues to follow.

Classical Myths: Web Sites and Dictionaries

See also the mythology resources cited in [X-B-1].

Bulfinch's Mythology: The Age of Fable or Stories of Gods and Heroes, by Thomas Bulfinch
<http://www.showgate.com/medea/bulfinch/welcome.html>

Classical Myth: The Ancient Sources includes a list of classical gods with their attributes and a brief timeline for Greek history and literature
<http://web.UVic.ca/athena/bowman/myth/index.html>

Classical Mythology Course, Princeton University, Ruth Webb's course provides entries for Greek gods, titans, monsters, heroes, those involved in the Trojan War and the Theban legends, the House of Atreus, and women
<http://www.princeton.edu/~rhwebb/cla212/INDEX.HTM>

Dictionary of Classical Mythology, by Pierre Grimal (Oxford: Blackwell, 1985)

Dictionary of Greek and Roman Mythology, by Michael Stapleton (London: Paul Hamlyn, 1978; reprinted as *An Illustrated Dictionary of Greek and Roman Mythology.* Reprint ed., New York: Peter Bedrick Books, 1986)

Gods and Heroes of Classical Antiquity, Flammarion Iconographic Guides, by Irène Aghion et al. (New York: Flammarion, 1996). Lists literary sources and a few works of art with some entries including bibliographes and illustrations.

Loves of the Gods: Mythological Painting from Watteau to David, by Colin B. Bailey (New York: Rizzoli International Publications, 1991)

Mythology of Gods (Greece) includes "The Olympians," "The Lesser Gods," and "The Titans"
<http://www.focusmm.com.au/gr_mymn.htm>

New Century Handbook of Greek Mythology and Legend, edited by Catherine B. Avery (New York: Appleton-Century-Crofts, 1972)

Classical Myths: Literature

The works of writers on Greek myths—especially Homer, Virgil, and Ovid—were popular over many centuries and were used as subjects for paintings and sculpture. All of these works greatly influenced artists. Most works cited below have had numerous translations and editions; they are recorded only as a reminder of these momentous works.

Little is known about the Greek poet Homer, who probably lived in the ninth century B.C. His *Iliad* is the tale of the Trojan War, won by the Greeks after 10 years of fighting. It describes Troy's final destruction, variously dated around the 1190s B.C. Homer's *Odyssey* recounts the 10-year adventures of Odysseus—the Roman Ulysses—as he returns from Troy to his home in Greece. The Latin poet Virgil, also spelled Vergil (Publius Vergilius Maro, 70 B.C.–19 B.C.), wrote the *Aeneid,* an epic poem relating Aeneas's adventures as he escapes the destruction of Troy. Ovid (Publius Ovidius Naso, 43 B.C.–A.D. 17) is the Latin poet who wrote the 15-volume *Metamorphoses,* in which characters drawn from classical mythology undergo various kinds of transformation.

Aeneid, by Virgil, translated by John Dryden
<http://classics.mit.edu/Virgil/aeneid.html>

Aeneid, by Virgil, translated by Edward McCrorie (Ann Arbor: University of Michigan Press, 1995)

Athena: Classical Mythology on CD-ROM (New York: Macmillan, 1995). Includes full-text translations of 20 widely read works, among them *Iliad, Odyssey, Theogony,* Ovid's *Metamorphoses,* and Virgil's *Aeneid,* and 1,200 myth summaries. It also provides a dictionary of names, along with 500 images of figures and scenes.

Gods Made Flesh: Metamorphosis and the Pursuit of Paganism, by Leonard Barkan (New Haven, CT: Yale University Press, 1986)

Iliad, by Homer, translated by Samuel Butler
<http://classics.mit.edu/Homer/iliad.html>

Iliad of Homer, translated by Alexander Pope, edited by Steven Shankman (New York: Penguin Books, 1996)

Metamorphoses, by Ovid, translated by Sir Samuel Garth <http://classics.mit.edu/Ovid/metam.html>

Metamorphoses of Ovid, translated by David R. Slavitt (Baltimore: Johns Hopkins University Press, 1994)

Odyssey, by Homer, translated by A.T. Murray, revised by George Dimock (2 vols. Cambridge, MA: Harvard University Press, 1995)

Odyssey, by Homer, translated by Samuel Butler <http://classics.mit.edu/Homer/odyssey.html>

Odyssey of Homer, translated by George Chapman <http://www.columbia.edu/acis/bartleby/chapman/>

Ovid Project: Metamorphosing the Metamorphoses <http://www.uvm.edu/~hag/ovid/index.html>

Perseus Project [IV-A-3]

Who's Who in the Metamorphoses of Ovid: An Analytical Onomasticon Project, Princeton University, by Willard McCarty, Burton Wright, and Aara Suksi <http://www.princeton.edu/~mccarty/Onomasticon/>

World of Ovid's Metamorphoses, by Ovid, edited by Joseph B. Solodow (Chapel Hill: University of North Carolina Press, 1988)

Indexes to Visual Material on Mythology

Oxford Guide to Classical Mythology in the Arts, 1300–1990s, compiled by Jane Davidson Reid (2 vols. New York: Oxford University Press, 1993). Uses a dictionary format to provide data on Greek and Roman mythological figures. This information includes a summary of the myth accompanied by variations in the story, the chapter and verse of the literary references, and a chronological listing of works of art representing the subject in the Western world from the late Middle Ages to the present.

Paintings in German Museums: Gemälde in Deutschen Museen [IX-B-7]. The iconographic index in Volume 5 covers mythology.

XII-B-3. Portraiture

Portraiture documents how people appear to the artist. Research on this subject also requires subject-related tools. The same nine basic steps discussed above still apply.

Members of the Maynard Family in the Park at Waltons, c. 1755–1762, by the English artist Arthur Devis (Na-

National Gallery of Art's Web Page for Devis's *Members of the Maynard Family* <http://www.nga.gov/search/search.htm>

tional Gallery of Art, Washington, D.C.) is used as an example. At its Web site, the NGA provides a reproduction of the painting, plus seven details, titles of literature written about the piece, its exhibition history, its provenance, and some conservation notes. Notice the other online information provided: title, date, medium, dimensions, plus acquisition number and date. To locate the NGA entry, access <http://www.nga.gov/search/search.htm>, then request material on Devis and Maynard.

1. Examine the Work of Art Carefully and Describe What Is Depicted

You need to look closely at the work of art, describing every object and item in the scene, a process made easier because of the seven details the museum provides. These close-ups offer clues on the fashionable clothing, the furniture, the musical instrument, the landscape, and the manor house pictured in the background. Some references, such as those under fashion and jewelry [XIII-C], may assist you in this process.

2. Check Specialized Dictionaries to Locate Information on the Subject

In studying the entry the museum provides, notice that the title, *Members of the Maynard Family in the Park at Waltons,* was cited in early catalogues as *Conversation Piece, Ashdon House.* Moreover, the painting was exhibited at the Yale Center for British Art in a 1980 exhibition. This painting was reproduced in the catalogue, *The Conversation Piece: Arthur Devis and His Contemporaries,* by Ellen G. D'Oench, which you should examine. You will need to consult an art dictionary for the term *conversation piece.*

Consult printed references and museum Web sites that are concerned with portraiture. You may wish to read *Art of the Portrait: Masterpieces of European Portrait-Painting 1420–1670,* by Norbert Schneider, translated by Iain Galbraith (Cologne: Benedikt Taschen, 1994). Even when exhibition catalogues discuss portraiture of other centuries or media, such as photography, the essays often detail the history of this type of art. Of interest might be *Renoir's Portraits: Impressions of an Age,* by Colin B. Bailey (New Haven, CT: Yale University Press, 1997) and *Picasso and Portraiture: Representation and Transformation,* edited by William Rubin (New York: Museum of Modern Art, 1996).

The Metropolitan Museum of Art has a program called *What Makes a Portrait a Portrait* <http://www.metmuseum.org/htmlfile/education/portrait.html>. Although presently, the two major portrait museums do not have any online exhibitions relevant to the study, you should continue to access their Web sites, since both have active online exhibition programs. The Web site for the National Portrait Gallery, London, is <http://www.npg.org.uk/>; the site for the one in Washington, D.C., is <http://www.npg.si.edu/>. Remember that the latter has the *Catalog of American Portraits,* which can be searched on the Internet [XIV-A-9].

3. Consult All Types of Reference Material, Exhibition Catalogues, and Any Pertinent Web Sites to Learn More about the Subject and Symbols

Since the work is a portrait, information on the sitter is needed. The NGA provides the provenance of the painting, including a biographical paragraph on the person who commissioned it, Sir William Maynard, 4th Baronet of Waltons, Ashdon, Essex, England. The NGA states that Sir William and his wife had two sons; there is no reference to daughters. You need to discover if the two children wearing dresses are these sons.

For the 1995 exhibition "The New Child: British Art and the Origins of Modern Childhood, 1730–1830," there was both a printed catalogue [X-B-3] and an outstanding Internet program [III-A-4]. The online material includes a section on the Georgian family and its parental role and reproduces two Devis paintings <http://www.bampfa.berkeley.edu/exhibits/newchild/>. Studying scholarly catalogue entries for art similar to the one you are researching will frequently provide leads in the text, footnotes, or bibliographies. Important information can be located in these printed catalogues, such as *British Painting at the Philadelphia Museum of Art: From the Seventeenth through the Nineteenth Century,* by Richard Dorment, 1986. These catalogues of permanent collections illustrate that conversation pieces were important documents of the lineage of the aristocrats depicted, whose status was based on family ties, not necessarily on merit or ability.

4. Read the Literature from Which the Story or the Symbols Might Have Derived

Two books cited in [X-B-3] seem particularly promising: *Art in Europe 1700-1830* and *Painting for Money.*

The former provides an overview of the period; the latter discusses literature that may have influenced the paintings called conversation pieces. It mentions books such as *Characteristics of Men, Manners, Opinions, Times* by Anthony Cooper, 3rd Earl of Shaftesbury in 1711 (1964 publication edited by John M. Robertson, New York: Indiana University Press). *Painting for Money* also includes Abraham Cowley's poem "Of Solitude" (reprinted in *The Oxford Book of Seventeenth Century Verse,* 1934) with the line "Hail, old Patrician Trees," which may have inspired the common use of large trees in conversation pieces. The footnotes and bibliographies of these types of books can be particularly helpful in providing additional leads to other materials.

5. Learn As Much about the Artist As Possible

The NGA entry includes a brief biography on the artist, mentioning that he exhibited irregularly at the Free Society of Artists; you may wish to check *The Society of Artists of Great Britain 1760–1791: The Free Society of Artists 1761–1783* (Appendix One) for more information. *The Dictionary of Art* [IX-B-2] reproduces one illustration and provides about a half page on Arthur Devis (1712–87) and his family members who were also painters.

6. Formulate a Record for the Artist's Work, and Place It within Its Art Historical Period

The characteristics of the painting are provided by the museum. Under its conservation notes, there is information concerning a horse that was once depicted in the painting, but during conservation between 1934 and 1951, the animal was removed. In a 1951 Christie's sales catalogue there is mention of a kite, which is not revealed by the use of either infrared reflectography or x-radiographs. Early prints or photographs might show these objects.

7. Compile a Reading List on the Social History of the Period

To understand the relationship between the members depicted in a dual portrait or a conversation piece, you should read social history books, studying the footnotes and bibliographies. A number of resources cited in [X-B-3] that might be of interest include: (a) *History of Private Life,* Vol. III: *Passions of the Renaissance;* (b) *History of Women in the West,* Vol. III: *Renaissance and Enlightenment Paradoxes;* (c) *Prospect before Her: A History of Women in Western Europe, 1500–1800;* and (d) *History of Their Own: Women in Europe from Prehistory to the Present.*

The research is focused heavily on women and children, as in other references that are listed—*Experience of Women, Images of Childhood,* and *Yesterday's Children*—because much of the recent literature has explored this aspect of history. Two other works that might assist you in understanding this period of art are *Everyday Life in the Eighteenth Century* and the documentary video *Eighteenth-Century Women.* The Web site *Eighteenth-Century Resources* hyperlinks to relevant sites, such as those concerned with art, architecture, and costume <http://www.english.upenn.edu/~jlynch/18th/>.

8. Study Individual Works on the Subject Related to the Geographical Region and Time

The NGA, which at its Web site highlights works through online tours, provides an overview of the subject *conversation pieces,* which is illustrated by six paintings. *The British Conversation Pieces and Portraits of the 1700s* mentions the involvement of William Hogarth with this art form <http://www.nga.gov/collection/gallery/gg63/gg63-main1. html>. You now have another artist to research.

Some CD-ROMs on museum collections also provide tours of their collections. *The Art Gallery* [II-D], which illustrates London's National Gallery, has a section on portraits that includes Hogarth's *The Graham Children,* 1742, and discusses some of the details of this group portrait.

9. Read Any Scholarly Monographs, Catalogues Raisonnés, Œuvres Catalogues, or Exhibition Catalogues on These Additional Individual Works of Art, Studying with Care Their Footnotes and Bibliographies

Information on the artists displayed in the museum tour, as well as on Hogarth, should be located. The National Gallery has a biographical sketch on Hogarth accompanied by the titles of nine books concerning this artist. Searching a library's OPAC located *Manners and Morals: Hogarth and British Painting 1700–1760,* a catalogue for a 1988 exhibition at London's Tate Gallery. Three Devis paintings were reproduced in the catalogue.

In checking the Web sites listed in [X-B-3], a location was discovered at Northwestern University for *William Hogarth and the 18th-Century Print Culture*

<http://www.library.nwu.edu/ spec/hogarth/ main.html>. Although this material facilitates your research, for an in-depth study you may wish to pursue the basic methodology steps [XI-A] for Hogarth.

XII-B-4. Other Subjects

When searching for material on subjects and symbols unrelated to religion, myths, or portraiture, try to locate an exhibition catalogue on the subject. For instance, *Jan Steen: Painter and Storyteller,* the catalogue for the 1996–97 exhibition held at the National Gallery of Art in Washington, D.C., and the Rijksmuseum, Amsterdam, discusses the significance of items extensively documented in Steen's paintings. Although this catalogue is concerned with symbols depicted in the exhibited works, the information may be relevant to other 17th-century Dutch art.

This section includes references on (a) secular objects, (b) animal symbolism, and (c) landscapes and seascapes. The following references indicate the type of material available on secular subjects. For additional resources and methodological suggestions, especially for emblem books, see *Sources in Iconography in the Blackader Lauterman Library of Architecture and Art: An Annotated Bibliography*, edited by Irene Zantovska Murray and compiled by Kathryn A. Jackson (Montreal: McGill University, 1997) and Jones's *Art Information* [II-A], pages 81–86, 280–86.

Secular Subjects

Before studying a secular subject, read the following article, which is one of the best written on this subject: Sarah Scott Gibson's "Humanist and Secular Iconography, 16th to 18th Centuries, Bibliographic Sources: A Preliminary Bibliography" (*Special Libraries* 72, July 1981: 249–60). Be sure to consult relevant works listed above that are on one secular subject.

Resources on Secular Art Culture

See also the books developed on a single work of art; [XII-B], above.

History and Its Images: Art and the Interpretation of the Past, by Francis Haskell (New Haven, CT: Yale University Press, 1993)

History of Ideas and Images in Italian Art, by James Hall (New York: Harper & Row, 1983). Traces the survival of images, changing attitude of the Christian Church, belief in magical powers of art, and role of patrons in Italy from time of the Etruscans to the 19th century.

Iconography at the Crossroads, edited by Brendan Cassidy (Princeton, NJ: Princeton University Press, 1993)

Paintings in German Museums: Gemälde in Deutschen Museen [IX-B-7]. The iconographic index of Volume 5 includes historical themes, themes, and Volume 7 covers everyday life and interior scenes.

Papal Art and Cultural Politics: Rome in the Age of Clement XI, by Christopher M. S. Johns (New York: Cambridge University Press, 1993)

Paragons of Virtue: Women and Domesticity in Seventeenth-Century Dutch Art, by Wayne E. Franits (New York: Cambridge University Press, 1993)

Peasants, Warriors, and Wives: Popular Imagery in the Reformation, by Keith Moxey (Chicago: University of Chicago Press, 1989)

Perspectives Series (New York: Harry N. Abrams); access the Abrams Web site for additional information on this interesting series
<http://www.abramsbooks.com/index.htm>
Avant-Garde and After: Rethinking Art Now, by Brandon Taylor, 1995
Impressionism: Beneath the Surface, by Paul Smith, 1995
Mirror of the Artist: Northern Renaissance Art in Its Historical Context, by Craig Harbison, 1995
Virtue and Magnificence: Art of the Italian Renaissance Courts, by Alison Cole, 1995
Worldly Art: The Dutch Republic 1585–1718, by Mariët Westermann, 1996

Studies in Iconography and Studies in the Fine Arts Series, Linda Seidel, Series Editor (Ann Arbor, MI: UMI Research)
Alchemical Imagery in Bosch's "Garden of Delights," by Laurinda S. Dixon, 1981
Boerenzerdriet: Violence between Peasants and Soldiers in Early Modern Netherlands Art, by Jane Susannah Fishman, 1982
Charity in the Dutch Republic: Pictures of Rich and Poor for Charitable Institutions, by Sheila D. Muller, 1985
Child in Seventeenth-Century Dutch Painting, by Mary Francis Durantini, 1983
How the West Was Drawn: American Art and the Settling of the Frontier, by Dawn Glanz, 1982
Masks of Wedlock: Seventeenth-Century Dutch Marriage Portraiture, by David R. Smith, 1982
Political Ideas in Medieval Italian Art: The Frescoes in the Palazzo dei Priori, Perugia, by Jonathan B. Riess, 1981
Realism and Politics in Victorian Art of the Crimean War, by Matthew Paul Lalumia, 1984
Rise of the Black Mangus in Western Art, by Paul H. D. Kaplan, 1985
"With Bodilie Eyes": Eschatological Themes in Puritan Literature and Gravestone Art, by David H. Watters, 1981

Victorians: British Painting 1837–1901 (Washington, D.C.: National Gallery of Art, 1997)

Animal Symbolism

Animal symbolism in Christian art is often based upon the *Physiologus* or Aesop's *Fables*. The former, developed between A.D. 100 and 400, were popular

tales that were included in sermons during the Middle Ages to illustrate the Bible. The latter were animal stories that were moralized.

There are many different approaches to animal lore; on the Internet, some people are placing information on one animal. These sites frequently provide definitions, visual material, bibliographical entries, and hyperlinks to other significant sites.

Aesop without Morals: The Famous Fables and a Life of Aesop, translated and edited by Lloyd William Daly (New York: Thomas Yoseloff, 1961)

Animals and the Symbolic in Medieval Art and Literature, edited by L. A. J. R. Houwen (Gronigen, Netherlands: Egbert Forsten, 1997)

Bestiary of Christ, by Louis Charbonneau-Lassay, translated and abridged by D.M. Dooling (New York: Penguin Books, 1991)

Butterfly WebSite
<http://mgfx.com/butterfly/articles/index.htm>

Enchantment of Butterflies
<http://www.lpb.org/programs/butterflies/about.html>

Ornithology Web Site
<http://mgfx.com/bird/>

Paintings in German Museums: Gemälde in Deutschen Museen [IX-B-7] Vol. 7 covers animal and flower paintings and still lifes, fantastic imagery, and allegories.

Seven Deadly Sins, by Morton W. Bloomfield (East Lansing, MI: Michigan State College Press, 1952). Discusses animal symbolism.

Symbolic and Mythological Animals, by J. C. Cooper (London: Aquarian Press, 1992)

Unicorn Web Page
<http://perso.wanadoo.fr/bruno.faidutli/licornes/unicorn.html>

Landscapes and Seascapes

See also the books in the Amon Carter Museum Focus Exhibitions Series; [XII-B], above.

Day in the Country: Impressionism and the French Landscape (Los Angeles County Museum, 1984)

Iconography of Landscape, by Denis Cosgrove (New York: Cambridge University Press, 1988)

Joachim Patinir: Landscape as an Image of the Pilgrimage of Life, by Reindert L. Falkenburg, translated by Michael Hoyle (Philadelphia: John Benjamins, 1985)

Paintings in German Museums: Gemälde in Deutschen Museen [IX-B-7]. Vol. 6 covers the subject and symbolism of landscapes.

Tempest and Shipwreck in Dutch and Flemish Art: Convention, Rhetoric, and Interpretation, by Lawrence Otto Goedde (University Park: Pennsylvania State University Press, 1989)

XII-C. Criticism of the Work

An early writer on the Paris Salons was Denis Diderot (1713–84), who wrote at great length, often in minute detail, on nine of the biennial salons between 1759 and 1781.[2] Written for an audience who could not attend the exhibitions, Diderot's critiques were published many years after his death. Their influence on the Parisian Salon viewer was probably nil, but these comments undoubtedly influenced the foreign market for French art, as well as the method and style of writing used by later art critics. It is a measure of the importance of the French Academy system, with its salons and prizes, that information on the prize called the prix de Rome is now on the Internet <http://www.culture.fr/ENSBA/ensba.html>.

Art criticism has had a tremendous influence on art; it can sometimes make or break an artist. In order to discover what critics have had to say about an artist's works and to assess the quality of a critic's artistic judgment, consult books and articles concerning the critic. For details on public art exhibitions in France, England, Italy, and Germany from 1785 to 1848, consult *Triumph of Art for the Public: The Emerging Role of Exhibitions and Critics,* edited by Elizabeth Gilmore Holt. In *Art of All Nations, 1850–73,* Holt continues this history of criticism. Remember to consult the important resources for art criticism, cited below.

For material on contemporary criticism, check the indexes to art literature, especially *ARTbibliographies Modern* [VII-B]. One-artist exhibition catalogues that reprint evaluative critiques are another good source for material by critics. Scholarly catalogues of exhibitions on a single artist often translate and include the critics' views of the artist's works, a trend that is expanding. In *Cézanne: The Late Work,* the 1978 exhibition catalogue for works displayed at the Museum of Modern Art in New York City and the Museum of Fine Arts in Houston, there is a 10-page essay on Cézanne and his critics. In the 1995 exhibi-

tion catalogue *Cézanne,* there are 20 pages on this same subject [III-A-2].

References: Art Critics and Criticism of Artists' Exhibitions

Anti-Aesthetic: Essays on Postmodern Culture, edited by Hal Foster (Seattle: Bay Press, 1983)

Art Criticism as Narrative: Diderot's Salon of 1767, by Julie Wegner Arnold (New York: P. Lang, 1995)

Art Criticism Series (Ann Arbor: UMI Research). Includes many volumes on individual critics. Only books covering criticism for a particular style are cited here.

 Art Critics and the Avant-Garde, by Arlene Rita Olson, 1980

 Critics of Abstract Expressionism, by Stephen C. Foster, 1980

 Cubist Criticism, by Lynn Gamwell, 1980

 Feminist Art Criticism: An Anthology, edited by Arlene Raven, et al., 1988

 Metaphor of Painting: Essays on Baudelaire, Ruskin, Proust, and Pater, by Lee McKay Johnson, 1980

 Modernism in the 1920s: Interpretations of Modern Art in New York from Expressionism to Constructivism, by Susan Noyes Platt, 1985

 The New Subjectivism: Art in the 1980s, by Donald Kuspit, 1988

 Pop Art and the Critics, by Carol Anne Mahsum, 1987

 Postminimalism into Maximalism: American Art, 1966–1986, by Robert Pincus-Witten, 1987

 Roger Fry and the Beginnings of Formalist Art Criticism, by Jacqueline Victoria Falkenheim and Roger Eliot Fry, 1980

Art, Experience, and Criticism, by William T. Squires (Needham Heights, MA: Simon & Schuster, 1997)

Art of All Nations, 1850–73: The Emerging Role of Exhibitions and Critics, edited by Elizabeth Gilmore Holt (Princeton, NJ: Princeton University Press, 1981). Covers European exhibitions (see Appendix One).

Avant-Gardes and Partisans Reviewed, by Fred Orton and Griselda Pollock (New York: St. Martin's Press, 1996)

Bibliography of the Salon Criticism in Second Empire Paris, by Christopher Parsons and Martha Ward (Cambridge: Cambridge University Press, 1986)

Blasted Allegories: An Anthology of Writings by Contemporary Artists, edited by Brian Wallis (2 vols. New York: The New Museum of Contemporary Art, 1987)

Clement Greenberg: Collected Essays and Criticism, by Clement Greenberg (2 vols. Chicago: University of Chicago Press, 1986)

Clement Greenberg between the Lines, by Thierry de Duve, translated by Brian Holmes (Paris: Des Voir, 1996)

Contemporary Artists and Their Critics Series (New York: Cambridge University Press)

 Art into Ideas: Essays on Conceptual Art, by Robert C. Morgan, 1996

Beyond the Mainstream: Essays on Modern and Contemporary Art, by Peter Selz, 1998

Building Art: Modern Architecture under Cultural Construction, by Joseph Masheck, 1993

Critical Condition: American Culture at the Crossroads, by Eleanor Heartney, 1997

Exile's Return: Toward a Redefinition of Painting for the Post-Modern Era, by Thomas McEvilley, 1994

Looking at Art from the Inside Out: The Psychoiconographic Approach to Modern Art, by Mary Mathews Gedo, 1994

Signs of Psyche in Modern and Postmodern Art, by Donald Kuspit, 1993

Surrealist Art and Writings, 1919–1939: The Gold of Time, by Jack J. Spector, 1996

Widening Circle: The Consequences of Modernism in Contemporary Art, by Barry Schwabsky, 1997

Critic Is Artist: The Intentionality of Art, by Donald Kuspit (Ann Arbor, MI: UMI Research, 1984)

Diderot: A Critical Biography, by P. N. Furbank (New York: Alfred A. Knopf, 1992)

Diderot on Art, edited and translated by John Goodman (2 vols. New Haven: Yale University Press, 1995)

Discussions on Contemporary Culture, edited by Hal Foster (Seattle: Bay Press, 1987)

Feminist Art Criticism: An Annotated Bibliography, by Cassandra Langer (Boston: G.K. Hall, 1994)

New Painting: Impressionism 1874–1886 (Fine Arts Museums of San Francisco, 1986). Translates and reproduces art critics' views of some of the art.

Origins of French Art Criticism: From the Ancien Régime to the Restoration, by Richard Wrigley (New York: Oxford University Press, 1993)

Pollock and After: The Critical Debate, edited by Francis Frascina (New York: Harper & Row, 1985)

Pre-Raphaelite Critic: Contemporary Criticism of the Pre-Raphaelites from 1849–1900, by Thomas J. Tobin, Duquesne University
 <http://www.engl.duq.edu/servus/PR_Critic/>

Return of the Real: The Avant-Garde at the End of the Century, by Hal Foster (Cambridge, MA: MIT Press, 1996)

Roger Fry Reader, edited by Christopher Reed (Chicago: University of Chicago Press, 1996)

Ruskin and the Rhetoric of Infallibility, by Gary Wihl (New Haven, CT: Yale University Press, 1985)

Shock of the New, by Robert Hughes (New York: Alfred A. Knopf, 1981)

Triumph of Art for the Public: The Emerging Role of Exhibitions and Critics, edited by Elizabeth Gilmore Holt (Garden City, NY: Anchor, 1979). Covers European exhibitions from 1785 to 1848 in France, England, Italy, and Germany (Appendix One).

Victorian Painting: Essays and Reviews, edited by John Charles Olmsted (3 vols. New York: Garland, 1983–85). Includes essays on criticism and exhibitions (see Appendix One).

Vision and Visuality, edited by Hal Foster (Seattle: Bay Press, 1988)

XII-D. Art in Context: Its Special History

Any special history of the work should be discussed, for it often provides great insight into the art. *The Categories for the Description of Works of Art,* developed by the Getty Information Institute and the College Art Association [V-G-2], lists a number of items that are relevant to this category. This includes such items as the name of the event or the place being depicted, historical persons connected to the art, critical dates concerning the work, or any significant events or group exhibitions.

Knowing an art object's specific history adds interest and often monetary value to the work. Students are usually intrigued by the historical accounts pertaining to the art they study; many are well known and are discussed in the general art history textbooks [IX-B-1]. For instance, when the artist Veronese (Paolo Caliari, Italian, 1528–88) was working on a painting of the Last Supper, he was called before the Catholic Inquisition to explain why his painting depicted offensive people. Veronese quickly changed the title to *Feast in the House of Levi,* 1573 (now in the Galleria dell'Accademia, Venice).

During his military campaign of 1800, Napoleon confiscated *The Battle of Issus* (Bayerische Staatsgemäldesammlungen, Munich), painted in 1529 by Albrecht Altdorfer (German, 1480–1538). Napoleon prominently displayed this painting—which was also entitled *Victory of Alexander the Great over Darius, King of the Persians, at the Battle of Issus*—at his Palace of St. Cloud to remind himself of the famous conqueror's success.

The fame of some art revolves around the exhibitions in which it was displayed. Although the information may also be included in the Exhibition section—see [XII-A-2, item 10]—a discussion of the importance of the exhibition may need to be highlighted. For instance, when the Salon jurors rejected more than 3,000 works of art from the 1863 Salon, the artists were furious. To appease the public and to illustrate that the judges had been correct in their decisions, Napoleon III inititated a Salon des Refusés. Part of the fame of *The Luncheon on the Grass,* 1863 (*Le Déjeuner sur l'herbe,* Musée d'Orsay, Paris) by Edouard Manet (French, 1832–83), stems from its inclusion in this scandalous salon. Most art history textbooks discuss this painting [IX-B-1], as does the *WebMuseum*

<http://sunsite.unc.edu/wm/paint/auth/manet/dejeuner/>.

Recent approaches to art include recreating famous or infamous art exhibitions to place the art in its historical and cultural context. These recreations and their printed catalogues provide lasting records of the simulated events and new insights into the art and people's perception of it, then and now. The following examples highlight some remarkable landmark exhibits that allowed a retrospective look at works of art.

Examples

1. The recreation of the 1913 Armory Show was displayed in 1963 at the Manson-Williams-Proctor Institute and the Armory of the 69th Regiment, New York City. The exhibition catalogue, *1913 Armory Show: 50th Anniversary Exhibition, 1963* (New York: Henry Street Settlement, 1963), is a lasting record of this event that brought European avant-garde art to America's attention.

2. In 1986, the National Gallery of Art, Washington, D.C., and the Fine Arts Museums of San Francisco held an exhibition recreating on a smaller scale the eight Impressionists Exhibitions. The catalogue, *The New Painting: Impressionism: 1874–86* (Fine Arts Museums of San Francisco, 1986), contains four essays on the Impressionism movement. The catalogue has eight separate sections; each represents a single Impressionism exhibition and includes an essay and a reproduction of the bulletin distributed at these 19th-century shows. In addition, for each of the 160 paintings displayed in the 20th-century exhibition, there are catalogue entries accompanied by critiques from the time of the original exhibition.

3. *"Noble and Patriotic": The Beaumont Gift, 1828* (London: National Gallery Publications, 1988), recreated the first gift to London's National Gallery. Sir George Beaumont promised his collection of 16 paintings if the English Parliament purchased the art of the late John Julius Angerstein, whose collection was considered one of London's finest. Beaumont's collection contained four works then thought to be by Claude Lorraine; one has since been demoted to "after Claude." The Rembrandt oil painting has also lost its authentication and is now considered to be by a "follower of Rembrandt." An interesting result of some of these exhibitions is to allow scholars to view the body of work together, forming and changing ideas as to their quality and value.

4. The 1991–92 exhibition called *"Degenerate Art": The Fate of the Avant-Garde in Nazi Germany* was a recreation of the 1937 Entartete Kunst exhibition sponsored by the National Socialists and held in Munich. For the 1991–92 exhibition, there was biographical material for the artists whose works were displayed in 1937.

There are two permanent records of this reconstructed exhibition: (a) a videotape, *Degenerate Art*, based on the 1991 exhibition and available through the Los Angeles County Museum of Art <http://www.lacma.org/videoparc/DegnerateArt.htm>, and (b) a profusely illustrated catalogue (New York: Harry N. Abrams, 1991), by Stephanie Barron which provides 10 essays by international scholars explaining the climate in Germany during Nazi Party control. There is also biographical material on the artists whose works were displayed in the 1937 exhibition. The catalogue also includes (a) a chronology of historical and cultural events in Germany between 1870 and 1945; (b) a complete reproduction of the Entartete Kunst 1937 exhibition brochure, and (c) a selected bibliography. To trace the 650 works in the earlier Munich exhibit, some of which have since disappeared or been destroyed, was a monumental task! The catalogue is a lasting record of one of the most devastating attacks on avant-garde art.

Notes

1. In Italian, the centuries are cited thus: *dugento* (or *duecento*) means the 1200s, or the 13th century; *trecento,* the 1300s, or the 14th century; *quattrocento,* the 1400s, or the 15th century; *cinquecento,* the 1500s, or 16th century.

2. Printed in *Correspondance littéraire, philosophique et critique de Frederic Melchior Grimm,* a newsletter that was circulated to an exclusive list of subscribers, such as Catherine the Great of Russia. The *Encyclopédie* or *Dictionnaire raisonné des sciences, des arts et des métiers* was a project to classify the world's learning. This multivolume reference work was published under the direction of Diderot and consisted of 17 text volumes and 11 volumes of plates issued between 1751 and 1772. The complete 28 volumes are being placed on the Web, see <http://tuna.uchicago.edu/forms_unrest/ENC.query.html>. For a reproduction of a painting of Diderot by the French artist Fragonard, see <http://www.culture.fr/cgi-bin/cookie-test-en/>.

XIII. Resources for Architecture, Decorative Arts, Fashion, Graphic Arts, Photography, and Sculpture

Many resources discussed in the previous chapters are concerned with painting: the history of its styles and the artists who created it. This chapter was compiled to provide a listing of some resources—Web sites, printed material, and special visual collections—focused on other art media and disciplines. The material outlined below supplements the methodology and resources discussed in previous chapters. If your project concerns an architect or artist working in a non-paint medium, follow the procedures cited below:

First, choose your subject's specific discipline: (a) architecture, (b) decorative arts and crafts, (c) fashion and historic costumes, (d) graphic art and prints, (e) photography, or (f) sculpture. Remember that many artists work in more than one medium.

Second, review the seven basic steps discussed in Chapter IX: "Basic Research Methodology: Finding and Supplementing Web Data."

Third, consult the following chapters, since many of the resources will be pertinent to your study; the material discussed in this section builds upon these references.

- Chapter X: "Art Historical Styles and Periods: Ancient World to Modern Era"
- Chapter XI: "Documenting the Lives of Artists and Art Collectors"

Fourth, if your research involves a subject or person outside the Western European tradition, read the suggestions furnished in these chapters:

- Chapter XIV: "North American (U.S.), Canadian, and Native American Studies"
- Chapter XV: "Non-European Cultures"

Finally, examine the resources for your chosen project, which are detailed in this chapter. Special bibliographies are mentioned only if they are particularly important or recently published. Printed references and Web sites are interspersed throughout these sections; English-language sources are emphasized. The main focus of the general art history books [IX-B-1] is painting, although architecture and sculpture are discussed. Therefore specific references are needed for the disciplines discussed in this chapter. No artists' or architects' monographs are listed; only books with a broad-based subject are included. Many books were published or reissued after 1980; for earlier material, check the standard general art bibliographies [II-A].

The home pages of professional organizations (Appendix Two) often provide access to recent articles, dissertation subjects, and hyperlinks to other related Internet sources. The Internet is ever-changing, and some of the URLs may no longer be on the Web. As always, when you find a good site, add it to this list for later reference.

XIII-A. Architecture

The importance of architecture can be measured by the immense body of literature available on the subject. Major historical buildings are included in the general art history books. You will need to read some of the references cited below to appreciate the vastness of this discipline. Some classic works have had numerous editions, such as Sir Banister Fletcher's *History of Architecture,* the 20th edition of which was issued in 1996.

For articles, use the architecture indexes: *Architectural Periodicals Index* and the *Avery Index to Architectural Periodicals* [VII-B-2]. Remember that until a building is complete, most national newspapers and magazines do not mention it. Only the local papers will provide data on the building project; see Chapter VII for material on indexes to newspapers.

The following bibliographies provide pertinent material:

Architecture and Women: A Bibliography Documenting Women Architects, Landscape Architects, Designers, Architectural Critics and Writers and Women in Related Fields Working in the United States (New York: Garland, 1988)

Architecture Sourcebook, by Kathryn M. Wayne (Detroit: Omnigraphics, 1997)

Information Sources in Architecture and Construction, edited by Valerie J. Nurcombe (2nd ed. London: Bowker Saur, 1996)

Women and Architecture: Selected Bibliography and Guide to Sources, created by Kim Hardy and reviewed by Jeanne Brown
<http://www.nscee.edu/unlv/Libraries/arch/rsrce/resguide/archwom.html>

Some library pathfinders on architectural research may assist you in locating pertinent references; for example:

University of Southern California, *Basic Reference Sources in Architecture*
<http://www-lib.usc.edu/Info/AFA/arch/bib.html>
Columbia University's Avery Library, *How to Research a New York City Building*
<http://www.columbia.edu/cu/libraries/indiv/avery/nycbuild.html>

XIII-A-1. Architecture History

Architecture: From Prehistory to Post-Modernism, by Marvin Trachtenbert (New York: Harry N. Abrams, 1986)

Contemporary Canadian Architecture, by Ruth Cawker and William Bernstein (Markham, Ontario: Fitzhenry & Whiteside, 1988)

Encyclopedia of Architecture, Design, Engineering and Construction (5 vols. New York: John Wiley, 1988)

Encyclopedia of Modern Architecture, edited by Wolfgang Pehnt; translated revised edition by Barry Bergdoll (London: Thames & Hudson, 1986)

Encyclopedia of 20th-Century Architecture (New York: Harry N. Abrams, 1986)

Encyclopedia of World Architecture (2 vols. London: Macmillan, 1979)

History of Architecture, by Sir Banister Fletcher (20th ed. Oxford: Architectural Press, 1996)

History of Architecture: Settings and Rituals, by Spiro Kostof (New York: Oxford University Press, 1995)

Illustrated Dictionary of Historic Architecture, edited by Cyril M. Harris (New York: Dover, 1983)

Illustrated Encyclopedia of Architects and Architecture, edited by Dennis Sharp (New York: Whitney Library of Design, 1991)

Modern Architecture: A Critical History, by Kenneth Frampton (3rd ed. London: Thames & Hudson, 1992)

XIII-A-2. Biographical Dictionaries of Architects

See also U.S. General Services Administration programs [XIV-A-9].

Contemporary Architects

Many architectural firms have their own Web sites that include biographical data on their principal architects and recent projects. Once you know the location of buildings planned by your architect, see whether the companies owning these buildings have Web sites. Check the vertical files cited below [XIII-A-6].

Contemporary Architects, edited by Muriel Emanuel (3rd ed. New York: St. Martin's, 1994). Covers more than 585 international architects.

International Archive of Women in Architecture (IAWA) furnishes biographical sketches on women architects worldwide and hyperlinks to other pertinent Web sites
<http://scholar2.lib.vt.edu/spec/iawa/iawa.htm>

Macmillan Encyclopedia of Architects, edited by Adolf Placzek (4 vols. New York: Macmillan, 1982). Covers 2,450 architects.

Pro File: Professional File Architectural Firms, American Institute of Architects (Annual until 5th ed. [1987–88]; now biennial. Topeka, KS: Archimedia, 1983+). Official AIA directory of firms and individual members.

Historically Prominent Architects

American Architects from the Civil War to the First World War: A Guide to Information Sources, by Laurence Wodehouse (Detroit: Gale Research, 1976)

American Architects from the First World War to the Present: A Guide to Information Sources, by Laurence Wodehouse (Detroit: Gale Research, 1977)

Avery Obituary Index of Architects (2nd ed. Boston: G. K. Hall, 1980). Covers 17,000 architects living in the 19th and 20th centuries.

Biographical Dictionary of American Architects (Deceased), by Henry F. Withey and Elsie Rathburn Withey (Los Angeles: Hennessey & Ingalls, 1965; reprinted, 1970). Covers 2,000 architects living between 1740 and 1952.

Biographical Dictionary of British Architects, 1600–1840, by Howard Colvin (3rd ed. New Haven, CT: Yale University Press, 1995)

Brief Biographies of American Architects Who Died between 1897 and 1947, by Earle G. Shettleworth Jr., consists of verbatim transcriptions of the more than 1,200 brief obituaries pub-

lished in the *American Art Annual* and its successor, *Who's Who in American Art.*
<http://www.upenn.edu/sah/aame/bioint.html>

British Architects 1840–1976: A Guide to Information Sources, by Laurence Wodehouse (Detroit: Gale Research, 1979)

Dictionary of Architecture and Building: Biographical, Historical, and Descriptive, by Russell Sturgis (3 vols. New York: Macmillan, 1902; reprinted, Detroit: Gale Research, 1966)

Directory of British Architects 1834–1900, Royal Institute of British Architects (London: Mansell, 1993)

English Medieval Architects, by John Harvey (2nd ed. Gloucester, England: Sutton, 1987)

Macmillan Encyclopedia of Architects, edited by Adolf Placzek (4 vols. New York: Macmillan, 1982)

Master Builders: A Guide to Famous American Architects, by Diane Madden (Washington, D.C.: National Trust for Historic Preservation, 1985)

Who's Who in Architecture: From 1400 to the Present, edited by James M. Richards (New York: Holt, Rinehart & Winston, 1977)

XIII-A-3. Architecture Web Sites

Academic Architecture Courses

The following are just a few suggestions:

University of Nevada, Las Vegas, *Design Communications & Skills,* taught by architecture studies librarian Jeanne Brown
<http://www.nscee.edu/unlv/Libraries/arch/instr/aad283/aad283.html>

University of Texas, *World Lecture Hall,* taught by a Web team of professors from such academic institutions as Harvard, Michigan State, MIT, Columbia, and the University of Virginia
<http://www.utexas.edu/world/lecture/arc/>

Indexes to Architecture Web Material

AEC InfoCenter: The Internet Expo for Architecture Engineering and Construction
<http://www.aecinfo.com/>

Architecture and Building: Net Resources, compiled by Jeanne M. Brown, University of Nevada, Las Vegas, includes Web and Gopher sites organized by such categories as architecture courses and instruction, associations and societies, building and engineering, research centers, sites devoted to single architects or firms, and U.S. government publications
<http://www.nscee.edu/unlv/Libraries/arch/rsrce/webrsrce/index.html>

Art History Resources on the Web indexes architectural sites at Internet locations by historical style
<http://witcombe.bcpw.sbc.edu/ARTHLinks3.html>

ArtSource links to Web sites concerned with architectural resources, architecture programs, and architecture libraries
<http://www.uky.edu/Artsource/>

Design Architecture
<http://www.cornishproductions.com/>

Voice of the Shuttle has sections on archaeology and architecture
<http://humanitas.ucsb.edu/>

World Wide Web Virtual Library: Architecture includes hyperlinks to numerous firms, constructions, projects, history, and courses
<http://www.clr.toronto.edu:1080/VIRTUALLIB/arch.html>

World Wide Web Virtual Library: Landscape Architecture has a similar format to the site above
<http://www.clr.toronto.edu:1080/VIRTUALLIB/larch.html>

Miscellaneous: Architecture

Alexander Palace, former home of the Romanov Tsar Nicholas II in Tsarskoye Selo, Russia, developed by Bob Atchison
<http://205.187.161.152/palace/index.html>

Architronic: The Electronic Journal of Architecture includes book reviews on the Web
<http://www.saed.kent.edu/Architronic/>

Frank Lloyd Wright: Designs for an American Landscape, 1922–1932, Library of Congress Exhibition
<http://lcweb.loc.gov/exhibits/flw/flw.html>

Frank Lloyd Wright in Wisconsin
<http://flw.badgernet.com:2080/>

Temple of Liberty: Building the Capitol for a New Nation, Library of Congress Exhibition
<http://lcweb.loc.gov/exhibits/us.capitol/s0.html>

Thomas Register of American Manufacturers
<http://www.thomasregister.com:8000/>

XIII-A-4. Museums and Libraries concerned with Architecture

A number of libraries with excellent collections of architectural resources have published catalogues of their bibliographic holdings. Some of these institutions now have their OPACs available on the Internet. This means that you can search for the material online using more sophisticated search strategies than are available for finding information from the printed versions. The LC classification code for architecture is NA.

You may wish to consult *A Guide to the Description of Architectural Drawings,* by Vicki Porter and Robin Thornes (Boston: G. K. Hall, 1994). Information concerning this guide is at the Getty Information Institute Web site: <http://www.getty.edu/publications/>.

Avery Memorial Library, Columbia University, New York, includes material since 1981
<Telnet://columbianet.columbia.edu>

Blackader-Lauterman Library of Architecture and Art, McGill University, Montreal, Quebec
<http://blackader.library.mcgill.ca/>

Canadian Centre for Architecture (CCA), Montreal
<http://cca.qc.ca/>

New York Public Library, Art and Architecture Division
<http://catnyp.nypl.org/>

Royal Institute of British Architects (RIBA), London
<http://www.riba.org/>

XIII-A-5. Visual Resources for Architecture

Microfiche Collections

The Conway Library, The Courtauld Institute of Art, The University of London: Photographic Research Library for Art History (Microfiche. Haslemere, Surrey, England: Emmett Publishing, 1987+). One of the world's largest picture collections, with an estimated 800,000 black-and-white images. The microfiche set can be purchased in sections:
 (a) French and Italian architecture, medieval to 20th century
 (b) architecture, medieval to 20th century, Europe, Asia, Africa, and South America
 (c) architectural drawings, 14th century to the present
 (d) sculpture, 15th century to the present
 (e) medieval arts—sculpture, metalwork, ivories, panel paintings, Byzantine monuments
 (f) Western, Byzantine, and Eastern Christian manuscripts, 4th to 18th century

Conway Library Index on the Internet: Architecture: Medieval to Modern, 1997. *Sculpture: Post Medieval to Modern,* to be published 1998. This index will coordinate with the microfiche sections listed above, which can be purchased individually, and will be on a subscription basis; only libraries owning the microfiche set will provide use of the index.
 <http://www.emmettpub.co.uk/>

Architectural Visual Material on the Web

Digital Image Center, University of Virginia, provides more than 500 photographs of Renaissance and Baroque architectural monuments
 <http://www.lib.virginia.edu/dic/collections/collections.html>

SILs: Art Image Browser
 <http://www.sils.umich.edu/Art_History/>

SPIRO, University of California, Berkeley's Architecture Slide Library, directed by Maryly Snow, displays more than 25,000 images from its collection of 200,000 35-mm slides. For off-campus access, the digitized images are displayed as low-resolution thumbnail-size photographs that can be used for identification. Images are linked to their sources, either data on the vendors that sell them or the books from which they were photographed. The *SPIRO* Web site addresses the copyright issue; be sure to read it. Access the *College of Environmental Design,* then choose *SPIRO.*
 <http://www.ced.berkeley.edu/>

Documentary Videos

There are numerous documentaries concerned with architecture; see the suggestions cited below and [II-E] for locating them.

American Institute of Architects has more than 100 videotapes for rental, both to members and nonmembers. Some programs are professionally edited tapes of AIA convention programs; others are on diverse subjects, including individual architects, architectural styles, and concerns of the discipline.
 <http://www.aia.org/>

Architecture on Screen (Boston: G. K. Hall, 1994) [II-E]

University of Nevada, Las Vegas, video collection
 <http://www.ncsee.edu/unlv/Libraries/arch/archhome.html>

Indexes to Locating Architectural Monuments

See the U.S. General Services Administration's *Art-in-Architecture Installations* and *Historic Federal Buildings* project [XIV-A-9]. This government agency has information on the disposal and sale of property, as well as a section on cultural and environment concerns <http://www.gsa.gov/pbs/pt/pts/cultural.htm>. To locate illustrations in books, see Edward H. Teague's *Index to Italian Architecture,* 1992, and *World Architecture Index,* 1991 (Westport, CT: Greenwood Press).

CD-ROMs and Laser Discs

The ability to illustrate three-dimensional space and interact with the visual material—provided by the latest technology—is important to architectural instruction. *RealSuite* is cited below; other products are constantly being developed. To locate the most current publications, use the advanced search mode of the Library of Congress Experimental Search System <http://lcweb2.loc.gov/cgi-bin/queryess/>; be sure to choose *software.* Try search terms such as *computer graphics—Software* or *3D studio.*

Cybertools for the 21st Century Builder and Developer, by Tim R. Newell (Washington, D.C.: Home Builder Press, 1997). Demonstrates and explains computer visualization technologies.

Frank Lloyd Wright: Presentation and Conceptual Drawings (4 laser optical discs and 2 computer disks. Venice, CA: Luna Imaging, 1994). Includes almost 5,000 drawings from the architect's archives and covers 860 projects of all varieties.

Great Buildings Collection: A Designer's Library of Architecture on CD-ROM, by Kevin Matthews (Laser optical disc. New York: Van Nostrand Reinhold, 1995). Represents more than 750 buildings worldwide and includes interactive 3-D models of them.

RealSuite for Architectural Presentation: Using 3D Studio Release 3 (Albany: Autodesk Press, 1996). An instructional guide to learning how to use 3D material.

Ultimate Frank Lloyd Wright (CD-ROM. Redmond, WA: Microsoft, 1996)

XIII-A-6. Architecture Archives and Vertical Files

Archives of Architectural Drawings, Graduate School of Fine Arts (GSFA) of the University of Pennsylvania
 <http://www.upenn.edu/gsfa/>

Canadian Architecture Collections at McGill School of Architecture
 <http://blackader.library.mcgill.ca/cac/cac_over.html>

Canadian Center for Architecture, The Vertical Files of Architects, covers international architects, as well as Canadians. Material is available only at the Center, but there is a complete list of the architects at their Web site.
 <http://cca.qc.ca/contents.html>

Catalogue of Sir Chr. Wren's Drawings, Wren Society, London (20 vols. Oxford: Oxford University Press, 1924–43)

Catalogue of the Drawings Collection of the Royal Institute of British Architects, 1968–89 (London: Gregg. n.d. Microfilm publication available through London: World Microfilms)

Dunlap Society Visual Archives (Microfiche. Princeton, NJ: Princeton University Press)

 The Architecture of Washington, D.C., 2 vols.

 The County Court Houses of America, 1976–79, 2 vols.

Garland Architectural Archives Series:
 Architectural Drawings of Alvar Aalto, 1917–1939, 1994, 11 vols.

 Architectural Drawings of R.M. Schindler, 1993, 4 vols.

 Artifacts of R. Buckminister Fuller, 1985, 4 vols.

 Le Corbusier Archive, 1982, 32 vols.

 Louis I. Kahn Archive, 1987, 7 vols.

 Mies van der Rohe Archive:
 Part I: *1907–1938*
 Part II: *1938–1969,* 1986, total of 20 vols.

 Louis Sullivan, 1989

 Walter Gropius Archive, 1990, 4 vols.

 Holabird & Roche and Holabird & Root: A Catalogue of Works, 1880–1940, 3 vols., 1991

Inigo Jones: Complete Architectural Drawings, by John Harris and Gordon Higgott (London: Zwemmer, 1989)

Sanborn Maps (Pelham, NY: Sanborn Map Company). These date from 1867 to the present, providing street-by-street information for commercial, industrial, and residential districts of 12,000 cities and towns in United States, Canada, and Mexico. *Fire Insurance Maps in the Library of Congress* (U.S. Government Printing Office, 1981) is a checklist for holdings of some 11,000 volumes of Sanborn maps owned by LC. Some maps are available on microfilm from LC.
 <http://lcweb.loc.gov/>

XIII-A-7. Topographical Guides and Travel Books

See [X-A-6]. Many nations have financed or encouraged historical surveys, such as the *Historical American Building Survey (HABS)* and *Historic Buildings in Britain,* cited below. For an extensive list of other topographical handbooks, see Ehresmann's *Fine Arts* [II-A].

Architecture of the United States, by George Kidder Smith (3 vols. Garden City, NY: Anchor, 1981)

Buildings of England, edited by Nikolaus Pevsner (46 vols. London: Penguin, 1951–74). A series constantly being revised that includes Scotland and Wales.

Historic American Buildings Series (New York: Garland) reproduces drawings in *Historic American Buildings Survey* and includes photographs of many buildings.

Historic American Buildings Survey (HABS) and the *Historic American Engineering Record (HAER)* comprise one of the world's largest collections of architectural records. For information, consult the LC Web site.
 <http://lcweb.loc.gov/rr/print/145_habs.html>

To search a database of the more than 32,800 historic structures, see:
 <http://www.cr.nps.gov/habshaer/database.html>

The following publications reproduce the actual material, which usually consists of architects' drawings and plans.

American Preserved: A Checklist of Historic Buildings, Structures, and Sites Recorded by the Historic American Buildings Survey/Historic American Engineering Record (Washington, D.C.: Library of Congress, 1995, available through the LC Cataloging Distribution Service). Includes *HABS* and *HAER.*

HABS: Virginia Catalog: A List of Measured Drawings, Photographs, and Written Documents from the Survey (Virginia Historic Landmarks Commission, 1975)

Historic American Buildings Survey, U.S. Library of Congress (Microfiche. New York: distributed by Chadwyck-Healey, 1980s). Includes all the documentation, including the drawings, of *HABS/HAER* as of 1988. All states are available.

Historic Buildings in Britain Series (Microfiche. New York: Chadwyck-Healey, 1977). Commissioned by the Royal Commissions on Historic Monuments in England, Scotland, and Wales to inventory all notable buildings recommended for preservation and constructed before 1700, a date later changed to 1850. These inventories provide detailed descriptions of the monuments as well as visual materials—photographs, line drawings, maps, and floor plans.

XIII-B. Decorative Arts and Design

None of the general art history books covers decorative design or designers. The literature of this field is often reprinted.

Antique galleries and dealers have a large presence on the Web [VIII-D]; these resources are not repeated here. For this field, use *Design and Applied Arts Index* (CD-ROM. Woodlands, East Sussex, England: Design Documentation, 1997), which indexes articles on such subjects as textile design, interior design, furniture design, ergonomics, design for the disabled, ceramics, and glass <http://ourworld.compuserve.com/homepages/design_documentation/>. Many of the reference books cited here were issued prior to 1985, due to the lack of more recent publications.

XIII-B-1. Dictionaries of Decorative Arts and Design

Finding information on designers—whether historically important or presently popular—usually requires persistence, both on the Internet and off. Many of the books cited below include biographical sketches on designers. Most books on antiques cover carpets and rugs, ceramics, embroidery and needlework, furniture, glass, jewelry, metalwork, pewter, and silver. Some include facsimiles of ceramic and silver hallmarks and museums with particularly good antique examples. For contemporary designers, see *Contemporary Designers,* edited by Sara Pendergast, which is updated about every 5 to 8 years (Detroit: St. James Press, 1997).

If you locate the name of a firm for which the designer you are researching has worked, check the Internet to see whether it has a home page. Then contact the firm for additional data. The Henry Miller Company, for instance, has an extensive online presence that provides data on its designers as well as information on the products they designed <http://www.hmiller.com/>. See also *InterPlan Design & Furnishings* <http://www. interplan-opi.com/default.html>.

For an extensive list of interior design resources, see Jones's *Art Information,* pages 235–39 [II-A].

General References

Antique Collectors' Club publishes and distributes hundreds of books on various aspects of decorative arts. A few books are cited below to suggest the extent of the coverage; consult its Web site for the latest material <http://www.antiquecc.com/>.

A Collector's History of British Porcelain, by John Cushion (Woodbridge, England: Antique Collectors' Club, 1992)

A Collector's History of English Pottery, by Griselda Lewis (Woodbridge, England: Antique Collectors' Club, 1987)

Oak Furniture, by Victor Chinnery (Woodbridge, England: Antique Collectors' Club, 1986)

Regency Furniture, by Frances Collard (Woodbridge, England: Antique Collectors' Club, 1995)

Dictionary of Interior Design, by Martin Pegler (New York: Crown, 1966. Reprinted: Fairchild, 1983)

Dictionary of Ornament, by Philippa Lewis and Gillian Darley (New York: Pantheon, 1986)

Encyclopedia of Decorative Styles, 1850–1935, by William Hardy, et al. (Oxford: Phaidon, 1978; reprinted, Secaucus, NJ: 1988)

Evaluate Any Antique—Large or Small—Like an Expert, Know Your Antiques: How to Recognize Series, by Ralph and Terry Kovel (3rd ed. New York: Crown, 1981)

Facts On File Dictionary of Design and Designers, by Simon Jervis (New York: Facts On File, 1984). Published in England as *The Penguin Dictionary of Design and Designers.*

Miller's International Antiques Price Guide (London: Reed International Books, Ltd.). Includes illustrated books on the decorative arts.
 <http://www.antiquecc.com/>
 Miller's Victoriana to Art Deco: A Collector's Guide, 1995
 Miller's Understanding Antiques, 1989

Oxford Companion to the Decorative Arts, edited by Harold Osborne (London: Oxford University Press, 1975)

Phaidon Encyclopedia of Decorative Arts 1890–1940, edited by Philip Garner (London: Phaidon, 1978; reprint ed., 1988)

Story of Craft: The Craftsman's Role in Society, by Edward Lucie-Smith (Ithaca, NY: Cornell University Press, 1982; reprint ed., New York: Van Nostrand Reinhold, 1984)

Textiles in America 1650–1870, by Florence M. Montgomery (New York: W. W. Norton, 1984)

Furniture

American Windsor Chairs, by Nancy Goyne Evans (New York: Hudson Hill Press, 1996)

Complete Guide to Furniture Styles, by Louise Ade Boger (Enlarged ed. New York: Charles Scribner's Sons, 1969; reprinted, 1982)

Dictionary of English Furniture: From the Middle Ages to the Late Georgian Period, by Ralph Edwards (3 vols. London: Antique

Collectors' Club, 1983). Includes brief biographical entries for about 180 cabinetmakers.

Dictionary of English Furniture Makers 1660–1840, edited by Geoffrey Beard and Christopher Gilbert (London: Furniture History Society, 1986). Includes commissions and data on signed or documented pieces.

History of English Furniture, by Percy Macquoid (4 vols. London: Lawrence and Bullen, 1904–08; reprint ed., London: Antique Collectors' Club, 1987)

Vol. 1: *Age of Oak, 1500–1660*

Vol. 2: *Age of Walnut, 1660–1720*

Vol. 3: *Age of Mahogany, 1720–1770*

Vol. 4: *Age of Satinwood, 1770–1820*

Modern Furniture in Canada 1920–1970, by Virginia Wright (Toronto: University of Toronto Press, 1997)

Ceramics

Encyclopaedia of British Porcelain Manufacturers, by Geoffrey A. Godden (London: Barrie & Jenkins, 1988)

Encyclopedia of Pottery and Porcelain: 1800–1960, by Elizabeth Cameron (New York: Facts On File, 1986)

European Porcelain: A Handbook for the Collector, by Maria Penkala (3rd ed. Schiedam, Netherlands: Interbook International, 1980)

European Pottery: A Handbook for the Collector, by Maria Penkala (3rd ed. Schiedam, Netherlands: Interbook International, 1980)

Kovel's New Dictionary of Marks: Pottery and Porcelain, by Ralph and Terry Kovel (New York: Crown, 1986)

Silver, Pewter, and Gold

Collectors' Dictionary of the Silver and Gold of Great Britain and North America, by Michael Clayton (2nd ed. New York: World, 1985)

Directory of Gold & Silversmiths: Jewellers & Allied Traders 1838–1914, by John Culme (London: Antique Collectors' Club, 1981)

Vol. 1: *Biographies*

Vol. 2: *Marks*

Illustrated Dictionary of Silverware: 2,373 Entries Relating to British and North American Wares, Decorative Techniques and Styles, and Leading Designers and Makers, Principally from c. 1500 to the Present, by Harold Newman (London: Thames & Hudson, 1987)

Jackson's Silver and Gold Marks of England, Scotland, and Ireland, by Charles James Jackson, rev. ed. by Ian Pickford (Woodbridge, England: Antique Collectors' Club, 1989)

Marks of London Goldsmiths and Silversmiths (c. 1697–1837), by John P. Fallon (Rev. ed. Newton Abbot, England: David & Charles, 1988)

Sotheby's Directory of Silver 1600–1940, by Vanessa Brett (London: Sotheby's, 1986)

XIII-B-2. Decorative Arts Web Sites

Museums with decorative arts departments and historical museums are usually good sources for decorative arts information; for a list, see below.

Antique Collectors' Club publishes a magazine entitled *Antique Collecting,* and some of its articles are reproduced at its Web site. The club also publishes numerous reference books and illustrated guides to such subjects as ceramics, collectibles, design, furniture, glass, jewelry, and textiles.
 <http://www.antiquecc.com/>

Arts & Crafts Movement
 <http://www.arts-crafts.com/>

Conservation Department, Philadelphia Museum of Art, includes information on some of the items it has completed: an 18th century, English Ormerod bedcover, and an Adam/Linnell sofa
 <http://www.philamuseum.org/html/conserv.html>

"Contemporary Design from the Netherlands," 1996 Museum of Modern Art Exhibition, New York City
 <http://www.moma.org/exhibitions/dutchdesign/index.html>

Design Source, Vancouver, provides access to material for apparel designers, architects, graphic designers, industrial designers, interior designers, and landscape architects
 <http://www.designsource.bc.ca/>

Ergonomic Criteria for the Design of a New Work Chair: The Kinetics of Sitting
 <http://www.crisj.com/ergoplan.htm>

HomeArts Network of the Hearst Corporation provides illustrated essays on furniture:

"Windsor Chairs: Collecting an American Classic," by Bruce E. Johnson, discusses the history and types of chairs, the American Windsor, and its British influence. Photographs are supplied by the Winterthur Museum.
 <http://homearts.com/cl/collect/10windf1.htm>

"Furniture Design," by Thomas Klenck, provides general information on designers that shaped American furniture styles, such as Duncan Phyfe
 <http://homearts.com/pm/shoptalk/04furnb7.htm>

See its home page for additional material:
 <http://homearts.com/>

Maine Antique Digest magazine provides all types of articles, hyperlinks, and other information
 <http://www.maineantiquedigest.com/Welcome.html>

Mutant Materials in Contemporary Design, Museum of Modern Art Exhibition, New York City
 <http://www.sva.edu/moma/mutantmaterials/>

Sotheby's Web site, *Emerging Collector,* provides information on caring for all types of art, including ceramics, metal, Oriental carpets, and furniture
 <http://www.sothebys.com:80/Collector/emerge3.html>

See also *Caring for Antiques,* by Mette Tang Simpson
 <http://www.antiquecc.com/antiq/029867xd.htm>

Symmetry and Pattern: The Art of Oriental Carpets, Swarthmore College
 <http://forum.swarthmore.edu/geometry/rugs/>

Tulane University provides illustrations of furnishings from various historical styles
<http://www.tulane.edu/lester/text/>

"25 Years at the Renwick" is an exhibition of contemporary arts and crafts at the National Museum of American Art
<http://nmaa-ryder.si.edu/renwick25/index.html>

Victorian Web Overview Site has information on such items as the Crystal Palace International Exhibition of 1851 and William Morris's designs, with hyperlinks to other relevant locations
<http://www.stg.brown.edu/projects/hypertext/landow/victorian/art/artov.html>

White House Collection of American Crafts, National Museum of American Art
<http://nmaa-ryder.si.edu/whc/whcpretourintro.html>

William Morris Carpet Designs, J. R. Burrows & Company
<http://www.burrows.com/morris.html>

William Morris Home Page provides data on Morris and hyperlinks to other Web sites
<http://www.ccny.cuny.edu/wmorris/morris.html>

XIII-B-3. Museums and Libraries concerned with Decorative Arts

At their Web sites, many museums provide data on their decorative arts collection; some furnish illustrations of these works and hyperlinks to other relevant material. These sites can change rapidly, so check them often. See also the historical houses and museums [III-C-3]. The LC classification is NC.

Apsley House, managed by the Victoria and Albert Museum
<http://www.vam.ac.uk/apsley/welcome.html>

Colonial Williamsburg
<http://www.history.org/>

Cooper-Hewitt National Design Museum, Smithsonian Institution, New York
<http://www.si.edu/ndm/>

Corning Museum of Glass, Corning, New York
<http://www.pennynet.org/glmuseum/corningm.htm>

ECIAD: Emily Carr Institute of Art and Design, Vancouver, Canada
<http://www.eciad.bc.ca/global/main.html>

Museum of the City of New York
<http://www.mcny.org/>

Renwick Gallery, National Museum of American Art, Smithsonian Institution, Washington, D.C.
<http://nmaa-ryder.si.edu/renwick/renwickhomepage.html>

Textile Museum, Washington, D.C.
<http://www.textilemuseum.org/>

Victoria and Albert Museum, London
<http://www.vam.ac.uk/>

Wallace Collection, London
<http://www.demon.co.uk/heritage/wallace/>

White House, Washington, D.C.
<http://www1.whitehouse.gov/WH/Welcome.htm>

Winterthur Museum, Garden and Library
<http://www.udel.edu/winterthur/>

XIII-B-4. Visual Resources for Decorative Arts

For details on these resources, see the publisher's Web sites or the general art bibliographies [II-A].

Published Picture Collections

Drawings of Robert and James Adam in the Sir John Soane's Museum (Microfilm. New York: Chadwyck-Healey, 1979)

Index of American Design (Microfiche. New York: Chadwyck-Healey, 1979). Part of the Federal Art Project of the 1930s, this provides a visual survey of decorative, folk, and popular arts made in America up to about 1900. Original renditions are at the National Gallery of Art, Washington, D.C.; 26 watercolors are illustrated in its online tour of furniture.
<http://www.nga.gov/collection/gallery/iadfurn/iadfurn-main1.html>

Reprints of Trade Catalogues

Architectural Trade Catalogues from Avery Library (Microfiche. New York: Clearwater, 1988)

1902 Edition of the Sears Roebuck Catalogue (New York: Crown, 1970)

Reprints of Trade Literature Series (Research Publications)
Montgomery Ward & Company, Catalog and Buyers Guide No. 57 (reprint of Spring and Summer 1895 catalogue), 1969
Sears Roebuck & Company, The Great Price Maker, Catalog No. 117: 1908, 1969
Victorian Shopping: Harrod's Catalogue 1895, 1972

Trade Catalogues at Winterthur (Microfiche. New York: Clearwater, 1984). To be used with the printed volume: *Trade Catalogues at Winterthur: A Guide to the Literature of Merchandising 1750 to 1980*, by E. Richard McKinstry (New York: Garland, 1984).

Trade Catalogues in the Victoria and Albert Museum 1762–1939 (Microfiche. London: Mindata, 1986)

Victoria and Albert Museum: The Department Collections (Microfiche. London: Mindata, n.d.). Includes reprints of photographs in various departments, such as ceramics, furniture and woodwork, metalwork, and textiles.

Victoria and Albert Museum: Liberty's Catalogues: Fashion, Design, Furnishings 1881–1949 (Microfiche. London: Mindata, 1985)

CD-ROMs and Videos

History of Textiles (Kax Wilson, 1979)

Story of English Furniture (London: BBC, 1986). Part 1 covers from the Middle Ages to the late 18th century; Part 2, the late 18th century to the present.

Treasure Houses of Britain (London: National Gallery of Art, 1985, three cassettes; 1986, one cassette).

XIII-C. Fashion and Historic Costumes

The Costume Society of America is the publisher of (a) *Bibliography: Of Recent Publications and Reprints Relating to Aspects of Dress* (compiled by Adele Filene; revised by Polly Willman, 1974–79) and (b) *Bibliography* (compiled by Polly Willman, 1983). A great deal of material is published in *Women's Wear Daily* (1927+. Since 1976, titled *WWD*, but literature still refers to it by its original title. Past issues available on microfilm); see its Web site <http://www.wwd.com/>.

For locating articles, use *Design and Applied Arts Index* (CD-ROM. Woodlands, East Sussex, England: Design Documentation, 1997), which indexes articles on such subjects as fashion, textile design, embroidery, and jewelry; see its home page <http://ourworld. compuserve.com/homepages/design_documentation/>. Other indexes are *Reader's Guide to Periodical Literature* and *Magazine Database* [VII-B-2] and *Clothing and Textile Arts Index* (Annual. Monument, CO: Clothing and Textile Arts Index. 1970+), which since 1989 has been available on CD-ROM.

XIII-C-1. History of Fashion

The following are some general interest examples of references concerned with social history, works of art, and dress. Most are profusely illustrated by works of art.

Agony of Fashion, by Eline Canter Cremers-Van der Does (Poole, Dorse, England: Blandford Press, 1980). Relates discomfort in dress from the time of the ancient Egyptians to today.

Dictionary of Costume, by Ruth Turner Wilcox (New York: Charles Scribner's Sons, 1969; reprint ed., New York: Macmillan, 1986)

Fashion, the Mirror of History, by Michael and Ariane Batterberry (New York: Greenwich House, 1982)

Fifty Years of Fashion, from New Look to Now, by Valerie Steele (New Haven, CT: Yale University Press, 1997)

Greek Jewelry, Five Thousand Years of Tradition. Covers jewelry techniques and information on jewelry from prehistoric times through 1900.
<http://www.addgr.com/jewelry.elka/index.html>

St. James Fashion Encyclopedia: A Survey of Style from 1945 to the Present, edited by Richard Martin (Revised ed. of Contemporary Fashion, 1995. Detroit: Visible Ink, 1997)

Seeing through Clothes, by Anne Hollander (New York: Viking, 1975). Discusses drapery, nudity, costume, dress, and mirrors and their impact on artists and viewers.

20,000 Years of Fashion: The History of Costume and Personal Adornment, by François Boucher (Expanded ed. New York: Harry N. Abrams, 1987)

XIII-C-2. History of Costume

Remember that what we call a costume today may have been yesterday's fashion. Clothes and accessories can sometimes be used to date portraits. For an extensive list of historical surveys of fashion and costume, see Jones's *Art Information,* pages 244–46 [II-A-2].

Godey's Lady's Book, by Hope Greenberg, Universtiy of Vermont
<http://www.uvm.edu/~hag/godey/>

Godey's Lady's Book: 1850, a Web site under the directorship of Roger Corrie, is putting the complete issues online, including the illustrations and essays that cover more than just fashion. There are sections describing children's games, costumes of other nations, and popular furnishings for the home.
<http://www.history.rochester.edu/godeys/>

History of Costume by Braun & Schneider— c.1861–1880, by C. Otis Sweezey, Southern Illinois University, reproduces 500 costume designs from out-of-print books. Its scope is from ancient Egypt to 1880, with an emphasis on German dress and folk dress.
<http://www.siue.edu/COSTUMES/history.html>

XIII-C-3. Biographical Dictionaries of Fashion Designers

Many designers have Web sites; Yahoo's search engine will link you to additional Web sites concerned with the designer you are researching. See also *Current Biography Yearbook* [XI-B].

Contemporary Designers, edited by Colin Naylor (2nd ed. Chicago: St. James Press, 1990)

Couture: The Great Designers, by Caroline Milbank (New York: Stewart, Tabori, & Chang, 1985)

Encyclopedia of Fashion, by Georgina O'Hara (New York: Harry N. Abrams, 1986)

Fairchild's Dictionary of Fashion, by Charlotte Calasibetta (2nd ed. New York: Fairchild, 1988)

McDowell's Directory of Twentieth Century Fashion, by Colin McDowell (Englewood Cliffs, NJ: Prentice Hall, 1985)

Who's Who in Fashion, by Anne Stegemeyer (2nd ed. New York: Fairchild, 1988)

Yahoo's Fashion Data provides URLs for individual designers' home pages and includes hyperlinks to sites criticizing their work, such as a site containing accusations that Calvin Klein glamorizes heroin addiction.
 <http://www.yahoo.com/Arts/Design_Arts/Fashion/Designers/>

XIII-C-4. Fashion and Costume Web Sites

Some designers have Web pages that illustrate their recent creations. Although mostly concerned with the business side of fashion, brief information can frequently be located on magazine sites; check a current issue for the URL or access the magazine through the publisher's Web site. Remember to check Yahoo's many lists for pertinent URLs; examples include <http://www.yahoo.com/Business_and_Economy/Companies/Apparel/> and <http://www.yahoo.com/Arts/Design_Arts/Fashion/Magazines/>. Some fashion Web sites require users to register and pay for the service.

In 1997, Sotheby's inaugurated a fashion department. Sales information placed on its Web site for forthcoming auctions is often retained on the Internet long after the sale has taken place. *Paris à la Mode: 20th Century Haute Couture* provides illustrations and comments on some of the fashions that comprised that auction <http://www.sothebys.com/>.

ApparelNet is a directory to apparel stores with Web pages
 <http://www.apparel.net/>

Armani Exchange
 <http://www.armaniexchange.com/>

Bazaar Magazine
 <http://viabazaar.com/index.html>

"Best Dressed: 250 Years of Style," 1997–98, online exhibition. Philadelphia Museum of Art highlights 16 designers, such as Elsa Schiaparelli, Norman Norell, Bill Blass and Pierre Cardin.
 <http://www.philamuseum.org/best/>

Best Dressed Exhibition, Conservation Department, Philadelphia Museum of Art
 <http://www.philamuseum.org/html/conserv.html>

Beverly Birks Couture Collection of Camrax Inc., New York, displays examples from some major couturiers—Vionnet, Chanel, Patou, Dior, and Balenciaga
 <http://www.camrax.com/pages/birks0.htm>

CNN Style
 <http://www.cnn.com/STYLE/>

Costume Page: Costuming Resources Online, by Julie Zetterberg, has numerous hyperlinks to dictionaries and exhibitions
 <http://members.aol.com/nebual5/tcpinfo.html>

Donna Karan
 <http://www.donnakaran.com/>

Elegance after Dark: Evening Wear in Louisiana 1896–1996
 <http://www.crt.state.la.us/crt/museum/exhibit.htm>

Elle Magazine
 <http://www.ellemag.com/>

EXE Daily Magazine
 <http://www.exe.ca/>

Fashion Internet provides hyperlinks to relevant sites, including designers' showrooms, international material, and fashion features
 <http://www.finy.com/>

Fashion Net
 <http://www.fashion.net/>

Fashion Page
 <http://www.charm.net/>

FirstView provides excellent illustrations from the designers' latest showcases, at per-year and per-hour fees
 <http://www.firstview.com/home.html>

Guess Company
 <http://www.guess.com/>

Kashmir Shawls: A Brief History, by Jehan S. Rajab, Tareq Rajab Museum, Kuwait
 <http://www.kuwait.net/~trm/shawls.html>

Label France, is a quarterly Internet magazine published by Ministère des Affaires étrangères, for which English selections are provided. This is a great source for French haute couture fashion.
 <http://www.france.diplomatie.fr/label_france/label.gb.html>

Museums New York provides information on fashion and lists current exhibitions
 <http://www.museumsny.com/>

New York Style
 <http://www.nystyle.com/>

Nicole Miller Online
 <http://www.nicolemiller.com/>

Shoe Museum of Elda, Spain, provides a brief illustrated history of footwear
 <http://www.sho.es/museo/ingles/mueo_i.htm>

Texas Fashion Collection, University of North Texas, illustrates selections from its collection online, especially of designers Balenciaga, de la Renta, Givenchy, and Norell.
 <http://www.art.unt.edu/tfc/index.html/>

Uncommon Threads: Three Hundred Years of New York Style is an illustrated online exhibition of the Museum of the City of New York
 <http://www.mcny.org/mcny/threads.html/>

Vogue, published by the Condé Nast Publications, Ltd.
 <http://www.condenast.co.uk/>

Women's Wear Daily
 <http://www.wwd.com/>

Wrapped in Splendor: The Art of the Paisley Shawl, Kent State University
 <http://www.kent.edu/museum/>

XIII-C-5. Museums and Libraries concerned with Fashion

Some museum libraries listed below have (a) extensive holdings of 18th- and 19th-century fashion journals; (b) photographic archives for fashion designers, regional costumes, and couture firms, which can be used to browse for design ideas; (c) video documentaries; (d) costume exhibition catalogues; and (e) vertical files on designers and commercial firms. The LC classification is GT.

Costume Institute, Metropolitan Museum of Art, New York
 <http://www.costumeinstitute.org/>

Costumes and Textiles Division, Los Angeles County Museum of Art
 <http://www.lacma.org/Masterpieces/Costumes.htm>

Fashion Institute of Design and Merchandising, Los Angeles
 <http://www.fidm.com/>

Fashion Institute of Technology, New York City
 <http://www.fitnyc.suny.edu/>

Museum of the City of New York
 <http://www.mcny.org/>

Victoria and Albert Museum, London
 <http://www.vam.ac.uk/>

XIII-C-6. Visual Resources for Fashion and Costumes

Photographic Collections on Microforms

Bibliothèque Nationale: Collections of the Department of Prints and Photographs (Microfilm. Paris: Studios Photographiques Harcourt)

Costumes de Regne de Louis XIV, 17th-century engravings

Costumes du XVIIIeme Siècle, engravings made between 1778 and 1785 by the Parisian firm of Esnault and Rapilly, of then-current fashions and manners.

"La Mesangere" Parisian Costumes, 1797–1839, drawings made for *Journal des Dames et des Modes,* which depicted contemporary society

Victoria and Albert Museum (Color microfiche Haslemere, Surrey, England: Emmet Microform)

Jewellery Gallery, 1983

Local and Traditional Costumes, 1987

Paquin Worth Fashion Drawings: 1865–1956, 1982

Schiaparelli, 1984

Swinging Sixties: Fashion in Britain, 1985

Theatre Costume Designs, 1984

Visual Catalogue of Fashion and Costume, 1981

Victoria and Albert Museum: The House of Worth: Fashion Designs, a Photographic Record 1895–1927 (Microfiche. London: Mindata, 1983). 7,000 photographs of fashions created by Charles Frederick Worth.

Videos and Microfiche of Fashion

Of utmost importance to the fashion world are the seasonal showings of the couturier collections, which receive international press coverage. A few libraries have videotapes made by various couture houses of their showings. These videos are not usually for sale or rent, but can be viewed at the institution's library. *Fashion Update* is a record of the international couturier collections using single photographs of the events. *FirstView* provides illustrations from the latest designer's showcases; there is a fee per year and per hour <http://www.firstview.com/home.html>.

A recent development is the video magazine, which provides views in motion of how specific fashions work with the human body. Seeing a model move in a dress provides insight into how the construction influenced the achieved look. Video magazines illustrate the important international couturier shows, have pictorial essays on various aspects of the clothing industry, and interview designers, models, and others involved in fashion.

Chanel, Chanel (Home Vision, 1986)

Eighteenth-Century Women (New York: Metropolitan Museum of Art, 1982)

Fashion Update (Quarterly. Color microfiche. Haslemere, Surrey, England: Emmet Microform, 1983 +). Contains about 1,400 reproductions of clothing by about 120 designers.

FirstView
 <http://www.firstview.com/>

Story of Fashion (Home Vision, 1986)

Videofashion Network (Half-hour videotapes. Jersey City, NJ: Speier Enterprises, 1976 +). Composed of several series: *Videofashion Monthly, Videofashion News, Videofashion Men,* and *Videofashion Specials.*
 <http://www.videofashion.com>

XIII-D. Graphic Arts and Prints

For research in this field, use *Design and Applied Arts Index* (CD-ROM. Woodlands, East Sussex, England: Design Documentation, 1997), which indexes articles on graphic design. See its homepage: <http://ourworld.compuserve.com/homepages/design_documentation/>.

For a bibliography of Canadian designers, see *Design by Canadians: A Bibliographic Guide,* by Ken Chamberlain (Richmond, BC, Canada; KE Chamberlain, 1994), which covers the years 1940 to 1990.

XIII-D-1. History of Graphic Arts and Prints

American Engravers upon Copper and Steel, by David McNeely Stauffer, Mantle Fielding, and Thomas Hovey Gage (3 vols. Originally vols. 1 and 2 were published in 1907; vol. 3 is Mantle Fielding's 1917 supplement. New Castle, DE: Oak Knoll Books, 1994)

American Printmaking: A Century of American Printmaking, 1880–1980, by James Watrous (Madison: University of Wisconsin, 1984)

American Prints and Printmakers, by Una E. Johnson (Garden City, NY: Doubleday, 1980). Covers the field from 1900.

Chicago Graphic Design: The Best of Contemporary Chicago Graphic Design with Essays on Past and Future Trends, edited by Rob Dewey (Natick, MA: RWP/RP Elite Editions, 1994)

Contemporary Print: From Pre-Pop to Postmodern, by Susan Tallman (London: Thames & Hudson, 1996)

History of the Illustrated Book: The Western Tradition, by John Harthan (New York: Thames & Hudson, 1981)

Print in the Western World: An Introductory History, by Linda C. Hults (Madison: University of Wisconsin Press, 1996)

Prints and People: A Social History of Printed Pictures, by A. Hyatt Mayor (New York: Metropolitan Museum of Art, 1971; reprint ed., Princeton, NJ: Princeton University Press, 1980)

Prints and Printmaking: An Introduction to the History and Techniques, by Antony Griffiths (2nd ed. Berkeley: University of California Press, 1996)

Prints of the Twentieth Century: A History, by Riva Castleman (Revised and enlarged. New York: Thames & Hudson, 1988). An important print survey of various 20th-century styles, such as expressionism, cubism, non-objective art, dada and surrealism, and pop, op, kinetic, concrete, and conceptual art.

Sightlines: Prints in Evolution, edited by Walter Jule (Edmonton, Canada: University of Alberta Press, 1997)

XIII-D-2. Biographical Dictionaries of Graphic Artists

For material, see *New York Public Library, The Print File;* [XIII-D-6], below. This section is organized by contemporary and historically prominent printmakers.

Contemporary Printmakers

Check the dictionaries listed under Contemporary Artists [XI-B]. There are a number of printmakers with their own Web sites; see Yahoo's list below and galleries that sell their prints (Chapter VIII).

American Lithographers, 1900–1960: The Artists and Their Printers, by Clinton Adams (Albuquerque: University of New Mexico, 1983)

Contemporary Graphic Artists: A Biographical, Bibliographical, and Critical Guide to Current Illustrators, Animators, Cartoonists, Designers, and Other Graphic Artists, edited by Maurice Horn (Detroit: Gale Research, 1986)

Design Firm Directory: A Listing of Firms and Consultants in Industry, Graphic, Interior, and Exterior Design, edited by W. Daniel Wefler (Annual. Evanston, IL: Wefler & Associates, 1986+). Lists more than 1,350 firms in geographical order by state, then city, citing the date the firm was established, number of employees, names of major personnel, services, and clients.

Illustrated World Review of Leading Contemporary Graphic Designers, by Walter Amstutz (Dubendorf, Switzerland: De Clivo, 1982)

Yahoo's List of Graphic Design includes URLs for individual artists
 <http://www.yahoo.com/Arts/Design_Arts/Graphic_Design/>

Yahoo's List of Graphic Design Directories
 <http://www.yahoo.com/Business_and_Economy/Companies/Graphic_Design/Directories/Commercial/>

Index to Biographical Data

American Printmakers 1880–1945: An Index to Reproductions and Biocritical Information, by Lynn Barstis Williams (Metuchen, NJ: Scarecrow Press, 1993). Covers illustrations and biographical data in 86 books.

Historically Prominent Printmakers

There is a large body of literature on this subject. Many of the works were published more than a century ago but remain the principal text for the field.

American Engravers upon Copper and Steel, by David McNeely Stauffer and Mantle Fielding (3 vols. New York: Burt Franklin, 1964)

Biographical Dictionary: Containing an Historical Account of All the Engravers, from the Earliest Period of the Art of Engraving to

the Present Time, and a Short List of Their Most Esteemed Works, by Joseph Strutt (2 vols. in 1 book. London: J. Davis, 1785–86; reprint ed., Geneva, Switzerland: Minkoff, 1972)

Der deutsche Peintre-Graveur; oder, Die deutschen Maler als Kupferstecher nach ihrem Leben und ihren Werken, von dem letzten Drittel des 16. Jahrhunderts bis zum Schluss des 18. Jahrhunderts, by Andreas Andreson (5 vols. Leipzig: Rudolph Weigel, 1864–78; reprinted, New York: Collectors, 1969). Covers 140 German engravers working from 1560 to 1800.

Die deutschen Maler-Radirer (peintres-graveurs) des neunzehnten Jahrhunderts, nach ihren Leben und Werken, by Andreas Andreson (5 vols. Leipzig: von Rudolph Weigel, 1866–70; reprinted, New York: Georg Olms, 1971). Covers over 70 German 19th-century engravers.

Dictionary of Victorian Engravers, Print Publishers and Their Works, by Rodney K. Engen (Teaneck, NJ: Chadwyck-Healey, 1979)

Dictionary of Victorian Wood Engravers, by Loys Delteil (Teaneck, NJ: Chadwyck-Healey, 1985)

Dutch and Flemish Etchings, Engravings, and Woodcuts, ca. 1450–1700, by F. W. H Hollestein, et al. (39 vols. Amsterdam: Menno Hertzberger, 1949+)

Early Italian Engraving: A Critical Catalogue with Complete Reproductions of All the Prints Described, by Arthur M. Hind (7 vols. in 4 books. New York: Knoedler, 1938–48, reprinted, Nendeln, Liechtenstein: Kraus, 1970)

German Engravings, Etchings, and Woodcuts, ca. 1400–1700, F. W. H. Hollstein (Amsterdam: Menno Hertzberger, 1954)

German Single-Leaf Woodcut

1500–1550, by Max Geisberg, revised and edited by Walter L. Strauss. (4 vols. New York: Hacker, 1974). A translation of *Der deutsche Einblatt Holzschnitt, 1923–30.*

1550–1600, by Walter L. Strauss (3 vols. New York: Abaris, 1975)

1600–1700: A Pictorial Catalogue, by Dorothy Alexander in collaboration with Walter L. Strauss (2 vols. New York: Abaris, 1977)

Les graveurs du dix-huitieme siècle, by Baron Roger Portalis and Henri Beraldi. (3 vols. Paris: Morgand et Fatout, 1880–82; reprint ed., New York: Burt Franklin, 1970)

Les graveurs du XIXe siècle: guide de l'amateur d'estampes modernes, by Henri Beraldi (12 vols. in 10 books. Paris: L. Conquet, 1885–95; reprint ed., Nogent-le-Roi, France: Jacques Laget L.A.M.E., 1981)

Le peintre graveur, by Adam von Bartsch (21 vols. in 4 books. Vienne, France: Degen, 1802–21; reduced size reprinted., Nieuwkoop, Holland: B. de Graaf, 1982). Covers more than 500 artists working between the 15th and 18th centuries: Volumes 1–5 cover Dutch and Flemish artists; Volumes 6–11, German artists; and volumes 12–21, Italian masters. These original volumes and others based on Bartsch's work contain no illustrations or subject indexes. *The Illustrated Bartsch: Le Peintre-Graveur Illustre* [XIII-D-5] provides reproductions of his work; the *Iconclass Indexes* [XIII-D-5] are iconographic indexes of Bartsch's prints.

Le peintre-graveur: Contenant l'histoire de la gravure sur bois, sur métal et au burin jusque vers la fin du XVI. siècle. L'histoire du nielle avec complément de la partie descriptive de l'Essai sur les nielles de Duchesne aîné. Et un catalogue supplémentaire aux estampes du XV. et XVI. siècle du Peintre-graveur de Adam

Bartsch, by Johann David Passavant (6 vols. in 3 books. Leipzig: Weigel, 1860–64; reprint ed., New York: Burt Franklin, 1970)

Le peintre-graveur français, ou Catalogue raisonné des estampes gravées par les peintres et les dessinateurs de l'école française, by A. P. F. Robert-Dumesnil, with Vol. 11, a supplement by Georges Duplessis (11 vols. Paris: Gabriel Waree, 1835–71; reprint ed., Paris: F. Nobele, 1967)

Le peintre-graveur français continué, ou Catalogue raisonné des estampes gravées par les peintres et les dessinateurs de l'école française nés dans le XVIIIe siècle, ouvrage faisant suite au Peintre-graveur français de M. Robert-Dumesnil, by Prosper de Baudicour (2 vols. Paris: Bouchard-Huzard, 1859–61). Covers 60 French engravers.

Le peintre-graveur illustré (XIX et XX siecles), by Loys Delteil (31 vols. Paris: Chez l'auteur, 1906–30; reprint ed., New York: Collectors Editions and DaCapo Press, 1969)

XIII-D-3. Graphic Arts Web Sites

American Institute of Graphic Arts provides information on the essential business texts—such as *Selling Graphic Design, Design and Printing Buyer's Survival Guide,* and *Legal Guide for the Visual Artist*—that it has compiled and sells
 <http://www.aiga.org/>

"Art of Exaggeration: Piranesi's Perspectives on Rome," was an exhibition at the Fisher Gallery, University of Southern California, with an introduction and checklist of the works shown and a bibliography
 <http://www.usc.edu/dept/fisher_gallery/piranesi/>

Art History Resources on the Web has a section on prints
 <http://witcombe. bcpw.sbc.edu/ARTHLinks4.html>

ArtSource
 <http://www.uky.edu/Artsource/>

Color Printing: An Introduction, University of Delaware Exhibition
 <http://www.lib.udel.edu/ud/spec/exhibits/color/>

"Expressionist Bible," Los Angeles County Museum of Art Exhibition
 <http://www.lacma.org/Exhibits/Bible/default.htm>

Hogarth and His Times: Serious Comedy, Berkeley Art Museum
 <http://www.bampfa.berkeley.edu/exhibits/hogarth/>

Honoré Daumier (1808–1879) reproduces some of the 100 prints by this artist owned by the University of Montana Museum of Fine Arts
 <http://www.umt.edu/partv/famus/print/daumier/Daumier.htm>

Posters of Toulouse-Lautrec, San Diego Museum of Art
 <http://www.sandiegomuseum.org/lautrec/>

Singular Impressions: The Monotype in America, National Museum of American Art, is organized by material on the process, color prints, American artists abroad, and contemporary monotypes
 <http://nmaa-ryder.si.edu/monotypes/index.html>

Spencer Museum of Art Print Room, University of Kansas, includes a glossary of print terms, discussion on looking at

older prints, listing of printmakers in the museum's collection, and hyperlinks to other relevant sites
<http://www.ukans.edu/~sma/prints.html>

William Hogarth and 18th-Century Print Culture, Northwestern University
<http://www.library.nwu.edu/spec/hogarth/>

Yahoo's List of Graphic Design includes hyperlinks to such items as companies, graphic designers, professional organizations and magazines
<http://www.yahoo.com/Arts/Design_Arts/
Graphic_Design>

XIII-D-4. Museums and Collections concerned with Graphic Arts

The LC classification number is NE.

The Albertina, Vienna, Austria, holds one of the world's greatest graphic arts collections of master works. Its 1997 Web site is in German but can be easily understood.
<http://www2.telecom.at/albertina/>

The Library of Congress Prints and Photographs Division in 1997 contained more than 13,000,000 original graphic items [VI-A]. For a printed index that provides brief biographical data and lists of works in the collections, see *American Prints in the Library of Congress: A Catalog of the Collection,* compiled by Karen F. Beall (Baltimore: Johns Hopkins University Press, 1970). It provides brief biographical data of artists, and for the works, it cites titles, dates, media, dimensions, numbers in editions, signature data, and acquisition information. There are indexes to subjects and to geographical locations depicted in the prints.
<http://www.loc.gov/coll/print/guide/>

New York Public Library, *Dictionary Catalog of the Prints Division* (5 vols. Boston: G. K. Hall, 1975). Includes titles of referrence books on print history and terms, subjects of prints, and techniques of printmaking. Notation for "Catalogues and other pamphlet material" indicates that the material is located in the New York Public Library's extensive vertical files on printmakers. Organized in 1903, the Print Division's vertical files include about 35,000 artists; this material has been published on microfiche [XIII-D-6].
<http://catnyp.nypl.org/>

The San Francisco Fine Arts Museums, through *Art Imagebase,* are placing the collections of the Achenbach Foundation for Graphic Arts on the Internet. It includes prints, illustrated books, and other media on paper, with more than 60,000 records spanning six centuries and representing more than 15,000 artists.
<http://www.thinker.org/imagebase/index.html>

XIII-D-5. Visual Resources for Prints

Some visual resources have been photocopied onto microfiche, which is analog technology. As of 1997, only digitized technology can be used in a computer, which includes CD-ROMs and the World Wide Web. As a result, most of this material will most likely never be placed on the Internet.

Print Collections

Bibliothèque Nationale: Collections of the Department of Prints and Photographs (Microfilm. Paris: Studios Photographiques Harcourt).The oldest such department in the world, created in 1667 by Louis XIV. Since 1689 it has been the official print repository for all of France. It currently comprises 14,000,000 items.

British Museum: Historical Prints (Microfiche. London: Mindata). Includes more than 10,000 prints representing European history from the 15th to the 20th century. Arranged chronologically by events depicted; the prints are captioned and can be ordered singly.

Illustrated Bartsch: Le Peintre-Graveur Illustre, Walter L. Strauss and John Spike, general editors (Projected 175 printed books. New York: Abaris Books, 1979+). When completed, this will provide reproductions for all 20,000 European prints discussed in *Bartsch* [XIII-D-2] and supplement and update his material. There are also supplementary books that cover artists omitted by *Bartsch* or active after his death.

Indexes to Prints

Iconclass Indexes: Dutch Prints, by Roelof van Straten (Leiden, The Netherlands: Foleor Publishers, 1994+). Lists prints depicting specific subjects.

Vol. 4: *Hendrik Goltzius and His School: An Iconographic Index to A. Bartsch, "Le Peintre-Graveur,"* vol. 3, 1994

Vol. 7: *Seventeenth Century Dutch Prints I: An Iconographic Index to A. Bartsch, "Le peintre-graveur,"* vols. 19, 20, and 21; 2 vols, 1994

Iconclass Indexes: Early German Prints, by Fritz Laupichler and Roelof van Straten (Leiden, The Netherlands: Foleor Publishers, 1995+). Provides indexes to specific subjects.

Vol. 1: *Martin Schongauer and His School: An Iconographic Index to A. Bartsch, "Le Peintre-Graveur,"* vols. 6 and 10, 1995

Iconclass Indexes: Italian Prints, by Roelof van Straten (Doornspijk, The Netherlands: Davaco, 1987+). Lists prints depicting specific subjects using *Iconclass* [IX-B-7].

Vol. 1: *Early Italian Engravings: An Iconographic Index to A.M. Hind, "Early Italian Engraving,"* London, 1938–1948, 1987, which includes artists active the second half of the 15th century

Vol. 2: *Marcantonio Raimondi and His School: An Iconographic Index to A. Bartsch, "Le Peinture-Graveur,"* vols. 14, 15, and 16, 1988

Vol. 3: *Antonio Tempesta and His Time: An Iconographic Index to A. Bartsch, "Le Peinture-Graveur,"* vols. 12, 17, and 18, 1987

Print Index: A Guide to Reproductions, by Pamela Jeffcott Parry and Kathe Chipman (Westport, CT: Greenwood, 1983). Indexes reproductions of works of 2,100 printmakers.

XIII-D-6. Graphic Arts Archives and Vertical Files

New York Public Library: The Print File (Microfiche. Alexandria, VA: Chadwyck-Healey, 1989–90). A reprint of this famous library's vertical files containing information on graphic artists. For an index to this material, see [XIII-D-4]. The material is similar to that found in the *New York Public Library: The Artists File* [IX-B-6].

XIII-E. Photography

The discipline of photography has developed an extensive bibliography, although the information on the earlier masters in this field is often brief and repetitive. A subject search for *history AND photography* in the New York Public Library's OPAC yielded 9,420 records. To locate photography literature, use the following:

Design and Applied Arts Index (CD-ROM. Woodlands, East Sussex, England: Design Documentation, 1997). Indexes articles on photography; see their homepage.
<http://ourworld.compuserve.com/homepages/design_documentation/>

International Photography Index, edited by William S. Johnson (Boston: G.K. Hall, 1983+). Indexes books, articles, and exhibition reviews, covering more than 2,000 photographers. It was irregularly issued from 1977 to 1981 and titled *Index to Articles on Photography 1977–1978,* published by Visual Studies Workshop, Rochester, New York.

Photohistorica: Literature Index of the European Society for the History of Photography (Irregularly published. Antwerp: European Society for the History of Photography, 1980+). Covers about 80 international serials and includes subject heading on iconography.

Searching some of the outstanding library collections, such as the New York Public Library <http://catnyp.nypl.org/> and the Library of Congress <http://www.loc.gov/>, will produce a prodigious amount of material. Remember, a library's OPAC acts as a broad bibliography [II-A]. See also (a) *Bibliography of the Daguerreotype,* based on "A Survey of Daguerreian Literature," by John Wood, published in *The Daguerreian Annual,* 1994, with additional titles catalogued by Gary W. Ewer <http://abell.austinc.edu/dag/resource/biblio/biblio.html>, and (b) *Nineteenth-Century Photography: An Annotated Bibliography, 1839–1879,* by William S. Johnson (Boston: G. K. Hall, 1990).

XIII-E-1. History of Photography

American Photography: A Critical History, 1945 to the Present, by Jonathan Green (New York: Harry N. Abrams, 1984)

Art of Persuasion: A History of Advertising Photography, Robert A. Sobieszek (New York: Harry N. Abrams, 1988)

Art of Photography, 1839–1989, edited by Mike Weaver (New Haven, CT: Yale University Press, 1989)

Art of the French Calotype: With a Critical Dictionary of Photographers, by Andre Jammes and Eugenia Parry Janis (Princeton, NJ: Princeton University Press, 1983)

Focal Encyclopedia of Photography (3rd ed. Boston: Focal Press, 1993)

History of Daguerreotype, by Ken Nelson
<http://abell.austinc.edu/dag/resource/history/history.html>

History of Photography
<http://www.primenet.com/~sos/history.html>

History of Photography: Social and Cultural Perspectives, edited by Jean-Claude Lemagny and Andre Rouille (New York: Cambridge University Press, 1987)

History of Photography from Its Beginnings till the 1920s, by Robert Leggat. Includes additional material on photographers, societies, and English and Scottish museums noted for their photographic interests.
<http://host1.kbnet.co.uk/rleggat/photo/>

History of Photography from the Camera Obscura to the Beginning of the Modern Era, by Helmut Gernsheim (New York: McGraw-Hill, 2nd. ed., 1969; revised ed. titled *Origins of Photography,* London: Thames & Hudson, 1982)

On the Art of Fixing a Shadow: One Hundred and Fifty Years of Photography, by Sarah Greenough, et al. (Washington, D.C.: National Gallery of Art, 1989)

Origins of Photography, by Helmut Gernsheim (3rd revised ed. of the first part of his *History of Photography,* see above. London: Thames & Hudson, 1982)

Photographic Experience 1839–1914: Images and Attitudes (University Park: Pennsylvania State University Press, 1994)

Photography and Its Critics: A Cultural History, 1839–1900, by Mary Warner Marien (New York: Cambridge University Press, 1997)

Photography and Society, by Gisèle Freund (Boston: David R. Godine, 1982)

Photography until Now, by John Szarkowski (New York: Museum Modern of Art, 1989)

Rise of Photography, 1850–1880: The Age of Collodion, by Helmut Gernsheim (3rd revised ed. of the second part of his *History of Photography,* see above. London: Thames & Hudson, 1988)

Timeline of Photography includes a few brief sketches of early photographers and terms
<http://www.eastman.org/timeline/timeline.html>

World History of Photography, by Naomi Rosenblum (revised ed. New York: Abbeville, 1989)

XIII-E-2. Biographical Dictionaries of Photographers

Remember to check for individual photographers' home pages; a few are cited below.

Contemporary Photographers

If you know the name and address of a photographer's agent, you can write the public relations department of the agency for additional information.

ArtScene includes photographers biographies
<http://artscenecal.com/Articles.html>

Black Photographers, 1840–1940: An Illustrated Bio-Bibliography, by Deborah Willis-Thomas (New York: Garland, 1985)

Contemporary Photographers, Martin Marix Evans, executive editor (3rd ed. Updated about every 5 yrs. New York: St. James Press, 1995). Gives data on family, career, awards, exhibitions, and publications by and about photographers. In addition, a list of institutions owning their works, their present addresses, and the names and addresses of their agents are provided.

Index of Photographers, International Museum of Photography at George Eastman House (Microfiche. Rochester, NY: George Eastman House, 1979). Lists photographers whose work is owned by George Eastman House. The index can be searched by photographers, geographic regions in which they worked, or photographic format used.

Photographers on Disc: An International Index of Photographers, Exhibitions, and Collections: International Museum of Photography at George Eastman House, edited by Andrew H. Eskind (CD-ROM. Boston: G.K. Hall, 1996). Includes 80,000 listings of photographers, photographic manufacturers, and publishers.

Who's Who in Professional Photography (Annual. Des Plaines, IL: The Photographers, 1988+)

Yahoo's List for Photography
<http://www.yahoo.com/Arts/Photography/>

Historically Prominent Photographers

See also the entries under "History of Photography" and the *Index of Photographers* and *Black Photographers,* listed above. Some photographers have their own Web sites; see below.

Adams (Ansel) Home Page
<http://www.book.uci.edu/AdamsHome.html>

Berenice Abbott, Changing New York 1935–1938, a New York Public Library exhibition on this American photographer, includes (a) biographical data, (b) reproductions of more than 50 photographs, and (c) material on her Federal Art Project, which documented New York City.
<http://www.nypl.org/research/chss/spe/art/photo/abbottex/abbott.html>

Encyclopedia of Photography, edited by Willard D. Morgan (20 vols. New York: Greystone, 1974)

Encyclopedia of Photography, International Center of Photography (New York: Crown, 1984)

Fox Talbot Museum
<http://www.r-cube.co.uk/fox-talbot/>

From Adams to Stieglitz: Pioneers of Modern Photography, by Nancy Lynne Newhall (New York: Aperture, 1989)

Lewis Carroll Home Page
<http://www.lewiscarroll.org/>

Macmillan Biographical Encyclopedia of Photographic Artists and Innovators (New York: Macmillan, 1983). Covers more than 2,000 artists.

Muybridge Home Page
<http://www.linder.com/muybridge/muybridge.html>

Photographer's Dictionary, by Bruce Pinkard (London: B.T. Batsford, 1982)

Photographers Encyclopedia International 1839 to the Present, by Michele Auer and Michel Auer (2 vols. Hermance, Switzerland: Camera Obscura, 1985). Now available on CD-ROM through Andrew Cahan, Chapel Hill, North Carolina.

XIII-E-3. Photography Web Sites

See also the examples in [VI-A-1].

Web Sites

American Kaleidoscope: Themes and Perspectives in Recent Art, National Museum of American Art
<http://nmaa-ryder.si.edu/kscope/index.html>

America's First Look into the Camera: Daguerreotypes 1842–1862, Library of Congress
<http://memory.loc.gov/ammem/daghtml/daghome.html>

(Art) ^ n Laboratory/Virtual Photography emphasizes avant-garde photography
<http://www.artn.nwu.edu/>

Black & White ArtZone
<http://www.artzone.gr/>

California Heritage Collection, Bancroft Library, University of California, Berkeley, created a digital archive of material on photography of California and the American West
<http://sunsite.berkeley.edu/CalHeritage/>

Civil War Photographs 1861–1865, Library of Congress
<http://memory.loc.gov/ammem/cwphone.html>

Creative Americans: Portraits by Carl Van Vechten 1932–1964, Library of Congress, includes reproductions of some of his photographs, his biography and chronology, a selected bibliography, and a list of U.S. institutions owning his work.
<http://memory.loc.gov/ammem/vvhome.html>

Daguerreian Society is a photography database shared by George Eastman House and Harry Ransom Humanities Research Center, University of Texas. It includes a bibliography, an illustrated essay on making a daguerreotype, a brief history of the daguerreotype, and hyperlinks to exhibitions, collections, and other resources.
<http://abell.austinc.edu/dag/>

Daguerreotypes.com provides information on galleries, auctions, dealers, and supplies. It also displays photographs and advertisements for New York Swann Galleries and includes space to report stolen photographs.
<http://www.daguerreotypes.com/>

For My Best Beloved Sister Mia: An Album of Photographs by Julia Margaret Cameron
<http://www.wellesley.edu/DavisMuseum/mia_album.html>

Helios: National Museum of American Art Photography Online
<http://nmaa-ryder.si.edu/helios/>

Mathew Brady's Portraits, Images as History, Photograph As Art, National Portrait Gallery
<http://www.npg.si.edu/exh/brady/index.htm>

Nineteenth Century Photography of Ancient Greece: The Gary Edwards Collection, Getty Institute
<http://www.getty.edu/gri/greece/>

Panoramic Maps 1847–1944, Library of Congress
<http://memory.loc.gov/ammem/pnhtml/pnhome.html>

Photographic Terms
<http://www.hyperzine.com/scripts/glossary.cgi/>

Photography Exhibitions, see list under *George Eastman House*
<http://www.eastman.org/exhibits/exhibits.html>

Virtual Magnifying Glass, California Museum of Photography
<http://cmp1.ucr.edu/exhibitions/mapped_photos/magnifying_glass.html>

Indexes to Other Web Material

ArtScene includes materials on photographers
<http://artscenecal.com/Articles.html>

Bengt's Photo Page
<http://www.algonet.se/~bengtha/photo/>

Internet Resources on Photography
<http://www.photo.net/photo/internet-resources.html>

List of WWW Photo Sites
<http://users.aol.com/BrunoN/www_photo_sites.htm>

Voice of the Shuttle: Photography Page
<http://humanitas.ucsb.edu/shuttle/photog.html>

Yahoo's List for Photography is organized by books, companies, education, exhibits, history, magazines, museums and galleries, organizations, photographers, resources, and supplies and equipment. "Photographers" has more than 860 listings.
<http://www.yahoo.com/Arts/Photography/>

Commercial Firms

This short list is a small sampling of the commercial firms that often place material important to researchers on the Web.

Canon
<http://www.canon.com/>

Fuji
<http://www.fujifilm.co.jp/>

Eastman Kodak discusses photographic terms
<http://www.kodak.com/>

Leica
<http://www.leica-camera.com/>

XIII-E-4. Museums and Libraries: Photography Collections

At their Web sites, some museums display online exhibits; others discuss their archives. The libraries' OPACs may not be available on the Internet. The LC classification number is TR; some libraries use the alternate LC classification of NH.

Amon Carter Museum, Fort Worth
<http://www.cartermuseum.org/>

Arizona State University, Nightlight Gallery
<http://www-northlight.fa.asu.edu/>

University of California, Riverside, California Museum of Photography,
<http://www.cmp.ucr.edu/>

Getty Research Institute [V-G-1]
<http://www.getty.edu/gri/>

International Center of Photography, New York City
<http://www.icp.org/>

International Museum of Photography and Film, George Eastman House, Rochester New York
<http://www.eastman.org/menu.html>

Library of Congress Prints and Photographs Division
<http://www.loc.gov/coll/print/guide/>

Museum of Modern Art
<http://www.moma.org/menu.html>

National Museum of Photography, Film and Television, Bradford, England, displays photographs from its collection on the Web and provides hyperlinks to other international Internet material
<http://www.nmsi.ac.uk/>

New York Public Library, Division of Art, Prints and Photographs
<http://www.nypl.org/>

University of Arizona, Center for Creative Photography, Tucson
<http://dizzy.library.arizona.edu/branches/ccp/ccphone.html>

XIII-E-5. Visual Resources for Photography

Photographic Collections

Some of these have been reproduced on microforms; others are available on the Web.

Bancroft Library Pictorial Collections contains an estimated 3,500,000 items on the history of California and the American West; see also the *California Heritage Collection* Web site, above
<http://library.berkeley.edu/BANC/pictorial.html>

One of the most extensive photography collections is held by the Library of Congress. The *Library of Congress Prints and Photographs Division* [VI-A] owns more than 15,000,000 pictorial works. *American Memory: Historical Collections for the LC National Digital Library* is an extensive Web site for photographs important in American photographic history.
<http://lcweb2.loc.gov/amhome.html>

On the Web are a number of illustrated programs, such as those cited above [XIII-E-3]. The LC Internet site has information on how the photographs can be purchased.
<http://www.loc.gov/coll/print/guide/>

Oxford Photograph Collection
<http://www.comlab.ox.ac.uk/archive/ox/photos.html>

Royal Archives at Windsor Castle: Victorian Photographic Collection (Microfilm. London: World Microfilms, n.d.). Includes more than 7,000 photographs, mostly made from 1845 to 1901.

Victoria and Albert Museum: Early Rare Photographic Collection, 1843–1915 (Microfilm. London: World Microfilms, 1980)

Indexes to Photographs

Photographic Collections

Directory of British Photographic Collections, edited by John Wall (New York: Camera/Graphic Press, 1977). Covers 1,600 collections and about 1,000 photographers.

Index to American Photographic Collections, edited by Andrew Eskind (3rd ed. Boston: G. K. Hall, 1995). Covers 585 American photographic collections and about 65,000 photographers, with cross-references to collections that own their works.

Photographic Collections in Texas: A Union Guide, by Richard Pearce-Moses (College Station, TX: Texas A & M University Press, 1987). Covers about 350 collections, with more than 100,000 photographs.

Tulane University Latin American Photographic Archive
<http://www.tulane.edu/~latinlib/lalphoto.html>

Books

Photography Books Index: A Subject Guide to Photo Anthologies, by Martha Moss (Metuchen, NJ: Scarecrow, 1980), and *Photography Books Index II,* 1985. Both volumes have sections for photographers, subjects, and portraits.

Photography Index: A Guide to Reproductions, by Pamela Jeffcott Parry (Westport, CT: Greenwood, 1979). Covers about 90 books with photographs taken from 1820 to 1920; indexes by photographer, subjects of prints, and titles of works.

XIII-E-6. Photography Archives and Vertical Files

Many of the museums and libraries cited above contain archives of photographs.

Guide to Archival Materials of the Center for Creative Photography, by Roger Myers (Tucson: University of Arizona, 1986). Founded in 1975, the center has more than 40,000 master photographs, covering the history of photography as an art form. Individual chapters describe 76 archive groups.

Guide to Canadian Photographic Archives/Guide des archives photographicques canadiennes, by Christopher Seifried (2nd ed. Ottawa: Public Archives, 1984). The 8,631 entries represent collections owned by 139 archives.

Photograph Archives, Marriott Library, University of Utah, has about 800,000 photographs over 650 separate photograph collections
<http://www.lib.utah.edu/spc/photo/hp2.html>

XIII-F. Sculpture

Check the sites where monumental sculpture is placed. For instance, the New York Public Library has material on the famous lions, *Patience* and *Fortitude,* by Edward Clark Potter (American, 1857–1923), that grace the front of the building <http://www.nypl. org/admin/pro/lions.html>.

Sculptors work in various media—bronze and other metals, glass, stone, sand, and wood—and can sometimes be searched under these terms. The LC classification for sculpture is NB.

XIII-F-1. History of Recent Sculpture

Many references discussed in Chapter X on art history and in Chapter XI on artists' biographies include sculpture and sculptors.

Contemporary Public Sculpture: Tradition, Transformation, and Controversy, by H. Senie (New York: Oxford University Press, 1992)

Earthworks and Beyond: Contemporary Art in the Landscape, by John Beardsley (New York: Abbeville Press, 1984)

Landscape for Modern Sculpture: Storm King Art Center, by John Beardsley (New York: Abbeville Press, 1985)

Sculpture: Tools, Materials, and Techniques, by Wolbert Verhelst (2nd ed. Englewood Cliffs, NJ: Prentice Hall, 1987)

Sculpture Since 1945, by Edward Lucie-Smith (New York: Universe, 1987)

Transformations in Sculpture: Four Decades of American and European Art, by Diane Waldman (New York: Guggenheim Foundation, 1985)

XIII-F-2. Biographical Dictionaries of Sculptors

Some contemporary sculptors have their own Web pages; many can be accessed through the Yahoo site, listed below. For American sculptors, see Art Inventories [XIV-A-9], which includes the Inventory of American Sculpture and the Fine Arts Collection. See also the list for artists in Chapter XI and the Archives of American Art [XIV-A-8].

Contemporary American Women Sculptors, by Virginia Watson-Jones (Phoenix, AZ: Oryx Press, 1986). Covers 328 artists and includes artists' statements.

Dictionary of American Sculptors, 18th Century to the Present, by Glenn B. Opitz (Poughkeepsie, NY: Apollo, 1984). Covers more than 5,000 sculptors.

Dictionary of Sculptors in Bronze, by James Macakay (Woodbridge, Suffolk, England: Antique Collectors' Club, 1977)

French Sculptors of the 17th and 18th Centuries: The Reign of Louis XIV, by François Souchal (Translated by Elsie and George Hill. 3 vols. Oxford: Bruno Cassirer, 1977–87). Covers sculptors from the Middle Ages to late 19th century. Includes bibliographies; all known works accompanied by scholarly catalogue entries; photographs; drawings; and an index to artists, sites, titles of works, and collections. The book also reproduces some genealogical trees.

Metamorphoses in Nineteenth-Century Sculpture, edited by Jeanne Wasserman (Cambridge, MA: Fogg Art Museum, Harvard University, 1975). Includes the technical aspects of sculpture.

Yahoo's List of Sculptors furnishes access to the many Web references available on an artist. For instance, a search for *Henry Moore* (English, 1889–1986) yielded seven entries, including a brief chronology of the sculptor's life, accompanied by a list of museums that own his work.
<http://www.yahoo.com/Arts/Art_History/Artists/ Sculptors/>

XIII-F-3. Sculpture Web Sites

Web sites for individual sculptors whose work is located in sculpture gardens are cited below.

Auguste Rodin Page
<http://www.wilweb.com/rsite/>

"Botero in Washington, D.C.," an exhibition of Fernando Botero's work at the Art Museum of the Americas
<http://www.oas.org/EN/PROG/MUSEUM/BOTERO/ main.htm>

Century of Sculpture: The Nasher Collection, Guggenheim Museum
<http://www.guggenheim.org/nasher.html>

Chaim Gross: A Celebration, American Artist (1904–91), National Museum of American Art
<http://nmaa-ryder.si.edu/>

Conservation of Rodin's "The Thinker," Rodin Museum
<http://www.philamuseum.org/conserv/rodin1.html>

Public Art, Public Controversy, discusses sculpture in Dallas, Texas, by Henry Moore and Robert Summers
<http://www.art.unt.edu/ntieva/artcurr/public/ sculp.htm>

Resources for Sculptors, Richard Collins provides hyperlinks to a great variety of subjects concerned with sculpture
<http://www.sculptor.org/>

Save Outdoor Sculpture! (SOS)
<http://www.nic.org/SOS/>

Sculpture at Goodwood Website, British Contemporary Sculptors
<http://www.sculpture.org.uk/>

Storm King Art Center, which displays 120 modern sculptures in a 400-acre park
<http://www.skac.org/>

Strolling among Sculpture on Campus, Princeton University, by Jennifer Sheppard
<http://princetonol.com/patron/sculpt/>

Thais: 1200 Anni di scultura italiana is a major site for Italian sculpture. Three major search strategies to retrieve illustrations of Italian sculpture exist: choosing from historical styles of sculpture from medieval to modern, from a list of more than 200 Italian sculptors' names, and from a slate of more than 90 Italian cities and regions.
<http://www.thais.it/scultura/default_uk.htm>

Torn Notebook Blows into Lincoln, relates the story of Claes Oldenburg's sculpture in Lincoln, Nebraska
<http://net.unl.edu/~swi/arts/ntbk.html>

U.S. National Park Service provides information on monuments and sculpture at its locations
<http://www.cr.nps.gov/>

XIII-F-4. Museums and Sculpture Collections

Many museums listed in Chapter III include sculpture; only a few institutions with major sculpture collections which are displayed on the Web are repeated here.

National Museo di Bargello, Florence, Italy. Access sculpture through the exhibition Web site *Thais: 1200 Anni de scultura*
<http://www.thais.it/scultura/default_uk.htm>
See also
<http://www.arca.net/db/musei/bargello.htm>

Elizabeth Meadows Sculpture Garden, Southern Methodist University, Dallas
<http://www.smu.edu/meadows/museum/sculptgarden.html>

Lillie & Roy Cullen Sculpture Garden, Museum of Fine Arts, Houston, provides a walk through the one-acre garden designed by Isamu Noguchi. A photograph of the sculpture and biographical data are provided for each of the 20 artists represented, including Matisse, Rodin, Maillol, Kelley, Stella, Smith, and Giacometti.
<http://mfah.org/garden/index.html>

Minneapolis Sculpture Garden is a collaborative project of the Walker Art Center and the Minneapolis Park and Recreation Board
<http://www.walkerart.org/resources/res_msg_mapright.html>

National Archaeological Museum, Athens, Greece
<http://www.culture.gr/2/21/214/21405m/e21405m1.html>

Villa Giulia National Museum, Rome, Italy
<http://www.roma2000.it/zvilagiu.html>

The Lillie and Hugh Roy Cullen Sculpture Garden Web Page <http://mfah.org/garden/index.html>

XIII-F-5. Visual Resources for Sculpture

Indexes to Sculpture

Iconographic Index to Stanislas Lami's "Dictionaire des sculpteurs de l'ècole française au dix-neuvième siècle," by H.W. Janson with Judith Herschmann (New York: Garland, 1983). A subject index for the 19th-century French sculpture discussed in Stanislas Lami's *Dictionnaire des sculpteurs de l'ècole française,* cited above. Locations given when known.

Inventory of American Sculpture [XIV-A-9] covers about 56,000 sculptures in public and private collections and outdoor monuments in the United States.

Indexes to Sculpture Illustrations

Clapp Sculpture Index, by Jane Clapp (2 vols. in 3 books. Metuchen, NJ: Scarecrow, 1970). Covers about 950 books; indexes subjects, artists, and historic persons represented in sculpture. it often provides the location of works.

Volume 1: *Sculpture of Europe and the Contemporary Middle East*

Volume 2: *Sculpture of the Americas, the Orient, Africa, the Pacific Areas and the Classical World*

XIV. NORTH AMERICAN (U.S.), CANADIAN, AND NATIVE AMERICAN STUDIES

Although many resources discussed in this book include information on art created in the United States and Canada, there are special references that focus specifically on North American art. Before examining the tools cited below, review the material in other chapters appropriate to your study, since the following data build upon these references.

First, study Chapter IX: "Basic Research Methodology: Finding and Supplementing Web Data." Second, consult any of the following that are relevant to your topic:

- Chapter X: "Art Historical Styles and Periods: Ancient World to Modern Era"
- Chapter XI: "Documenting the Lives of Artists and Art Collectors"
- Chapter XIII: "Resources for Architecture, Decorative Arts, Fashion, Graphic Arts, Photography, and Sculpture"

Third, use the additional resources detailed below to research your subject's specific art area—(a) American (U.S.), (b) Canadian, or (c) Native American (Indian and Inuit).

Printed references and Web sites are interspersed throughout this section; English-language sources are predominant. For earlier material, review the standard general art bibliographies [II-A]. A particularly good source for locating historical material is the *Index of Resources for Historians* [IV-A-4], which has more than 2,400 hyperlinks to Web sites <http://www.ukans. edu/history/>. This type of material is important, because it provides information on the social, economic, cultural, and religious aspects of society, and artwork often has cultural or religious significance.

Some Web sites reproduce current regional maps; for historical maps, see the Perry-Castañeda Library Map Collection, University of Texas <http://www. lib.utexas.edu/Libs/PCL/Map_Collection/ Map_Collection. html>. Remember, the Internet is ever-changing, and some of the URLs listed here may no longer be on the Web. As always, when you find a good site, add it to your list; it will help you later in finding pertinent material. For additional suggestions, ask the reference librarian for assistance.

XIV-A. American (U.S.) Studies

Remember that many of the resources cited in previous chapters include American art.

XIV-A-1. Special American (U.S.) Art Bibliographies

American Folk Art: A Guide to Sources, edited by Simon J. Bronner (New York: Garland, 1984)

American Women Artists, Past and Present: A Selective Bibliographical Guide, by Eleanor Tufts (New York: Garland, 1984). Covers about 500 artists.

Arte Chicano: A Comprehensive Annotated Bibliography of Chicano Art, 1965–1981, compiled by Shifra M. Goldman and Tomás Ybarra-Frausto (Berkeley: University of California Press, 1985)

Arts in America: A Bibliography, edited by Bernard Karpel (4 vols. Washington, D.C.: Archives of American Art, Smithsonian Institution, 1979)

Bibliographic Guide to Black Studies (Annual. Boston: G. K. Hall, 1990+)

Black Artists in the United States: An Annotated Bibliography of Books, Articles and Dissertations on Black Artists 1799–1979, by Lenwood G. Davis and Janet Sims (Westport, CT: Greenwood Press, 1980)

In Black and White: A Guide to Magazine Articles, Newspaper Articles, and Books concerning More Than 15,000 Black Individuals and Groups (3rd ed. Detroit, MI: Gale Research, 1980)

New Deal Fine Arts Projects: A Bibliography, 1933–1992, by Martin R. Kalfatovic (Metuchen, NJ: Scarecrow Press, 1994)

250 Years of Afro-American Art: An Annotated Bibliography, by Lynn Igoe and James Igoe (New York: R. R. Bowker, 1981). A new edition is expected in 1998.

XIV-A-2. History of American (U.S.) Art

American Art: Painting-Sculpture-Architecture-Decorative Arts-Photography, by Milton W. Brown, et al. (Englewood Cliffs, NJ: Prentice Hall, 1987)

American Art at the Nineteenth-Century Paris Salons, by Lois Marie Fink (Washington, D.C.: National Museum of American Art, Smithsonian Institution, 1990)

American Realism: A Pictorial Survey from the Early Eighteenth Century to the 1970s, by Francois Mathey (2nd ed. New York: Crown, 1987)

American Visions: The Epic History of Art in America, by Robert Hughes (New York: Alfred A. Knopf, 1997); see [XIV-A-11], below, for the video series

Chicano Art: Resistance and Affirmation, 1965–1985, edited by Richard Griswold del Castillo, Teresa McKenna, and Yvonne Yarbro-Bejarano (Los Angeles: University of California Press, Los Angeles, 1991)

Concise History of American Painting and Sculpture, by Matthew Baigell (New York: Harper & Row, 1984)

Harlem Renaissance: Art of Black America, by David C. Driskell, et al. (New York: Harry N. Abrams, 1987)

Image of the Black in Western Art (New York: Marrow, 1976+)

Vol. 1: *From the Pharaohs to the Fall of the Roman Empire,* by Jean Vercoutter, et al.

Vol. 2: *From the Early Christian Era to the Age of Discovery*
Part I: *From the Demonic Threat to the Incarnation of Sainthood,* by Jean Devisse, translated by William G. Ryan
Part II: *Africans in the Christian Ordinance of the World (Fourteenth to Sixteenth Century),* by Jean Devisse and Michel Mollat

Vol. 3: as of 1997, has not been issued

Vol. 4: *From the American Revolution to World War I*
Part I: *Slaves and Liberators,* by Hugh Honour
Part II: *Black Models and White Myths,* by Hugh Honour

Spanish New Mexico: The Spanish Colonial Arts Society Collection, edited by Donna Pierce and Marta Weigle (Santa Fe, NM: Museum of International Folk Art, 1996)

XIV-A-3. Biographical Dictionaries of American (U.S.) Artists

Augment the methodology on biographical research, explained in Chapter XI, with the following resources:

African American Biographical Database, Chadwick-Healey. Electronic collection of biographical data on African Americans, 1790–1950. Includes artists.
<http://aabd.chadwyck.com/>

American Art Annual (Published irregularly. New York: R. R. Bowker. 1898+). Name changed to *American Art Directory* after volume 37 (1945–48). Publication separated into *American Art Directory* and *Who's Who in American Art* after 1952. Early volumes included brief biographical data on artists and sometimes a directory of architects.

American Women Artists from Early Indian Times to the Present, by Charlotte Streifer Rubenstein (Boston: G. K. Hall, 1982)

Artists of the American West: A Biographical Dictionary, by Doris Ostrander Dawdy (3 vols. Chicago: Sage Books, 1979–85). Covers more than 2,700 artists born before 1900.

Contemporary Western Artists, by P. Samuels and H. Samuels (New York: Doubleday, 1982)

Dictionary of American Art, by Matthew Baigell (New York: Harper & Row, 1979)

Dictionary of Contemporary American Artists, edited by Paul Cummings (5th ed. New York: St. Martin's Press, 1988). Covers over 900 painters, sculptors, and printmakers.

Dictionary of Nineteenth-Century American Artists in Italy, 1760–1914, by Regina Soria (Rutherford, NJ: Fairleigh Dickinson University Press, 1982)

Mantle Fielding's Dictionary of American Painters, Sculptors, and Engravers, edited by Glenn B. Opitz (2nd ed. Poughkeepsie, NY: Apollo, 1986)

St. James Guide to Black Artists, edited by Thomas Riggs (Detroit, MI: St. James Press, 1997)

Samuels' Encyclopedia of Artists of the American West, by P. Samuels and H. Samuels (2nd ed. Secaucus, NJ: Castle, 1985)

Who Was Who in American Art: Compiled from the Original Thirty-Four Volumes of American Art Annual—Who's Who in Art, Biographies of American Artists Active from 1898–1947, by Peter H. Falk (Madison, CT: Sound View, 1985)

Women Artists in America: 18th Century to the Present (1790–1980), rev. ed. by Glenn B. Opitz and Jim Collins (Poughkeepsie, NY: Apollo, 1980). Includes data on more than 5,000 artists.

XIV-A-4. American (U.S.) Studies Web Sites

For information on museum programs concerned with American artists, see [III-A-4].

"Africa: One Continent, Many Worlds," is a 1997–98 traveling exhibition derived from Chicago's Field Museum's permanent exhibition on Africa. It furnishes information on African American artists and the celebration of Kwanzaa.
<http://www.lam.mus.ca.us/africa/main.htm>

"African-American Culture and History," Library of Congress Exhibition
<http://lcweb.loc.gov/exhibits/african/intro.html>

"1492: An Ongoing Voyage," Library of Congress Exhibition
<http://lcweb.loc.gov/exhibits/1492/intro.html>

"Metropolitan Lives: The Ashcan Artists and Their New York," National Museum of American Art
<http://www.nmaa.si.edu/>

"Russian Church and Native Alaskan Cultures," Library of Congress Exhibition
<http://lcweb.loc.gov/exhibits/russian/russch0.html>

"Temple of Liberty: Building the Capitol for a New Nation," Library of Congress Exhibition
<http://lcweb.loc.gov/exhibits/us.capitol/s0.html>

XIV-A-5. Museums and Libraries: American (U.S.) Studies

The OPACs of these museums and special libraries usually have good collections of relevant material. The museums are organized here by (a) American (U.S.) art collections, and (b) special American (U.S.) libraries.

American (U.S.) Art Collections

Most of these museum also have libraries with good American (U.S.) collections. Remember to consult the historic houses and museums cited in [III-C-3].

Amon Carter Museum, Fort Worth, Texas
<http://www.cartermuseum.org/>

Art Institute of Chicago
<http://www.artic.edu/>

Chrysler Museum of Art and Historic Houses, Virginia
<http://www.whro.org/cl/cmhh/>

Cleveland Museum of Art
<http://www.clemusart.com/>

Colonial Williamsburg, Virginia
<http://www.history.org/>

Detroit Institute of Arts
<http://www.dia.org/>

Los Angeles County Museum of Art
<http://www.lacma.org/>

Metropolitan Museum of Art, New York
<http://www.metmuseum.org/>

Museum of African American History, Detroit, highlighted by the *Internet Public Library*
<http://www.ipl.org/exhibit/maah/>

Museum of Fine Arts, Boston
<http://www.mfa.org/>

National Gallery of Art, Washington, D.C.
<http://www.nga.gov/>

National Museum of American Art, Smithsonian Institution, Washington, D.C.
<http://www.nmaa.si.edu/>

National Museum of American History, Smithsonian Institution, Washington, D.C.
<http://www.si.edu/organiza/museums/nmah/>

National Portrait Gallery, Smithsonian Institution, Washington, D.C.
<http://www.npg.si.edu/>

Old Sturbridge Village, Massachusetts
<http://www.osv.org/>

Philadelphia Museum of Art
<http://www.philamuseum.org/>

St. Louis Art Museum
<http://www.slam.org/mainmenu.html>

Sid Richardson Collection of Western Art, Fort Worth, Texas
<http://www.txcc.net/~sidr/>

Virginia Museum of Fine Arts
<http://www.state.va.us/vmfa/>

Whitney Museum of American Art, New York
<http://www.echonyc.com/~whitney/>

Winterthur Museum, Garden, and Library, Winterthur, Delaware
<http://www.udel.edu/winterthur/>

Special Libraries: American (U.S.) Studies

Everyone working on an American (U.S.) topic should utilize *SIRIS (Smithsonian Institution Research Information System)* <http://www.siris.si.edu/>, which provides access to the following:

- the NMAA/NPG Library catalogue, which includes the collections of the National Museum of American Art and the National Portrait Gallery, an institution particularly strong in books on American history, fine arts, design, and African American culture
- the archives and manuscript catalogues of such institutions as the National Museum of American History and the Archives of American Art [XIV-A-8], below
- the *Art Inventories* catalogue [XIV-A-9], below

A number of libraries have excellent collections of Americana; the OPACs of some are now available on the Internet.

Boston Public Library
<http://bpl.org/>

Chicago Public Library
<http://cpl.lib.uic.edu/>

Library of Congress, Hispanic Reading Room
<http://lcweb.loc.gov/rr/hispanic/explore.html>

Newark Public Library
<http://www.npl.org/>

New York Public Library, History of the Americas Collection
<http://www.nypl.org/>

University of California, Berkeley, Bancroft Library includes the Western Americana and Latin Americana Collection and the Bancroft Library Pictorial Collections, discussed below. Access the University of California library and choose "Bancroft."
<http://www.lib.berkeley.edu/>

University of California, Los Angeles, Chicano Studies Center
<http://latino.sscnet.ucla.edu/library/csl/>

Whitney Museum of American Art emphasizes 20th-century American art.
 <http://www.echonyc.com/~whitney/>

Winterthur Museum Libraries concentrate on material concerning works of art made or used by Americans between 1600 and 1840
 <http://www.udel.edu/winterthur/>

XIV-A-6. American (U.S.) History

The reference books and Web sites cited below emphasize photography and social history.

American Memory: Historical Collections for the National Digital Library of the Library of Congress is one of the most extensive sites on the Web for photographs important to American history
 <http://lcweb2.loc.gov/amhome.html>

Encyclopedia of African-American Culture and History, by Jack Salzman, David Lionel Smith, and Cornel West (New York: Macmillan Library Reference, 1996)

Everyday Life in the Age of Enterprise, 1865–1900: Everyday Life in Victorian America, by Robert H. Walker (Malabar, FL: Krieger Publishing, 1994)

Everyday Life in Early America, by David Freeman Hawke (New York: Harper & Row, 1988)

Index of Resources for Historians includes hyperlinks to a long list of sites on U.S. history.
 <http://www.ukans.edu/history/>

POTUS: Presidents of the United States, the Internet Public Library, has extensive data on each president
 <http://www.ipl.org/POTUS/>

WestWeb furnishes links to relevant sites
 <http://www.library.csi.cuny.edu/westweb/>

XIV-A-7. American (U.S.) Maps and Timelines

Civil War, timeline and photographs by *The History Place*
 <http://www.historyplace.com/civilwar/index.html>

The PBS Lewis & Clark television program Web site reproduces historical maps of this expedition
 <http://www.pbs.org/lewisandclark/archive/idx_map.html>

Louisiana State Museum has an illustrated section on perspectives of Louisiana (before and after it was a state) and the New World and includes a discussion of the maps, biographical data on the mapmakers and artists, and a bibliography
 <http://www.crt.state.la.us/crt/museum/map.htm>

Panoramic Maps 1847–1925, Geography and Map Division, Library of Congress
 <http://lcweb2.loc.gov/ammen/pmhtml/panhome.html>

XIV-A-8. Archives of American Art

The Archives of American Art was founded during the 1940s in Detroit, Michigan, as a national research institute for the visual arts in the United States; in 1970, it became a bureau of the Smithsonian Institution <http://www.si.edu/organiza/offices/archart/start.htm>. The Archives collects primary and secondary material on painters, sculptors, craft artists, dealers, critics, collectors, museum personnel, and art societies and institutions. Any artist who was born in America or immigrated here is considered an American artist. Presently the Archives contains more than 12,000,000 items: letters, clippings, journals, and scrapbooks. In addition, it includes 3,000 oral and video history interviews, 500,000 photographs, and 75,000 works of art on paper. The material is continually being microfilmed.

When you access the Archives, you may choose a brief view for the entry or a long view that provides a summary and fuller description. Moreover, there are finding aids to assist you in searching large, complicated collections of data. The Archives is also a source for reprints of American sales catalogues published between 1785 and 1960, called *American Art Auction Catalogues on Microfilm* [VIII-B-2]. The Archives has also filmed exhibition catalogues dating from the early 19th century to the 1960s; see Appendix One. For printed sources, use:

Government and Art: A Guide to Sources in the Archives of American Art (Washington, D.C.: Archives of American Art, Smithsonian Institution, 1995)

Papers of Latino and Latin American Artists, by Liza Kirwin (Washington, D.C.: Archives of American Art, Smithsonian Institution, 1996)

Paris: A Guide to Archival Sources for American Art History, by Susan Grant (Washington, D.C.: Archives of American Art, Smithsonian Institution, 1997)

Most of the archival material is available through interlibrary loans, coordinated from Detroit. The loan centers include:

American Art/Portrait Gallery Bldg., Smithsonian Institution
7th and F Streets NW
Washington, DC 20560 (202-357-2781)

Boston Public Library, Fine Arts Department
Boston, MA 02108 (617-536-5400)

M.H. de Young Memorial Museum American Study Center
San Francisco, CA 94118 (415-750-7637)

Midwest Regional Center/Inter-Library Loan Center
5200 Woodward Avenue,
Detroit, MI 48202 (313-226-7620)

New York City Research Center
1285 Avenue of the Americas
New York, NY 10019 (212-399-5015)

West Coast Regional Center Huntington Library
1151 Oxford Road
San Marino, CA 91108 (626-583-7847)

Example

In a keyword search for material on *John Marin,* 36 entries were found. Although most of the data were from other people's papers mentioning the artist, there were two letters actually written by Marin, information on an exhibition for which the artist was a juror, six notebooks of clippings on Marin lent by his son, four photographs of the artist, and notes collected by McKinley Helm, Marin's biographer.

XIV-A-9. U.S. Inventories

This section discusses (a) *Art Inventories,* (b) the *Catalog of American Portraits,* (c) the U.S. White House and Department of State, and (d) the U.S. General Services Administration.

Art Inventories

Two projects on American art were combined and are now called *Art Inventories.* This database includes (a) the *Inventory of American Paintings Executed before 1914* and (b) the *Inventory of American Sculpture.* The former was a bicentennial computer project, begun in the early 1970s, that inventoried American paintings created just before World War I. It presently includes about 264,000 paintings, by some 30,000 artists. Each entry provides the title of the work, its medium and measurements, and the present owner or last known sale. Access is through *SIRIS (Smithsonian Institution Research Information System)* <http://www.siris.si. edu/>.

Begun in 1985, the *Inventory of American Sculpture—* which includes the University of Delaware's *Index of American Sculpture—* covers about 56,000 works of art dating from early Colonial days to the present. The sculpture can be located as an outdoor monument or in public or private collections. Each entry lists artist, title, date, medium, owner and location, subject, provenance, and foundry data. This project was developed in connection with the SOS—Save Outdoor Sculpture—project. There are photographic reproductions for about one-fourth of the indexed works,

available only at the Art Inventories office in Washington, D.C.

Example

A search for material on *John Marin* found 790 entries organized by date followed by the titles of the works. The entries provide dates the works were created, media, dimensions, subjects, owners with their addresses, exhibitions in which the objects were displayed, books with illustrations of the works, and the provenance of the objects. Going through 790 entries may be time consuming, but the data gleaned could be essential.

Catalog of American Portraits

The *Catalog of American Portraits (CAP),* administered by the National Portrait Gallery, Smithsonian Institution, Washington, D.C., collects photographs and documents on historically prominent Americans, as well as portraits by noteworthy American artists. Paintings, sculpture, drawings, miniatures, silhouettes, and rare daguerreotypes are included. The computer records—arranged alphabetically by subjects' names, with cross-references to artists who created the likenesses—can be searched on the Internet. A costume study has been initiated to provide dress comparisons. Approximately 1,200 photographs, dating from the 18th to the mid-20th century, are available.

Illustrations of most of the portraits are available at the museum. Presently, there are about 100,000 portraits, with illustrations for about 80 percent of them. *CAP* has begun placing more than 3,000 images owned by the National Portrait Gallery onto the World Wide Web. This online index assists researchers in locating portraits; some of the current owners are small institutions whose art may not be listed elsewhere. *CAP* is a valuable research tool; its nationwide census is continuing <http://www.npg.si.edu/inf/ cap.htm>.

CAP Visual Material

National Portrait Gallery–Smithsonian Institution Permanent Collection of Notable Americans on CD-ROM (CD-ROM. Boston: G.K. Hall, 1991). This resource has 3,093 color and black-and-white images accompanied by an index.

Portraits of Americans (Microfiche. Teaneck, NJ: Chadwyck-Healey, n.d.). Represents a wide range of media, including photographs, and reproduces 1,926 portraits from the National Portrait Gallery. For an index, use *Portraits of Americans: Index to the Microfiche Edition,* edited by Sandra Shaffer Tinkham (Teaneck, NJ: Chadwyck-Healey).

Example

Searching for art in which John Marin was the sitter, *CAP* listed 20 records: 7 from the National Portrait Gallery and 13 from institutions as varied as the Beinecke Library at Yale University and the Grand Rapids Art Museum in Michigan.

U.S. White House and State Department

There are two Web sites that provide illustrated inventories of the art owned by the U.S. government. The U.S. Department of State includes access to seven different diplomatic rooms of state, each accompanied by a list of the paintings and furniture displayed there. Portraits of the presidents have links to biographical material at the White House Web site. The Department of State URL is <http://www.state.gov/www/about_state/diprooms/dipindex.html>.

The White House provides a number of programs, including information on the visitors' rooms and on the presidents and their spouses <http://www1.whitehouse.gov/>. For the former, you are provided (a) a history of the White House and its occupants, and (b) a floor plan from which you choose specific rooms, accompanied by illustrations of the paintings and furniture displayed there.

Example

After accessing the State Department's Web site, the Thomas Jefferson State Reception Room was chosen. Illustrated were two views of the room, seven works of art, plus two card tables. One of the artworks, a Benjamin Franklin portrait, was painted by the French artist Jean Baptiste Greuze in 1777. The American artist Charles Wilson Peale created the portrait of Thomas Jefferson. A link from *Jefferson* accesses the White House Web site, which furnishes biographical information on the president and his wife and the complete text of his two inaugural addresses. In addition, the White House Web site links to Columbia University for quotations from Jefferson provided by Project Bartleby [VI-F-2] <http://www.columbia.edu/acis/bartleby/>. These relevant hyperlinks illustrate the marvels of the World Wide Web!

U.S. General Services Administration

Information concerning art owned by the United States government can be accessed from the Web site of the General Services Administration (GSA) <http://www.gsa.gov/>. The GSA Public Building Service includes the programs listed below; all are accessed through the same URL: <http://www.gsa.gov/pbs/pt/pts/cultural.htm>.

Art-in-Architecture Installations

The Art-in-Architecture Installations, established in 1963, has a mandate to incorporate into the designs of federal buildings fine art, especially works by living American artists. The GSA directs that 2 percent of the estimated cost of a federal building be used for art. You may search this database by state, artist, or keyword.

Example

An inquiry into the name of the artist who created the sculpture in front of the Federal Building and Courthouse in Rochester, New York, brought forth a photograph of the work of art with its dimensions and the name of the artist, Duayne Hatchett, as well as the 1975 installation date.

Fine Arts Collection

The Fine Arts Collection provides an inventory of the works of art owned by the U.S. government. Today this consists of more than 5,000 paintings, sculpture, and graphics dating from the 1850s through the 1960s. Much of this collection is from the WPA (Works Progress Administration). You may search the database by state, artist, or keywords.

Example

In locating the name of the artist who decorated the Post Office/Courthouse in Albany, New York, the inventory reported the title, *Activities of Post Office;* the artist, Albert T. Stewart; and the work's dimensions, medium, and date. A black-and-white illustration was reproduced. In addition, there was a paragraph of biographical data on the artist.

Historic Federal Buildings

The Historic Federal Buildings project aims to preserve National Historic Landmarks as a means of preserving the U.S. heritage. You may search the database by state, architect, or keywords.

XIV-A-10. American (U.S.) Documents and Sources

These resources provide documentation for (a) writings by or interviews with artists, and (b) the opinions of critics of artists' works.

American Art: 1700–1960, by John W. McCoubrey, Sources and Documents in the History of Art Series (Englewood Cliffs, NJ: Prentice Hall, 1965)

American Art Since 1900: A Documentary Survey, edited by Barbara Rose (New York: Frederick A. Praeger, 1968)

American Artists on Art from 1940 to 1980, edited by Ellen H. Johnson (New York: Harper & Row, 1982)

Directory of Archives and Manuscript Repositories in the United States (2nd ed. Phoenix, AZ: Oryx Press, 1988). Includes all 50 states plus U.S. territories and districts.

Directory of Oral History Collections, edited by Allen Smith (Phoenix, AZ: Oryx Press, 1988). Indexes almost 500 U.S. collections of audios and videos featuring people in a wide variety of professions.

Ferdinand Perret Research Library: A Collection of Research Material in the Library of the National Museum of American Art and the National Portrait Gallery, compiled by Ferdinand Perret (Washington, D.C.: Archives of American Art, Smithsonian Institution, 1987)

Index to Personal Names in the National Union Catalog of Manuscript Collection 1959–1984 (2 vols. Alexandria, VA: Chadwyck-Healey, 1988)

National Inventory of Documentary Sources in the United States (Alexandria, VA: Chadwyck-Healey, 1983)

National Union Catalog of Manuscript Collections (NUCMC) (Annual. Washington, D.C.: Library of Congress). Can be used to find papers of artists and patrons and architectural drawings.

XIV-A-11. Visual Resources: American (U.S.) Art and History

Documentary Videos

American Visions: The Epic History of Art in America, written and narrated by Robert Hughes (London: BBC Productions, 1997). Eight one-hour episodes. See [XIV-A-2], above, for the book and [XVI-A] for the teachers' guide.

The Civil War, television programs produced by Ken Burns, 1991 (Alexandria, VA: PBS Video, 1991)

The Civil War: An Illustrated History, by Geoffrey C. Ward (New York: Alfred A. Knopf, 1990)

George Bellows: Portrait of an American Artist (Washington, D.C.: Smithsonian, 1982)

Hudson River and Its Painters (New York: Metropolitan Museum of Art, 1987)

Lewis & Clark, television program produced by Ken Burns (Alexandria, VA: PBS Video, 1997)
 <http://www.pbs.org/lewisandclark/class/index.html>

Real World of Andrew Wyeth (RM ARTS, 1980)

The West, television programs produced by Ken Burns, nine episodes of different lengths (New York: Time-Life Videos, 1996). See its Web site for material related to this program.
 <http://www.pbs.org/weta/thewest/wpages/wpgs000/w050_001.htm>

Computer Index Project

The Witt Computer Index: American School Computer Index Project furnishes subject access to 57,000 works of art by 3,800 American artists working since the 17th century [V-G].

XIV-B. Canadian Studies

When searching for Canadian material, use one of the Canadian libraries, such as the National Library of Canada/Bibliothèque Nationale du Canada's *resAnet* <http://www.amicus.nlc-bnc.ca/>, a library cited through the Associations of Universities and Colleges of Canada <http://www.aucc.ca/english/>, or one suggested below. For an index to periodical literature, use *Canadian Periodicals Index* (Ottawa, 1948+).

XIV-B-1. A Special Bibliography for Canadian Art

Art and Architecture in Canada/Art et Architecture au Canada, edited by Loren Singer and Mary Williamson (2 vols. Toronto: University of Toronto, 1990), contains about 9,600 annotated entries for books, articles, exhibition catalogues, and dissertations. It covers painting, sculpture, architecture, graphic arts, decorative arts and fine crafts, photography, and native arts, and provides historical data for almost 75 annual Canadian art exhibitions and 75 Canadian serials. This is the major resource for the documentation of Canadian art.

XIV-B-2. Canadian Art History

Most books concerned with Canadian art are written about individual provinces; few incorporate the whole country. Many of the works are small exhibition catalogues, which are not included here. You can locate them through searching the OPACs of the Canadian art libraries cited below.

By a Lady: Celebrating Three Centuries of Art by Canadian Women, by Maria Tippett (Toronto: Penguin Books, 1992)

Concise History of Canadian Painting, by Dennis Reid (2nd ed. Toronto: Oxford University, 1988)

Logic of Ecstasy: Canadian Mystical Painting, 1920–1940, by Ann Davis (Toronto: University of Toronto Press, 1992)

New Class of Art: The Artists' Print in Canadian Art, 1877–1920, by Rosemary Tovell (Ottawa: National Gallery of Canada, 1996)

Painting in Canada: A History, by J. Russell Harper (2nd ed. Toronto: University of Toronto Press, 1977)

Private Realms of Light: Canadian Amateur Photography 1839–1940, edited by Lilly Koltun (Markham, Ontario, CA: Fitzhenry & Whiteside, 1984)

Printmaking in Canada: The Earliest Views and Portraits/Les debuts de l'estampe imprimee au Canada: Vues et Portraits, by Mary Allodi (Toronto: Royal Ontario Museum, 1980)

Remembering Postmodernism: Trends in Recent Canadian Art, by Mark A. Cheetham and Linda Hutcheon (Don Miller, Ontario, CA: Oxford University Press, 1991)

XIV-B-3. Biographical Dictionaries of Canadian Artists

Information on Canadian artists and architects, often written in monographs, is scattered; you will need to search the OPAC of a Canadian library. For exhibitions an artist may have entered, see Appendix One for references to the Art Gallery of Ontario, the Museum Montreal of Fine Arts, and the Royal Canadian Academy of Arts. Remember, Canadian artists also may have entered U.S. competitive exhibitions.

Check the archives and vertical file material discussed below, such as *The New York Public Library: The Artists File* [IX-B-6], which includes Canadians. For sales information, see *Canadian Art Sales Index* [VIII-A-2] and the other sales indexes, since Canadian art sells internationally. Consult the various Canadian archives, [XIV-B-7], below, and the *Artists in Canada Vertical Files* [XIV-B-8].

Canadian Who's Who (Toronto: University of Toronto Press, 1910+). Also available on CD-ROM.
 <http://www.utpress.utoronto.ca/cww/>

Canadian Who's Who Index 1898–1984, by Evelyn de R. McMann (Toronto: University of Toronto Press, 1986)

Compendium of Canadian Folk Artists, by Terry Kobayashi and Michael Bird (Erin, Ontario: Boston Mills Press, 1985)

Dictionary of Canadian Artists, Colin S. MacDonald (Ottawa: Canadian Paperbacks, 1967+. 6 vols., A–S, issued by 1997; vol. 7, R–Z, in preparation)

Dictionary of Canadian Biography (12 vols. and 2 indexes. Toronto: University of Toronto Press, 1966+)

Early Painters and Engravers in Canada, by J. Russell Harper (Toronto: University of Toronto Press, 1970). Covers artists born before 1867.

Macmillan Dictionary of Canadian Biography (4th ed. Toronto: Macmillan Company of Canada, 1978)

XIV-B-4. Canadian Studies Web Sites

CultureNet provides hyperlinks to significant Web sites for visual arts, plus the Canada Council of the Arts and the Canadian Conference of the Arts
 <http://www.culturenet.ca/>

Emily Carr: At Home and at Work
 <http://www.schoolnet.ca/collections/carr/>

Group of Seven: Art of the Nation, Art Gallery of Ontario
 <http://www.ago.net/>
 then choose "Archive" followed by "The OH! Canada Project"

Making History Come Alive for Canadians, CRB Foundation's Heritage Project, has a section on painting in Canada
 <http://trinculo.edu.sfu.ca/>

Malaspina Interdisciplinary Matrix provides coverage on artists, with links to books written about them and to museums that own their works [IV-A-4]
 <http://www.mala.bc.ca/~mcneil/matrix.htm>

McMichael Canadian Art Collection provides online exhibitions, such as "Group of Seven and Their Contemporaries"
 <http://www.mcmichael.on.ca/>

XIV-B-5. Museums and Libraries: Canadian Art and Culture

Although there are numerous Canadian libraries, not all are accessible to those outside their community. Two that are especially easy to use are the University of British Columbia <http://www.ubc.ca/> and York University <http://www.library.yorku.ca/> libraries. For a longer list of Canadian museums, see [III-C]; for Canadian universities, see [IV-A-7].

Art Gallery of Ontario, Toronto
 <http://www.ago.net/>

Canadian Museum of Civilization, Hull
 <http://www.civilization.ca/>

Glenbow, Calgary
 <http://www.glenbow.org/>

National Gallery of Canada, Ottawa
 <http://national.gallery.ca/>

Royal Ontario Museum, Toronto
 <http://www.rom.on.ca/>

XIV-B-6. Canadian History

Some provincial archives reproduce maps on the Internet.

Canadian Encyclopedia (2nd ed. 4 vols. Edmonton: Hurtig, 1988). Now available only on CD-ROM, with updates provided on the Internet.

Illustrated History of Canada, edited by Craig Brown (Toronto: Lester & Orpen Dennys, 1987)

Index of Resources for Historians
 <http://www.ukans.edu/history/>

Oxford Companion to Canadian History and Literature, by Norah Story (Toronto: Oxford University Press, 1967; Supplement, 1973)

SchoolNet Digital Collections
 <http://www.schoolnet.ca/english/main.htm>

Timeline, see *Canadian Art History, 5000 BC–Present,* by Robert J. Belton
 <http://www.arts.ouc.bc.ca/fiar/timeline.html>

XIV-B-7. Canadian Archives

Archival material covers a vast array of subjects, but it usually concerns local activities and persons. For Canadian artists, search the archives of the specific provinces in which the artists lived. An excellent finding aid for archival material on artists is the University of Regina's *Papers of Artists and Art Historians* <http://www.uregina.ca/~library/archives/visual.html>.

The National Archives of Canada, founded in 1872, has about 1,000,000 different types of records, including approximately 250,000 paintings and caricatures plus 15,000,000 photographs documenting Canadian history <http://www.archives.ca/MainMenu.html>.

The Canadian Archival Resources on the Internet, the University of Saskatchewan Archives, has a well-organized index to various Canadian archives <http://www.usask.ca/archives/menu.html>. You can search by type of archive or by Canadian regions. Included are the Canadian Architecture Collections at the McGill School of Architecture <http://blackader.library.mcgill.ca/cac/cac_over.html>.

Some Canadian provinces have placed information concerning their archives on the Web. You never know what you will find in these depositories! The British Columbia Archives has listings for more than 20,000 images, including photographs, paintings, drawings, and prints. The records can be searched by subject, artist, or geographic region. There are also his-torical maps of the province <http://www.bcarchives.gov.bc.ca/index.htm>.

American (U.S.) resources frequently have valuable material for Canadian studies, especially the *New York Public Library: The Artists File* [IX-B-6] and the Archives of American Art [XIV-A-8].

Example
In a search for material on the Canadian artist Emily Carr (1871–1945), the British Columbia Archives yielded 1,108 entries. Each work of art has a brief catalogue entry and usually an illustration. Although not all of the Canadian archives may be this rewarding, don't forget to use these sources if your subject warrants it <http://www.bcarchives.gov.bc.ca/index.htm>.

Archives Ontario
 <http://www.gov.on.ca/MCZCR/archives/>
British Columbia Archives
 <http://www.bcarchives.gov.bc.ca/index.htm>
National Archives of Canada
 <http://www.archives.ca/>
Northwest Territories Archives
 <http://pwnhc.learnnet.nt.ca/programs/archive.htm>
Papers of Artists and Art Historians, University of Regina
 <http://www.uregina.ca/~library/archives/visual.html>
Provincial Archives: Newfoundland and Labrador
 <http://www.gov.nf.ca/tcr/cultural/archives.htm>
Provincial Archives of Alberta
 <http://www.gov.ab.ca/~mca/mhs/paa/paa.htm>
Provincial Archives of New Brunswick
 <http://www.gov.nb.ca/supply/archives/index.htm>
For more information, use the *Canadian Archival Resources on the Internet*
 <http://www.usask.ca/archives/menu.html>

XIV-B-8. *Artists in Canada Vertical Files*

In the 1920s, the National Gallery of Canada, Ottawa, began a union list of the vertical file material it and 23 other Canadian institutions were collecting. *Artists in Canada Vertical Files* is the compilation of this material, which now consists of approximately 30,000 files on Canadian artists—mostly painters, sculptors, and printmakers—plus another 10,000 files on Canadian art subjects. A list of artists included in these files is available on the Internet. The records are accompanied by the names of the institutions owning the vertical file material, no indication as to the contents is provided. Most material is available only at the institution maintaining the files. CHIN's Web site

cites the contributors' names with their addresses and telephone numbers. Access CHIN, then choose "Artists in Canada" <http://www.chin.gc.ca/Resources/e_resources.html>.

Artists in Canada: Files in the National Gallery of Canada/Artistes au Canada: Dossiers la Bibliothèque de la Galerie nationale, compiled by Alexandra Pritz (Ottawa: National Gallery Library, 1988), is a printed union list documenting these vertical files

Canadian Artist Files on Microfiche (Microfiche. Toronto: Metropolitan Toronto Reference Library). Covers art from 1962 to 1980.

Example

In a search for material on Emily Carr, the *Artists in Canada Vertical Files* provided her birth and death dates, plus the names of 17 institutions with some type of material on this Canadian artist.

XIV-C. Native American (Indian and Inuit) Studies

The word *Inuit* describes the people who inhabit the Canadian Arctic. For native people living in Alaska, Greenland, and Siberia, the term *Eskimo* is also still used. Galleries that sell Native American art often provide illustrations of the works they are selling; use Yahoo's list <http://www.yahoo.com/Business_and_Economy/Companies/Arts_and_Crafts/>. This section includes all Native American art, both of North and South America, as well as Precolumbian art.

XIV-C-1. Special Bibliographies for Native American Studies

Ancient Peruvian Art: An Annotated Bibliography, by Helaine Silverman (Boston: G. K. Hall, 1996)

Catalog of the Robert Goldwater Library of Primitive Art, Metropolitan Museum of Art (4 vols. Boston: G. K. Hall, 1982). Includes African, Precolumbian, Native American, and Pacific Islander art. About 50 percent of entries are for serial articles. As of January 1998, these references are no longer part of the OPAC of the Watson Library, Metropolitan Museum of Art.

Inuit Art Bibliography (Ottawa: Inuit Art Section, Indian and Northern Affairs Canada, 1986)

Mesoamerica Archaeology: A Guide to the Literature and Other Information Sources, by Susan Fortson Magee (Austin: University of Texas, Institute of Latin American Studies, 1981)

XIV-C-2. History of Native American Art

Material on Native American arts and crafts, such as jewelry and baskets, is frequently located in small exhibition catalogues that are not cited here; search *Worldwide Books* to locate the latest information <http://www.worldwide.com/>.

All Roads Are Good: Native Voices on Life and Culture (New York: National Museum of the American Indian, Smithsonian Institution, 1994)

American Indian Parfleche: A Tradition of Abstract Painting, by Gaylord Torrence (Des Moines: Des Moines Art Center, 1994)

Ancient Art of the American Woodland Indians, by David S. Brose, et al. (Washington, D.C.: National Gallery of Art, 1985)

Art and Architecture of Ancient America: The Mexican, Maya, and Andean Peoples, by George Kubler (Pelican History of Art Series. New York: Penguin Books, 1984)

Art of the American Indian Frontier: The Chandler-Pohrt Collection, by David W. Penney, et al. (Washington, D.C.: National Gallery of Art, 1992)

Arts of the North American Indian: Native Traditions in Evolution, edited by Edwin L. Wade and Carol Haralson (Tulsa: Philbrook Art Center, 1986)

Lost and Found Traditions: Native American Art 1965–1985, by Ralph T. Coe (Seattle: University of Washington Press, 1986)

Native Arts of North America, by Christian F. Feest (Updated version. New York: Thames & Hudson, 1992)

Our Way of Making Prayer: Yup'ik Masks and the Stories They Tell: Agayuliyarput: Kegginaqut, Kangiit-Llu, by Marie Meade and Ann Feinup-Riordan (Anchorage: Anchorage Museum of History and Art, 1996)

Pottery by American Indian Women: The Legacy of Generations, by Susan Peterson (Washington, D.C.: National Museum of Women in the Arts, 1997)

Shared Visions: Native American Painters and Sculptors in the Twentieth Century, by Margaret Archuleta and Rennard Strickland (Phoenix: Heard Museum, 1991)

Treasures of the National Museum of the American Indian: Smithsonian Institution, by Clara Sue Kidwell and Richard W. Hill (New York: Abbeville Press, 1996)

Visions and Voices: Native American Painting from the Philbrook Museum of Art, edited by Lydia L. Wyckoff (Tulsa: Philbrook Museum of Art, 1996)

Woven by the Grandmothers: Nineteenth-Century Navajo Textiles from the National Museum of the American Indian, edited by Eulalie H. Bonar (Washington, D.C.: Smithsonian Institution, 1996)

XIV-C-3. Biographical Dictionaries of Native American Artists

American Indian Painters: A Biographical Directory, by Jeanne O. Snodgrass (New York: Museum of the American Indian, Heye Foundation, 1968)

Biographies of Inuit Artists (4 vols. 3rd ed. Mississauga, Ontario: Tuttavik, 1988). Also available on CD-ROM.

Native American Artist Directory, by Mary Graham and Carol Ruppe (Phoenix: Heard Museum, 1985)

Native American Painters of the Twentieth Century: The Works of 61 Artists, by Robert Henkes (Jefferson, NC: McFarland & Co., 1995)

XIV-C-4. Native American Studies Web Sites

Art History Resources on the Web includes *Native Arts of the Americas*
<http://witcombe.bcpw.sbc.edu/ARTHLinks3.html>

Cape Dorset Inuit Art
<http://www.schoolnet.ca/collections/cape_dorset/>

First Nations Art
<http://indy4.fd1.cc.mn.us/>

Index of Native American Resources on the Internet has hyperlinks to numerous categories, including artists, culture, history, museums, archaeology, and nations
<http://hanksville.phast.umass.edu/misc/NAresources.html>

Inuit and the Northern First Nations People
<http://www.inac.gc.ca/>

Inuit Art Foundation
<http://www.inuitart.org/>

McMichael Canadian Art Collection provides various online exhibitions, such as "Contemporary First Nations Art," "Inuit Art," and "Tradition of Change: First Nations Art"
<http://www.mcmichael.on.ca/>

Mystery of the Maya, the Canadian Civilization Museum, provides illustrated information on all aspects of the Mayas: a timeline, a glossary of terms, details of their cities, and information on their religion and their knowledge of astronomy
<http://www.civilization.ca/membrs/civiliz/maya/mminteng.html>

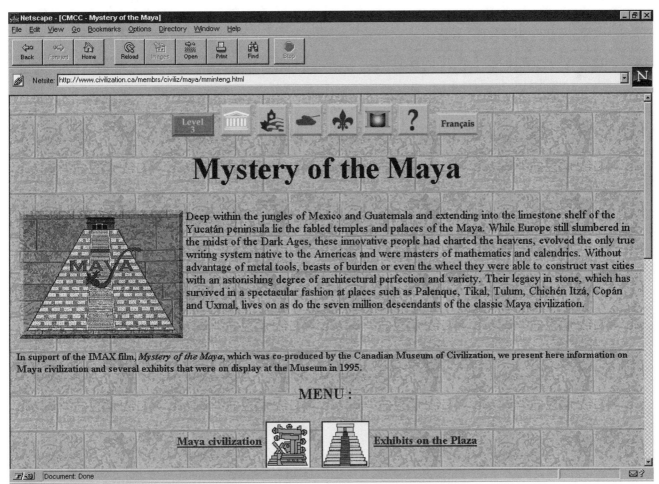

Mystery of the Maya Web Page <http://www.civilization.ca/membrs/civiliz/maya/mminteng.html>

National Portrait Gallery: Native Americans
 <http://www.npg.si.edu/col/native/index.htm>

Native American Indian Resources includes maps relevant to the Indian population and hyperlinks to tribal Internet home pages
 <http://www2.cr.nps.gov/tribal/other.html>

Oneida Indian Nation includes online exhibitions: "Wampum, 1777: The Oneidas and the Birth of the American Nation," and "Oskanondonha's Pipe, Bead Work, and Carvings"
 <http://one-web.org/oneida/exhibit.html>

Other Native American Resources on the Internet provides hyperlinks to UseNet News Groups and List Archives
 <http://hanksville.phast.umass.edu/misc/NAother.html>

Pueblo Pottery
 <http://www.ipl.org/exhibit/pottery/>

Russian Church and Native Alaskan Cultures
 <http://lcweb.loc.gov/exhibits/russian/russch0.html>

XIV-C-5. Museums and Libraries: Native American Collections

The museums cited below frequently have online exhibitions; check their Web sites for material on past, current, and future exhibitions.

Arizona State University Libraries, Tempe
 <http://www.asu.edu/lib/>

Bishop Museum, Honolulu, Hawaii
 <http://www.bishop.hawaii.org/>

Buffalo Bill Historical Center includes four museums—the Whitney Gallery of Western Art, the Buffalo Bill Museum, the Plains Indian Museum, and the Cody Firearms Museum—plus the Harold McCracken Research Library
 <http://www.TrueWest.com/BBHC/>

California Indian Library Collections, Berkeley
 <http://www.mip.berkeley.edu/cilc/brochure/brochure.html>

California Indian Museum and Culture Center, San Francisco
 <http://www.cimcc.indian.com/index.html>

Canadian Museum of Civilization, Hull
 <http://www.civilization.ca/>

Gilcrease Museum, Tulsa, Oklahoma
 <http://www.lawnchaps.com/index.htm>

Glenbow Museum Archives contains numerous records of Western Canadian peoples, and specializes in First Nations genealogy
 <http://www.glenbow.org/archives.htm>

Heard Museum, Phoenix, Arizona
 <http://www.heard.org/HOME.HTM>

Museo de las Culturas Prehispánicas, Puerto Vallarta, Jalisco, Mexico
 <http://mexplaza.udg.mz/Museo/>

Michael C. Carlos Museum, Emory University
 <http://www.cc.emory.edu/CARLOS/carlos.html>

National Gallery of Canada, Inuit Art Collection, Ottawa
 <http://national.gallery.ca/inuitc.html>

National Museum of American History, Smithsonian Institution, Washington, D.C.
 <http://www.si.edu/organiza/>

National Museum of the American Indian, Smithsonian Institution, Washington, D.C.
 <http://www.si.edu/organiza/>

Native Nations of Iowa
 <http://www.ames.net/native_nations/index.html>

Philbrook Museum, Tulsa, Oklahoma
 <http://www.philbrook.org/index.htm>

Royal Ontario Museum, Toronto
 <http://www.rom.on.ca/>

University of British Columbia Museum of Anthropology
 <http://www.moa.ubc.ca/>

University of Colorado, Colorado Springs
 <http://www.uccs.edu/~library/>

For additional museum sites, see:

Native American Museums at World Wide Arts Resources
 <http://wwar.com/museums/types/native_american_museums.htm>

XIV-C-6. History, Religion, and Mythology: Native American Studies

American Indian: A Multimedia Encyclopedia (Computer laser optical disc. New York: Facts On File, 1995). Contains source material: documents, sound bites of songs, 900 photographs, maps, and timelines. It also relates more that 100 legends from 60 tribes and tribal locations.

Art and Architecture of Ancient America: The Mexican, Maya and Andean Peoples, by George Kubler (3rd ed. rev. Pelican History of Art Series. Baltimore, MD: Penguin, 1984)

Art of the Maya: From the Olmecs to the Toltec-Maya, by Henri Stierlin, translated by Peter Graham (New York: Rizzoli, 1981)

Aztec Calendar
 <http://www.xs4all.nl/~voorburg/aztec.html>

Facts and Artifacts of Ancient Middle America: A Glossary of Terms and Words Used in the Archaeology and Art History of Precolumbian, Mexico, and Central America, by Curt Muser (New York: E.P. Dutton, 1978). Reproduces maps for archaeological sites; includes a pronunciation guide.

Global Journey through Five Centuries, Glenbow Museum, details the story of bison robes
 <http://www.glenbow.org/warrior.htm>

Handbook of North American Indians, William C. Sturtevant, general editor (17 vols. Washington, D.C.: Smithsonian Institution, 1978–96). Contains scholarly signed articles and extensive bibliographies on various aspects of Indian tribes. Each illustrated volume covers native Americans of a spe-

cific region and includes a map of tribal territories. Order from the Superintendent of Documents, U.S. Government Printing Office, Washington, D.C. 20402.

The Maya, by Michael D. Coe (3rd ed. London: Thames & Hudson, 1984)

Maya Iconography, edited by Elizabeth P. Benson and Gillett G. Griffin (Princeton, NJ: Princeton University Press, 1988)

Maya Calendar
 <http://www.halfmoon.org/calendar.html>

Mexico, by Michael D. Coe (Rev. and enlarged ed. London: Thames & Hudson, 1984)

Mexican and Central American Mythology, by Irene Nicholson (London: Paul Hamlyn, 1967)

Native American Dance: Ceremonies and Social Traditions, Charlotte Heth, general editor (Washington, D.C.: National Museum of the American Indian, 1992)

Navajo and Photography: A Critical History of the Representation of an American People, by James C. Faris (Albuquerque: University of New Mexico Press, 1996)

North American Indian Mythology, by Cottie Burland; new revised edition by Marion Wood (New revised ed., New York: Peter Bedrick Books, 1985)

The People: Indians of the American Southwest, by Stephen Trimble (Santa Fe: School of American Research Press, 1993)

South American Mythology, by Harold Osborne (London: Paul Hamlyn, 1968; reprint ed., New York: Peter Bedrick Books, 1986)

Studies in Pre-Columbian Art and Archaeology Series (Washington, D.C.: Dumbarton Oaks, 1966+). A mono-graphic series on various subjects, such as *An Early Stone Pectoral from South Eastern Mexico,* by Michael D. Coe, 1966.

Tribal Preservation Program provides hyperlinks to tribal Web sites
 <http://www2.cr.nps.gov/tribal/index.html>

Wisdom of American Indian Mythology, by John J. Ollivier (Pinellas Park, FL: Top of the Mountain Publishers, 1995)

XIV-C-7. Native American Maps and Timelines

Atlas of Ancient America, by Michael Coe, et al. (New York: Facts On File, 1986)

Everyday Life Series (London: B.T. Batsford)
 Everyday Life of the Aztecs, by Warwick Bray, 1968; reprinted, London: Dorset, 1987
 Everyday Life of the Maya, by Ralph Whitlock, 1987

Life of Series (Geneva: Minerva/Liber, 1987)
 Life of the Aztecs in Ancient Mexico, by Pierre Soisson and Janine Soisson, translated by David Macrae
 Life of the Incas in Ancient Peru, by Jesus Rome and Lucienne Rome, translated by Peter J. Tallon

Native American History Timeline, 1830–Present, The Heard Museum, Phoenix
 <http://www.heard.org/EDU/NAFAMRG/rsrctmln.htm>

Native Web has links to maps locating native tribes throughout the world.
 <http://www.nativeweb.org/>

XV. Non-European Cultures

Although all kinds of art is created throughout the world, until recently, the U.S. academic community emphasized the birth and development of Western European art. Art history textbooks often relegated non-European cultures to brief surveys or footnotes. Fortunately, this has been rapidly changing, and today there is more interest in and scholarly concern with art from elsewhere in the world. In studying the non-European art tradition, you should devise a research plan that uses the following procedures.

First, identify your subject's specific region or culture from those listed below: (a) Africa, (b) Asia, (c) Australia/Pacific Islands, (d) the Islamic world, and (e) Latin America.

Second, review Chapter IX: "Basic Research Methodology: Finding and Supplementing Web Data." If your research project concerns a historical period, re-examine Chapter X: "Art Historical Styles and Periods: Ancient World to Modern Era." Some of the resources will be pertinent to your study; the material below builds upon these references.

Third, check for additional resources on your chosen culture, detailed in this chapter. Printed references and Web sites are interspersed throughout these sections; most sources cited are in English. Many books were published or reissued after 1980; for earlier material, check the standard general art bibliographies [II-A].

The chapters mentioned above discuss many items; a few need to be emphasized. Remember, *The Dictionary of Art* has excellent coverage of non-European cultures. Some interdisciplinary courses [IV-A-2] provide extensive material, such as the University of Evansville's *World Cultures,* which includes material on ancient and medieval world cultures of the Near East, India, Egypt, China, and Islam <http://eawc.evansville.edu/about.htm>. For some studies, you may wish to access the *UNESCO World Heritage* site

[V-H], which provides illustrations for the properties on its endangered list. An excellent source for world-wide historical maps is the Perry-Castañeda Library Map Collection at the University of Texas <http://www.lib.utexas.edu/Libs/PCL/Map_Collection/Map_Collection.html>.

Be sure to use the indexes to Web material, such as (a) *Art History Resources on the Web, Part Four: Non-European Art* [IV-A-4] <http://witcombe.bcpw.sbc.edu/ARTHLinks3.html>, (b) *Index of Resources for Historians* [IV-A-4] <http://www.ukans.edu/history/>, and (c) *Metropolitan Museum of Art Hazen Center* <http://www.metmuseum.org/htmlfile/watson/tables/aaoa/index.htm>. Material on non-European art, such as ceramics, textiles, and jewelry, is frequently located in small exhibition catalogues not cited here; search *Worldwide Books* to locate the latest ones <http://www.worldwide.com/>.

You may also need to locate sources that discuss the theological aspects of society, since art often has a religious significance. Moreover, religious events and changes that affected a region also had an impact on its art. Europeans primarily follow the Judeo-Christian tradition, but this is not true of the rest of the world. For discussions of broad religious categories, see *Encyclopaedia of Religion and Ethics,* edited by James Hastings (13 vols. New York: Charles Scribner's Sons, 1928; reprint, Edinburgh: T. & T. Clark, 1979–81), and the *Encyclopedia of Religion*, edited by Mircea Eliade (New York: Macmillan, 1987). Judeo-Christian resources are cited in Chapter XII. For a discussion of all religions, see the *Religious Tolerance* Web site, which provides a summary of various faiths, including Buddhism, Confucianism, Hinduism, Islam, and Shinto <http://www.religioustolerance.org/>. For additional suggestions, ask the reference librarian for assistance.

XV-A. African Studies

There are more than 50 different countries on the continent of Africa, with varying cultures and religions. A separate section on Islam is provided later in this chapter; ancient Egypt, in northeastern Africa, is covered by the resources in Chapter X.

XV-A-1. African Culture Bibliographies

A good source for earlier African art bibliographies is Arntzen/Rainwater's *Guide to the Literature of Art History* [II-A-2].

Africa South of the Sahara: Index to Periodical Literature, 1900–1970 (4 vols. Boston: G.K. Hall, 1971). First Supplement, 1973. Second Supplement, 3 vols., 1982. Third Supplement, 1985 (Washington, D.C.: U.S. Government Printing Office).

African Art: A Bibliographic Guide, by Janet L. Stanley (New York: Africana, 1985). Kept current by annual publication: *Arts in Africa: An Annotated Bibliography* (Atlanta: Crossroads Press, African Studies Association. Vol. 1; 1986–87+).

African Dress II: A Select and Annotated Bibliography, by Ila M. Pokornowski, et al. (East Lansing, MI: African Studies Center, Michigan State University, 1985)

Arts of Central Africa: An Annotated Bibliography, by Daniel P. Biebuyck, G. K. Hall Art Bibliographies Series (Boston: G. K. Hall, 1987)

Bibliography of the Arts of Africa, by Dominique Western (Waltham, MA: Brandeis University Press, 1975)

International African Bibliography: Current Books, Articles, and Papers in African Studies, edited by David Hall (London: Mansell, 1971+). Quarterly with large classifications by regions and subject categories. Cumulative edition in 1982 for 1973–78.

Traditional Arts of Africa Series (Bloomington: Indiana University Press)

> *Annotated Bibliography of the Visual Arts of East Africa*, by Eugene C. Burt, 1980

> *Mande Blacksmiths: Knowledge, Power, and Art in West Africa*, by Patrick R. McNaughton, 1988

XV-A-2. History of African Art

Africa: The Art of a Continent (London: Royal Academy of Arts, 1995)

African Art: An Introduction, by Frank Willett (New York: Oxford University Press, 1971; reprint ed., 1985)

African Ethnonyms: Index to Art-Producing Peoples of Africa, by Daniel Biebuyck; Susan Kelliher; and Linda McRae (Boston: G. K. Hall, 1996). Provides the names of more than 2,500 African ethnic groups.

African Reflections: Art from Northeastern Zaire, by Enid Schildkrout and Curtis A. Keim (New York: American Museum of Natural History, 1990)

Art and Artists of South Africa: An Illustrated Biographical Dictionary and Historical Survey of Painters, Sculptors, and Graphic Artists Since 1875, by Esme Berman (Cape Town, South Africa: A. A. Balkema, 1983)

Art History in Africa: An Introduction to Method, by Jan Vansina (New York: Longman, 1984)

Baule: African Art, Western Eyes, by Susan Mullin Vogel (New Haven, CT: Yale University Art Gallery, 1997)

Memory: Luba Art and the Making of History, edited by Mary N. Roberts and Allen F. Roberts (New York: Museum of African Art, 1996)

Royal Art of Benin: The Perls Collection in the Metropolitan Museum of Art, by Kate Ezra (New York: Harry N. Abrams, 1992)

Seven Stories about Modern Art in Africa: An Exhibition, Clémentine Deliss, general editor (New York: Flammarion, 1995)

Visual Arts of Africa: Gender, Power and Life Cycle Rituals, by Judith Perani and Fred T. Smith (Upper Saddle River, NJ: Prentice Hall, 1998)

Yoruba: Nine Centuries of African Art and Thought, by Henry John Drewal, et al. (New York: Center for African Art, 1989)

XV-A-3. African Studies Web Sites

For Web sites on ancient Egypt, consult *World Cultures* <http://eawc.evansville.edu/about.htm> and the listings in [X-B-1]. African studies are also included in the *Index of Resources for Historians* <http://www.ukans.edu/history/> and *Art History Resources on the Web* <http://witcombe.bcpw.sbc.edu/ARTHLinks3.html>. Remember to check the museums with African American collections, as they frequently highlight African material; for instance, the Museum of African American History, Detroit, has a section called "Documenting the Past," which in 1997 had a sample exhibit of African tribal masks from their collection.

Africa-Art, Stanford University African Site <http:www-sul.stanford.edu/depts/ssrg/africa/art.html>

Africa: The Art of a Continent <http://artnetweb.com/guggenheim/africa/>

Africa: One Continent, Many Worlds <http://www.lam.mus.ca.us/africa/main.htm>

Africa Online <http://www.africaonline.com/>

African-American Culture and History
<http://lcweb.loc.gov/exhibits/african/intro.html>

African Art: Aesthetics and Meaning: An Electronic Catalog was created in 1993 by the Digital Imaging Center of the University of Virginia Library using works of art owned by the University's Bayly Art Museum. Information was provided on elements of the African aesthetic, along with a bibliography and data on creating this online exhibition.
<http://www.lib.virginia.edu/dic/exhib/93.ray.aa/African.html>

African Studies WWW, University of Pennsylvania, is supported by the African Studies Center at the university, Professor Sandra T. Barnes, Director, which incorporates diverse material on this continent, providing general information on a wide selection of topics for 55 African governmental entities. The site provides maps, U.S. State Department travel advisories, and hyperlinks to other resources.
<http://www.sas.upenn.edu/African_Studies/AS.html>

Cutting to the Essence, Shaping for the Fire: Yoruba and Akan Art in Wood and Metal is an exhibition of art collected by Richard Kempshall Meyer of Peoria, Illinois
<http://www.fa.indiana.edu/~conner/africart/home.html>

Egypt's *Culture Net* covers ancient, Coptic, Islamic, and modern history, plus sites and museums
<http://www.idsc.gov.eg/culture/index.htm>

Eternity of Forest: Paintings by Mbuti Women covers how the Mbuti (formerly known as Pygmies) make barkcloth paintings
<http://www.bampfa.berkeley.edu/exhibits/mbuti/>

Inspired by Dreams: African Art from Derby Collection, Middlebury College Museum of Art includes data on masking, divination, sacred power, political authority, and textiles
<http://www.middlebury.edu/~atherton/AR325/index.html>

National Museum of African Art Library provides hyperlinks to other relevant sites
<http://www.sil.si.edu/afahp.htm>

Objects of Diversity: Process and Interpretation considers works of art owned by the Trout Gallery of Dickinson College, Carlisle, Pennsylvania
<http://media.dickinson.edu/gallery/objects.html>

Sub-Saharan African Art, Michael C. Carlos Museum, Emory University
<http://www1.cc.emory.edu/CARLOS/carlos.html>

XV-A-4. African Maps

Cultural Atlas of Africa, edited by Jocelyn Murray (New York: Facts On File, 1981)

Stanford University
<http://www-sul.stanford.edu/depts/ssrg/africa/map.html>

Times Atlas of the World (Rev. ed. London: Times Books, 1996)

XV-A-5. History, Religion, and Mythology: African Studies

African Mythology, by Edward Geoffrey Parrinder (London: Paul Hamlyn, 1967; reprint ed., New York: Peter Bedrick Books, 1986)

Cambridge History of Africa (8 vols. Cambridge: Cambridge University Press, 1975–86)

Encyclopedia of Pre-Colonial Africa: Archaeology, History, Languages, Cultures, Environments, edited by Joseph Vogel (Walnut Creek, CA: AltaMira Press, 1997)

General History of Africa Series, UNESCO with J. Ki-Zerbo, general editor (8 vols. Berkeley: University of California Press, 1981–1993)

Kings, Gods and Spirits from African Mythology, by Jan Knappert (New York: Peter Bedrick Books, 1995)

Penguin Atlas of African History, by Colin McEvedy (New York: Penguin Books, 1995)

XV-A-6. Museums and Libraries: African Studies

The Web site for the African and Middle Eastern Reading Room of the Library of Congress provides all types of information on these countries <http://lcweb.loc.gov/rr/amed/>.

Museums

Several types of institutions exhibit African art: art museums, cultural institutions, natural history museums, and museums of ethnic arts. Most museums with encyclopedic collections, as well as many university museums, have information—and frequently, illustrations—on African art; see [III-C].

California African-American Museum, Los Angeles, exhibits African cultural material
<http://www.caam.ca.gov/>

Coptic Museum, Cairo
<http://www.idsc.gov.eg/culture/cop_mus.htm>

Durban Art Gallery, South Africa
<http://durbanet.aztec.co.za/exhib/dag/dagmain.htm>

Egyptian Museum, Cairo
<http://www.idsc.gov.eg/culture/egy_mus.htm>

Fowler Museum of Cultural History, University of California, Los Angeles
<http://www.fmch.ucla.edu/>

Goldwater Collection, Metropolitan Museum of Art, New York City
<http://www.metmuseum.org/>

National Museum of African Art, Washington, D.C.
<http://www.si.edu/organiza/>

National Museum of Namibia
<http://www.natmus.cul.na/>

Libraries

There are a number of libraries with excellent collections for African studies. Some have published catalogues of their bibliographic holdings; some have their OPACs available on the Internet.

The library catalogue of the *Smithsonian Institution Research Information System (SIRIS)* has particular strengths in African art and includes the holdings of the Warren M. Robbins Library of the National Museum of African Art, which cites books, exhibition catalogues, articles, chapters in books, and vertical file material available at the library <http://www.siris.si.edu/>.

Melville J. Herskovits Library of African Studies, Northwestern University Library, Evanston, Illinois
<http://www.library.nwu.edu/africana/>

Robert Goldwater Primitive Art Collection, Metropolitan Museum of Art (not on the Met's OPAC)
<http://www.metmuseum.org/>

XV-A-7. Visual Resources: African Studies

Africa, written and presented by Basil Davidson (Video. RM Arts, 1984). Eight 57-minute tapes on Africa yesterday and today.

Africa: A Voyage of Discovery, written and presented by Basil Davidson (Video. RM Arts, 1984)

National Museum of African Art, the Eliot Elisofon Photographic Archives, consists of photographer Elisofon's collection of photographs of African life, 1943–73, plus other photographic collections
<http://www.si.edu/organiza/museums/africart/resource/musresrc.htm>

XV-B. Asian Studies

In the 16th century, Jesuit missionaries developed a system for changing Japanese characters into the Portuguese language; since that time, other countries have developed different types of romanization, a process of changing oriental characters into the Latin alphabet. The Library of Congress MARC tapes have romanized the titles of books written in non-Roman alphabets.

If you are studying Asian art, remember that *Art Index* and its later form, *Art Abstracts,* are the only major art indexes [VII-B-2] covering periodical literature from this region. You may also wish to access the Association for Asian Studies Web site, since this professional group publishes *Journal of Asian Studies, Bibliography of Asian Studies,* and *Education about Asia* <http://www.easc.indiana.edu/pages/aas/default.htm>.

XV-B-1. History of Asian Art

Ancient China, Art and Archaeology, by Jessica Rawson (London: British Museum, 1980)

Antique Collectors' Club publishes and distributes books on Asian art of specific media. A few books are cited below to suggest the extent of the coverage; consult its Web site for the latest material.
<http://www.antiquecc.com/>

Art of Ancient Iran, by Houshang Mahboubian (London: Philip Wilson Publishers, 1998)

Arts of India 1550–1900, by Deborah Swallow (London: V & A Publications, 1997)

Korean Art and Design, by Beth McKillop (London: V & A Publications, 1997)

Tales from the Land of Dragons: One Thousand Years of Chinese Painting, by W. U. Tung (Boston: Museum of Fine Arts, Boston, 1997)

Art in China, by Craig Clunas (New York: Oxford University Press, 1997)

Art of Ancient India: Buddhist, Hindu, Jain, by Susan L. Huntington (New York: Weatherhill, 1985)

Art of Indian Asia: Its Mythology, edited by Heinrich Zimmer and Joseph Campbell (2 vols. Princeton, NJ: Princeton University Press, 1983)

Art of Japan, by J. Edward Kidder (New York: Crown, 1985)

Arts of China, by Michael Sullivan (3rd ed. Berkeley: University of California Press, 1984)

Arts of India, edited by Basil Gray (Ithaca, NY: Cornell University Press, 1981)

Chronological Table of Japanese Art, edited by Shigehisa Yamasaki (Tokyo: Geishinsha, 1981)

Hindu Art, by T. Richard Blurton (Cambridge, MA: Harvard University Press, 1993)

History of Far Eastern Art, by Sherman E. Lee (4th ed. New York: Harry N. Abrams, 1982)

Japanese Art, by Joan Stanley-Baker (New York: Thames & Hudson, 1984)

Pelican History of Art Series (Baltimore: Penguin; New Haven: Yale University Press)

Art and Architecture of the Indian Subcontinent, by J. C. Harle, 1986

Arts of China to A.D. 900, by William Watson, 1995

Symbolism in Ancient Chinese Art, by Hugo Munsterberg (New York: Hacker, 1986)

Three Thousand Years of Chinese Painting, by Richard M. Banhart, et al. (New Haven: Yale University Press, 1997). This is the inaugural book in the Culture & Civilization of China Series, a projected 75 volumes to be published by Yale University Press and the China International Publishing Company.

3000 Years of Sacred and Secular Art, Paintings, Sculpture, Textiles, Islamic, and Other Works of Art from India, Tibet, Nepal and Southeast Asia, by Aaron Freedman (New York: Art of the Past, 1996)

Understanding Far Eastern Art: A Complete Guide to the Arts of China, Japan and Korea—Ceramics, Sculpture, Painting, Prints, Lacquer, Textiles, and Metalwork, by Julia Hutt (New York: E. P. Dutton, 1987)

XV-B-2. Asian Biographical Dictionaries

Though some of the following printed resources were published many years ago, they are still useful. For contemporary artists, see the museum Web sites listed below, since they sometimes highlight the latest talent. This section has separate entries for Chinese and Japanese artists.

Chinese Artists

Chinese names are particularly difficult to pinpoint, because a man could have several: (a) his "T" or "Tzu" style or courtesy name, which may have been adopted in his youth; (b) his "H" or "Hao" style or fancy or literary name, which the person either adopted or was given; (c) the Western or romanized version of his name; and (d) sometimes, a posthumous name. A person can also have a *hsing* or family name and a *ming* or given name. Until the 1950s, Chinese names were romanized by the Wade-Giles System, developed in 1859 by Thomas Francis Wade and revised by Herbert Allen Giles in 1892. For a copy of the modified Wade-Giles system, consult the revised edition of the *Chinese-English Dictionary,* by R. H. Matthew (Harvard-Yenching Institute, 1943). Some references still use this system.

Chinese names can also be romanized according to Pinyin, the official system employed by the People's Republic of China <http://www.edu.cn/>. The differences are great. For example, the city of Pei-ching or Pei-p'ing (Wade-Giles) is called Beijing (Pinyin); the dynasty Ch'ing becomes Qing. The Pinyin system has largely supplanted Wade-Giles in geographic names as well as in most references. For instance, *Allgemeines*

Künstler Lexikon [XI-C-2] uses the Pinyin system with cross-references from the Wade-Giles version. For information on the conversion to this later system, consult *Reform of the Chinese Written Language* (Peking: Foreign Languages Press, 1958).

Owners of Chinese paintings added signatures and seals to their works of art indicating their ownership. In *Seals of Chinese Painters and Collectors,* Wang provides a historical discussion of these important imprints, stating that collectors' seals were probably first used in the T'ang Dynasty, A.D. 618–907, becoming popular during the Northern Sung Dynasty, 960–1127. These seals are used to authenticate Chinese paintings. If a Ming scroll seal needs identifying, check *Seals of Chinese Painters and Collectors* for the artist's name. *Dictionary of Ming Biography 1368–1644* can then be consulted. Both references, which are cited below, will be needed to document artists' biographical information.

Biographical Dictionary of Republican China, edited by Howard L. Boorman (4 vols. New York: Columbia University Press, 1967–71)

Chinese Biographical Dictionary, by Herbert A. Giles (London: B. Quaritch, 1898; reprinted, Taipei: Chin Ch'eng Wen, 1977). Alphabetized by romanized name with Chinese characters given; does not include bibliographical data. Includes indexes to Tzu and Hao names.

Chinese Reader's Manual: A Handbook of Biographical, Historical, Mythological, and General Literary Reference, by William Frederick Mayers (Shanghai: American Presbyterian Mission, 1874; reprint ed., Detroit: Gale Research, 1968). Includes biographical material on more than 1,000 persons, with chronological tables to Chinese dynasties.

Dictionary of Ming Biography 1368–1644, edited by L. Carrington Goodrich and Chaoying Fang (2 vols. New York: Columbia University Press, 1976). Includes maps and a list of Ming Dynasty emperors with dates, temple names, and titles of reigns.

Eminent Chinese of the Ch'ing Period (1644–1912), edited by Arthur Hummel (Washington, D.C.: U.S. Government Printing Office; reprinted, Taipei, China: Ch'eng Wen, 1970). Under romanized versions, provides Tzu and Hao names, brief biographical data, and short bibliographies.

Glossary of Chinese Art and Archaeology, by S. Howard Hansford (London: The China Society, 1954; reprint ed., New York: Beekman, 1972)

Index-Dictionary of Chinese Artists, Collectors, and Connoisseurs, by Nancy N. Seymour (Metuchen, NJ: Scarecrow, 1988). Includes brief biographies of figures from the T'ang Dynasty through the modern period.

Seals of Chinese Painters and Collectors of the Ming and Ch'ing Periods, by Victoria Contag and Chi-ch'ien Wang (Rev. ed. with supplement. Hong Kong: Hong Kong University, 1966). Under romanized names, provides surnames and given names, Tzu and Hao names, birth/death data, subjects of artists, and stylistic characteristics of their works.

Includes a brief discussion of Chinese seals and indexes to painters and collectors by stroke count, romanized names, and Tzu names. The book reproduces all the seals each artist used and includes seals found in American public and private collections.

Japanese Artists

The romanization scheme used in many English-language references—such as the *Kodansha Encyclopedia of Japan* and the *Allgemeines Künstler Lexikon*—is the Hepburn system, which was developed by a group of Japanese and interested foreigners; James Curtis Hepburn (American 1815–1911) was one of their advisers. When he published this romanization procedure in his Japanese–English dictionary, the system became associated with his name. For the modified Hepburn system, also called Hyojun or Standard, consult Kenkyusha's *New Japanese–English Dictionary,* Koh Masuda, editor-in-chief (4th ed. Tokyo: Kenkyusha, 1974). This is the method endorsed by the Romaji-kai, or Romanization Association.

Biographical Dictionary of Japanese Art, edited by Yutaka Tazawa (Tokyo: Kodansha International; New York: International Society for Educational Information, 1981). Covers all categories of art and includes 50 charts of artistic lineages.

Dictionary of Japanese Artists: Painting, Sculpture, Ceramics, Prints, Lacquer, by Laurance P. Roberts (New York: John Weatherhill, 1976). Alphabetized under Western names. Some biographical entries furnish bibliographical citations and list museums owning artists' works. Includes index to artists' names as written in Japanese characters.

Index of Japanese Painters, Society of Friends of Eastern Art (Tokyo: Institute of Art Research, 1940; reprint ed., Rutland, VT: Charles E. Tuttle, 1985). Contains about 600 brief biographies.

Japanese Women Artists 1600–1900, by Patricia Fister (New York: Harper & Row, 1989). Covers 27 artists.

Who's Who among Japanese Artists (Tokyo: Print Bureau, Japanese Government, 1961). Includes a bibliography on Japanese contemporary art.

XV-B-3. Asian Studies Web Sites

The Asia Society was founded in 1956 by John D. Rockefeller III to foster communications and understanding between Americans and citizens of the Asia-Pacific region
<http://www.asiasociety.org/>
It sponsors *AskAsia*, which provides information for teachers and students, kindergarten through 12th grade
<http://www.askasia.org/>

Asian Studies WWW Virtual Library has 32 worldwide editors who list and annotate data organized by 8 Asian regions and 60 individual countries or territories. Each separate site furnishes hyperlinks to all types of material, including art,

architecture, archaeology, and history. The Coombs Computing Unit of the Australian National University at Canberra provides the server. This is an excellent place to start your research.
<http://coombs.anu.edu.au/WWWVL-AsianStudies.html>

AsianNet has information on 10 countries: China, Hong Kong, Indonesia, Japan, Korea, Malaysia, the Philippines, Singapore, Taiwan, and Thailand. Each section reproduces a map and records general data on the country, including population, capital, and currency. The material is organized in four sections: Business, Government, Education, and Arts & Culture. The last furnishes hyperlinks to other Web sites under nine categories, including both traditional and contemporary arts.
<http://www.asiannet.com/index.html>

China: China Education and Research Network (CERNET) is the Web site of the People's Republic of China, which includes information on Chinese art
<http://www.edu.cn/>

Chinese Culture
<http://acc6.its.brooklyn.cuny.edu/~phalsall/texts.html>

East Asian Studies Center at the University of Indiana
<http://www.easc.indiana.edu/>

Fragrance of Ink: Korean Literati Paintings of the Choson Dynasty (1392–1910), Berkeley Museum
<http://www.bampfa.berkeley.edu/exhibits/korean/>

India WWW Virtual Library
<http://webhead.com/WWWVL/India/>

Many Faces—Many Paths: Art of Asia, Glenbow Museum, covers Hindu and Buddhist worship and ritual
<http://www.glenbow.org/bumper/>

Storytelling in India
<http://ccat.sas.upenn.edu/luna/savProj.html>

Stanford University Guide to Japan Information Resources
<http://fuji.stanford.edu/GUIDE/>

World Art Treasures [V-A] has, under the heading "First Program," 10 to 15 illustrations of art of China, India, Japan, Myanmar/Burma, Laos, Thailand, and Cambodia
<http://sgwww.epfl.ch/BERGER/index.html>

XV-B-4. Asian Studies Maps and Timelines

Cultural Atlas of China, by Caroline Blunden and Mark Elvin (Oxford: Equinox, 1983)

Cultural Atlas of India, by Gordon Johnson (New York: Facts On File, 1996)

Cultural Atlas of Japan, by Martin Collcut, et al. (Oxford: Phaidon, 1988)

For a Chinese history timeline, see:
<http://www.china5k.com/>

For a timeline of Japan's fine arts, see *Japan's Fine Arts*, by Masahide Kanzaki:
<http://www.kanzaki.com/jinfo/jart-fine.html>

XV-B-5. History, Religion, and Mythology: Asian Studies

This section is divided into references covering (a) Asian civilization, (b) China, (c) India, (d) Japan, and (e) other Asian countries.

Asian Civilization

Buddhism, by Louis Frédéric (New York: Flammarion, 1995)

Encyclopaedia of Asian Civilizations, edited by Louis Frédéric (11 vols. in 10 books. Villecresnes, France: L. Frédéric, 1987)

Encyclopedia of Asian History, Ainslie T. Embree, editor-in-chief (4 vols. New York: Scribner's, 1988)

History of Tea, by Stash Tea Company
<http://www.stashtea.com/>

China

Chinese History
<http://darkwing.uoregon.edu/~felsing/cstuff/history.html>

Chinese Mythology, by Anthony Christie (London: Paul Hamlyn, 1968; reprint ed., New York: Peter Bedrick Books, 1985)

Chinese Mythology: An Introduction, by Anne Birrell (Baltimore: Johns Hopkins University Press, 1993)

Dragons, Gods, and Spirits from Chinese Mythology, by Tao Tao Liu Sanders (London: Eurobook, Ltd., 1980; reprint ed. New York: Peter Bedrick Books, 1995)

Empires beyond the Great Wall: The Heritage of Genghis Khan, an exhibition catalogue by Adam T. Kessler. The material concerns the 1995 exhibition held only at Victoria's Royal British Columbia Museum.
<http://vvv.com/khan/khan.html>

Encyclopedia of China, Brian Hook, general editor (London: Cambridge University Press, 1982)

Everyday Life in Early Imperial China, by Michael Lowe (London: B.T. Batsford, 1968; reprint ed., New York: Dorset, 1988)

History of China, originally written for the *Army Area Handbook*
<http://www-chaos.umd.edu/history/welcome.html>

Silk Road, history of the world's oldest significant trade route, which influenced China, Central Asia, and the West
<http://www.atm.ch.cam.ac.uk/~oliver/silk.html>

Silk Road in China
<http://www.xanet.edu.cn/xjtu/silk1/eng/silk.html>

India

Classical Dictionary of Hindu Mythology and Religion, Geography, History, and Literature, by John Dowson (London: Kegan Paul, Trench, Trubner, 1928; reprint ed., Boston: Milford House, 1974). Written for those who do not read Sanskrit; the index of names in Sanskrit is accompanied by their Western equivalents and an explanation of Sanskrit.

Companion to Indian Mythology: Hindu, Buddhist, and Jaina/ Indian Mythology, by V. S. Naravane (Allahabad, India: Thinker's Library, 1987)

Encyclopaedia of Asian Civilizations, edited by Louis Frédéric (11 vols. in 10 Books. Villecresnes, France: L. Frédéric, 1987)

Encyclopaedia of Indian Culture, by Rajaram Narayan Saletore (5 vols. New Delhi: Sterling, 1981–85)

Encyclopaedia of Indian Temple Architecture, edited by Michael W. Meister, et al. (2 vols. Princeton, NJ: Princeton University Press, 1988)

Indian Mythology, by Veronica Ions (London: Paul Hamlyn, 1967; reprint ed., New York: Peter Bedrick, 1984)

Indian Theogony: A Comparative Study of Indian Mythology from the Vedas to the Puranas, by Sukumari Bhattacharji (Chambersburg, PA: Anima Publications, 1988)

Japan

Japanese Mythology, by Juliet Piggott (London: Paul Hamlyn, 1969; reprint ed., New York: Peter Bedrick Books, 1982)

Kodansha Encyclopedia of Japan (9 vols. New York: Kodansha International, 1983)

MOA: The Philosophy of Mokichi Okada
<http://www.moa.or.jp/index.html>

Snow, Moon, and Flowers: The Japanese View of Nature, a special exhibition held in Atami, Japan. All works are from the Edo Period. The Mokichi Okada Association (MOA) was inaugurated in 1980 to proselyte the ideas of the man for whom it is named. The exhibition includes material on Okada's philosophy about nature and his creation of the Japanese garden.
<http://www.moa.or.jp/index.html>

Other Asian Countries

History of Thailand
<http://sunsite.au.ac.th/thailand/thai_his/history.html>

Welcome to the History of the Philippines: Pearl of the Orient
<http://www.ualberta.ca/~vmitchel/>

XV-B-6. Museums: Asian Studies

The Web site for the Asian Reading Room of the Library of Congress provides all types of information on these countries <http://lcweb.loc.gov/rr/asian/>.

Art Institute of Chicago
<http://www.artic.edu/aic/firstpage.html>

Arthur M. Sackler Gallery, Washington, D.C. (now part of the Freer Gallery)
<http://www.si.edu/organiza/museums/freer/start.htm>

Asian Art Museum of San Francisco
<http://asianart.org/>

Cleveland Museum of Art
<http://www.clemusart.com/>

DeYoung Museum, San Francisco
 <http://www.famsf.org/>

Freer Gallery of Art, Smithsonian Institution, Washington, D.C.
 <http://www.si.edu/organiza/museums/freer/start.htm>

Kyoto National Museum
 <http://www.kyohaku.go.jp/>

Metropolitan Museum of Art, New York City
 <http://www.metmuseum.org/>

Morikami Museum and Japanese Gardens, Delray Beach, FL
 <http://www.icsi.com/ics/morikami/>

Museum of Fine Arts, Boston
 <http://www.mfa.org/>

Nelson-Atkins Museum of Art, Kansas City
 <http://www.nelson-atkins.org/>

Philadelphia Museum of Art
 <http://www.philamuseum.org/>

Singapore Art Museum (SAM)
 <http://www.museum.org.sg/sam/>

Tokugawa Art Museum, Tokyo, the third oldest privately endowed museum in Japan. Its Web site has data on Tokugawa Ieyasu, who established Edo (later renamed Tokyo) as his shogun government capital. It includes information on the Wabi tea service, the Noh Theater, and the *Illustrated Handscroll of The Tale of Genji,* the museum's most famous work of art.
 <http://www.cjn.or.jp/tokugawa/index.html>

Indexes to Asian Collections

Although texts are written in Chinese characters, these sources contain black-and-white identification photographs and can frequently be used to discover the location of specific works of art.

Comprehensive Illustrated Catalog of Chinese Paintings, compiled by Kei Suzuki (5 vols. Tokyo: University of Tokyo, 1982)
 Vol. 1: *America and Canada*
 Vol. 2: *Southeast Asia and Europe*
 Vol. 3: *Japan I*
 Vol. 4: *Japan II*
 Vol. 5: *Index*

The Connoisseur's Guide to Japanese Museums, by Laurance P. Roberts (2nd ed. Rutland, VT: Charles E. Tuttle, 1978)

Illustrated Catalogue of Selected Works of Ancient Chinese Painting and Calligraphy (Beijing: Cultural Relics, 1986+)

Index of Early Chinese Painters and Paintings: T'ang, Sung, and Yuan, by James Cahill (Berkeley: University of California Press, 1980).

Oriental Ceramics: The World's Great Collections (12 vols. Tokyo: Kodansha, 1976–78. 11 vols., second issue, 1980)

XV-B-7. Visual Resources: Asian Studies

Masterworks of Japanese Painting: The Etsuko and Joe Price Collection (CD-ROM. Berkeley, CA: Digital Collections, 1993). Includes 350 works from the Edo Period.

XV-C. Australian and Pacific Island Studies

Australian Art Index Database (Canberra: Australian National Gallery, 1982+). Covers art in Australia and the work of Australian artists overseas.

XV-C-1. History of Australian Art and Culture

Art in Australia: From Colonization to Postmodernism, by Christopher Allen (New York: Thames and Hudson, 1997)

Artists and Galleries of Australia and New Zealand, by Max Germaine (Dee Why West, New South Wales: Lansdowne, 1979)

Australian Sculptors, by Ken Scarlett (West Melbourne, Victoria, Australia: Thomas Nelson, 1980)

Australian Studio Glass: The Movement, Its Makers and Their Art, by Noris Ioannou (Roseville East, Australia: Craftsman House, 1995)

Cultural Atlas of Australia, New Zealand and the South Pacific, by Richard Nile and Christian Clerk (Surry Hills, NSW, Australia: RD Press, 1996)

Dreamings: The Art of Aboriginal Australia, edited by Peter Sutton, et al. (New York: George Braziller, 1988)

Encyclopedia of Australian Art, by Alan McCulloch (New York: Frederick A. Praeger, 1968)

Fire and Shadow: Spirituality in Contemporary Australian Art, by Nevill Drury and Anna Voigt (North Ryde, Australia: Craftsman House, 1996)

Golden Summers: Heidelberg and Beyond, by Jane Clark and Bridget Whitelaw (Rev. ed. Sydney: International Cultural Corporation of Australia, 1986)

Masters of Their Craft: Tradition and Innovation in the Australian Contemporary Decorative Arts, by Noris Ioannou (North Ryde, Australia: Craftsman House, 1997)

Monash Biographical Dictionary of 20th Century Australia, John Arnold and Deirdre Morris, general editors (Port Melbourne, Australia: Reed Reference Publishers, 1994)

New Visions, New Perspectives: Voices of Contemporary Australian Women Artists, by Anna Voigt (North Ryde, Australia: Craftsman House, 1996)

New Zealand Women Artists: A Survey of 150 Years, by Anne Kirker (Totola, Australia: Craftsman House, 1993)

Oceanic Mythology, by Roslyn Poignant (London: Paul Hamlyn, 1967)

Story of Australian Art from the Earliest Known Art of the Continent to the Art Today, by William Moore (Sydney: Angus & Robertson, 1934)

Two Centuries of New Zealand Landscape Art, by Roger Blackley (Revised ed. Auckland, NZ: Auckland City Art Gallery, 1990)

XV-C-2. Australian and Pacific Studies Web Sites

Aboriginal Studies
<http://www.ciolek.com/WWWVL-Aboriginal.html>

Asian Studies WWW Virtual Library has 32 worldwide editors who list and annotate the data; the Coombs Computing Unit of the Australian National University at Canberra provides the server. The library includes Australia, New Zealand, and the Pacific Region.
<http://coombs.anu.edu.au/WWWVL-AsianStudies.html>

Australia Studies
<http://austudies.org/vl/>

Ethnic Art Institute of Micronesia furnishes information on sacred and functional art.
<http://www.rgfa.com/eaimhome.htm>

New Zealand Studies
<http://austudies.org/nzvl/>

University of Queensland
<http://www.uq.edu.au/ArtHistory/>

XV-C-3. Museums: Australian and Pacific Studies

Fowler Museum of Cultural History, University of California, Los Angeles
<http://www.fmch.ucla.edu/>

Monash University Gallery, Port Melbourne
<http://www.monash.edu/mongall/monash.html>

National Gallery of Australia, Canberra
<http://www.nga.gov.au/>

National Gallery of Victoria, Melbourne, has a section, "Painting Australia," with data on individual Australian artists plus a few illustrations of their work
<http://www.ngv.vic.gov.au/main.html>

National Museum of Australia, Canberra
<http://www.nma.gov.au/>

XV-D. Islamic Studies

Because Islam encompasses more than one continent, being prevalent in both Asia and Africa, Islamic resources have been separated. All four major art history textbooks cover Islamic art [IX-B-1]. The Hazen Center for Electronic Information Resources, Metropolitan Museum of Art, New York City, provides selected Internet resources <http://www.metmuseum.org/htmlfile/watson/hazen.htm>.

XV-D-1. History of Islamic Art and Culture

Exploring Ancient World Cultures (EAWC) has a section on Islam
<http://cedar.evansville.edu/showcase/culture/>

Al-Andalus: The Art of Islamic Spain, by Jerrilynn D. Dodds (New York: Metropolitan Museum of Art, 1992)

Atlas of Islamic World Since 1500, by Francis Robinson (Oxford: Equinox, 1982; reprint ed., New York: Facts On File, 1984)

Cultural Atlas of Islam, by Isma'il R. al Faruqi and Lois Lamya' al Faruqi (New York: Macmillan, 1986)

1400 Years of Islamic Art, by Géza Fehérvári and Yasin H. Safadi (London: Khalili Gallery, 1981)

Islam and the Heroic Image: Themes in Literature and the Visual Arts, by John Renard (Columbia, SC: University of South Carolina Press, 1993)

Islamic Art, by Barbara Brend (Cambridge, MA: Harvard University Press, 1991)

Oxford Encyclopedia of the Modern Islamic World, John L. Esposito, editor-in-chief (New York: Oxford University Press, 1995)

Pelican History of Art Series (Baltimore, MD: Penguin; New Haven: Yale University Press)

Art and Architecture of Islam, 650–1250, by Richard Ettinghausen and Oleg Grabar, 1987

Art and Architecture of Islam, 1250–1800, by Sheila S. Blair and Jonathan M. Bloom, 1994

Renaissance of Islam: Art of the Mamluks, by Asin Atil (Washington, D.C.: Smithsonian Institution, 1981)

XV-D-2. Islamic Studies Web Sites

Cyber Mosque
<http://www.moslem.org/mosque2.htm>

Egypt's *Culture Net* covers Islam.
<http://www.idsc.gov.eg/culture/index.htm>

Detroit Institute of Arts, Ancient Islamic art galleries
<http://www.dia.org/galleries/ancient/islamicart/islamicart.html>

Dome of the Rock, by Roger Garaudy, provides an illustrated history of the sacred shrine
<http://www.erols.com/ameen/domerock.htm>

Islamic Art includes a brief glossary of Islamic terms, a list of historic Islamic events, chronologies organized according to dynasties, and information on architecture, Oriental rugs, and calligraphy
<http://www.islamicart.com/>

Islamic Holy Scriptures: The Holy Qur'ān, is the holy scripture revealed by Allah to Huhannad. Also spelled *Koran, Qur'ān* means "readings" or "recitations." For the history and translations, see the Web site of the University of Northumbria at Newcastle, England.
<http://www.unn.ac.uk/societies/islamic/quran/index.htm>

Places of Peace and Power: The Sacred Site Pilgrimage of Martin Gray, illustrates the Dome of the Rock
<http://www.sacredsites.com/1st30/domeof.html>

Tareq Rajab Museum, Kuwait, provides illustrated essays on Islamic jewelry, costumes, and textiles
<http://www.kuwait.net/~trm/overview.html>

Temple Mount in Jerusalem provides maps and a history of the Dome of the Rock
<http://www.templemount.org/>

Textual & Visual Resources on Islamic Architecture, Rotch Library and Visual Collection, Massachusetts Institute of Technology, provides views of the Aga Khan Visual Archives
<http://libraries.mit.edu/rvc/>

Topkapi Palace Museum, Istanbul, has illustrated information on the palace and the art in the collection
<http://www.ee.bilkent.edu.tr/~history/topkapi.html>

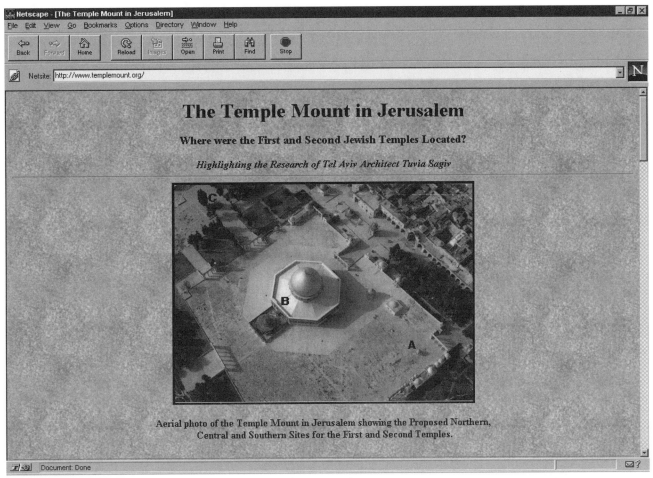

The Temple Mount in Jerusalem Web Page <http://www.templemount.org/>

XV-E. Latin American Studies

Keep in mind that some sources described in other chapters include the art of countries of the Spanish-speaking world. For instance, *Catalog of the Library of the Museum of Modern Art* lists the contents of its Latin American Archive. There is also material on Latin American art in the New York Public Library's *Artists File.* For material on the native Indian cultures of South and Central America, see [XIV-C].

XV-E-1. Latin American Art Bibliographies

Handbook of Latin American Art: A Bibliographic Compilation, Joyce Waddell Bailey, general ed (2 vols., Santa Barbara, CA: ABC-CLIO, 1984+)

Vol. 1: *General References and Art of the Nineteenth and Twentieth Centuries.* Part I: *North America.* Part II: *South America.* Excludes the U.S.; includes monographic studies listed under the artist's name.

Vol. 2: *Art of the Colonial Period,* has indexes to authors, artists, and Hispanic art in the U.S.

Handbook of Latin American Studies (HLAS) is a bibliography for Latin American subjects that has been published continuously since 1935. Edited by the Hispanic Division of the Library of Congress, *HLAS* is available on CD-ROMs and on the Internet. *HLAS Online* is updated monthly.
<http://lcweb.loc.gov/hlas/>

Latin American Women Artists, Kahlo and Look Who Else: A Selected Annotated Bibliography, by Cecilia Puerto (Westport, CT: Greenwood Press, 1996)

Modern Latin American Art: A Bibliography, by James A. Findlay (Westport, CT: Greenwood, 1983). Organized by countries, followed by media. It includes serials and exhibition catalogues, but not information on individual artists.

XV-E-2. History of Latin American Art and Culture

Animal Myths and Metaphors in South America, edited by Gary Urtion (Salt Lake City: University of Utah Press, 1985)

Art and Time in Mexico: From the Conquest to the Revolution, by Elizabeth Wilder Weismann (New York: Harper & Row, 1985)

Art in Latin America: The Modern Era, 1820–1980, by Dawn Ades (New Haven, CT: Yale University Press, 1989)

Art of Brazil, by Carlos Lemos, et al. translated by Jennifer Clay (New York: Harper & Row, 1983)

Behind the Mask in Mexico, edited by Janet Brody Esser (Santa Fe, NM: Museum of International Folk Art, 1988)

Cambridge History of Latin America, edited by Leslie Bethell (5 vols. Cambridge: Cambridge University Press, 1984)

Dimensions of the Americas: Art and Social Change in Latin America and the United States, by Shifra M. Goldman (Chicago: University of Chicago Press, 1994)

Latin America and Its Arts, by Damian Bayon (New York: Holmes & Meier, 1982)

Latin American Art of the 20th Century, by Edward Lucie-Smith (New York: Thames and Hudson, 1993)

Latin American Vanguards: The Art of Contentious Encounters, by Vicky Unruh (Berkeley: University of California Press, 1994)

South American Mythology, by Harold Osborne (London: Paul Hamlyn, 1968; reprint ed., New York: Peter Bedrick Books, 1986)

XV-E-3. Latin American Artists' Biographies

The Archives of American Art [XIV-A-8] lists *Papers of Latino and Latin American Artists,* by Liza Kirwin (Washington, D.C.: Archives of American Art, Smithsonian Institution, 1996). The *ArtsEdNet* Web site has material on Latin American artists, such as Jesús Bautista Moroles <http://artsednet.getty.edu/ArtsEdNet/images/index.html>.

Contemporary Latin American Artists: Exhibitions at the Organization of American States, edited by Annick Sanjurjo (Lanham, MD: Scarecrow Press)

Volume I: *1941–1964,* 1997
Volume II: *1965–1985,* 1993

Latin American Artists: Signatures and Monograms—Colonial Era to 1996, by John Castagno (Lanham, MD: Scarecrow Press, 1997)

Latin American Artists in Their Studios, by Marie-Pierre Colle (New York: Vendome Press, 1994)

XV-E-4. Latin American Studies Web Sites

Azteca Net includes a section for Mexican and Chicano artists
<http://www.azteca.net/aztec/art/index.shtml>

Coloquio indexes Web material
<http://coloquio.com/index.html>

Hispanic/Latino Telaraña indexes material on art and culture
<http://www.latela.com/>

Latin American Studies, WWW Virtual Library, under the Latin American Network Information Center, has an index to 27 separate countries and 41 categories, including art, maps, history, women, literature, publishers, and libraries
<http://info.lanic.utexas.edu/las.html>

Nettie Lee Benson Latin American Collection, University of Texas, has historical Latin American maps
 <http://www.lib.utexas.edu/Libs/Benson/benson.html>

Spain and Latin America on the WWW
 <http://www.sj-coop.net/~cgibbs/spain-la.html>

World Wide Web Server of Perú
 <http://ekeko2.rcp.net.pe/peru/peru_ingles.html>

XV-E-5. Museums and Libraries: Latin American Studies

Bancroft Library, University of California, Berkeley, includes the Western Americana and Latin Americana Collection. Access the University of California library and choose "Bancroft."
 <http://www.lib.berkeley.edu/>

Diego Rivera Virtual Museum includes a biography of Diego Rivera (Mexican, 1886–1957) and a chronology of his murals and other works
 <http://www.diegorivera.com/d iego_home_eng.html>

Florida Museum of Hispanic and Latin American Art, Miami, displays contemporary art
 <http://www.latinoweb.com/museo/>

Fowler Museum of Cultural History, University of California, Los Angeles, has art from Latin America.
 <http://www.fmch.ucla.edu/>

Meadows Museum, Southern Methodist University, Dallas, collects Spanish art and provides links to numerous Hispanic art Web sites
 <http://www.smu.edu/meadows/museum/directory.html>

Museum of Latin American Art: Contemporary Art of the Americas, Long Beach, California
 <http://www.rgfa.com/laam.htm>

Sofia Imber Contemporary Art Museums of Caracas, Venezuela
 <http://www.maccsi.org/>

Tulane University, Latin American Library, Photographic Archive, New Orleans, includes more than 50 major collections, dating from the mid-19th century to the present. Emphasis is on colonial architecture of Peru, Mexico, and Guatemala; pre-Columbian art; and Mexican and Central American archaeological sites. This Web site lists the collections and their contents.
 <http://www.tulane.edu/~latinlib/lalphoto.html>

Webmuseo de Latino América
 <http://museos.web.com.mx/>

University of Texas, Latin American Studies
 <http://lanic.utexas.edu/las.html>

XVI. Additional Art Information

This chapter discusses miscellaneous art subjects: (a) art education using the Internet; (b) some issues concerned with writing about art; (c) copyright, intellectual property rights, and other art legal issues; (d) art conservation and preservation; and (e) issues to consider before buying or selling art.

XVI-A. Art Education: Assistance from the Internet

The World Wide Web is a superior source for self-education! Web surfers can access the Internet and meander through hyperlinks to visual and text material, choosing whatever suits their needs or fancy. To benefit from this electronic revolution, teachers should take advantage of this exciting new medium. One method for learning and sharing ideas through the Internet is to join a discussion group on education issues. A good source for locating these groups is the Web site of Education Listservs <http://www.aspen sys.com/eric/list/>.

In the United States, educational materials are being produced by (a) governments, primarily federal and state; (b) academic institutions; (c) public broadcasting stations; and (d) professional associations. Museums and foundations, such as the Getty Institute, also create excellent educational materials and were discussed earlier. In addition, remember to access the Web sites of professional associations, since they often have pertinent material; see Appendix Two for a list of these organizations.

At the federal level, agencies provide significant information on education grants. For instance, the Department of Education furnishes data on grants, as well as U.S. state arts departments <http://www.ed. gov/>. There is information on the books the department publishes for teachers and students seeking financial aid, and hyperlinks to other sites are available. At its Web site, the National Endowment for the Arts (NEA) includes material on its grants and for some corporations and foundations that offer art funding <http://arts.endow.gov/>. For additional resources for grants, see [VI-F-5].

226

In 1964, the U.S. government created ERIC (Educational Resources Information Center) to collect, evaluate, and disseminate educational research results. Abstracts of this material are published in the monthly journal *Resources in Education (RIE),* created in 1966, and distributed to more than 700 U.S. libraries. In 1969, a second index, *Current Index to Journals in Education (CIJE),* was initiated to cover an additional 780 journals. International in scope, ERIC can be searched on the Internet [VII-B-2]. The *AskERIC* Web site, Syracuse University, provides access to the ERIC database for material dated from 1989 to the present and furnishes information on ordering pertinent materials <http://ericir.syr.edu/About/>.

The National Teaching and Learning Forum: The Newsletter for Faculty by Faculty began in 1991 as a joint venture of the Forum and the ERIC Clearinghouse on Higher Education. The emphasis of the newsletter is to encourage "a conversation about teaching." Its Web site provides a wealth of information on the printed serial[1]—table of contents of the current issue and full-text articles—along with a library of important literature published in the field and hyperlinks to locations concerned with academic teaching and electronic technology <http://www.ntlf.com/>. Search capabilities are also available for (a) teaching and learning grants, which are part of the Oryx Press database for grant information, and (b) sections of *Dissertation Abstracts* [VII-B-2]. In addition, the newsletter features a calendar listing future regional conferences.

Various states within the United States have educational programs on the Internet. Nebraska's program,

called *STATEWIDE Interactive*, assists teachers in planning lessons exclusively centered around this state <http://net.unl.edu/~swi/arts/ntbk.html>. Each month, state news that aired on Nebraska Public Television is connected to an interactive resource for teachers. One such program, "Torn Notebook Blows into Lincoln," is the story of Claes Oldenburg's *Torn Notebook,* a 22-foot aluminum and stainless steel sculpture commissioned by the Sheldon Memorial Art Gallery, Omaha. The news story on the *STATEWIDE Interactive Web site* describes Oldenburg's place in contemporary art, the process of creating the sculpture, its symbolism, and the questions it raised in the community. This Web site provides a fascinating account of the controversy that surrounded a community in the process of obtaining a new public sculpture.

Public Broadcasting Service (PBS) stations are developing extensive material for classroom use with their excellent television productions on art and history <http://www.pbs.org/stations/bystate.html>. Below are some programs that have been accompanied by resources for teachers. Corporate sponsorship has made most of this material possible. Videos of these documentaries are frequently available through local PBS stations. Since there are 156 U.S. PBS stations with Web sites, you may need to access the PBS Web site to determine the URL for your station.

American Visions, an eight-hour BBC production, with a teacher's guide produced by *Time* magazine
<http://www.pathfinder.com/>

Lewis & Clark, a television program produced in 1997 by Ken Burns
<http://www.pbs.org/lewisandclark/class/index.html>

The West, produced by Ken Burns (Time-Life Videos, 1996). Its Web site has extensive material on the U.S. West related to this program.
<http://www.pbs.org/weta/thewest/wpages/wpgs000/w050_001.htm>

XVI-A-1. Activities for Elementary Grades through High School

Since one mandate for museums is the education of its patrons, most institutions have education departments that develop programs, lectures, and workshops for adults and children. Accessed through the museums' Web sites, the education departments usually display a calendar of events and advertise their in-house programs. But the possibilities of a Web site

are endless, and fortunately, a few institutions are turning their Internet locations into exciting places for students and teachers. Some excellent programs were described in [III-A-4]; other examples are cited below.

Some museum and historic house Web sites provide lesson plans for teachers planning to visit their institutions. Teachers should access the Web sites of any museums they intend to visit. They may also wish to see the teachers' guides for taking students to museums developed by the University of Virginia.

Example

Going to a Museum? A Teacher's Guide, compiled under the auspices of the Curry School of Education at the University of Virginia, includes ideas for making a museum trip more enjoyable and educational. For about 20 art lesson plans, this Web site suggests (a) an appropriate grade level and objective; (b) ideas for pre-visit, on-site, and follow-up activities; and (c) sometimes a bibliography. There is a diverse list of subjects, such as African art, art appreciation, elements of design, photographs and history, and sculpture. In addition, there are plans for visiting specific Washington, D.C., museums: the Corcoran Gallery of Art, National Gallery of Art, National Portrait Gallery, and Phillips Collection <http://curry.edschool.virginia.edu/curry/class/Museums/Teacher_Guide/>.

At their Web sites, some museums feature special teachers' guides for the exhibitions and special events their institutions are hosting. These often include data on the lives of the artists, the works of art in the museum's collection, glossaries, and brief bibliographies. You should revisit these educational sites periodically, because some institutions continually produce fresh programs and challenging material.

Example

In 1997, Washington's National Gallery of Art highlighted its restoration of the plaster cast *Augustus Saint-Gaudens' Memorial to Robert Gould Shaw and the Massachusetts Fifty-fourth Regiment.* For this sculpture honoring the first African American Civil War unit, the Web site provides data on the artist, a history of the army regiment, and the creation of the memorial, plus lists resources and related works of art. There is also a bibliography and links to four related Web sites, including the home page of the Saint-Gaudens National Historic Site <http://www.valley.net/~stgaud/saga.html>. In addition, lesson plans for grades 3–8 and grades 9–12 are suggested <http://www.nga.gov/highlights/shawwel.htm>.

Making their Web site a stimulating place for children is the goal of museum educators. They plan programs that can be enjoyed at home, as well as by visiting the institution. Some have created online self-guided tours [III-A-4]. By analyzing specific works of art, some museum educators are providing online explanations of art appreciation methodology. Other educators, aware of the requirements of disabled patrons, are creating Internet programs to meet their special needs.

Examples

1. The Royal Ontario Museum in Toronto has always had an active educational program interested in making art informative and enjoyable. The *Fun Stuff* section provides games for analyzing archaeological pieces, comparing cuneiform to computers, using the hieroglyphic alphabet to spell a child's name, and making the child's own Egyptian mummy <http://www.rom.on.ca/eyouths/funstm.htm>.

2. The National Maritime Museum, Greenwich, just outside of London, provides two unusual tour programs: signed talks for the hearing impaired and touch talks for the visually impaired. At its Web site, there are biographical data on two deaf astronomers—John Goodricke (1764–86) and Konstantin Tsiolkowski (1857–1935)—and their works <http://www.nmm.ac.uk/ei/access/dastron.html>.

The Getty Institute for Education in the Arts has taken the lead in producing art education materials for students in grades K through 12. Discussed in [V-G-3] is the Getty's formation of (a) *ArtsEdNet* to develop online service programs that furnish links to other appropriate Internet sites, and (b) the Regional Professional Development Consortia to establish discipline-based art education (DBAE) programs <http://www.artsednet.getty.edu/>.

One Getty consortia member is the North Texas Institute of Educators on the Visual Arts (NTIEVA).[2] Using the integrated DBAE approach to art education,

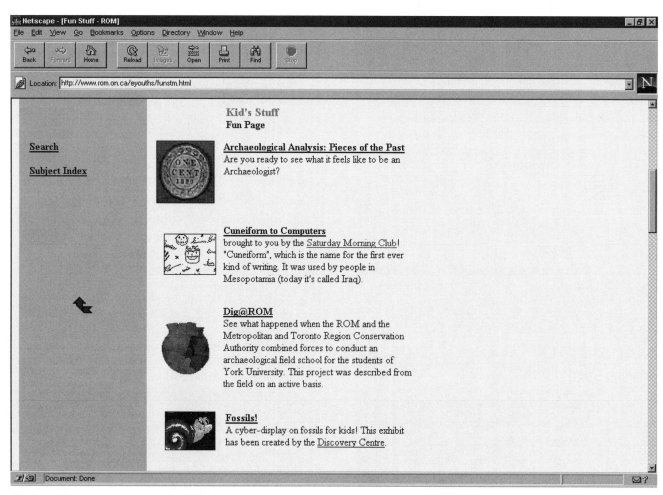

The Royal Ontario Museum's Fun Stuff Web Page <http://www.rom.on.ca/eyouths/funstm.html>

NTIEVA develops comprehensive art curriculum content materials for art and classroom teachers. Its Web site has extensive material on each of the four DBAE subdisciplines: art production, art history, art criticism, and aesthetics. Each content area is defined and its role explained. How DBAE issues can be addressed in the classroom is detailed, and lists of references are provided. In addition, there are several DBAE-based curricula examples on such topics as (a) Asian and Asian American art and culture, (b) Latino and Latin American art and culture, (c) public art, and (d) African American art and culture. At its Web site, NTIEVA has produced quality content material for teachers; check to see if any of it can be adapted to your classes <http://www.art.unt.edu/ntieva/artcurr/>.

Example

In the section developed on Japanese art and culture, NTIEVA provides teachers' guides that discuss (a) Japanese aesthetics, Wabi Sabi, and the tea ceremony; (b) traditional Japanese and Western aesthetics; and (c) the influence of Japanese art on Western artists, such as Mary Cassatt, Claude Monet, and Vincent van Gogh <http://www.art.unt.edu/ntieva/artcurr/japan/index.htm>.

Additional Web Sites

Many of the college teaching programs, such as those listed below, can be adjusted for different levels of students.

Aesthetics On-Line, Indiana University
<http://www.indiana.edu/~asanl/>

Annenberg/CPB Channel
<http://www.learner.org/channel/>

ArtsEdge: The Kennedy Center
<http://artsedge.Kennedy-center.org/>

ArtsWire
<http://artswire.org/Artswire/www.awfront.html>

Case of Grandpa's Painting explores color, composition, style, and subject to discover who painted the work.
<http://www.eduweb.com/pintura/>

Chicana and Chicano Space: A Thematic, Inquiry-Based Art Education Resource
<http://mati.eas.asu.edu:8421/ChicanArte/html_pages/Protest.TOC.html>

Cisco Educational Archives (CEARCH) provides links to examples of teaching using the Internet
<http://sunsite.unc.edu/cisco/>

Documenting the Past, Celebrating the Present, Directing the Future, Museum of African American History, *The Internet Public Library*
<http://www.ilp.org/exhibit/maah/>

EDSITEment, National Endowment for the Humanities, provides online teaching resources
<http://206.161.132.66/>

Education for Kids, Metropolitan Museum of Art, has such programs as *Winslow Homer* (American, 1836–1910) and *What Is It?*
<http://www.metmuseum.org/htmlfile/education.edu.html>

Education Index provides links to Web sites by subject and age of group, from primary to college education
<http://www.educationindex.com/index.html>

Educationally Interpretive Exhibition: Rethinking the Display of Student Art
<http://www.kutztown.edu/paea/res_opp/bass_book.html>

Exploring Leonardo, Science Learning Network, Museum of Science, Boston
<http://www.mos.org/sln/Leonardo/>

Gila Kasla is an interactive game using the collection of 2,000 prints from the Northwest Coast First Nations, Maltwood Art Museum, University of Victoria
<http://www.maltwood.uvic.ca/>

Inside Art creates interest in works of art by looking at a mystery painting
<http://hukilau.com/kidsrule/dbkids/arthistory.html>

Institute for Learning Technologies (ILT) Teachers College, Columbia University
<http://www.ilt.columbia.edu/k12/>

Learning by Design, American Institute of Architects
<http://www.aia.org/>

Masks and Meaning in Tiepolo's Venice, Berkeley Art Museum
<http://www.bampfa.berkeley.edu/exhibits/tiepolo/>

Minnesota Center for Arts Education
<http://www.mcae.k12.mn.us/>

National PTA, *Arts in Education Resource Libraries*
<http://www.pta.org/issues/arts.libr.htm>

Native American History Archive: A New Center for Native American Studies in Internet Worked Classrooms, is a feature of the K–12 education home page hosted by the Institute for Learning Technologies (ILT) of Teachers College, Columbia University
<http://www.ilt.columbia.edu/k12/naha/index.html>

Royal Ontario Museum, Toronto, *Fun Stuff*, see above.
<http://www.rom.on.ca/eyouths/funpgm.htm>

Teaching with Historic Places, U.S. National Park Service
<http://www.cr.nps.gov/nr/twhp/home.html>

Time Magazine produced a Web Classroom Edition for teachers and viewers of the 1997 PBS program *American Visions*, by Robert Hughes, *Time*'s art critic
<http://pathfinder.com/>

University of Iowa, in collaboration with local educational agencies, is developing teacher packets containing slides and text. The varied programs presently center around Africa and India.
<http://www.uiowa.edu/~cics/rft_home.html>

WebQuest Page
<http://edweb.sdsu.edu/webquest/webquest.html>

Welcome to West Web
<http://www.library.csi.cuny.edu/westweb/>

Why Study History, by Peter N. Stearns, American Historical Association
<http://chnm.gmu.edu/aha/mainpage.html>

XVI-A-2. College Teaching

Academic institutions are hosts to vast amounts of educational material—some technical, some pedagogic. For example, Vassar College Libraries provides an index to *Classroom Applications of Educational Technology* with hyperlinks to various programs throughout the United States <http://iberia.vassar.edu/vcl/electronics/etc/acad/edtech/classroom.html>.

The Instructional Development Office, George Mason University, Falls Church, Virginia, provides current technical information for its professors. Faculty projects, research literature, and hyperlinks are highlighted. Technical tools for teaching and learning and emerging technologies are explained. For the latter, hyperlinks to the companies that produce these innovations provide additional data. This Web site will assist you in keeping current with this ever-changing electronic world <http://www.ido.gmu.edu/>.

In its September 1997 newsletter, the College Art Association published an article, "The Electronic Syllabus," by Leila Kinney. The essay, which is also available through the CAA Web site, discusses the advantages of using the Internet in teaching and refers to the "productive cross-fertilization of ideas." It encourages teachers to critique some of the Internet material for their students. In addition, there are examples of teaching programs using the Internet with hyperlinks to their sources <http://www.collegeart.org/caa/news/1997/5/elecbb.html>.

One program mentioned by Professor Kinney is the American Studies Crossroads Project[3] at Georgetown University, Washington, D.C. At its Web site, the Crossroads Project furnishes detailed information on curriculum development, technology and learning, and research. There are also pertinent hyperlinks. In collaboration with the American Studies Association, the project has published *Engines of Inquiry: A Practical Guide for Using Technology to Teach American Culture in 1997.* See this extensive Internet location for more data on the book and the related activities <http://www.georgetown.edu:80/crossroads/guide/>.

Some academic institutions are using the electronic highway to provide students with experiences that might otherwise be impossible, due to the high costs of publishing catalogues. For instance, in art history and museum classes, the Internet is frequently used to display an experimental online catalogue produced as a class project with the cooperation of the academic institution's museum personnel. The art objects are illustrated, and exploratory essays are written by the students or the museum staff.

Examples

1. For the traveling exhibition "Inspired by Dreams: African Art from the Derby Collection," 12 students in a 1996 seminar created an online catalogue for the show displayed at Vermont's Middlebury College Museum of Art. The students organized the art by such categories as masking, divination, sacred power, political authority, and textiles <http://www.middlebury.edu/~atherton/AR325/index.html>.

2. For a 1995–96 seminar at Dickinson College, Carlisle, Pennsylvania, students researched and wrote footnoted entries for the online catalogue, *Objects of Diversity: Process and Interpretation,* which includes 30 works of art owned by the college's Trout Gallery. Because the introduction explains the various approaches the students used in their research, this site discusses a methodology for creating electronic catalogues <http://media.dickinson.edu/gallery/objects.html>.

Additional Web Sites

Some art history indexes to Web sites include material on teaching, such as *Labyrinth Pedagogical Resources* <http://www.georgetown.edu/labyrinth/>.

Art Teacher Education
 <http://ag.arizona.edu/~lgalbrai/>

Philosophy of Art and Beauty, a course taught on the Internet, by Julie Van Camp
 <http://www.csulb.edu/~jvancamp/361/>

Teaching with Perseus, see the *Perseus Project* [IV-A-3]
 <http://www.perseus.tufts.edu/Teaching.html>
 and the University of Wisconsin Web site, *Using Perseus*, by Nick Cahill
 <http://www.wisc.edu/arth/ah302/302descr.html>

University of Pennsylvania *World Wide Web Information*
 <http://ccat.sas.upenn.edu/jod/teachdemo/www.html>

XVI-B. Writing about Art

At their Web sites, academic institutions frequently host student writing guides, sometimes called OWLs (Online Writing Labs). Students should access similar guides at their school. If there is none, consult another academic institution and/or the extensive material provided by the *Internet Public Library* <http://www.ipl.org/>.

The *Internet Public Library (IPL)* has a section on Research and Writing that is placed under its Teen Section. Do not be fooled by the categorization. This is a comprehensive, step-by-step introduction to the serious business of writing. The six basic steps include (a) getting started, (b) discovering and choosing a topic, (c) looking for and forming a focus, (d) gathering information, (e) preparing to write, and (f) writing the paper. Each section has hyperlinks to OWL handouts on such topics as plagiarism, styles of citation, and writing style and technique. The links jump to such academic institutions as those cited below; IPL also has a list of OWLs.

OWL Web Sites

Brigham Young University
 <http://www.English.byu.edu/writing.ctr/handouts/>
Colgate University
 <http://www2.colgate.edu/diw/>
Princeton University
 <http://webware.princeton.edu/Writing/>
Purdue University
 <http://owl.english.purdue.edu/Files/>
University of Illinois at Urbana-Champaign
 <http://www.english.uiuc.edu/cws/wworkshop/mainmenu.html>
University of Richmond
 <http://www.urich/edu/~writing/>
University of Victoria, Canada
 <http://webserver.maclab.comp.uvic.ca/writersguide/>
University of Wisconsin-Madison
 <http://www.wisc.edu/writing/Handouts/>

XVI-B-1. Writing Guides

Art Theory Essay Writing Guide, by Ross Woodrow, Australia
 <http://www.newcastle.edu.au/department/fad/fi/essay.htm>
A Short Guide to Writing about Art, by Sylvan Barnet (5th ed. New York: Longman, 1997)
Students' Guide for Writing College Papers, by Kate L. Turabian (5th ed. Chicago: University of Chicago Press, 1987)

Writing about Art, by Henry M. Sayre (Englewood Cliffs, NJ: Prentice Hall, 1995)
Writing for Professional Publication, by William Van Til (2nd ed. Boston: Allyn and Bacon, 1986)

XVI-B-2. Style Manuals

Chicago Manual of Style for Authors, Editors, and Copywriters (14th ed. revised and expanded. Chicago: University of Chicago Press, 1993). With the 13th edition (1982), the title was changed from *The Manual of Style.* It includes sections on manuscript preparation and rights and permissions to republish or quote and provides sample request forms to reprint material.

Electronic Styles: A Handbook for Citing Electronic Information, by Xia Li and Nancy B. Crane (2nd ed. Medford, NJ: Information Today, 1996)

Manual for Writers of Term Papers, Theses, and Dissertations, by Kate L. Turabian (6th ed, revised and expanded.Chicago: University of Chicago Press, 1996). Based on *Chicago Manual of Style.*

MLA Handbook: For Writers of Research Papers, Theses, and Dissertations, by Joseph Gibaldi (4th. ed. New York: Modern Language Association, 1995)

Modern Researcher, by Jacques Barzun and Henry F. Graff (4th ed. New York: Harcourt, Brace, Jovanovich, 1985)

Publication Manual of the American Psychological Association (4th ed. Washington, D.C.: American Psychological Association, 1994)

XVI-B-3. Citing Electronic Resources

Remember, not all style manuals use the same system of citing information sources. For example, the method used by the American Psychological Association (APA) is vastly different from the one used by the Modern Language Association (MLA). Moreover, many publications require that you follow a specific manual. Be sure to follow the one your professor or publisher specifies.

APA Publication Manual Crib Sheet
 <http://www.gasou.edu/psychweb/tipsheet/apacrib.htm#Examples>
Electronic Sources: MLA Style of Citation, by Xia Li and Nancy Crane, University of Vermont
 For the MLA Style: <http://www.uvm.edu/~xli/reference/mla.html>
 For the APA Style: <http://www.uvm.edu/~xli/reference/apa.html>

Internet Public Library lists various sources for citing electronic resources
 <http://www.ipl.org/ref/QUE/FARQ/
 netciteFARQ.html>
Society for American Archaeology publishes style guides for submitting papers
 <http://www.saa.org/PublicationstyleGuide/
 stygu3_0.html>

XVI-B-4. Permission for Visual Material

When publishing an illustrated article or book, you need (a) good visual material, perhaps black-and-white photographs and/or color transparencies, and (b) the right to reproduce them. Keep in mind that there are two kinds of copyright for photographs of artworks: one for the art, one for the photograph. So even if the art is old and no longer enjoys copyright status, the person who photographed it may own the copyright for the picture.

Museums have special departments, often called "Rights and Permissions" or "Image Rights," to handle this legal matter. For instance, at its Web site, the Art Institute of Chicago details the procedures for obtaining a copy of an image and permission to use it for research purposes as well as for commercial licensing <http://widow.artic.edu/aic/rights/rights.html>. Commercial firms [II-E] can advise you as to methods for obtaining legal rights to the images they sell.

XVI-C. Copyright, Intellectual Property Rights, and Other Legal Issues

One of the most important Internet issues today is that of copyright and intellectual property rights. Since technology is usually ahead of the law, there may not be legal precedence for some of the issues confronting this enormous international unregulated network of computers. For instance, do people scanning material from magazines, books, and slides onto the Web have permission to do so? Do they need permission? The concern of museum administrators has resulted in warnings on some institutions' home pages. For instance, the Museum of Fine Arts, Boston, cautions that anyone using anything from the museum's online site must receive "prior written permission" and then furnishes the departments and fax numbers to use in applying for permission <http://www.mfa.org/>.

One issue prevalent on the Internet is the fair use provision in the U.S. Copyright Act. Because of the vagueness of this legal document's wording, the distinction between copyright infringement and the fair use of copyrighted material is not always crystal clear.

One outcome of the 1993 Information Infrastructure Task Force (IITF) was the convening of the Conference on Fair Use, called CONFU. Some material on the Internet revolves around the issues CONFU discussed.

The Web has also become a significant resource for the dissemination of information concerning legal issues. The following section is organized by (a) government agencies that explain how to obtain copyright registration forms and provide hyperlinks to current information, (b) Web sites for copyright issues, and (c) locations that discuss some interesting and relevant legal cases.

XVI-C-1. Government Agencies

European Commission Legal Advisory Board for the Information Markets
 <http://www2.echo.lu/>
Library of Congress, Copyright Resources
 <http://lcweb.loc.gov/copyright/resces.html>
United States Copyright Office provides information and registration forms. Write to Copyright Office, Library of Congress, Washington, D.C. 20559, or use their Web site:
 <http://lcweb.loc.gov/copyright/>
United States Patent and Trademark Office furnishes information on CONFU
 <http://www.uspto.gov/web/offices/dcom/olia/confu/>

XVI-C-2. Web Sites for Copyright Issues

ArtsWire hyperlinks reflect the serial's interest in the legal aspects of art
<http://artswire.org/awfront.html>

Copyright and Intellectual Property Web Site, Stanford University, is a major source for the dissemination of copyright information. For those who are not familiar with this subject, read the online article "Copyright Law, Libraries, and Universities: Overview, Recent Developments, and Future Issues", by Kenneth D. Crews, J.D., Ph.D., a law professor at San Jose State University California. Although prepared in 1992, this excellent essay is still relevant.
<http://palimpsest.stanford.edu/bytopic/intprop/crews.html>

Copyright Clearance Center, Visual Resource Association (VRA), furnishes an online bibliography of reports, papers, and resources available through the Internet
<http://www.vra.oberlin.edu/copyright.html>

Copyright Website, developed by Benedict O'Mahoney, provides relevant information on copyright fundamentals and registration, a consideration of the question of fair use and public domain, and a list of famous copyright infringements. It includes definitions of terms used in copyright issues and hyperlinks to World Wide Web sites interested in these issues.
<http://www.benedict.com/home.html/>

Internet Public Library, Especially for Librarians considers such issues as hyperlinks to Web sites covering censorship, copyright, and Internet access.
<http://ipl.org/svcs/issues.html>

Penn State's University Libraries furnish information and hyperlinks to material on fair use guidelines for educational multimedia
<http://www.libraries.psu.edu/avs/>

Stanford University Libraries *Copyright and Fair Use Page*
<http://fairuse.stanford.edu/>

University of California at Berkeley has *Fair Use Guidelines for Educational Multimedia*
<http://sims.berkeley.edu/courses/ids113/fairuse.html>

Visual Resources Association provides numerous articles on copyright and fair usage, both in their publications and at their Web site
<http://www.oberlin.edu/art/vra/new.html>

See Maryly Snow's "Digital Images and Fair Use Web Sites." *VRA Bulletin* (Winter 1997) or
<http://www.utsystem.edu/ogc/intellectualproperty/portland.htm>

Web Bibliography on Art and Copyright, compiled by Jeanette Mills and Cynthia Caci
<http://weber.u.washington.edu/~jcmills/class/biblio.html#biblio>

XVI-C-3. Interesting Art Legal Cases

American Association of University Professors' File Room: Censorship discusses legal cases ranging from the 1933 mural painted by Diego Rivera for Rockefeller Center in New York to the 1994 problems Karl Lagerfeld, a designer for the House of Chanel, had when a few Arabic words from the Koran were embroidered on some of his dresses.
<http://fileroom.aaup.uic.edu/FileRoom/documents/TofCont.html>

College Art Association, Legal News is a regular addition to the association's Web site, its focus is on issues important to artists
<http://www.collegeart.org/>

Gennie Chronicles, the Web site that used Barbie dolls to poke fun at famous works of art, was mentioned in *Newsweek*'s "Cyberscope" page. Later its photographs were blanked-out due to threatened legal action
<http://www.erols.com/browndk/index.html>

Museum Security Network: Lessons from the Denney Collection concerns the art collector and some of the problems that can arise when an art collection is lent to a museum and the collector dies
<http://museum-security.org/denney.html>

Robert Rauschenberg: The Vulture of Culture describes how a photographer successfully sued the artist for using his copyrighted photograph in a collage without his permission
<http://www.benedict.com/rausch.htm>

XVI-D. Conservation and Preservation

The Internet has become an international information highway for conservation and preservation. This section cites (a) some conservation and preservation Web sites, and (b) books with information on artists' pigments, health hazards, and conservation research.

Conservation/Preservation Web Sites

America's National Trust for Historic Preservation (NTHP) provides a list of videos concerned with historic preservation and a section on current U.S. legal decisions affecting restoration
<http://www.nthp.org/>

Amsterdam Park includes "The Invisible Rembrandt," by Ernst van de Wetering, who discusses the results of various

technical and scientific examinations to which Rembrandt's paintings were subjected [V-A]

<http://amsterdam.park.org:8888/Netherlands/pavilions/culture/rembrandt/>

Canadian Conservation Institute
<http://www.pch.qc.ca/cci-icc/english/ENGLISH.HTM>

Conservation Department, National Gallery of Art
<http://www.nga.gov/>

Conservation Department, National Museum of American Art, *The Death of Cleopatra*
<http://nmaa-ryder.si.edu/lewis/fate.html>

Conservation Department, Philadelphia Museum of Art, details their work for such exhibitions as "Clothing: Best Dressed," "Decorative Arts: 18th Century English Ormerod Bedcover and Adam/Linnell Sofa," and "Sculpture: Rodin's *The Thinker,* Rodin Museum"
<http://www.philamuseum.org/html/conserv.html>

CoOL: Conservation OnLine, a project developed by Walter Henry, Stanford University Libraries, provides data on the conservation of library and museum materials. CoOL also furnishes full-text information published in journals, annuals, and newsletters, and provides access to special preservation Web sites. The varied topics include copyright and intellectual property, digital imaging, health and safety, library binding, mold and pest management, as well as bibliographies and resource guides.
<http://palimpsest.stanford.edu/>

French Ministry of Culture discusses and illustrates the results of using radiography and ultraviolet and infrared technology, as well as natural and raking light. The emphasis is on the scientific examination and restoration of two paintings by JeanBaptiste Camille Corot: *Chartres Cathedral* and *Woman with a Pearl,* both in the Musée du Louvre [V-C].
<http://www.culture.fr/culture/corot/expos/corot.htm>

Getty Conservation Institute
<http://www.getty.edu/gci/>

Library of Congress Preservation provides links to other relevant sites.
<http://lcweb.loc.gov/preserv/preserve.html>

Malcolm and Carolyn Wiener Laboratory for Aegean and Near Eastern Dendrochronology, Cornell University
<http://www.arts.cornell.edu/dendro/index.html>

Save Outdoor Sculpture (SOS), National Institute for the Conservation of Cultural Property
<http://www.nic.org/SOS/>

Artists' Materials and Conservation Research

Airborne Particles in Museums, Research in Conservation Technical Report, Series 6, by William W. Nazaroff, et al. (Los Angeles: Getty Conservation Institute, 1993)

Ancient and Historic Metals: Conservation and Scientific Research, edited by David A. Scott, Jerry Podany, and Brian Considine (Los Angeles: Getty Conservation Institute, 1993)

Art in the Making Series, by David Bomford, et al. (London: National Gallery Publications)
 Impressionism, 1991
 Italian Painting Before 1400, 1989
 Rembrandt, 1988

The Artist's Handbook of Materials and Techniques, by Ralph Mayer; 5th ed. revised and updated by Steven Sheehan (New York: Viking, 1991)

Artist's Pigments: A Handbook of Their History and Characteristics (Washington, D.C.: National Gallery of Art Distributed by Oxford University Press).
 Volume 1, edited by Robert L. Feller, 1986
 Volume 2, edited by Ashok Roy, 1994

Conservation of Wall Paintings, edited by Sharon Cather (Los Angeles: Getty Conservation Institute, 1992)

Health Hazards Manual for Artists, by Michael McCann (4th rev. ed. New York: Lyons & Burford, 1994)

Making Art Safely: Alternatives in Drawing, Painting, Printmaking, Graphic Design, and Photography, by Merle Spandorfer, Deborah Curtiss, and Jack Snyder (New York: Van Nostrand Reinhold, 1993)

Painting Materials: A Short Encyclopedia, by Rutherford John Gettens and George L. Stout (New York: Dover, 1966)

The Unbroken Thread: Conserving the Textile Traditions of Oaxaca, edited by Kathryn Klein (Malibu, CA: Getty Conservation Institute, 1997)

XVI-E. Buying and Selling Art

Before buying or selling art, you should learn as much about the marketplace as possible. The following section is concerned with (a) artists selling their creations, (b) legal resources for artists and collectors, and (c) art thefts, lost art, and forgeries.

XVI-E-1. Artists Selling Their Art

Creating art sometimes seems to be the easy part; marketing it can often be more difficult! Artists should be cognizant of the methods by which they can sell art and the legal ramifications of their actions.

Some artists have their own Web sites to display their wares; others use galleries. To develop your own Web studio, see some of the technology locations on the Internet that explain this methodology [I-F] and view some of the artists' sites to help you determine how you wish to design yours. Consult the list at *WWAR* <http://wwar.com/> and the lists provided in [VIII-F].

There are a number of galleries and Web sites that will display your art for a fee. *Art on the Net* provides guidelines for submitting artwork to an organization, including instructions for scanning the art and sending it via the Internet for review <http://www.art.net/Submissions/submissions.html>. Be sure to read the disclaimers.

Those in the field of art should be aware of the legal pitfalls that may affect them both now and in the future. Artists should be aware of such issues as resale rights *(droit de suite),* copyright protection, and business contracts, as well as obscenity laws and censorship. Read "Copyright Registration" at the *Copyright Website* for information on the importance of providing your work with legal protection <http://www.benedict.com/home.html/>. The Web sites cited below will provide you with articles and hyperlinks to other sites concerned with these issues. Reading some of the books and case histories listed here will help you become familiar with the terminology and issues; however, they are not a substitute for advice from someone in the legal profession.

XVI-E-2. Legal Resources for Artists and Collectors

Although most of these references were published more than a decade ago, some have sample legal forms for contracts and sales agreements, commission agreements, releases, print documentation, and deeds of gifts that may still be pertinent. For additional references, see Stephen Allan Patrick's "Legal Resources in Art: A Bibliographic Search Strategy," *Art Reference Services Quarterly,* Vol. 1 (1993), pages 63–83. When laws change, so must these books; always seek the latest editions.

Art Law: Rights and Liabilities of Creators and Collectors, by Franklin Feldman and Stephen E. Weil (2 vols. Boston: Little, Brown, 1986. Supplement, 1988)

Art Marketing Sourcebook for the Fine Artist, edited by Constance Franklin-Smith (Renaissance, CA: ArtNetwork Press, 1992)

Artist's Friendly Legal Guide (Rev. ed. Cincinnati: North Light Books, 1991)

Graphic Artist's Guide to Marketing and Self-Promotion, by Sally Prince Davis (Rev. ed. Cincinnati: North Light Books, 1991)

The Law (in Plain English) for Photographers, by Leonard D. DuBoff (New York: Allwood Press, 1995)

XVI-E-3. Art Thefts, Lost Art, and Forgeries

The International Foundation for Art Research (IFAR), London and New York City, is a nonprofit organization dedicated to preventing the circulation of stolen, forged, and misattributed works of art. In 1991, IFAR joined with The Art Loss Register (ALR) to form an information clearinghouse database, which now has a listing of more than 70,000 stolen items. Through its magazine, *IFARreports* and *The Art Loss Register,* and its Web site, ALR provides an avenue by which stolen art can be reported internationally. For a small fee, all kinds of art can be registered <http://www.artloss.com/repus.htm>.

When art is purchased, the owner is responsible for providing it with an object identification. For this process, you will need the work's essential data and a good color photograph. By following the suggestions of the Getty Information Institute, owners will be able to safeguard their art and aid in its recovery should it be stolen <http://www.gii.getty.edu/pco/objectid/index.html>. *The Art Loss Register* also has recommendations of the type of information needed in case of a calamity <http://www.artloss.com/repus.htm>. Collectors should keep adequate information on their works of art for insurance purposes and in case of theft; see Chapter XII for types of information.

The Internet is also becoming an avenue for identifying art that is located in occupied lands, which may eventually be linked to the plunder of art [XI-D-4]. Once stolen art is identified, information concerning it is circulated to dealers, collectors, and the police throughout the world. There is also (a) an Art Theft Search Service, which will determine if a potential purchase has been registered as stolen, and (b) an Art Authentication Service, which resolves controversies concerning authenticity. For both, there is a charge. The Web site provides data concerning the stolen or lost articles <http://www.artloss.com/>.

Stolen Art—Resources

Art Crime, by John E. Conklin (Westport, CT: Praeger, 1994)

The Art Loss Register describes cases of recovered art
<http://www.artloss.com/>

Art Theft/Most Wanted Art provides a list and some illustrations of the 10 greatest unsolved art thefts since 1972
<http://www.saztv.com/>

"Degenerate Art": The Fate of the Avant-Garde in Nazi Germany, by Stephanie Barron (New York: Harry N. Abrams, 1991) [XII-D]

See *First Search* example for the Isabella Stewart Gardner Museum 1990 art theft [VII-D-2]

Maine Antique Digest has a section highlighting stolen art and antiques
<http://www.maineantiquedigest.com/other/stolist.htm>

Rogues in the Gallery: The Modern Plague of Art Thefts, by Hugh McLeave (Boston: D. R. Godine, 1981)

Authenticating works of art is difficult due to many factors, and some authentication requires using scientific techniques. The books and Web sites cited below will not make you an expert able to detect fakes and forgeries, but they provide fascinating reading. When trying to ascertain the authenticity of a work of art, experts try to determine whether the work is the creation of the artist whose name is attached or a fake. One method used is to compare artists' signatures. For this type of detective work, experts need to obtain reproductions of the artist's signature from other sources [XI-C-4]. It is necessary, however, to be aware that artists often change the style of their signature over the years.

Example

Was a work by the stated artist, or is it a fake or a work by one of the artist's students? These complicated matters are illuminated in the printed exhibition catalogue *Rembrandt/Not Rembrandt in the Metropolitan Museum of Art: Aspects of Connoisseurship* (2 volumes. New York: Metropolitan Museum, 1995). Volume I: *Paintings: Problems and Issues,* by Hubert von Sonnenburg, discusses various scientific techniques for determining authenticity as well as consistencies and inconsistencies in the Dutch artist's style. Volume II: *Paintings, Drawings, and Prints: Art Historical Perspectives,* by Walter Liedtke, et al., reviews Rembrandt and his style in relation to the 17th century and then details the works that were in the exhibition, many of which are no longer considered to be by the Dutch master. Anyone interested in this subject should read about the work of the Rembrandt Research Project [V-A].

Fakes and Forgeries—Resources

Art of the Fake: Egyptian Forgeries from the Kelsey Museum of Archeology, Internet Public Library
<http://www.ipl.org/exhibit/kelsey/>

Art of the Forger, by Christopher Wright (London: Gordon Fraser, 1984)

Art or Forgery? The Strange Case of Han van Meegeren, Center for the Advancement of Applied Ethics, Philosophy Department, Carnegie Mellon University, Pittsburgh
<http://www.ici.cmu.edu/CAAE/Home/Multimedia/Meegeren.html>

Fakes and Forgery and the Art World, by Alice Beckett (London: Cohen Books, 1995)

Faking It: Art and the Politics of Forgery, by Ian Haywood (New York: St. Martin's Press, 1987)

Vincent van Gogh: The Fakes Controversy
<http://www.interlog.com/~vangogh/fakes.htm>

Why Fakes Matter: Essays on Problems of Authenticity/Fake, the Art of Deception, edited by Mark Jones (London: British Museum Press, 1992)

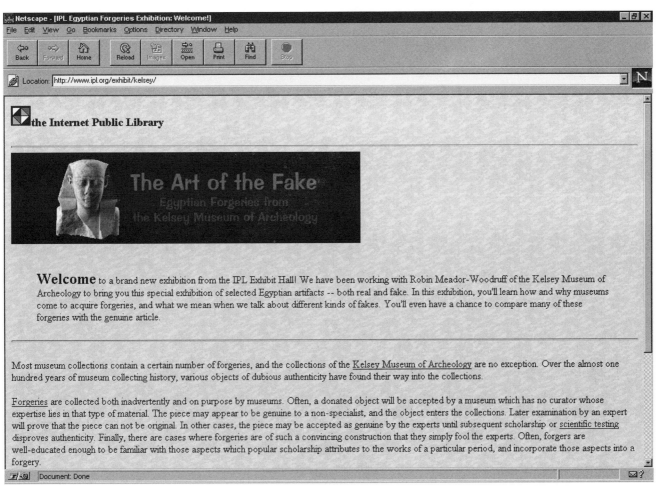

The Kelsey Museum's Art of the Fake Web Page <http://www.ipl.org/exhibit/kelsey/>

Notes

1. The printed serial has been published since 1992 by Oryx Press in conjunction with James Rhem & Associates.

2. The membership of the North Texas Institute of Educators on the Visual Arts includes the University of North Texas and five area museums: the Amon Carter Museum, the Kimbell Art Museum, the Meadows Museum, the Modern Art Museum of Fort Worth, and the Dallas Museum of Art. The Texas Commission on the Arts and five area independent school districts are also members. The co-directors of NTIEVA are D. Jack Davis and R. William McCarter, University of North Texas professors. Nancy Walkup and Pam Stephes are the project coordinators.

3. The American Studies Crossroads Project is funded by the U.S. Department of Education FIPSE Program, the Annenberg/CPB Project, and the American Studies Program.

APPENDIXES

APPENDIX ONE.
ARTISTS' PAST COMPETITIVE EXHIBITIONS

Competitive exhibitions to which artists have submitted their work can provide invaluable information for documenting the artists' lives and works. Reading some books that explain the history of artists' exhibitions will help you understand their importance. For information on competitive exhibitions, see [XI-A-6]; for criticism of artists' works, see [XII-C]. This section is organized by (a) references on the history and criticism of artists' group exhibitions, (b) indexes to group exhibitions, and (c) methods for locating reprints of group exhibition catalogues.

History and Criticism of Artists' Group Exhibitions

Academies of Art Past and Present, by Nikolaus Pevsner (New York: Macmillan, 1940; reprint ed., 1973)

The Academy and French Painting of the 19th Century, by Albert Boime (London: Phaidon, 1971). Discusses the French Academy and the Ecole des Beaux-Arts.

Art Criticism As Narrative: Diderot's Salon of 1767, by Julie Wegner Arnold (New York: P. Lang, 1995)

Art of All Nations, 1850–73: The Emerging Role of Exhibitions and Critics, edited by Elizabeth Gilmore Holt (Princeton, NJ: Princeton University Press, 1981). Covers European exhibitions in France, England, Germany, Italy, and Austria. It includes an index to artists, critics, painting titles, associations, patrons, and political figures mentioned in the text.

Bibliography of the Salon Criticism in Second Empire Paris, by Christopher Parsons and Martha Ward (Cambridge: Cambridge University Press, 1986)

Le concours des prix de Rome explains the prizes awarded, called the prix de Rome; see [V-C] for details
 <http://www.culture.fr/ENSBA/VF.html>

Diderot: A Critical Biography, by P. N. Furbank (New York: Alfred A. Knopf, 1992)

Diderot on Art, edited and translated by John Goodman (2 vols. New Haven: Yale University Press, 1995)

The Grand Prix de Rome: Paintings from the École des Beaux-Arts, 1797–1863, by Philippe Grunchec (Washington, D.C.: International Exhibitions Foundation, 1984)

History of the Royal Academy, 1768–1968, by Sidney C. Hutchison (New York: Taplinger Publishing, 1968)

Loves of the Gods: Mythological Painting from Watteau to David, by Colin B. Bailey (New York: Rizzoli International Publications, 1991). Lists the mythological paintings exhibited at the French Salons, 1699–1791.

New Painting Impressionism: 1874–1886 (Fine Arts Museums of San Francisco, 1986). Reproduces the eight bulletins distributed at the 19th-century Impressionist exhibitions.

Passionate Spirits: A History of the Royal Canadian Academy of Arts, 1880–1980, by Rebecca Sisler (Toronto: Clarke, Irwin, 1980)

Triumph of Art for the Public: The Emerging Role of Exhibitions and Critics, edited by Elizabeth Gilmore Holt (Garden City, NY: Anchor, 1979). Covers exhibitions from 1785 to 1848 in France, England, Italy, and Germany, with a short introduction to the history of criticism and art exhibitions.

Victorian Painting: Essays and Reviews, edited by John Charles Olmsted (3 vols. New York: Garland, 1983–85). Includes an introductory survey of the art scene, essays on criticism, and reviews for exhibitions at such places as the Royal Academy and the British Institution. Vol. 1: *1832–1848,* Vol. 2: *1849–1860,* Vol. 3: *1861–1880.*

Printed Indexes to Group Exhibitions

This section is divided into exhibitions at (a) the French salons; (b) during the 18th and 19th centuries in England, Scotland, and Ireland; (c) during the 19th and 20th centuries in North America; and (d) in the 20th century in Europe.

The French Salons

American Art at the Nineteenth-Century Paris Salons, by Lois Marie Fink (Washington, D.C.: National Museum of American Art, 1990)

End of the Salon: Art and the State in the Early Third Republic, by Patricia Mainardi (New York: Cambridge University Press, 1993)

French Salon Artists, 1800–1900, Richard R. Brettell (Chicago: Art Institute of Chicago, 1987)

England, Scotland, and Ireland: 18th and 19th Centuries

British Institution 1806–1867: A Complete Dictionary of Contributors and Their Work from the Foundation of the Institution, compiled by Algernon Graves (London: George Bell and Sons, 1908; reprint ed, West Orange, NJ: Albert Saifer, 1969). Contains an index to portraits, which were chiefly in sculpture.

Century of Loan Exhibitions 1813–1912, compiled by Algernon Graves (5 vols. Originally; some reprints in 3 books. London: H. Graves, 1913–15; reprint ed., New York: Burt Franklin, 1965). Covers important English and Scottish exhibitions, with indexes to portraits and owners.

Dictionary of Artists Who Have Exhibited Works in the Principal London Exhibitions from 1760 to 1893, compiled by Algernon Graves (3rd ed. London: H. Graves, 1901; reprint ed., New York: Burt Franklin, 1970). Records artists who exhibited in shows of 16 societies, including the Society of Artists, Royal Academy, British Institution, and Grosvenor Gallery. No titles of works are listed.

Irish Art Loan Exhibitions 1765–1927: Index of Artists, by Ann M. Stewart (Dublin: Manton, 1990)

Norwich Society of Artists 1805–1833: A Dictionary of Contributors and Their Work, compiled by Miklos Rajnai for the Paul Mellon Center for Studies in British Art (Norfolk, England: Norfolk Museum Service, 1976)

Royal Academy of Arts: A Complete Dictionary of Contributors and Their Work from Its Foundation in 1769 to 1904, compiled by Algernon Graves (8 vols. in 4 books. London: H. Graves, 1905–06; reprint ed., New York: Burt Franklin, 1970). The serials—*Academy Notes*, published between 1875 and 1902, and *Royal Academy Illustrated*, which began publication in 1884—contain reproductions of some displayed works.

Royal Hibernian Academy of Arts: Index of Exhibitors 1826–1979, compiled by Ann M. Stewart. (3 vols. Dublin:

Manton, 1985–87) begins with the first annual exhibition in Dublin.

Royal Scottish Academy 1826–1916: A Complete List of the Exhibited Works by Raeburn and by Academicians, Associates and Hon. Members, compiled under the direction of Frank Rinder (Glasgow: Maclehose & Sons, 1917; reprint ed., Bath, England: Kingsmead, 1975)

Royal Scottish Academy of Painting, Sculpture and Architecture: 1826–1976, by Esme Gordon (Edinburgh: Skilton, 1976)

Royal Society of British Artists, compiled by Maurice Bradshaw (Leigh-on-Sea, England: F. Lewis Publishers). Some volumes indicate prices artists placed on exhibited works.

 Vol. 1: *Members Exhibiting 1824–1892*, 1973
 Vol. 2: *Members Exhibiting 1893–1910*, 1975
 Vol. 3: *Members Exhibiting 1911–1930*, 1975
 Vol. 4: *Members Exhibiting 1931–1946*, 1976
 Vol. 5: *Members Exhibiting 1947–1962*, 1977

Royal Society of British Artists 1824–93, compiled by Jane Johnson (2 vols. Woodbridge: Antique Collectors' Club, 1975). Also listed as *Works of Art Exhibited at the Royal Society of British Artists 1824–1893 and the New English Art Club 1888–1917*. Gives addresses of artists and prices for which items sold.

Society of Artists in Ireland: Index of Exhibits 1765–80, compiled by George Breeze (Dublin: National Gallery of Ireland, 1985)

The Society of Artists of Great Britain 1760–1791: The Free Society of Artists 1761–1783: A Complete Dictionary of Contributors and Their Work from the Foundation of the Societies to 1791, compiled by Algernon Graves (London: G. Bell & Sons, 1907; reprint ed., Bath, England: Kingsmead Reprints, 1969). Provides a brief history and a portrait index.

North America: 19th and 20th Centuries

Consult the Archives of American Art's *Collection of Exhibition Catalogs*, which lists one-person exhibitions by artist's name; see "Locating Reprints of Group Exhibition Catalogues," below.

American Academy of Fine Arts and American Art-Union, by Mary Bartlett Cowdrey (2 vols. New York: New York Historical Society, 1953). Lists European and American works exhibited 1816–52; states artist's status of membership plus some sale prices.

American Art Annual (Published irregularly. New York: R.R. Bowker. 1898+). The early volumes had brief biographical data on artists.

Annual & Biennial Exhibition Record of the Whitney Museum of American Art, 1918–89 edited by Peter Hastings Falk (Madison, CT: Sound View, 1991). Includes the Whitney Studio Club, 1918–28, Whitney Studio Club Galleries, 1928–30, and Whitney Museum of American Art, 1932–89.

Annual Exhibition Record of the Fine Art Institute of Chicago, 1888–1950, edited by Peter Hastings Falk (Madison, CT: Sound View Press, 1990). Includes three annual exhibition series: *Annual Exhibition of American Paintings & Sculpture 1888–1950, Annual Exhibition of Works by Artists of Chicago & Vicinity, 1888–1950,* and *Annual Exhibition of Watercolors by American Artists, 1887–1950 including the International Exhibition of Water Colors, 1921–1943.*

Annual Exhibition Record of the National Academy of Design Exhibition Record, 1901–1950: Incorporating the Annual Exhibitions, 1901–1950 and the Winter Exhibitions, 1906–1932, edited by Peter Hastings Falk (Madison, CT: Sound View Press, 1990)

Annual Exhibition Record of the Pennsylvania Academy of the Fine Arts, edited by Peter Hastings Falk (3 vols. Madison, CT: Sound View, 1988–89). Includes Society of Artists, 1810–14, and Artists' Fund Society, 1835–45.

"Art Gallery of Ontario: Sixty Years of Exhibitions, 1906–1966," by Karen McKenzie and Larry Pfaff; *RACAR*[1] 17 (1980): 62–91.

Biennial Exhibition Record of the Corcoran Gallery of Art, 1907–1967, edited by Peter Hastings Falk (Madison, CT: Sound View Press, 1991)

Boston Art Club 1873–1909: Exhibition Record, 1873–1909, by Janice H. Chadbourne, et al. (Madison, CT: Sound View Press, 1991)

Boston Athenaeum Art Exhibition Index 1827–1874, compiled by Robert F. Perkins Jr. and William J. Gavin III (Boston: Library of the Boston Athenaeum, 1980). Includes more than 1,500 artists from 133 catalogues.

Cumulative Record of Exhibition Catalogues: The Pennsylvania Academy of the Fine Arts 1807–1870; The Society of Artists 1800–1814; The Artists' Fund Society 1835–1845, edited by Anna Wells Rutledge (Philadelphia: American Philosophical Society, 1955). Lists 69 exhibition catalogues of painting and sculpture, with indexes to artists, owners, and subjects.

History of the Brooklyn Art Association with an Index of Exhibitions, compiled by Clark S. Marlor (New York: James F. Carr, 1970). Provides an index to exhibitions, 1859 to 1892.

Index of American Print Exhibitions, 1882–1940, compiled by Raymond L. Wilson (Metuchen, NJ: Scarecrow Press, 1988). Covers the New York Etching Club, Chicago Society of Etchers, California Society of Etchers, Printmakers Society of California, Brooklyn Society of Etchers, Fine Prints of the Year, Fifty Prints of the Year, Panama-Pacific International Exposition, Victoria and Albert Museum, and New York World's Fair. Not all institutions held annual exhibitions. Includes an index to artists.

Index of American Watercolor Exhibitions, 1900–1945, compiled by Raymond L. Wilson (Metuchen, NJ: Scarecrow Press, 1994)

Inventory of the Records of the National Arts Club, 1898–1960, by Catherine Stover (Washington, D.C.: Archives of American Art, Smithsonian Institution, 1990)

Museum Montreal of Fine Arts: Formerly Art Association of Montreal: Spring Exhibitions 1880–1970/Musée des beaux arts du Montreal: Salons du printemps 1880–1970, compiled by Evelyn de Rostaing McMann (Toronto: University of Toronto, 1988). Includes more than 3,000 artists.

National Academy of Design Exhibition Record 1826–1860 (2 vols. New York: New York Historical Society, 1943). Covers the first 35 annual exhibitions and provides membership status. Includes an index of artists, owners, subjects, and places.

National Academy of Design Exhibition Record 1861–1900, compiled by Maria Naylor (2 vols. New York: Kennedy Galleries, 1973)

National Museum of American Art's Index to American Art Exhibition Catalogues: From the Beginning through the 1876 Centennial Year, compiled by James L. Yarnall and William H. Gerdts (6 vols. Boston: G.K. Hall, 1986). Provides multiple access to detailed information from 900 catalogues of U.S. and Canadian exhibitions held before 1877. Includes private collections, galleries, clubs, and fairs, with an extensive subject index.

Royal Canadian Academy of Arts/Academie royale des arts du Canada: Exhibitions and Members 1880–1979, compiled by Evelyn de Rostaing McMann (Toronto: University of Toronto Press, 1981). Indexes more than 3,000 artists. Provides biographical data, Academy status, and, where available, present location of work.

Europe: 20th Century

See above listings under "England, Scotland, and Ireland" for Royal Academy of Arts, Royal Hibernian Academy of Arts, Royal Society of British Artists, and Royal Scottish Academy.

Modern Art Exhibitions 1900–1916: Selected Catalogue Documentation, compiled by Donald E. Gordon (2 vols. Munich: Prestel-Verlag, 1974). Lists works displayed by 426 painters and sculptors in 851 exhibitions of modern art from 1900 to 1916 in 15 countries and 82 cities, whose catalogues were owned by 52 libraries. Volume 1 has a chronological list of exhibition catalogues, over 1,900 small black-and-white illustrations of works by 272 artists, and an index to artists. Volume 2 lists exhibition catalogues and contains an index to cities and exhibitors.

Royal Academy of Arts. Royal Academy Exhibitors 1905–1970: A Dictionary of Artists and Their Work in the Summer Exhibitions of the Royal Academy of Arts (6 vols. in 5 books. Wakefield, Yorkshire, England: E. P. Publishing, 1973–82)

Royal Academy Exhibitors, 1971–89: A Dictionary of Artists and Their Works in the Summer Exhibitions of the Royal Academy of Arts, edited by Charles Baile de Laperriere (Wilshire, England: Hilmarton Manor Presss, 1989)

Locating Reprints of
Group Exhibition Catalogues

Reprints of group exhibition catalogues dating from the 1600s are available. Frequently published in sets, individual titles are not always added to a library's OPAC, thus making it difficult to know exactly what catalogues are in each set. In addition, some of them are issued on microforms, generally located in a separate section of the library. When searching for a specific exhibition catalogue, ask the reference librarian for assistance.

The Archives of American Art. *Collection of Exhibition Catalogs* (Microfilm. Boston: G.K. Hall, 1979). Indexes more than 20,000 exhibition catalogues dating from the early 19th century to the 1960s, with entries arranged by gallery, museum, and atist's name. Artist's name entries cites one-person shows or exhibitions of no more than three people. Also includes many group exhibitions and annual group exhibits listed by gallery. Contact the Archives [XIV-A-8].

Art Exhibition Catalogues on Microfiche (Microfiche. New York: Chadwyck-Healey, n.d.). Reprints the catalogues of more than 3,100 important exhibitions in London (Arts Council of Great Britain 1940–79, Fine Arts Society 1878–1976, Royal Academy of Arts Winter Exhibitions 1852–1976, and Victoria and Albert Museum 1862–1974) and Paris (French Salon Catalogues 1673–1925, Musée des Arts Décoratifs 1904–76, and National Museums of France 1885–1974). Also includes a wide range of catalogues for North American exhibitions: Chicago Museum of Contemporary Art 1967–1976, Los Angeles County Museum of Art 1932–76, and a large number of exhibitons in New York (American Federation of Arts 1929–75, Buchholz Gallery-Curt Valentin 1937–55, Galerie Chalette 1954–70, Sidney Janis Gallery 1950–76, and Solomon R. Guggenheim Museum 1953–72).

Catalogues of the Paris Salon 1673 to 1881, compiled by Horst Woldemar Janson (60 vols. New York: Garland, 1977). Facsimile edition of all 101 livrets issued by the Paris Salon, the official French art exhibition sponsored by the Académie Royale de Peinture et de Sculpture until 1789 and then by the Direction des Beaux-Arts.

Encyclopédie des arts décoratifs et industriels modernes au XXème siècle, Wolfgang M. Freitag, advisory editor (12 vols. New York: Garland, 1977) Facsimile edition of the official publication of the 1925 Paris exhibition. Includes over 1,100 full-page illustrations.

Knoedler Library of Art Exhibition Catalogues on Microfiche (Microfiche. New York: Chadwick-Healey, Knoedler Gallery, 1970s). Covers the collection from the library of M. Knoedler and Company, one of oldest art galleries in New York, of more than 5,200 catalogues from various institutions. Although not every series is complete, it includes most catalogues from Royal Academy of Arts Winter Exhibitions from 1870 to 1927; British Institute Exhibitions from 1813 to 1867; Paris Salons, 1673–1939; Salon d'Automne, 1905–1970; Société des Artistes Français, 1885–1939; individual European exhibition catalogues; and the catalogues of other major national and international expositions and world fairs, as well as those of the Knoedler Galleries. The holdings of catalogues of American exhibitions—which include the National Academy of Design, 1832–1918, and the Pennsylvania Academy, 1812–1969—are extensive.

Modern Art in Paris, 1855 to 1900, selected and organized by Theodore Reff (47 vols. New York: Garland, 1981). Reproduces 200 diversified exhibition catalogues, including those of eight Parisian World's Fairs, 1855–1900; the three Salons of the Independents, 1884–91; the French Salons, 1884–99; the four Salons of the Refusals, including the famous one in 1863; all eight of the Impressionist Exhibitions, in one book entitled *Impressionist Group Exhibitions; the Post-Impressionist shows, 1889–97,* and numerous other exhibition catalogues.

National Gallery of Canada Exhibition Catalogues on Microfiche, 1919–59 (Microfiche. Toronto: McLaren Micropublishing, 1980). Reproduces 167 catalogues on architecture, photography, prints, and book illustrations. For an index, see Garry Mainprize's "The National Gallery of Canada: A Hundred Years of Exhibitions, List and Index," *RACAR* 11(1984): 3–78. Entries include artists in one-person shows, collectors, associations, galleries, museums, and exhibition titles.

Note

1. *RACAR (Revue d'art canadienne/Canadian Art Review)* is the official magazine of the Universities Art Association of Canada.

Appendix Two.
Professional Associations:
Web Sites and Journals

The Web pages of professional associations [V-D] include information important to their membership, data on their publications, and links to pertinent Web sites. Some are producing limited online versions of their publications.

Professional association home pages are sometimes located through an officer's academic affiliation. Consequently, if a member's duties alter within the organization, the URL may also change.

For new addresses or additional associations, try one of the search engines. The College Art Association (CAA) publishes an online Directory of Affiliated Societies <http://www.collegeart.org/caa/professional/affsocieties.html>. Jeanne Brown, architecture slides librarian, University of Nevada at Las Vegas, issues a list of architectural associations <http://www.nscee.edu/univ/Libraries/arch/rsrce/archassn.html>.

American Art Therapy Association
<http://www.arttherapy.org/>
Art Therapy

American Association for Higher Education
<http://www.aahe.org/welcome.htm>
AAHE Bulletin
Change

American Association for State and Local History
<http://www.aaslh.org/>
History News

American Association of Museums (AAM)
<http://www.aam-us.org/>
Aviso
Museum News

American Association of University Professors
<http://www.aaup.org/>
Academe

American Historical Association (AHA)
<http://chnm.gmu.edu/aha/mainpage.html>
Perspectives

American Institute of Architects (AIA)
<http://www.aia.org/>
AI Architect
Architectural Record

American Institute for Conservation (AIC)
<http://palimpsest.stanford.edu/aic/>
Journal of the AIC
AIC News

American Institute of Graphic Arts (AIGA)
<http://www.aiga.org/>
Graphic Design USA
AIGA Journal of Graphic Design

American Library Association (ALA)
<http://www.ala.org/>
American Libraries
Booklist
Choice

American Photographic Historical Society
<http://www.superexpo.com/APHS.htm>
In Focus

American Society for Eighteenth-Century Studies
<http://www.muse.jhu.edu/associations/asecs/>
Eighteenth-Century Studies
Studies in Eighteenth-Century Culture

Archaeological Institute of America
<http://csaws.brynmawr.edu/433.aia.html>
American Journal of Archaeology
<http://classics.lsa.umich.edu/AJA.html>
Archaeology Magazine
<http://www.he.net/~archaeol/>

Art Dealers Association of America
<http://www.artdealers.org/>

Art Libraries Society of North America (ARLIS/NA)
<http://www.lib.duke.edu/lilly/arlis>
ARLIS/NA Update
Art Documentation

Art Libraries Society/United Kingdom & Ireland (ARLIS/UK & Ireland)
<http://arlis.nal.vam.ac.uk/>
Art Libraries Journal
ARLIS/UK & Ireland News-sheet

Association of American Universities (AAU)
<http://www.tulane.edu/~aau/index.html>

Association of Art Historians
<http://scorpio.gold.ac.uk/aah/welcome.html>
Art Book
Art History
Bulletin

Association of Art History
<http://www.indiana.edu/~aah/welcome!.html>

Association of Art Museum Directors (AAMD)
<http://www.AAMD.net/>

Association of College and Research Libraries (ACRL)
<http://www.ala.org/acrl.html>
C&RL

Association of Research Libraries (ARL)
<http://arl.cni.org/>

Association for Asian Studies
<http://www.aasianst.org/>
Asian Studies Newsletter
Bibliography of Asian Studies
Education about Asia
Journal of Asian Studies

Canadian Library Association (CLA)
<http://cla.amlibs.ca/>
Feliciter

College Art Association (CAA)
<http://www.collegeart.org/>
Art Bulletin
Art Journal
CAA News

Computers and History of Art (CHArt)
<http://www.hart.bbk.ac.uk/chart/chart.html>
CHArts Newsletter
Computers and the History of Art

International Center of Medieval Art
<http://medievalart.org/>
Gesta

International Council of Museums (ICOM)
<http://palimpsest.stanford.edu/icom/>

International Federation of Library Associations and Institutions (IFLA)
<http://www.nlc-bnc.ca/ifla/>

Medieval Academy of America
<http://www.georgetown.edu/MedievalAcademy/>
Medieval Academy News
Speculum: A Journal of Medieval Studies

National Art Education Association
<http://www.naea-reston.org/>
Art Education
NEA News
Studies in Art Education

Oral History Association
<http://www.baylor.edu/~OHA/>
OHA Newsletter

Photographic Historical Society of Canada
<http://web.onramp.ca/phsc/index.html>
Photographic Canadiana

Renaissance Society of America
<http://www.r-s-a.org/>
Renaissance News and Notes
Renaissance Quarterly

Royal Architectural Institute of Canada
<http://www.raic.org/>
RAIC Update

Royal Photographic Society of Great Britain
<http://www.rps.org/>
Imaging Science Journal
Photographic Journal

Society for American Archaeology
<http://www.saa.org/>
American Antiquity
Archaeology and Public Education
Latin American Antiquity
SAA Bulletin

Society for the Promotion of Hellenic Studies (London)
<http://www.sas.ac.uk/icls/Hellenic/>
Journal of Hellenic Studies

Society for the Promotion of Roman Studies (London)
<http://www.sas.ac.uk/icls/Roman/>
Journal of Roman Studies
Britannia

Society of Architectural Historians (SAH)
<http://www.sah.org/>
Journal of the Society of Architectural Historians

Special Libraries Association (SLA)
<http://www.sla.org/>
Information Outlook

Visual Resource Association (VRA)
<http://www.vra.oberlin.edu/>
VRA Bulletin
Visual Resources: An International Journal of Documentation
Visual Resources Association Bulletin

Women's Caucus for Art
<http://www.nationalwca.com/>

INDEX

by Kay Banning

All titles are indexed, including specific serial, newspaper, and video documentary titles. Some titles are shortened. Books that are part of a series are listed by their individual titles; the series title is also listed. Numbers are alphabetized as if spelled out. Illustrations are designated by the subheading "illustration of."